Art across Time

Art across Time

VOLUME II

THE THIRTEENTH CENTURY TO THE PRESENT

LAURIE SCHNEIDER ADAMS

John Jay College and the Graduate Center
City University of New York

Boston Burr Ridge, IL Dubuque, IA Madison, WI New York San Francisco St. Louis
Bangkok Bogotá Caracas Lisbon London Madrid Mexico City Milan New Delhi
Seoul Singapore Sydney Taipei Toronto

*To the Memory of Howard McP. Davis
and Rudolf Wittkower*

McGraw-Hill College

A Division of The **McGraw·Hill** *Companies*

Art across Time

Copyright © 1999 by Laurie Schneider Adams. Printed in the
United States of America. Except as permitted under the United
States Copyright Act of 1976, no part of this publication may be
reproduced or distributed in any form or by any means, or
stored in a data base or retrieval system, without the prior
written permission of the publisher.

This book is printed on acid-free paper.

1 2 3 4 5 6 7 8 9 0 DOW/DOW 9 3 2 1 0 9 8

ISBN 0–697–27480–2 (volume 2)

Editorial director: Phillip A. Butcher
Executive editor: Cynthia Ward
Developmental editor: Allison McNamara
Marketing manager: David Patterson
Project manager: Denise Santor-Mitzit
Production supervisor: Scott Hamilton
Photo research coordinator: Keri Johnson
Cover designer: Michael Warrell
Supplement coordinator: Bethany J. Stubbe
Repro house: Articolor, Verona, Italy
Typesetter: Fakenham Photosetting, Norfolk, U.K.
Printer: R. R. Donnelley & Sons Company

This book was designed and produced by
CALMANN & KING LTD
71 Great Russell Street, London WC1B 3BN

Senior managing editor: Richard Mason
Editor: Nell Graville
Copyeditor: Kim Richardson
Designers: Ian Hunt and Linda Henley
Picture researcher: Callie Kendall
Maps by Advanced Illustration

Library of Congress Cataloging-in-Publication Data

Adams, Laurie.
 Art across time / Laurie Schneider Adams.
 p. cm.
 ISBN 0-697-27478-0 (one vol. ed.) 0-697-27479-9 (v. 1)
0-697-27480-2 (v. 2)
 Includes bibliographical references and index.
 1. Art -- History. I. Title.
N5300.A3 1999
709dc—21 98-38707

Cover and halftitle: Paul Cézanne, *Pommes et Biscuits* (*Apples and Bis-
cuits*), c. 1880. Oil on canvas, 18⅛ × 21⅝ in (46 × 55 cm).
Musée national de l'Orangerie, Paris. Giraudon, Paris/Superstock.
Frontispiece: Vincent van Gogh, *Wheatfield with Reaper* (detail), 1889.
Oil on canvas, 29¼ × 36¼ in (74.3 × 92.1 cm).
Vincent van Gogh Foundation/Rijksmuseum, Amsterdam.
Back cover: Baule ancestor, Ivory Coast. Wood, 20½ in (52.1 cm) high.
British Museum, London.

http://www.mhhe.com

Contents

13

Precursors of the Renaissance 449

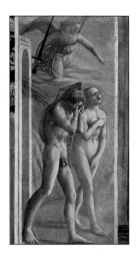

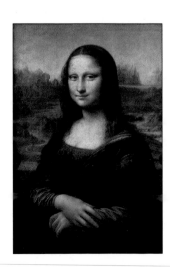

18

The Baroque Style in Western Europe 625

19

Rococo and the Eighteenth Century 675

20

Neoclassicism: The Late Eighteenth and Early Nineteenth Centuries 699

21

Romanticism: The Late Eighteenth and Early Nineteenth Centuries 716

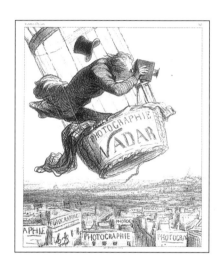

22

Nineteenth-Century Realism 739

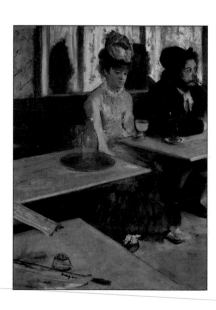

23

Nineteenth-Century Impressionism 762

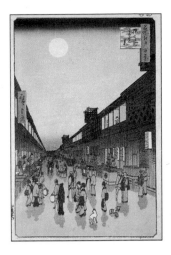

24

Post-Impressionism and the Late Nineteenth Century 792

25

Turn of the Century: Early Picasso, Fauvism, Expressionism, and Matisse 818

28

Abstract Expressionism 883

29

Pop Art, Op Art, Minimalism, and Conceptualism 899

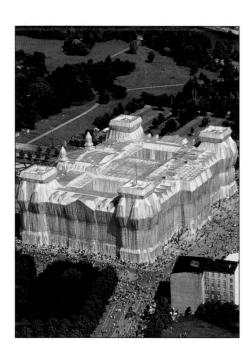

30

Innovation and Continuity 916

Timelines

Maps

Preface

We are bombarded with images from birth and tend to assume that we understand their meaning. But the paradoxical fact is that, although children read pictures before words, a picture is more complex than a word—hence the proverbial "a picture is worth a thousand words." One aim of *Art across Time* is therefore to introduce readers to the complexity of images, while also surveying the history of those images. Context is a particular area of concern, for works of art lose much of their meaning if separated from the time and place in which they were created. Context also includes questions of function, patronage, and the character and talent of the individual artist.

The complexity of the visual arts has led to different approaches to reading images. Throughout the text, therefore, there are discussions of methodology, and there is a brief survey of the modern methodologies of art historical interpretation in the Introduction (and also in Chapter 1 in Volume I). Van Eyck's *Arnolfini Wedding Portrait* is considered from various methodological viewpoints in Chapter 14 (**14.74**), as is Manet's *A Bar at the Folies-Bergère* in Chapter 23 (**23.18**).

While comprehensive, *Art across Time* avoids an encyclopedic approach to art history and attempts instead a more manageable narrative that is suitable for a one-year survey course. Certain key works and artists are given more attention than in some books, while other works and artists are omitted entirely. An effort is made to present the history of art as a dynamic narrative grounded in scholarship, a narrative that is a dialogue between modern viewers and their past.

"Windows on the World"

Sections entitled "Windows on the World" provide an introduction to certain non-Western cultures and their art. They are intended to highlight specific periods within cultures, particularly when they are thematically related to, or have significantly influenced, Western art. Some of the Windows—such as Aboriginal rock paintings in the chapter on prehistory (Volume I, Chapter 2) and Japanese woodblock prints in the chapter on Impressionism (Chapter 23)—are within Western chapters. Others in Volume I—for example those dealing with the Indus Valley Civilization, Olmec culture, and the Far East—are placed chronologically between Western chapters. These Windows offer a sense of the range of world art and remind readers that the history of Western art is only one of the many art historical narratives. These narratives reflect the differences, as well as the similarities, between cultures, and emphasize the complexity of the visual arts by taking Western readers far afield from their accustomed territory and exposing them to unfamiliar ways of thinking about the arts. Like the European artists of the early twentieth century who collected African and Oceanic sculpture in search of new, non-Classical ways of representing the human figure, so viewers who encounter such works for the first time are encouraged to stretch their own limits of seeing and understanding.

Boxes

Within chapters, readers will find "boxes" that encapsulate background information necessary for the study of art. These boxes take students aside, without interrupting the flow of the text, to explain media and techniques, as well as the different philosophies of art from Plato to Marx, Burke to Freud, and Winckelmann to Greenberg. Significant works of literature related to the arts are also covered: epics such as *Gilgamesh*, the *Iliad* and the *Odyssey*, the *Edda*, and *Beowulf* (Volume I), as well as excerpts of Romantic, Dada, and contemporary poetry. A few of the boxes show artists quoting from their predecessors—Horace Pippin quoting Edward Hicks, for example, and Bob Thompson quoting Lucas Cranach and Paul Gauguin. This helps to establish personal artistic genealogies within the broader narrative of art history.

Illustration Program

The illustrations in *Art across Time* are in a consistently large format, which encourages careful looking. Most of the paintings are reproduced in color, and the percentage of color is higher than in any other survey text presently on the market. Two shades of black are used for the black-and-white illustrations, resulting in greater tonal density, and all illustrations are printed on a five-color press for optimal quality. Occasionally, more than one view of a sculpture or a building is illustrated to give readers a sense of its three-dimensional reality. Architectural discussions are enhanced with labeled plans, sections, and axonometric diagrams. Many of the picture captions include anecdotes or biographical information about the artists; these are intended to encourage readers to identify with painters, sculptors, and architects, and they also provide a sense of the role of artists in society. Maps both define geographical context and indicate the changing of national boundaries over time.

Other Pedagogical Features

Languages as well as the visual arts have a history, and the etymology of many art historical terms are therefore provided. This reinforces the meanings of words and reveals their continuity through time. In the chapter on ancient Greece (Volume I), transcriptions of terms and proper names are given according to Greek spelling, with certain

exceptions in deference to convention: Acropolis, Euclid, Socrates, and Laocoön, all of which would have a "k" rather than a "c" in Greek. Likewise, Roman names and terms are given according to Latin transcription. The first time an art historical term appears in the text, it is highlighted in bold to indicate that it is also defined in the glossary at the back of the book.

At the end of each chapter, a chronological timeline of the works illustrated is useful for review purposes. This lists contemporary developments in other fields as well as cross-cultural artistic developments, and it contains selected images for review.

Acknowledgments

Many people have been extremely generous with their time and expertise during the preparation of this text. John Adams has helped on all phases of the book's development. Marlene Park was especially helpful during the formative stages of the one-volume text; others who have offered useful comments and saved me from egregious errors include Paul Barolsky, Hugh Baron, James Beck, Allison Coudert, Jack Flam, Sidney Geist, Mona Hadler, Arnold Jacobs, Donna and Carroll Janis, Carla Lord, Maria Grazia Pernis, Elizabeth Simpson, Leo Steinberg, Rose-Carol Washton Long, and Mark Zucker. Steve Arbury has read the text several times.

For invaluable assistance with the chapters on antiquity, I am indebted to Larissa Bonfante, Professor of Classics at New York University; Ellen Davis, Associate Professor of Art and Archaeology at Queens College, CUNY; and Oscar White Muscarella of the Department of Ancient Near Eastern Art at the Metropolitan Museum of Art, New York.

For assistance with illustrations, I have to thank, among others, ACA Galleries, Warren Adelson, Margaret Aspinwall, Christo and Jeanne-Claude, Anita Duquette, Georgia de Havenon, the Flavin Institute, Duane Hanson, M. Knoedler and Co., Inc., Thomas Messer, John Perkins, Jim Romano, Irving Sandler, Sidney Janis Gallery, Ronald Feldman Gallery, Robert Miller Gallery, Pace Gallery, and Allan Stone Gallery.

I would like to thank the following readers of the proposal and/or manuscript whose advice has shaped the finished book in many positive ways: Jeffrey C. Anderson, George Washington University; Charlene Villaseñor Black, University of New Mexico; Bill Bryant, Northwestern State University; Kathleen Burke-Kelly, Glendale Community College; Deborah H. Cibelli, Youngstown State University; Andrew L. Cohen, University of Central Arkansas; Ann Glenn Crowe, Virginia Commonwealth University; Jeffrey Dalton, University of North Texas; Carol E. Damian, Florida International University; Kevin Dean, Ringling School of Art and Design; Mark S. Deka, Edinboro University of Pennsylvania; Michael H. Duffy, East Carolina University; Martha Dunkelman, Canisius College; James Farmer, Virginia Commonwealth University; Dorothy B. Fletcher, Emory University; Phyllis Floyd, Michigan State University; Elizabeth L. Flynn-Chapman, Longwood College; Norman Gambill, South Dakota State University; Larry Gleeson, University of North Texas; Thomas Hardy, Northern Virginia Community College; Sandra C. Haynes, Pasadena City College; Felix Heap, Boise State University; Michael Heinlen, University of North Texas; Sandra J. Jordan, University of Montevallo; Ellen Kosmer, Worcester State College; Kathryn Kramer, Purdue University, West Lafayette; Nancy LaPaglia, Daley College; Cynthia Lawrence, Temple University; Carla Lord, Kean College of New Jersey; Brian Madigan, Wayne State University; Susan Madigan, Michigan State University; Richard Mann, San Francisco State University; Virginia Marquardt, Marist College; Julia I. Miller, California State University, Long Beach; Joanne Mannell Noel, Montana State University; Christina J. Riggs, Boston Museum of Fine Arts; Howard Rodee, University of New Mexico; Adrienne Michel Sager, Madison Area Technical College; Patricia B. Sanders, San Jose State University; Fred T. Smith, Kent State University; Stephen Smithers, Indiana State University; Elizabeth Tebow, Northern Virginia Community College; J. N. Thompson, San Jose State University; Robert Tracy, University of Nevada, Las Vegas; Barry Wind, University of Wisconsin, Milwaukee; Astri Wright, University of Victoria.

I would also like to thank Sabra Maya Feldman, whose editing on Volume I was very helpful, and the team at McGraw-Hill: Allison McNamara, Kari Grimsby, David Patterson, Anne Sachs, Scott Hamilton, Michael Warrell, and Denise Santor-Mitzit, and especially executive editor Cynthia Ward, who oversaw the entire management of the project. At Calmann & King, I am grateful for the work of Richard Mason, who supervised the editing process and art program with great skill and good humor, picture researcher Callie Kendall, designers Ian Hunt and Linda Henley, editor Nell Graville, editorial director Lee Ripley Greenfield, and production director Judy Rasmussen.

Laurie Schneider Adams
New York, 1998

Introduction

Why Do We Study the History of Art?

We study the arts and their history because they teach us about our own creative expressions and those of our past. Studying the history of art is one way of exploring human cultures—both ancient and modern—that have not developed written documents.

Art is also a window onto human thought and emotion. For example, van Gogh's self-portraits are explicitly autobiographical. From what is known about his life, he was sustained by his art. In figure **1.1** he depicts himself behind a painting that we do not see, even though we might suspect that it, too, is a self-portrait. For there are several elements in the visible painting that assert the artist's presence. Van Gogh's self-image predominates; he holds a set of brushes and a palette of unformed paint composed of the same colors used in the picture. At the center of the palette is an intense orange, the distinctive color of his beard, as well as of his name (Vincent) and the date ('88), with which he simultaneously signs both the painting we see and the painting we do not see.

The arts exemplify the variety of creative expression from one culture to the next. This book surveys the major periods and styles of Western art, with certain highlights of non-Western art included to give readers a sense of differences—as well as similarities—in works of art around the world.

In the West, the major visual arts fall into three broad categories: pictures, sculpture, and architecture. Pictures (from the Latin *pingo*, meaning "I paint") are two-dimensional images (from the Latin *imago*, meaning "likeness") with height and width, and are usually flat. Pictures are not only paintings, however: they include mosaics, stained glass, tapestries, drawings, prints, and photographs.

Sculptures (from the Latin *sculpere*, meaning "to carve"), unlike pictures, are three-dimensional: besides height and width, they have depth. Sculptures have traditionally been made of a variety of materials such as stone, metal, wood, and clay. More modern materials include glass, plastics, cloth, string, wire, television monitors, and even animal carcasses.

Architecture, which literally means "high (*archi*) building (*tecture*)," is the most utilitarian of the three categories.

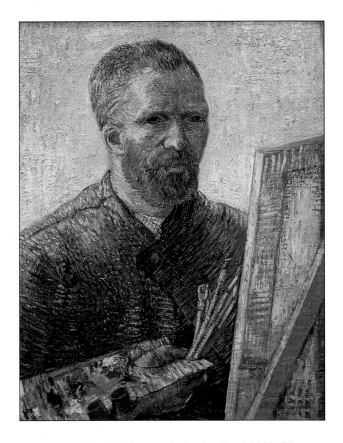

1.1 Vincent van Gogh, *Self-portrait Before his Easel*, 1888. Oil on canvas, 25¾ in × 19⅞ in (65.5 × 50.5 cm). Rijksmuseum, Amsterdam. Vincent van Gogh Foundation.

Buildings are designed to enclose and order space for specific purposes. They often contain pictures and sculptures, as well as other forms of visual art.

The Artistic Impulse

Art is a vital and persistent aspect of human experience. But where does the artistic impulse originate? We can see that it is inborn by observing children, who make pictures, sculptures, and model buildings before learning to read or

write. Children trace images in dirt, build snowmen and sandcastles, and decorate just about anything from their own faces to the walls of their houses. All are efforts to impose order on disorder and to create form from form-lessness.

In the adult world, creating art is a continuation and development of the child's inborn impulse to play. This is clear from the statements of artists themselves: Picasso said that he was unable to learn math, because every time he looked at the number 7 he thought he saw an upside-down nose. The self-taught American artist Horace Pippin described his impulse to attach drawings to words when learning to spell. But the art created by adults takes on different meanings, which are cultural as well as individual.

The Values of Art

Works of art are valued not only by artists and patrons, but also by entire cultures. In fact, the periods of history that we tend to identify as the high points of human achievement are those in which art was most highly valued and encouraged.

Material Value

Works of art may be valued because they are made of a precious material. Through the centuries art objects have been stolen and plundered, in disregard of their cultural, religious, or artistic significance, simply because of the value of their materials. Even the monumental cult statue of Athena in the Parthenon disappeared without a trace, presumably because of the value of the gold and ivory from which it was made.

Intrinsic Value

A work of art may contain valuable material, but that is not the primary basis on which its quality is judged. Its intrinsic value depends largely on the general assessment of the artist who created it, and on its own esthetic character. The *Mona Lisa*, for example, is made of relatively modest materials—paint and wood—but it is a priceless object nonetheless, and arguably the Western world's most famous image. Leonardo da Vinci, who painted it around 1503 in Italy, was acknowledged as a genius in his own day, and his work has stood the test of time. The paintings of the late nineteenth-century Dutch painter Vincent van Gogh have also endured, although he was ignored in his lifetime. It was not until after his death that the esthetic value of his work was widely recognized. In the 1980s one of van Gogh's paintings was bought by a Japanese collector for $80 million. Intrinsic value is not always apparent, and in fact it varies in different times and places, as we can see in the changing assessment of van Gogh's works. "Is it art?" is a familiar question, which expresses the difficulty of defining "art" and of recognizing the esthetic value of an object (see Box).

Religious Value

One of the traditional ways in which art has been valued is in terms of its religious significance. Paintings and sculptures depicting gods and goddesses make their images accessible. Such buildings as the Mesopotamian **ziggurat** (stepped tower), temples in many cultures, and Christian churches have served as symbolic dwellings of the gods, relating worshipers to their deities. Tombs express belief in an afterlife. During the European Middle Ages, art often served an educational function. One important way of communicating Bible stories and legends of the saints to a largely illiterate population was through the sculptures, paintings, mosaics, wall-hangings, and stained-glass windows in churches. Beyond its didactic (teaching) function, the religious significance of a work of art may be so great that entire groups of people identify with the object. The value of such a work is highlighted when it is taken away. In 1973, the Afo-a-Kom—a sacred figure embodying the soul of an African village in Cameroon—disappeared. The villagers reportedly fell into a depression when they discovered that their statue was missing. The subsequent reappearance of the Afo-a-Kom in the window of a New York art gallery caused an international scandal that subsided only after the statue was returned to its African home.

Nationalistic Value

Works of art have nationalistic value inasmuch as they express the pride and accomplishment of a particular culture. But works of art need not represent national figures, or even national or religious themes, to have nationalistic value. In 1945, at the end of World War II, the Dutch authorities arrested an art dealer, Han van Meegeren, for treason. They accused him of having sold a painting by the great seventeenth-century Dutch artist Jan Vermeer to Hermann Goering, the Nazi Reichsmarschall and Hitler's most loyal supporter. When van Meegeren's case went to trial, he lashed out at the court: "Fools!" he cried, "I painted it myself." What he had sold to the Nazis was actually his own forgery, and he proved it by painting another "Vermeer" under supervision while in prison. It would have been treason to sell Vermeer's paintings, which are considered national treasures, to the German enemy.

Another expression of the nationalistic value of art can be seen in recent exhibitions made possible by shifts in world politics. Since the end of the Cold War between communist eastern Europe and the West, Russia has been sending works of art from its museums for temporary exhibitions in the United States. In such circumstances, the traveling works become a kind of diplomatic currency, improving relations between nations.

The nationalistic value of certain works of art has frequently made them spoils of war. In the early nineteenth century, when Napoleon's armies overran Europe, they plundered thousands of works of art that are now part of

Brancusi's *Bird*: Manufactured Metal or a Work of Art?

A trial held in New York City in 1927 illustrates just how hard it can be to agree on what constitutes "art." Edward Steichen, a prominent American photographer, had purchased a bronze sculpture entitled *Bird in Space* (fig. 1.2) from the Romanian artist Constantin Brancusi, who was living in France. Steichen imported the sculpture to the United States, whose laws do not require payment of customs duty on original works of art as long as they are declared to customs on entering the country. But when the customs official saw the *Bird*, he balked. It was not art, he said: it was "manufactured metal." Steichen's protests fell on deaf ears. The sculpture was admitted into the United States under the category of "Kitchen Utensils and Hospital Supplies," which meant that Steichen had to pay $600 in import duty.

Later, with the financial backing of Gertrude Vanderbilt Whitney, an American sculptor and patron of the arts, Steichen appealed the ruling of the customs official. The ensuing trial received a great deal of publicity. Witnesses discussed whether the *Bird* was a bird at all, whether the artist could make it a bird by calling it one, whether it could be said to have characteristics of "birdness," and so on. The conservative witnesses refused to accept the work as a bird because it lacked certain biological attributes, such as wings and tail feathers. The more progressive witnesses pointed out that it had birdlike qualities: upward movement and a sense of spatial freedom. The court decided in favor of the plaintiff. The *Bird* was declared a work of art, and Steichen got his money back. In today's market, a Brancusi *Bird* would sell for millions of dollars.

1.2 Constantin Brancusi, *Bird in Space*, 1928. Bronze, unique cast, 54 × 8½ × 6½ in (137.2 × 21.6 × 16.5 cm). Museum of Modern Art, New York. Given anonymously. Photograph © 1999 The Museum of Modern Art. Brancusi objected to the view of his work as abstract. In a statement published shortly after his death in 1957, he declared: "They are imbeciles who call my work abstract; that which they call abstract is the most realist, because what is real is not the exterior form but the idea, the essence of things."

the French national art collection in the Musée du Louvre, in Paris.

The nationalistic value of art can be so great that countries whose works have been taken go to considerable lengths to recover them. Thus, at the end of World War II, the Allied Army assigned a special division to recover the vast numbers of artworks stolen by the Nazis. A United States army taskforce discovered Hermann Goering's two personal hoards of stolen art in Bavaria, one in a medieval castle and the other in a bomb-proof tunnel in nearby mountains. The taskforce arrived just in time, for Goering had equipped an "art train" with thermostatic temperature control to take "his" collection to safety. At the Nuremberg war trials, Goering claimed that his intentions had been purely honorable: he was protecting the art from air raids.

Modern legislation in some countries is designed to avoid similar problems by restricting or banning the export of national treasures. International cooperation agreements attempt to protect cultural property and archaeological heritage worldwide.

Psychological Value

Another symbolic value of art is psychological. Our reactions to art span virtually the entire range of human emotion. They include pleasure, fright, amusement, avoidance, and outrage.

One of the psychological aspects of art is its ability to attract and repel us, and this is not necessarily a function of whether or not we find a particular image esthetically pleasing. People can become attached to a work of art, as Leonardo was to his *Mona Lisa*. Instead of delivering it to the patron, Leonardo kept the painting until his death. Conversely, one may wish to destroy certain works because they arouse anger. In London in the early twentieth century, an angry suffragette slashed Velázquez's *Rokeby Venus* because she was offended by what she considered to be its sexist representation of a woman. During the French Revolution of 1789, mobs protesting the injustices of the royal family destroyed statues and paintings of earlier kings and queens. In 1989 and 1990, when eastern Europe began to rebel against communism, the protesters tore down statues of their former leaders. Such examples illustrate intense responses to the symbolic power of art.

Art and Illusion

Before considering illusion and the arts, it is necessary to point out that when we think of illusion in connection with an image, we usually assume that the image is true to life, or naturalistic (cf. **naturalism**). This is often, but not always, the case. With certain exceptions, such as some Judaic and Islamic art, Western art was mainly representational until the twentieth century. **Representational**, or **figurative**, art depicts recognizable natural forms or created objects (see "Stylistic Terminology," p. xxxi). When the subjects of representational pictures and sculptures are so convincingly portrayed that they may be mistaken for the real thing, they are said to be illusionistic (cf. **illusionism**). Where the artist's purpose is to fool the eye, the effect is described by the French term *trompe-l'oeil*.

The deceptive nature of pictorial illusion was simply but eloquently stated by the Belgian Surrealist painter René Magritte in *The Betrayal of Images* (see Box). This work is a convincing (although not a *trompe-l'oeil*) rendition of a pipe. Directly below the image, Magritte reminds the viewer that in fact it is not a pipe at all—"Ceci n'est pas une pipe" ("This is not a pipe") is Magritte's explicit message. To the extent that observers are convinced by the image, they have been betrayed. Even though Magritte was right about the illusion falling short of reality, the observer nevertheless enjoys having been fooled.

The pleasure produced by *trompe-l'oeil* images is reflected in many anecdotes, perhaps not literally true but illustrations of underlying truths. For example, the ancient Greek artist Zeuxis was said to have painted grapes so realistically that birds pecked at them. In the Renaissance, a favorite story recounted that the painter Cimabue was so deceived by Giotto's realism that he tried to brush off a fly

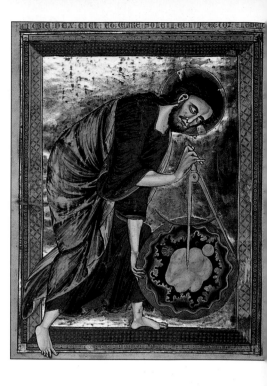

1.4 *God as Architect (God Drawing the Universe with a Compass)*, from the *Bible moralisée*, Reims, France, fol. 1v, mid-13th century. Illumination, 8⅓ in (21.2 cm) wide. Österreichische Nationalbibliothek, Vienna.

Images and Words

Artists express themselves through a visual language which has pictorial, sculptural, and architectural rather than verbal elements. As a result, no amount of description can replace the direct experience of viewing art. The artist's language consists of formal elements—line, shape, space, color, light, dark, and so forth (see "The Language of Art," p. xxvii)—whereas discussion about art is in words. Imagine, for example, if the words in Magritte's *The Betrayal of Images* (fig. 1.3) read "This is a pipe" (*Ceci est une pipe*) instead of "This is not a pipe" (*Ceci n'est pas une pipe*), or even only "Pipe." Although we might receive the same meaning of "pipeness" from both the word and the image, our experience of the verbal description would be quite different from our experience of its subject.

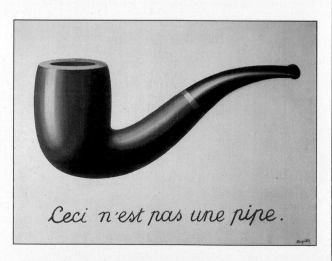

Ceci n'est pas une pipe.

1.3 René Magritte, *The Betrayal of Images* ("This is Not a Pipe"), 1928. Oil on canvas, 23½ × 28½ in (55 × 72 cm). Los Angeles County Museum of Art, California.

that Giotto had painted on a figure's nose. The twentieth-century American sculptor Duane Hanson was a master of *trompe-l'oeil*. He used synthetic materials to create statues which look so alive that it is not unusual for people to approach and speak to them.

Traditions Equating Artists with Gods

The fine line between reality and illusion, and the fact that gods are said to create reality while artists create illusion, have given rise to traditions equating artists with gods. Both are seen as creators, the former making replicas of nature and the latter making nature itself. Alberti referred to the artist as an *alter deus*, Latin for "other god," and Dürer said that artists create as God did. Leonardo wrote in his *Notebooks* that artists are God's grandsons and that painting, the grandchild of nature, is related to God. Giorgio Vasari, the Italian Renaissance biographer of artists, called Michelangelo "divine," a reflection of the notion of divine inspiration. The nineteenth-century American painter James McNeill Whistler declared that artists are "chosen by the gods."

Artists have been compared with gods, and gods have been represented as artists. In ancient Babylonian texts, God is described as the architect of the world. In the Middle Ages, God is sometimes depicted as an architect drawing the universe with a compass (fig. **1.4**). Legends in the Apocrypha, the unofficial books of the Bible, portray Christ as a sculptor who made clay birds and breathed life into them. Legends such as these are in the tradition of the supreme and omnipotent male artist-as-genius, and they reflect the fact that the original meaning of "genius" was "divinity."

The comparison of artists with gods, especially when artists make lifelike work, has inspired legends of rivalry between these two types of creator. Even when the work itself is not lifelike, the artist may risk incurring divine anger. For example, the Old Testament account of the

Tower of Babel illustrates the dangers of building too high and rivaling God by invading the heavens. God reacted by confounding the speech of the builders, so that they seemed to each other to be "babbling" incomprehensibly. They scattered across the earth, forming different language groups. In the sixteenth-century painting by the Flemish artist Pieter Bruegel the Elder (fig. **1.5**), the Tower of Babel seems about to cave in from within, although it does not actually do so. Bruegel's tower is thus a metaphor for the collapsed ambition of the builders.

Art and Identification

Reflections and Shadows: Legends of How Art Began

Belief in the power of images extends beyond the work of human hands. In many societies, not only certain works of art but also reflections and shadows are thought to embody the spirit of an animal, or the soul of a person. Ancient traditions trace the origin of image-making to drawing a line around a reflected image or shadow. Alberti recalled the myth of Narcissus—a Greek youth who fell in love with his own image in a pool of water—and compared the art of painting to the reflection. The Roman writer Quintilian, on the other hand, identified the first painting as a line traced around a shadow. A Buddhist tradition recounts that the Buddha was unable to find an artist who could paint his portrait. As a last resort, he had an outline drawn around his shadow and filled it in with color himself.

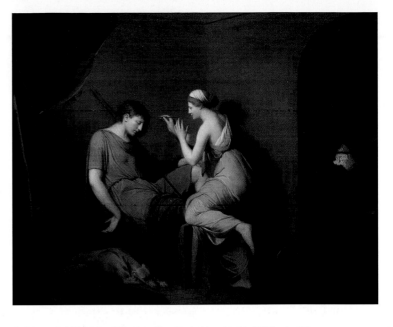

1.6 Joseph Wright of Derby, *The Corinthian Maid*, 1782–4. Oil on canvas, 41⅞ × 51½ in (1.06 × 1.30 m). National Gallery of Art, Washington, D.C. Paul Mellon Collection.

A Greek legend attributes the origin of portraiture to a young woman of Corinth, who traced the shadow of her lover's face cast on the wall by lamplight. Her father, a potter, filled in the outline with clay, which he then fired. This story became particularly popular during the Romantic period in Europe and has been memorialized in *The Corinthian Maid* (fig. **1.6**) by the English painter, Joseph Wright of Derby. Legends such as this indicate that works of art are inspired not only by the impulse to create form, but also by the discovery or recognition of forms that already exist, and the wish to capture and preserve them.

1.5 Pieter Bruegel the Elder, *The Tower of Babel*, 1563. Tempera on panel, 3 ft 9 in × 5 ft 1 in (1.14 × 1.55 m). Kunsthistorisches Museum, Vienna.

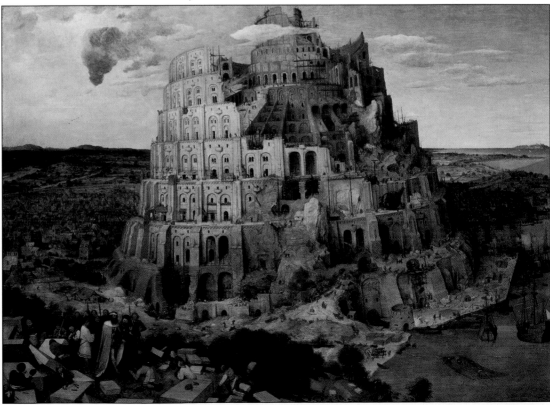

Image Magic

People in many cultures believe that harm done to an image of someone will hurt the actual person. In sixteenth-century England, Queen Elizabeth I's advisers summoned a famous astrologer to counteract witchcraft when they discovered a wax effigy of the queen stuck through with pins.

Sometimes, usually in cultures without strong traditions of figural art, people fear that pictures of themselves may embody—and snatch away—their souls. Many nineteenth-century Native Americans objected to having their portraits painted. One of the outsiders who did so was the artist George Catlin, whose memoirs record suspicious and occasionally violent reactions. Even today, with media images permeating so much of the globe, people in remote areas may resist being photographed for fear of losing themselves. In fact, the very language we use to describe photography reflects this phenomenon: we "take" pictures and "capture" our subjects on film.

Portraits can also create very strong impressions. The nineteenth-century English art critic John Ruskin fell in love with an image on two separate occasions. He became so enamored with the marble tomb effigy of Ilaria del Caretto in Lucca, Italy, that he wrote letters home to his parents describing the statue as if it were a living girl. Later, when Ruskin was in an even more delusional state, he persuaded the Accademia, a museum in Venice, to lend him a painting of Saint Ursula by the sixteenth-century artist Carpaccio. Ruskin kept it in his room for six months and became convinced that he had been reunited with his former fiancée, a young Irish girl named Rose la Touche, whom he merged in his mind with the painted saint. A less extreme form of the identification of a woman with an image concerns Whistler's famous portrait of his mother (fig. **1.7**). "Yes," he replied when complimented on the picture. "One does like to make one's mummy just as nice as possible."

In the modern era, as societies have become increasingly technological, traditional imagery seems to have lost some of its magic power. But art still engages us. A peaceful **landscape** painting, for example, provides a respite from everyday tensions as we contemplate its rolling hills or distant horizon. A **still life** depicting fruit in a bowl reminds us of the beauty inherent in objects we take for granted. And it remains true that abstract works of art containing no recognizable objects or figures can involve us in the rhythms of their shapes, the movements of their lines, and the moods of their colors. Large public sculptures, many of which are **nonrepresentational**, mark our social spaces and humanize them. Architecture, too, defines and enriches our environment. In addition, contemporary images, many in electronic media, exert power over us in both obvious and subtle ways by drawing on our image-making traditions. Movies and television affect our tastes and esthetic judgments. Advertising images influence our decisions—what we buy and which candidates we vote for. Computer-based art is one of the fastest

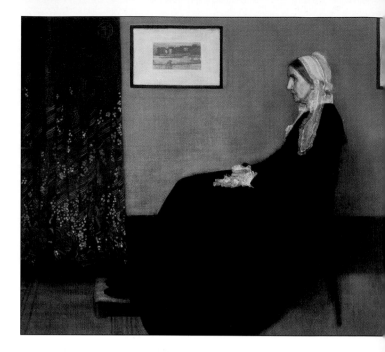

1.7 James Abbott McNeill Whistler, *Arrangement in Black and Gray (Portrait of the Artist's Mother)*, 1871. Oil on canvas, 4 ft 9 in × 5 ft 4½ in (1.45 × 1.64 m). Musée d'Orsay, Paris.

growing art fields. Such modern media use certain traditional techniques of image-making to convey their messages.

Architecture

As is true of pictorial and sculptural images, architecture evokes a response by identification. A building may seem inviting or forbidding, gracious or imposing, depending on how its appearance strikes the viewer. One might think of a country cottage as welcoming and picturesque, or of a haunted house as endowed with the spirits of former inhabitants who inflict mischief on trespassers.

Architecture is more functional, or utilitarian, than pictures and sculptures. Usually the very design of a building conforms to the purpose for which it was built. The criterion for a successful building is not only whether it looks good, but also whether it fulfills its function well. A hospital, for example, may be esthetically pleasing, but its ultimate test is whether it serves the patients and medical staff adequately. A medieval castle was not only a place to live, it was also a fortress requiring defensive features such as a moat, towers, small windows, and thick walls.

Beyond function, the next most important consideration in architecture is its use of space. The scale (size) of buildings and the fact that, with very few exceptions, they can enclose us make our response to them significantly different from our reactions to either pictures or sculptures. Pictures convey only the illusion of space. Sculptures occupy actual, three-dimensional space, although the observer generally remains on the outside of that space looking in.

In the ancient world many buildings, such as Egyptian pyramids and Greek temples, were intended to be experi-

enced either exclusively or primarily from the outside. Access to their inner sanctuaries was frequently restricted. Psychologically as well as esthetically, therefore, our response to architecture is incomplete until we have experienced it physically. Because such an experience involves time and motion as well as vision, it is particularly challenging to describe architecture through words and pictures.

The experience of architectural space appears in everyday language. We speak of "insiders" and "outsiders," of being "in on" something, and of being "out of it." The significance of "in" and "out" recurs in certain traditional architectural arrangements. In parts of the ancient world the innermost room of a temple, its sanctuary, was considered the most sacred, the "holy of holies" which only a high priest or priestess could enter. Likewise, an appointment with a VIP is often held in an inner room which is generally closed to the public at large. Access is typically through a series of doors, so that in popular speech we say of people who have influence that they can "open doors."

Our identification with the experience of being inside begins before birth. Unborn children exist in the enclosed space of their mother's womb, where they are provided with protection, nourishment, and warmth. This biological reality has resulted in a traditional association between women and architecture. In Christianity, the intuitive relationship between motherhood and architecture gave rise to a popular metaphor. This equated the Virgin Mary (as mother of Christ) with the Church building itself. This metaphor is given visual form in Jan van Eyck's fifteenth-century oil painting *The Virgin in a Church* (fig. **1.8**). Here Mary is enlarged in relation to the architecture, identifying her with the Church as the house of God. Van Eyck portrays an intimacy between the Virgin and Christ that evokes both the natural closeness of mother and child and the spiritual union between the human and the divine.

1.8 Jan van Eyck, *The Virgin in a Church*, c. 1410–25. Oil on panel, 12¼ × 5½ in (31 × 14 cm). Gemäldegalerie, Staatliche Museen, Berlin. It is thought that, given the narrowness of this picture, it may originally have been part of a **diptych**— a work of art consisting of two panels— in which case the other section is lost.

This union is an important aspect of the sense of space in religious architecture. For example, Gothic cathedrals, such as the one in van Eyck's picture, contain several references to it. The vast interior spaces of such buildings are awe-inspiring, making worshipers feel small compared to an all-encompassing God. The upward movement of the interior space, together with the tall towers and spires on either side of the entrance, echo the Christian belief that paradise is up in the heavens. The rounded spaces of certain other places of worship, such as the domed ceilings of some mosques, likewise symbolize the dome of heaven. In a sense, then, these religious buildings stand as a kind of transitional space between earth and sky, between our limited time on earth and beliefs about infinite time, or eternity.

Just as we respond emotionally and physically to the open and closed spaces of architecture, so our metaphors indicate our concern for the structural security of our buildings. "A house of cards" or a "castle in the air" denotes instability and irrational thinking. Since buildings are constructed from the bottom up, a house built on a "firm foundation" can symbolize stability, even rational thinking, forethought, and advance planning. In the initial stages of a building's conception, the architect makes a plan. Called a **ground plan**, or floor plan, it is a detailed drawing of each story of the structure indicating where walls and other architectural elements are located. Although in everyday speech we use the term "to plan" in a figurative sense, unless the architect constructs a literal and well-thought-out plan, the building, like a weak argument, will not stand up.

Art Collecting

In Europe, art collecting for the intrinsic value of the works began considerably later, in Hellenistic Greece (323–31 B.C.). Romans plundered Greek art, and also had a thriving industry copying Greek art, which was collected, especially by emperors. During the Middle Ages, the Christian Church was the main collector of art in Europe.

Interest in collecting ancient art revived in the West during the Renaissance, and continued in royal families for several centuries. Some of these royal collections then became the basis for major

museums; in the late eighteenth century, the Louvre was opened in Paris, and the Russian and British royal collections were opened to the public in the early nineteenth century. By that time more and more private individuals collected art, and since then dealers, auction houses, museums, and the media have further expanded collecting.

The Methodologies of Art History

The complexity of images has led to the development of various interpretative approaches. Principal among these so-called methodologies of art historical analysis are formalism, iconography and iconology, Marxism, feminism, biography and autobiography, semiology, deconstruction, and psychoanalysis.

Formalism

Chronologically, the earliest codified methodology is **formalism**, which grew out of the nineteenth-century esthetic of "Art for Art's Sake"—artistic activity as an end in itself. Adherents of pure formalism view works of art independently of their context, function, and **content**. They respond to the formal elements and to the esthetic effect that the arrangement of those elements creates. Two philosophers, Plato in ancient Greece and Immanuel Kant in eighteenth-century Germany, can be seen as precursors of formalist methodology. They believed in an ideal, essential beauty that transcends time and place. Other formalist writers on art did relate changes in artistic style to cultural change. This approach was demonstrated by the Swiss art historian Heinrich Wölfflin, considered one of the founders of modern art history. In his *Principles of Art History*, first published in German in 1915, he demonstrated the formal consistency of Renaissance and Baroque styles.

In order to grasp the effect of formal elements, let us take as an example Brancusi's *Bird in Space* (see fig. 1.2). Imagine how different it would look lying in a horizontal plane. A large part of the effect of the work depends on its verticality. But it also has curved outlines, sleek proportions, and a highly reflective bronze surface. Its golden color might remind one of the sun and thus reinforce the association of birds and sky. Imagine if the *Bird* were made of another material (Brancusi did make some white marble *Birds*): its esthetic effect would be very different.

1.9 Meret Oppenheim, *Fur-covered Cup, Saucer, and Spoon (Le Déjeuner en Fourrure)*, 1936. Cup 4⅜ in (10.9 cm) diameter; saucer 9⅜ in (23.7 cm) diameter; spoon 8 in (20.2 cm) long; overall height 2⅞ in (7.3 cm). Museum of Modern Art, New York. Photograph © 1999 Museum of Modern Art.

Even more radical an idea: what if the texture of the *Bird* were furry instead of hard and smooth? Consider, for example, the *Fur-covered Cup, Saucer, and Spoon* of 1936 (fig. **1.9**) by the Swiss artist Meret Oppenheim. When we experience the formal qualities of texture in these two sculptures, we respond to the *Bird* from a distance, as if it were suspended in space, as the title indicates. But the *Cup* evokes an immediate tactile response because we think of drinking from it, of touching it to our lips, and its furry texture repels us. At the same time, however, the *Cup* amuses us because of its contradictory nature. Whereas our line of vision soars vertically *with* the *Bird*, we instinctively withdraw *from* the *Cup*.

Iconography and Iconology

In contrast to formalism, the **iconographic** method emphasizes content over form in individual works of art. The term itself denotes the "writing" (*graphe* in Greek) of an image (from the Greek *eikon*), and implies that a written text underlies an image. In Bruegel's *Tower of Babel* (see fig. 1.5) the biblical text is Genesis 11:6, in which God becomes alarmed at the height of the tower. He fears that the builders will invade his territory and threaten his authority. The iconographic elements of Bruegel's picture include the tower, as well as the figures and other objects depicted. The actual tower referred to in the Bible was probably a ziggurat commissioned by King Nebuchadnezzar of ancient Babylon, who is depicted with his royal entourage at the lower left of the picture. He has apparently come to review the progress of the work, which—according to the text—is about to stop. Bruegel shows this by the downward pull at the center of the tower that makes it seem about to cave in. He also refers to God's fear that the tower will reach into the heavens by painting a small, white cloud overlapping the top of the tower. The cloud thus heightens dramatic tension by referring to the divine retribution that will follow. Recognizing the symbolic importance of this iconographic detail significantly enriches our understanding of the work as a whole.

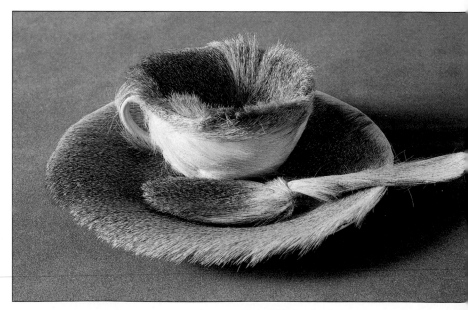

Iconology refers to the interpretation or rationale of a group of works, which is called a **program**. In a Gothic cathedral, for example, an iconographic approach would consider the textual basis for a single statue or scene in a stained-glass window. Iconology, on the other hand, would consider the choice and arrangement of subjects represented in the entire cathedral, and explore their interrelationships.

Marxism

The Marxist approach to art history derives from the writings of Karl Marx, the nineteenth-century German social scientist and philosopher whose ideas were developed into the political doctrines of socialism and communism. Marx himself, influenced by the Industrial Revolution, was interested in the process of making art and its exploitation by the ruling classes. He contrasted the workers (proletariat) who create art with the property-owning classes (the bourgeoisie) who exploit the workers, and believed that this distinction led to the alienation of artists from their own productions. Marxist art historians, and those influenced by Marxism, study the relationship of art to the economic factors (e.g. cost and availability of materials) operating within its social context. They analyze patronage in relation to political and economic systems. Marxists study form and content not for their own sake, but for the social messages they convey and for evidence of the manipulation of art by the ruling class to enhance its own power.

A Marxist reading of the message of Bruegel's *Tower* might associate the builders with the proletariat and God with the bourgeoisie. In between is Nebuchadnezzar who, because he is a king, is not punished as the workers are. It is they who assume the brunt of God's anger; their language is confounded and they are scattered across the earth, whereas Nebuchadnezzar continues to rule his empire. Bruegel emphasizes the greater importance of Nebuchadnezzar in relation to the workers by his larger size, his upright stance, and his royal following. The workers are not only much smaller, but some kneel before the king.

Feminism

Feminist methodology assumes that the making of art, as well as its iconography and its reception by viewers, is influenced by gender. Like Marxists, feminists are opposed to pure formalism on the grounds that it ignores the message conveyed by content. Feminist art historians have pointed out ways in which women have been discriminated against by the male-dominated art world. They have noted, for example, that before the 1970s the leading art history textbooks did not include female artists. Through their research, they have also done a great deal to establish the importance of women's contributions to art history as both artists and patrons—rescuing significant figures from obscurity as well as broadening our sense of the role of art in society. Feminists take issue with traditional definitions of art and notions of artistic genius, both of which have historically tended to exclude women. The fact that traditionally it has been difficult for women to receive the same training in art as men, due in part to family obligations and the demands of motherhood and partly to social taboos, is an issue which the feminists have done much to illuminate.

Taking the example of this introductory chapter, a feminist might point out that of fourteen illustrations of works of art only one is by a woman (Meret Oppenheim, see fig. 1.9). Furthermore, its subject is related to the woman's traditional role as the maker and server of food in the household. At the same time, the work is a visual joke constructed by a woman that combines female sexuality with the oral activity of eating and drinking. The "household" character of the *Cup* contrasts with the "divine" character of *God as Architect* (*God Drawing the Universe with a Compass*) (fig. 1.4). As depicted in the chapter, the male figures are gods, kings, soldiers, and workers, whereas female figures (except *The Corinthian Maid*, fig. 1.6) are mothers.

Biography and Autobiography

Biographical and autobiographical approaches to art history interpret works as expressions of their artists' lives and personalities. These methods have the longest history, beginning with the mythic associations of gods and artists described above. Epic heroes such as Gilgamesh and Aeneas are credited with the architectural activity of building walls and founding cities. The anecdotes of Pliny the Elder about ancient Greek artists have a more historical character, which was revived in fourteenth-century Italy. Vasari's *Lives of the Artists*, written in the sixteenth century, covers artists from the late thirteenth century up to his own time and concludes with his own autobiography. From the fifteenth century on, the genre of biography and autobiography of artists has expanded into various literary forms—for example, sonnets (Michelangelo), memoirs (Vigée-Lebrun), journals (Delacroix), letters (van Gogh), and, more recently, films and taped interviews.

The biographical method emphasizes the notion of authorship, and can be used to interpret iconography using the artist's life as an underlying "text." This being said, there are certain standard conventions in artists' biographies and autobiographies which are remarkably consistent and which show up in quite divergent social and historical contexts. These conventions parallel artists with gods, especially in the ability to create illusion. They also include episodes in which an older artist recognizes talent in a child destined to become great, the renunciation of one's art (or even suicide) when confronted with the work of superior artists, sibling rivalry between artists, artists who are rescued from danger by their talent, and women as muses for (male) artists.

Whistler's portrait of his mother (fig. 1.7) obviously has autobiographical meaning. By placing his own etchings on

the wall beside her, he relates her dour personality to his black-and-white drawings and etchings, rather than to his more colorful paintings. Vincent van Gogh's *Self-portrait Before his Easel* (1888) in figure 1.1 is one of many self-portraits that reflect the artist's inner conflicts through the dynamic tension of line and color. In works such as these it is possible to apply the biographical method because the artist's identity is known, and because he makes aspects of himself manifest in his imagery.

Semiology

Semiology—the science of signs—takes issue with the biographical method and with much of formalism. It has come to include elements of structuralism, post-structuralism, and deconstruction. Structuralism developed from a branch of language study called structural linguistics in the late nineteenth and early twentieth centuries as an attempt to identify universal and meaningful patterns in various cultural expressions. There are several structuralist approaches to art, but in general they diverge from the equation of artists with gods, from the Platonic notion of art as *mimesis* (making exact copies of nature), and from the view that the meaning of a work is conveyed exclusively by its author.

In the structural linguistics of the Swiss scholar Ferdinand de Saussure, a "sign" is composed of "signifier" and "signified." The former is the sound or written element (such as the four letters p-i-p-e) and the latter is the concept of what the signifier refers to (in this case a pipe). A central feature of this theory is that the relation between signifier and signified is entirely arbitrary. Saussure insists on that point specifically to counter the notion that there is an ideal essence of a thing (as stated by Plato and Kant). He is also arguing against the tradition of a "linguistic equivalent." The notion of linguistic equivalents derived from the belief that, in the original language spoken by Adam and Eve, words naturally matched the essence of what they referred to, so that signifier and signified *were* naturally related to each other. Even before Adam and Eve, the logocentric (word-centered) Judaic God had created the world through language: "Let there be light" made light, and "Let there be darkness" made darkness. The New Testament Gospel of John (1:1) takes up this notion again, opening with "In the beginning was the Word."

For certain semioticians, however, some relation between signifier and signified is allowed. These would agree that Magritte's painted pipe is closer to the idea of pipeness than the four letters *p-i-p-e*. But most semioticians prefer to base stylistic categories on signs rather than on formal elements. For example, Magritte's pipe and Oppenheim's cup do not resemble each other formally, and yet both have been related to Dada and Surrealism. Their similarities do not lie in shared formal elements, but rather in their ability to evoke surprise by disrupting expectations. We do not expect to read a denial of the "pipeness" of a convincing image of a pipe written by the very artist who painted it. Nor do we expect fur-covered

cups and spoons, because the fur interferes with their function. The unexpected—and humorous—qualities of the pipe and the cup could be considered signs of certain twentieth-century developments in imagery. Another element shared by these two works is the twentieth-century primacy of everyday objects, which can also be considered a sign.

Deconstruction

The analytical method known as deconstruction is most often associated with Jacques Derrida, a French post-structuralist philosopher who writes about art as well as written texts. Derrida's deconstruction opens up meanings rather than fixing them within structural patterns. But he shares with the structuralists the idea that works have no ultimate meanings conferred by their authors.

Derrida's technique for opening up meanings is to question assumptions about works. Whistler's mother (see fig. 1.7), for example, seems to be sitting for her portrait, but we have no proof from the painting itself that she ever did so. Whistler could have painted her from a photograph or from memory, in which case our initial assumption about the circumstances of the work's creation would be basically untrue, even though the portrait is a remarkably "truthful" rendering of a puritanical woman.

Derrida also opens up the Western tendency to binary pairing: right/left, positive/negative, male/female, and so forth. He notes that one of a pair evokes its other half and plays on the relationship of presence and absence. Since a pair of parents is a biological given, where, a Derridean might ask, is Whistler's father? In the pairing of father and mother, the present parent evokes the absent parent. There is, in Whistler's painting, no reference to his father, only to himself via the etchings hanging on the wall. The absent father, the present mother, the etchings of the son—the combination invites speculation about their relationships: was the son trying to displace the father? Such psychological considerations lead us to the psychoanalytic methodologies.

Psychoanalysis

The branch of psychology known as psychoanalysis was originated by the Austrian neurologist Sigmund Freud in the late nineteenth century. Like art history, psychoanalysis deals with imagery, history, and individual creativity. Like archaeology, it reconstructs the past and interprets its relevance to the present. The imagery examined by psychoanalysts is found in dreams, jokes, slips of the tongue, and neurotic symptoms, and it reveals the unconscious mind (which, like a buried city, is a repository of the past). In a work of art, personal imagery is reworked into a new form that "speaks" to a cultural audience. It thus becomes part of a history of style (and, for semioticians, of signs).

Psychoanalysis has been applied to art in different ways, and according to different theories. In 1910 Freud published the first psychobiography of an artist, in which

he explored the personality of Leonardo da Vinci through his iconography and his working methods. For Freud, the cornerstone of psychoanalysis was the Oedipus complex, which refers to various aspects of children's relationships to their parents.

As we have seen, the Oedipus complex can be applied to Whistler's painting of his mother. An oedipal reading of that work is enriched by the fact that it contains an **underpainting** of a baby. An oedipal reading of Brancusi's *Bird* would have to consider the artist's relationship to his peasant father, an ignorant and abusive man who would have preferred his son to have been born a girl. In that light, the sculpture has been interpreted as a phallic self-image, declaring its triumph over gravity and outshining the sun. With *Bird in Space*, Brancusi symbolically "defeats" his father and "stands up" for himself as a creator.

According to classical psychoanalysis, works of art are "sublimations of instinct" through which instinctual energy is transformed by work and talent into esthetic form. The ability to sublimate is one of the main differences between humans and animals, and it is necessary for creative development in any field. Because art is expressive, it reveals aspects of the artist who creates it, of the patron who funds it, and of the culture in which it is produced.

The Language of Art

Form

The overall form of a work of art refers to the visual elements of its **composition**, arrangement, or structure. Within this overall form are individual forms. The individual forms in a still life, for example, might include a table, a bowl, apples, and a jug of wine. The forms in a building could include its walls, doors, windows, roof, as well as any architectural ornament and the site surrounding it.

Plane

A **plane** is a flat surface having a direction in space. Brancusi's *Bird* (fig. 1.2) rises in a vertical plane, Magritte's pipe (fig. 1.3) lies in a horizontal plane, and the figure of God in *God Drawing the Universe with a Compass* (fig. 1.4) bends over to create two diagonal planes.

Line

A line is the path traced by a moving point. For the artist, the moving point is the tip of the brush, pen, crayon, or whatever instrument is used to create an image on a surface. In geometry, a line has no width or volume; its only quality is inherent in its location, a straight line being defined as the shortest distance between two points. In the language of art, however, a line can have many qualities, depending on how it is drawn (fig. **1.10**). A vertical line seems to stand stiffly at attention, a horizontal line lies

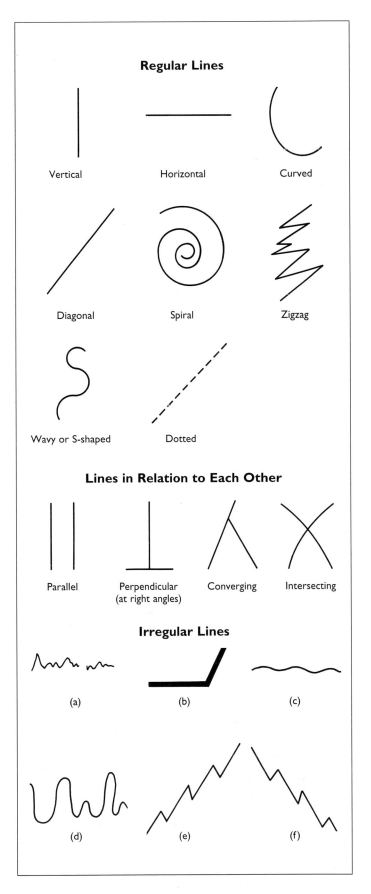

1.10 Lines.

down, and a diagonal seems to be falling over. Zigzags have an aggressive, sharp quality, whereas a wavy line is more graceful and, like a curve, more naturally associated with the outline of the human body. Parallel lines are balanced and harmonious, implying an endless, continuous movement, while perpendicular, converging, and intersecting lines meet and create a sense of force and counterforce. The thin line (a) seems delicate, unassertive, even weak. The thick one (b) seems aggressive, forceful, strong. The undulating line (c) suggests calmness, like the surface of a calm sea, whereas the more irregularly wavy line (d) implies the reverse. The angular line (e) climbs upward like the edge of a rocky mountain. (Westerners understand (e) as going up and (f) as going down, as we read from left to right.)

Expressive Qualities of Line Many of the lines in figure 1.10 are familiar from geometry and can therefore be described formally. But the formal qualities of line also convey an expressive character because we identify them with our bodies and our experience of nature. By analogy with a straight line being the shortest distance between two points, a person who follows a straight, clear line in thought or action is believed to have a sense of purpose. "Straight" is associated with rightness, honesty, and truth, while "crooked"—whether referring to a line or a person's character—denotes the opposite. We speak of a "line of work," a phrase adopted by the former television program *What's my Line?* When a baseball player hits a line drive, the bat connects firmly with the ball, and a "hardliner" takes a strong position on an issue.

It is especially easy to see the expressive impact of lines in the configuration of the face (fig. **1.11**). In (a), the upward curves create a happy face, and the downward curves of (b) create a sad one. These characteristics of upward and downward curves actually correspond to the emotions as expressed in natural physiognomy. And they are reflected in language when we speak of people having "ups and downs" or of events being "uppers" or "downers."

Alexander Calder's (1898–1976) illustration (fig. **1.12**) merges the linear quality of the written word with the pictorial quality of what the word represents. The curve of the *c* outlines the face, a dot stands for the eye, and a slight diagonal of white in the curve suggests the mouth. The large *A* comprises the body, feet, and tail, while the tiny *t* completes the word, without interfering with reading the ensemble as *cat*. The figure seems to be walking, because the left diagonal of the *A* is lower than the right one, and the short horizontals at the base of the *A* suggest feet. Not only is this cat a self-image—*C A* are the artist's initials reversed—but it defies the semiotic argument that signifier (*c–a–t*) and signified (the mental image of a cat) have no natural relation to each other.

The importance of the line in the artist's vocabulary is illustrated by an account of two ancient Greek painters, Apelles, who was Alexander the Great's portraitist, and his contemporary Protogenes. Apelles traveled to Rhodes

1.11 Lines used to create facial expressions.

to see Protogenes' work, but when he arrived at the studio, Protogenes was away. The old woman in charge of the studio asked Apelles to leave his name. Instead, Apelles took up a brush and painted a line of color on a panel prepared for painting. "Say it was this person," Apelles instructed the old woman.

When Protogenes returned and saw the line, he recognized that only Apelles could have painted it so well. In response, Protogenes painted a second, and finer, line on top of Apelles' line. Apelles returned and added a third line of color, leaving no more room on the original line. When Protogenes returned a second time, he admitted defeat and went to look for Apelles.

Protogenes decided to leave the panel to posterity as something for artists to marvel at. Later it was exhibited in Rome, where it impressed viewers for its nearly invisible lines on a vast surface. To many artists, the panel seemed a blank space, and for that it was esteemed over other famous works. After his encounter with Protogenes, it was said that Apelles never let a day go by without drawing at least one line. This incident was the origin of an ancient proverb, "No day without a line."

1.12 Alexander Calder, *Cat*, 1976. 22 × 30 in (55.88 × 76.2 cm).

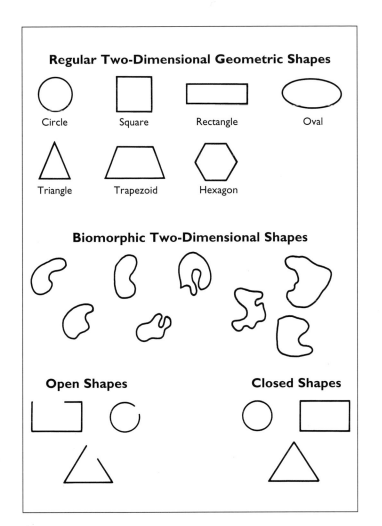

1.13 Shapes.

certain equity or evenness is implied; a "square meal" refers to both the amount and content of the food. When the term "brick" is applied to people, it means that they are good-natured and reliable. Too much rectangularity, on the other hand, may imply dullness or monotony—to call someone "a square" suggests over-conservatism or conventionality.

The circle has had a special significance for artists since the Neolithic era. In the Roman period, the circle was considered a divine shape and thus most suitable for temples. This view persisted in the Middle Ages and the Renaissance, when the circle was considered to be the ideal church plan—even though such buildings were rarely constructed.

Even though lines are two-dimensional, the use of **modeling** lines to form **hatching** or **cross-hatching** (fig. **1.14**) creates the illusion of mass and volume, making a shape appear three-dimensional. Hatching and cross-hatching can also suggest shade or **shading** (the gradual transition from light to dark), on the side of an object that is turned away from a light source.

Light and Color

The technical definition of light is electromagnetic energy of certain wavelengths which, when it strikes the retina of the eye, produces visual sensations. The absence, or opposite, of light is dark.

Rays of light having certain wavelengths create the sensation of color, which can be demonstrated by passing a

Lines enclosing space create shapes. Shapes are another basic unit, or formal element, used by artists. There are regular and irregular shapes. Regular ones are geometric and have specific names. Irregular shapes are also called "biomorphs," or biomorphic (from the Greek *bios,* "life," and *morphe,* "shape"), because they seem to move like living, organic matter (fig. **1.13**).

Shape

Expressive Qualities of Shape Like lines, shapes can be used by artists to convey ideas and emotions. Open shapes create a greater sense of movement than closed shapes (see fig. 1.13). Similarly, we speak of open and closed minds; open minds allow for a flow of ideas, flexibility, and the willingness to entertain new possibilities. Closed minds, on the other hand, are not susceptible to new ideas.

Specific shapes can evoke associations with everyday experience. Squares, for example, are symbols of reliability, stability, and symmetry. To call people "foursquare" means that they are forthright and unequivocal, that they confront things "squarely." If something is "all square," a

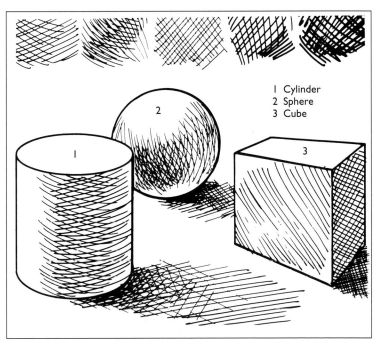

1.14 Drawing of solid shapes showing hatching and cross-hatching. The lines inside the objects create the illusion that they are solid, and also suggest that there is a source of light coming from the upper left and shining down on the objects. Such lines are called modeling lines.

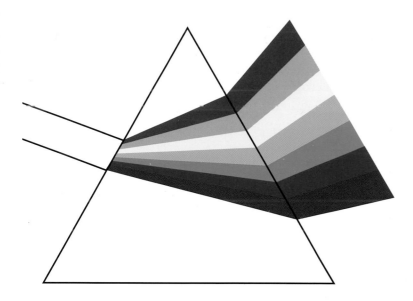

1.15 The visible spectrum has seven principal colors—red, orange, yellow, green, blue, indigo (or blue-violet), and violet—that blend together in a continuum. Beyond the ends is a range of other colors, starting with infrared and ultraviolet, which are invisible to the human eye. If all the colors of the spectrum are recombined, white light is again reproduced.

beam of light through a prism (fig. **1.15**). This breaks the light down into its constituent **hues**. Red, yellow, and blue are the three **primary colors** because they cannot be produced by mixing any other colors. A combination of two primary colors produces a **secondary color**: yellow and blue make green, red and blue make purple, yellow and red make orange.

The **color wheel** (fig. **1.16**) illustrates the relationships between the various colors. The farther away hues are, the less they have in common, and the higher their contrast. Hues directly opposite each other on the wheel (red and green, for example) are the most contrasting and are known as **complementary colors**. They are often juxtaposed when a strong, eye-catching contrast is desired. Mixing two complementary hues, on the other hand, has a neutralizing effect and lessens the intensity of each. This can be seen in figure 1.16 as you look across the wheel from red to green. The red's intensity decreases, and the gray circle in the center represents a "stand-off" between all the complementary colors.

The relative lightness or darkness of an object is its **value**, which is a function of the amount of light reflected from its surface. Gray is darker in value than white, but lighter in value than black. Value is characteristic of both **achromatic** works of art—those with no color, consisting of black, white, and shades of gray—and of **chromatic** ones (from the Greek *chroma*, meaning "color"). The normal value of each color indicates the amount of light it reflects at its maximum intensity. The addition of white or black would alter its value (i.e. make it lighter or darker) but not its hue. The addition of one color to another would change not only the values of the two colors but also their hues.

Intensity, which is also called **saturation**, refers to the relative brightness or dullness of a color. Dark red (red mixed with black) is darker in value, but less intense than pink (red mixed with white). There are four methods of changing the intensity of colors. The first is to add white. Adding white to pure red creates light red or pink, which is lighter in value and less intense. If black is added, the result is darker in value and less intense. If gray of the same value as the red is added, the result is less intense but retains the same value. The fourth way of changing a color's intensity is to add its complementary hue. For example, when green (a secondary color composed of the primaries yellow and blue) is added to red, gray is produced as a consequence of the balance between the three primaries. If red is the dominant color in the mixture, the result is a grayish red; if green is dominant, the product is a grayish green. In any event, the result is a color less intense and more neutral than the original.

Expressive Qualities of Color Just as lines and shapes have expressive qualities, so too do colors. Artists select colors for their effect. Certain ones appear to have intrinsic qualities. Bright or warm colors convey a feeling of gaiety and happiness. Red, orange, and yellow are generally considered warm, perhaps because of their associations with fire and the sun. It has been verified by psychological tests that the color red tends to pro-

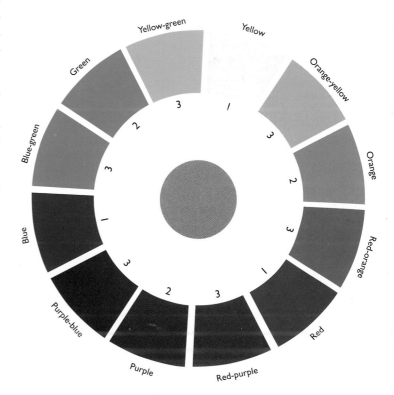

1.16 The color wheel. Note that the three primary colors—red, yellow, and blue—are equally spaced around the circumference. They are separated by their secondary colors. Between each primary color and its two secondary colors are their related tertiaries, giving a total of twelve hues on the rim of the wheel.

duce feelings of happiness. Blue and any other hue containing blue—green, violet, blue-green—are considered cool, possibly because of their association with the sky and water. They produce feelings of sadness and pessimism.

Colors can also have symbolic significance and suggest abstract qualities. A single color, such as red, can have multiple meanings. It can symbolize danger, as when one waves a red flag in front of a bull. But to "roll out the red carpet" means to welcome someone in an extravagant way, and we speak of a "red letter day" when something particularly exciting has occurred. Yellow can be associated with cowardice, white with purity, and purple with luxury, wealth, and royalty. We might call people "green with envy," "purple with rage," or "in a brown study" if they are quietly gloomy.

Texture

Texture is the quality conveyed by the surface of an object. This may be an actual surface, or a simulated or represented surface. The surface of Oppenheim's *Fur-covered Cup* (see fig. 1.9), for example, is actually furry, but the heavy cloth dress of Whistler's mother is simulated by means of its shaded surface (see fig. 1.7).

Stylistic Terminology

Subject matter refers to the actual elements represented in a work of art, such as figures and objects or lines and colors. **Content** refers to the themes, values, or ideas in a work of art, as distinct from its form. The following terms are used to describe **representational**, or **figurative**, works of art which depict their subject-matter so that it is relatively recognizable:

- **naturalistic**: depicting figures and objects more or less as we see them. Often used interchangeably with "realistic."
- **realistic**: depicting figures and objects to resemble their actual appearances, rather than in a distorted or abstract way.
- **illusionistic**: depicting figures, objects, and the space they occupy so convincingly that the appearance of reality is achieved.

Note that an image may be representational without being realistic. Figures **1.17–1.20** are recognizable as images of a cow and are therefore representational, but only figures 1.17–1.19 can be considered relatively naturalistic.

If an image is representational but is not especially faithful to its subject, it may be described as:

- **idealized**: depicting an object according to an accepted standard of beauty.
- **stylized**: depicting certain features as nonorganic surface elements rather than naturalistically or realistically.
- **romanticized**: depicting its subject in a nostalgic, emotional, fanciful, and/or mysterious way.

If the subject-matter of a work has little or no relationship to observable reality, it may be called:

- **nonrepresentational** or **nonfigurative**: the opposite of representational or figurative, implying that the work does not depict (or claim to depict) real figures or objects.
- **abstract**: describes forms that do not accurately depict real objects. The artist may be attempting to convey the essence of an object rather than its actual appearance. Note that the subject-matter may be recognizable (making the work representational), but in a non-naturalistic form.

The transition from naturalism to geometric abstraction is encapsulated in a series by the early twentieth-century Dutch artist Theo van Doesburg (figs. 1.17–**1.21**). He gradually changed his drawing of a cow from 1.17, which could be called naturalistic, figurative, or representational, to image 1.21, which is an abstract arrangement of flat squares and rectangles. In 1.17 and 1.18, the cow's form is recognizable as that of a cow—it is composed of curved outlines and a shaded surface that creates a three-dimensional illusion. In image 1.19, the cow form is still recognizable, especially as it follows 1.17 and 1.18. It is now devoid of curves, but still shaded—it has become a series of volumetric (solid, geometric) shapes. Even in image 1.20, the general form of the cow is recognizable in terms of squares, rectangles, and triangles, but there is no longer any shading. As a result, each distinct color area is flat. In image 1.21, however, the shapes can no longer be related to the original natural form. It is thus a pure abstraction, and is also nonfigurative and nonrepresentational.

1.17 Theo van Doesburg, Study 1 for *Composition (The Cow)*, 1916. Pencil on paper, 4⅝ × 6¼ in (11.7 × 15.9 cm). Museum of Modern Art, New York. Purchase.

1.18 Theo van Doesburg, Study 2 for *Composition (The Cow)*, 1917. Pencil on paper, 4⅝ × 6¼ in (11.7 × 15.9 cm). Museum of Modern Art, New York. Purchase.

1.19 Theo van Doesburg, Study 3 for *Composition (The Cow)*, 1917. Pencil on paper, 4⅝ × 6¼ in (11.7 × 15.9 cm). Museum of Modern Art, New York. Gift of Nelly van Doesburg.

1.20 Theo van Doesburg, Study for *Composition (The Cow)*, (c. 1917; dated 1916). Tempera, oil, and charcoal on paper, 15⅝ × 22¾ in (39.7 × 57.8 cm). Museum of Modern Art, New York. Purchase.

1.21 Theo van Doesburg, Study for *Composition (The Cow)*, c. 1917. Oil on canvas, 14¾ × 25 in (37.5 × 63.5 cm). Museum of Modern Art, New York. Purchase. All images © 1999 MOMA.

13

Precursors of the Renaissance

Thirteenth-Century Italy

During the eleventh and twelfth centuries, Italy continued to be accessible to Byzantine influences, particularly through its eastern port cities, Venice and Ravenna. Around the turn of the thirteenth century, however, momentous developments in Italy, inspired by imperial Roman traditions, laid the foundations for a major shift in western European art.

The name given to the period of Italian history from the thirteenth through the sixteenth centuries is "Renaissance"—the French word for "rebirth," or *rinascimento* in Italian. Dating the beginning of Renaissance style remains an issue of debate, and some would consider the works in this chapter to be late Gothic. But the term "Renaissance" denotes a self-conscious revival of interest in ancient Greek and Roman texts and culture which is reflected in the work of most of the artists discussed here. Italy was the logical place for such a revival, since the model of imperial Rome was part of its own history and territory.

Nicola Pisano

Around 1260 the late Gothic sculptor Nicola Pisano (c. 1220–84) carved the marble pulpit (fig. **13.1**) for the Baptistry in Pisa. The relief of the *Nativity* (fig. **13.2**) provides a good example of the Roman heritage in Italian medieval art. It is crowded with figures, including, from left to right at the bottom, a bearded Joseph, two midwives washing the infant in a basin, and sheep and goats. The largest figure, showing the influence of Etruscan and Roman tomb effigies, is Mary, whose monumentality and central position evoke her connections with the earth goddesses of antiquity. Despite the Christian subject and symbolism, the forms are reminiscent of imperial Roman reliefs. Most clearly related to the Roman past is the artist's rendition of draperies, which identify the organic, three-dimensional movements of figures in space.

Furthermore, the pulpit as a whole shows a fusion of Gothic arrangement (the combination of columns with Corinthian capitals and trilobed arches) with the round

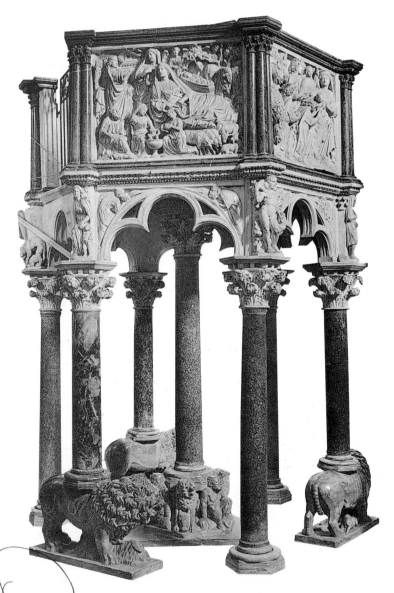

13.1 Nicola Pisano, pulpit, Pisa Baptistry, 1259–60. Marble, 15 ft (4.6 m) high. Nicola probably came from southern Italy and trained at the court of Frederick II. When Frederick died in about 1250, Nicola went north to Tuscany. He and his son Giovanni settled in Pisa, where they worked mainly in marble.

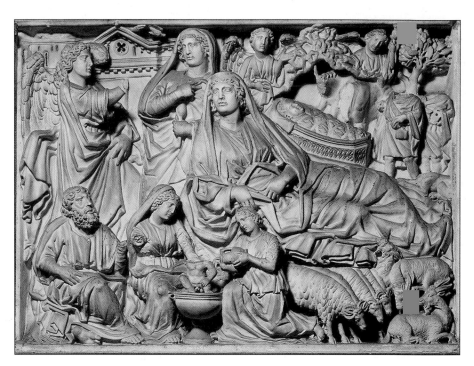

13.2 Nicola Pisano, relief of the *Nativity* (detail of fig. 13.1). Marble, approx. 34 in (86.4 cm) high.

arches of the Roman (and Romanesque) styles. Every other column rests on a lion, which recalls typological parallels between the Old and New Testaments. In that context, the lions refer to Solomon's throne, and here denote the foundation on which the teachings of Christ are built.

Both the conception and execution of the pulpit reflect the cultural and stylistic crosscurrents to which Nicola Pisano had been exposed at the court of the Holy Roman Emperor, Frederick II. During the first half of the thirteenth century, Frederick controlled territories in southern Italy, and his patronage brought French and German artists, as well as Italians, to his court at Capua, just north of Naples. There, imported and local elements were combined with Frederick's personal taste for ancient Roman styles. Like many rulers before and after him, Frederick used the revival of Classical antiquity for his own political purposes, relating his accomplishments to those of imperial Rome.

Cimabue

Byzantine influence remained strong in Italy, as can be seen in the monumental *Madonna Enthroned* (fig. **13.4**) by Cimabue (c. 1240–1302). The gold background, the flecks of gold in Mary's drapery, and the long, thin figures are characteristic of Byzantine style. The elaborate throne has no visible support at the back, but seems instead to rise upward, denying the material reality of its weight. As in Byzantine and medieval art, the Christ Child is depicted with the proportions and gestures of an adult (see p. 302). Four elderly men at the foot of the throne hold scrolls, attributes of Old Testament prophets. Mary and Christ are thus represented according to the typological reading of history and embody the New Dispensation in fulfillment of Old Testament prophecy.

Fourteenth-Century Italy

Cimabue is generally thought of as the last great painter working in the Byzantine tradition. The rise of humanism in the fourteenth century reflected, but also significantly extended, the High Gothic interest in nature. Humanists began to collect Classical texts, establishing major libraries of Greek and Roman authors. Artists began to study the forms of antiquity by observing Roman ruins. And gradually a new synthesis emerged, in which nature—including human character and human form—became the ideal pursued during the Renaissance.

Awareness of the Classical revival began to be reflected in the works of several Italian writers such as Dante, Petrarch, and Boccaccio, who discussed art and artists in a new way.

Literacy among the general population increased dramatically, and works of literature dealt more and more with art and artists, bringing their achievements to a wider public. Another important feature of the Renaissance in Italy was a new attitude to individual fame. While most medieval artists remained anonymous, those of the Renaissance frequently signed their works. The very fact that the names of many more Italian artists of the thirteenth and fourteenth centuries are documented than in the Early Christian and medieval periods in Europe attests to the artists' intention to record their identity and to preserve it for posterity.

Giotto

In painting, the individual who most exemplified, and in large part created, the new developments was Giotto di Bondone (c. 1267–1337). He was born in the Mugello Valley near Florence, and lived mainly in that city, which was to be the center of the new Renaissance culture. His fame was such that he was summoned all over Italy, and possibly also to France, on various commissions.

Boccaccio, an ardent admirer of ancient Rome, described Giotto as having brought the art of painting out of medieval darkness into daylight. He also compared Giotto with the Greek Classical painter Apelles as a master of clarity and illusionism. Petrarch, who was an avid collector of Classical texts and had written extensively about the benefits of nature, owned a painting by Giotto. In his will, he bequeathed the work to his lord. "The beauty of this painting," wrote Petrarch around 1361, "the ignorant

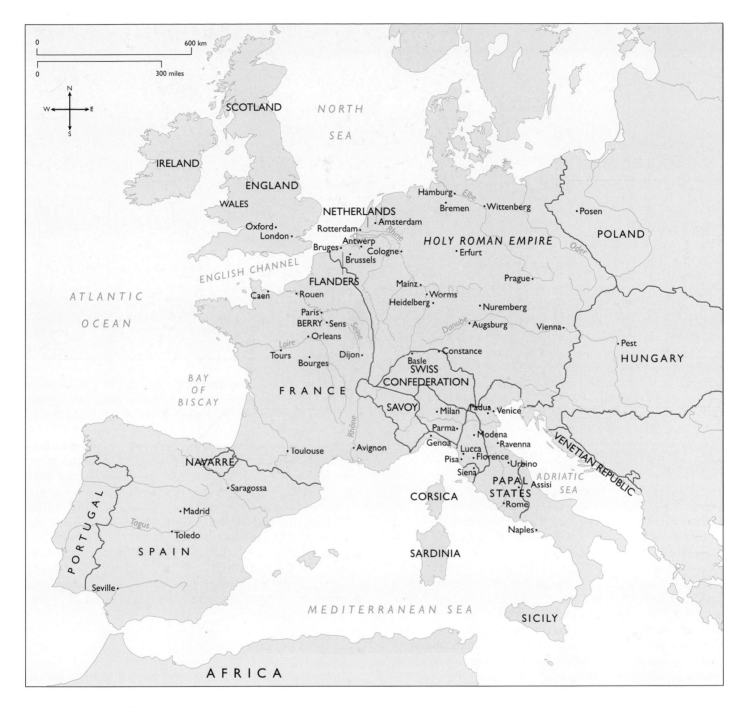

13.3 Map of leading art centers during the Renaissance in western Europe.

cannot comprehend, but masters of the art marvel at it."[1] Petrarch thus shared Boccaccio's view that Giotto appealed to the intellectually and artistically enlightened. Ignorance, by implication, was associated with the "darkness" of the Middle Ages.

Giotto became the subject of a growing number of anecdotes about artists that became popular from the fourteenth century onward. The anecdotal tradition is itself indicative of the Classical revival and derives from accounts of Classical Greek painters who were renowned for their illusionistic skill. These survive primarily in Pliny

the Elder's *Natural History* (see p. 213), which was an important source on ancient art and artists during the Renaissance.

In Dante's *Purgatory* (see Box), Giotto and Cimabue are juxtaposed as a lesson in the transience of earthly fame:

O empty glory of human powers! How short the time
its green endures at its peak, if it be not
overtaken by crude ages! Cimabue thought to hold
the field in painting, and now Giotto has the cry,
so that the fame of the former is obscured.[2]

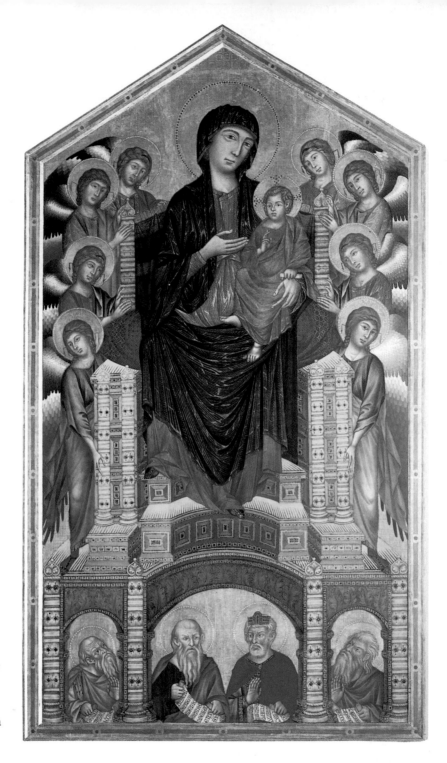

13.4 Cimabue, *Madonna Enthroned,* c. 1280–90. Tempera on wood, 12 ft 7 in × 7 ft 4 in (3.84 × 2.24 m). Galleria degli Uffizi, Florence.

Dante: The Poet of Heaven and Hell

The Florentine poet Dante Alighieri (1265–1321) wrote *The Divine Comedy*, a long poem divided into three parts: *Inferno* (Hell), *Purgatorio* (Purgatory), and *Paradiso* (Paradise). Dante describes a week's journey in the year 1300 down through the circles of hell to Satan's realm. From there he climbs up the mountain of purgatory, with its seven terraces, and finally ascends the spheres of heaven.

The Roman poet Virgil, author of *The Aeneid*, guides Dante through hell and purgatory. The very fact that Dante chooses Virgil as his guide is evidence of the growing interest in Roman antiquity. But because Virgil lived in a pre-Christian

era, according to Dante he cannot continue past purgatory into paradise. Instead, it is Beatrice, Dante's deceased beloved, who guides him through heaven and presents him to the Virgin Mary.

Long valued for its literary and spiritual qualities, Dante's poem is equally important for its insights into medieval and early Renaissance history. In the course of his journey, Dante encounters many historical figures to whom he metes out various punishments or rewards, according to his opinion of them.

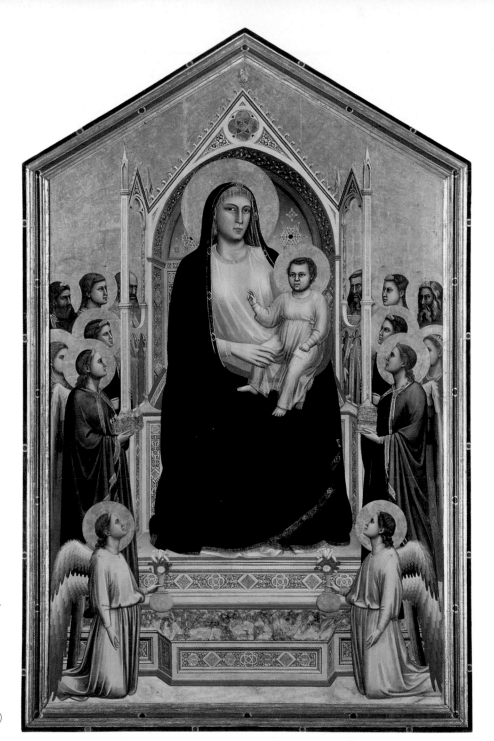

13.5 Giotto, *Madonna Enthroned* (Ognissanti Madonna), c. 1310. Tempera on wood, 10 ft 8 in × 6 ft 8 in (3.25 × 2.03 m). Galleria degli Uffizi, Florence. Despite Giotto's fame, few of his works are undisputed. This is the only panel painting unanimously attributed to him. It was commissioned for the Church of Ognissanti (All Saints) in Florence.

In the fifteenth century, the sculptor and goldsmith Lorenzo Ghiberti (see Vol II, chapter 14) would record the popular anecdote that inspired Dante's lines. He described Giotto as a boy tending sheep: Giotto was drawing the image of a sheep on a rock, when Cimabue happened by. Instantly recognizing the artistic genius of the young shepherd, the older artist obtained permission from Giotto's father to train his son as a painter. This account exemplifies the conventional recognition story, in which inborn talent reveals itself in childhood. The necessary corollary is discovery and encouragement by an older practitioner of the same art. According to Ghiberti, Giotto was skilled in all the arts, abandoned the Byzantine style, and revived the genius of Classical antiquity.

Filippo Villani, writing at the turn of the fifteenth century on the history of Florence, commented on the role of art in the development of the Renaissance. In Villani's opinion, Cimabue had laid the foundations of the new style, and Giotto "is not only celebrated enough to be compared with the painters of Antiquity, but is even to be preferred to them in skill and genius—[he] restored painting to its pristine dignity and high reputation. For pictures formed by his brush follow nature's outlines so closely that they seem to the observer to live and breathe."[3]

A comparison of Giotto's *Madonna Enthroned* (fig. **13.5**) of c. 1300 with Cimabue's (see fig. 13.4) illustrates their different approaches to space and to the relationship between space and form. Both pictures are tempera on

panel (see Box) and were intended as altarpieces (see Box). Giotto's is surrounded by an architectural frame that cuts off parts of the angels around the throne, while Cimabue's has no such framework. Both have elaborate thrones (Giotto's with Gothic pointed arches), Byzantine gold backgrounds, and flat, round haloes that do not turn illusionistically with the heads. Whereas Cimabue's throne rises in an irrational, unknown space (there is no floor), Giotto's is on a horizontal support approached by steps. In contrast to Cimabue's long, thin, elegant figures, Giotto's are bulky, with draperies that correspond convincingly to organic form and obey the law of gravity. Giotto has thus created an illusion of three-dimensional space—his figures seem to turn and move as in nature.

Tempera: Painstaking Preparation and Delicate Detail

Examples of the use of tempera are found as early as ancient Egyptian times. From the medieval period through the fifteenth century, however, it was the preferred medium for wooden panel paintings, especially in Italy, lending itself to precise details and clear edges.

For large panels, such as those illustrated in figures 13.4 and 13.5, elaborate preparations were required before painting could begin. Generally, a carpenter made the panel from poplar, which was glued and braced on the back with strips of wood. He also made and attached the frame. Apprentices then prepared the panel, under the artist's supervision, by sanding the wood until it was smooth. They sealed it with several layers of size, a glutinous material used to fill in the pores of the panel and to make a stable surface for later layers. Strips of linen reinforced the wood to prevent warping. The last step in the preparation of the panel was the addition of several layers of **gesso**, a water-based paint thickened with chalk and size. Once each layer of gesso had dried, the surface was again sanded, smoothed, and scraped. The gesso thus became the support for the artwork.

At this point, painting could begin. Using a brush, the artist lightly outlined the figures and forms in charcoal before reinforcing the outline with ink. The decorative gold designs, haloes, and gold background were applied next, and were polished so that they would glow in the dark churches.

Apprentices made the paint by grinding pigments from mineral or vegetable extracts to a paste and suspending them in a mixture of water and egg. The artist then applied the paint with small brushes made of animal hair. Once the artist had completed the finishing touches, the painting was left to dry—a year was the recommended time—and then it was varnished.

Altarpieces

An altarpiece is a devotional panel painting (usually tempera on wood), which was originally located behind an altar, visible only to the clergy. After the church's Lateran Council of 1215, however, the altarpiece was moved to the front of the altar in order to engage viewers in the sacred drama of the Mass. From the twelfth century onward, altarpieces became more common and increasingly elaborate. They typically had a fixed base (the **predella**), surmounted by one or more large panel paintings. In most cases the large panels contain the more iconic images—such as an enthroned Virgin and Christ, or individual saints—and the predellas contain narrative scenes related to the larger figures.

Taking as examples the illustrations in this chapter, figures 13.4 and 13.5 would have been central altarpiece panels. Figure 13.14 is a reconstruction of the front of Duccio's *Maestà*, the original of which replaced a small, undistinguished early thirteenth-century panel painting. Duccio's large panel of the *Enthroned Virgin and Christ* surrounded by saints and angels rests on a predella with scenes of Christ's early life—from the *Annunciation* at the left to *Christ among the Doctors* at the right, and individual figures between the narrative scenes. Above is a row of saints under round arches surmounted by scenes from Mary's life—starting with the *Annunciation* of her death and ending with her *Burial*. The upper sections of the pinnacles are lost.

Simone Martini's *Saint Louis* altarpiece (fig. 13.23) shows the saint crowning his brother Robert in the larger panel. Small scenes on the predella depict events from the saint's life.

Originally, wings (side panels) would usually have been attached with hinges. These wings would then "close" the altarpiece when it was not on display or being used for a service. The Ghent altarpiece (see Vol. II) is particularly elaborate. Figure 14.72 shows the altarpiece closed so that the paintings on the outside of the wings are visible.

Whereas Cimabue uses lines of gold to emphasize Mary's drapery folds, Giotto's folds are rendered by shading. Giotto's V-shaped folds between Mary's knees identify both their solidity and the void between them, while the curving folds above the waist impart a suggestion of *contrapposto* and also direct the viewer's attention to Christ.

A comparison of the two figures of Christ reveals at once that Giotto was more interested in the reality of childhood than Cimabue. The latter's Christ retains aspects of the medieval homunculus (see p. 302). He has a small head and thin proportions, and he is not logically supported on Mary's lap. Giotto's Christ, on the other hand, has chubby proportions and rolls of baby fat around his neck and wrists; he sits firmly on the horizontal surface of Mary's leg. Although Giotto's Christ is depicted in a regal and

frontal position, his right hand raised in a gesture of blessing, his proportions are more natural than those of Cimabue's Christ.

It was precisely in the rendition of nature that Giotto seemed to his contemporaries to have surpassed Cimabue and to have revived the forms of antiquity, heralding the emergence of a new generation of artists. Giotto's success also exemplifies the benefits of the master–apprentice relationship in medieval and Renaissance artistic training (see Boxes).

The Arena Chapel

The best preserved examples of Giotto's work are the paintings in the Arena Chapel in Padua, a small town about 25 miles (40 km) southwest of Venice. In the second half of the thirteenth century, under a republican form of government, a group of Paduan lawyers developed an interest in Roman law, which led to an enthusiasm for Classical thought and literature. Roman theater was revived, along with Classical poetry and rhetoric. As the site of an old and distinguished university, Padua was a natural center for a humanist revival, which acknowledged

Cennino Cennini: *Il libro dell'arte* (*The Craftsman's Handbook*)

Cennino Cennini was born around 1370 in Colle, near Florence, but worked in Padua. He had learned painting from students of Giotto, and proclaimed his descent from the master. His handbook, written at the turn of the century, mediates between the medieval and Renaissance approaches to training and style. He traces the art of painting to Adam and Eve, who turned to agriculture and crafts after the Fall. One of these crafts was painting, "which calls for imagination," according to Cennino, "and skill of hand, in order to discover things not seen, hiding themselves under the shadow of natural objects, and to fix them with the hand, presenting to plain sight what does not actually exist. And it justly deserves to be enthroned next to theory, and to be crowned with poetry."[4]

Cennino recommends that artists apprentice themselves to a good master. He describes the preparation of pigments, techniques of drawing, and the ideal lifestyle of the artist. Above all, he prescribes constant drawing from nature, which, he says, is the best model of all. In this sentiment, Cennino departs from medieval practice and states what would become a Renaissance ideal in art.

Training in the Master's Workshop

In the Middle Ages and Renaissance, artists learned their trade by undertaking a prolonged period of technical training in the shop of a master artist. Young men became apprentices in their early teens, either because they had already shown talent or because their families wanted them to be artists. Artists usually came from the middle classes, often from families of artists. Quite a few married into such families and went into business with their relatives.

The term of apprenticeship varied. Cennino Cennini recommended six years. Apprentices began learning their trade at the most menial level. They mixed paints, prepared pigments and the painting surface, and occasionally worked on less important border areas or painted the minor figures of a master's composition. By the time an apprentice was ready to start his own shop, he had a thorough grounding in techniques and media. He would probably also have assimilated elements of his master's style.

Renaissance artists were an influential professional group, and the increased demand for art was the result of growth in the sources of patronage. During the Middle Ages, most of the patronage had been ecclesiastic (i.e. from the Church authorities). In the Renaissance, art was also commissioned by civic or corporate groups, and even by wealthy individuals. The commissions were generally sealed by legal contract between artist and patron, and these contracts have become an important documentary source for modern art historians.

the primacy of individual intellect, character, and talent. Giotto, more than any other artist, transformed these qualities into painting.

The Arena Chapel (named after the old Roman arena adjacent to it) was founded by Enrico Scrovegni, Padua's wealthiest citizen—hence its designation as the Scrovegni Chapel. Having inherited a fortune from his father Reginaldo Scrovegni, whom Dante had consigned to the seventh circle of hell for usury (money-lending), Enrico commissioned the chapel and its decoration as an act of atonement. The building itself is a simple, barrel-vaulted, rectangular structure, faced on the exterior with brick and plain pilasters. The interior is decorated with one of the most remarkable fresco cycles in Western art (fig. **13.6**). Architectural elements are kept to a minimum: the south wall has six windows while the north wall is solid, making it an ideal surface for fresco painting (see Box). The west wall, which has one window divided into three lancets, is covered with an enormous *Last Judgment* (see fig. 13.10).

On the north and south walls, three levels of rectangular scenes illustrate the lives of Mary, her parents Anna and Joachim, and Christ. Below the narrative scenes on the north and south walls are Virtues and Vices (see Box), disposed according to traditional left–right symbolism. As the viewer enters the chapel, the Virtues are on the right and the Vices are on the left. Facing the observer is the chancel arch, containing *Gabriel's Mission* at the top, two other events from Christ's life (the *Betrayal of Judas* on the left, and the *Visitation* on the right), and two illusionistic chapels.

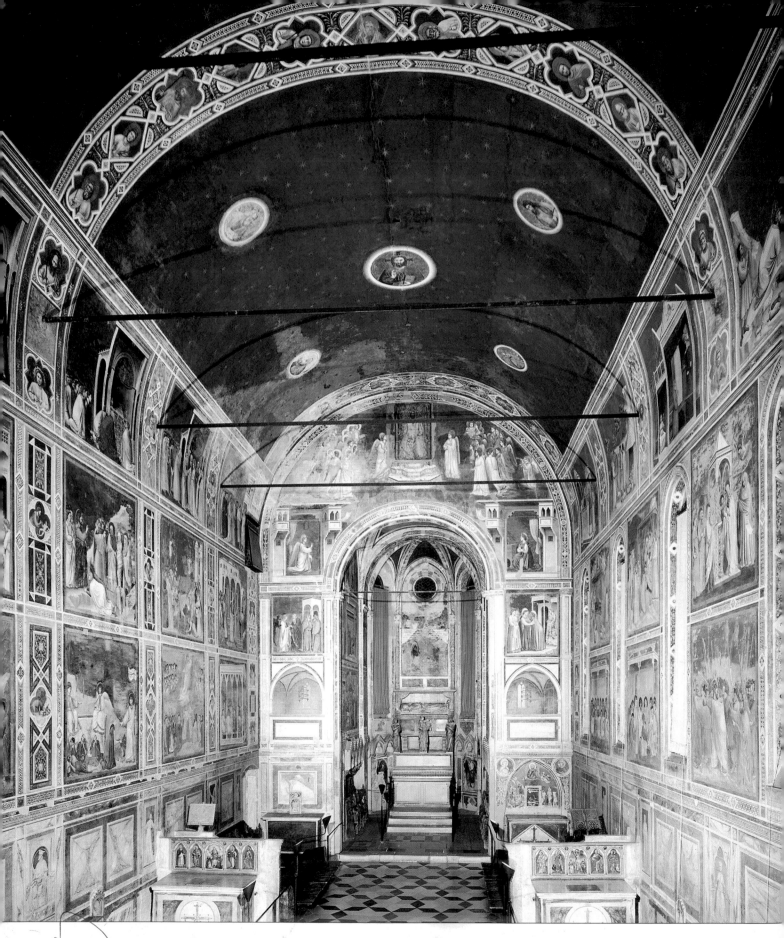

13.6 Interior view, looking east, Arena Chapel, Padua. At the top of the round chancel arch, which is reminiscent of Roman triumphal arches, there is a tempera panel set into the plaster wall, depicting God the Father enthroned. He summons the angel Gabriel and entrusts him with the Annunciation of Christ's birth to Mary.

Fresco: A Medium for Speed and Confidence

From the thirteenth to the sixteenth centuries, there was a significant increase in the number of monumental fresco cycles, especially in Italy.

Fresco cycles were typically located on plaster walls in churches or private palaces, and large scaffolds were erected for such projects. First, the wall was covered with a coarse plaster, called the **arriccio**, which was rough enough to hold the final layer of plaster. When the first layer had dried, the artist found his bearings by establishing the exact center of the surface to be painted, and by locating the vertical and horizontal axes. He blocked out the composition with charcoal, and made a brush drawing in red ocher pigment mixed with water. These drawings are called *sinopie* (*sinopia* in the singular) after Sinope, a town on the Black Sea known for the red color of its earth.

Once the artist had completed the *sinopia*, he added the final layer of smooth plaster, or *intonaco*, to the walls one patch at a time. The artist applied the colors to the *intonaco* while it was still damp and able to absorb them. Thus when the plaster dried and hardened, the colors became integrated with it. Each patch was what the artist planned to paint in a single day—hence the term *giornata*, the Italian word for a day's work. Because each *giornata* had to be painted in a day, fresco technique encouraged advance planning, speed of execution, broad brushstrokes, and monumental forms. Sometimes small details were added in tempera, and certain colors, such as blue, were applied *secco* (dry). These have been largely lost or turned black by chemical reaction.

Virtues and Deadly Sins

The seven Christian Virtues and Vices, or Deadly Sins, are commonly personified in Christian art. The seven Virtues are divided into four Cardinal Virtues—Prudence, Temperance, Fortitude, and Justice—and three Theological Virtues—Faith, Hope, and Charity.

The seven Vices vary slightly, but generally consist of Pride, Covetousness, Lust, Envy, Gluttony, Anger, and Sloth.

Immediately below *Gabriel's Mission*, separated into two images on either side of the arch, is the *Annunciation* (fig. **13.7**). The setting is a rectangular architectural space with balconies that seem to project outward. Equally illusionistic are the curtains, which appear to hang outside the architecture and swing in toward the windows.

Illusion is an important aspect of theater, and in the Arena Chapel the space in which the sacred drama unfolds has been compared with a stage. In the *Annunciation*, for example, the painted space is three-dimensional but narrow, and the architecture—like a stage set—is small in relation to the figures. Gabriel and Mary face each other across the span of the actual arch, while the viewer observes them as if through the "fourth wall" of a stage.

The combination of Classical restraint and psychological insight in Giotto's frescoes may be related to the contemporary revival of Roman theater in Padua. Although

13.7 Giotto, *Annunciation*, Arena Chapel, Padua, c. 1305. Fresco.

13.8 Giotto, *Nativity*, Arena Chapel, Padua, c. 1305. Fresco.

there is no documentary evidence for it, the pictures themselves suggest that, in creating the most dramatic fresco cycles of his generation, Giotto was influenced by this revival, as well as by the traditional Christian mystery plays performed in front of churches. This combination of influences may also explain Giotto's dramatic depictions of pose and gesture.

In the *Annunciation*, both Mary and Gabriel are rendered as solid, sculpturesque figures, their poses identified mainly by their drapery folds. Gabriel raises his right hand in a gesture of greeting. Mary holds a book, signifying that Gabriel has interrupted her reading, a conventional detail in Annunciation scenes which is from the Apocrypha (see p. 8). As Gabriel makes his announcement, diagonal rays of light enter Mary's room. The lack of a logical or natural source for this light emphasizes that it is divine light, emanating from heaven. As such, it is prophetic of the symbolic light, or en*light*enment, that Christ will bring to the world. Equally prophetic is Mary's gesture, for her crossed arms refer forward in time to Christ's Crucifixion. According to Christian doctrine, this is the means by which salvation is achieved.

A comparison of the Arena Chapel *Nativity* (fig. **13.8**) with Nicola Pisano's *Nativity* on the Pisa pulpit (see fig.

13.2) illustrates Giotto's reduction of form and content to its dramatic essence. In Giotto's fresco, as in Nicola's sculpture, two events are merged into a single space. Nicola combines the *Nativity* with the *Washing of the Infant Christ*, and the shepherds arrive in Bethlehem at the upper right. Giotto combines the *Annunciation to the Shepherds* at the right with the *Nativity* at the left. Both artists use simple, massive draperies that naturally outline human form and monumentalize the figures. But Nicola's composition is more crowded, and the dramatic relationships between figures do not have the power of Giotto's version.

Giotto's shepherds, for example, are rendered in back view, and stand riveted to the angels' announcement. In the *Nativity*, the human figures are reduced to four: Mary, Christ, Joseph, and a midwife. A single foreshortened angel above the shed gazes down at the scene, interrupting the left-to-right flow of the other angels toward the shepherds and focusing the viewer's attention onto the Nativity.

A sculpturesque Joseph dozes in the foreground, withdrawing from the intimate relationship between mother and infant. Giotto accentuates this by the power of a gaze that excludes a third party. Nicola's Mary, on the other

13.9 Giotto, *Crucifixion*, Arena Chapel, Padua, c. 1305. Fresco. The raised ground beneath the cross represents the hill of Calvary (from the Latin *calvaria*, meaning "skull"). According to tradition, Christ was crucified on the Hill of Skulls outside Jerusalem. The skull that appears in the opening of the rock is Adam's—a reminder of the tradition that Christ was crucified on the site of Adam's burial. Both that tradition and its visual reference here are typological in character, for Christ was considered the new Adam and the redeemer of Adam's sins.

hand, stares forward while Christ lies in the manger behind her. Rather than emphasize the dramatic impact of the mother's first view of her son, Nicola monumentalizes Mary as an individual maternal image and, in the *Nativity*, relegates Christ to the background. In the *Washing of Christ*, the same Mary towers over Christ, but does not exchange a glance with him.

Giotto reinforces his perception of the mother–child relationship in the depiction of the animals. Among the sheep, he repeats the theme of protection and physical closeness. In the ox and ass at the manger, he plays on the Christian meaning of their glances and merges it with the emotional significance of the gaze. The ass looks down and fails to see the importance of the event before him. He thus becomes a symbol of ignorance and sin. The ox, however, stares at the gaze of Mary and Christ, recognizing its importance in Christian terms and also replicating the role of the outsider looking in, like the viewer, on a dramatic confrontation.

In contrast to the *Annunciation*, the *Crucifixion* (fig. **13.9**) takes place outdoors, on a narrow, rocky, horizontal ground. Christ hangs heavily from the Cross, his neck and

shoulders forced below the level of his hands. His arms are elongated, his muscles are stretched, and his rib-cage is visible beneath his flesh. Transparent drapery reveals the form of his body. Family and friends are gathered to Christ's right. Mary, dressed in blue, slumps in a faint, her weight supported by Saint John and an unidentified woman. Forming a diagonal bridge from Mary and John to the Cross is the kneeling figure of Mary Magdalen, traditionally understood to have been a prostitute before she became one of Christ's most devoted followers. In this painting, she wears her hair long, an iconographic convention denoting her penance.

In contrast to the formal and psychological link between Christ and his followers on his right (our left), there is a void immediately to the left of the Cross. The symbolic distance between Christ and his executioners is reinforced by the diagonal bulk of the Roman soldier leaning to the right. The group of soldiers haggles over Christ's cloak, which one soldier prepares to divide up with a knife. (See Matthew 27:35: "they divided his clothes among them by casting lots.") Framing the head of a Roman soldier in the background is a halo, which sets him apart from

13.10 *Last Judgment*, Arena Chapel, Padua, c. 1305. Fresco, approx. 33 ft × 27 ft ¾ in (10.06 × 8.38 m).

the others and identifies him as Longinus, who converted to Christianity and became a martyr.

The sky is filled with two symmetrical groups of mourning angels. Like a Greek chorus, they echo and enhance the human emotions of Christ's followers. The spatial positions of the angels are indicated by varying degrees of foreshortening, the two above the arms of the Cross being the most radically foreshortened. Two angels extend cups to catch Christ's blood flowing from his **stigmata**, or wounds. The greater formal activity and melodrama of the angels act as a foil to the restraint of the human figures.

Chronologically, the last scene in the chapel is the *Last Judgment* (fig. **13.10**), which fulfills the Christian prophecy of Christ's Second Coming. The finality of that event corresponds to its location on the west wall of the Arena Chapel, where it is the last image to confront viewers on their way out. The fresco occupies the entire wall, adding a monumental dimension to its impact. The host of heaven, consisting of military angels, is assembled on either side of the window. Above the angels, two figures roll up the sky, to reveal the golden vaults of heaven, again evoking the image of a theater, as if stagehands were rolling up a curtain at the end of a play.

Immediately below the window, Christ sits in a circle of light, surrounded by angels. Seated on a curved horizontal platform on either side of Christ are the twelve apostles. Christ's right hand summons the saved souls, while his left rejects the damned. He inclines his head to the lower left of the fresco (his right), where two levels of saved souls rise upward. At the head of the upper group stands the Virgin Mary, who appears in her role as intercessor with Christ on behalf of humanity.

Giotto's hell, conventionally placed below heaven and on Christ's left, is the most medieval aspect of the Arena Chapel frescoes. It is surrounded by flames emanating from the circle around Christ. In contrast to the orderly rows of saved souls, those in hell are disordered—as in the Romanesque example from Conques (fig. 11.8). The elaborate visual descriptions of the tortures inflicted on the damned by the blue and red devils, and their contorted poses, are reminiscent of medieval border figures, whether on manuscripts or church sculptures.

The large, blue-gray Satan in the depths of hell is typical of the medieval taste for monstrous forms merging with each other. Satan swallows one soul while the serpentine creatures who emerge from his ears bite into other souls, an image of oral aggression that appears in many medieval manuscripts. Dragons on either side of Satan's rear also swallow souls, and, from the ear of one of the dragons, rises a ratlike creature biting into a soul, who falls back in despair. The falling and tumbling figures emphasize the

Christian conception of hell as disordered, violent, and located among the lowest realms of the universe.

Directly under Christ, two angels hold the Cross, which divides the lower section of the fresco into the areas populated by the saved and the damned. Giotto's reputation for humor is exemplified in the little soul behind the Cross who is trying to sneak over to the side of the saved. Toward the bottom of hell, a mitered bishop is approached by a damned soul holding a bag of money, possibly hoping to buy an indulgence. Besides being a criticism of corruption in the Church, this detail may be an implied reference to Reginaldo Scrovegni's financial sin, for which his son tried to atone through his patronage of the Arena Chapel. Nor surprisingly, Enrico is placed on the side of the saved (fig. **13.11**). As he kneels, his drapery falls on the ground in soft folds, suggesting the weight of the fabric. Such portrayal of the donor within a work of art was to become characteristic of the Renaissance.

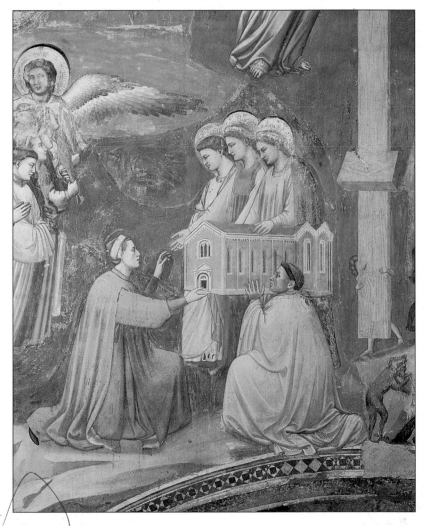

13.11 Giotto, *Last Judgment* (detail of fig. 13.10), Arena Chapel, Padua, c. 1305. Enrico Scrovegni, assisted by a monk, lifts up a model of the Arena Chapel and presents it to three female saints. Scrovegni holds the model and faces the exterior of the entrance wall, the interior of which contains the *Last Judgment*. The monk's cloak looks as if it is falling out of the picture plane over the doorway arch, another illustration of the Classical taste for illusionism.

Saint Francis was the son of a rich merchant in the Umbrian town of Assisi. As a young man, Francis made a pilgrimage to Rome, where he felt a sudden sense of identification with a beggar and traded clothes with him. For the first time in his life of privilege, Francis experienced poverty and realized its spiritual potential. He then renounced his father's wealth and dedicated his life to poverty. In 1224, while he was praying and meditating on the mountain of La Verna, he looked into the rising sun and saw a vision of Christ on the Cross. Christ's arms were the outstretched wings of a seraph (a type of angel). Scars corresponding to the wounds of the crucified Christ are then believed to have appeared on Saint Francis's body (a phenomenon known as "stigmatization"). In 1209 Francis received the pope's permission to found an order of friars, the Franciscan Order. He established a strict, simple Rule, insisting that his followers—the Friars Minor— live by the work of their own hands, or by begging. They were forbidden to accept money or property in exchange for services. Pope Innocent III approved the Rule in 1209–10, and Francis traveled to Spain, eastern Europe, and Egypt to spread his message.

Around 1212, a noblewoman of Assisi, Clare, decided to follow the Rule of Saint Francis. When other women joined her, Francis established a separate community with Clare as its abbess. Her followers became known as the Poor Clares. The power of the Franciscan movement attests to its wide appeal and, in the course of the thirteenth century, Franciscan churches proliferated. So-called "Daughter houses," established by the Poor Clares, also sprang up throughout Europe.

Partly because of the large number of Saint Francis' followers, and partly because of conflict over the rigors of his Rule, the Franciscans split into two factions. The Spiritualists adhered to strict interpretation of the Rule, whereas the Conventualists took a more flexible position.

After Saint Francis received the stigmata, he wrote his most famous work, *The Canticle of Brother Sun*. It is a long hymn in praise of the divine presence he believed resided in nature:

> Praised be You, my Lord, with all your creatures,
> especially Sir Brother Sun,
> Who is the day and through whom You give us light.
> And he is beautiful and radiant with great splendor;
> and bears a likeness of You, Most High One.
> Praised be You, my Lord, through Sister Moon and
> the stars,
> In heaven You formed them clear and precious and
> beautiful.[5]

This hymn reflects the role of Saint Francis in the new emphasis on nature that developed in the later Gothic period, and that would characterize much of the Renaissance. Saint Francis' Rule heralded a shift from monastic isolation to greater involvement—largely through preaching—with urban populations, especially the poor.

On July 6, 1228, two years after his death, Francis was canonized by Pope Gregory IX. His remains are in the thirteenth-century basilica of San Francesco in Assisi, which is the center of his cult.

Before leaving the Arena Chapel, we consider the Virtue of *Justice* (fig. **13.12**), which illustrates the contemporary Italian concern with government. Two forms of government prevailed in Italy as the Renaissance dawned. Popes and princes ruled the relatively authoritarian states, while republics and communes were more democratic. Although the latter were, in practice, more often oligarchies (governments controlled by a few aristocrats) than democracies in the modern sense, the concept of a republican government was based on the Classical ideal.

Giotto's *Saint Francis*

Although Giotto's acknowledged masterpiece is the Arena Chapel in Padua, he himself was a citizen of Florence. In that city he later decorated two surviving chapels in the medieval Franciscan church of Santa Croce. These were the family chapels of two leading banking families, the

13.12 Giotto, *Justice*, Arena Chapel, Padua, c. 1305. Fresco. Justice is personified as an enthroned queen in a Gothic architectural setting. She holds a Nike in her right hand, as did Phidias' Athena in the Parthenon *naos*, indicating that justice brings victory. Justice also leads to good government and a well-run state, with all the benefits that this implies. Painted as an imitation relief in the rectangle at the bottom of the picture are images of dancing, travel (men on horseback), and agriculture.

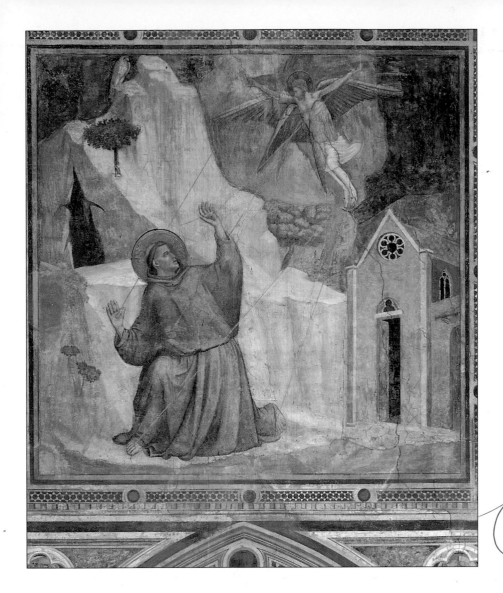

13.13 Giotto, *Stigmatization of Saint Francis*, exterior of the Bardi Chapel, Sta. Croce, Florence, after 1317. Fresco.

Bardi and the Peruzzi. In the Bardi Chapel, Giotto painted scenes from the life of Saint Francis (see Box), whose cult was one of the most prominent in Italy. Because of his insistence on poverty, the issue of decorating Franciscan churches became controversial. Likewise, the role of rich patrons in commissioning works of art depicting the lives of saints highlighted the contrast between wealthy patrons and the message of the works they commissioned.

Saint Francis pursued poverty in imitation of Christ, with whom he identified, particularly in receiving the wounds that Christ had suffered on the Cross. Giotto depicted the *Stigmatization of Saint Francis* (fig. **13.13**) in a fresco on the outer wall of the Bardi Chapel. The scene takes place in a rocky, mountainous landscape dotted with a few trees. A church stands at the right. As in the Arena Chapel, landscape and architecture are subordinate to the human figures, and reinforce them. The cubic mass of Saint Francis from the waist down is mirrored in the building and the base of the mountain. The diagonal of the torso repeats the slanting triangle of the mountaintop. Despite the mystical content of the event, Giotto represents Saint Francis as a solid, three-dimensional figure and conveys a sense of physical reaction to the experience of religious transport. He is shown as if "taken aback" by the force of light rays emanating from his vision.

By virtue of the fresco's location on the chapel's outside wall the scene is the first to be encountered by visitors. Its purpose must have been at least partly to proclaim the spiritual sentiments of the Bardi family, whose commercial acumen and wealth were well known.

Duccio's *Maestà*

The leading early fourteenth-century artists in Siena, Florence's rival city, worked in a style that was influenced by Byzantine tradition. Siena was ruled by a group known as the Nine, which was in charge of public commissions. The Nine were particularly devoted to the Virgin, for they believed her intercession had been responsible for a major thirteenth-century military victory over Florence. Her cult was a significant feature of Sienese culture, and she was the city's patron saint. Siena called itself "the Virgin's ancient city" (*vetusta civitas virginis*).

In 1308, the Nine commissioned the prominent Sienese painter Duccio di Buoninsegna (active 1278–1318) to create a new altarpiece for the high altar of their cathedral. It was to honor the Virgin, whose image is the largest in the entire work. The completed altarpiece was two-sided, and originally consisted of between fifty-four and fifty-eight panels, fifteen of which have been lost; most of

13.14a John White, photo montage of Duccio's *Maestà* (front), 1308–11. This is Duccio's only signed work (signed on the base of the throne). According to the commission contract, which was signed October 9, 1308, Duccio would receive 16 *soldi* for every day that he worked on the altarpiece. For those days that he did not work, he was docked from a monthly stipend of 10 *lire*.

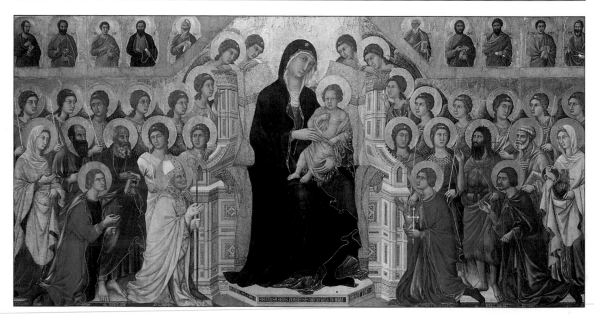

13.14b Duccio, *Maestà*, from Siena Cathedral, 1308–11. Tempera and gold on panel, 7 ft × 13 ft 6¼ in (2.13 × 4.12 m). Museo dell'Opera del Duoma, Siena.

13.15 John White, photo montage of Duccio's *Maestà* (back), 1308–11.

the dismantled panels are now in museums elsewhere (e.g. the National Gallery of Art, Washington, and National Gallery, London). In its original state, Duccio's *Maestà* was about as high as the monumental altarpieces by Cimabue and Giotto discussed above, but was considerably wider (about 13 feet/4 m). Its former appearance has been reconstructed in photo montage by the art historian John White. The front (fig. **13.14**) exalts the Virgin in her aspect as Queen of Heaven—*maestà* means "majesty." She occupies the large, horizontal panel, the sides of her throne opening up as if to welcome the viewer. Surrounding her are saints, angels, and the apostles of Christ. Above is a row of saints, each standing under a round arch. The lower sections of the pinnacles contain scenes of her last days, beginning on the left with the *Annunciation of the Death of the Virgin* and ending with the *Burial of the Virgin* on the right. At the bottom are predella panels with scenes of Christ's early life, from left to right: the *Annunciation of*

his birth, the *Nativity, Adoration of the Magi, Presentation in the Temple, Massacre of the Innocents, Flight into Egypt,* and *Christ among the Doctors.* Standing by each of these events is the Old Testament prophet interpreted as having foretold it.

The four registers on the reconstructed back of the *Maestà* (fig. **13.15**) depict Christ's Passion in thirty-two scenes. The largest, at the center, is the *Crucifixion.* The six pinnacle scenes illustrate Christ's miraculous appearances after his death, and on the predellas are scenes of his ministry.

The iconography of the altarpiece covers the full range of the Virgin's majesty and of her maternity. She is not only the heavenly mother of Christ, but of the saints and apostles, and of the citizens of Siena as their patron. In 1311, when Duccio completed the *Maestà*, it was carried in a triumphal procession, accompanied by pipes and drums, from his studio to the cathedral.

The *Kiss of Judas*

Duccio and Giotto exemplify two significant currents in early fourteenth-century Italian painting. Duccio was more closely tied to the Byzantine tradition, whereas Giotto was steeped in the humanist revival of Classical antiquity. These relationships can be clarified by comparing three examples of the *Kiss of Judas*: a Byzantine mosaic (fig. **13.16**), Duccio's panel below the Crucifixion in the *Maestà* (fig. **13.17**), and the Arena Chapel fresco (fig. **13.18**). All three represent the moment when Judas identifies Christ to the Romans with a kiss. In the mosaic and in Duccio's panel, Christ is nearly frontal, and Judas leans over in a sweeping curved plane to embrace him. Their heads connect, but in neither case do Judas' lips actually touch Christ's face. Both scenes are set outdoors, against a gold sky. The figures in the mosaic face the viewer, and are only minimally engaged with each other. They are outlined in black, and their diagonal feet accentuate the two-dimensionality of their space. As the largest figure, Christ stands out as the most significant; he also has a jeweled halo and wears the purple robe of royalty, denoting his future role as King of Heaven.

Duccio's panel is more densely packed with figures than the mosaic. This, together with the landscape background, conveys an illusion of greater depth. The more subtle shading of the drapery folds also gives the figures a greater sense of three-dimensional form. In the mosaic, the apostles at the right wear Roman-style togas, and stand in vertical planes. The only sign of emotion at the arrest of their leader is the slight agitation of their tilted heads. In the Duccio, however, the apostles break away from the central crowd, and rush off to the right. Their long, curvilinear planes have the quality of a graceful dance movement performed in unison. At the left, Saint Peter also turns from Christ, but, in a rage, he cuts off the ear of Malchus, the servant of the High Priest.

Giotto's version of the *Kiss of Judas* (fig. 13.18) lives up to his reputation among humanist authors for having reintroduced naturalism to painting. The sky, for example, is no longer gold, but rather a natural blue. (It is likely that Giotto knew the Ravenna mosaics in the mausoleum of Galla Placidia, where the skies are also blue.) The fresco is virtually devoid of landscape forms that might distract viewers from the central event. Nor do any of Giotto's figures face the picture plane. All are focused on the dramatic confrontation between Christ and Judas. These two, in turn, are locked in each other's gaze, surrounded ominously by the black helmets framing their heads. Over Christ's head, the two hands holding stakes accentuate the rage of the mob against him; none of the stakes is vertical,

13.16 *Kiss of Judas*, Sant'Apollinare Nuovo, Ravenna, early 6th century. Mosaic.

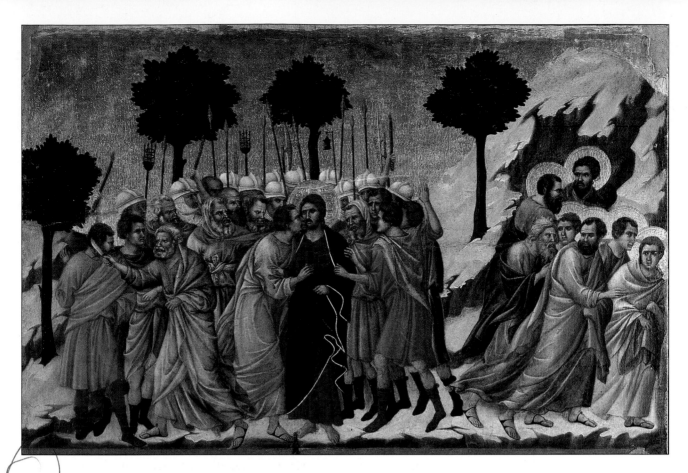

13.17 Duccio, *Kiss of Judas*, from the *Maestà*, 1308–11. Tempera on panel. Museo dell'Opera del Duomo, Siena.

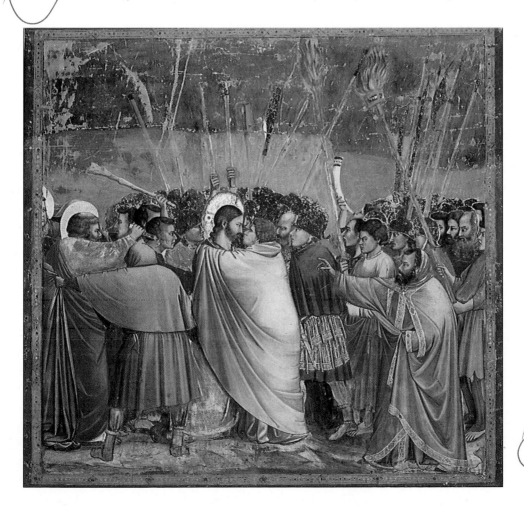

13.18 Giotto, *Kiss of Judas*, Arena Chapel, Padua, c. 1305. Fresco.

as in the Duccio, those behind Christ seeming to radiate from an unseen point. In this convergence of forms, therefore, Giotto signals the violence of Christ's death, and also his ultimate triumph.

Giotto is the first Western artist since ancient Rome to have depicted figures in back view. In the *Kiss of Judas*, he places three figures as if in different stages of a turn: the pointing man at the right is in three-quarter view; Judas turns farther to the right as his yellow cloak envelops Christ; and the hooded man in gray is seen directly from the rear. Together, these three create a sense of movement from right to left across the picture plane, counteracting the left–right flow of the narrative. Another counter-motion can be seen in the figure of Saint Peter, who raises his hand behind the head of the hooded man, and vigorously cuts off the ear of Malchus. Saint Peter does not, as in Duccio's scene, turn away from Christ. The thrust of his blow interacts with the gesture of the hooded figure, whose very presence conveys an air of foreboding. His facelessness, characteristic of the executioner, alludes to Christ's imminent death on the Cross.

Ambrogio Lorenzetti and the *Effects of Good Government*

Some twenty-seven years after the triumphal procession for Duccio's *Maestà*, the innovative Sienese artist Ambrogio Lorenzetti (active 1319–47) painted *Allegories of Good and Bad Government* for the Palazzo Pubblico (Town Hall) of Siena. Figure **13.19**, like Giotto's *Justice* (fig. 13.12), illustrates the effects of good government on a

city—in this case Siena. In contrast to the *Maestà*, Ambrogio's *Allegory* is secular, and reflects the new humanist interest in republican government. He depicts a broad civic panorama with remarkable realism. In the foreground (from left to right), women wearing the latest fashions dance and sing in celebration of the joys of good government; people ride on horseback among the buildings, whose open archways reveal a school, a cobbler's shop, and a tavern; farmers are shown entering the city to sell their produce. On top of the central building in the background, workers carry baskets and lay masonry. In this imagery, Lorenzetti suggests that both agricultural prosperity and architectural construction are among the advantages of good government.

Just outside the city walls, people ride off to the country. Below, a group of peasants tills the soil, and the cultivated landscape visible in the distance draws the viewer into an almost unprecedented degree of spatial depth. Floating above this tranquil scene, an allegorical figure of Security holds a scroll with an inscription reminding viewers that peace reigns under her aegis. And should one fail to read the inscription, she provides a pictorial message in the form of a gallows. Swinging from the rope is a criminal executed for violating the laws of good government. Accompanying Ambrogio's vision of prosperity and tranquility, therefore, is a clear warning of the consequences of social disruption.

Just behind the left foot of Security, Ambrogio has included the statue of the legendary she-wolf who nursed Romulus and Remus. Projecting from the city's wall, she seems to survey the surrounding countryside. At the

same time, the wolf makes explicit the link between ancient Rome and Siena.

Stylistically, Ambrogio's *Allegories* fall between Giotto and Duccio. Although the *Allegory of Bad Government* is severely damaged, certain details are clear. That in figure **13.20** shows two soldiers attacking a woman, rendered in a graceful S-curve. Above are the feet of two hanged criminals, echoing the exemplary gallows of Security. Despite its violence, the scene lacks the dramatic power that characterizes Giotto's work. On the other hand, Ambrogio's figures are closer to Giotto's than to Duccio's in their sense of mass and volume. Nor are their draperies trimmed with gold as Duccio's often are.

13.19 (opposite and below) Ambrogio Lorenzetti, *Effects of Good Government in the City and the Country*, from the *Allegory of Good Government*, 1338–39. Fresco, entire wall 46 ft (14 m) long. Sala della Pace, Palazzo Pubblico, Siena. Ambrogio was the younger of two artist brothers who were active in the first half of the 14th century. Both were born and worked in Siena, and they are believed to have died from the Black Death, since nothing is heard of them after 1348. Ambrogio also worked in Florence, where he was exposed to Giotto's style. The *Allegory of Good Government*, which has considerable documentary value as well as artistic merit, is considered his greatest surviving work.

13.20 (right) Ambrogio Lorenzetti, detail showing soldiers attacking a woman, from the *Allegory of Bad Government*, 1338–39. Fresco. Palazzo Pubblico, Siena.

The Black Death

13.21 Andrea Orcagna, detail showing figures invoking Death, from the *Triumph of Death*, c. 1360. Fresco. Museo dell'Opera di Santa Croce, Florence.

The bubonic plague of 1348 killed some 25 million people. It was carried by a bacillus in fleas that lodged in the fur of common rodents. The effects of the Black Death were described by Boccaccio in the preface of the *Decameron*, a collection of 100 stories set in fourteenth-century Italy:

> 1348. The mortal pestilence then arrived in the excellent city of Florence.... It carried off uncounted numbers of inhabitants, and kept moving ... in its early stages both men, and women too, acquired certain swellings, either in the groin or under the armpits. Some of these swellings reached the size of a common apple ... people called them plague-boils ... the deadly swellings began to reach ... every part of the body. Then ... began to change into black or livid blotches ... almost everyone died within the third day ... even to handle the clothing or other things touched by the sick seemed to carry with it that same disease....

> Some persons advised that a moderate manner of living, and the avoidance of all excesses, greatly strengthened resistance to this danger.... Others ... affirmed that heavy drinking and enjoyment ... were the most effective medicine for this great evil....

> The city was full of corpses ... there was not enough blessed burial ground ... they made huge trenches in every churchyard, in which they stacked hundreds of bodies in layers like goods stowed in the hold of a ship, covering them with a bit of earth until the bodies reached the very top.[6]

There was, as Boccaccio observed, a general air of penance on the one hand, and a "seize the day" mentality on the other. As a result of the disasters that swept Europe during the first half of the fourteenth century, artists became drawn to such subjects as the Triumph of Death. Andrea di Cione—known as Orcagna (active c. 1343–68)—painted a monumental fresco in the church of Santa Croce in Florence in which he combined the theme with depictions of hell and the Last Judgment. Although the work survives only in fragments, its message of impending doom remains clear.

The detail in figure **13.21** shows two cripples and two blind men invoking Death. The anxious gesture of one of the sightless men contrasts with the wide-eyed stares of the cripples, whose hands are needed for their crutches. The inscription reads: "Since prosperity has departed, Death, the cure of all pain, come and give us our last supper." In another fragment of Orcagna's *Triumph of Death* (fig. **13.22**), two men gaze at an eclipse of the sun. Since contemporary documents related the eclipse of 1333 to subsequent flooding, it is likely that this detail associates those events with both the Old Testament Flood and the apocalyptic "day of wrath" (Revelation 6:12–17).

13.22 Andrea Orcagna, detail showing two men watching an eclipse of the sun, from the *Triumph of Death*, c. 1360. Fresco. Museo dell'Opera di Santa Croce, Florence.

Ambrogio Lorenzetti's monumental secular paintings were the first of their kind in Western art since Christianity had become the official religion of Rome. They reflected the shift that had occurred in patronage, which was no longer exclusively tied to the Church—even in Siena where the Virgin's cult was at its strongest. As Lorenzetti's work reveals, the new cultural and intellectual concerns of the early fourteenth century had resulted in a revolutionary development in style. Giotto had created a new approach to painted space, influenced as he was by the sculpture of Nicola Pisano and his son Giovanni, and by discoveries of Classical texts. For the first time since Greco-Roman antiquity, human figures occupy three-dimensional settings. Backgrounds are no longer gold but rather defined by natural blue skies or landscape. Architecture is set at an oblique angle to the picture plane, creating an illusion of spatial recession.

A series of disasters in western Europe disrupted the activities of the next generations of fourteenth-century artists. In 1304 a fire destroyed much of Florence; eight years later, the city was under siege by the Emperor of Luxemburg, who had sacked the Tuscan countryside. In 1329, there was famine, an eclipse followed by a flood in 1333, and a smallpox epidemic in 1335 that killed thousands of children. In the early 1340s, both the Bardi and Peruzzi banks failed, and in 1348 the bubonic plague—referred to as the Black Death—devastated Europe (see Box). In Florence and Siena, between 50 and 70 percent of the residents died, resulting in population shifts, economic depression, and radical changes in artistic patronage and style.

Contemporary sermons document the resurgence of religious fervor following the Black Death. In the visual arts there was a revival of certain aspects of the Byzantine style. The increasingly humanistic style of the first half of the century yielded to a more pessimistic view of the world, with greater emphasis on death and damnation. The innovations of Giotto and other early fourteenth-century artists remained in abeyance, and were revived by the first generation of Italian painters, sculptors, and architects of the fifteenth century.

The International Gothic Style

An entirely different mood characterized works commissioned by the courts in fourteenth-century Italy and France. Their wealth made it possible to import artists from different regions and to pay them well. The resulting convergence of styles, generally known as International Gothic, continued into the fifteenth century; the best fourteenth-century examples were executed under French patronage.

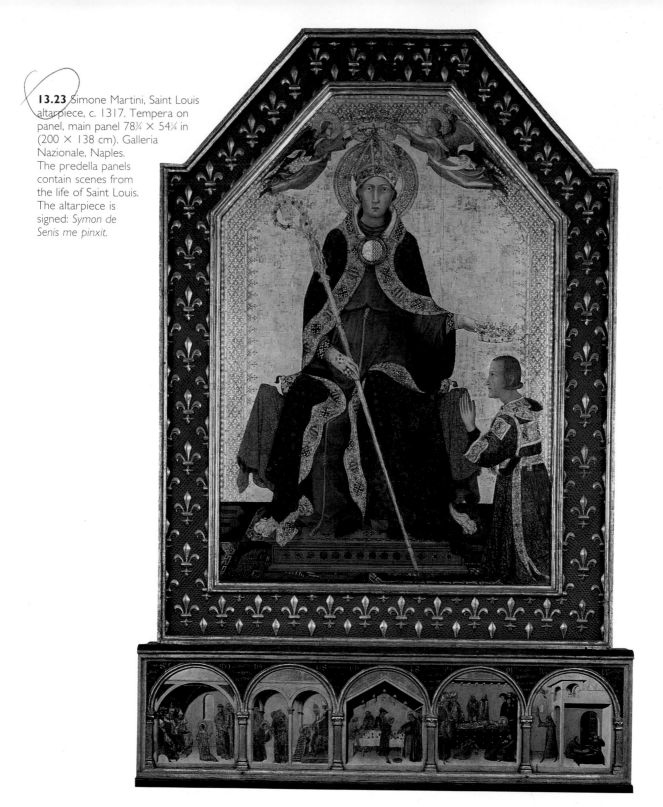

13.23 Simone Martini, Saint Louis altarpiece, c. 1317. Tempera on panel, main panel 78¾ × 54¼ in (200 × 138 cm). Galleria Nazionale, Naples. The predella panels contain scenes from the life of Saint Louis. The altarpiece is signed: *Symon de Senis me pinxit.*

Simone Martini

In the Angevin court at Naples (in southern Italy), French taste predominated, even in the work of Italian artists. King Robert of Anjou was the younger brother of Louis of Toulouse, who had joined the Franciscan order of the Friars Minor. When elected to the rank of bishop in 1296, Louis renounced the throne in favor of Robert, and died a year later. Amid rumors that he had usurped the throne, Robert commissioned the Sienese artist Simone Martini to paint the altarpiece illustrated in figure

13.23. The date of the commission, 1317, coincided with Louis' canonization.

The enthroned Franciscan saint is dressed in embroidered velvet robes, and wears a bishop's miter. He is set against a rich gold background with a raised gold halo and border inside the frame. In keeping with courtly tastes, especially that of Naples, the drapery was originally decorated with real jewels embedded in the panel. Simone Martini's attraction to such taste is further evident in the fluid, curvilinear robes, the jeweled crozier (bishop's staff) and crowns, the long, thin hands, and

pale, delicate faces of his figures. Two angels crown Saint Louis as he bestows the earthly crown on his brother. Through his large size, central position, and frontality, Louis is endowed with an imposing, iconic presence, whereas Robert is portrayed in miniature, and in three-quarter view. It is clear that Simone (and presumably his patron) intended the viewer to perceive the saint as the more important figure and his ecclesiastic office as more powerful than that of the earthly ruler. The gold fleurs-de-lis on the blue background of the frame identify the scene with the French royal family, which reinforces the legitimacy of Robert's claim to the throne.

Claus Sluter

Toward the end of the fourteenth century, France was ruled by Charles V. Two of his brothers—Philip the Bold (1342–1404) and Jean, Duc de Berry (1340–1416)—presided over lavish courts, which were enriched by their ambitious patronage. The sumptuousness of the works produced for them shows the degree to which the courts were far removed from the real world, with France and other areas of Europe suffering continual upheaval from the ravages of the Hundred Years' War.

Philip's court was located at Dijon, in the Burgundy region of central France. His wife, Margaret of Flanders

13.24 Claus Sluter, Portal, Chartreuse de Champmol, Dijon, 1385–93. The sculptor Claus Sluter was born in Haarlem, the Netherlands. After he went to the court of Philip the Bold, he was quickly promoted to the position of *imagier* and *valet de chambre*.

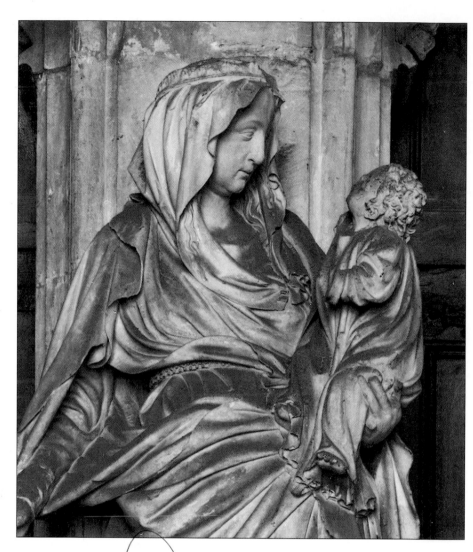

13.25 (above left) Claus Sluter, *Virgin Mary*, central trumeau of portal, Chartreuse de Champmol, Dijon, 1385–93.

13.26 (above right) Claus Sluter (detail of fig. 13.25).

(modern Holland, Belgium, and parts of France), provided a link with the North. Reflecting the international character of his court and his patronage, Philip commissioned an architect from Paris and a sculptor from the Netherlands to design a Carthusian monastery—the Chartreuse de Champmol—near his Dijon palace. This building was to house the family tombs. Philip's competition with the king is suggested by the fact that his architect had worked for Charles in Paris, and that the monastery's portal followed Charles' lead in placing portrait sculptures of living people on the door jambs—a site formerly reserved for Old Testament kings, queens, and prophets, and for Christian saints.

Philip's sculptor, Claus Sluter (active 1379–1406), placed a figure of the *Virgin Mary* on the trumeau of the portal (figs. **13.24**, **13.25**, and **13.26**). She is crowned, but her character is primarily maternal. Although the architectural feature above her is entirely Gothic and Sluter worked in an essentially Gothic tradition, a comparison of his *Virgin* with the thirteenth-century *Vierge dorée* at Amiens (see fig. 12.37) shows the degree to which he has transformed the representation of human figures. His *Virgin* turns more freely in space, and gazes on a Christ who is more child-

like than his Gothic predecessors. Christ's floppy head and chubby proportions articulated by the drapery folds indicate that Sluter was a careful observer of children. He has represented the physical and psychological character of this infant Christ with a new, naturalistic accuracy, while Mary is animated by the sweep of her billowing draperies. The arrangement of the folds emphasizes her spatial flexibility, and creates a sense of dynamic energy.

Mary's gaze, focused as it is on Christ, is repeated by the door jamb figures. Philip (on the left) and Margaret (on the right) are represented kneeling in prayer toward the Virgin. They adore the Queen of Heaven as she adores the child. Leaning over the noble pair and interceding on their behalf are saints, John the Baptist and Catherine. Sluter contrasts the rhythmic orchestration of deeply carved, elegant drapery curves with the fixed, arrested concentration of the door jamb figures on Mary and Christ.

Two years after completing the portal, Sluter set to work on the Well of Moses, a monumental fountain for the Chartreuse (figs. **13.27** and **13.28**). It was set on a hexagonal base with an Old Testament figure on each side. Six small angels stand on colonnettes located between the life-size figures. They lean over in the compressed space under the edge of the basin, and spread out their wings to form an arch over each large figure. Their crossed arms allude to the Crucifixion, which was originally represented by a great Cross (now lost). It was set in stone that was carved

in imitation of Mount Golgotha. This was supported by the "Well," just as the Old Testament was seen as the foundation of the New. Christ was thus the "fountain of life"— the *fons vitae*—and he faced east, in the same direction as David (fig. 13.27), the ancestor of Christ, represented as both prophet (the scroll) and king (his crown). Philip the Bold's identification with David is accentuated by the design of the crown, which is ringed with fleurs-de-lis. To the right of David is Jeremiah, who prophesied that the New Covenant would replace the Old. To David's left is

13.27 Claus Sluter, Well of Moses, Chartreuse de Champmol, Dijon, begun 1395. Painted stone, interior diameter of basin 23 ft 6 in ×
23 ft 7 in (7.16 × 7.19 m). David's right hand rests on his harp, and he holds a scroll in his left hand. The inscription on the scroll is from Psalms 22:16–17: "they pierced my hands and my feet. I may tell all my bones" (*foderunt manus meas et pedes meos, numerarunt ossa mea*).

13.28 Claus Sluter, head of Moses (detail of fig. 13.27).

Sinai with the Tables of the Law. These ushered in a new social and religious order. Moses, therefore, stands as a prefiguration of the new Christian order signified in the great Crucifix over the fountain. And it is to that event that the inscription of Moses' scroll refers: "the whole assembly of the congregation of Israel shall kill it [the lamb] in the evening" (Exodus 12:6).

The Limbourg Brothers

In northern Europe, manuscript illumination was the primary medium of painting at the turn of the century. The illuminated manuscripts of the Limbourg brothers were among the most impressive works of art produced at the court of Jean, Duc de Berry. Jean was an ardent patron, who collected jewels and books, tapestries and goldwork, and led a life of immense luxury. The three Limbourg brothers—Paul, Herman, and Jean—came from the Netherlands, first to the Burgundy court and then to Berry. They made Books of Hours, which are prayer books organized according to the liturgical calendar. The most famous of these is the *Très Riches Heures du Duc de Berry* (the *Very Rich Hours of the Duke of Berry*).

Books of Hours were made for lay people, and most were commissioned by the aristocracy and upper middle class. They were expensive heirlooms, prized by their owners and passed down from one generation to the next. Ever since the fourth century, the illuminated manuscripts accompanying Books of Hours had been sources of learning and esthetic pleasure. The contents of these books vary, but generally include the prayers to be said at the eight canonical hours of the day. In the fourteenth century, Books of Hours had become best sellers, and, for the first time in the Christian era, they were even more popular outside clerical circles than the Bible. Most were produced in France, England, and the Netherlands, while Italy, Spain, and Germany were more likely to import them. Their significance for the rise of literacy in the fourteenth century is problematic, although it is clear that literacy did increase in the later Middle Ages. Strictly speaking, one did not have to be able to read to enjoy Books of Hours: merely gazing on their illuminations was considered a form of prayer, and, in any case, their owners would have known their contents by heart. The primary function of these images was to evoke identification through prayer as a route to salvation.

Moses, who transmitted the Old Testament Law to the Hebrews; the other figures on the fountain are the prophets Zechariah, Daniel, and Isaiah.

The detail of Moses (fig. 13.28) shows a powerful, thoughtful patriarch. His lined face, strong nose, and slight frown give the sculpture a portrait-like quality. But the features are overwhelmed by the swirling energy of the beard, and the stunted horns emerging from his head. These became an iconographic convention in representations of Moses, when the word *cornuta*, meaning "rays of light," was misread as "horns." They make manifest the radiance of Moses on descending from Mount

The manuscript page of the *Annunciation* from the *Très Riches Heures* (fig. **13.29**) shows Mary interrupted at her *prie-dieu* (a type of prayer desk) by Gabriel's arrival. He

13.29 Limbourg Brothers, *Annunciation,* from the *Très Riches Heures du Duc de Berry,* 1413–16. Illumination. Musée Condé, Chantilly, France.

carries three lilies, signifying the passion and purity of the Virgin, and a scroll with the inscription *"Ave gratia plena"* ("Hail [Mary] full of grace"). The scene takes place in a Gothic chapel (despite the round arch) decorated with delicate stone tracery, and set against a sumptuous, blue brocade backdrop. An angelic choir makes music on the chapel roof, and at the left are statues of two prophets. In the upper left, outside the frame, God the Father appears in a winged circle of light. He holds an orb with a cross, and sends down to Mary the impregnating rays of his light. Decorating the rest of the border are musician angels (those beneath the text are singing angels) intertwined with elegant, curvilinear foliate forms. Jean de Berry's two coats of arms are held by his emblems, the swan and the bear, and serve as the signature of his patronage.

The manuscript page illustrating the month of *February* (fig. **13.30**) is the first snowscape in Western art. In the semicircle above are the zodiac signs that correspond to the time of year. The detailed observation of nature in this scene is typical of the Limbourg brothers' work, and reflects a new focus on the representation of everyday life.

In the distance, a man drives his donkey to town. In the middle ground, a man cuts wood for fire. The foreground is a specific depiction of a farm in winter. Four beehives are neatly lined up on a low platform. A woman rushes toward the house, and blows warm breath on her cold hands. The sheep huddle together for warmth in their fold, and birds search for food under the snow. Smoke rises from the chimney of the farmhouse. Inside the house, the peasant couple lift their clothing to get the full benefit of the fire, but they immodestly expose themselves. The mistress of the house is more discreet: she turns from the peasants and gingerly raises her own skirt, exposing only her lower leg and a slip.

Such representation of observed detail, whether to reveal social distinctions or to depict nature, entered the vocabulary of painting in the course of the fourteenth century. The art of the courts seems to have avoided the effects of the disasters that swept western Europe in the first half of the century. The International Gothic style persisted into the fifteenth century, but the major innovations in art from 1400 resume the developments introduced by Giotto.

13.30 Limbourg Brothers, *February*, from the *Très Riches Heures du Duc de Berry*, 1413–16. Illumination, 8¾ × 5⁵⁄₁₆ in (22.2 × 13.5 cm). Musée Condé, Chantilly.

	Style/Period	Works of Art	Cultural/Historical Developments
1250	**PRECURSORS OF THE RENAISSANCE** Mid-13th to 14th century	*Kiss of Judas* (**13.16**), Sant'Apollinare Nuovo Pisano, *Nativity* (**13.1**), Pisa Baptistry Cimabue, *Madonna Enthroned* (**13.4**) Giotto, *Kiss of Judas* (**13.18**), Arena Chapel Giotto, Frescoes (**13.7–13.12**), Arena Chapel Duccio, *Kiss of Judas* (**13.17**), *Maestà* altarpiece Giotto, *Madonna Enthroned* (**13.5**) Martini, Saint Louis altarpiece (**13.23**) Giotto, *Stigmatization of Saint Francis* (**13.13**), Bardi Chapel Lorenzetti, *Allegory of Good Government* (**13.19**), Palazzo Pubblico, Siena Lorenzetti, *Allegory of Bad Government* (**13.20**), Palazzo Pubblico, Siena Orcagna, *Triumph of Death* (**13.21–13.22**) Sluter, Chartreuse de Champmol Portal (**13.24–13.26**), Dijon Sluter, Well of Moses (**13.27–13.28**)	Invention of the glass mirror (1278) Rise of Florence as a leading commercial center (c. 1280) The "Pied Piper of Hamelin" (1284) End of the Crusades; Knights of Saint John of Jerusalem settle in Malta (1291) Building of Palazzo Vecchio, Florence (1299–1301) Birth of Italian poet Petrarch 1304 (d. 1374) Dante writes *The Divine Comedy* (1307–21) Papal seat moves to Avignon (1309) Birth of John Wycliffe, English church reformer (1328) Bankruptcy of Bardi and Peruzzi banking houses of Florence (1345) The Black Death ravages Europe (1347–51) Giovanni Boccaccio writes the *Decameron* (1353) The Aztecs build their capital at Tenochtitlán, Mexico (1364) Development of the steel crossbow (c. 1370) Peasants' Revolt in England (1381) Chaucer writes *The Canterbury Tales* (1387–1400) Birth of Johann Gutenberg, inventor of printing in Europe (1396)
1400	**EARLY RENAISSANCE** 15th century	Limbourg Brothers, *Très Riches Heures du Duc de Berry* (**13.29–13.30**)	The invention of scientific perspective (c. 1400) Rise to power of the Medicis in Florence (1400) The English defeat the French at Agincourt (1415)

Martini, Saint Louis altarpiece

Sluter, Chartreuse de Champmol Portal

Duccio, Kiss of Judas

Kiss of Judas

Giotto, Kiss of Judas

14
The Early Renaissance

Italy in the Fifteenth Century

Renaissance Humanism

For most of the Quattrocento (or 1400s) the city of Florence in Tuscany was the intellectual, financial, and artistic center of Renaissance Italy (fig. **14.1**). Florence followed the lead of the fourteenth-century poet Petrarch in the pursuit of humanism (see Box) and the revival of Classical texts. Fifteenth-century writers, such as Leonardo Bruni (see Box on p. 483 and fig. **14.2**), extolled Florence as a new Athens and the heir of ancient Roman republicanism. A chair of Greek studies had been established at the University of Florence in the 1390s, and in the next few decades translations of Plato and other Greek authors would become available.

The dominant Florentine banking family in the fifteenth century, the Medici, was among the leading humanists. They, and other powerful families, supported humanism financially and philosophically, encouraging the study of Plato and Neoplatonism, one goal of which was to reconcile Christianity with Platonic philosophy. They collected ancient Greek and Roman sculpture, and gave contemporary artists access to it. Humanist **patrons** commissioned works by the most progressive fifteenth-century artists, particularly those who were humanists themselves.

Another aspect of humanism was the new Renaissance interest in individual fame that had developed in the fourteenth century. It was associated not only with territorial, financial, and political power, but also with the arts. Renaissance patrons understood the power of imagery

Humanism

The Renaissance is sometimes called the great age of humanism, because it revived the ideals embodied in the ancient Greek maxim "Man is the measure of all things" (see Vol. I, p. 141). Renaissance humanism, which flourished from about 1300 to 1600, was many-faceted. There was a movement away from the medieval, and specifically the Scholastic, use of Aristotelian logic toward the study of original Greek and Roman texts. Beginning with Petrarch in the fourteenth century, educational reforms approached Classical studies independently, rather than linking them with Christianity. Scholars no longer used Gothic script, or pursued intellectual inquiry in the service of the Church, but rather preferred the clarity of the Latin alphabet, standardized spelling and grammar, and skill in the art of rhetoric. Classical texts were translated, and history, literature, and mythology were studied along with Christian subjects. Professorships in Greek were established, humanist schools and libraries were founded, and art collectors sought out original Greek and Latin works. There was a new awareness of history, and a fledgling interest in archaeology as a means of uncovering ancient objects and resuming contact with the Classical past.

The pursuit of the literature of antiquity had a parallel in the visual arts. Now artists wanted to bypass the Middle Ages and recover the Greek and Roman forms. Sometimes, because of faulty historical information, Renaissance artists mistook Romanesque for Roman, just as scholars believed the Carolingian script to be Latin. In literature, the anecdotal tradition led to full-length biography and autobiography, especially of artists; fewer lives of the saints were written. Above all, the philosophical idea that man was rational, and capable of achieving dignity, intellectual excellence, and high ethical standards by means of a Classical education, determined the character of Renaissance humanism. (Women were generally omitted from such characterization.) Several humanist authors wrote on the dignity of man. Gianozzo Manetti (1396–1459), for example, wrote, "how great and wonderful is the dignity of the human body; secondly, how lofty and sublime the human soul, and finally, how great and illustrious is the excellence of man himself made up of these two parts."[1]

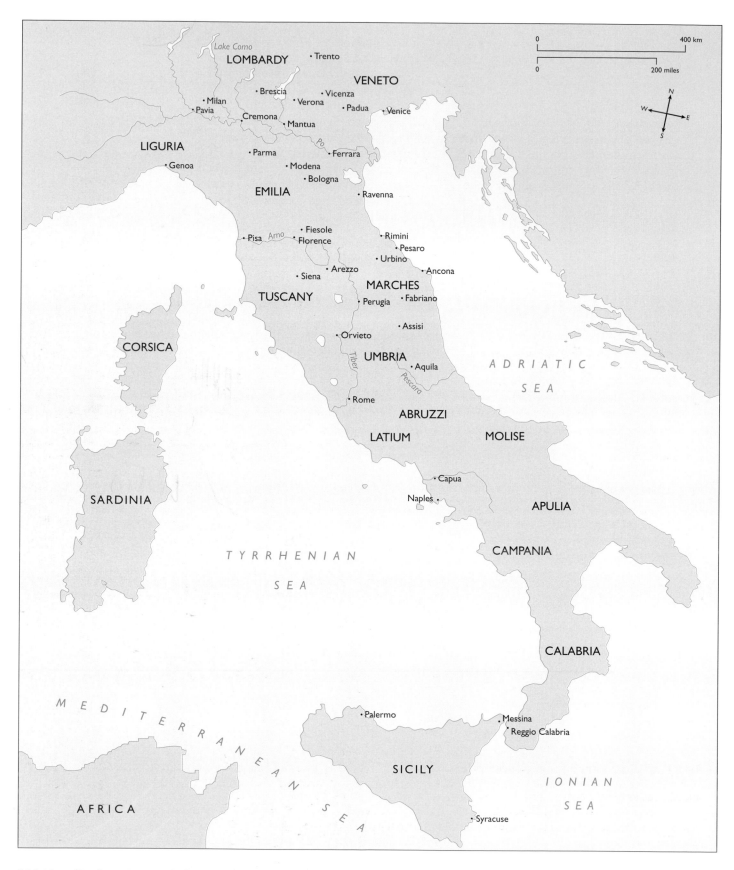

14.1 Map of leading art centers in Renaissance Italy.

Leonardo Bruni and the Humanist Tomb

The life and work of Leonardo Bruni (1369–1444)—Chancellor of Florence, an apostolic secretary, and a historian—exemplify the humanist ideal. Around 1403, he wrote the *Laudatio [Praise] of the City of Florence*, linking Florence with Classical antiquity and praising the city as a center of liberty and justice. As in ancient Athens and republican Rome, Florentine citizens participated in their government. According to Bruni, the political and social organization of Florence conformed to the Classical ideal of harmonious order. Each civic institution was both an independent entity, and integrated into the whole structure of the city. Later, from 1415 to 1429, Bruni wrote a *History of the Florentine People*, in which he argued that classically educated citizens produced the best kind of government.

When he died, the republic of Florence commissioned the sculptor Bernardo Rossellino (1409–64) to create a monumental wall tomb for his **sarcophagus** (fig. 14.2). Its design became the prototype of Renaissance wall tombs. In effigy, Bruni lies with his head resting on a pillow as if asleep, and holds a book. Two eagles—a reference to the emblem of the Roman legions—support his bier. On the side of the sarcophagus itself, two **Nikes** (winged Victories) carry a Latin inscription proclaiming that the Greek and Roman Muses mourn Leonardo's death, and that the art of eloquent speech has been silenced. Framing the effigy and the sarcophagus is a classicizing **niche**. **Corinthian pilasters** support a round arch carved with a laurel wreath design. In the **lunette**, a **tondo** flanked by praying angels depicts the Virgin and Child. Over the arch, two winged *putti* hold a wreath, which frames a Marzocco (the lion symbol of Florence). Note that the presence of the lion is also an allusion to the "Leo" in Bruni's name.

The humanist character of Bruni's tomb resides in the exaltation of an individual for his achievements, as well as in the details of its iconography. The book, for example, refers to Bruni as a classically educated man of letters, as well as to his own history of Florence. He used his education and talents in the service of the state—hence the Marzocco at the apex of the structure. The combination of Classical with Christian motifs and the specific links to antiquity echo Bruni's own writing. In honoring Bruni with a monumental tomb of this type, therefore, the republic of Florence was also honoring its own Classical heritage.

14.2 Bernardo Rossellino, Tomb of Leonardo Bruni, Santa Croce, Florence, 1444. Marble, 20 ft (6 m) high.

and used it to extend their fame and influence beyond the borders of their own states.

Courts throughout Italy were thriving centers of artistic activity and vied with each other for prominent humanist scientists, writers, architects, painters, and sculptors. They established libraries as collections of Classical and Christian **manuscripts** expanded. In Mantua, the Gonzaga court founded an innovative school, La Gioiosa, where promising students from less wealthy families were educated alongside the children of the nobility. In the most enlightened families, girls were taught together with boys, and both learned Latin and Greek, as well as other humanist subjects. Such humanist schools also stressed physical education and discipline. Girls and boys learned sports, including swimming, ball games, and horse-riding, but boys were more likely than girls to study the martial arts.

By the time these students became princes, dukes and duchesses themselves, they were skilled in politics, diplomacy, and rhetoric, and were knowledgeable in the Classics. In some cases, women were sufficiently well educated to run the state while their husbands were away—either fighting as *condottieri* (see Box) or engaged in diplomatic missions abroad. A few women became important patrons of the arts. Painters and sculptors made portraits of the patrons or, as in the Arena Chapel (see figs. 13.6–13.12), included their portraits in monumental fresco cycles. The humanist writers praised their patrons in works of literature, which were generally based on ancient Greek and Roman models.

Artists gained stature as they absorbed the culture of Classical antiquity. Leon Battista Alberti, for example (see below, p. 506), recommended a humanist education for all artists and advised them to befriend poets, orators, and princes. The writing and sculpture of Lorenzo Ghiberti, the goldsmith whose *Commentarii* of around 1450 combined art theory with history, biography, and autobiography, reflected the new interest in Classical texts. Even though Ghiberti himself had not received a formal humanist education, he advocated it as a foundation for artistic training.

Artists and others who admired antiquity traveled to Rome to draw ancient ruins, while antiquarians went to Constantinople and to Greece to collect Classical texts and Greek statuary. This search for the Classical past was combined during the Renaissance with an interest in empirical experience and a taste for intellectual and geographical discovery. In the second half of the fifteenth century Leonardo da Vinci, for example, pursued science as well as art, dissecting bodies and producing detailed anatomical drawings (see fig. 15.13). The invention of printing and the use of moveable type in the fifteenth century made books more available to the general population. In the last decade of the century, financed by the Spanish monarchs Ferdinand and Isabella, Columbus sailed to America in ships owned by the Medici, thereby heralding the great age of world exploration in the sixteenth century.

One of the energizing features of the Renaissance was its interdisciplinary nature. The most influential synthesis derived from the integration of antiquity, especially ancient history and art, with the ideas and attitudes of the Quattrocento. Whereas the medieval Scholastic tradition had integrated Aristotelian thought with Christianity, the Renaissance encouraged the study of Plato and the revival of Platonic ideas. Far from treating this pagan influence as threatening, the most enlightened Renaissance popes encouraged humanist assimilation of ancient Greek and Roman philosophies into their own Christian faith.

The Competition for the Florence Baptistry Doors

A good example of the increase in the range of patronage during the Renaissance was the competition of 1401 to design a set of doors for the east side of the Florence Baptistry. (This was subsequently changed to the north side.)

Soldiers of Fortune

Condottiere (*condottieri* in the plural) is the Italian word for a soldier of fortune. During the Renaissance, Italy was divided into separate states, and individual mercenaries led armies of one state against another, according to their loyalties, their pay, or both. A *condottiere* could be a ruler earning money for his state, as was Federico da Montefeltro (see fig. 14.52), or a private citizen, such as Gattamelata (see fig. 14.49), who had trained as a soldier. Training to be a *condottiere* took place under a kind of apprentice system, usually through the tutelage of an experienced "master" *condottiere*. In the course of the fifteenth century, several *condottieri* were honored with portraits commissioned by the states for which they had fought.

A fourteenth-century pair of doors was already in place, but two more were needed, each to be decorated with **gilded** bronze reliefs illustrating Old and New Testament scenes. Members of the wool refiners' **guild** supervised the contest, and clerics, artists, and businessmen comprised the jury. The familiar subject chosen for the competition was the Sacrifice of Isaac. According to the Old Testament account (Genesis 22), Isaac's father, Abraham, obeys God's command to sacrifice his only son as an act of faith. At the last moment, as Abraham is about to kill Isaac, an angel intervenes and Abraham, having proved his obedience to God, is instructed to substitute a ram for Isaac.

Of the seven contestants for the Baptistry doors, the most important were two young artists in their twenties: Filippo Brunelleschi (1377–1446) and Lorenzo Ghiberti (c.

1381–1455). Ghiberti won the competition despite, or perhaps because of, his less monumental, more graceful style. Brunelleschi's figures (fig. **14.3**) are more direct and forceful than those of Ghiberti. His Abraham grasps Isaac by the throat and is physically restrained by the angel. The thrust of Brunelleschi's Abraham, emphasized by his drapery folds, is also more energetic than Ghiberti's (fig. **14.4**). The ambivalence of Ghiberti's figure is implicit in its pose; Abraham simultaneously leans toward Isaac and pulls away from him.

Another reason for Ghiberti's victory may have been the technical differences between the reliefs. Brunelleschi cast his panel in several pieces, while Ghiberti cast his in two. Ghiberti also required less bronze, which would have made his door considerably less costly to produce than Brunelleschi's.

14.3 Filippo Brunelleschi, *The Sacrifice of Isaac*, competition panel for the east doors of the Florence Baptistry, 1401–2. Gilded bronze relief, 21 × 17 in (53.3 × 43.2 cm). Museo Nazionale del Bargello, Florence.

14.4 Lorenzo Ghiberti, *The Sacrifice of Isaac*, competition panel for the east doors of the Florence Baptistry, 1401–2. Gilded bronze relief, 21 × 17 in (53.3 × 43.2 cm). Museo Nazionale del Bargello, Florence.

14.3, 14.4 Both Brunelleschi and Ghiberti were born in Florence— Brunelleschi, the son of a lawyer, trained as a gold- and silversmith, while Ghiberti was the son of a goldsmith. The scenes are framed by a **quatrefoil** and depict the moment when the angel appears just in time to prevent Abraham from cutting his son's throat.

There are no surviving records of the judges' deliberations to explain their decision. From the perspective of historical hindsight, however, it is clear that both reliefs are indebted to the new synthesis of Classical and Christian thought. Ghiberti's Isaac, in particular, is a Classical nude that attests the artist's awareness of Greek sculpture. Brunelleschi, too, refers to ancient sculpture in the seated figure at the lower left which repeats the pose of the well-known Hellenistic statue of *The Thorn Puller*, a man removing a thorn from his foot.

The depiction of nature in both reliefs continues in the tradition of Giotto. Landscape forms provide a narrow, but convincing, three-dimensional space, in which the surfaces rationally support the figures and architecture. The cubic altars on which both Isaacs kneel are set at oblique angles to the relief surfaces so that, as in the case of Giotto's architecture, their sides imply recession in space. Examples of radical foreshortening in certain figures, such as Ghiberti's angel and the man leaning forward on the lower right of the Brunelleschi, also enhance the impression of three-dimensional space.

The competition reverberated with political and civic levels of meaning. Florence had recently been ravaged by a plague that had killed some 30,000 citizens, and the survivors probably identified with Isaac. Danger had also come from the powerful and tyrannical Duke of Milan, who threatened the Florentine republic. With the Duke's death in 1402, Florence must have felt that she, like Isaac, had been granted a reprieve.

Brunelleschi and Architecture

After losing the Baptistry competition to Ghiberti, Brunelleschi was said to have given up sculpture, only to become the seminal figure in Renaissance architecture. He moved for a few years to Rome, where he studied ancient buildings and monuments. The effect of Rome on Brunelleschi was recorded by the sixteenth-century biographer of the artists, Giorgio Vasari (see Box):

> Through the studies and diligence of Filippo Brunelleschi, architecture rediscovered the proportions and measurements of the antique.... Then it carefully distinguished the various orders, leaving no doubt about the difference between them; care was taken to follow the Classical rules and orders and the correct architectural proportions ...[2]

The roots of Brunelleschi's early architecture can be traced to Classical precedents. Compared with the complexity of Abbot Suger's search for perfect mathematical ratios based on musical harmonies, Brunelleschi's concept of architectural beauty lay in simpler ratios and shapes. He also preferred simple to irrational numbers, and ratios of 1:2 and 1:3. Shapes such as the circle and square formed the basis of his building plans, and he constructed round, rather than pointed, arches, which were supported by Classical **columns** rather than Gothic piers.

The Dome of Florence Cathedral On returning to Florence about 1410, Brunelleschi became actively involved in constructing a **dome** for the cathedral (figs. **14.5–14.7**). This undertaking was to last until 1436, but Brunelleschi died in 1446 before the **lantern**, which he also designed, could be completed. The dome had been a perennial problem for the city. As early as 1294 Florence had decided to rebuild the old cathedral and, in the course of the fourteenth century, the original design was enlarged. By the fifteenth century, the cathedral required a dome to surmount an octagonal **drum** (already in place) measuring 138 feet (42 m) across.

In Rome, Brunelleschi had learned from the example of the Pantheon—which had a hemispherical dome 142 feet (43.28 m) in diameter—that it was theoretically possible to span an opening of this width. However, the structure of Florence Cathedral did not lend itself to Roman building techniques. The octagonal drum was too weak to support a heavy concrete dome, and it was also too wide to be built with the wooden **centering** used in the Middle Ages.

In 1417–30 Brunelleschi proposed a solution to this problem, which he illustrated with a model on a 1:12 scale. He followed a horizontal construction plan based on a system of vertical **ribs**. Primary ribs were placed at each of the eight corners of the octagonal drum (fig. 14.7). At their base, they were approximately 11 feet by 7 feet (3.35 × 2.13 m), tapering towards their apex and visible to the viewer from the outside. Between each primary rib were two secondary vertical ribs, not visible from the outside, making a total of twenty-four ribs. Around these ribs Brunelleschi constructed, in horizontal sections, two shells comprising a single dome and connected by horizontal ties placed at intervals. Building two thin shells instead of a

14.5 Exterior of Florence Cathedral. According to Vasari, Brunelleschi's rivalry with Ghiberti did not end with the Baptistry doors. Ghiberti's political connections won him a commission to work with Brunelleschi on the dome of Florence Cathedral for equal credit and equal pay. Brunelleschi found fault with Ghiberti's work and ideas, but his protests fell on deaf ears. It was not until he took to his bed, feigning illness and refusing to advise on the project, that Ghiberti was removed—although he was allowed to keep his salary.

1 Nave
2 Side aisle
3 Apse
4 Dome
5 Campanile

14.6 Filippo Brunelleschi, plan of Florence Cathedral (after W. Blaser).

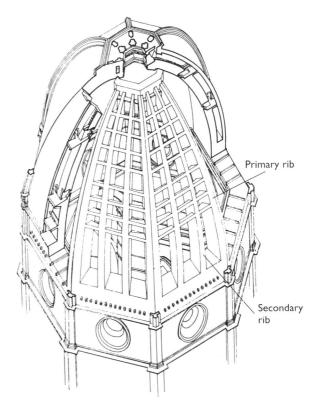

Primary rib

Secondary rib

14.7 Axonometric section of the dome of Florence Cathedral. The overall height of the dome is slightly over 100 feet (30.48 m), the radius is less than 70 feet (21.34 m). © Electa Archive, Milan.

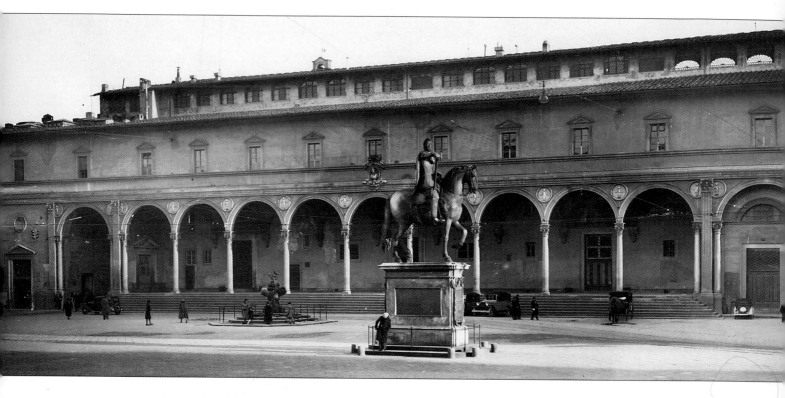

14.8 Filippo Brunelleschi, Hospital of the Innocents, Piazza di Santissima Annunziata, Florence, begun 1419.

single thicker one lessened the weight of the dome. Its **thrust** was further reduced by building the walls of the dome at a steep angle—they rose a full 58 feet (17.7 m) before needing support from below. As a result, the dome was slightly pointed rather than perfectly hemispherical.

Ospedale degli Innocenti Brunelleschi's work on the dome, which lasted eighteen years, did not prevent him from undertaking other projects. One of the first of these was the Ospedale degli Innocenti (Hospital of the Innocents) in Florence (fig. **14.8**). It was commissioned in 1419 by the republic of Florence to shelter orphans and foundlings, and largely financed by Giovanni di Bicci di Medici, who had established the Medici fortune.

The hospital, often regarded as the first true Renaissance building, is a long, low, graceful, symmetrical structure, dominated by a continuous **façade**. Renaissance architects preferred that **arcades** be composed of round arches, because of their ability to lead the viewer's eye across the building surface rather than upwards, as in Gothic—an effect that Brunelleschi would have seen in the Colosseum in Rome. The **loggia** of Brunelleschi's hospital is divided into **bays**, and the transverse arch between each bay rests on a **corbel** (attached to the wall) and a column of the **colonnade**. Above each second-floor window is a small blank **pediment**, which derives from Greek temple architecture.

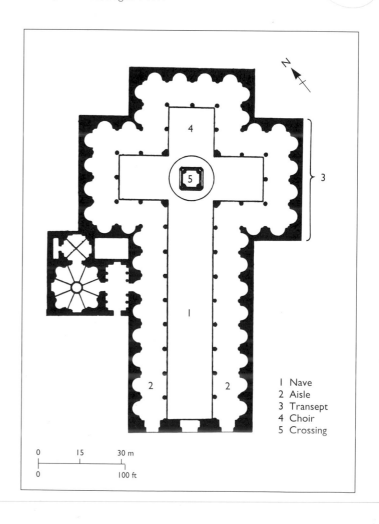

1 Nave
2 Aisle
3 Transept
4 Choir
5 Crossing

14.9 Filippo Brunelleschi, plan of Santo Spirito, Florence (after R. Sturgis).

The overall design of the loggia is based on a unified system of cubes and squares. Distances from column to column are equal to the distance from each column to the wall of the main structure and also to the distance from the foot of each column to the point where the arches appear to meet. The surface decoration of the façade is simple and limited to the Corinthian capitals at the top of each column and to tondos in the triangular spaces between the arches. Inside the tondos are reliefs of infants, reminders of the hospital's function.

Santo Spirito, Florence In his church architecture, Brunelleschi rejected medieval, especially Gothic, style and reverted to the relative simplicity of the Early Christian **basilica**. The church of Santo Spirito, begun in 1445, one year before Brunelleschi's death, illustrates the basic principles of his architecture—simplicity, **proportion**, and **symmetry**. Spatial units are based on the square **module** formed by each bay of the **aisles**, and the whole geometry of the structure is based on a series of interrelated circles and squares.

The plan (fig. **14.9**) is a simple **Latin cross**. The depths of the **choir** and of the **transept** arms are the same. The perimeter forms a continuous **ambulatory** and, apart from at the western end, is ringed with forty semicircular chapels. Round arches in the **nave** and the aisles are supported by Corinthian columns (fig. **14.10**), and reduce the size and height of the church to human scale. As a result, there is much less space in the structure for **stained glass** or the luminous quality that had been characteristic of Gothic cathedrals.

14.10 Filippo Brunelleschi, interior of Santo Spirito, Florence, facing east. Begun 1445. Each double bay of the nave forms a large square equivalent to four modular squares. The larger square is repeated in the crossing bays, the transept arms, and the choir. The semicircle of each chapel is one half the size of a circle that would fit exactly into the square module. If the larger squares were cubed and placed one on top of another, they would exactly match the height of the nave. The height of the side aisle is exactly half that of the nave.

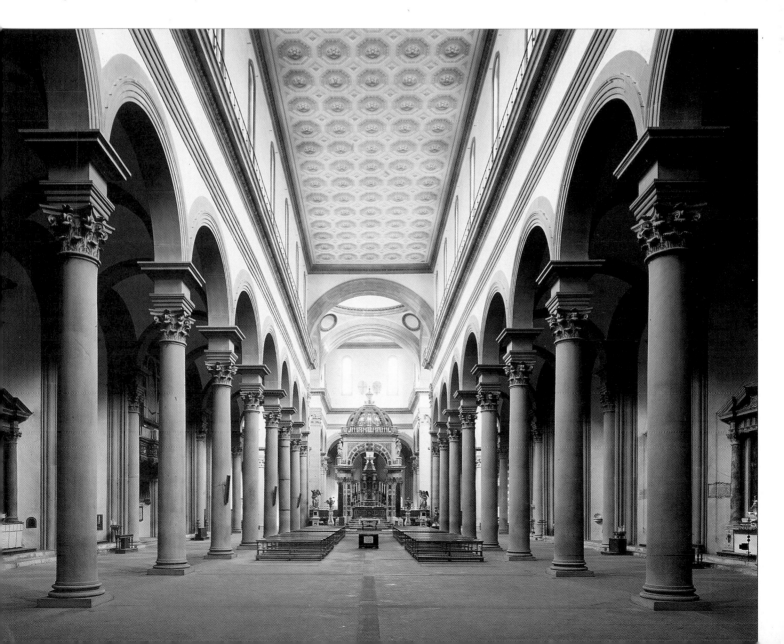

Lines of Vision

Giotto and other fourteenth-century painters had used oblique views of architecture and natural settings to create an illusion of spatial recession on a flat surface. But their empirical system had not provided an objective way to determine the relative sizes of figures and objects on a picture plane or the surface of a relief.

In addition to establishing the basis for Renaissance architecture, Filippo Brunelleschi is credited with the invention of **linear perspective**. This system is based on the observed fact that distant objects seem smaller than closer ones and that the far edges of uniformly shaped objects appear shorter than the near edges.

Brunelleschi conceived of the picture plane—the surface of a painting or relief sculpture—as a window and the frame of the painting as the window frame. Through this "window" the viewer sees the scene to be depicted. The edges of architectural objects such as roofs and walls are extended along imaginary lines, known as **orthogonals**, to converge at a single point, the **vanishing point**, which generally corresponds to the viewer's eye-level. A good example of this use of one-point perspective is Masaccio's *Holy Trinity* (see figs. 14.23, 14.24), painted around 1425.

In his *De Pictura* (*On Painting*), published in 1435, Leon Battista Alberti refined Brunelleschi's system, although it is

14.11 Piero della Francesca, *The Flagellation*, c. 1460. Tempera on panel, 22⅞ × 32 in (58.4 × 81.4 cm). Ducal Palace, Urbino.

14.12 Reconstructed plan and elevation of the foreground and praetorium in Piero della Francesca's *The Flagellation*. Drawing by Thomas Czarnowski.

not clear to what extent he was proposing a new theory or merely describing current artistic practice. He proposed a method of establishing relative proportions for every figure and object within a picture plane and of transposing them on to a grid consisting of orthogonals and transverse lines parallel to the base line.

The paintings of Piero della Francesca (c. 1420–92) are notable for their architectural content and geometric rigor. Nowhere is this more evident than in his *Flagellation* of c. 1460 (fig. **14.11**), which portrays two distinct groups of figures: in the right **foreground** three men converse, while in the middle distance Christ, bound to a freestanding column, is whipped in the presence of Pontius Pilate (seated) and another man. Piero has left a number of architectural clues—in the form of regularly arranged tiles and other pavement decoration, the interplay of light and shadow, and clear views between the figures—which make it possible to reconstruct a floor plan (figs. **14.12** and **14.13**). A work of this complexity required meticulous planning and detailed perspective studies.

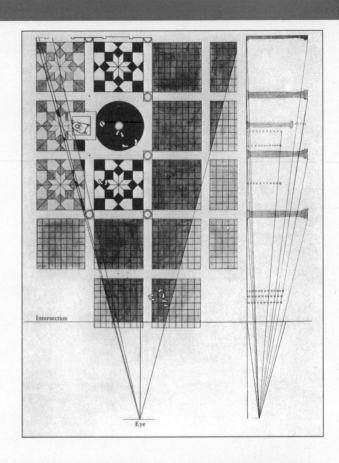

14.13 (right) Reconstructed plan and elevation of Piero della Francesca's *The Flagellation*. Drawing by Thomas Czarnowski.

14.14 Leonardo da Vinci, perspective study for the *Adoration of the Magi*, c. 1481. Pen, **bistre**, and wash, 6½ × 11½ in (16.5 × 29.2 cm). Galleria degli Uffizi, Florence. Leonardo created a perspective grid by drawing a series of horizontal lines parallel to the picture plane. Then he drew a series of lines perpendicular to the horizontals and converging at the vanishing point, which is just to the left of the figure on a rearing horse. All architectural forms in the study are aligned with the grid, so that the sides of the buildings are either parallel or perpendicular to the picture plane.

In addition to Piero, many artists using linear perspective made preliminary studies in the planning stages of their work. Most were on paper and are now lost. One that survives is Leonardo da Vinci's study for the *Adoration of the Magi* (fig. **14.14**), which allows us a rare look at an artist's working plans laid out in a schematic form.

Linear perspective permitted Renaissance artists to fulfill their ideal of creating the illusion of nature on a flat surface. One fifteenth-century painter who delighted in solving problems of perspective was Paolo Uccello (1397–1475). In his drawing of a chalice in figure **14.15**, Uccello uses geometric shapes, mainly squares and rectangles, to create the illusion of spinning motion in a rounded, transparent object.

Some sixty years later, Andrea Mantegna (1431–1506) used perspectival theory to achieve radical foreshortening in the *Dead Christ* (fig. **14.16**). The body is shown feet foremost, with the wounds of the Crucifixion clearly visible and the head slightly tilted forward by a pillow. Mantegna's idealization of the body and mastery of perspective create a haunting psychological effect.

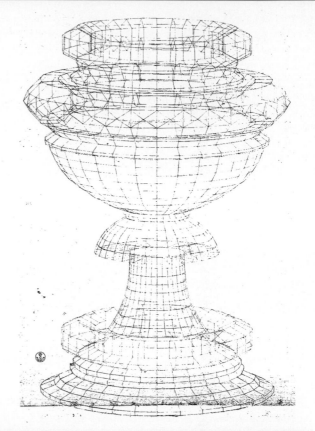

14.15 (far right) Paolo Uccello, perspective drawing of a chalice, c. 1430–40. Pen and ink on paper, 13⅜ × 9½ in (34 × 24 cm). Gabinetto dei Disegni e Stampe, Galleria degli Uffizi, Florence. Vasari criticized Uccello for his obsession with mathematics and perspective which, he said, interfered with his art. According to a popular anecdote, they also interfered with his marital life. On being called to bed by his wife, Uccello allegedly extolled the beauty of *la prospettiva* (perspective)—a feminine noun in Italian.

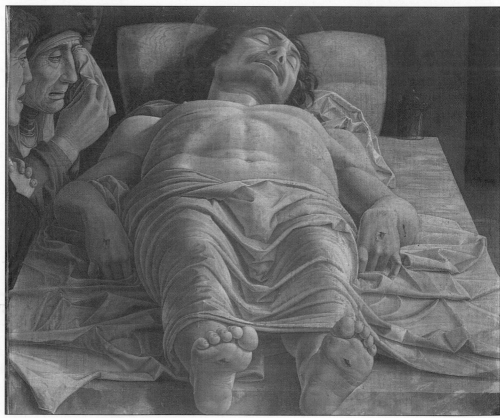

14.16 Andrea Mantegna, *Dead Christ*, c. 1500. Tempera on canvas, 26¾ × 31⅞ in (67.9 × 81 cm). Pinacoteca di Brera, Milan.

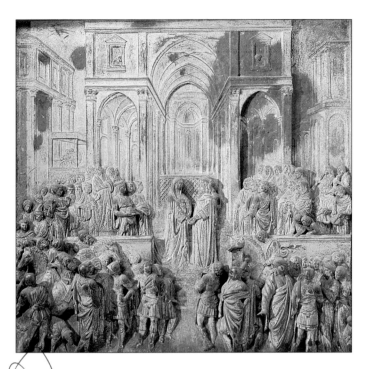

14.17 Lorenzo Ghiberti, *The Meeting of Solomon and Sheba*, east door of the Baptistry (single panel of fig. 14.20), Florence Cathedral. Gilded bronze relief, 31½ × 31½ in (80 × 80 cm). This relief illustrates two techniques used by Ghiberti to create the illusion of depth. One is Brunelleschi's system of one-point perspective. The vanishing point is located at the meeting of Solomon and Sheba, at the center. The other combines the diminishing size of figures and objects with a decrease in the degree of relief. What is in lower relief appears more distant than what is in higher relief.

Ghiberti's East Doors for the Baptistry

A good example of the one-point perspective system (in which there is a single vanishing point) occurs in Ghiberti's relief of *The Meeting of Solomon and Sheba* on the east door of the Florence Baptistry (figs. **14.17–14.18**). As had been true of the competition reliefs, the *Solomon and Sheba* has political as well as Christian implications, for it illustrates the extension of very traditional typology (the pairing of Old and New Testament events and personages) to include contemporary politics. Typologically, the Meeting was paired with the Adoration of the **Magi**; in both cases eastern personages (the Queen of Sheba and the Magi, respectively) traveled westwards to honor a king (Solomon and Christ). Politically, the biblical meeting of east and west was related to efforts in the fifteenth century to unite the eastern (or Byzantine) branch of the Church with the western branch in Rome (see Box, p. 495).

Before leaving Ghiberti's *Gates of Paradise* (see caption, fig. **14.20**), we should note that he has included his self-portrait at the lower right corner of Jacob and Esau, the middle panel on the left (fig. **14.19**). The face is clearly a likeness, and has an expression of slight puzzlement. The bald, dome-shaped head repeats the circular frame, and also echoes Brunelleschi's architectural dome across the way. It has been suggested that Ghiberti's image was a humorous visual comment on his rival's more monumental dome crowning the Cathedral.

14.18 Lorenzo Ghiberti, *The Meeting of Solomon and Sheba*, east door of the Baptistry (single panel of fig. 14.20), showing perspective lines.

14.19 Lorenzo Ghiberti, *Self-portrait*, from the east door of the Baptistry, Florence Cathedral. Gilded bronze, approx. 36 in (91 cm) high (single panel of fig. 14.20).

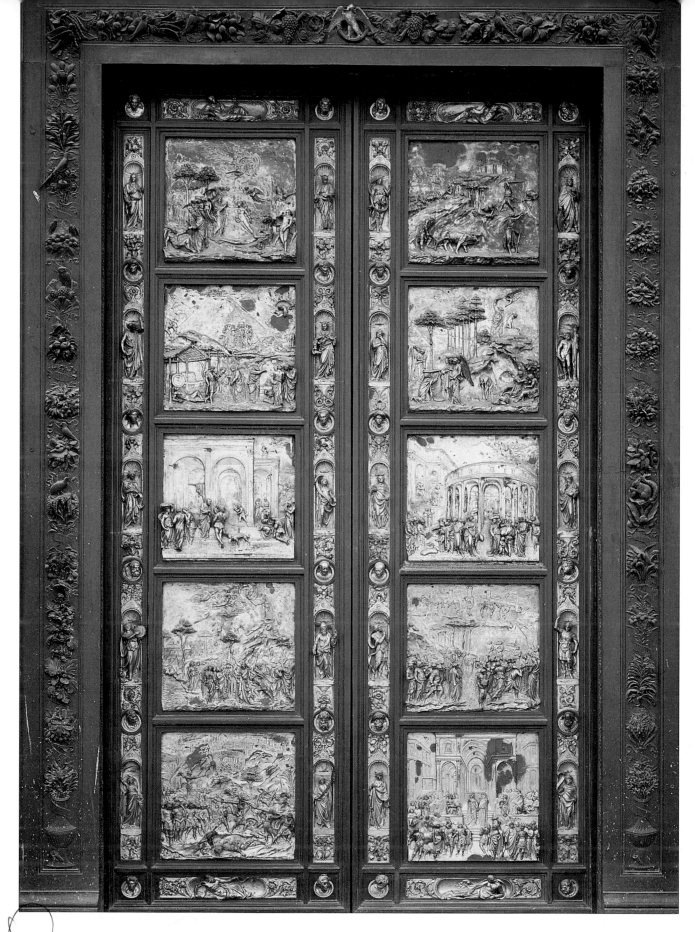

14.20 Lorenzo Ghiberti, *The Gates of Paradise*, east door, Florence Baptistry, 1424–52. Gilded bronze relief, approx. 17 ft (5.18 m) high. Here Ghiberti has eliminated the medieval quatrefoil frame and uses the square, which is more suited to the new perspective system. The door is divided into two sets of five Old Testament scenes, which were modeled in wax, cast in bronze, and faced with gold. The east door was nicknamed *The Gates of Paradise*, because the space between a cathedral and its baptistry is called a *paradiso*.

Pisanello's Medal of John Paleologus

For political reasons, the Byzantine emperor John VIII Paleologus traveled to Italy in 1438 to discuss unifying the eastern (Byzantine) and western (Roman) branches of the Church. Ferrara was chosen as the seat of the Council, where John VIII and the papal court would meet. Deliberations continued until January 1439, when an outbreak of plague sent both sides to Florence.

While in Italy, the Byzantine emperor and his retinue impressed the Italians with their exotic attire. This appealed to the International Style artist Antonio Pisano, known as Pisanello (c. 1395–c. 1455), whose work was praised by humanists for its Classical emphasis. His interest in ancient coins inspired him to cast bronze medals.

Pisanello's medal in honor of John VIII is the earliest known Renaissance example of its type. The **obverse** (front) shows the Emperor's bust in profile (fig. 14.21) and his characteristic headdress. A Greek inscription around the edge reads: "John Paleologus Emperor and Autocrat of the Romans." On the **reverse** (back), the Emperor is on horseback (fig. 14.22). He approaches a Cross at the right, while his page rides off to the left, which gives Pisanello the opportunity to depict one horse strongly foreshortened in rear view. The rocky background situates the scene in a natural landscape. The inscription at the top reads, in Latin: "The work of the painter Pisanello," and the same inscription is repeated below in Greek.

This medal became extremely popular in the fifteenth century. Other artists used the emperor's image to portray figures of antiquity, both in monumental painting and in manuscript illumination. Medals of contemporary rulers also became popular as images of propaganda. Because they were small and portable, medals could be disseminated throughout Italy far more easily than major paintings and sculptures. They could also be made in multiples, and therefore had the advantage of repeatedly exposing the desired audience to the patron's message. Medals satisfied the Renaissance wish to revive the practices of Classical antiquity—patrons' portraits on the obverse and their emblem or symbol on the reverse.

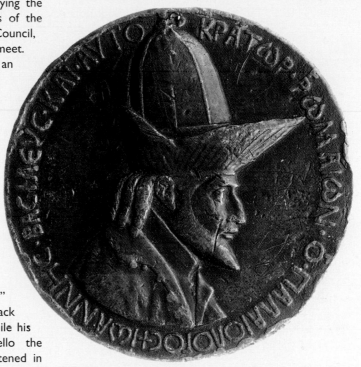

14.21 Pisanello, medal of John VIII Paleologus (obverse), 1438–39. British Museum, London.

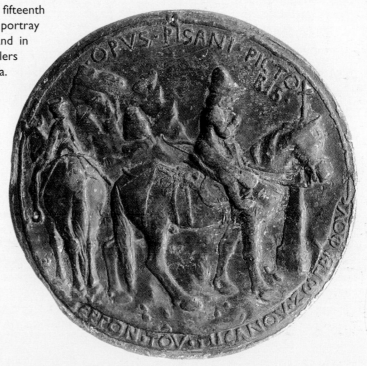

14.22 Pisanello, medal of John VIII Paleologus (reverse).

Early Fifteenth-Century Painting

Masaccio

Of the first generation of fifteenth-century painters it was Masaccio (1401 c. 1428) who most thoroughly assimilated the innovations of Giotto and developed them into an increasingly monumental style.

The Holy Trinity Masaccio's *Holy Trinity* (figs. **14.23–14.24**) in the church of Santa Maria Novella in Florence uses not only the new perspective system, but also the new architectural forms established by Brunelleschi. A single vanishing point is located at the center of the step, corresponding to the eye-level of the observer standing in the church. Orthogonals, provided by the receding lines of the barrel-vaulted, **coffered** ceiling, create the illusion of an

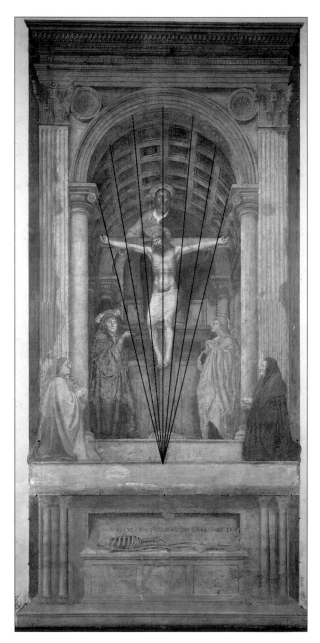

14.23 (left) Masaccio, *The Holy Trinity*, 1425. Fresco, 21 ft 9 in × 9 ft 4 in (6.63 × 2.85 m). Santa Maria Novella, Florence. Tommaso di Ser Giovanni de Mone (1401–c. 1428) was nicknamed Masaccio ("Sloppy Tom") because he seemed to neglect everything, including his own appearance, in favor of his art. In 1422 he enrolled in the painter's guild of Florence, and in 1424 joined the Company of Saint Luke, a lay confraternity consisting mostly of artists. By his death at age twenty-seven or twenty-eight, Masaccio had become the most powerful and innovative painter of his generation.

14.24 (right) Masaccio, *The Holy Trinity*, 1425. Fresco, 21 ft 9 in × 9 ft 4 in (6.63 × 2.85 m), showing perspective lines. Santa Maria Novella, Florence.

actual space extending beyond the nave wall. This pictorial space is defined on the outside by two Corinthian pilasters supporting an **architrave**, above which is a projecting **cornice**. The pilasters frame a round arch supported by composite columns.

The interior is a rectangular room with a barrel-vaulted ceiling and a ledge on the back wall. Below the illusionistic interior, a projecting step surmounts a ledge supported by Corinthian columns. Framed by the columns, a skeleton lies on a sarcophagus. The inscription above reads: "I was once what you are. You will be what I am." This kind of warning to the living from the dead, called a **memento mori** or "reminder of death," had been popular in the Middle Ages and continued as a motif in the Renaissance. One purpose of the warning was to remind viewers that their time on earth was finite and that belief in Christ offered the route to eternal salvation.

The spatial arrangement of the figures in *The Holy Trinity* is pyramidal, so that the geometric organization of the image reflects its meaning. The three persons of the Trinity—Father, Son, and Holy Spirit—occupy the higher space. God stands on the foreshortened ledge, his head corresponding to the top of the pyramid. He faces the observer and stretches out his hands to support the arms of the Cross. Between God's head and that of Christ floats the dove, symbol of the Holy Spirit. As in Giotto's *Crucifixion* (fig. 13.9), Masaccio has emphasized the pull of gravity on Christ's arms, which are stretched by the weight of his torso, causing his head to slump forward. His body is rendered organically, and his nearly transparent drapery defines his form. Above and below the Cross, triangular spaces geometrically reinforce the triple aspect of the Trinity.

Standing on the floor, but still inside the sacred space of the barrel-vaulted chamber, are Mary—who looks out and gestures toward Christ—and Saint John, in an attitude of adoration. Outside the sacred space, on the illusionistic step, kneel two donors, members of the politically influential Lenzi family who commissioned the fresco. They form the base of the figural pyramid.

The Renaissance convention of including donors in Christian scenes served a twofold purpose. In paying for the work, the donors hoped for prayers of intercession with God or Christ to be made on their behalf. Their presence was the visual sign of their donation, and of their wish to be associated with holy figures in a sacred space. The donors of *The Holy Trinity* occupy a transitional space between the natural, historical world of the observer, and the spiritual, timeless space of the painted room.

The Brancacci Chapel Masaccio's other major commission in Florence was the fresco cycle illustrating events

14.25 View of the Brancacci Chapel (before restoration), looking toward the altar. Santa Maria del Carmine, Florence. Masaccio worked on the Brancacci Chapel in the 1420s. He received the commission only when the older artist Masolino, whose *Temptation of Adam and Eve* is on the right pilaster, left Italy to work in Hungary. After Masaccio's untimely death, the frescoes were completed by a third artist, Filippino Lippi. Lippi completed most of *Saint Peter in Prison* and the large lower fresco on the left wall (see fig. 14.26).

from the life of Saint Peter in the Brancacci Chapel, in the church of Santa Maria del Carmine (figs. **14.25** and **14.26**). Masaccio, like Giotto, used the lighting technique called **chiaroscuro** (from the Italian *chiaro*, meaning "light," and *scuro*, meaning "dark"). This is a more natural use of light and shade than line because it allows artists to model forms and create the illusion of mass and volume.

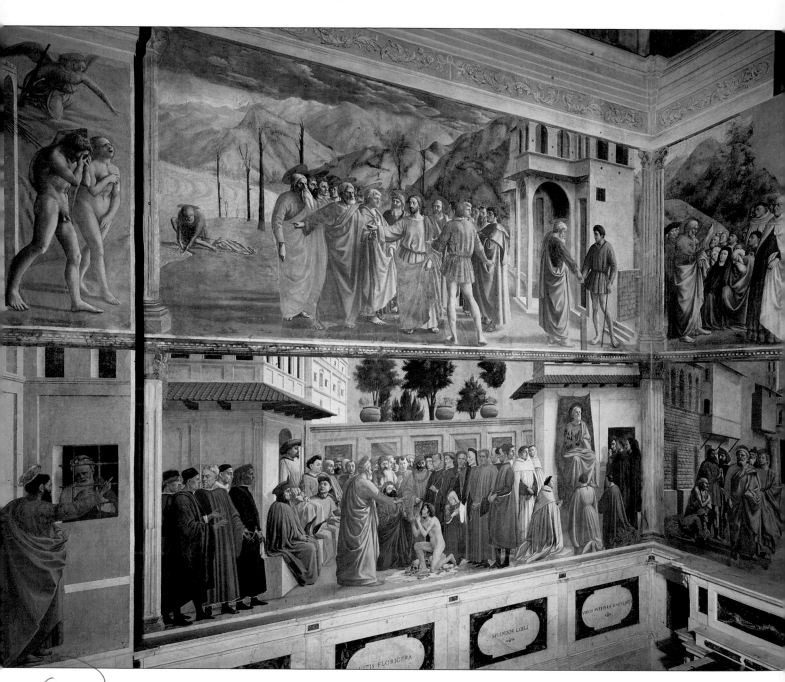

14.26 Left side of the Brancacci Chapel, Santa Maria del Carmine, Florence (after restoration, 1989). The scene on the upper left of the pilaster is *The Expulsion from Eden* (1425), and below is *Saint Peter in Prison*. The large scene to the right of the *Expulsion* is from the New Testament Gospel of Matthew (17:24–7), in which Christ arrives at the Roman colony of Capernaum, in modern Israel, with his twelve apostles. A Roman tax collector asks Christ to pay a tribute to Rome. This biblical event was topical in Florence in the 1420s because taxation was being considered as a way of financing the struggle against the imperialistic dukes of Milan. Below, Saint Peter preaches and raises a boy from the dead. The two scenes on the altar wall (far right) show *Saint Peter Baptizing* (above) and *Saint Peter Curing by the Fall of his Shadow* (below). The latter is by Masaccio and takes place in a contemporary Florentine street. In it, Saint Peter purposefully keeps his right arm at his side and gazes straight ahead to emphasize that it is his shadow alone that has curative power. As he passes and his shadow falls on the cripples to his right, they are miraculously cured and stand upright. The figure with crossed arms—a reference to the Cross—is in the process of rising, while the kneeling figure has not yet benefited from Saint Peter's passage. All the frescoes are illuminated as if from the window behind the altar. As a result, the light consistently hits the forms from the right, gradually increasing the shading toward the left. So monumental were the forms created by Masaccio in these frescoes that Michelangelo (see. p. 556) practiced drawing them in order to learn the style of his great Florentine predecessor.

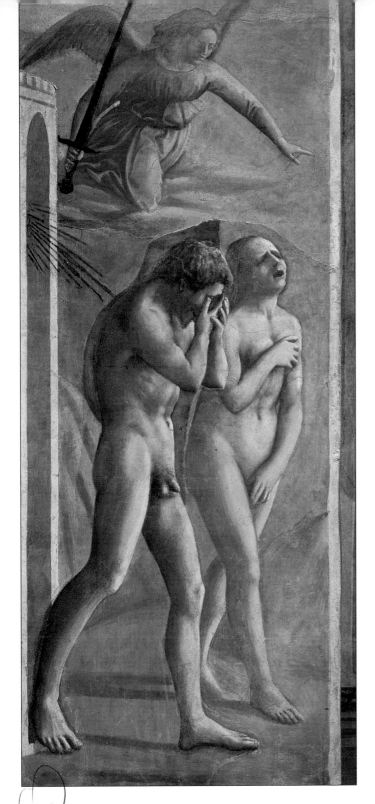

14.27 Masaccio, *Adam and Eve* (detail of fig. 14.26, left pilaster of the Brancacci Chapel).

ated right shoulder and the extended backward curve of his right leg emphasize his reluctance to face his destiny. Adam and Eve leave the gateway to Paradise behind them at the command of the foreshortened, swordbearing archangel Michael.

Masaccio's characteristic use of massive draperies can be seen in the large horizontal fresco of *The Tribute Money* (see fig. 14.26) immediately to the right of the *Expulsion*. The fresco is divided into three scenes corresponding to three separate events. Occupying the largest, central section is Christ. He faces the viewer, surrounded by a semicircle of apostles. They wear simple, heavy drapery, whose folds and surface gradations are rendered in *chiaroscuro*. Seen from the back, wearing a short tunic and formally continuing the circular group around Christ, is the Roman tax-collector. Horizontal unity in this central group is maintained by strict **isocephaly**. The foreshortened haloes conform to the geometric harmony of Christ and his circle of followers by repeating the circular arrangement of figures and matching their convincing three-dimensional quality.

Masaccio's Adam and Eve (fig. **14.27**) in the scene of *The Expulsion from Eden* are the two most powerful painted nudes since antiquity. Eve's pose is derived from the type of Greek Venus illustrated in figure **14.28**, which was in the Medici collection. The artist has transformed the figure of the modest goddess after her bath into an extroverted, wailing Eve, who realizes what she has lost and covers her nakedness in shame. The more introverted Adam covers his face and hunches forward. His exagger

14.28 The *Medici Venus*, 1st century A.D. Marble, 5 ft ¼ in (1.53 m) high. Galleria degli Uffizi, Florence.

14.29 Masaccio, *Saint Peter* (detail of *The Tribute Money* in fig. 14.26, left side of the Brancacci Chapel).

The psychology of this scene is as convincing as its forms. Christ has no money with which to pay the tax. He tells Saint Peter (the elderly bearded apostle in yellow and blue on his right, fig. **14.29**)—through both word and gesture—to go to the Sea of Galilee, where he will find the money in the mouth of a fish. Saint Peter's not unreasonable skepticism is masterfully conveyed by his expression and gesture. A close look at his face reveals his displeasure with Christ's instructions. The corners of his mouth turn down, his jaw juts forward, and his left eyebrow is raised

in doubt. His gesture—echoing Christ's outstretched arm and pointing finger with his right hand, while drawing his left arm back in protest—expresses his emotional conflict and crisis of faith.

At the far left of the scene, separated by space and distance from the central group, is the radically foreshortened figure of Saint Peter retrieving a coin from the fish. At the right, Saint Peter, framed by an arch, pays the tax-collector. Masaccio has thus organized the narrative so that the point of greatest dramatic conflict—between Christ and Saint Peter—occupies the largest and most central space, while the *dénouement* takes place on either side.

Masaccio uses both linear and **aerial**, or **atmospheric**, **perspective** (see Box) in the Brancacci Chapel frescoes. That he has set his figures in a boxlike, cubic space is clear from the horizontal ground and the architecture to the right of *The Tribute Money*. To find the vanishing point of the painting, extend the orthogonals at the right and the receding line of the entrance to Paradise in the *Expulsion*. The orthogonals meet at the head of Christ, who is also at the mathematical center of the combined scenes. Rather than provide the vanishing point within a single frame, as he had done in *The Holy Trinity*, in the Brancacci Chapel Masaccio has unified several scenes through a shared perspective construction. The diminished figure of Saint Peter at the left of *The Tribute Money* and the gradually decreasing size of the trees also indicate the use of linear perspective, in this case to create the illusion of a spatial recession far into the distance, beyond the Sea of Galilee. The shaded **contours** and slightly blurred mountains and clouds are partly the result of damage caused by centuries of burning candles and incense in the chapel. They also, however, exemplify Masaccio's use of aerial perspective to suggest their distance in relation to the monumental figures in the foreground.

A Distant Haze

Aerial, or atmospheric, perspective is a painting technique based on the fact that objects in the distance appear to be less distinct and vivid than nearby objects. This is because of the presence of dust, moisture, and other impurities in the atmosphere. The artist may therefore use fainter, thinner lines and less detail for distant objects, while depicting foreground objects with bolder, darker lines and in greater detail. The artist may also create the illusion of distance by subduing the colors in order to imitate the bluish haze that tends to infuse distant views. In his advice to painters, Leonardo da Vinci (see p. 552) recommended that all horizons be blue, as his were. Atmospheric perspective was also employed by Masaccio. In *The Tribute Money* (see fig. 14.26), for example, although the distant mountains are larger than the figures, they are less clearly defined.

International Style: Gentile da Fabriano

Masaccio's originality as a painter can be seen by comparing his work with that of an older contemporary, Gentile da Fabriano (c. 1370–1427). Gentile's greatest extant work is the large altarpiece in figure **14.30**, in which *The Procession and Adoration of the Magi* occupy the main panel.

In contrast to Masaccio's taste for simplicity, Gentile's frame is elaborately Gothic, and his gold sky continues Byzantine **convention**. Gentile's crowds wind their way from distant fortified hill towns down to the foreground where the three Magi worship Christ. The crowded composition, elaborate gold drapery patterns, the exotic animals—birds and monkeys, for example—are all typical features of the International Gothic style.

14.30 Gentile da Fabriano, *The Procession and Adoration of the Magi*, altarpiece, 1423. Tempera on wood panel, approx. 9 ft 11 in × 9 ft 3 in (3.02 × 2.82 m). Galleria degli Uffizi, Florence. Gentile was born in Fabriano, in the Marches (a region of central Italy bordering on the Adriatic coast). He trained in Lombardy and established himself as a leading painter of the International Gothic style in northern Italy. *The Adoration of the Magi* was commissioned in 1423 by Florence's richest merchant, Palla Strozzi, to decorate his family chapel in the sacristy of Santa Trinità, thereby reflecting his wealth in the panel's rich materials and abundance of gold.

Perspective in the Far East

Although aerial perspective is used in Western art, it is much more usual in the Far East. *The Pleasures of Fishing* (fig. **14.31**) of c. 1490 by the Chinese painter Wu Wei (1459–1508) shows the use of aerial perspective to create an atmospheric landscape. Unlike most Western landscapes, there is no single vanishing point or set of points. The observer's viewpoint is elevated so that the landscape is seen as if from above. The forms that are meant to be closest to the picture plane are more clearly delineated, and more thickly painted. Thus, the trees and rocks at the lower right have darker edges, pronounced knots in the trunks, and visible roots, in contrast to the distant trees. The background mountains are washed out and fade into the sky, compared with those at the right. And the fishermen who are detailed in the foreground become horizontal brushstrokes as they recede into the distance.

Another Far Eastern approach to perspective can be seen in Persian miniature painting of the fifteenth century. This consisted primarily of

14.31 Wu Wei, *The Pleasures of Fishing*, c. 1490. Hanging scroll, ink and color on paper, 8 ft 10 in × 5 ft 7 in (2.71 × 1.74 m). Wu Wei was born in 1459 in Hubei Province to a family of government functionaries. His father, who was also an artist, became obsessed with alchemy and died in poverty. Wu was then taken in by Qian Xin and studied with his sons. Wu started to use his calligraphy brush to make pictures on the floor. Qian asked him if he wished to be a painting master, and he then arranged for his training. Wu became a successful artist and worked for the imperial court.

manuscript illumination, which departed from the usual conventions of Islamic art (see Vol. I, Chapter 10) in depicting the human figure. Persian perspective can be both two- and three-dimensional within a single frame or scene. The artists preferred harmony of design to illusionistic representations of the natural environment. As a result, they create a world rich in color, pattern, and variations in proportion and in spatial arrangement. The bright, rich colors of Persian miniatures come from the abundant use of gold, silver, and lapis lazuli. Bright vermilion was made by grinding cinnabar, and green came from malachite. Many illuminations were commissioned by royal patrons, but there was also a demand for commercially produced illustrated manuscripts.

A page from a commercial manuscript is illustrated in figure **14.32**, and shows the shifting perspective typical of Persian miniatures. It depicts the enthronement of Kuyuk the Great Khan (ruled 1246–48; grandson of Genghis Khan) at his camp near Qaraqorum, in Iran. At the right, Kuyuk sits in a three-dimensional pose on his throne, but occupies a two-dimensional, unmodulated orange space. The table in front of him, on the other hand, is three-dimensional, but is seen from above. At the left, two figures kneel on a carpet, which tilts up as if suspended over the ground. A blue and white cloud overlaps the tree, and alters the natural relation between landscape and sky. The irrational character of such spatial shifts, however, is subsumed by the brilliant color and intricate patterns of the image.

14.32 *Kuyuk the Great Khan*, from a Ta'rikh-i Jahan-gusha of 'Ata Malik ibn Muhammad Juvayni, Timurid, Shiraz, 1438. 10⅓ × 6⅔ in (26.5 × 17.2 cm). British Museum, London.

Gentile's altarpiece has the same combination of Gothic quality as some of the new Renaissance perspective innovations and the interest in nature that appears in the painting of the Limbourg brothers (see p. 477). In the foreground, though Gentile's use of linear perspective is not consistent, he has radically foreshortened the horses and the kneeling page removing the spurs from the youngest Magus. Gentile's elegance, like Ghiberti's, appealed more to popular, conservative tastes than did the unadorned monumentality of Brunelleschi and Masaccio.

Early Fifteenth-Century Sculpture

Donatello's Early Years

The most important sculptor of early fifteenth-century Florence was Donatello (1386–1466). He outlived Masaccio by nearly forty years, continuing to develop his style well into the next generation.

Saint Mark In his early marble statue of Saint Mark, of around 1411–15, Donatello fulfilled a commission from the Guild of Linen Weavers and Peddlers for their niche in the church of Or San Michele (fig. **14.33**). The Florentine guilds had been obliged to provide sculptures for the exterior niches of the church since the middle of the fourteenth century. This integration of the civic and the religious in the commission and display of works of art was an important development in the transition from the Middle Ages to the Renaissance.

The statue of Saint Mark illustrates the revolutionary method of rendering organic form and drapery that distinguishes the Renaissance from the Middle Ages. The drapery folds identify the saint's bent left knee and the *contrapposto* at the waist. The vertical folds of the supporting right leg recall the fluted columnar draperies of the Classical Erechtheum **caryatids** (see Vol. I, p. 176). Saint Mark's relaxed, slightly languid pose is reminiscent of the *Spearbearer* by Polykleitos (see Vol. I, fig. 6.26), except that the saint is clothed. However, whereas in Classical sculpture the subjects tend to have no distinctive personalities, Saint Mark is represented here as a mature and thoughtful man, carrying the **Gospel** which he wrote.

The Bronze *David* Donatello's bronze *David* (fig. **14.34**), commissioned by the Medici family for a pedestal in their palace courtyard, is a revolutionary depiction of the nude. Its pose, like that of the *Saint Mark*, recalls that of Polykleitos's *Spearbearer*. David stands over Goliath's head, which he has severed with the giant's own sword. In his left hand, David holds the stone thrown from his sling. He wears a shepherd's hat ringed with laurel, the ancient Greek and Roman symbol of victory, and boots. His facial expression is one of complacency at having conquered so formidable an enemy.

The genius of this statue lies not only in its revival of antique forms, but also in its enigmatic character and complex meaning. David and Goliath, whose encounter is described in the Old Testament (I Samuel 17:28–51), were traditional Christian **types** for Christ and Satan, respectively, and David's victory over Goliath was paired with the

14.33 Donatello, *Saint Mark*, shown in its original Gothic niche on the outside wall of Or San Michele, Florence, with a teaching Christ above and the Evangelist's lion symbol below, 1411–15. Marble.

moral triumph of Christ over the Devil. David was also an important symbol for the Florentine republic in its resistance against tyranny, for he represented the success of the apparent underdog against a more powerful aggressor.

The erotic aspect of the *David* is suggested by the large, lifelike wing sprouting from Goliath's helmet and rising up the inside of David's leg. It is enhanced by the casual way in which David's toes play with the hair of Goliath's beard. The elegance of the polished bronze, together with David's self-absorption, feminine pose, and slim, graceful, adolescent form, enhances the narcissism and the homosexual quality of the statue. This aspect of the *David*'s iconography probably reflects a Platonic version of the ideal warrior, who fights to impress and protect his male lover. In an unusually personal Renaissance synthesis, Donatello has combined the adolescent friendship of David and King Saul's son Jonathan as described in the Bible with Plato's philosophy. (Plato argues that homosexuality is tolerated under republican forms of government and discouraged by tyrants.) It is also likely that Donatello drew on his own homosexuality—for such was his reputation in fifteenth-century Florence—in his interpretation of the *David*.

The homosexual intent of Donatello's *David* is reinforced by the curious relief on Goliath's helmet depicting a triumph (fig. **14.35**). It is clearly based on Roman triumphs, in which animals imbued with allegorical meanings pull a chariot. But Donatello's chariot is manned instead by a group of playful winged *putti* (little nude boys). It seems that the artist has created a homosexual triumph, the satirical quality of which is consistent with the personality of the *David*. Combinations of this kind are characteristic of the synthetic character of the best Renaissance art.

14.34 Donatello, *David*, c. 1430–40. Bronze, 5 ft 2½ in (1.58 m) high. Museo Nazionale del Bargello, Florence. The *David* is the first large, naturalistic nude sculpture that we know of since antiquity. By 1430 to 1440, fragments of original Greek statues had been added to the collections of wealthy Florentine humanists, particularly the Medici. Like Masaccio and Brunelleschi, Donatello studied those works and also went to Rome to study ancient ruins. The pose of his *David* was influenced by Classical statues that he had seen.

14.35 Donatello, *David* (detail of fig. 14.34, showing *putti* relief on Goliath's helmet).

Second-Generation Developments

Once Donatello, Masaccio and Brunelleschi had established the foundations of the new Renaissance style, subsequent generations of fifteenth-century artists developed and elaborated their innovations.

Leon Battista Alberti

In his treatise *On Painting*, Leon Battista Alberti (c. 1402–72) summed up the contributions that Brunelleschi, Masaccio, Ghiberti, and Donatello had made to the visual arts. But Alberti's *On Painting* was more than a summation of what had already been done; it was also the first text of art theory. Alberti himself (fig. **14.36**) was a versatile prolific humanist writer on many different subjects in both Latin and the vernacular. In addition to art theory, he wrote plays, satirical stories, a Tuscan grammar, a book on dogs, an autobiography, and a book in the form of a dialogue on the family in Renaissance Florence. The latter was his most popular work and its precepts influenced childrearing in fifteenth-century humanist families. In particular, he advocated a father's watchfulness in raising his sons and, contrary to the general practice of entrusting infants to the care of wet nurses, he recommended that they be breastfed by their own mothers. At the same time, however, Alberti's virulent misogyny led him to insist that girls be separated from boys lest they infect them with their inferior moral character. From the 1440s onwards Alberti worked as an architect. His influential treatise *De Re Aedificatoria* was based on the Roman architectural treatise of Vitruvius (see Vol. I, p. 190). In contrast to the more technical preoccupations of Brunelleschi, Alberti emphasized the esthetic importance of harmonious proportions.

The Rucellai Palace From 1446 to 1450, Alberti designed the Rucellai Palace in Florence (fig. **14.37**). It belonged to the wealthy merchant Giovanni Rucellai, who had made a fortune manufacturing red dye. The façade, which is symmetrical and composed of Classical details, illustrates Alberti's interest in harmonious surface design. The second- and third-story windows, for example, contain round arches subdivided by two smaller arches on either side of a colonnette. Alberti has blended the large window arches with the rest of the wall by leaving visible the stone wedges of which they are composed. In so doing, he retains the surface pattern of the individual stones, setting them in curves around the windows and in horizontals elsewhere. In contrast, the pilasters framing each bay on all three stories (the Tuscan Order for the first story, modified Ionic for the second, and Corinthian for the third) have a smooth surface and serve as vertical accents. The vertical progression follows the order of the Colosseum in Rome (see Vol. I, p. 224). Crowning the third story is a projecting cornice, which echoes the horizontal courses separating the lower stories and reinforces the unity of the façade.

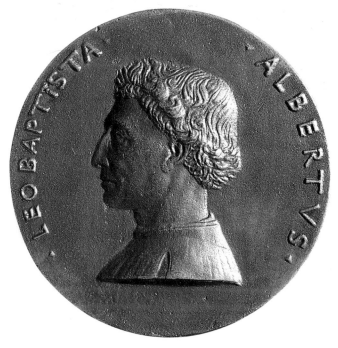

14.36 Matteo de' Pasti, medal showing Leon Battista Alberti (obverse left, reverse right, with the emblem of the winged eye), 1446–50. Museo Nazionale del Bargello, Florence. The winged eye is a complex iconographic composite, including eagle wings and rays. The latter are the sun's rays and refer to the astrological sign of Leo, which is the house of the sun in the zodiac. As such, the motif also refers to Alberti's name, Leo, which he chose himself—his given name was Battista. The eye denotes watchfulness and evokes the guardian lions of antiquity, as well as being the Egyptian hieroglyph for God (cf. the eye on the United States dollar bill).

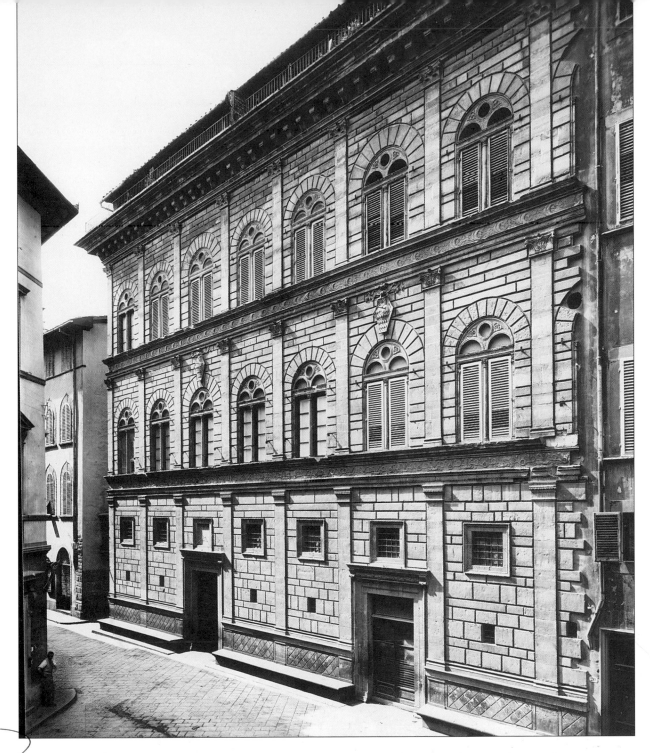

14.37 (above) Leon Battista Alberti, Rucellai Palace, Florence, c. 1450s. By way of a family signature, the Rucellai coat of arms appears above each second-story window that is over a ground-floor door. An upward glance from either of the main entrances would therefore have identified the owner of the palace.

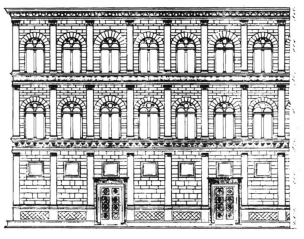

14.38 Diagram of the Rucellai Palace façade (after A. Grandjean de Montigny and A. Famin).

The Tempio Malatestiano Alberti's most intriguing commission—which was also his first church—followed soon after the Rucellai Palace. Sigismondo Malatesta, the humanist ruler of Rimini on the Adriatic coast of Italy, hired Alberti to advise on the reconstruction of the Church of San Francesco. Sigismondo, reputed to have been one of the most perverse tyrants of fifteenth-century Italy and a pagan at heart, wanted the church converted to a pagan temple, which he called the Tempio Malatestiano after himself. Its purpose was to glorify him and his young mistress, Isotta degli Atti. Sigismondo's eventual disgrace—in 1462 Pope Pius II consigned him to hell for perversion, rape, murder, and heresy—and his financial setbacks prevented the completion of the Tempio. Nevertheless, what remains is a good example of Alberti's plan to harmonize the Christian church with the forms of antiquity.

The Tempio façade (fig. **14.39**) shows Alberti's use of the triple Roman triumphal arch. The two side arches are blind arches, originally intended for the tombs of Sigismondo and Isotta. All three arches are framed by four **fluted engaged** columns with Corinthian capitals. A Classical triangular pediment crowns the façade. The transition from the façade to the long sides was effected by a rectangular pier. On each side is an arcade consisting of seven round arches supported by piers. Each niche of the arcade contained the sarcophagus of a humanist admired by Sigismondo. Visually uniting the long sides with the façade are the lower **frieze** (around the base), the upper cornice, and the circles on either side of each arch, all of which wrap around the building.

In 1450, the medallist Matteo de' Pasti, who worked for Sigismondo, cast the Tempio's foundation medal (fig. **14.40**). It documents Alberti's unrealized intentions for the

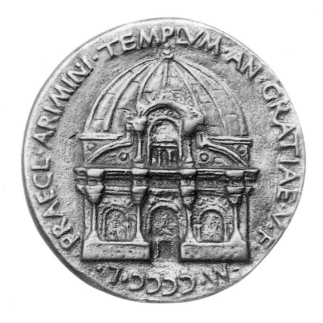

14.40 Matteo de' Pasti, foundation medal of the Tempio Malatestiano, Rimini, 1450. National Gallery of Art (Kress Collection), Washington, D.C.

completion of the building. He planned to add a central arch flanked by arcs to the second story of the façade, which would correspond to the nave and the side aisles, respectively. Most significantly, Alberti planned a huge hemispherical dome supported by a cylindrical drum, as in the Roman Pantheon. Because he had to respect the existing longitudinal structure, Alberti was unable to create his ideal temple, which would have been centrally planned. Alberti's ideal of the circular form in architecture, especially for religious buildings, had been inspired by the example of the Pantheon; it became the ideal architectural form of the Renaissance.

14.39 Leon Battista Alberti, exterior of the Tempio Malatestiano, Rimini, designed 1450.

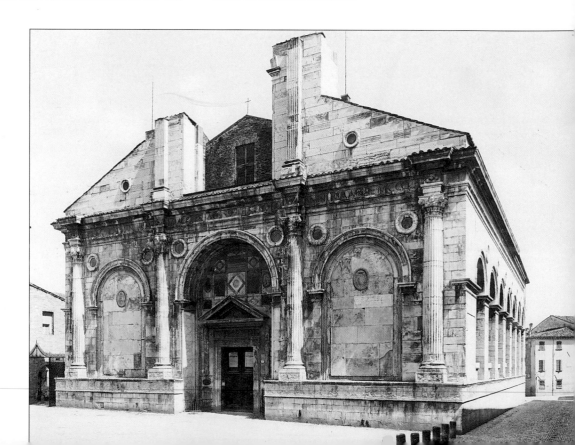

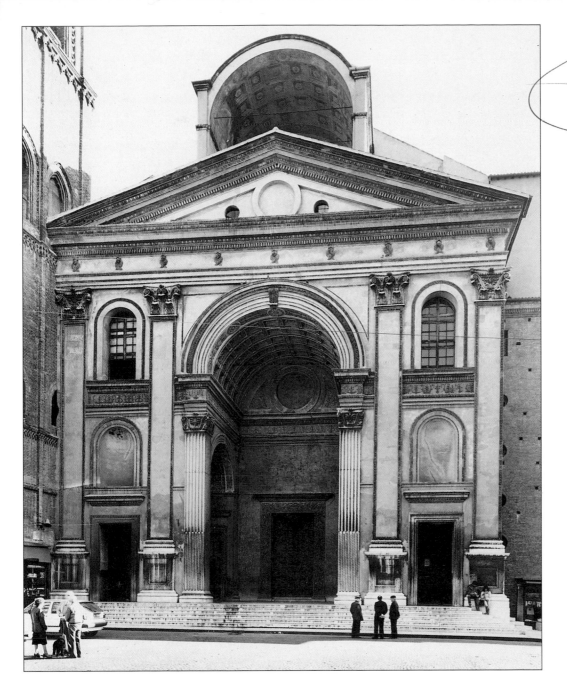

14.41 Leon Battista Alberti, Sant'Andrea, Mantua, 1470–93.

Sant'Andrea in Mantua Twenty years later, Alberti was commissioned by Duke Lodovico of Mantua (see below) to design the church of Sant'Andrea (figs. **14.41** and **14.42**). Here again he had to accommodate an existing structure, but the façade achieves the solution left unfinished in the Tempio. Although not completed until some twenty-one years after his death in 1472, Sant'Andrea conforms to Alberti's plan. On the outside, he combined the Classical temple portico (pilasters supporting an architrave surmounted by a pediment) with the Roman triumphal arch. The height of this huge, central arch and its barrel-vaulted space in front of the door are reminiscent of ancient Roman basilicas. Alberti's concern for symmetry is evident in the organization of the façade, as is his insistence on unity in the way that each section of the façade matches the interior nave and side aisles. His interest in geometry is reflected in the proportions of the façade, which fits into a perfect square.

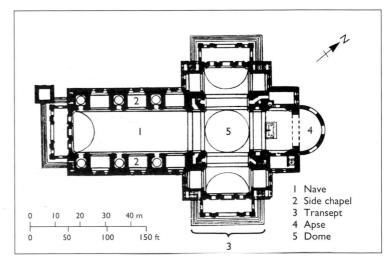

1 Nave
2 Side chapel
3 Transept
4 Apse
5 Dome

14.42 Plan of Sant'Andrea, Mantua.

The Theme of David and Goliath

Because of its associations with republicanism and David's role as a symbol of Florence, the theme of David and Goliath continued to preoccupy Italian artists—especially in Florence—throughout the Renaissance. A unique example is *The Youthful David* (fig. **14.43**) of Castagno (c. 1417/19–57), which is painted on the curved surface of a leather shield. The shield itself was probably ceremonial, perhaps carried in civic processions. Castagno's sculpturesque style is evident in the figure of David, as well as in the rocky terrain. David is depicted in vigorous motion, with the wind blowing his hair and drapery to the right. He raises his foreshortened left arm, and fixes his stare as if sighting Goliath. Whereas Donatello's *David* (fig. 14.34) is relaxed, Castagno's participates in a narrative moment that requires action. The resulting tension of Castagno's *David* is indicated by his taut leg muscles and the bulging veins of his arms. He draws back his right arm, preparing to shoot the stone from his sling.

In a striking condensation of time, Castagno has simultaneously depicted two separate moments in the narrative. For although David is about to slay Goliath, the giant's decapitated head lies on the ground between his feet. The same stone that David launches from his sling is embedded in Goliath's head. Temporal condensation of this kind speeds up our vision and our grasp of the narrative so that we see the middle and end of the episode at the same time.

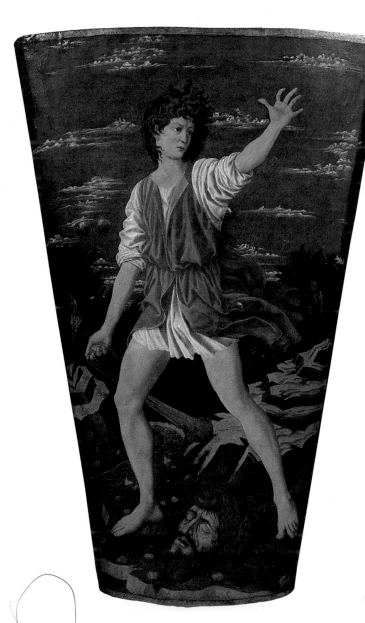

14.43 Andrea del Castagno, *The Youthful David*, c. 1450. Tempera on leather mounted on wood, 45½ × 30¼ in (115.6 × 76.9 cm); lower end 16⅛ in (41 cm) wide. National Gallery of Art (Widener Collection), Washington, D.C.

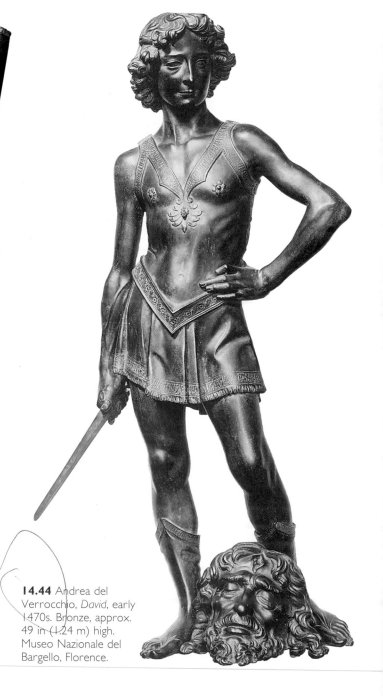

14.44 Andrea del Verrocchio, *David*, early 1470s. Bronze, approx. 49 in (1.24 m) high. Museo Nazionale del Bargello, Florence.

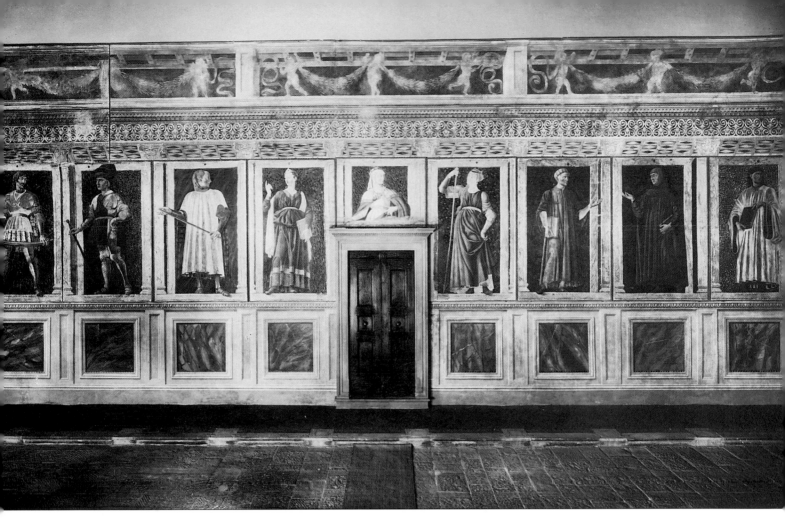

14.45 Andrea del Castagno, *Famous Men and Women*, from the Villa Carducci at Legnaia, 1450. Frescoes transferred to plaster, entire width 50 ft 10 in (15.5 m); each panel 8 ft × 5 ft ⅜ in (2.45 × 1.65 m). Galleria degli Uffizi, Florence.

Andrea del Verrocchio (1435–88), the leading sculptor of the second half of the fifteenth century, cast a bronze *David* (fig. **14.44**), commissioned sometime in the early 1470s by Lorenzo de' Medici, great-grandson of Giovanni di Bicci and known as *Il Magnifico* ("the Magnificent"). The work is at once more straightforward than Donatello's and a comment on it. Verrocchio has transformed the graceful curves and soft flesh of Donatello's effeminate *David* into a sinewy, angular adolescent. The protruding ribcage and bony arms of the later *David* express a different facet of adolescent arrogance. Here, Goliath's head lies at David's feet, without the erotic interplay of wings and legs, or of toes and beard. Instead of a giant sword closing the space and enhancing David's self-absorption as in Donatello's version, Verrocchio's *David* carries a short dagger. He also gazes out into space, rather than down onto his victim. The general effect of the Verrocchio is that of a slightly gawky, outgoing, and energetic boy.

Castagno's *Famous Men and Women*

One aspect of the biblical David that appealed to Renaissance taste was his fame. Since the revival of antiquity in the fourteenth century, fame had been an important preoccupation of the Renaissance mind. It was reflected in the comparisons between Cimabue and Giotto (see p. 453),

and particularly in Dante's verse on the transience of earthly fame (p. 451).

In 1448, Castagno was commissioned to paint a series of frescoes depicting famous men and women for the loggia of the Villa Carducci at Legnaia, outside Florence. These consisted of nine figures: three Florentine *condottieri*, three poets (Dante, Petrarch, and Boccaccio), and three women (the Old Testament queen Esther, the Tartar queen Tomyris, and the Cumaean **Sibyl**). Figure **14.45** shows all nine in the Uffizi in Florence. The three women are flanked by two sets of three men—Queen Esther is the half-length figure over the door. A painted frieze of dancing *putti* with garlands is a reminder of the humanist character of this theme. And the prominence accorded to women (even though they are historical rather than contemporary) is humanist, for Boccaccio had begun the discussion of famous women, as well as men, in the fourteenth century.

The men and women chosen for this particular commission reflect the humanist interest in freedom and the primacy of intellect. The *condottieri* fought to maintain the political independence of Florence, while the women defended the liberty of their people. The Sibyl represents wisdom, for she understood and interpreted the future. In the original layout of the frescoes, the Sibyl was portrayed as turning and pointing to what is now a badly damaged

fresco of the Virgin on the loggia's short wall—a reference to her foreknowledge of Christ. Large images of Adam and Eve, also on the short wall, indicate a typological level of meaning in Castagno's program. The three poets were included in the humanist school curriculum of fifteenth-century Florence, and it was their writing that helped spark the Renaissance.

Each figure dominates its niche and seems to step out of its frame. Their dignified self-confidence conforms to the humanist emphasis on individual achievement and talent. The figure of Dante (fig. **14.46**), for example, stands in a relaxed, self-assured pose. He carries a book and raises his left hand in a gesture of casual conversation. His scholar's robe falls in sculpturesque folds, except where it defines the bend of his right leg. His foot overlaps the lower frame—inscribed DANTE ALIGHIERI THE FLORENTINE—and continues the illusionistic trend set by Giotto over a century earlier.

The Equestrian Portrait

Another type of image that became increasingly popular in fifteenth-century Italy was the equestrian portrait, typically commissioned to honor a *condottiere*. This, too, can be related to the notion of fame and the wish to preserve one's features in the cultural memory.

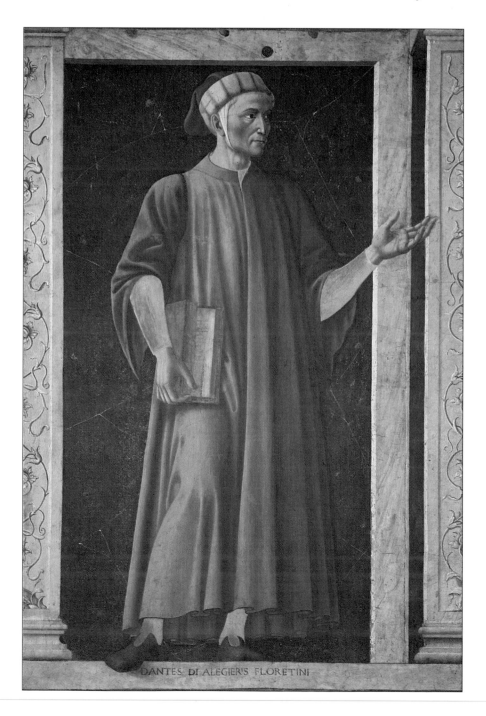

14.46 Andrea del Castagno, *Dante* (detail of fig. 14.45).

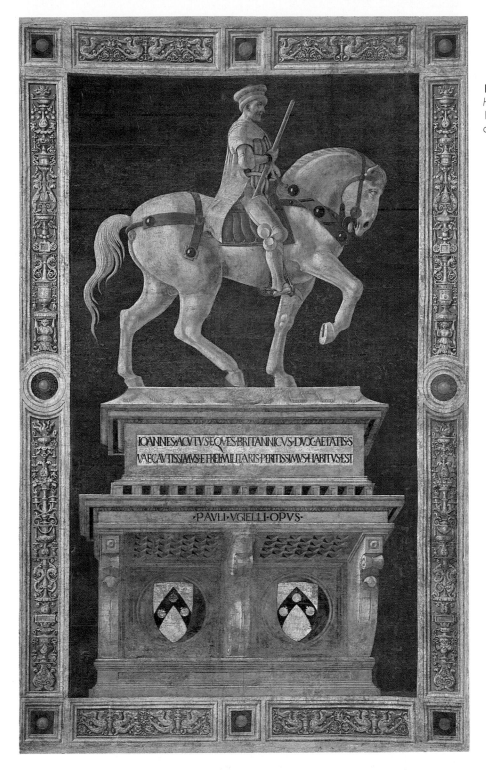

14.47 Paolo Uccello, *Sir John Hawkwood*, Florence Cathedral, 1430s. Fresco transferred to canvas.

On the pedestal:

IOANNES·ACVTVS·EQVES·BRITANNICVS·DVX·AETATISS
VAE·CAVTISSIMVS·ET·REI·MILITARIS·PERITISSIMVS·HABITVS·EST

·PAVLI·VGIELLI·OPVS·

Paolo Uccello In the 1430s, the Florentine artist Paolo Uccello (1397–1475) painted an enormous fresco on the north wall of the Cathedral (fig. **14.47**). It was to honor Sir John Hawkwood, an English soldier of fortune who had led the Florentine army in the fourteenth century. Both the Latin inscription on the **pedestal** and two shields bearing Hawkwood's coat of arms were a means of securing his fame for posterity. Uccello's memory is preserved in the signature at the top of the base. Consistent with the new Renaissance synthesis of secular and sacred is the very location of an image memorializing a military hero on the wall of a Christian cathedral.

Uccello's interest in geometry is seen in the spherical quality of the details on the horse trappings, Hawkwood's medieval armor, and his hat. Although the horse's forms are rendered organically, they have a wooden, toy-like character created by crisp edges separating light and dark.

Uccello has constructed a double perspective system in the Hawkwood fresco, in order to accommodate the observer. The base and pedestal are rendered as if from the eye level of a viewer standing below the lower edge of the fresco. As a result, the underside of the top ledge is visible, while the sides of both base and pedestal are foreshortened. The horse and rider, however, are painted as if

the viewer were higher up or the horse were lower down. This shift permits us to see the soldier and his horse in profile, and the pedestal from below. Uccello thus condenses space by portraying a double viewpoint on one flat picture plane, while Castagno, in his *David*, condenses two narrative moments within one frame.

Andrea del Castagno Paired with Uccello's fresco on the north wall of Florence Cathedral, but commissioned three decades later, is another monumental fresco by Castagno (fig. **14.48**). This work honored the *condottiere* Niccolò da Tolentino, who had defeated Siena in 1432. It is painted to resemble a marble tomb with the mounted

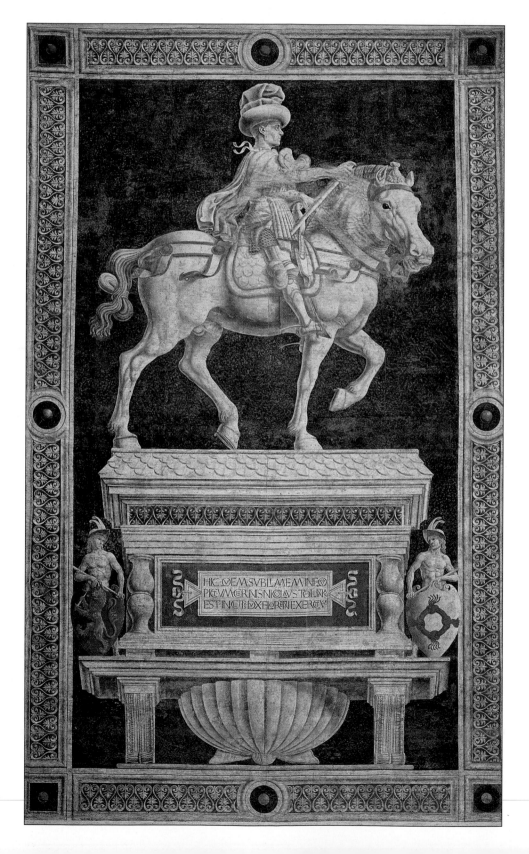

14.48 Andrea del Castagno, *Niccolò da Tolentino*, Florence Cathedral, 1455–56. Fresco transferred to canvas, 27 ft 3 in × 16 ft 7 in (8.33 × 5.12 m). Niccolò da Tolentino defeated Siena in 1432 in the Battle of San Romano, but was himself defeated in the war between Florence and Milan. He died in prison in 1435, and was buried in Florence Cathedral. The inscription on the sarcophagus reads: *HIC QUEM SUBLIMEN IN EQUO PICTUM CERNIS NICOLAUS TOLENTINAS EST INCLITUS DUX FLORENTINI EXERCITUS* ("Here Nicholas Tolentinas whom you see mounted on a horse was appointed leader of the Florentine army").

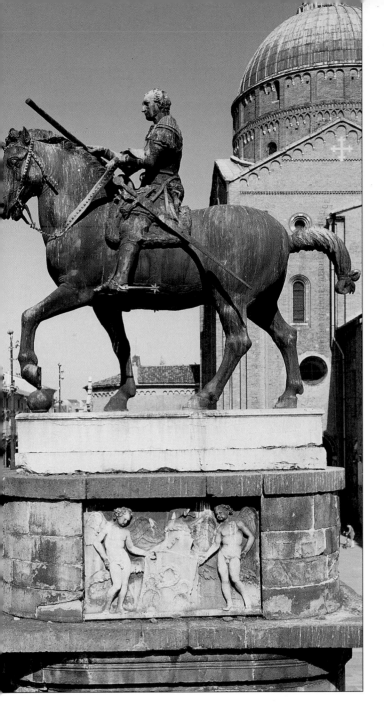

Donatello Donatello's monumental bronze equestrian portrait of Gattamelata stands on a high pedestal in front of the Church of Sant'Antonio in Padua (fig. **14.49**). It was inspired by the *Marcus Aurelius* (see Vol. I, fig. 8.52), which Donatello would certainly have seen in Rome. Both horses raise one foreleg, and their massive forms are rendered with a sense of weight and power. Donatello's rider, like Marcus Aurelius, is assertive, extending his baton in the conventional gesture of command. Gattamelata's armor is also inspired by ancient Roman models and is decorated with figures from Greek and Roman mythology. On his breastplate, a ferocious, winged Medusa head symbolically wards off his enemies (fig. **14.50**). Donatello's combination of these elements is a Renaissance synthesis of earthly fame and power with themes and motifs of Classical antiquity. Like the equestrian frescoes of Uccello and Castagno, it is a secular work, sanctioned by civic authority, but placed in a Christian site.

14.49 Donatello, *Gattamelata*, 1445–50. Bronze, approx. 11 × 13 ft (3.35 × 3.96 m). Piazza del Santo, Padua. "Gattamelata," meaning "honeyed cat," was the nickname of the *condottiere* Erasmo da Narni. He had led the army of Venice, which at that time controlled Padua. Even though the *condottiere*'s family had, according to the terms of his will, financed the sculpture, its prominent location would have needed approval from the Venetian government.

figure of the deceased on the lid. This work is more powerful than Uccello's, for the horse has greater mass, and turns toward the picture plane. The resulting foreshortening of the neck and head compresses space and monumentalizes the image. Castagno's rider is also heavier than Uccello's, and his assertive character conveys an increased tension compared with Sir John Hawkwood. Here again, the coats of arms—a gold lion on the left, and a knot of Solomon on the right—proclaim Niccolò's noble heritage. The large scallop shell connotes resurrection and rebirth.

14.50 Detail of figure 14.49.

State Portraits

Another portrait type that became popular in fifteenth-century Italy was the official, or state, portrait of an individual ruler. Portrait busts, a revival of an ancient Roman sculptural type, had been commissioned from the earliest years of the Renaissance, and Donatello was reputed to have cast portraits from death masks, just as the Romans had done.

The Umbrian artist Piero della Francesca painted a double portrait of the Duke (Federico da Montefeltro) and Duchess (Battista Sforza) of Urbino (figs. **14.51** and **14.52**) in **oil** and **tempera** on wood panels (see Box), with images of their triumphs on the back of each. The iconography is inspired by imperial Roman portraits, particularly by profile busts on ancient coins. Duke Federico's coat and hat, for example, are in the red that had been conventional for Roman emperors.

The Duke and Duchess are in strict profile (concealing the loss in a tournament of Federico's right eye). They dominate the landscape backgrounds and are also formally connected to them. Figures and landscapes are bathed in the white light that is characteristic of Piero's style. Battista Sforza's pearls repeat the diagonal plane of the white buildings in the distance, while the diamond shapes in her necklace and her brocade sleeve echo the rolling hills and distant mountains. The moles on Federico's face and the curls overlapping his ear create patterns of dark on light, just as the trees do against the landscape. The triangle of his neck and under his chin repeat the triangular mountains. Such formal parallels between rulers and landscape signified the relationship between them and their territory. Piero's perspective construction, which makes the background forms radically smaller than the figures, implies the greatness of the ruler and the expanse of his duchy.

Monumentality vs. Spirituality in Fifteenth-Century Painting

Piero della Francesca was interested in the mathematical and geometric possibilities of painting (note Federico's perfectly round, foreshortened hat in figure 14.51), and wrote two books, one on geometry and one on perspective, in Latin. A comparison of Piero's *Annunciation* (fig. **14.53**) with a painting of the same subject by Fra Angelico (fig. **14.54**) illustrates two of the leading stylistic trends in mid-fifteenth-century Italian Renaissance painting.

Fra Angelico and Piero della Francesca Both pictures must be understood within a specific context. Piero's picture is part of a fresco cycle in the Church of San Francesco in Arezzo, while Fra Angelico's is one of many pictures in the Dominican **monastery** of San Marco (Saint Mark) in Florence. In addition to different contexts, the paintings were commissioned by patrons—Franciscans and Dominicans—with differing attitudes to Christian imagery and church decoration.

Oil Painting

In oil painting, pigments are ground to a powder and mixed to a paste with oil, usually linseed or walnut. In Italy, oil first came into use as part of tempera paintings and was applied to panels coated with a gesso support. Although oil had been known and occasionally used in Italy since the fourteenth century, it was not prevalent before about 1500. In northern Europe, on the other hand, oil was the most popular medium for painters from the early 1400s.

There are several advantages to using oil paint. It can be applied more thickly than fresco or tempera, because the brush will hold more paint. Oil dries very slowly, which allows artists time to revise their work as they proceed. Oil also increases the possibilities for blending and mixing colors, opening up a much wider color range. Modeling in light and dark became easier, because oil enabled artists to blend their shades more subtly. As the oil paint tended to retain the marks made by the brush, artists began to emphasize their brushstrokes, so that they became a kind of personal signature. Tempera, a brittle medium, required a rigid support. Oil, on the other hand, was very flexible, so canvas became popular as a painting surface. This meant that artists did not have to worry as much about warping. The woven texture of canvas also held the paint better than wood.

The Dominican order, to which Fra Angelico belonged, had been founded by Saint Dominic (1170–1221), who was born in Old Castile in Spain, and its mission was to defend the Church and convert heretics. Since Dominican monks wore black mantles, they were also known as the Black Friars. In their choice of church decoration, the Dominicans tended to emphasize the spiritual qualities of Christian subject-matter. Humanist artists such as Piero della Francesca, who worked in the tradition of Giotto, were likely to have Franciscan rather than Dominican patron-

14.51 (opposite, above) Piero della Francesca, *Battista Sforza, Duchess of Urbino* and *Federico da Montefeltro, Duke of Urbino*, after 1475. Oil and tempera on panel, each 18½ × 13 in (47 × 33 cm). Galleria degli Uffizi, Florence. Before cleaning.

14.52 (opposite, below) Figure 14.51 after cleaning.

14.51 and **14.52** Federico da Montefeltro, a successful *condottiere*, and his wife were leading patrons of the arts, and presided over one of the most enlightened humanist courts in 15th-century Italy. Artists, scientists, and writers (including Alberti) came from various parts of Europe to work for Federico. The fact that Piero used oil in his painting was probably a result of his contacts with Flemish painters working at the court of Urbino. Note the difference between the top pair of paintings and the panels below. The lower pair shows the diptych after a recent cleaning, which has restored the blue sky and intensified the colors throughout.

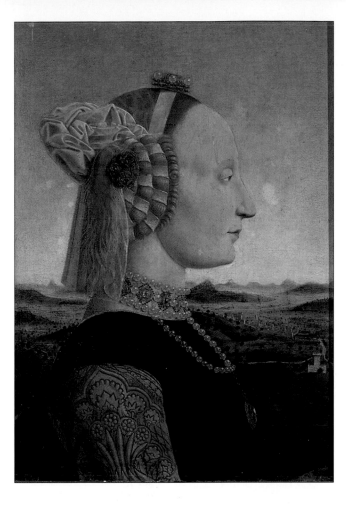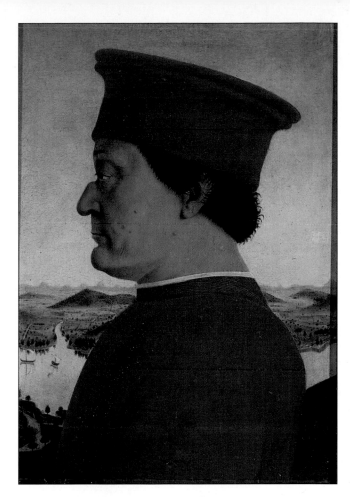

age. Piero's *Annunciation* is a good example of the artist's interest in combining Christian iconography with geometry and the Classical revival. The scene takes place in a white marble Classical building with composite Corinthian and Ionic columns. Mary holds a book, Gabriel enters from the left, and God the Father hovers over a cloud at the upper left. Mary is related to the Classical architecture as both a form and a symbol. She fills the space of the por-

tico, evoking the Christian convention equating Mary's monumental proportions with the Church building. The column swells slightly, even though it is not Doric and should not exhibit *entasis* (see Vol. I, p. 160), and is thus an architectural metaphor for Mary's pregnancy through the miraculous Incarnation of Christ. Mary's formal relationship with the architecture confirms her symbolic role as the "House of God."

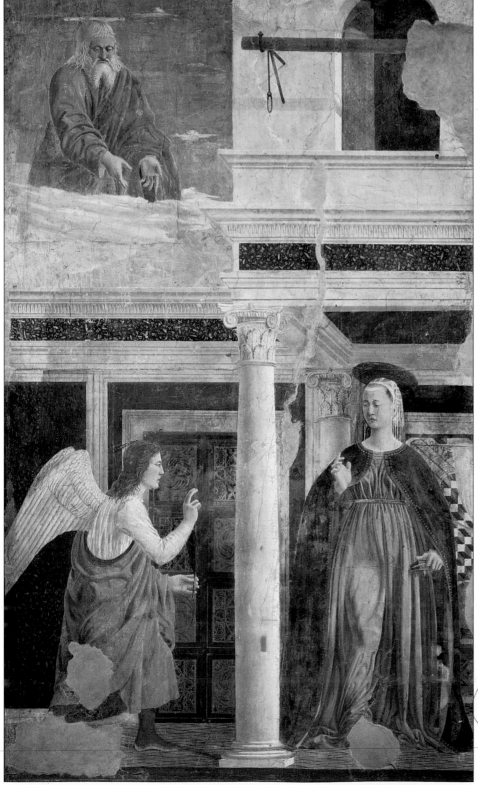

Piero's *Annunciation* contains several allusions to the miraculous nature of Mary's impregnation. In the liturgy, Mary is the "closed door," or *porta clausa*, because she is a virgin. This is the connotation of the closed door behind Gabriel. But she also stands before an open door, which represents Mary herself, because she is receptive, or "open," to God's word. The rays of light that God transmits toward Mary signify Christ, who refers to himself in the Bible as "the light of the world."

The opposite of light—in nature, in painting, and in metaphor—is shadow. Piero uses shadow to create another allusion to impregnation in the *Annunciation*. The horizontal wooden bar that crosses the upper-story window casts a shadow that seems to pierce the loop hanging from it, turn the corner, and enter the window. Because in the west we read pictures from left to right, the shadow, like the light, may be read as coming from God. Both shadow and light enter the building and, in a metaphor for conception, symbolically enter Mary. The maternal significance of these images is implicit in the figure of Mary. Her monumental presence allies her with Piero's classicizing architecture, with Christian liturgy, and with the mother goddesses of antiquity.

14.53 Piero della Francesca, *Annunciation*, c. 1450. Fresco, 10 ft 9½ in × 6 ft 4 in (3.29 × 1.93 m). San Francesco, Arezzo.

Fra Angelico's fresco of the Annunciation (fig. 14.54), dating to about 1440, offers an instructive contrast to Piero's. Although Fra Angelico (c. 1400?–55) was a Dominican friar who painted Christian subjects exclusively, his style reflects the new fifteenth-century painting techniques. His Annunciation takes place in a cubic space, and orthogonals indicate the presence of a vanishing point. However, compared with those in Piero's Annunciation, Fra Angelico's figures are thin and delicate. Their gently curving draperies echo the curve of the ceiling vaults above them. The haloes, rather than being radically foreshortened as on Piero's God the Father, are flat circles placed on the far sides of the heads. The patterned rays in Gabriel's halo and the design on his wings reveal a taste for surface decoration more compatible with International Gothic than with the monumental artistic trends of fifteenth-century Florence.

Fra Angelico uses light to convey a sense of spirituality. Like Gabriel himself, the light enters from the left and falls on Mary's bowed form. More striking is the fact that the vanishing point lies on the plain back wall of the porch, where the white light is at its most intense. In contemplating this event, therefore, one's line of sight is directed to pure light which, in the context of the Annunciation, signifies the miraculous presence of Christ—the "light of the world" and the source of enlightenment for Christians.

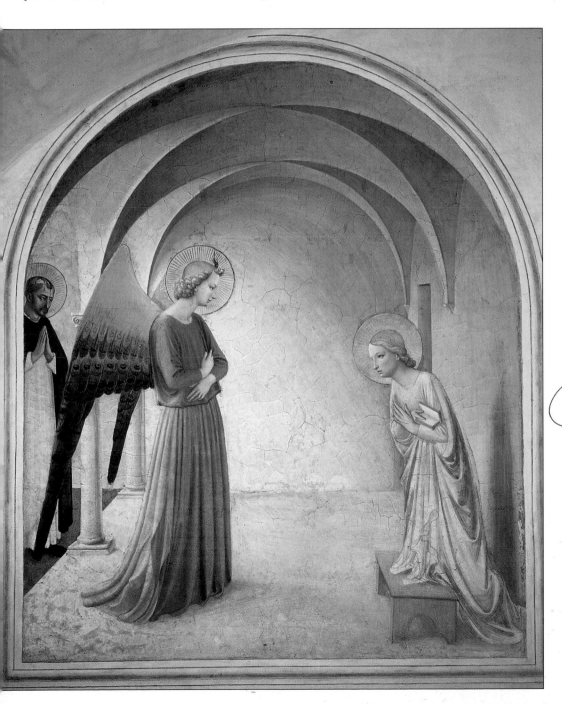

14.54 Fra Angelico, *Annunciation*, c. 1440. Fresco, 6 ft 1½ in × 5 ft 1½ in (1.87 × 1.56 m). San Marco, Florence. The purpose of Fra Angelico's *Annunciation* is related to its location—in the cell of a Dominican monk in the monastery of San Marco. On the far left, just outside the sacred space of the Annunciation, stands the 13th-century Dominican saint Peter Martyr, who devoted his life to converting heretics to orthodox Christianity. A member of the Dominican order who had evoked visions of the Annunciation through prayer and meditation, he was a daily inspiration to the monks of San Marco.

Piero della Francesca's *Legend of the True Cross*

In 1452, the Bacci of Arezzo hired Piero to complete the fresco cycle in their family chapel, in the church of San Francesco. It had been barely started by an artist of lesser reputation who had died. The subject was the Legend of the True Cross (see Vol. I, p. 372), which was depicted in

ten scenes symmetrically arranged on either side of the chapel and separated by the window (figs. **14.55** and **14.56**). Saints, an angel, and a Cupid are represented on the side pilasters, and two prophets flank the window in the lunette of the altar wall. Piero's *Annunciation* is illustrated in its context in figure 14.55.

Piero's rendition of this popular medieval legend reveals both formal and iconographic complexity. His scenes do

14.55 Piero della Francesca, left wall of the Bacci Chapel, San Francesco, Arezzo, 1452.

not follow in chronological sequence, but are arranged according to a system of visual, typological, and liturgical parallels. At the top, the two lunettes contain the beginning and the end of the legend: *The Death of Adam* on the right, and *The Exaltation of the Cross* (in which the True Cross is restored to Jerusalem) on the left. In the middle register, the two large scenes parallel the women most involved in the legend: *The Queen of Sheba Visits Solomon* and *Recognizes the Holy Wood* on the right, and *Saint Helena Discovers and Proves the True Cross* on the left. The small scenes next to these show *The Burial of the Wood* (right) and *The Torture of the Jew* (left). The two large scenes below are both of battles in the name of the Cross: *Constantine Routs Maxentius* (right) and *Heraclius Recovers the Stolen Cross from the Persian Infidel Chosroes* (left).

14.56 Piero della Francesca, right wall of the Bacci Chapel, San Francesco, Arezzo, 1452.

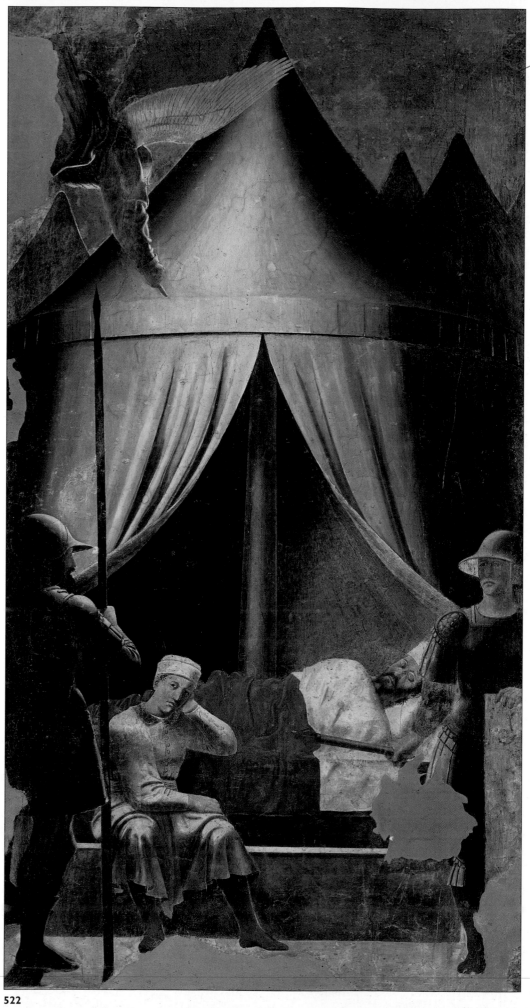

On either side of the window, on the lowest level, are the *Annunciation* and *The Dream of Constantine* (fig. **14.57**). The parallelism of these two scenes conveys some idea of Piero's complex layers of meaning. They also reflect the mathematical character of the most monumental Renaissance art. Both are scenes of revelation, which initiate a new historical order. The Annunciation brought about the New Dispensation and all the events from the New Testament onward. Constantine's dream revealed the power of the Cross, and led to his legal sanction of Christianity (see Vol. I, p. 372). Light is the form by which the revelations are made, and from which en*light*enment results. As in the Brancacci Chapel, each fresco here is illuminated as if from the window, so that the *Annunciation* is lit from the right and the *Dream* from the left.

In both scenes, the news comes from the left—in the *Dream* from the angel, in the *Annunciation* from both God and Gabriel. The unity of light is reinforced by the structural relationship between the *Annunciation* and the *Dream*. Despite the opposition of day and night, both scenes are divided by a prominent cylindrical form—the column and the tent post respectively, accentuating the geometric character of each scene. The *Annunciation* is divided into strict rectangles, the only variation being the column's *entasis* and the round arch of the window. The *Dream* is divided into triangles by the top of the tent and its open flaps.

Piero's genius for synthesizing many levels of meaning makes this fresco cycle one of the masterpieces of the fifteenth century, in which geometry coincides with history, liturgy, formal considerations, and typology. Mary was typed with Saint Helena, Constantine's mother who found and proved the True Cross, and Constantine was typed with Christ. Piero parallels Christ's conception with Constantine's rebirth into the Christian faith. In a sense, the *Dream*, like the *Annunciation*, is about birth; the birth of an idea is juxtaposed with a biological conception. In that context, the architectural implications of Mary as the House of God are echoed in the tent that both encloses and reveals the dreaming Constantine.

Andrea Mantegna's Illusionism

In northern Italy, the leading painter from the middle of the Quattrocento was Andrea Mantegna (1431–1506). From about 1465 to 1474, Mantegna worked for Lodovico Gonzaga, the Duke of Mantua, who, like Federico da Montefeltro, ruled a humanist court. Mantegna decorated the state bedroom of the Ducal Palace in Mantua, using the new perspective techniques to create an illusionistic environment (fig. **14.58**).

14.58 Andrea Mantegna, *Camera degli Sposi*, Ducal Palace, Mantua, 1474. Room approx. 26 ft 6 in × 26 ft 6 in (8.1 × 8.1 m). Two walls are covered with frescoes depicting members of the Gonzaga family, their court, horses, and dogs, together with decorative motifs, and a distant landscape. The landscape view to the left of the door exemplifies the Renaissance idea of a painting as a window.

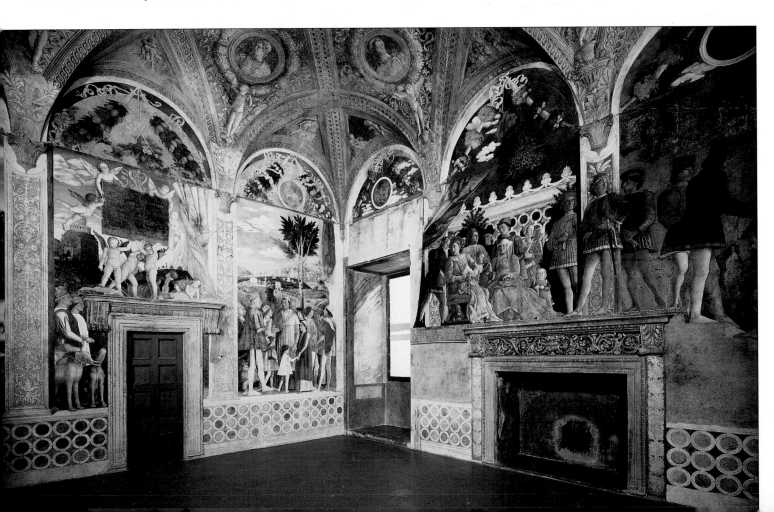

In the painted wall above the fireplace (fig. **14.59**), the room seems to open onto a balcony where the family sits with children, courtiers, household servants, and a dwarf. Lodovico has just been given a letter by a messenger. An illusionistic curtain flutters out of the picture plane, over Lodovico's head, and overlaps the pilaster on the left. To the right, figures come and go, as painted and real architecture merge.

The most dramatic instance of Mantegna's illusionism in the Ducal Palace is the ceiling tondo, painted to resemble an architectural **oculus** (fig. **14.60**). Visually, it is integrated with the ceiling, so that it is difficult for the casual observer to identify the borders between reality and illusion. The portrait **busts** of Roman rulers (see fig. 14.58, top) around the tondo are painted to imitate relief sculpture and associate the Duke of Mantua with imperial Rome. The tondo itself simulates a cloudy sky above a round parapet, with figures peering down as if into real space. Mantegna's taste for radical foreshortening, also evident in the *Dead Christ* (see fig. 14.16), can be seen here in the spatial compression of the parapet and the point of view from which the figures—particularly the *putti*—are depicted. Such illusionistic painted environments, which elaborate the fourteenth-century spatial innovations of Giotto, could not have developed without the invention of perspective.

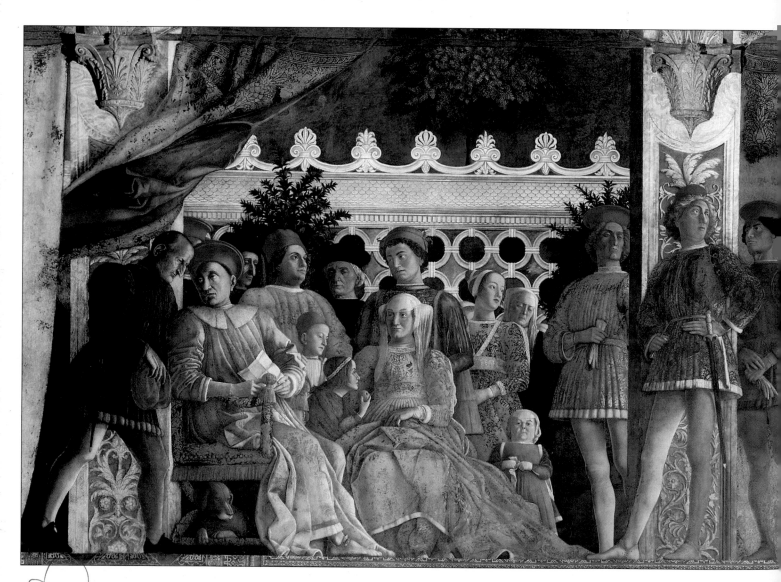

14.59 (above) Andrea Mantegna, *Camera degli Sposi* (detail of fig. 14.58, showing the view over the fireplace, including the Duke and Duchess of Mantua, their family, and pages).

14.60 (opposite) Andrea Mantegna, ceiling tondo of the *Camera degli Sposi*, Ducal Palace, Mantua, 1474. Fresco, diameter of balcony 5 ft (1.52 m). Mantegna's humor is given full rein in this tondo. A potted plant balances precariously on the edge of the wall. Three leering women lean over and stare, while two more engage in conversation. A group of playful *putti* is up to various pranks. One prepares to drop an apple over the edge, while three others have got their heads stuck in the round spaces of the parapet. In this scene of surreptitious looking, Mantegna plays upon the dangers that await the observers as well as the observed.

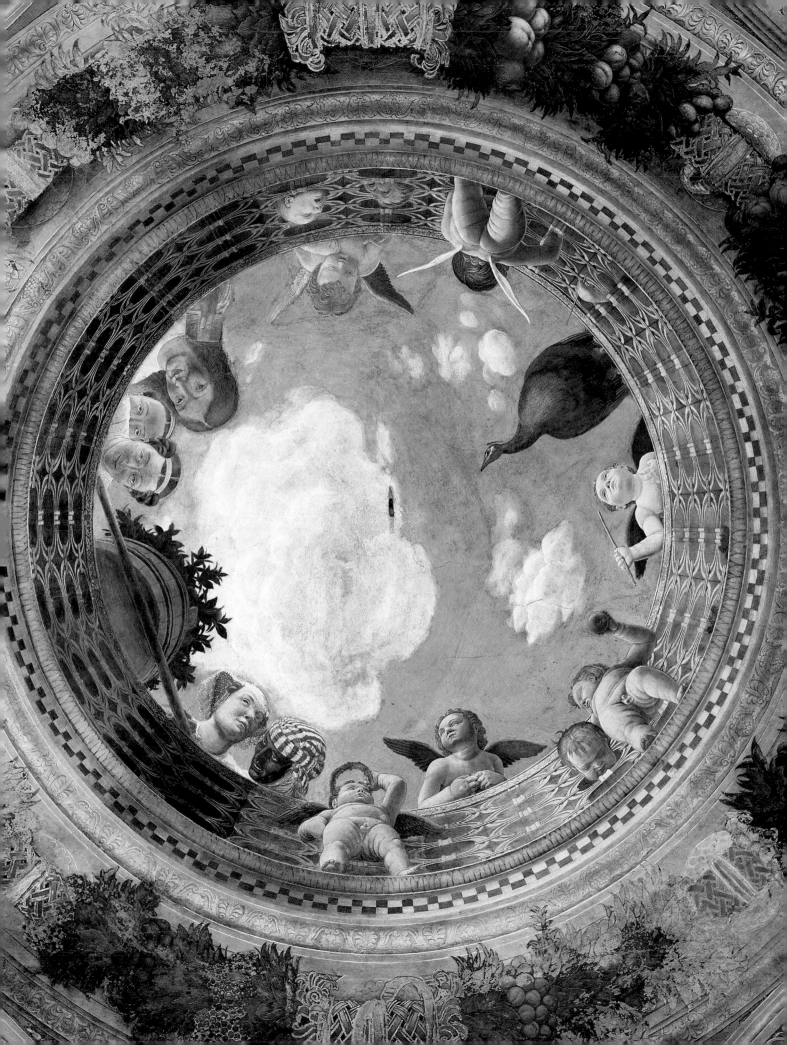

Mantegna and the *Studiolo* of Isabella d'Este

In the last decade of his life, Mantegna worked for Isabella d'Este (1474–1539), Marchesa of Mantua (see Box). She commissioned nine paintings, seven large and two small, from different artists for her *studiolo* (private study) in the Ducal Palace. Together they constituted a cycle of allegorical mythologies based mainly on the romances of the gods. The primary text was Ovid's *Metamorphoses* (see Vol. I, p. 210), and throughout the project Isabella herself supervised the content and arrangement of the pictures.

Two of these pictures were by Mantegna, a *Parnassus* (fig. **14.61**) paired with a *Minerva Expelling the Vices from the Garden of Virtue*. The *Parnassus* (now in the Louvre) is complex and its message elusive, but it is certainly concerned with the arts and the triumph of love. Presiding over the scene from the top of a landscape arch are the illicit lovers, Mars and Venus. At the left, waving angrily from his cave, is Venus's husband, the blacksmith god

Vulcan. Making light of Vulcan's cuckolded state is Cupid, who blows a dart at his genitals. In Ovid's account of the myth, Vulcan ensnares the lovers in a finely woven bronze net, to which the yellow threads hanging from the cave's entrance probably refer.

The physical beauty of Mars and Venus and the calm triumph of their love (implied in the landscape arch) are contrasted with the frantic gestures, agitated pose, and bright red cloak of Vulcan. Nevertheless, Vulcan is a crafts god and, despite being lame (Hera threw him from Olympus when he was born, because he was unattractive), a creator of beautiful things. At the right, Mercury, identified by his winged hat, boots, and caduceus, stands with the winged horse Pegasus. Both listen to Apollo's music, which he plays on the lyre at the left. Dancing across the center of the picture plane are the nine Muses, who stand for inspiration in poetry, art, history, and music. Music is related to Mars and Venus by virtue of its harmony, for the daughter of their union was Harmonia.

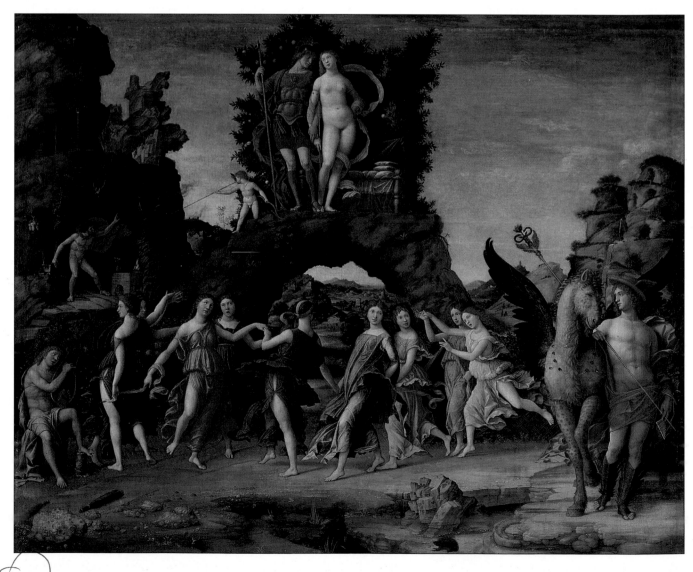

14.61 Andrea Mantegna, *Parnassus*, c. 1497. Tempera on canvas, 5 ft 3 in × 6 ft 4 in (160 × 192 cm). Louvre, Paris.

Isabella d'Este

Isabella d'Este was raised at the Este court in Ferrara. She received a humanist education, and read Classical Latin authors in the original; she could recite Virgil's *Eclogues* by heart. At the age of sixteen, she married Francesco II Gonzaga, Marquis of Mantua and grandson of Lodovico, Mantegna's previous patron. Isabella was instrumental in making the Mantuan court a leading center of humanism, and became a shrewd patron of the arts and a bibliophile. She also continued her studies and hired tutors to instruct her.

Isabella exemplified the success of certain Renaissance women—usually of noble birth—who married important rulers, and governed the state in their absence. She followed the contemporary fashion for designing intimate, private studies which, before Isabella, had been reserved for men. It was Isabella's great uncle, Leonello d'Este, who had created the first known Renaissance *studiolo* in Ferrara. A more famous *studiolo* was built for Federico da Montefeltro in the Ducal Palace of Urbino, and a smaller version was commissioned for his palace in Gubbio. Isabella, in creating her own *studiolo*, as well as hiring important artists to decorate it, was self-consciously projecting the image of herself as the intellectual equal of humanist princes.

The likely location of this scene is Mount Helikon, which was frequented by Apollo and the Muses in Greek mythology. According to Greek myth, when Pegasus stamped on the ground of Helikon, the fountain of Hippokrene appeared and became a source of inspiration to poets. Helikon was a retreat of the gods, and therefore a metaphor for the *studiolo*, to which Isabella retreated. Like Apollo, Isabella was devoted to music, and she enjoyed singing before small audiences. Her love of art and music, together with her humanist education, achieved full expression in the paintings she commissioned for her private, fifteenth-century Helikon.

Botticelli's Mythological Subject-Matter

Sandro Botticelli's (1445–1510) version of *Mars and Venus* (fig. **14.62**) predates Mantegna's by some twenty years, and shows the two lovers in a different relation to each other. Venus sits up; she is awake and clothed. Mars is nearly nude and reclines in sleep. This iconography expresses the theme of the dangers to men who fall in love with women. The helpless, sleeping state of Mars, exhausted by his amorous pursuits, makes him the butt of the satyrs' joke. Three of them playfully make off with the war god's lance and helmet; one of these blows a trumpet shell in Mars's ear, but fails to awaken him. At the lower right corner, a fourth satyr crawls through the breastplate and sticks out his tongue. All four literally *satirize* Mars—a god of war weakened by a woman. The elongation of the figures and the linear quality of Venus's drapery are characteristic of Botticelli. Their elegance distinguishes them from the classically inspired, sculpturesque forms of Mantegna, despite their mythological content. It is possible that Botticelli's Mars and Venus are portraits—perhaps of members of the donor's family, whose identity is unknown—for their physiognomy seems quite specific.

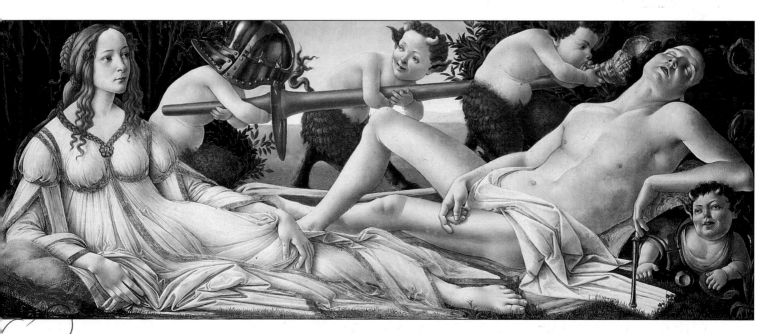

14.62 Sandro Botticelli, *Mars and Venus*, c. 1475. Tempera on panel, 27¼ × 68¼ in (69.2 × 173.3 cm). National Gallery, London. It has been suggested that, given its shape, this work was designed as a panel for a *cassone* (large chest).

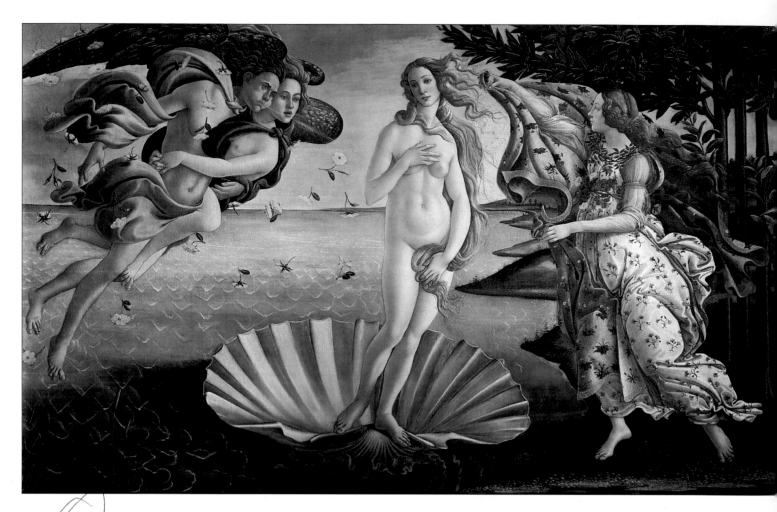

14.63 Sandro Botticelli, *Birth of Venus*, c. 1482. Tempera on canvas, approx. 5 ft 8 in × 9 ft 1 in (1.73 × 2.77 m). Galleria degli Uffizi, Florence. According to Classical myth, Venus was born when the severed genitals of Uranus were cast into the sea. Botticelli's Venus floats ashore on a scallop shell, gently blown by the wind god Zephyr (also the English word for a light breeze). He is clad in blue drapery, suggesting a cool wind, and is embraced by an unidentified female. On the right, a mortal woman rushes to cover Venus with a pink floral cloak. As a goddess of love and fertility, Venus is appropriately surrounded by flowers.

The Platonic Academy

Cosimo de' Medici was an enthusiastic patron of humanism. From the 1460s, humanists met informally at the Medici Villa in Careggi, outside Florence. Their discussions were based on Plato's school of philosophy, which was established in Athens in 387 B.C. There, in a public garden, philosophical interchanges became the basis of Plato's *Dialogues*, a literary form revived in the Renaissance. After Cosimo's death, his grandson Lorenzo (1449–92) continued to support the humanists and founded the Platonic Academy of Florence in 1469.

The philosophy of Neoplatonism, a combination of Plato's philosophy with Christianity, prevailed at Lorenzo's Academy. It was led by Marsilio Ficino, who lived at the villa, where philosophical discussion provided regular dinner table entertainment. Artists as well as authors participated in these humanist gatherings, along with members of the Medici family.

Ficino translated all of Plato's *Dialogues*, and other Greek works, into Latin. In his *Commentary on Plato's Symposium*, Ficino notes the twofold nature of Venus—one divine, the other vulgar. The divine Venus is Mind and Intelligence, and loves spiritual beauty. The other Venus is procreative energy, fuelled by the impulse to transform spiritual beauty into physical beauty. "On both sides, therefore," according to Ficino, "there is a love: there a desire to contemplate beauty, here a desire to propagate it. Each love is virtuous and praiseworthy, for each follows a divine image."[3]

More generalized is Botticelli's *Birth of Venus* (fig. **14.63**) of around 1480. This work is one of a series of mythological pictures probably executed for a member of the Medici family, perhaps a cousin of Lorenzo the Magnificent. It was the Medici interest in Classical themes and the revival of Plato's philosophy that had led to the founding of the Platonic Academy in Florence in 1469 (see Box). Botticelli's nude Venus, like Masaccio's Eve (see fig. 14.27), is derived from the type of the Medici *Venus* (see fig. 14.28). Her languid pose, however, conveys the impression that she is just waking up. Her flowing hair, echoing the elegant drapery curves and translucent waves, has the same linear quality as the *Mars and Venus*.

The Question of an Old-Age Style: Donatello and Botticelli

The question of an old-age style has recently become a topic of discussion among art historians. Although most artists develop according to their talents and their energies, and "old age" is a variable, often subjective time, some artists make radical changes at certain periods in their lives. This appears to have been true of Donatello and Botticelli. In their youth and maturity, both artists had been enthusiastic proponents of the Classical revival. Their subject-matter was wide-ranging and included Christian iconography, portraits, and mythological themes that reflected the new interest in Neoplatonic philosophy. Both Donatello and Botticelli portrayed nudes in Classical poses, and both were influenced by Classical texts.

In their fifties, however, these two artists changed the emotional tone of their work, renouncing pagan content and displaying an undeniable anxiety and a new sense of spiritual concern. If, for example, we compare Donatello's painted wood statue of *Mary Magdalen* of around 1455 (fig. **14.64**) with his bronze *David* (see fig. 14.34), a change in the artist's outlook is readily apparent. The *Mary Magdalen* is devoid of mythological reference (such as the *putti* relief on Goliath's helmet). In contrast to the self-confident, assertive pose of Donatello's public statue of *Saint Mark* (see fig. 14.33), the *Magdalen*'s despair is consistent with its function as a devotional work. Her long, thin proportions, skeletal appearance, sunken cheeks, and missing teeth reflect the ravages of time. In place of drapery, Donatello has clothed the figure in her own hair, grown long as a conventional sign of penance for her sins.

14.64 Donatello, *Mary Magdalen*, c. 1455. Painted wood, 6 ft 2 in (1.88 m) high. Museo dell'Opera del Duomo, Florence.

Botticelli's *Mystical Nativity* (fig. **14.65**), dated 1501, has an agitated quality that differs sharply from the languid atmosphere of his mythological pictures. As in Donatello's *Magdalen*, Botticelli's proportions have become even longer and thinner, and there is an increase in formal movement, particularly in repeated curves. The picture plane is divided into three horizontal sections. In the middle, an Adoration of Christ takes place at the entrance to a rocky cavern that symbolizes the Church building. (The alignment and lighting of the trees visible behind Mary suggest stained glass windows.) On the roof of the wooden shed are three angels. Above, a group of dancing angels circles around in a gold light. In the scene below,

angels grasp the souls who have escaped the clutches of the devils (at the corners) and entered heaven. The sharp color and light/dark contrasts enhance the sense of ecstatic emotionalism that pervades the painting. Since this was not a commissioned work, one can assume that it is a good barometer of Botticelli's state of mind at the turn of the century.

Neither artist recorded an explanation for the radical shift in style and iconography. But it is possible that Donatello and Botticelli were responding to contemporary turbulence in politics and religion. Their most powerful patrons, the Medici, were having difficulty with opposing political factions. As economic tensions increased, the

14.65 Sandro Botticelli, *Mystical Nativity*, 1501. Oil on canvas, 42¾ × 29½ in (108.6 × 74.9 cm). National Gallery, London.

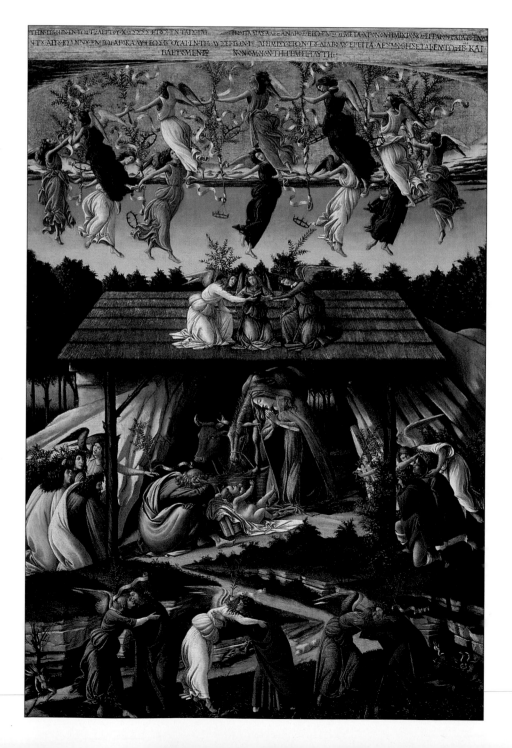

Medici banks declined and finally closed down. Religious pressures also mounted in a reaction against the liberalism of the humanists and the Neoplatonists.

Two influential Dominicans, first Saint Antonine (1389–1459) and later Girolamo Savonarola (1452–98), railed against nudity in art and pagan subject-matter. In 1450, Antonine participated in the burning of a heretic at the entrance to the Florence Cathedral. He cited Augustine (see Vol. I, p. 397) on the nature of Mary Magdalen as a "body, mass of corruption …" Such sentiments may have affected Donatello's depiction of the Magdalen as a repentant, decaying figure. His subsequent works have more in common with the *Mary Magdalen* than with the fresh, vibrant, youthful optimism of the bronze *David* and of other works before 1455.

Savonarola, the Dominican Abbot of San Marco, vigorously opposed Medici support of humanism. In 1494, in the wake of the death of Lorenzo the Magnificent and the exile of the Medici, he gained control of Florence, and preached fire and brimstone. In 1498, he presided over the so-called "Bonfire of the Vanities," in which Florentines burned their elegant clothing, books, and works of art that offended him. Later that same year, public and papal sentiment turned against Savonarola. He was hanged; but before he died, he was cut down and burned as a heretic. A Greek inscription at the top of Botticelli's *Mystic Nativity* suggests that it was inspired by Savonarola's sermon warning of the end of the world and the eternal damnation of sinners..

Fifteenth-Century Painting in Flanders

In Flanders (fig. **14.66**), economic changes similar to those in Italy began to occur in the early fifteenth century. Medieval feudalism and court patronage gradually gave

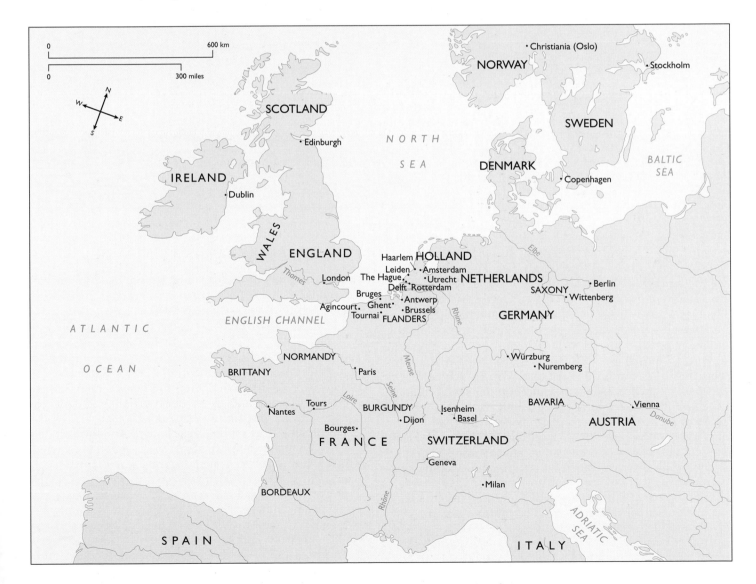

14.66 Map of northern and central Europe in the Renaissance.

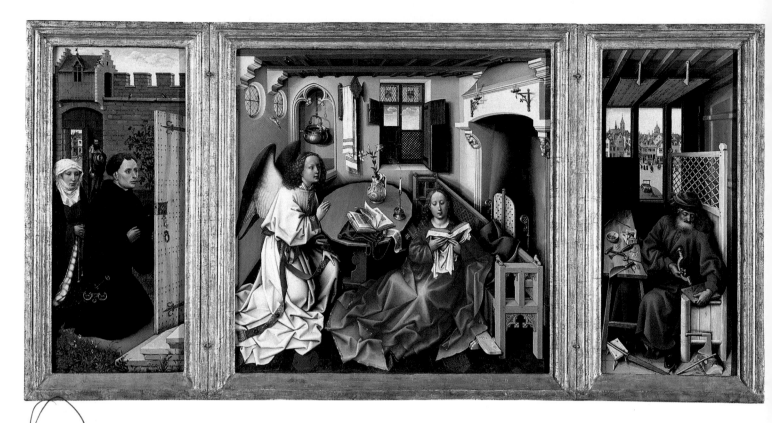

14.67 Robert Campin (Master of Flémalle), *Mérode Altarpiece* (open), c. 1425–30. Tempera and oil on wood, central panel 25 × 25 in (63.5 × 63.5 cm). Each wing 25 × 10¾ in (63.5 × 27.30 cm). Metropolitan Museum of Art, New York (Cloisters Collection, purchase). Campin was a master painter in the painters' guild in Tournai, Flanders, from 1406, as well as being active in local government. A married man, he was convicted of living openly with a mistress and was banished from Tournai, though his punishment was later commuted to a fine. This triptych is called the *Mérode Altarpiece* after the 19th-century family that owned it.

way to a more bourgeois society and a merchant economy based mainly on wool trading and banking. By the fifteenth century, commercial ties between Italy and Flanders were close and business travel quite common. Flemish artists worked in Italian courts, and Italian princes and wealthy businessmen commissioned works of art from Flanders.

For the most part, Flemish artists of the Renaissance were more innovative in painting than in sculpture or architecture. Whereas in Italy panel paintings were mainly executed in tempera until the sixteenth century, Flemish painters preferred oil paint and refined the technique for altarpieces. The use of oil paint satisfied the Flemish interest in meticulous, decorative, and naturalistic detail, which characterizes much fifteenth-century northern painting.

Although artists in the north of Europe shared the Italian preference for the representation of three-dimensional space and lifelike figures, they were less directly affected by the Classical revival than the Italians. Artists in the north continued to work in a Gothic tradition, which they nevertheless integrated into the new Renaissance style.

Campin's *Mérode Altarpiece*

A good example of a Flemish altarpiece used for private devotions in a home rather than in a church is the **triptych** (fig. **14.67**) by Robert Campin, also called the Master of Flémalle (c. 1375–1444). The large central panel of the triptych shows the Annunciation. In the right wing, Joseph makes mousetraps in his carpentry workshop; in the left, two donors kneel by an open door. As in contemporary Italian painting, Campin's figures occupy a three-dimensional, cubic space and are modeled in light and dark. The light source is consistent and unified.

In contrast to contemporary Italian art, however, the Flemish painters preferred sharp, precise details, some of which are so small that magnification is necessary to see them clearly. Campin does not use one-point perspective to unify all three panels of the triptych. Instead, each panel is seen from a different viewpoint. The Annunciation takes place entirely indoors, whereas in the side panels a distant medieval town is visible. Unlike floors in Italian perspective constructions, Campin's floor appears to rise slightly, even though the ceilings are nearly horizontal. The gradual upward movement of the painted space, together with

the attention to minute detail, has been attributed by some scholars to late Gothic influence. Elongated, angular draperies also combine the Gothic taste for elegant surface design with the new Renaissance understanding of organic form.

This altarpiece contains a wealth of complex Christian symbols. Unlike Italian Annunciations, Campin's takes place in a bourgeois home, whose everyday, secular objects are endowed with Christian meaning. The lilies have the same significance here as in Italian art. They represent the purity and passion of the Virgin, and their triple aspect refers to the three persons of the Trinity. The copper basin and the towel are more specific to the Flemish taste for household objects and may refer to Christ cleansing the sins of the world. At the same time, the niche corresponds to an altar niche, where the priest washed his hands, symbolically purifying himself before Mass.

Gabriel's dress, the white robe worn by priests at Mass, and other priestly accoutrements endow the central space with liturgical meaning. In such a context, the prominence given to the table identifies it as a reference to the altar—which was originally an actual table alluding to the ritual of the Last Supper. The candle, which on a naturalistic level has been blown out by the draft from the open door in the left panel, can also represent Christ's Incarnation. Entering the room from the round window on the left wall, a tiny Christ carrying his Cross slides down rays of light (fig. **14.68**). Mary herself sits reading on the floor. Her lowered position is an allusion to her humility, a quality that, like her virginity, endeared her to God.

In the right panel, the attention to detail and the convincing variety of surface textures—for example, the wood, the metal tools, Joseph's fluffy beard, and his heavy simple drapery—reflect Campin's study of the natural world. The image of Joseph making mousetraps signifies his symbolic role as a trap for the Devil: his marriage to Mary was interpreted as a divine plan to fool Satan into believing that Christ's father was mortal. Joseph thus protects Mary and Christ, and so guards the sanctity of the central panel. In working alone, isolated from the miraculous Annunciation, Joseph is both part of, and separate from, the central drama. His inclusion in Annunciation scenes was unusual, and has been linked by some scholars to a growing cult of Saint Joseph in Flanders. Joseph is thus depicted as a family man, reflecting a bourgeois, upper-middle-class environment.

The left panel illustrates the donor, who has been identified by the coat of arms at the top of the back-wall window of the *Annunciation* as belonging to the Ingelbrechts family from Mechelen. His wife, a figure thought to have been added after their marriage, kneels behind him and holds a string of rosary beads. Husband and wife are privileged to witness the moment of the Incarnation through the slightly open door, but they remain outside the central sacred space. Their presence reinforces the private, devotional function of Campin's triptych. The small figure in the background has been variously identified—from the artist himself to Isaiah, whose Old Testament prophecies are the source of several iconographic conventions used in Annunciation scenes.

Jan van Eyck

The most prominent painter of the early fifteenth century in Flanders was Jan van Eyck (c. 1390–1441), whose work synthesizes Flemish interest in natural detail and tactile sensibility with Christian symbolism. He was a successful artist who worked for private patrons and, from 1425, for the Burgundian court of Philip the Good, where he was employed for the last sixteen years of his life. In 1430 he married and bought a house in Bruges (in modern Belgium).

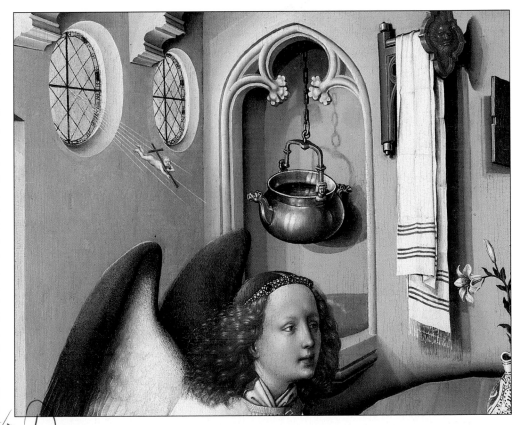

14.68 Detail of figure 14.67. Here Christ enters the sacred, though domestic, space of the Annunciation. He carries a small Cross, referring forward in time to his Crucifixion. Christ and the Cross leave the glass intact, illustrating the popular Christian metaphor that equates the entry of light through a window with the Virgin Conception and Birth.

The Ghent Altarpiece Van Eyck's most elaborate and complex work is the Altarpiece of the Lamb, also called *The Ghent Altarpiece* because it is in the cathedral of Saint Bavon in the Belgian city of Ghent (figs. **14.69**, **14.70**, **14.71**, and **14.72**). Jan worked on the altarpiece with his brother Hubert, who died in 1426, a year into the project. Six years later, Jan completed the altarpiece on his own. Although it is not entirely clear which brother was responsible for which parts, Jan is credited with the final product. The altarpiece is a **polyptych** (many-panelled painting), its sections held together by hinges. There are twenty panels in all, twelve inside (visible when open) and eight outside (visible when closed).

Van Eyck refined the medieval technique of oil painting to such a degree that the brilliant glow of his light and color took on a symbolic character consistent with the iconography of his works. He mixed pigment with linseed oil, which he built up through several layers into a rich, but translucent, paint surface. By using tiny brushes, he was able to apply minute dabs of paint that seem to replicate details of the material world. Medium and content thus combine to create a new synthesis in which both form and technique become significant.

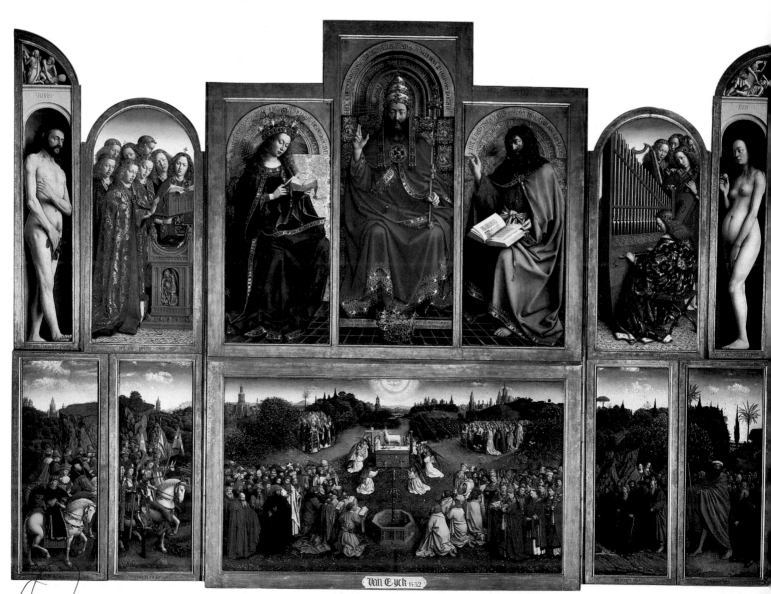

14.69 Jan van Eyck, *The Ghent Altarpiece* (open), completed 1432. Oil on panel, approx. 11 ft 6 in × 14 ft 5 in (3.5 × 4.4 m). Cathedral of Saint Bavon, Ghent, Belgium.

14.70 (above) Jan van Eyck, *The Ghent Altarpiece* (detail of Cathedral of Saint Bavon in fig. 14.69).

14.71 Jan van Eyck, *The Ghent Altarpiece* (detail of God's crown in fig. 14.69).

14.72 Jan van Eyck, *The Ghent Altarpiece* (closed), approx. 11 ft 6 in × 7 ft 7 in (3.5 × 2.33 m).

Figure 14.69 shows *The Ghent Altarpiece* opened. *The Adoration of the Lamb by All Saints*, the lower central scene, occupies the largest panel. Its literary source is a passage from the Book of Revelation, which was read on All Saints' Day (November 1). The Lamb, which is the symbol of Christ's sacrifice, stands on an altar, its blood dripping into a gold chalice. A fountain, the *fons vitae*, stands before the altar. Water pours forth from the font, symbolically washing away the sins of the worshiper celebrating Mass before the altar in Saint Bavon.

Above the altar, rays of light emanate from the semicircle around the dove of the Holy Spirit, and extend toward the crowds of worshipers. At the right are the twelve apostles and a group of martyrs in red robes, and at the

left are figures from the Old Testament and pagan antiquity considered by the Church to have merited salvation. In the background a group of confessors wearing blue robes congregates at the left, with virgin martyrs at the right. They carry palms, signifying the triumph of martyrdom over death. The far distance glows with minute landscape details and the skyline of a city (including a view of Saint Bavon Cathedral—fig. 14.70) evoking the Heavenly Jerusalem.

On the side panels, worshipers are shown still traveling to the site of the altar. Just judges (representing the power of Christendom) and knights approach on horseback at the left, and holy hermits and pilgrims on foot at the right. The Altar of the Lamb is both the formal focus of the altarpiece and the destination of the travelers. When they arrive at the open field, they stop. When they reach the altar and the fountain, they kneel in adoration, their movement arrested by the holy sight.

The upper register contains seven additional panels. God the Father, merged with the Christ of the Last Judgment and the **Deësis** (see Vol. I, fig. 9.49), occupies the largest space on this level. He sits in a frontal pose and raises his right hand in the manner of Judgment, but is flanked by the Virgin and John the Baptist as in the *Deësis*. The Virgin is crowned Queen of Heaven, and Saint John wears a green robe over his hair shirt. On either side of these figures are music-making angels in elaborate brocade cloaks juxtaposed with the nude Adam to the left and Eve to the right.

The representation of God/Christ is a good example of hieratic scale. His importance is indicated by his central position, his height, his frontality, and his regal gestures and accoutrements. The elaborate crown at his feet accentuates his kingly role, and also links him with the semicircle of light in *The Adoration of the Lamb*. Figure 14.71 shows the detail of the crown, and the exquisite embroidery on the cloak. The minute depiction of the jewels set in the crown and its gold tracery is characteristic of Flemish taste. Here, however, the rich materials also have a symbolic meaning, for they belong to the personage who embodies the power of the Christian universe. Despite the frontality of the God/Christ figure, he is set in three-dimensional space. The grid pattern in the floor, like that in the panels of the Virgin and John the Baptist, is composed of orthogonals, although van Eyck's perspective is never as mathematically precise as in Italian paintings. All three figures appear to occupy a unified space, but are separated by the frames of their individual panels.

Adam and Eve stand in the narrow end panels, depicted illusionistically as stone niches. Above Adam and Eve are painted imitation sculptures (representing Cain's Offering and the Murder of Abel). Van Eyck's Adam and Eve provide an instructive contrast to those by Masaccio (see fig. 14.27) in the Brancacci Chapel. The latter are derived from the more idealized forms of Classical antiquity, whereas van Eyck's are more specific, as if painted from live models, and more Gothic. They are somewhat elongated and their physiognomy is portrait-like.

Figure 14.72 shows *The Ghent Altarpiece* closed. The central lower panels contain representations of John the Baptist holding a lamb (left), and John the Evangelist holding a chalice (right). Both, like the Cain and Abel, are painted in **grisaille**. Their prominence in the altarpiece is directly related to its commission and iconography. Saint Bavon Cathedral was originally the church of Saint John, dedicated to John the Baptist, and remained so in the fifteenth century. John the Evangelist was the author of the visionary Book of Revelation, and hence wrote the text celebrated in the interior scenes. Kneeling on either side of the saints are the donors, Jodocus Vijd, an official of Ghent, and his wife Isabel Borluut, who commissioned the altarpiece for their private chapel. They are identified by an inscription on the frame. Although set in a cubic space, with a single source of light (from the right), the architectural framework around these figures is the typical Gothic **trefoil**.

In the upper panels, too, the floor tiles and the distant cityscape reveal van Eyck's knowledge of linear perspective. But the pointed arch of the niche containing the wash basin betrays the predominance of Gothic taste in the north. Represented in these panels is *The Annunciation*. Gabriel arrives from the left carrying the lilies of Mary's passion and purity. His words are painted in gold and seem to travel across the picture plane from his mouth to Mary's ear. She inclines her head, and turns from her book to receive Gabriel's message. The position of the written words refers to the medieval tradition that Mary was impregnated through her ear. Her crossed arms and the cruciform shape of the Holy Spirit remind viewers of the Crucifixion.

The figures in the small panels at the top confirm the typological intent of the altarpiece. At the ends are two Old Testament prophets and, in the center, two sibyls, the female seers of Classical antiquity. As a whole, the iconography of *The Ghent Altarpiece* encompasses a vast time span. On the exterior, we are reminded that both the Old Testament prophets and the pagan seers were interpreted as having foretold the coming of Christ. The Annunciation marks the New Dispensation, while the two Saints John frame Christ's earthly mission—John the Baptist, who identified Christ to the multitudes and baptized him, and John the Evangelist, the author of one of the Gospels. The presence of the donors situates the time and place of the altarpiece itself in fifteenth-century Flanders.

Inside the altarpiece, the scenes encompass an even greater time span. Adam and Eve refer to the beginning of human time. Mary and John the Baptist mark the life of Christ, which is celebrated by the music-making angels. The lower scenes take Christ's temporal life into the realm of ritual—his sacrifice and rebirth—and therefore into timelessness. Although Christ himself never actually appears, except merged with the figure of God, every aspect of the iconography alludes to his presence. Even the little scenes of Cain and Abel refer to Christ's death, for Abel was the first biblical victim, and thus typologically paired with Christ.

Man in a Red Turban A year after van Eyck completed *The Ghent Altarpiece*, he painted the *Man in a Red Turban* (fig. **14.73**). It is widely believed to represent himself, which would make it one of the first individual self-portraits of the Renaissance. The depiction of the turban reveals the artist's delight in the angular folds and their rich red color. In contrast to the expansive flourishes of the turban, van Eyck's own meticulously defined features betray the strain of an artist concentrating on his work. His lips are thin and drawn, while the corners of his piercing eyes are covered with slight wrinkles. At the top is a text in semi-Greek letters, painted to look as if it is carved into the picture frame. It reads "Als Ich Kan," which are the first words of a proverb meaning "As I can, but not as I would."

The Arnolfini Wedding Portrait Jan van Eyck's so-called *Arnolfini Wedding Portrait* of 1434 (fig. **14.74**) is a unique subject in western European art. A great deal has been written about this picture and scholars have proposed

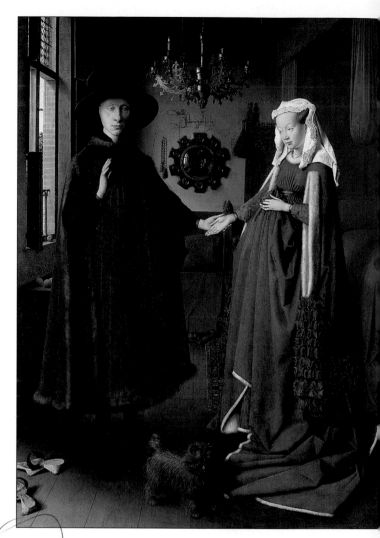

14.74 Jan van Eyck, *The Arnolfini Wedding Portrait*, 1434. Oil on wood, 32¼ × 23½ in (81.9 × 59.7 cm). National Gallery, London. Giovanni Arnolfini, a rich Italian merchant who lived in Flanders, exemplifies the cultural and economic ties that existed between Italy and northern Europe. He commissioned van Eyck to make a pictorial record of his marriage to Giovanna Cenami.

14.73 Jan van Eyck, *Man in a Red Turban (Self-portrait ?)*, 1433. Tempera and oil on wood, approx. 13⅛ × 10⅛ in (33.3 × 25.8 cm). National Gallery, London. Van Eyck worked in The Hague as painter to John of Bavaria, and in Bruges for Philip the Good, Duke of Burgundy. He also received commissions from private individuals, often in collaboration with his brother Hubert until the latter's death in 1426. Jan was a master of the oil medium. He used alternating layers of transparent glaze and opaque tempera to produce his characteristic effects of light and shade.

numerous interpretations of it (see Box). There is, however, general agreement about the basic elements of the painting, if not about the overall intentions of the patron and artist.

The couple, Giovanni Arnolfini and Giovanna Cenami, stand in a bedroom, holding hands, in formalized poses. In their costume, each individual fabric and texture—for example, the fur, the lace, the gold and leather belt—is convincingly portrayed. The two pairs of shoes on the floor indicate that, while this is a bedroom, it is also a sacred space (compare this with the removal of the king's shoes on holy ground in the Egyptian *Palette of Narmer*, Vol. I, figs. 4.2–4.3). At the same time, the scene contains several references to the woman's potential fertility. She holds her drapery in a way that suggests pregnancy. The seemingly casual positioning of pieces of fruit on the chest

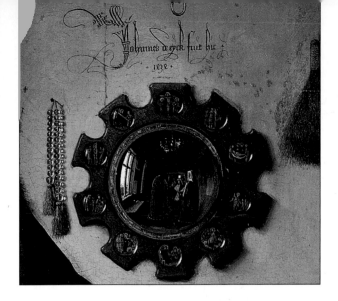

14.75 Detail of the mirror in fig. 14.74. Convex mirrors were popular in homes before the development of full-length mirrors in Europe around 1500. Because they reflect a large area, they were used by shopkeepers (as they still are today) to detect pilfering. As such, they were the "eyes" of owners who wanted to guard their possessions. Van Eyck's mirror has therefore been interpreted, in Christian terms, as God's eye witnessing the marriage ceremony.

and window sill denote natural abundance; and the little wooden statue on the headboard of the bed represents Saint Margaret, patron of women in childbirth. The dog, whose prominence in the foreground is surely meaningful, signifies fidelity, though it can also have erotic associations.

As in Campin's *Annunciation*, almost every household detail in *The Arnolfini Wedding* has Christian significance. The single candle burning in the chandelier, for example, can refer to Christ's divine presence, and also stands for the traditional marriage candle that brides brought to the bridal chamber. Once a marriage was consummated, the flame was snuffed. The most controversial detail in this painting is the convex mirror on the back wall of the bedroom (fig. **14.75**). It is surrounded by ten small circles, each of which contains a scene of Christ's Passion. Reflected in the mirror are figures observing the ceremony from a door in front of the couple—the human witnesses. One of the figures is Jan van Eyck himself. He has, in fact, documented his own presence twice, both as a reflection

The Arnolfini Wedding Portrait: Art Historical Methodology

As van Eyck's picture has been interpreted in so many ways, it provides a good example of the potential for applying different methodological approaches to a single work. In 1934, the German scholar Erwin Panofsky read the painting as a marriage certificate, and its signature as proof that the artist was a witness to the wedding. This reading identifies the tiny figure wearing red and blue reflected in the mirror as the artist's self-portrait. Panofsky's methodology also includes the iconographic method, for it explicates the underlying symbolic "text" of individual motifs.

Later historians have considered the social and economic context of the painting, questioning whether it represents a wedding at all. One argues that van Eyck signed the picture as a notary would sign a legal document. Another consideration is the picture's relation to the position of women as pawns in arranged marriages, and its function as part of a contract. As it happens, the feminist aspect of such a reading is reinforced by a formal analysis. The bride, for example, is shorter than her husband, and bows her head before him. He is more upright, literally an "upstanding" character whose verticality is accentuated by the gesture of his right hand. With his left, he "takes" the woman, whose open right hand is a sign of her receptivity.

The painting invites additional approaches. One could consider a post-structuralist reading based on the Roland Barthes of *Camera Lucida*, and the question of the photographic "being there" versus the painted fiction. Aside from the issue of whether van Eyck's self-portrait appears in the mirror is the fact of his signature *over* the mirror, *as if* he were there, stating in fact that he *was* there. The same problem arises in regard to the couple. If we were to see a photograph of them standing in the same room, we would know (or think we know) that the camera had recorded an actual "being there." But van Eyck could have painted the couple from memory, or from sketches, and then placed them in the room for purposes of the painting, having nothing to do with the outside world.

Enter the Deconstruction of Jacques Derrida, and the opening up of closed systems, to ask "how do we *know* van Eyck was there at the wedding?" He could have lied, like the author who writes a Preface after he has finished the book, but locates it structurally as if it had preceded the text.

A psychoanalytic reading of *The Arnolfini Wedding* might consider the image as a primal scene, which is the child's view (seen or imagined) of how adults create children. The picture is, after all, set in a bedroom, complete with a man and a woman, a bed, and allusions to childbirth (Saint Margaret), fertility (the fruit), and pregnancy (the position of the bride's dress). One reference to the gaze of the curious child is the mirror—sometimes read as the eye of God—which draws the viewer's gaze into a depth beyond the wall. The ambivalence of the mirror in that context—simultaneously looking *out* at us, extending our vision, and also recording the space from which we "as witnesses" view the painting—corresponds to the ambivalence of the child witnessing the forbidden primal scene.

A psychoanalytic reading would also add a level of meaning to the dog—traditionally a sign of lust, or fidelity, or both—which can represent the child's identification with animals that has enriched many a toy manufacturer. In van Eyck's painting, the dog is a reversal, that is, instead of looking *at* the couple and/or the bed, he looks at *us* looking at them. His riveted gaze is displaced from the primal scene to its audience, and also replicates that of the child who confronts the act by which he himself is created.

and by his signature. Above the mirror he has written on the wall in Latin, in an elaborate script usually reserved for legal documents, "Johannes de eyck fuit hic," or "Jan van Eyck was here," and added the date, 1434. Van Eyck's presence as both witness and artist recalls the traditional parallel between God, as Creator of the universe, and the mortal artist, who imitates God's creations in making works of art.

Van der Weyden

The third great Flemish painter of the first half of the fifteenth century was Rogier van der Weyden (c. 1399–1463), the official painter of Brussels, who had been trained in the Tournai workshop of Robert Campin. His figures are typically larger in relation to their spatial setting than van Eyck's. They seem to enact monumental dramas as if on a narrow stage that brings them close to the picture plane.

The Descent from the Cross Rogier's *Descent from the Cross* (fig. **14.76**) of around 1435 illustrates a theme imbued with emotional content that became popular in fifteenth-century Flemish art. The event takes place in a tight, cubic space, whose association with the Church building is suggested by the Gothic tracery at the four upper corners. Ten harshly illuminated figures are crowded inside the space. The heavy, angular draperies of the two Marys and Saint John are somewhat relieved by the brocade robe and red stockings worn by Joseph of Arimathea (the patron saint of embalmers and grave diggers), who is directly behind Christ. The figures create a series of long, flowing curves that unite them within the compressed, structured setting. Christ's horizontal S-shape form echoes the Virgin's. Both are supported by figures in countervailing S-shapes, which are arranged in vertical planes. The diagonal pull from Christ's bowed head to Mary's limp right arm is anchored between Saint John's bare foot and Adam's skull—the latter an ironic reminder that the Crucifixion takes place over his grave.

Mary's pose echoes Christ's, indicating her emotional and physical identification with his suffering and death. Her empathic response reflects the power of contemporary religious movements, especially prominent in northern Europe, that strove for mystical communion with the simplicity of Christ's life and message. The most influential spokesman for this sentiment in the early fifteenth century was

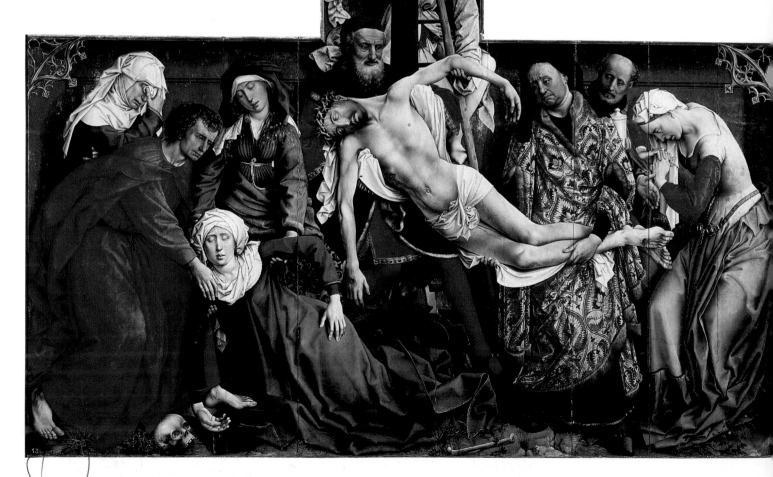

14.76 Rogier van der Weyden, *The Descent from the Cross*, c. 1435–38. Oil on wood, 7 ft 2⅝ in × 8 ft 7⅛ in (2.19 × 2.65 m). The Prado, Madrid.

the German cleric Thomas à Kempis (1380–1471). He is credited as the author of *The Imitation of Christ*, written around 1420, which advocates spiritual merger with Christ through self-denial and prayer. The work emphasizes the abject wretchedness of mortal sinners, in contrast to the sweet purity of Christ.

Saint Luke Painting the Virgin Rogier creates an altogether different mood in *Saint Luke Painting the Virgin* (fig. **14.77**) of around the same year as the *Descent*. Here, figures with specific personalities occupy a perspectival architectural setting. Through the open wall of the room, the observer joins the two Flemish figures seen in back view, in looking beyond the distant city toward the horizon. Figures, landscape, and architecture diminish abruptly in size, creating the illusion of great distance. At the same time, the elaborate patterns continue the tradition of International Gothic in Flanders.

Mary and Christ, whose proportions depart more from the Classical ideal than their Italian counterparts, constitute an insightful psychological depiction of the mother–child relationship. Christ is contained within

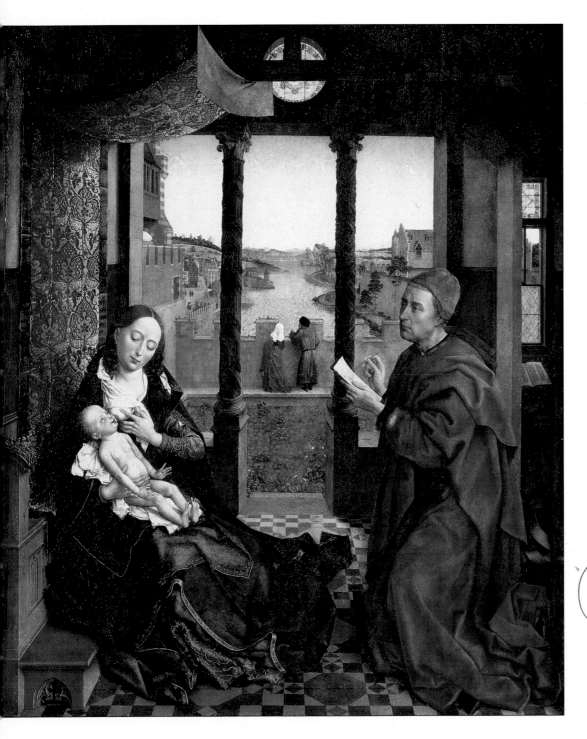

14.77 Rogier van der Weyden, *Saint Luke Painting the Virgin*, c. 1435–40. Oil and tempera on panel; panel 4 ft 6⅛ in × 3 ft 7⅝ in (1.38 × 1.11 m). Courtesy of the Museum of Fine Arts, Boston. Gift of Mr. and Mrs. Henry Lee Higginson.

Mary's voluminous form. He is framed by the white cloth underneath him, which links him with Mary's proffered breast and its white cloth. As Mary looks down at Christ, Christ gazes up at her. His physical pleasure in breastfeeding is revealed by his upturned toes and extended fingers.

A pervasive subtext of this painting is the psychology of the gaze and its relationship to the artist's eye. Just as the observer is drawn to the river flowing towards the horizon, so Saint Luke gazes at Mary and Christ, and Mary and Christ gaze at each other. Symbolically looking back at the viewer from the wall over the open space between the columns is the "eye of God," implied by the round window. In contrast to the open space in the wall, which is uninterrupted by glass, the round window is somewhat opaque, as if "returning our gaze," and watching the watchers in the painted room.

The specific physiognomy of Saint Luke has led to the suggestion that he is a self-portrait of Rogier. His slightly wrinkled forehead, intense gaze, poised stylus, and posture reveal a physical tension that could well be autobiographical. There are no records of this painting's commission. However, it may have been painted for an artists' guild, since Saint Luke was the patron saint of artists and tradition had it that he had actually drawn the Virgin during her lifetime. The identification of himself with the patron saint of his own profession would have been a logical one for Rogier to make.

Later Developments

Hugo's *Portinari Altarpiece* The *Portinari Altarpiece*, a triptych of c. 1476 by Hugo van der Goes (c. 1435/40–82) is an example of later fifteenth-century painting in Flanders (fig. **14.78**). It was commissioned for the Church of Sant'Egidio in Florence by the Italian Tommaso Portinari, who was the Medici bank's representative in Bruges. The central panel represents Mary, Joseph, shepherds, and angels adoring the newborn Christ, who lies on the ground surrounded by a glow of light. In the distance, at the upper right, an angel announces Christ's birth to the shepherds.

Hugo's colors are deeper and richer than those of van Eyck. Certain details, such as the vases of flowers in the foreground, express the typical Flemish taste for endowing everyday objects with specific Christian meaning. The vase at the left, for example, contains flowers that denote Christ's royal nature, as well as his purity and passion. The grapes and vinescrolls on the surface of the vase allude to the wine of the **Eucharist** and to Christ as the Church (cf. "I am the vine"). Behind the vases is a sheaf of wheat, the placement of which nearly parallels that of the infant Christ. This refers to his institution of the Eucharist at the Last Supper, when Christ proclaimed the wine his blood and the bread his body.

The glass container at the right is penetrated by light as Mary was impregnated by God's divine light and became the vessel of Christ. It holds three types of flowers—red

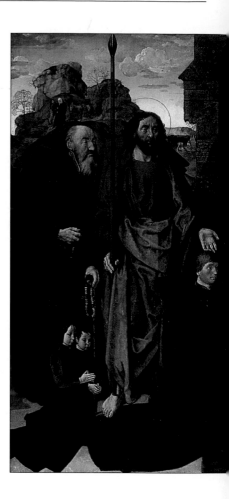

14.78 Hugo van der Goes, *Portinari Altarpiece* (open), c. 1476. Oil on wood, central panel 8 ft 3½ in ×10 ft (2.53 × 3.05 m). Galleria degli Uffizi, Florence. This is Hugo van der Goes' only documented picture. In 1475 Hugo entered the monastery of the Red Cloister near Brussels as a lay brother. But his fellow monks accused him of being too worldly, because of his artistic success. He suffered several episodes of depression, and in 1481 tried to commit suicide. Contemporary rumor attributed his depression to disappointment because he had failed to produce works as good as van Eyck's *Ghent Altarpiece*.

carnations (symbolizing pure love), and violets and columbines (symbolizing Mary's suffering and humility). The particular arrangement and iconography of the vases, wheat, and flowers, and their formal relationship to Christ, reveal the liturgical implications of Hugo's image and its relation to the enactment of the Eucharist in its actual setting in a church.

In the background, David's harp on his palace refers to Mary's descent from the "House of David." In the shed, the ox looks up and observes the event taking place before him, while the ass keeps on munching. This indifference to the birth of Christ on the part of the ass became associated with heretics and non-believers who failed to recognize Christ as the Savior. Just to the right of the ox and ass, gazing out from the shadows, is a demon whose presence has been identified as connoting the Incarnation as a means of foiling Satan's plans for the world.

Compared to van Eyck, Hugo's style, at least in this altarpiece, conveys a sense of tension and anxiety. This is particularly true of the shepherds at the right of the central panel, whose grimacing faces and frantic gestures reflect their eagerness and wonder before Christ. They form part of a circle of figures whose excitement is revealed by the variety of praying gestures and angular, animated draperies. The tension is somewhat muted in the side panels, where members of the donor's family kneel in front of their patron saints. The children in the

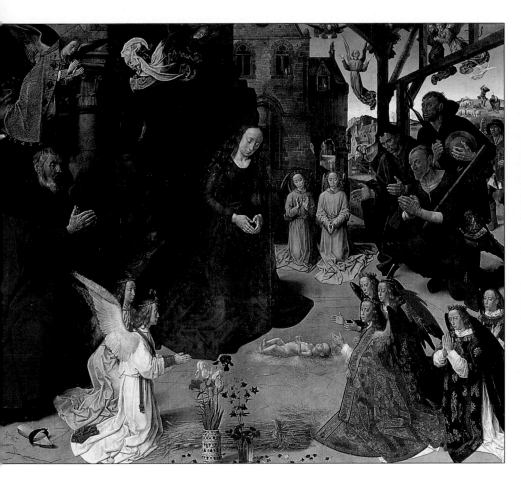
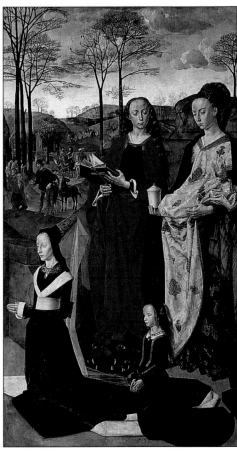

family group are the first in Flemish art to have facial features suitable for their age. By depicting the family members as so much smaller in scale than the saints, however, Hugo creates an oddly irrational juxtaposition.

Whether the tensions in this painting are a result of the artist's personal conflicts or a reflection of contemporary stylistic developments is difficult to determine. Most likely, a combination of factors was at work. In any case, it is Hugo's greatest surviving work. In 1483 it was sent to Florence, where it was greatly admired, and its influence on Italian artists during the latter part of the fifteenth century was considerable.

Ghirlandaio's *Adoration of the Shepherds* Most of all, the *Portinari Altarpiece* impressed Domenico Ghirlandaio (1449–94), who was the leading Florentine painter at the close of the fifteenth century. His most important commissions were for the Tornabuoni (in-laws of the Medici) and Sassetti families, both wealthy bankers. The two fresco cycles he painted for them are unique in the large numbers of family members represented as taking part in the sacred events. His *Adoration of the Shepherds* (fig. **14.79**) was for the altar in the Sassetti Chapel, in Santa Trinità, which was decorated with scenes from the life of Saint Francis, the name saint of Francesco Sassetti.

Ghirlandaio's *Adoration* is clearly related to Hugo's, and would attest the commercial and artistic ties between Italy and Flanders, even if they were not independently documented. Nevertheless, Ghirlandaio's mood is different from that of his northern inspiration, and his proportions are more Classical. The shepherds at the right are rustic individuals with craggy physiognomies like those in the *Portinari Altarpiece*, but they do not exhibit the signs of agitation or mental disturbance suggested by those of Hugo van der Goes. Their nature corresponds to the relaxed atmosphere of the picture as a whole, and also to its naturalism. Both the ox and ass gaze in a friendly manner on Christ. The third shepherd points to Christ while turning to talk with the man praying.

In contrast to the tension exhibited in the *Portinari Altarpiece*, Ghirlandaio's painting is relaxed and seemingly casual. Joseph, for example, turns as if to watch the procession winding around the hill. There is also, in the Ghirlandaio, an emphasis on physical, tactile warmth, which is lacking in the van der Goes. This can be seen in the way the lamb appears to touch the shepherd's head, the ox's horn to caress the ass's forehead, and Joseph's left hand to rest on the rim of the sarcophagus. Whereas the *Portinari* Christ lies flat on the ground, isolated and separated from human contact, Ghirlandaio's Christ sucks his thumb, lies on his mother's extended drapery, and rests his feet on it.

This painting is both a summation of certain fifteenth-century humanist concerns and a synthesis of Classical

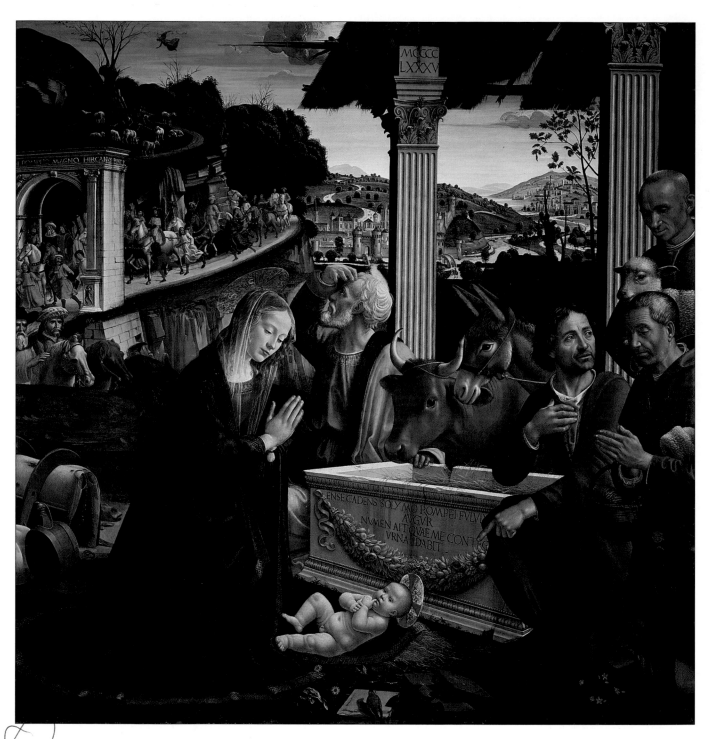

14.79 Domenico del Ghirlandaio, *Adoration of the Shepherds*, 1485. Panel, 65¼ in (165.7 cm) square. Sassetti Chapel, Santa Trinità, Florence.

innovations with remnants of the International Style. Ghirlandaio's attention to the details of landscape, the distant town, and the elegantly attired crowd traveling to adore Christ, all appealed to popular taste. The rules of linear perspective are strictly followed in the diminishing size of figures and landscape. Finally, Ghirlandaio has incorporated a Classical sarcophagus and Classical archi-

tecture into the Christian scene. Two Corinthian pilasters stand behind the Adoration; the one on the left is inscribed with the date of the painting, 1485. The inscription on the sarcophagus identifies its occupant as one who will be resurrected, and the garland implies victory over death. Likewise, the Roman arch on the road ironically marks the triumph of Christianity over paganism.

Style/Period	Works of Art	Cultural/Historical Developments
THE EARLY RENAISSANCE 1410	1st century A.D.: The *Medici Venus* (14.28) Brunelleschi, *The Sacrifice of Isaac* (14.3) Ghiberti, *The Sacrifice of Isaac* (14.4)	Invention of scientific perspective (C. 1400)
1410–1415	Donatello, *Saint Mark* (14.33)	Founding of St. Andrews University, Scotland (1411) Thomas à Kempis, *Imitatio Christi* (1414) England under Henry V defeats France at Agincourt (1415)
1420–1430 **Masaccio, *Saint Peter***	Brunelleschi, Hospital of the Innocents (14.8), Florence Gentile da Fabriano, *The Procession and Adoration of the Magi* (14.30) Ghiberti, *The Gates of Paradise* (14.17–14.20) Masaccio, *The Holy Trinity* (14.23–14.24) Masaccio, Brancacci Chapel frescoes (14.25–14.27, 14.29) Campin, *Mérode Altarpiece* (14.67–14.68)	Itzcoatl, king of the Aztecs, enlarges his empire (1427)
1430–1440 **Donatello, *David***	Uccello, *Chalice* (14.15) Donatello, *David* (14.34–14.35) Uccello, *Sir John Hawkwood* (14.47) van Eyck, *The Ghent Altarpiece* (14.69–14.72) van Eyck, *Man in a Red Turban* (14.73) van Eyck, *The Arnolfini Wedding Portrait* (14.74–14.75) van der Weyden, *Saint Luke Painting the Virgin* (14.77) van der Weyden, *The Descent from the Cross* (14.76) Brunelleschi, Florence Cathedral dome (14.5) Pisanello, *Paleologus medal* (14.21–14.22) Juvayni, *Kuyuk the Great Khan* (14.32)	Joan of Arc burned at the stake (1431) Cosimo de' Medici becomes ruler of Florence (1434) Leon Battista Alberti, *On Painting* (c. 1435) **van Eyck, *Man in a Red Turban***
1440–1450	Fra Angelico, San Marco frescoes (14.54) Brunelleschi, Santo Spirito (14.10), Florence Donatello, *Gattamelata* (14.49–14.50) Rossellino, Tomb of Leonardo Bruni (14.2) Castagno, *Famous Men and Women* (14.45–14.46)	First record of the suction pump (1440) Eton College and King's College, Cambridge, founded (1441) Cosimo de' Medici founds Biblioteca Medicea Laurenziana, Florence (1444)
1450–1460 **Piero della Francesca, *The Flagellation***	Castagno, *The Youthful David* (14.43) Piero della Francesca, Arezzo frescoes (14.53, 14.55–14.57) Alberti, Rucellai Palace (14.37), Florence Alberti, Tempio Malatestiano (14.39), Rimini de' Pasti, Tempio Malatestiano medal (14.40) Donatello, *Mary Magdalen* (14.64) Castagno, *Niccolò da Tolentino* (14.48)	Francesco Sforza becomes Duke of Milan (1450) Vatican Library founded (1450) Gutenberg prints Bible at Mainz (1453–5) Turks capture Constantinople; end of Byzantine Empire (1453) End of Hundred Years' War between England and France (1453) Turks conquer Athens (1456)
1460–1480 **Mantegna, *Camera degli Sposi***	Piero della Francesca, *The Flagellation* (14.11) Verrocchio, *David* (14.44) Piero della Francesca, *Duke and Duchess of Urbino* (14.51–14.52) Alberti, Sant'Andrea (14.41), Mantua Mantegna, *Camera degli Sposi* frescoes (14.58–14.60) Botticelli, *Mars and Venus* (14.62) van der Goes, *Portinari Altarpiece* (14.78)	Erasmus of Rotterdam, humanist (1465–1536) First printed music (1465) Lorenzo de' Medici, "the Magnificent," rules Florence (1469–92) Nicolaus Copernicus, European astronomer (1473–1543) William Caxton prints first book in English (1474) Medici family become bankers to the papacy (1476) Revival of Inquisition in Spain (1478) Union of Aragon and Castile under Ferdinand and Isabella; birth of the Spanish state (1479)
1480–1500 **Botticelli, *Birth of Venus***	Leonardo, *Adoration of the Magi* study (14.14) Botticelli, *Birth of Venus* (14.63) Ghirlandaio, *Adoration of the Shepherds* (14.79) Wu Wei, *The Pleasures of Fishing* (14.31) Mantegna, *Parnassus* (14.61) Mantegna, *Dead Christ* (14.16) Botticelli, *Mystical Nativity* (14.65)	Richard of Gloucester claims English throne as Richard III (1483) Diaz rounds Cape of Good Hope (1486) Leon Battista Alberti, *On Architecture* (1485) Spain finances voyage of Columbus to New World (1492) Muslims lose Granada, their last stronghold in Spain (1492) Charles VIII of France invades Italy (1494–9) François Rabelais, French writer (1494–1553) Imperial Diet opens in Worms (1495) Cabot reaches east coast of North America (1497) Severe famine in Florence (1497) Savonarola burned at the stake in Florence (1498) Vasco da Gama discovers sea route to India (1498)

15

The High Renaissance in Italy

The High Renaissance in Italy was an age of great accomplishments in Western art which occurred in the late fifteenth century and the first half of the sixteenth (fig. **15.1**). The term "High" that is used to designate this period reflects the esteem in which it is generally held.

Politically, the High Renaissance was a period of tension and turbulence. Foreign invasions and internal conflicts produced upheaval and instability. The French invaded northern Italy and sacked Milan. The Medici were expelled from Florence in 1494, and the fervent Dominican, Savonarola, was executed only four years later. Although the Medici were reinstated in 1512, their political style was autocratic. Eighteen years later Florence would come under the sway of the Hapsburg dynasty.

Florence remained an important artistic center, but it no longer provided the primary impetus for creative activity. Rome, meanwhile, under the control of ambitious popes, succeeded Florence as the artistic center of Italy. Pope Julius II (1503–13), determined to expand his political and military power, was also an enlightened humanist. In terms of patronage of the arts, Julius made perhaps the greatest contributions to the High Renaissance. His successor, Leo X (1513–21), continued the patronage of major painters, sculptors, and architects, but the artistic achievements of the period were not matched by political success. In 1527 the Holy Roman Emperor, Charles V, invaded Italy and sacked Rome.

Although many important artists helped to lay the foundations of the High Renaissance in the first three-quarters of the fifteenth century, the period itself is dominated by a relatively small number of powerful artistic personalities. Those considered in this chapter are Leonardo da Vinci, Bramante, Michelangelo, Raphael, Giorgione and Titian. In the section on Venice, several precursors of the High Renaissance are also discussed.

Leonardo (1452–1519) succeeded Alberti as the embodiment of the "universal Renaissance man," or *uomo universale*. He painted only a small number of pictures, but also worked as a sculptor and architect, and wrote on nearly every aspect of human endeavor, including the arts and sciences. Bramante (c. 1444–1514), Raphael (1483–1520), and Michelangelo (1475–1564), all of whom were influenced by Leonardo, received their training in Milan, Umbria, and Florence, respectively, but achieved their greatest success in Rome. In Venice, the High Renaissance was dominated by Giorgione (c. 1477–1510) and above all by Titian (c. 1485–1576), whose life was long and productive. Of these six, only Titian and Michelangelo lived beyond the year 1520, when new artistic styles began to emerge and the short period of the High Renaissance came to an end.

15.1 Map of leading art centers in Renaissance Italy.

Architecture

The Ideal of the Circle and Centrally Planned Churches

An important architectural ideal that preoccupied many artists and writers on art from the fifteenth century through the High Renaissance was the centrally planned church building. It was based on the ancient notion that the circle is the ideal shape. As early as the Neolithic era, **cromlechs** (see Vol. I, p. 44) such as Stonehenge in England reflect the sacred significance of circular structures. Plato, writing in the fourth century B.C., considered the circle to be the perfect geometric form, associating it with divinity. In the Near Eastern cultures and Byzantium, belief in the divine property of the circle was reflected in the churches and mosques, the domed ceilings of which symbolized heaven. Domed buildings also had royal and mortuary associations. Examples of the latter are the *tholos* tombs of the Aegean (see Vol. I, figs. 5.26–5.27), and the round plan typically used for *martyria* in Greek, Early Christian, and Byzantine architecture (see Vol. I, figs. 9.11–9.13). Churches whose plans are based on the Greek

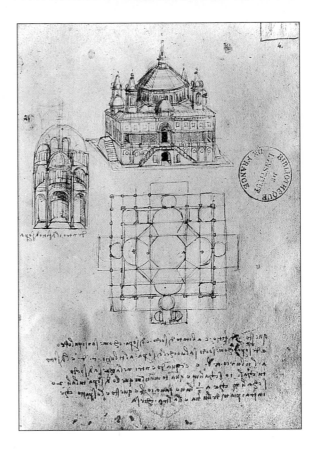

15.3 Leonardo da Vinci, church resembling the Holy Sepulcher in Milan, Ms. 2184 fol. 4r. Pen and ink. Institut de France, Paris. The octagonal plan in this drawing is composed of eight geometric shapes arranged in a circle. Leonardo left thousands of notebook pages with such drawings accompanied by explanatory text.

cross (see Vol. I, fig. 9.9) are also centralized, in contrast to the longitudinal design of the Latin cross and the basilican plan of the Early Christian church. The divine associations of the circle persisted through the European Middle Ages, recurring, for example, in the huge **rose windows** of the Gothic cathedrals (see Vol. I, fig. 12.31).

In fifteenth-century Italy, the circular ideal was an aspect of the humanist synthesis of Classical with Christian thought. It was also related to the new interest in the direct observation of nature. Alberti, for example, noted that in antiquity temples dedicated to certain gods were round, and he connected the divinity of the circle with round structures in nature. He wrote in his treatise on architecture that "Nature delights primarily in the circle," as well as in other centrally planned shapes such as the hexagon. In support of this view, Alberti observed that all insects create their living quarters in hexagonal shapes (the cells of bees, for example). Further, Alberti and other fifteenth-century architects followed Vitruvius (see Vol. I, p. 190) in relating architectural harmony to human symmetry. Temples, according to Vitruvius, required symmetry and proportion in order to achieve the proper relation between parts that is found in a well-shaped man (fig. **15.2**).

Leonardo da Vinci seems to have followed these principles when devising his own projects for churches. From the 1480s, during his stay in Milan, Leonardo designed domed, centrally planned churches (fig. **15.3**). Although these designs were never executed, Leonardo influenced the older architect Donato Bramante, who moved from

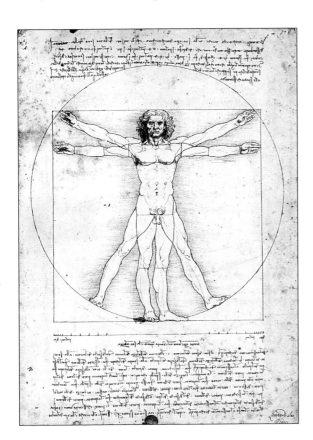

15.2 Leonardo da Vinci, *Vitruvian Man*, c. 1485–90. Pen and ink, 13½ × 9⅝ in (34.3 × 24.5 cm). Galleria dell'Accademia, Venice. This drawing illustrates the observation made by Vitruvius that, if a man extends his four limbs so that his hands and feet touch the circumference of a circle, his navel will correspond to the center of that circle. Vitruvius also drew a square whose sides were touched by the head, feet, and outstretched arms of a man.

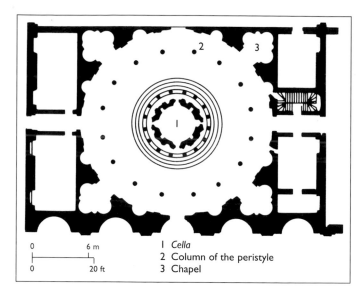

I *Cella*
2 Column of the peristyle
3 Chapel

15.5 (above) Donato Bramante, Plan of the Tempietto with projected courtyard, after 16th-century engraving by Sebastiano Serlio. From the geometrical center of the *cella*, equidistant lines can be drawn to each column of the peristyle, just as they can from the navel of Leonardo's *Vitruvian Man*, which lies at the center of a circle.

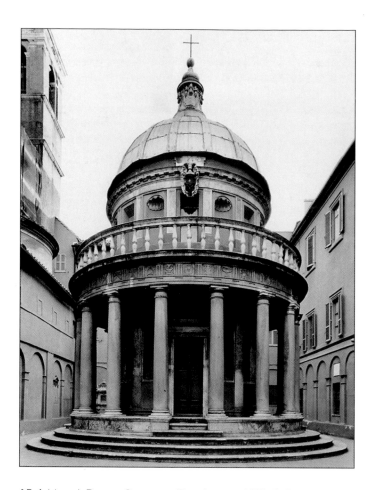

15.4 (above) Donato Bramante, Tempietto, c. 1502–3. San Pietro in Montorio, Rome. The Tempietto ("Little Temple" in Italian) was a small *martyrium* commissioned by King Ferdinand and Queen Isabella of Spain and erected in Montorio, Rome, shortly after 1500. It stood on the purported site of Saint Peter's crucifixion. The hole in which Saint Peter's cross supposedly stood marked the center of a chamber below the round *cella*. In the *cella* itself, just above the hole, stood a single altar.

Milan to Rome when the French invaded Milan in 1499. Bramante's Tempietto of San Pietro in Rome fulfills the ideal of the round building (fig. **15.4**). The exterior, sixteen-column **Doric peristyle** supports a Doric frieze (see Vol. I, fig. 6.31) and a shallow **balustrade**. Above the peristyle is a drum surmounted by a ribbed, hemispherical dome. In selecting Doric columns and a Doric frieze, Bramante conformed to Vitruvius's view that an order should correspond to the god to whom the temple was dedicated. Doric, according to Vitruvius, was suitable for the active male gods—a category consistent with Saint Peter's hot-tempered nature. Finally, Bramante adopted the practice, also dating back to antiquity, of treating a building as one massive block of stone with openings and spaces carved out of it. This has been referred to as the **sculptured wall motif.**

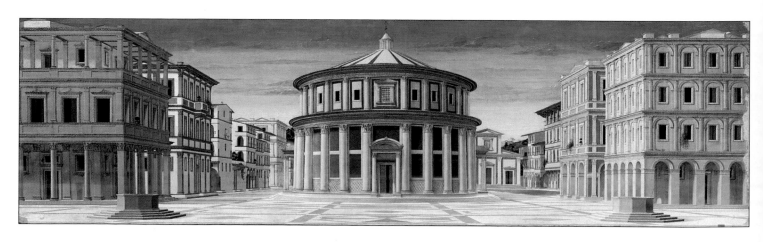

15.6 Sometimes attributed to Piero della Francesca or his circle, *Painting of an Ideal City*, mid-15th century. Panel painting, 79 × 23½ in (200.7 × 59.7 cm). Palazzo Ducale, Urbino. A circular building occupies the center of the composition. By implication it is the navel of the ideal city. The rectangular buildings surrounding it differ in size and type, but all have the symmetrical, geometrical quality that is a feature of Renaissance architecture. This painting has also been attributed to Luciano Laurana, who worked for Federico da Montefeltro at the court of Urbino.

The relatively small interior of the Tempietto meant that very few people could enter it at once, so it was probably intended to be appreciated more from the outside. The building now stands in a rather constricted place, but Bramante's original ground plan, as recorded in a sixteenth-century engraving (fig. **15.5**), placed it in the middle of a circular, arcaded enclosure. The enclosure was itself inscribed in a square with a tiny chapel in each corner.

Centrally planned buildings were clearly regarded as key elements in Renaissance urban architecture, as can be seen in the *Painting of an Ideal City* (fig. **15.6**). Another example is the circular building in Raphael's *Betrothal of the Virgin* (fig. **15.7**). Like Bramante's Tempietto, it has steps leading to a round **cella**, and is crowned by a drum supporting a dome and lantern, though the peristyle of Raphael's building has

round arches on Ionic columns. Raphael has emphasized the geometric symmetry of his structure by placing it at the center of the top half of the picture plane. Because the composition is symmetrical and constructed according to a one-point perspective system, the vanishing point can be readily located by extending the short sides of the pave-

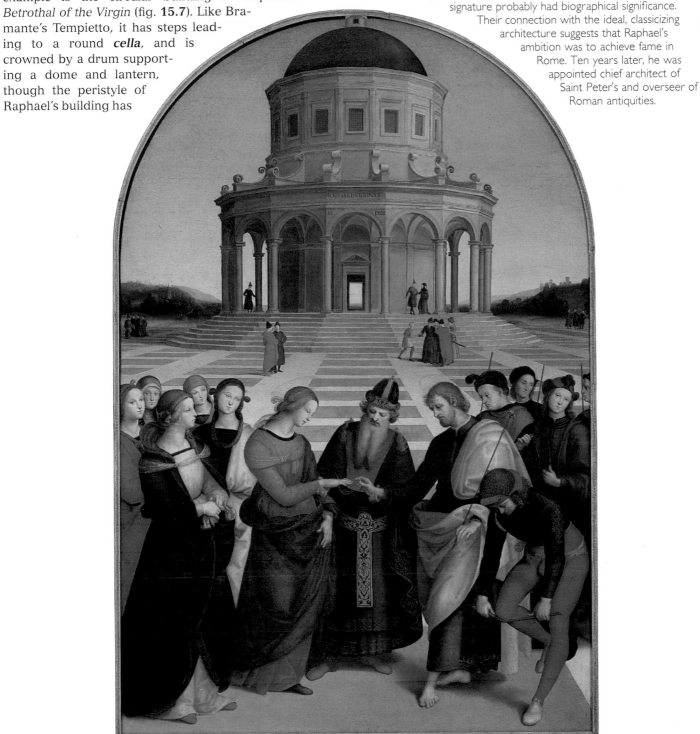

15.7 Raphael, *Betrothal of the Virgin*, 1504. Oil on wood, 5 ft 7 in × 3 ft 10½ in (1.70 × 1.18 m). Pinacoteca di Brera, Milan. This painting is signed "Raphael of Urbino" and dated "1504," when the artist was twenty-one. The prominence and location of both date and signature probably had biographical significance. Their connection with the ideal, classicizing architecture suggests that Raphael's ambition was to achieve fame in Rome. Ten years later, he was appointed chief architect of Saint Peter's and overseer of Roman antiquities.

ment tiles into the central space of the open door. The fact that Raphael's vanishing point is directly above the ring that Joseph is about to place on Mary's finger integrates the painting's geometry with its iconography.

Saint Peter's and the Central Plan

Bramante and Raphael arrived in Rome within a few years of each other. The Tempietto established Bramante as Rome's leading architect, a position from which he acted as Raphael's mentor. In 1503 Julius II (see Box) became pope and immediately set about recreating the ancient glory of imperial Rome. As part of his plan, Julius decided that the basilica of Saint Peter's, by then over a thousand years old and in bad condition, would have to be rebuilt. He gave the commission to Bramante who, by 1506, had designed a complex plan (fig. **15.8**). Bramante's design for the New Saint Peter's was notable for its size. It was 550 feet (167.6 m) long, making it the largest church in history; in fact a sizeable church could be accommodated in each of its four wings. Bramante also envisaged a large semicircular stepped dome above a relatively shallow drum. This conception was recorded in a medal of 1506 (fig. **15.9**), which shows the smaller domes surmounting the chapels. From the front, the viewer would have seen the two towers flanking the massive, symmetrical façade. The

Julius II: Humanist Pope

Julius II, one of the greatest humanist popes (1503–13), was born Giuliano della Rovere in 1443, the nephew of Sixtus IV. His patronage of the arts endorsed mythological as well as Christian subject-matter, and encouraged their Neoplatonic synthesis. He added to the manuscripts in the Vatican Library, and launched the papal collection of Greek and Roman sculpture. The artists he employed—Bramante, Raphael, Michelangelo—were, without question, the geniuses of their age. Julius was also a man of secular ambition, and for this he was admired by Machiavelli. He restored the power and influence of the Papal States, successfully administered the papal finances, maneuvered legal and financial reforms for papal advantage, and advocated missionary activity in the newly discovered Americas.

central portion would have been a unified alternation of domes and porticoes that was inspired by the design of the Pantheon. It is also likely that, as in the Pantheon, Bramante's large drum would have been of concrete.

In 1506 the foundation stone of the New Saint Peter's was laid, and seven years later Pope Julius II died. Bramante himself died in 1514, but had arranged for Raphael to succeed him as the new architect of Saint Peter's. By the time of Raphael's death in 1520, little had been achieved beyond the demolition of the old basilica and the construction of the four great piers at the crossing.

In 1546, the task was entrusted to Michelangelo, then aged seventy-two. He decided to retain the underlying concept of a huge dome resting on four piers, but simplified Bramante's complex spatial arrangements (fig. **15.10**). As a result of Michelangelo's changes, work proceeded quickly, and at his death in 1564, Saint Peter's was nearly finished except for the dome. Despite the succession of architects who contributed to the New Saint Peter's, the final result (figs. **15.11** and **15.12**) retained the original central Greek cross plan, with the addition of a nave to form a Latin cross. The dome's profile is slightly pointed—following Michelangelo's design—and small double columns soften the projection of the **buttresses**. Vertical ribs and a high lantern create a greater degree of verticality than in Bramante's original design.

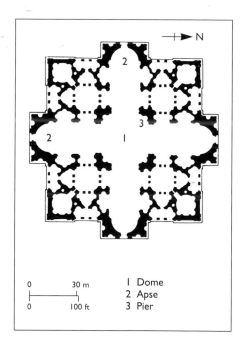

15.8 (above) Donato Bramante, plan for the New Saint Peter's, Vatican, Rome, 1505. Bramante's plan is centrally planned, with four arms of a Greek cross ending in semicircular apses. A central, semicircular dome, larger than that of the Pantheon, would cover the central crossing. Between the arms of the cross would be four smaller, cross-shaped units, surmounted by smaller domes, and four tall towers. This plan is strictly symmetrical and follows the "sculptured wall" concept.

0	30 m	1 Dome
		2 Apse
0	100 ft	3 Pier

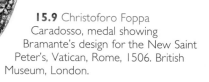

15.9 Christoforo Foppa Caradosso, medal showing Bramante's design for the New Saint Peter's, Vatican, Rome, 1506. British Museum, London.

15.10 (right) Michelangelo, plan for the New Saint Peter's, Vatican, Rome, c. 1537–50. Michelangelo reduced the area of the floor by eliminating the smaller cruciform units (except for their domes), the corner towers, and the individual ambulatories of the apses. He also simplified Bramante's proposed exterior by introducing a colossal order of pilasters topped by a cornice, and an attic high enough to conceal the smaller interior cupolas.

15.11 (far right) Plan for the New Saint Peter's as built to Michelangelo's design with additions by Carlo Maderno, 1606–15 (see also fig. 18.5).

15.12 (below) New Saint Peter's, Vatican, Rome, view from the south.

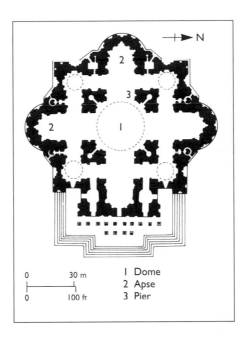

1 Dome
2 Apse
3 Pier

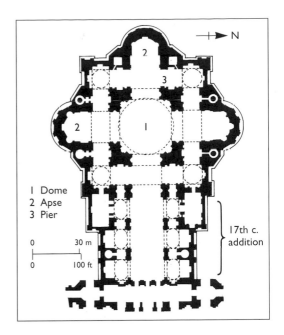

1 Dome
2 Apse
3 Pier

17th c. addition

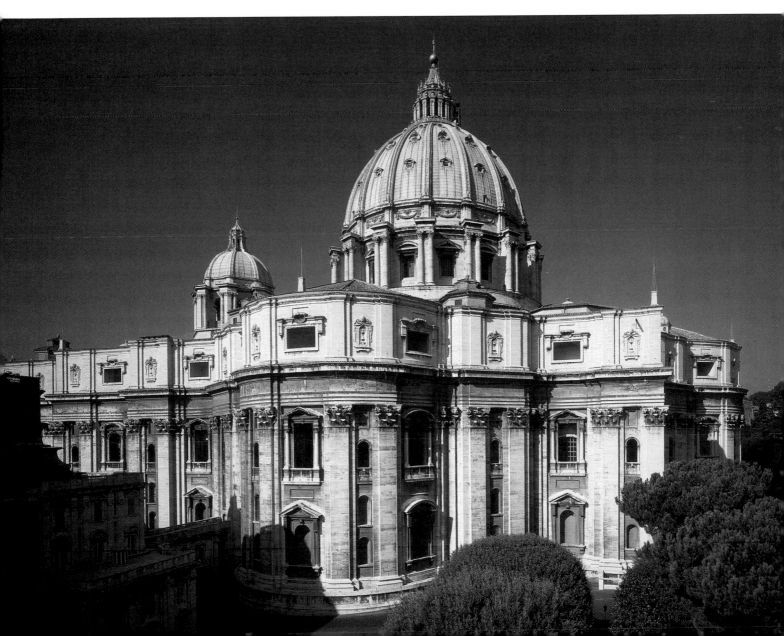

Painting and Sculpture

Leonardo da Vinci

Scientific Drawings Leonardo's numerous anatomical drawings illustrate the Renaissance synthesis of art and science. Among the most intriguing are his studies of fetuses in the womb (fig. **15.13**). In the main image, Leonardo depicts an opened uterus, a fetus in the breech position, and the umbilical cord. A smaller drawing to the right depicts the fetus as if seen through the amniotic membrane. Other drawings illustrate the systems by which the fetus is linked to the mother's blood supply.

Such drawings, apart from demonstrating his superb draughtsmanship, reflect Leonardo's obsessive interest in the origins of life and in discovering scientific explanations for natural phenomena. The thousands of studies, covering virtually every aspect of scientific and artistic endeavor, contrast strikingly with the unusually small number of finished paintings by his hand. Leonardo's artistic nature may thus be characterized as investigative, preliminary, and experimental. Only rarely did he actually complete a work and deliver it to a patron.

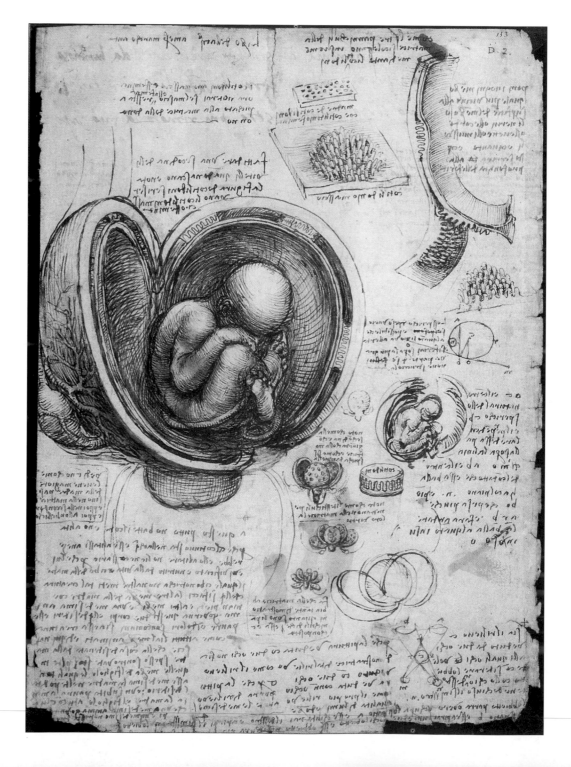

15.13 Leonardo da Vinci, *Embryo in the Womb*, c. 1510. Pen and brown ink, 11¾ × 8½ in (29.8 × 21.6 cm). Royal Collection, Windsor Castle, Royal Library, © 1990 Her Majesty Queen Elizabeth II. Many Renaissance artists studied human anatomy, but Leonardo went far beyond the usual artistic concern with musculature, and studied the digestive, reproductive, and respiratory systems. He apparently intended to collect his anatomical drawings into a treatise, but never completed the project. His script runs from right to left and must be read in a mirror. To date there is no generally accepted explanation for this curious "mirror writing."

Paintings Leonardo's earliest known painting is the angel at the far left of Verrocchio's *Baptism of Christ* (fig. **15.14**). Verrocchio was a prominent sculptor (see p. 511), but he ran a workshop in Florence that produced paintings as well. Leonardo entered Verrocchio's workshop as an apprentice when he was in his early teens. The presence of his angel in the master's painting conforms to the practice of allowing pupils to work on peripheral figures. Even at this early stage of Leonardo's career, however, his remarkable talent is obvious. His angel is rendered in three-quarter view from the back, and shows Leonardo's command of convincing, sculpturesque drapery. In contrast to the craggy forms of Christ and John the Baptist, Leonardo has given his angel smooth features bathed in a golden light. Compared with Verrocchio's angel, Leonardo's is suffused with a distinctive softness. In particular, the blond curls have a fluffy quality, rather than the precisely delineated curls of Verrocchio's angel.

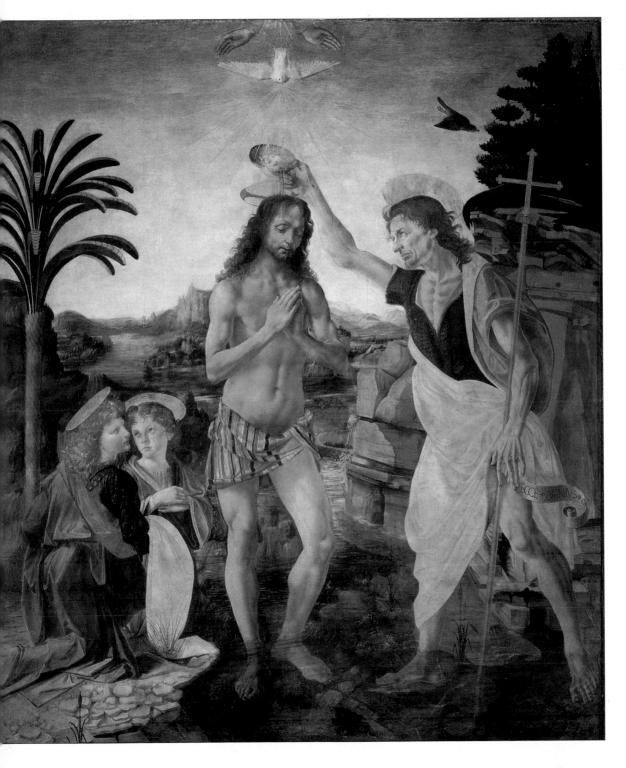

15.14 Andrea Verrocchio, *The Baptism of Christ*, c. 1470. Oil on panel, 69½ × 59½ in (1.77 × 1.51 m). Galleria degli Uffizi, Florence. A popular anecdote related that when Verrocchio saw the genius of Leonardo's angel, he realized that he could never emulate it. As a result, he renounced painting and devoted himself entirely to sculpture.

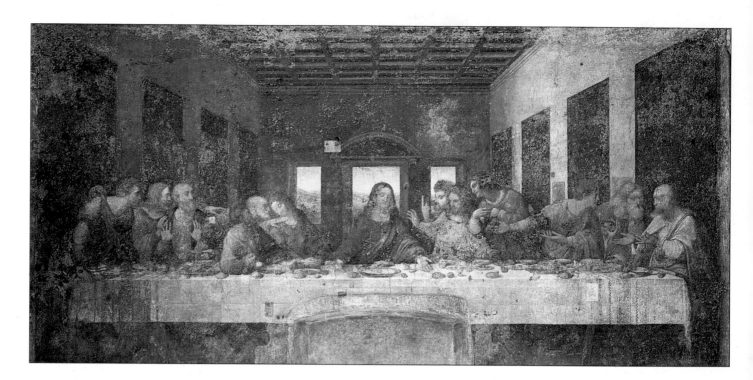

15.15 Leonardo da Vinci, *The Last Supper*, refectory of Santa Maria delle Grazie, Milan, c. 1495–8. Fresco (oil and tempera on plaster), 15 ft 1⅛ in × 28 ft 10½ in (4.6 × 8.56 m). Leonardo's experimentation had negative as well as positive results. Because of his slow, deliberate working methods, he could not keep pace with the speed required by the *buon fresco* technique. He seems to have applied a mixture of oil and tempera to the dry plaster. Sadly, the fusion between pigment and plaster was imperfect, and the paint soon began to flake off the wall. What we see today is a badly damaged painting, which has undergone several stages of restoration—and is still being restored.

Leonardo's single most important mature work is his great mural of *The Last Supper* (fig. **15.15**) of around 1495 to 1498. Despite its poor condition, *The Last Supper* has become an icon of Christian painting and one of the most widely recognized images in Western art. Its success as an image comes from Leonardo's genius in conveying character, capturing a significant narrative moment, and integrating these qualities with an imposing and unified architectural setting.

The painting fills a short wall of what was the refectory, or monastery dining room, of Santa Maria delle Grazie in Milan. The opposite wall had previously been decorated with a fresco of the Crucifixion to remind the monks of the connection between the Eucharist and Christ's Passion. Like Masaccio's *Holy Trinity* (see fig. 14.23), Leonardo's *Last Supper* is set within an illusionistic room receding beyond the space of the existing wall. But *The Last Supper* is above the eye level of the observer, and on a loftier plane—physically as well as spiritually—than the refectory itself.

Leonardo has represented the moment of Christ's announcement that one of his twelve apostles will betray him. Each apostle reacts according to his biblical personality. Saint Peter, whose head is fifth from the left, angrily grasps the knife with which he will later cut off the ear of Malchus. John, the youngest apostle and future evangelist, slumps toward Saint Peter in a faint. Thomas, the doubter, on Christ's left, points upwards, his gesture accented by the dark wall behind his hand. Judas, to the left of Saint Peter, is the villain of the piece. He leans back, forming the most vigorous diagonal away from Christ. In placing Judas on the same side of the table as Christ and the other apostles, Leonardo departs from the traditional scenes of the Last Supper, in which Judas is distinguished by location, rather than by pose and gesture. Here Judas is the only apostle whose face is in darkness—a symbol of the evil that comes from ignorance and sin, or the absence of enlightenment.

The figures also play their part in the geometry of the composition. The twelve apostles are in four groups of three, echoing the four wall hangings on each side of the room and the three windows on the wall behind Christ. Christ forms a triangle, as he extends his arms forward across the table. His triangular form corresponds to the triple windows, and both allude to the three persons of the Trinity. The curved pediment over the central window functions as an architectural halo. Combined with the light background behind Christ's head, it acts as a formal reminder that Christ is the "light of the world." This aspect of Christ is reinforced in the perspective construction. The orthogonals radiate outward from his head, so Christ becomes the sun, or literal "light of the world," extending his "rays" to the world outside the picture.

The small area of landscape in the distance links Christ with nature, and connects the natural space with the architecture. Nature, as well as geometry, is an important

aspect of Leonardo's paintings. In the unfinished *Madonna and Child with Saint Anne* (fig. **15.16**), the underpainting of which remains visible, Leonardo arranges the figures to form a pyramid set in a landscape. The three generations, represented by Saint Anne (Mary's mother), Mary, and Christ, correspond to the triangulation of their formal organization. The triple aspect of time—past, present, and future—is also a feature of Leonardo's integration of geometry with landscape and narrative. In this painting, past combines with future to form the present image: the lamb and the tree refer forward in time to Christ's sacrificial death on the Cross.

Leonardo's original handling of *chiaroscuro* is more evident in the *Saint Anne* than in the badly damaged and over-restored *Last Supper*. The soft, yellowish light bathing the figures and the gradual shading characteristic of Leonardo's style endow both flesh and drapery with a degree of softness unprecedented in Christian art. The landscape is also softened by the mists of Leonardo's *sfumato* (see Box), which filter through the atmosphere. Furthermore, just as the figures in *The Last Supper* echo the architectural composition, so in the *Saint Anne* figures and landscape are interrelated. In particular, the atmospheric mist in the background filters through the veil covering Saint Anne's head. The angles of her veil and the strong zigzag thrust of her left arm, which creates another triangular form, repeat the rocky background. In this way, Leonardo depicts Saint Anne as if she is a metaphor of the landscape, and perhaps also the symbolic architectural foundation of the three generations in the painting.

The painting that epitomizes Leonardo's synthesis of nature, architecture, human form, geometry, and character is the *Mona Lisa* (fig. **15.17**). Vasari says that the portrait depicts the wife of Francesco del Giocondo (hence its nickname, *La Gioconda*, meaning "the smiling one"). The figure forms a pyramidal shape in three-quarter view, set within the cubic space of a loggia. The observer's point of view is made to shift from figure to landscape, and while Mona Lisa is seen from the same level as the observer, the viewpoint shifts upwards in the landscape. The light also shifts, bathing the figure in subdued, dark yellow tones and the landscape in a blue-grey mist. Compared to the landscape in Verrocchio's *Baptism*, the rocky background of the *Mona Lisa*, which is imaginary, has a hazier and more mysterious atmosphere.

The contrasts of viewpoint and light serve to distinguish the landscape from the figure.

Sfumato

Sfumato, an Italian word meaning "toned down" or, literally, "vanished in smoke," is a technique—used with particular success by Leonardo—for defining form by delicate gradations of light and shade. It is achieved in oil painting through the use of glazes, and produces a misty, dreamlike effect.

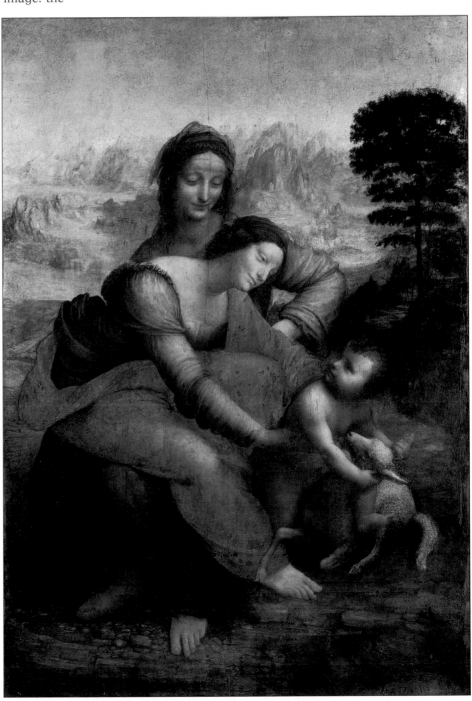

15.16 Leonardo da Vinci, *Madonna and Child with Saint Anne*, 1503–6. Wood panel, 5 ft 6⅛ in × 3 ft 8 in (1.68 × 1.12 m). Louvre, Paris.

At the same time, however, Leonardo has created formal parallels between figure and landscape. For example, the form of Mona Lisa repeats the triangular mountains, and her transparent veil echoes the filtered light of the *sfumato* mists. The curved aqueduct continues into the highlighted drapery fold over her left shoulder, and the spiral road on her right is repeated in the short curves on her sleeves. These, in turn, correspond to the line of her fingers.

Such formal parallels do not explain the mystery of the figure, whose expression has been the subject of songs, stories, poems, even other works of art (e.g. fig. 27.1). They do, however, illustrate Leonardo's own description, found in his notebooks, of the human body as a metaphor for the earth. He compares flesh to the soil, bones to rocks, and

15.17 Leonardo da Vinci, *Mona Lisa*, c. 1503–5. Oil on wood, 30¼ × 21 in (76.8 × 53.3 cm). Louvre, Paris. The enigmatic smile of the *Mona Lisa* is the subject of volumes of scholarly interpretation. Vasari says that Leonardo hired singers and jesters to keep the smile on her face while he painted. According to Freud, the smile evoked the dimly remembered smile of Leonardo's mother. Leonardo was unwilling to part with the picture, and took it with him to the court of Francis I of France, where he died in 1519. It then became part of the French royal collection and was later trimmed by about an inch on either side.

blood to waterways. This metaphorical style of thinking, which recurs in visual form throughout his paintings and drawings, is characteristic of Leonardo's genius.

Michelangelo di Buonarroti Simoni

Michelangelo, born near Arezzo, lived to be eighty-nine; his life is documented in contemporary biographies, comments on his personality and work, and from his own letters and sonnets. Like Leonardo, Michelangelo was an architect, painter and writer, although he thought of himself primarily as a sculptor.

Michelangelo's father vigorously opposed his wish to become a sculptor, but, when his son was thirteen, apprenticed him to Domenico Ghirlandaio (see p. 542). Michelangelo's talent was recognized before the age of sixteen by Lorenzo de' Medici, under whose patronage he studied sculpture and was exposed to Classical art and humanist thought. His style was formed in Florence well before he went to Rome to work for Julius II. His attraction to the most monumental of his Florentine predecessors is evident from his habit of visiting the Brancacci Chapel and making drawings of Masaccio's frescoes. Figure **15.18** shows Michelangelo's copy of Masaccio's Saint Peter paying the tax collector in *The Tribute Money* (see fig. 14.26). By studying and drawing Masaccio's work, the young Michelangelo absorbed the techniques of the older artist. In the drawing, Michelangelo has concentrated on the heavy draperies, which he darkens by dense cross-hatching. The jutting chin and the strong gesture of Saint Peter emphasize his anger at having to pay a tax, and also correspond to Michelangelo's own frequent outbursts of temper.

Early Sculpture Michelangelo's first great work of sculpture is the marble *Pietà* of 1498–1500 (fig. **15.19**), now located in Saint Peter's, which he carved in Rome for the tomb chapel of a French cardinal. A youthful Mary mourns the dead Christ, and both are contained within a pyramidal space and set on a circular base, reflecting the Renaissance synthesis of geometry and nature.

Mary and Christ are formally and psychologically interrelated, so that one hardly notices Christ's relatively small size compared with Mary's massive form. The zigzag of Christ's body blends harmoniously with the arrangement of Mary's legs and her voluminous drapery folds. Mary's left hand repeats the movement of Christ's left leg. She inclines her head forward as Christ's tilts back, and the slow curve of her drapery on the left is repeated by Christ's limp right arm. His right hand falls so that his fingers enclose and continue the prominent drapery curve between Mary's legs. In addition to the formal rhythms uniting Mary and Christ, Michelangelo makes them appear to be about the same age. He thus creates a powerful emotional and formal bond between the two figures who, though separated by death, will eventually be reunited, in Christian tradition, as king and queen of heaven. According to one report, when Michelangelo was

15.18 (above) Michelangelo, copy of Masaccio's Saint Peter in *The Tribute Money* (see fig. 14.26), 1489–90. Pen drawing, 12½ × 7¾ in (31.7 × 19.7 cm). Kupferstich Kabinett, Munich. According to Vasari and other contemporary accounts, Michelangelo regularly drew Masaccio's frescoes in the Brancacci Chapel. At one point, Michelangelo was sarcastic about a drawing by his fellow art student Torrigiano. In retaliation, Torrigiano punched Michelangelo, breaking and permanently flattening his nose.

15.19 (right) Michelangelo, *Pietà*, 1498/9–1500. Marble, 5 ft 8½ in (1.74 m) high. Saint Peter's, Vatican, Rome. Michelangelo's favorite material was marble, and he spent much time in the quarries selecting the right stone for his sculptures. This *Pietà* is his only signed work. The signature, carved in the band across Mary's chest, may be related to Michelangelo's comment that he imbibed the hammer and chisels of his trade with the milk of his wet nurse (the wife of a stonecutter).

asked about the age of the Virgin, he replied that her youthfulness was the result of her chaste character.

The other great statue of Michelangelo's youth is the marble *David* (fig. **15.20**). The little tree trunk supporting it is a reminder of the ancient Roman copies of Greek statuary and evokes the Classical past. Although both Michelangelo's *David* and Donatello's (see fig. 14.34) assume a *contrapposto* pose, the latter figure is relaxed whereas Michelangelo's is tense and watchful. He is represented at a moment before the battle, and so does not stand on the head of the slain Goliath. His creased forehead, and his strained neck and torso muscles, betray apprehension as he sights his adversary. Michelangelo's *David* is the most monumental marble nude since antiquity, its proportions corresponding more to Hellenistic than to Classical style. David's hands, in particular, are large in relation to his overall size, and his veins and muscles seem to bulge from beneath his skin.

Shortly after completing the *David*, Michelangelo was summoned to Rome by Pope Julius II to design his tomb. The project, probably intended for Old Saint Peter's, was designed as a monumental group of over forty statues. It is now in the church of San Pietro in Vincoli (Saint Peter in Chains), in Rome. The Pope's tomb and effigy were planned for the summit, but the project was never finished. Nevertheless, Michelangelo's great statue of *Moses*

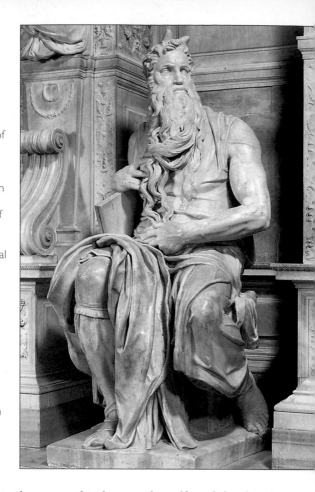

15.20 (left) Michelangelo, *David*, 1501–4. Marble, approx. 13 ft 5 in (4.09 m) high. Galleria dell'Accademia, Florence. In 1501 Florence commissioned a statue of David, the symbol of Florentine republicanism. For three years Michelangelo worked secretly on a huge and difficult block of marble over 14 ft (4.27 m) high. Originally destined for an exterior niche of the cathedral, the *David* was placed in 1504 in front of the Palazzo Vecchio (the government seat of Florence)—a more suitable location for a political sculpture. In 1873 the original was removed to the Accademia and a copy was put in its place.

15.21 (right) Michelangelo, *Moses*, c. 1513–15. Marble, 7 ft 8½ in (2.35 m) high. San Pietro in Vincoli, Rome. Michelangelo began work on the tomb of Julius II in 1505. Julius died in 1513, but left money for the completion of the tomb. Altogether, the project dragged on through six contracts and forty years.

(fig. **15.21**) forms part of what remains today. The work is Michelangelo at his most powerful. Moses turns angrily to glare at the Hebrews defying God's law and worshiping the golden calf. He has the Tables of the Ten Commandments under his right arm, indicating that he has recently descended from Mount Sinai. His disturbed state of mind is accentuated by the confusion in his long, flowing beard, the strands of which are caught up in the fingers of his right hand. The massive drapery folds framing his legs emphasize the suddenness of his spatial turn, and the bulging muscles and veins of his arms echo the force of his inner tension.

A unique aspect of Michelangelo's *Moses* is its departure from the biblical text. This point in the story appears in Exodus 32:19: "And it came to pass, as soon as he came

nigh unto the camp, that he saw the calf, and the dancing; and Moses' anger waxed hot, and he cast the tables out of his hands, and brake them beneath the mount." The *Moses* of Michelangelo does not break the Tables, but prevents them from falling by clutching them under his right elbow. More than one interpretation has been proposed for this detail. The most plausible identifies Julius II with the biblical Moses, both men of high intelligence who were nevertheless prone to outbursts of anger. Since Michelangelo himself had these qualities, the alteration of the biblical Moses to one who controls his rage in the interests of preserving the law invites comparison with the artist as well as with his patron.

Sistine Chapel Frescoes Before Michelangelo was able to finish the tomb complex, the Pope commissioned him to paint the ceiling of the Sistine Chapel in the Vatican (fig. **15.22**). The side walls had already been painted by fifteenth-century artists according to typological pairing, with Old and New Testament scenes on the left and right, respectively. Michelangelo considered himself a sculptor rather than a painter, and was initially reluctant to undertake the project. He finally agreed, however, designed the scaffold himself, and worked on the ceiling and the window lunettes from 1508 to 1512. Michelangelo's descriptions of the work dwell on the physical discomfort of having to contort his body in order to paint the ceiling. Over twenty years later, from 1536 to 1541, he painted the *Last Judgment* on the altar wall (see figs. **15.28** and **15.29**).

Figure **15.23** is a view of the frescoed ceiling from below. Figure **15.24** shows it in diagrammatic form. The

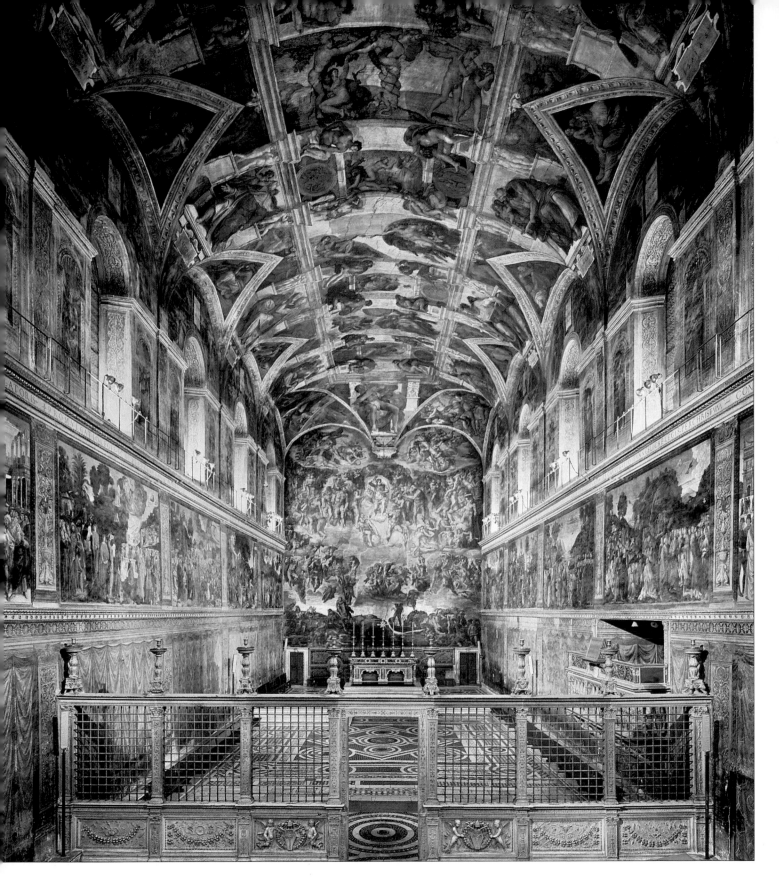

15.22 Michelangelo, Sistine Chapel, 1508–12. Vatican, Rome. This was the pope's personal chapel, and the site of the conclave that elected new popes. Its proportions are exactly the same as those of the Temple of Solomon—twice as long as it is high, and three times as long as it is wide. It was built in 1473 by Pope Sixtus IV, after whom it is named. Sixtus was the uncle of Julius II, both members of the Della Rovere family. Vasari believed that giving Michelangelo this commission was a plot engineered by Bramante to divert him from sculpture. Michelangelo accused Bramante of having let his rival, Raphael, into the chapel before the frescoes were finished. The purpose, according to Michelangelo, was so that Raphael could steal his style.

15.23 (pp. 560–561) Michelangelo, Ceiling of the Sistine Chapel, Vatican, Rome (before cleaning), 1508–12. Fresco, 5800 sq ft (538 m^2).

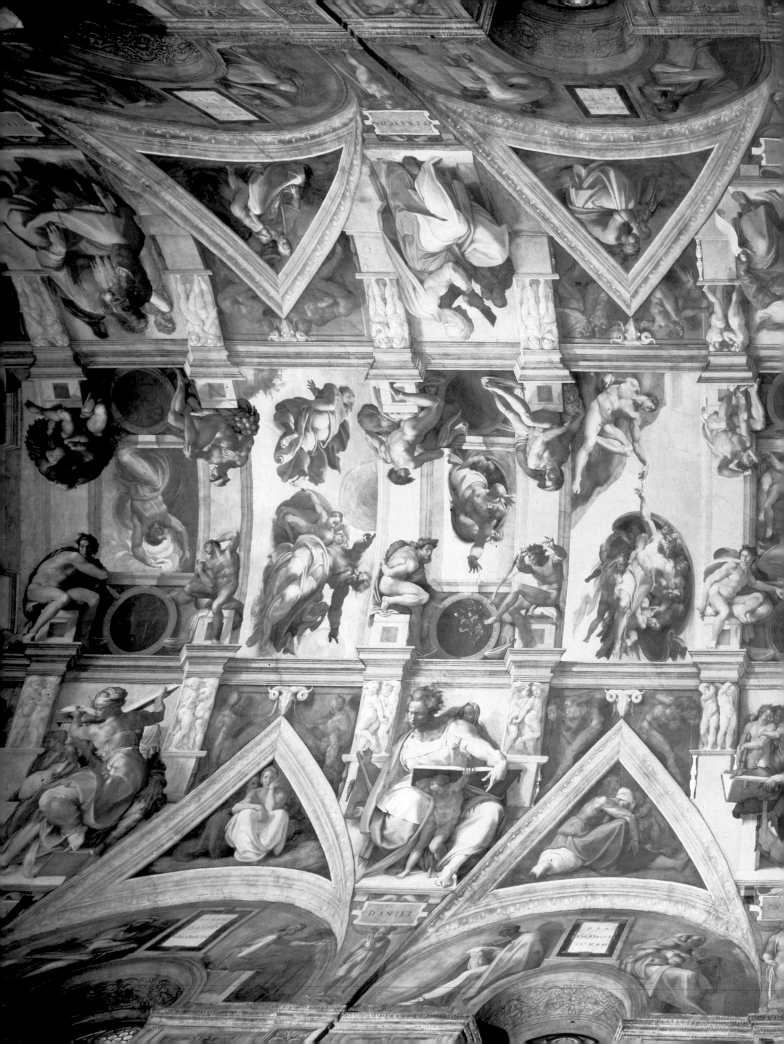

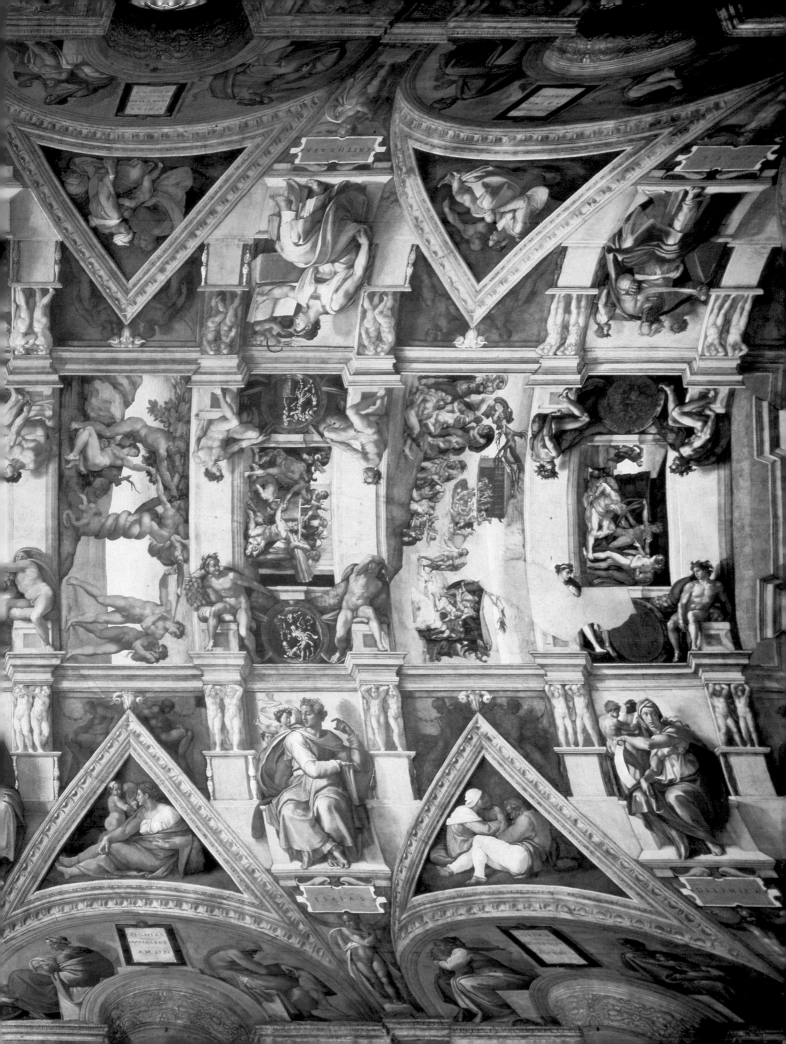

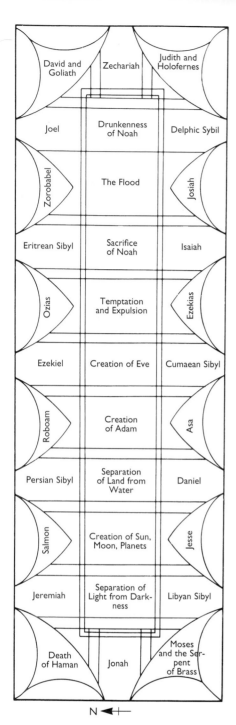

N ◄—+—

15.24 Diagram of scenes from the ceiling of the Sistine Chapel. The first three scenes represent God's creation of the universe, the second three, Adam and Eve, and the last three, Noah and the Flood. Each small scene is surrounded by four nudes (called **ignudi**) in radically twisted poses. In each corner of the ceiling, the **spandrels** (curved triangular sections) contain an additional Old Testament scene. The spandrels and lunettes above the windows depict the ancestors of Christ.

nine main narrative scenes in three sets of three occupy the center of the barrel vault. Michelangelo painted the scenes in reverse chronological order, ending with the three creation scenes, in which God orders the universe. The Adam and Eve scenes depict the Fall of Man, while the Noah scenes show both God's destructive power and his willingness to save the righteous. When viewers stand at the entrance opposite the altar wall, the ceiling scenes appear right-side up and are read beginning with the earliest creation scene at the greatest distance.

Although none of the figures or scenes on the Sistine ceiling is from the New Testament, they nevertheless have a typological intent, all referring in some way to the Christian future. The Old Testament prophets and the sibyls of antiquity, who are portrayed between the window spandrels, were viewed as having foretold the coming of Christ. The inclusion of Christ's ancestors in the spandrels and lunettes above the windows alludes to the divine plan, in which Christ and Mary redeem the sins of Adam and Eve.

In the *Creation of Adam* (fig. **15.25**), a monumental, patriarchal God extends dramatically across the picture plane. He is framed by a sweeping, dark red cloak containing a crowd of nude figures, including a woman (identified by some scholars as Eve), who looks expectantly over his left shoulder. In contrast to the vibrant energy of God, Adam reclines languidly on the newly created earth, for he has not yet received the spark of life from God's touch. Michelangelo's interest in landscape was minimal compared to his emphasis on the power inherent in the human body, especially the torso. Whether clothed or nude, Michelangelo's muscular figures, rendered in exaggerated *contrapposto*, are among the most monumental images in Western art.

The Fall of Man (fig. **15.26**), which combines the Temptation on the left with the Expulsion on the right, is clearly influenced by Masaccio, in particular by his

15.25 (below) Michelangelo, *Creation of Adam* (detail of fig. 15.23), 1510.

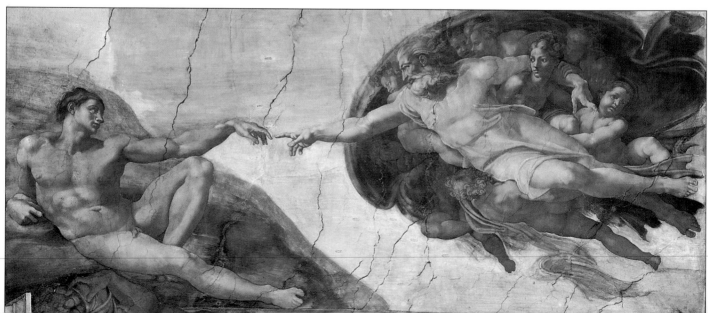

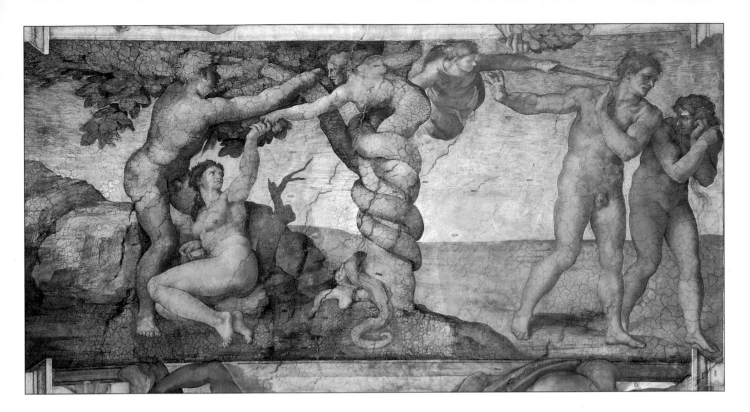

15.26 Michelangelo, *The Fall of Man* (detail of fig. 15.23), 1510.

Expulsion of Adam and Eve in the Brancacci Chapel (see fig. 14.27). Michelangelo follows Masaccio in painting the primal couple as powerful nudes. But there is less Classical restraint in Michelangelo's figures than in Masaccio's. In the Temptation scene, Michelangelo represents Eve in strong *contrapposto*. She twists around to take the forbidden fruit from a coiled, human-headed serpent. Adam's massive form looms over Eve from the left as he reaches up in an ambivalent gesture that simultaneously echoes and opposes the outstretched arm of the serpent. To the right of the tree, in the Expulsion, an angry, foreshortened Archangel Michael stabs at the back of Adam's neck as he expels the sinners from Paradise. Adam protests, a pained expression on his face, as he tries to repel the archangel's attack. Eve cowers at the far right, slinking away from the avenging angel and turning back, as if to avoid facing her future.

The centrality of the tree in this fresco is both a formal division between the two scenes and a symbolic reference to Christ's crucifixion. Formally, the long, curved branch on the viewer's left is paralleled by the curve of the archangel's extended arm. According to the Legend of the True Cross (see Vol. I, p. 372), this is the very tree that provided the wood for Christ's Cross. It is also a fig tree, associated in antiquity with fertility. But the leaves that we see above the archangel's arm are oak leaves, which were emblems of the Della Rovere family. In that motif, Michelangelo reminds views that his patron, Julius II, was a Della Rovere pope.

In the brooding figure of the prophet Jeremiah (fig. **15.27**), Michelangelo has created one of the most powerful images of inner absorption and melancholy in Western painting. Jeremiah's massive form hunches over, like Dürer's *Melencolia* (see fig. 17.15), his chin resting on his

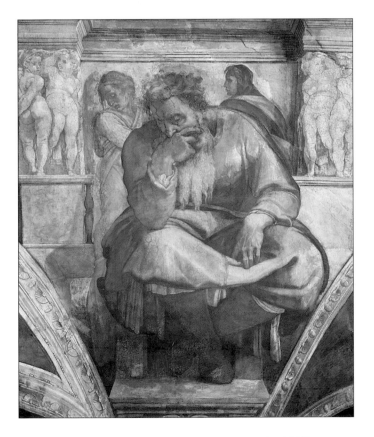

15.27 Michelangelo, *The Prophet Jeremiah* (detail of fig. 15.23). Jeremiah was a 7th-century B.C. Hebrew prophet known for his pessimistic despair over the fortunes of the Kingdom of Judah. The word **jeremiad**, meaning a "lamentation" or "doleful complaint," comes from his name. Here Jeremiah laments the destruction of Jerusalem. In Michelangelo's time, the Old Testament *Book of Lamentations* was attributed to Jeremiah, although now there are doubts about his authorship.

hand, and he barely seems contained within the painted space. Located beneath the first creation scene, Jeremiah sits on an illusionistic marble bench, between two pairs of caryatids in the form of *putti*.

Late Style When Michelangelo had completed the Sistine ceiling, he went back to Florence and worked for the Medici family. In 1534, on the order of Pope Paul III, he returned to Rome and began *The Last Judgment*, cov-ering the altar wall of the Sistine Chapel (fig. **15.28** and **15.29**). There has been a great deal of discussion about Michelangelo's late style. Some scholars consider that it marks the close of the Renaissance, while others prefer to see it as part of new Mannerist developments (see Chapter 16). Both views contain some truth, since Mannerist trends, which share certain characteristics of Michelangelo's late style, were well under way by the mid-sixteenth century. Nevertheless, *The Last Judgment* is

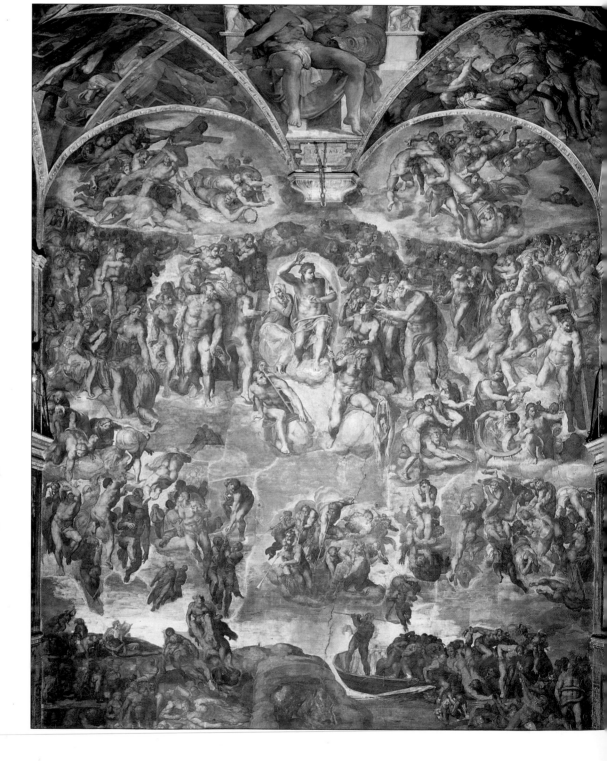

15.28 Michelangelo, *The Last Judgment* (before cleaning), fresco on altar wall of the Sistine Chapel, 1534–41. Vatican, Rome. Commissioned in 1534, *The Last Judgment* was completed in 1541, when Michelangelo was sixty-six. The effect on contemporary viewers was strong—and not always favorable. During Michelangelo's lifetime Pope Paul IV wanted to erase it and, after Michelangelo's death, loincloths and draperies were painted over the nude figures. Many of these have been removed in the recent cleaning.

considered here within the context of Michelangelo's style as it developed beyond the High Renaissance.

The picture is divided horizontally into three levels, which correspond roughly to three planes of existence. At the top is heaven; in the lunettes, angels carry the instruments of Christ's Passion—the crown of thorns, the column of the Flagellation, and the Cross. In the center, below the lunettes, Christ is surrounded by a glow of light. He raises his hand and turns toward the damned. Mary crouches beneath his upraised right arm, and crowds of saints and martyrs twist and turn in space, exhibiting the instruments of their martyrdom. In the middle level, at the sound of the Last Trump (blown by angels in the lower center), saved souls ascend toward heaven on Christ's right (our left), while the damned descend into hell on Christ's left. At the lowest level, the saved climb from their graves and are separated from the scene of hell on the lower right by a rocky river bank.

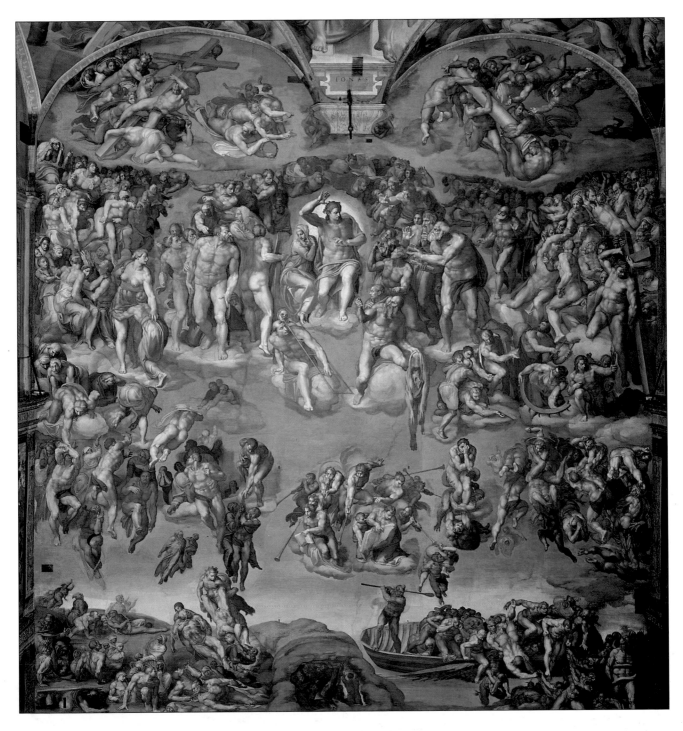

15.29 Michelangelo, *The Last Judgment* (after cleaning, 1990–4), Sistine Chapel.

15.30 Michelangelo, Saint Bartholomew with flayed skin (detail of fig. 15.29).

Michelangelo's hell is a new conception in Christian art. Unlike the medieval Hell of Giotto's Arena Chapel (see figs. 13.10–13.11), Michelangelo's draws on Classical antiquity. The boatman of Greek mythology, Charon, ferries the damned across the River Styx into Hades. At the far right corner, the monstrous figure of Minos has replaced Satan and is entwined by a giant serpent. In contrast to Giotto's *Last Judgment*, which, except for hell, is orderly, restrained, and clear, Michelangelo's is filled with overlapping figures whose twisted poses, radical *contrapposto* and sharp foreshortening energize the surface of the wall. In Giotto's conception, actual tortures are confined to hell. In Michelangelo's, tortuous movement pervades the whole work. That this mood reflects the artist himself, as well as the troubled times, is evident in the detail of Saint Bartholomew (fig. 15.30), the Christian martyr who was flayed alive. He brandishes a knife and displays a flayed skin containing Michelangelo's self-portrait.

Michelangelo's self-portrait also appears in the features of Christ in the unfinished *Rondanini Pietà* (fig. 15.31) in Milan. Michelangelo worked on this sculpture until six days before his death. The long, thin forms are strikingly distinct from the powerful, muscular, and energetic figures of his earlier sculptures. These figures have lost their boundaries—their merger is psychological as well as formal. Michelangelo's anxiety about completing this sculpture is revealed in his working and reworking, and in his removal of two figures originally intended as part of the group, leaving only the unfinished figures of Mary and Christ. The *Pietà* seems to have reflected Michelangelo's sense of his approaching death, and his identification with the suffering of Christ.

15.31 Michelangelo, *Rondanini Pietà*, c. 1555–64. Marble, 6 ft 5½ in (1.97 m) high. Castello Sforzesco, Milan.

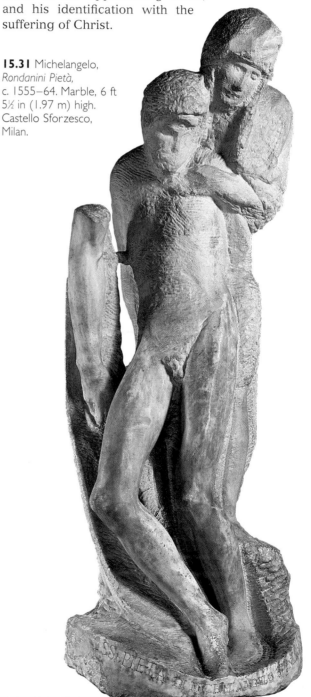

Raphael

Raphael (Raffaello Sanzio) was born eight years after Michelangelo, but died forty-four years before him. During his short life he came to embody the Classical character of High Renaissance style, assimilating the forms and philosophy of Classical antiquity and hiring scholars to translate Greek and Roman texts. Prolific and influential, he was primarily a painter, although it is clear from figure 15.7 and his appointment as overseer of the New Saint Peter's that his skills included architecture.

Raphael grew up at the humanist Urbino court, where his father, Giovanni Santi, was the official court poet and painter. At the age of eleven, he was apprenticed to Perugino, then the leading painter in Umbria. At the beginning of his independent career, Raphael worked in Florence, where he painted many versions of the Virgin and Child. The *Madonna of the Meadow* of 1505 (fig. **15.32**) is a good example of his clear, straightforward, classicizing style. Figures are arranged in the pyramidal form favored by Leonardo, though the landscape lacks the *sfumato* of Leonardo's mysterious backgrounds. Christ stands in the security of Mary's embrace, while John the Baptist, his second cousin and playmate, hands Christ the symbol of his earthly mission. Mary observes this exchange from above, recognizing that it means the future sacrifice of her son. In contrast to the ambiguities of Leonardo's iconography and the contorted, anxious figures of Michelangelo, Raphael's style is calm, harmonious, and restrained.

15.32 Raphael, *Madonna of the Meadow*, 1505. Oil on panel, 3 ft 8½ in × 2 ft 10¼ in (1.13 × 0.87 m). Kunsthistorisches Museum, Vienna.

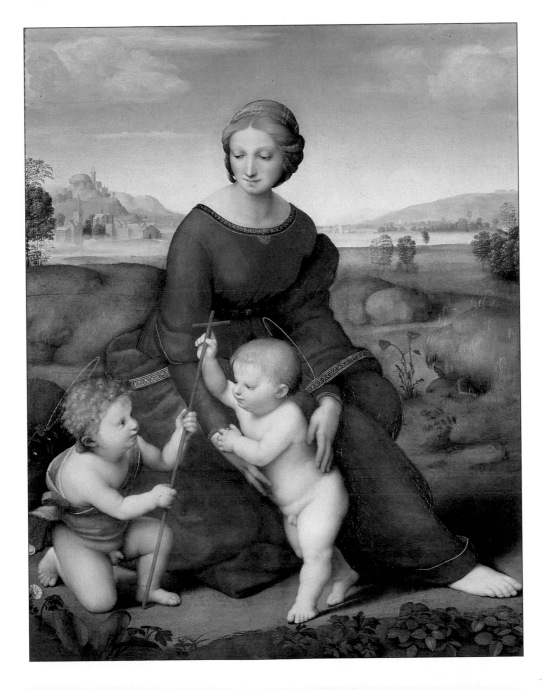

15.33 Raphael (attrib.), *Drawing of Pope Julius II*, 1511. Red chalk drawing, 14³⁄₁₆ × 9⅞ in (36 × 25 cm). Duke of Devonshire Collection, Chatsworth, Derbyshire.

15.34 Raphael, *Portrait of Pope Julius II*, 1511–12. Oil on panel, 3 ft 6½ in × 2 ft 7½ in (1.08 × 0.80 m). National Gallery, London. Julius II (1443–1513) was a forceful ruler and the greatest patron of his age. As pope, he restored the papal states as the leading power in Italy. A fearless military leader, he drove out the French forces of Louis XII. He led a worldly life (he was the father of three illegitimate daughters), and had a reputation for being hot-tempered and *terribile* (awe-inspiring). The acorn motif on the pope's chair was an emblem of his family, the della Rovere. X-ray analysis of the painting has revealed that Raphael originally included papal insignia in the background, but later painted them out. The rings on six of his fingers confirm reports that Julius liked to spend money on jewels.

At the age of twenty-six, Raphael went to Rome where, in addition to religious works, he painted portraits and mythological pictures. His patrons were among the political, social, and financial leaders of the High Renaissance. In 1511 he drew Pope Julius II (fig. **15.33**) in preparation for painting his portrait (fig. **15.34**) a year or so later. The drawing illustrates Raphael's skillful use of line to evoke the Pope's personality. He has emphasized with darker strokes the eye sockets and the right cheek, which, in the painting, will be shaded so that they appear recessed. The forehead, left blank in the drawing, is highlighted in the painting. The more textured drawing of the cap resembles dark red felt. The final result—the first known independent portrait of an individual pope—shows a man of about seventy, dressed in everyday (rather than ceremonial) official garb. Raphael has captured a sense of Julius II's intellect and his capacity for deep introspection. The Pope's portrait is a psychological portrayal rather than a conventional icon of power. The oblique position and three-quarter length view of the figure became typical for portraiture throughout the High Renaissance.

Raphael also painted a number of mythological scenes. His fresco of *Galatea* (fig. **15.35**) was commissioned by the banker Agostino Chigi for the grand salon of his villa in Rome. Figure **15.36** shows the location of the work on the long wall of the salon, known as the Sala di Galatea. Unlike the calm Madonnas of his early period and the psychological introspection of the *Julius II*, Raphael's *Galatea* represents a pagan, amorous chase. Galatea flees from the Cyclops Polyphemos (see Vol. I, p. 130), who is depicted to the left on the same wall. The one-eyed giant of Greek myth has killed Galatea's lover, Acis, and now has designs on her. Galatea escapes in a seashell-chariot pulled by a pair of dolphins, one of whom bites a small octopus. She herself turns and stares apprehensively back at Polyphemos. Surrounding her are sea-creatures engaged in erotic pursuits or blowing trumpets. Above, three

15.35 (below) Raphael, *Galatea*, Villa Farnesina, Rome, c. 1512. Fresco, 9 ft 8½ in × 7 ft 4 in (2.96 × 2.24 m). After starting work on the *Galatea*, Raphael reportedly requested an additional payment beyond what had been agreed upon. When Chigi's accountants protested, Raphael produced Michelangelo as an expert witness on his behalf. Michelangelo said that *he* would charge 100 scudi per head. Chigi advised his accountants to pay, saying: "Be polite and keep him happy, because we'd be ruined if he made us pay for the draperies."

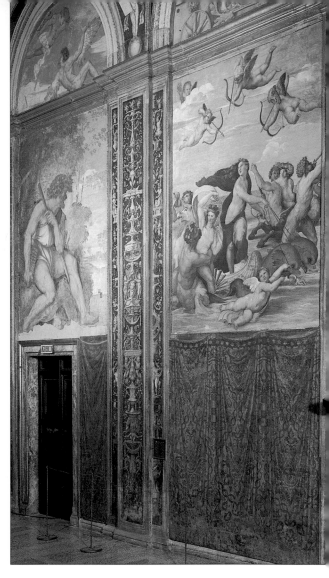

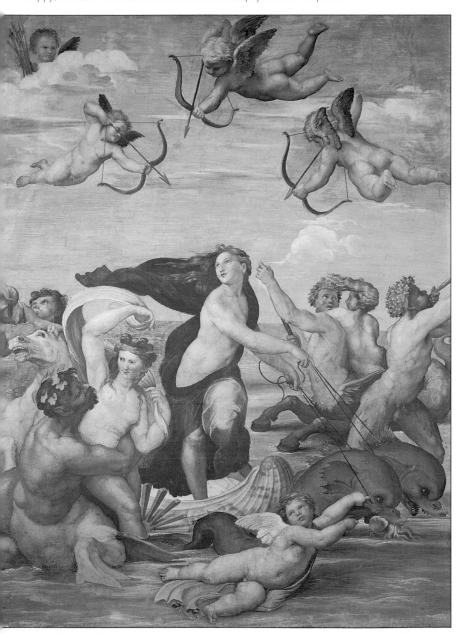

15.36 (above) *Galatea* in situ, Grand Salon, Villa Farnesina, Rome. In 1514 Baldassare Castiglione, author of *The Courtier*, complimented Raphael on the *Galatea*. Raphael replied that "to paint a beautiful woman, I would need to see many . . . [without them] I use an idea . . ." By "idea," Raphael meant the Platonic "idea," in the sense of an ideal, or perfect, model. He thus combined the Renaissance study of nature with the Neoplatonic ideal relating physical beauty to a corresponding state of the soul.

Cupids aim their arrows at Galatea, while a fourth gazes down from a cloud in the upper left corner. Below, another Cupid desperately hangs on to one of the speeding dolphins. Although this is a classically balanced picture, with Galatea centrally positioned, the variety of poses, the strong diagonal planes of movement, and the twisting, overlapping figures impart a sense of erotic excitement which reflects the narrative of the myth.

Frescoes in the Stanza della Segnatura In 1508, the year of the contract for the Sistine Chapel ceiling, Julius II commissioned Raphael to decorate the Stanza della Segnatura, a room that has been variously identified as a judicial tribunal and as the Pope's private library. Raphael's program was a monumental synthesis of the Christian world and its thought with Classical antiquity and its philosophy. The ceiling contained four tondos of allegories represented as females: *Theology, Poetry, Philosophy,* and *Jurisprudence.* On either side of the tondos, set in the four corners, are four scenes in rectangular frames: *The Judgment of Solomon, The Temptation of Adam and Eve, The Mythical Musical Contest between Apollo and the Satyr Marsyas,* and *The Muse of Astronomy (Urania) Leaning over the Sphere of Universal Harmony.* Below each of the four allegories is a corresponding large, lunette-shaped fresco filled with life-size figures: *Parnassus* under *Poetry, The Disputation over the Sacrament* under *Theology, The School of Athens* under *Philosophy,* and personifications of those Virtues necessary for the administration of justice under *Jurisprudence.*

We will consider two of the lunettes—The *Disputation over the Sacrament,* known as *The Disputa* (fig. **15.37**), and *The School of Athens* (fig. **15.38**). *The Disputa* is a thoroughly Christian painting, which represents theologians discoursing on the validity of the Transubstantiation (the literal transformation of the wine and wafer into the blood and body of Christ) celebrated in the Eucharist. In Raphael's fresco, the wafer in which Christ is believed to be embodied is enclosed by the ring of a monstrance (the enclosure of the host, or wafer). The monstrance, which is the location of the vanishing point, stands on the altar at the mathematical center of the picture. The Eucharist is thus its formal and theological center, suggesting that Julius II accepted the doctrine of the Transubstantiation.

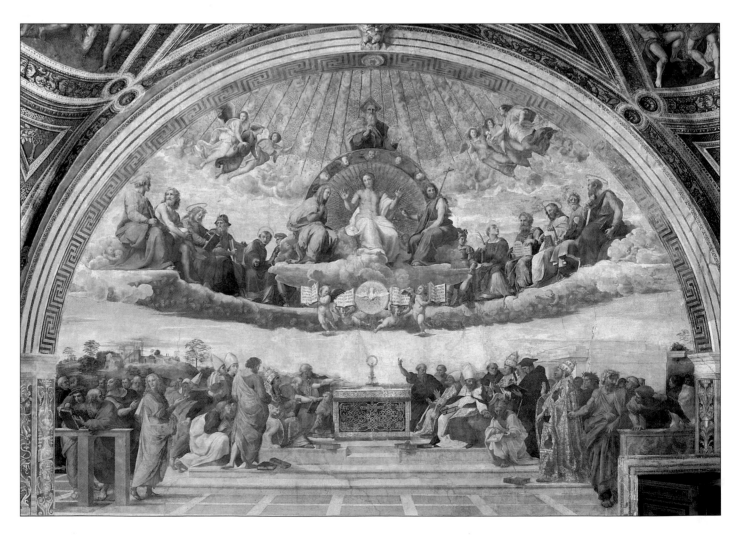

15.37 Raphael, *Disputation over the Sacrament,* 1509–11, Stanza della Segnatura, Vatican, Rome. Fresco, at base 25 ft 3 in (7.7 m).

Further, in providing a visual link between the earthly and heavenly planes of existence, the image of the monstrance is a metaphor for its function in the liturgy of the Eucharist, which is literally to merge the worshiper with Christ.

As depicted by Raphael, the material world is the world of perspective, distant landscape and architecture, and figures that obey the laws of gravity. Saints Jerome and Gregory the Great are to the left of the altar, and to the right are Saints Ambrose and Augustine. Together with these four Doctors of the Church are other saints and popes, including Sixtus IV (the uncle of Julius II), who stands at the right, wearing a gold robe and papal tiara. Dante, with a laurel wreath, is just behind him. Leaning on the railing at the left is Bramante, Raphael's mentor, who was still alive at the time the fresco was being painted.

The heavenly host occupies the upper half of the lunette. Biblical figures and saints are seated on a semicircular cloud formation, and angels are suspended in mid-air. At the center sits Christ, flanked by Mary and John the Baptist (the *Deësis*). God appears above Christ, and the Holy Spirit is below him.

Raphael's geometric unity in *The Disputa* is tightly organized, and this contributes to its clarity. On the earthly level, the rectangular altar echoes the grid pattern of the floor. The alignment of the figures, despite considerable variety of pose, conforms to the planes of the orthogonals, and the horizontal floor plan conforms to the lower frame. The upper, heavenly portion of the fresco is governed by curves and circles (divine shapes). Below, only the gold ring of the monstrance and wafer within it form perfect circles. Echoing these are the gold circles surrounding the Holy Spirit and Christ. Two concentric semicircles of clouds cut through the curve of the lunette in a reverse direction, one supporting the seated figures, the other framing the lower section of heavenly light surrounding God the Father. The Eucharist is the smaller, earthly part of a vertically aligned hierarchy of circles; at the top is the heavenly circle of gold light.

Directly across the Stanza from *The Disputa* is Raphael's monumental *School of Athens* (fig. 15.38), which reveals the Classical harmony of his style. Philosophers from the leading schools of ancient Greek philosophy are assembled into a single, unified compositional space. The

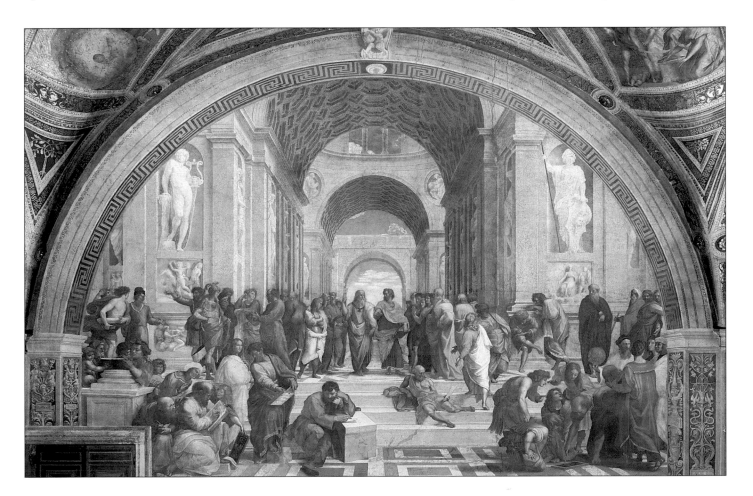

15.38 Raphael, *The School of Athens*, 1509–11, Stanza della Segnatura, Vatican, Rome. Fresco, 26 × 18 ft (7.92 × 5.49 m). This fresco covered one entire wall of the private library of Julius II. The room was known as the Stanza della Segnatura because it used to be the place where the *Signatura Curiae*, a division of the supreme papal tribunal, met. Raphael was commissioned by Julius II to decorate this vast room with frescoes of Classical and Christian subjects.

fresco lacks any reference to Christian themes—it is a world of reason and philosophy, science and art. The figures at the top of the steps occupy a horizontal plane, with distinct groups on either side; further groups are placed at the bottom of the steps. On the left, Pythagoras demonstrates his system of proportions to students. Diogenes the Cynic, who proverbially carried a lantern through the streets of ancient Athens in search of an honest man, sprawls across the steps slightly to the right of center. At the center of the top step, framed and accented by the round arches, are the two most famous Greek philosophers. On the left, Plato carries a text of his dialogue, the *Timaeus*, and on the right is Aristotle with his *Ethics*. A point between the shoulders of these two giants of Western thought corresponds to the vanishing point of the painting. At Plato's left is Socrates, whose features were known from an ancient marble portrait bust.

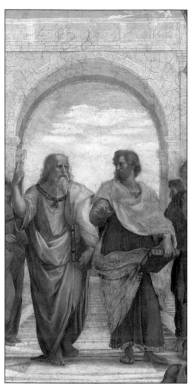

15.39 Raphael, Plato, left (detail of fig. 15.38).

Not only has Raphael integrated different philosophical schools, but he has also included portraits of his contemporaries among the philosophers. Plato (fig. **15.39**) is a portrait of Leonardo, whose physiognomy corresponds closely to his *Self-portrait* drawing (fig. **15.40**). The upward pointing finger of Plato is also a characteristic gesture in Leonardo's own pictures—for example, the doubting Thomas in *The Last Supper* (see fig. 15.15). Raphael thus pays tribute to Leonardo's central role as a thinker and artist in establishing the High Renaissance style. Plato points upwards also as a reference to the Platonic ideal and the notion of a realm of ideas, while Aristotle the empiricist points forward. The brooding foreground figure to the left of center, presumed to represent the philosopher Heraklitos, is a portrait of Michelangelo, who was working on the Sistine Chapel ceiling while Raphael was painting the papal apartments. Michelangelo's massive, sculpturesque form, and his meditative pose, is quite similar to that of his own *Jeremiah* (see fig. 15.27) in the Sistine Chapel. Both figures hunch forward and seem to be pondering weighty issues.

On the far right is a self-portrait of Raphael (fig. **15.41**), looking out from the picture plane. He wears a black hat, and stands to the right of the figure in the white robe and hat. This man has been variously identified as the painter Sodoma and as Perugino, to whom Raphael was appren-

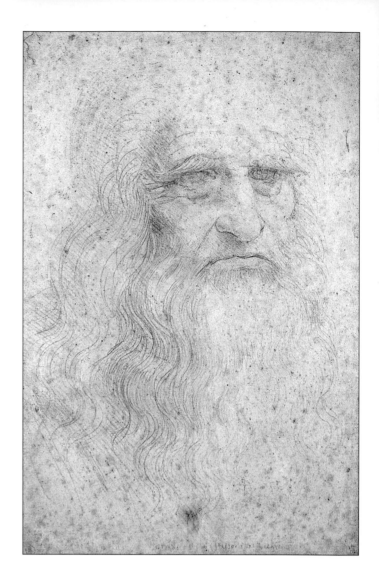

15.40 Leonardo da Vinci, *Self-portrait*. Pen and ink. National Library, Turin.

ticed at the age of eleven. Euclid, who is drawing a geometric figure with a compass, is a portrait of Bramante. His prominent, domed bald head is repeated in the globe and in the unseen dome crowning the painted architectural setting. The architecture of the painting, which is a tribute by Raphael to his mentor, is itself based on Bramante's ideas. The figure holding up the globe is Zoroaster, the astronomer, and standing with his back to the viewer is Ptolemy, the Egyptian geographer from Alexandria.

Raphael has portrayed Michelangelo and himself according to their respective personalities and styles. Michelangelo is brooding, isolated, and muscular. Raphael, who was known for his easy, gregarious manner, relates freely to his companions and to the observer, and is painted in the soft, restrained style of his own early works. Raphael sets Leonardo apart at the top of the steps, as if to show that his predecessor is above the competitive rivalry between Michelangelo and himself.

Raphael's style became more complex after *The School of Athens*, expanding in scale, in the range of movement, and in the use of light and dark. He, more than any other High Renaissance artist, combined Classical purity with

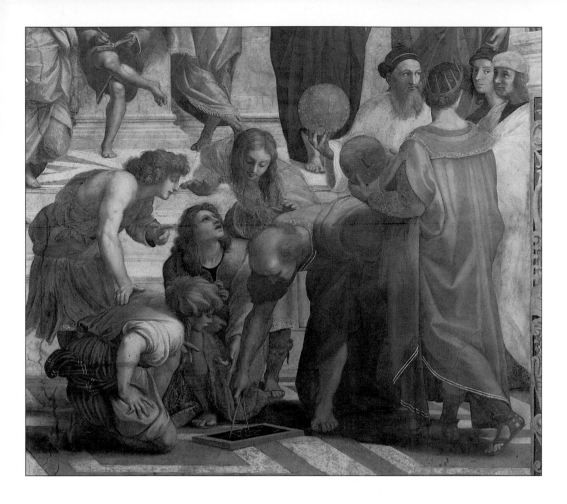

15.41 Raphael's self-portrait (detail of fig. 15.38). The proverbial contrast between Raphael's sociability and Michelangelo's brooding isolation is captured by a 16th-century anecdote. The two artists run into each other on a street in Rome. Michelangelo, noting the crowd around Raphael, asks: "Where are you going, surrounded like a provost?" Raphael replies: "And you? Alone like the executioner?"

the Christian tradition in painting. He was also a fast and efficient worker, in contrast to Leonardo, who had enormous difficulty completing his works. Likewise, Michelangelo's difficult personality often interfered with his relationships with patrons and affected his ability to finish and deliver certain sculptures. Raphael, on the other hand, was sociable and an adept diplomat. In 1520 his early death cut short a remarkable career. In a final tribute to the Classical past and its relevance to present and future, Raphael was, at his own request, buried in the Pantheon, and his painting of Christ's Transfiguration was placed over his tomb.

Developments in Venice

Venice was a port city and an international center of trade throughout the Middle Ages and Renaissance. Because it was built on water, it had a different effect on painters than other Italian cities. Its soft yellow light, at once muted and reflected by its waterways, has influenced painters up to the present day. During the Renaissance, Venice was a republic, which remained invulnerable to foreign attack. The Venetian constitution had lasted since the late thirteenth century, fostering relative political continuity despite upheaval in other Italian states. By 1500, the city had been free of foreign domination for about one thousand years, a fact that contributed to the so-called "myth of Venice." Venice considered itself a harmonious blend of the best qualities of different types of government—the freedom of democracy, the elegant, aristocratic style of oli-

garchy, and the stability of monarchy. Under its constitution, Venice was ruled by patrician senators (the Doges) who formed the Great Council, which emphasized the rule of law over individual expression. This led to greater stability, as well as to greater political repression, than in Florence.

In the early fifteenth century, the visual arts in Venice were somewhat more conservative than in Florence. They were rooted in the Byzantine and Gothic traditions, and Venetian taste was more in tune with the rich colors and elaborate patterns of the International Style. More so than in Florence and Rome, Venetian artists tended to receive their training in family-run workshops maintained for several generations. A major reason for the durability of this tradition was the fact that visual art was still considered a manual craft in Venice and therefore intellectually below the art of letters—the profession of painting was closely controlled by the Painters' Guild, the *Arte dei Depentori*. In Florence, on the other hand, painting had attained the status of a liberal art.

The Bellini: A Family of Painters

One of the most successful examples of the family workshop tradition in Venice is the Bellini family. The workshop of Jacopo Bellini (c. 1400–70) included himself and his two sons, Gentile (c. 1429–1507) and Giovanni (c. 1432–1516). All three were major artists of their time. In addition, Jacopo's daughter married Andrea Mantegna, whose interest in Classical antiquity was shared by his in-laws.

Jacopo Bellini Jacopo Bellini was born in Venice, and studied with Gentile da Fabriano. Around 1420 he went to Florence, and met the first-generation innovators of the Renaissance style. Their knowledge of perspective interested Jacopo, who incorporated it into his own work. Unfortunately, very few of his paintings survive, but those that do share the Gothic taste for elegant patterns and decorative detail. Jacopo is best known today for his many extant drawings, most of which are in two sketchbooks, one in the Louvre and one in the British Museum.

These indicate a command of perspective, foreshortening, and shading, and an attraction to Classical motifs.

Folio 35 of the Louvre sketchbook is a scene of Christ before Pilate (fig. **15.42**), which shows Jacopo's combination of Classical and Venetian architecture. The Roman arch rises above a palace with typical Venetian windows and balconies on the back wall. An Ionic frieze is prominently displayed on the **entablature** of the front wall. The arch itself is flanked by pairs of huge Composite columns, the bases and capitals of which are rather fancifully

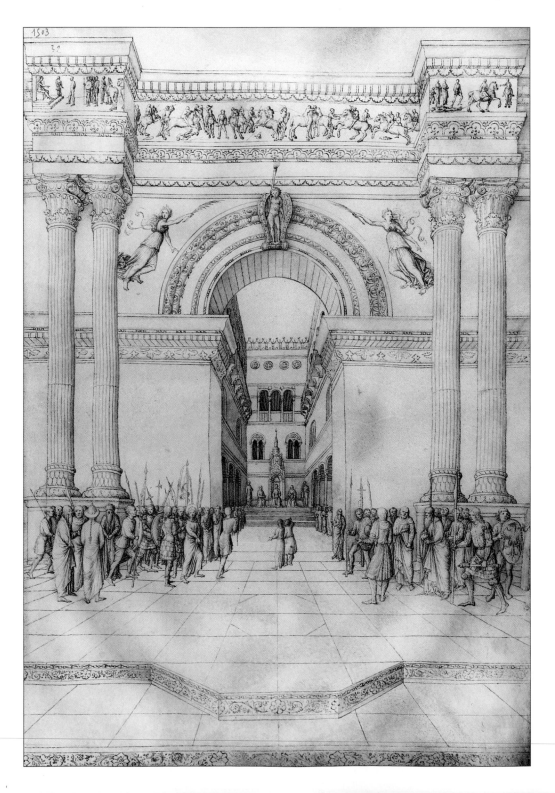

15.42 Jacopo Bellini, *Christ Before Pilate*, Louvre sketchbook, folio 35, Louvre inv. R. F., 1503. Drawing on paper.

carved. Between the columns and the arch are representations of Classical winged Victories in relief. The nude male figure at the center of the arch holds up a flaming torch, a motif signifying rebirth and eternal life on Roman sarcophagi. In the context of Christ brought before Pilate, the motif also refers to the triumph of Christianity and Christ's resurrection.

Jacopo's perspective is calculated to juxtapose the enormity of Pilate's palace with the small scale of humanity. Pilate himself occupies the Gothic throne at the center of the picture plane. The viewer's line of sight is guided by the orthogonals of the floor tiles to the vanishing point at Pilate's feet, and carried upwards by the spire of his throne, to the scene of the Winged Victory over the arch. In addition to integrating Venetian with ancient architecture, therefore, Jacopo also reflects the influence of Neoplatonism by reinforcing the meaning of a Christian scene with pagan iconography.

Gentile Bellini Gentile's early style is unknown, possibly because he was in his father's workshop, where he and Giovanni remained until 1460. From 1474, he worked on frescoes for the Great Council Hall of Venice, and his reputation as a portraitist won him many official commissions. Most of these are lost, but his portrait of Sultan Mehmet II (fig. **15.43**) survives. After concluding a celebrated peace treaty with Venice, the Sultan had requested that a Venetian portrait painter be sent to his court. On September 3, 1479, Gentile left Venice for a year in Constantinople, bringing with him a book—later the Louvre sketchbook—of Jacopo's drawings for his host. The grateful Sultan made Gentile a Knight of the Ottoman Empire. While he was away, Gentile's brother Giovanni took over the work for the Great Council Hall in Venice.

Gentile's portrait of the Sultan shows his taste for textures created by gradual shading and for the illusion of distinctive materials. Mehmet II is framed by a decorative,

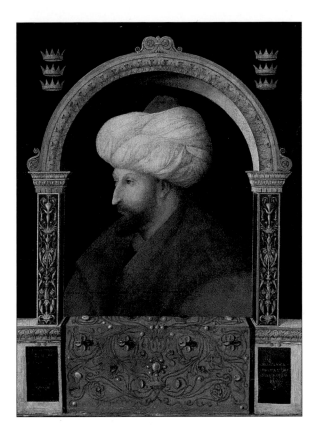

15.43 Gentile Bellini, *Sultan Mehmet II*, c. 1480. Oil on canvas, 27¾ × 20⅝ in (70.5 × 52.4 cm). National Gallery, London.

round arch, and a rich fabric with Islamic designs is draped over the balustrade in front of him. His heavy robe, beard, turban, and long pointed nose seem to weigh him down and accentuate his serious, thoughtful character. Shortly after returning to Venice in 1480, Gentile cast a medal with the Sultan's portrait on the obverse, and three crowns on the reverse (fig. **15.44**).

15.44 Gentile Bellini, *Sultan Mehmet II*, medal (obverse left, reverse right). National Gallery of Art (Samuel Kress Collection), Washington, D.C.

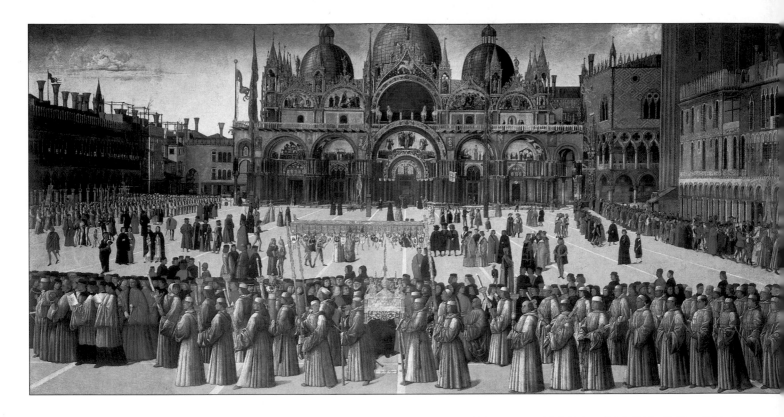

15.45 Gentile Bellini, *Procession of the Reliquary of the Cross in Piazza San Marco*, 1496. Oil on canvas, 12 ft ½ in × 24 ft 5¼ in (3.67 × 7.45 m). Galleria dell'Accademia, Venice. Gentile was appointed the official painter of the Venetian Republic and knighted by Frederick III. This work was one of a cycle on canvas for the Scuola di San Giovanni Evangelista (Saint John the Baptist).

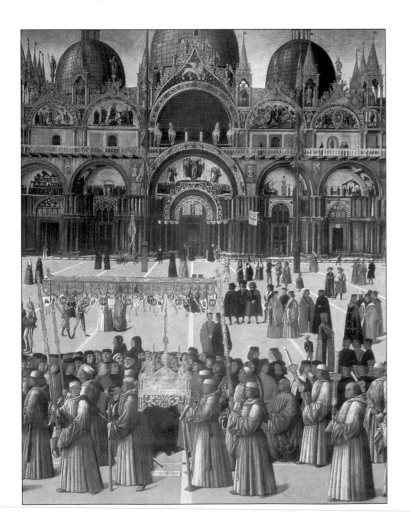

15.46 Detail of figure 15.45.

Gentile's *Procession of the Reliquary of the Cross in Piazza San Marco* (fig. **15.45**) of 1496 combines a taste for pageantry characteristic of the International Style with Renaissance perspective. It is a monumental historical painting which shows a panoramic view of the Venetian piazza and the domed Byzantine basilica of San Marco in the background. The receding orthogonals formed by the buildings on either side, which are aligned with participants in the procession, meet at a vanishing point in the basilica's central lunette. At the front of the picture plane, the Confraternity of San Giovanni Evangelista proceeds parallel to San Marco. Its members carry a relic of the True Cross, which is encased in the gold **reliquary** under the canopy (fig. **15.46**). The detailed patterns of Gentile's painting are combined with perspectival control and a large, three-dimensional space. These relieve the sense of crowding and set a stage with the architectural splendor of Venice as a backdrop.

The procession Gentile represented includes an actual event witnessed by the artist. Every year on April 25, Venice celebrated the feast of its patron saint, Mark. But in this instance a merchant from Brescia (the man in red kneeling to the right of the canopy) stopped to pray for his son, who was dying of a fractured skull. On returning home the following day, the merchant found his son completely cured. A miraculous event is thus juxtaposed with

the secular image of an orderly, opulent, timeless city dominated architecturally by its cathedral, ruled by its Doges, where members of different social strata peacefully co-exist. The latter, including aristocrats, merchants, children, and foreigners, are gathered in the Piazza San Marco to watch the procession.

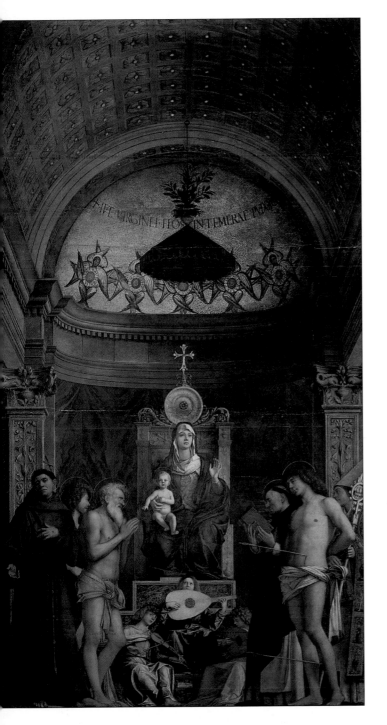

15.47 Giovanni Bellini, *San Giobbe Altarpiece*, 1480s. Oil on wood, 15 ft 4 in × 8 ft 4 in (4.67 × 2.54 m). Galleria dell'Accademia, Venice.

Giovanni Bellini Giovanni Bellini, who was active for over sixty years, was the artist most instrumental in bringing the Renaissance style to Venice. His subjects are mainly Christian, although he produced many portraits and a few mythological pictures. His monumental *San Giobbe Altarpiece* (fig. **15.47**) is the first surviving example of the *sacra conversazione* (holy conversation) type in Venetian art. The painted space ends in a fictive apse, which is suffused with a rich, yellow light. This is consistent with the Byzantine flavor of the gold mosaic in the half-dome behind Mary and Christ. At the same time, the classicizing pilasters and the relative precision of their surface carving are reminiscent of Mantegna. Enthroned in front of the apse, Mary and Christ are the focal point of the painting, even though—as in Masaccio's *Holy Trinity* (see fig. 14.23)—eye level is at the center of the lower frame. As a result, we look up at Mary and Christ, whose central importance is both literal (in their placement) and symbolic (in their significance).

This type of image is referred to as a *sacra conversazione* because of the postural and gestural communication between the painted figures and the observer. Mary and Christ look out of the picture plane, but they are not as iconic as their more static, frontal counterparts in Byzantine art. Saint Francis stands at the left, his head tilted on an angle parallel to the cross of John the Baptist. Francis gestures toward the viewer and, in displaying the stigmata, invites us to participate, as he does, in Christ's sacrifice. Reading from left to right, we follow Saint Francis's left elbow to the right arm of Saint Job. His gesture of prayer, in turn, leads diagonally up toward Christ's lowered right arm. At this point, we realize that the gesture of Christ's right hand is an echo of Saint Francis's gesture, and therefore also an allusion to the Crucifixion.

Mary's raised left arm recedes on a downward diagonal toward the upward diagonal of the book that Saint Dominic reads, which repeats the red of her garment. From Dominic's book, we are led to Saint Sebastian, whose arrows link him with Christ through martyrdom, and with Saint Francis through his wounds. At the same time, Sebastian's arms, crossed behind his back, lead to the young Saint Augustine in his characteristically elaborate robe. The three music-making angels at the foot of the throne are at once a reference to the Trinity and a formal echo of the Cross at the back of the throne.

In this altarpiece, Giovanni Bellini lays the groundwork for future developments in High Renaissance Venetian painting. The soft yellow light playing over the nudes, and their *chiaroscuro*, create sensual flesh tones that recur in the work of Giorgione and Titian (see below). Intense colors—especially reds—and textural variations also develop as oil paint becomes the primary medium in Venice. The climate of Venice was not conducive to fresco, because of dampness and salt air from the sea. Oil on stretched canvas proved more durable, and also allowed for richer, more **painterly** effects. By the late fifteenth century, Giovanni Bellini was already using oil, even for large-scale cycles such as those in the Scuola San Giorgio.

The same taste for rich textures and subtle shading is evident in Giovanni's portrait of *Doge Leonardo Loredan* (fig. **15.48**). Each individual gold thread of the buttons is visible. The gold embroidery of the cloak and the hat band reflects the influence of Flemish painting. Giovanni delineates Doge Loredan's expression by the play of light and dark across his features. His upright posture and precise physiognomy convey the impression of a stern, but slightly pensive, character. In the clarity of forms—the cubic space and the single, unified source of light—Giovanni Bellini is in the forefront of Renaissance innovation.

His unusual painting of *Saint Francis in Ecstasy* (fig. **15.49**) shows the influence of Flemish attention to detail. Saint Francis is enveloped by landscape, which can be associated with his devotion to nature, and his belief that God's presence resided in nature. This is reinforced by the peaceful animals, who allude to the Garden of Eden and the saint's reputation for communicating with birds and other wildlife. The craggy, linear depiction of the rock formations, the specificity of the leaves, and the accoutrements of the saint's rustic abode all reflect Flemish taste. The distant landscape, with its medieval walls and towers, and the horizontal disposition of the clouds, show the influence of Giovanni's brother-in-law, Andrea Mantegna.

15.48 Giovanni Bellini, *Doge Leonardo Loredan*, soon after 1501. Oil on wood, 24¼ × 17¾ in (61.5 × 45 cm). National Gallery, London. Leonardo Loredan (1438–1521) was a member of an influential Venetian family. He was Doge from 1501, during a period of political defeat for Venice. The Doges were chairmen of the ruling committees of Venice, and their position was permanent, even though the members of the committees often changed.

The Dispute over Painting vs. Sculpture

Competition between the arts has a long history in the West. In his *Life* of Giorgione, Vasari takes up the dispute over the virtues of painting, which is seen from a single vantage point, versus sculpture, which is three-dimensional. Giorgione, according to Vasari, set out to prove that "there could be shown in a painted scene, without any necessity for walking round, at one single glance, all the various aspects that a man can present in many gestures—a thing which sculpture cannot do without a change of position and point of view, so that in her [sculpture's] case the points of view are many, and not one."[1]

Giorgione demonstrated this by painting a nude man from the back. In a pool of water at the man's feet, Giorgione painted the reflection of his front. On the man's left was a shiny cuirass that reflected his left side, and on his right, a mirror reflected his right side. This, says Vasari, "was a thing of most beautiful and bizarre fancy," which proved that painting does "with more excellence, labor, and effect, achieve more at one single view of a living figure than does sculpture."[2] Unfortunately, Giorgione's painting is lost, so Vasari's effusive praise cannot be confirmed.

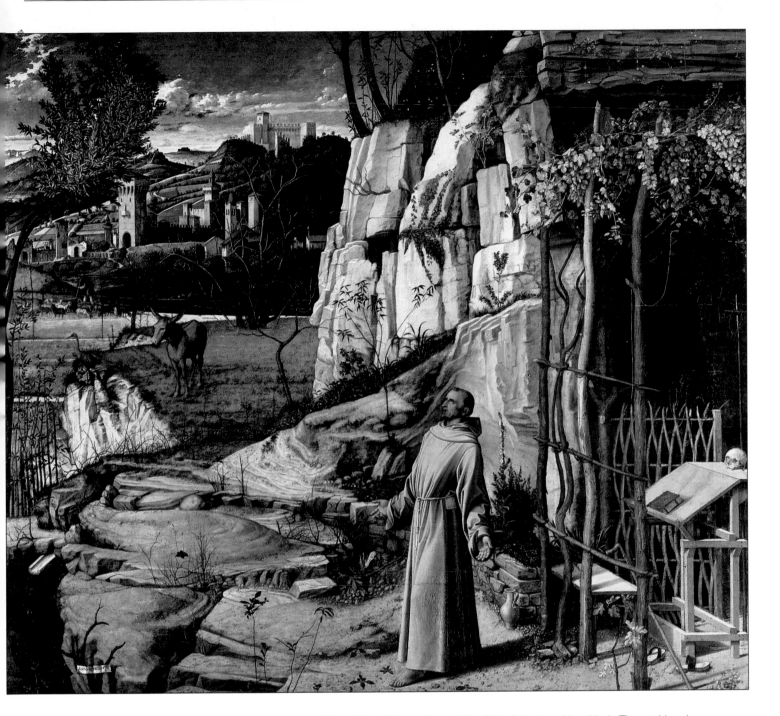

15.49 Giovanni Bellini, *Saint Francis in Ecstasy*, c. 1485. Panel, 48½ × 55 in (123 × 140 cm). The Frick Collection, New York. The art historian Millard Meiss has persuasively argued that in this painting Saint Francis is actually receiving the stigmata without the vision of Christ on the Cross (cf. Giotto's version, fig. 13.13), and that Bellini has conveyed this by pose and gesture. The stigmata thus become the result of an *inner* vision, which is expressed outwardly as ecstasy.

Giorgione

The Venetian love of landscape, especially when softened by muted lighting, became an important feature in the work of Giorgio da Castelfranco, known as Giorgione (see Box). Very little about his life is documented, although he is believed to have studied with Giovanni Bellini. Giorgione lived only to the age of thirty-two or thirty-three,

and few of his paintings survive. Because most were neither signed nor dated, and because Giorgione died while in the formative stage of his artistic development, there have been continual problems of attribution. Nevertheless, he emerges as a distinct personality, who creates a clear stylistic link between Giovanni Bellini and Titian (see below). His so-called *Tempesta*, or *Tempest* (fig. **15.50**), of

around 1506 shares with Bellini's *Saint Francis* the subordination of human figures to landscape. As in the *Saint Francis*, the viewer has the impression that there is an intimate relationship between landscape and figures, but scholars disagree on the precise meaning of Giorgione's picture.

The *Tempesta* is one of the persistent mysteries of Renaissance iconography. At the right, a virtually nude woman nurses a baby and, at the left, a soldier seems to watch over them. Together they create a "dialogue" of glance—the soldier gazes at the woman, she gazes at us, and the infant focuses on the breast. The figures are connected but distanced from each other. This ambivalent relationship is reflected in the background landscape and architecture. Woman and child are distinguished from the soldier by their nudity, in contrast to his state of dress, and physically by the space between them. Their separation, bridged as it is by the soldier's gaze, is accentuated by open space. They are likewise connected by the painted bridge in the background. Woman and child are surrounded by the knoll on which they sit, and by foliage, while the vertical plane of the soldier recurs in the lance, the trees on the left, and the truncated columns.

Giorgione enhances the figures' tension with the storm. A flash of lightning cuts through a darkened sky made turbulent by rolling clouds, its atmospheric effects accentuated by the artist's taste for layers of **glaze** and the visible texture of the brushstrokes. Whatever the real meaning of

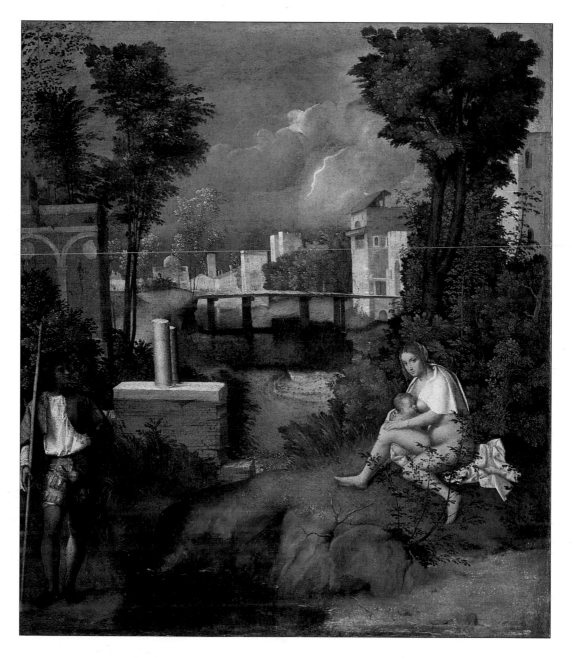

15.50 Giorgione, *The Tempest*, c. 1505. Oil on canvas, 31¼ × 28¾ in (79.4 × 73 cm). Galleria dell' Accademia, Venice.

15.51 Giorgione, *Portrait of an Old Woman (Col Tempo)*, early 16th century. Oil on canvas, 26¾ × 23¼ in (68 × 59 cm). Galleria dell'Accademia, Venice.

this picture is, Giorgione had become an undisputed master of technique and psychology, which he expressed in the most advanced style of his time.

In his *Portrait of an Old Woman* (fig. **15.51**), Giorgione's mastery of physiognomy enhances the psychological portrayal. It is a study of the ravages of time and its emotional impact. The figure looks out at the viewer—like Giovanni Bellini's Doge—from behind a narrow sill, which barely distances her from the picture plane. Her dress is simple, her hair slightly dishevelled, and her wrinkled skin a formal echo of the creases in her drapery. The gaps in her teeth are revealed by her open mouth. She seems to be speaking to us, but her message is mute. Instead, it is manifest in her image, and written on the piece of paper that she holds while pointing to herself—COL TEMPO ("with Time").

An entirely different conception of woman is presented in Giorgione's *Sleeping Venus* (fig. **15.52**) of around 1509. The picture may have been unfinished at his death and completed by Titian, but the basic style is Giorgione's. He shows the woman as a metaphor of landscape, which is a recurring theme in Western iconography. The long, slow curve of the left leg repeats the contour of the hill above, while the shorter curves formed by the outlines of the left arm, breast, and shoulder, echo the landscape as it approaches the horizon.

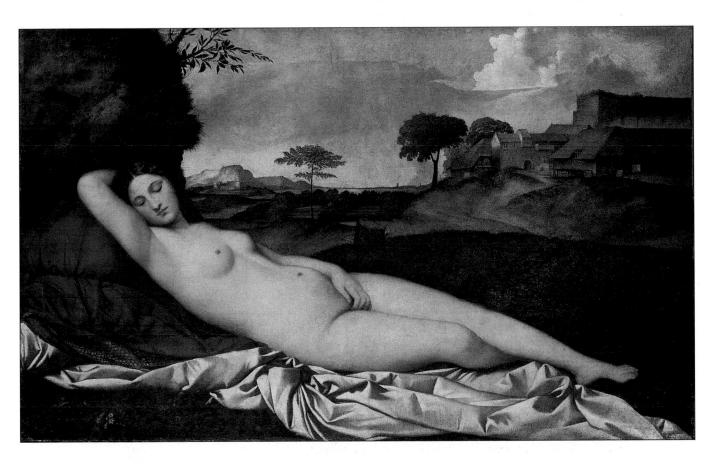

15.52 Giorgione, *Sleeping Venus*, c. 1509. Oil on canvas, 3 ft 6¾ in × 5 ft 9 in (1.08 × 1.75 m). Gemäldegalerie, Dresden. The woman is identified as Venus by the presence of a Cupid at her feet. Cupid was later painted out, but is visible with X-ray analysis.

Giorgione's *Venus* is perhaps dreaming and, if so, her dream is erotic. This is made clear in the gesture of her left hand, as well as in the upraised right arm (in certain periods of Western art, an exposed armpit is associated with seduction). But the eroticism is also displaced on to the silver drapery, the folds and texture of which convey an agitation that is absent from the calm pose and relaxed physiognomy of the nude. It is believed that the sky is primarily the work of Titian, and it is certainly typical of his taste for rich reds and glowing, subdued lighting.

Because of their collaboration and stylistic affinities, the transition from Giorgione to Titian seems to be a natural development. In contrast to Giorgione, who died of plague in 1510, Titian had a long, productive life and became the undisputed master of the High Renaissance in Venice.

Titian

The paintings of Tiziano Vecellio (Titian, in English) cover a wide range of subject-matter, including portraits, and religious, mythological, and allegorical scenes. Particularly impressive are his warm colors, deepened by many layers of glaze, his insight into the character of his figures, and his daring compositional arrangements. Compared with the paintings of his Roman and Florentine contemporaries, Titian's are soft, textured, and richly material.

These qualities appealed to the critic Pietro Aretino, who became involved in one of the major esthetic quarrels of the time—namely, the virtues of color (*colorito*) versus drawing (*disegno*) (see Box).

In an important early picture, *The Pesaro Madonna* (fig. **15.53**), painted for the Venetian church of Santa Maria Gloriosa dei Frari, Titian modified the pyramidal composition of Giovanni Bellini's *San Giobbe Altarpiece*. In contrast to the Bellini, Titian's Mary and Christ are off-center, high up on the base of a column, and the asymmetrical architecture is positioned at an oblique angle. The painting was commissioned by Jacopo Pesaro, whose family acquired the chapel in 1518. Jacopo was Bishop of Paphos, in Cyprus, and had been named commander of the papal fleet by the Borgia pope, Alexander VI. Titian shows his patron in a devotional pose, kneeling before the Virgin and presented to her by Saint Peter. Prominently displayed on the step is Saint Peter's key; its diagonal plane, leading toward

15.53 Titian, *The Pesaro Madonna*, 1519–26. Oil on canvas, 16 ft × 8 ft 10 in (4.88 × 2.69 m). Santa Maria Gloriosa dei Frari, Venice. Titian became the official painter of the Venetian republic in 1516 and raised the social position of the artist in Venice to the level achieved by Michelangelo and Raphael in Rome.

Pietro Aretino and Color versus Drawing

Pietro Aretino (1492–1556) was a flamboyant Venetian personality, an author writing in the vernacular, and a scathing social critic. For this latter activity, he was dubbed the "Scourge of Princes." His *Dialogues* (1534–5) reflect his own variable sexual mores, and comment pessimistically on those around him. The main character is Nanna, who converses in Volume I with a friend about the lives of nuns, married women, and courtesans. In Volume 2, she instructs her daughter on how to succeed as a prostitute.

Pietro's passionate sensibilities led him to take sides in the competition between Michelangelo and Titian, which embodied, among other things, the esthetic quarrel between *disegno* and *colorito*, respectively. Aretino came squarely down on the side of color. He championed the poetic effects of the oil medium applied directly to the canvas without preliminary drawing, in contrast to the more linear styles in fresco and tempera preferred in Florence and Rome. In particular, he responded to Titian's sensual use of paint, which enhanced the erotic character of his figures. He much preferred Titian's *chiaroscuro* and rich color to the sculpturesque figures of Michelangelo, which he believed failed to differentiate adequately between men, women, and children. Aretino's critical pen was aimed against Michelangelo, in defense of Titian, just as it was directed at the social and political corruption of his time.

the Virgin, parallels that of Jacopo. The Virgin's position at the top of the steps alludes to her celestial role as Madonna della Scala (Madonna of the Stairs) and as the Stairway to Heaven.

The large red banner at the far left prominently displays the papal arms in the center, and those of Jacopo below. An unidentified knight has two prisoners in tow, a turbaned Turk and a Moor, probably a reference to Jacopo's victory over the Turks in 1502. At the right of the painting, Saint Francis links the five kneeling Pesaro family members to the figure of Christ, suggesting that through his own route of identification with Christ salvation can be achieved.

The members of the donor's family are motionless. All the other figures gesture energetically and occupy diagonal planes of space. The steps, surmounted by large columns cut off at the top, are thrust diagonally back into space. Infant angels appear on the cloud above. One seen in rear view holds the Cross. The back of this angel is juxtaposed with the infant Christ, who turns playfully on Mary's lap and looks out at the viewer. The fabrics are characteristically rich and textured, particularly the Pesaro flag and costumes. This attention to material textures is further enhanced by the variation of bright lights and dark accents in the sky. The light of Venice, sparkling in its waterways, in contrast to the darkened setting of the Bellini, seems to illuminate this painting.

In the *Venus of Urbino* (fig. **15.54**) of c. 1538, Titian's debt to Giorgione is undeniable. But Titian's nude is awake, consciously observing and being observed. The

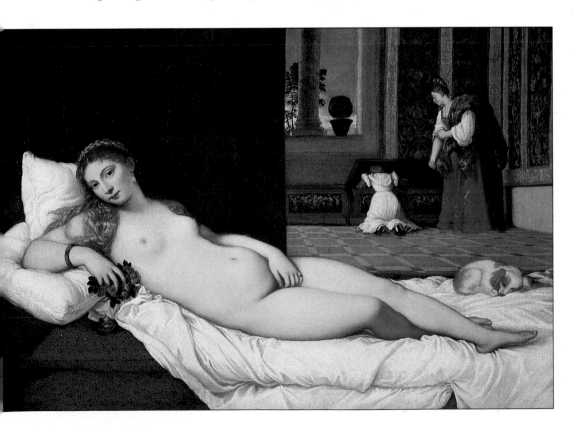

15.54 Titian, *Venus of Urbino*, c. 1538. Oil on canvas, 3 ft 11 in × 5 ft 5 in (1.19 × 1.65 m). Galleria degli Uffizi, Florence. The meaning of this painting has been the subject of much discussion. Some claim that the Venus is a Venetian courtesan and that the theme of the work is illicit love. Others, while admitting its sensuality, see it as representing marital love and fidelity. Recently, the gesture of Venus has been read as a prelude to sexual intercourse in the context of being a marriage picture.

relation of the figure to the drapery has also been reversed—here the drapery is arranged in easy rhythms, but Venus is a more active participant in the "seduction" of the observer than Giorgione's sleeping figure. Titian's Venus has been transported from a natural to a contemporary Venetian interior. She reclines in the foreground, and the bed is parallel to the picture plane, while a relatively symmetrical, rectangular room occupies the background. Two maids remove garments from a chest, accentuating the interior character of the setting. Titian's Venus is clearly descended from the Giorgione; as we shall see, the pose recurs in Western art up to the present.

The rich red of Venus's long flowing hair is characteristic of Titian, as are the yellow light and gradual shading that enhance the fleshy texture of her body. The roses, which languidly drop from her hand, and the myrtle in the flower pot on the window sill, are attributes of Venus. The dog, as in the *Arnolfini Wedding Portrait* (see fig. 14.74), signifies both fidelity and erotic desire.

Titian's fame resulted in an invitation to the court of the Holy Roman Emperor Charles V at Augsburg, and he became the Emperor's painter. In 1530, he attended Charles's coronation in the northern Italian city of Bologna, and three years later was made a member of the nobility. In 1548 Titian painted the equestrian portrait of *Charles V at the Battle of Mühlberg* (fig. **15.55**) to commemorate the Emperor's victory against the Protestants at Mühlberg in 1547. In keeping with the conventional iconography of equestrian monuments, Titian renders the Emperor as an assertive leader. Charles sits upright, armed for battle. His bearded chin juts out aggressively as he thrusts his lance forward. The horse, nervously pawing the ground, seems to emerge from a dark forest on the left into an open space against a richly colored sky. In Titian's portrait, the Emperor, defender of the Catholic faith, is both a specific individual and a symbol of power.

Titian's late painting, *Rape of Europa* (fig. **15.56**), illustrates his mythological interests. We have already encountered this subject in the **red-figure** Greek vase by the fifth-century B.C. Berlin Painter (see Vol. I, fig. 6.12). But Titian portrays the event in the idiom of sixteenth-century Venice, delighting in the deeply glazed colors and the background mists of purple and gold. He endows the scene with erotic excitement by virtue of pose, gesture, and energetic curves and diagonals. Jupiter, in the guise of a white bull, plows the sea with Europa on his back. She, in turn, combines the receptive pose of the reclining nude with gestures of excited protest, accompanied by fluttering drapery. Like the Europa on the red-figure vase, Titian's grabs on to the horn of the bull. Two Cupids in the sky echo Europa's excitement, while a third rides a dolphin swimming after the bull. This Cupid gazes at the abduction like a child riveted by the erotic activity of adults. The dolphin echoes the child's gaze by staring back at the viewer out of one, very prominent, eye. In the distant background, Europa's companions wave helplessly from the shore.

About six years before his death, when he was eighty years old, Titian painted the *Allegory of Prudence*, an unusual triple portrait (fig. **15.57**). It reflects his preoccupation with the stages of life and with time, and can be related to the message of Giorgione's *Old Woman*. Reading from left to right, we begin with the self-portrait of Titian himself. In the allegorical context, he stands for old age, his fierce expression matched by the angry wolf beneath him. The inscription over his head reads EX PRAETERITO ("From the Past"). His red cap identifies him with his most characteristic color. The thin transparent paint with which he has rendered his self-portrait conveys the loss of skin and muscle tone that comes with age, and makes the underlying bone structure more visible.

15.55 Titian, *Charles V at the Battle of Mühlberg*, 1548. Oil on canvas, 10 ft 11 in × 9 ft 2 in (3.32 × 2.79 m). Prado, Madrid. Although Titian's painting seems to be a faithful portrait, it actually idealizes Charles, who was short and had a deformity of the jaw that made it impossible to close his mouth. Titian has masterfully disguised these shortcomings, and portrays Charles as dignified and self-confident.

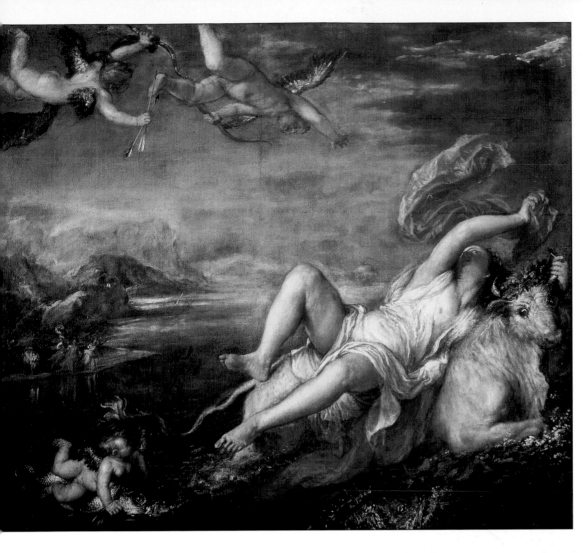

15.56 (left) Titian, *Rape of Europa*, 1559–62. Oil on canvas, 73 × 81 in (185 × 206 cm). Isabella Stewart Gardner Museum, Boston. This is one of a series of mythological scenes, known as **poesia**, that Titian painted from 1550–60 for Philip II of Spain. Titian would have known the description of the episode in Ovid's *Metamorphoses* (ll. 843–75), and possibly also in the 2nd-century A.D. novel by Achilles Tatius, who includes certain details depicted here.

15.57 (below) Titian, *Allegory of Prudence*, c. 1570. Oil on canvas, 29¾ × 27 in (75.6 × 68.6 cm). National Gallery, London.

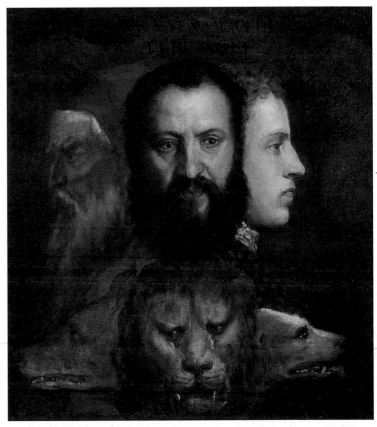

The central figure, in the prime of maturity, is Titian's son Orazio, whose thick, black beard echoes the lion's mane. Both stare straight ahead and convey the impression of self-confident strength. The inscription above Orazio asserts that PRAESENS PRUDENTER AGIT ("The Present Acts Prudently"). At the right, the head of a clean-shaven young man, presumed to be Titian's relative, Marco Vecellio, surmounts a dog's head. He represents the unsuspecting innocence of youth, and corresponds to the mild-mannered nature of the dog. The inscription reads NI FUTURA ACTIONE DETURPET ("Lest it Spoil Future Action").

The sources of this iconography lie in the texts of Classical antiquity, which Titian combined with the Christian allegorical tradition. Much like Raphael and Michelangelo, Titian incorporated these many currents into his personal life and arrived at an original humanist vision of the arts.

Titian's long career, like Michelangelo's, chronologically overlapped the Mannerist style, which developed after the High Renaissance. The late styles of both artists went beyond the High Renaissance classicism of Raphael—Titian in his loose brushwork and Michelangelo in his elongated forms. This demonstrates the difficulty of confining dynamic artists to specific stylistic categories. Nevertheless, by virtue of their training and their impact on the history of art, both Titian and Michelangelo are considered to epitomize the High Renaissance.

Style/Period	Works of Art	Cultural/Historical Developments

1450

THE HIGH RENAISSANCE
c. 1450–1500

Circle of Piero della Francesca,
Painting of an Ideal City

Circle of Piero della Francesca, *Painting of an Ideal City* (**15.6**)
Verrocchio, *The Baptism of Christ* (**15.14**)
Gentile Bellini, *Sultan Mehmet II* (**15.43**)
Gentile Bellini, *Sultan Mehmet II medal* (**15.44**)
Giovanni Bellini, *Saint Francis in Ecstasy* (**15.49**)
Leonardo, *Vitruvian Man* (**15.2**)
Giovanni Bellini, *San Giobbe Altarpiece* (**15.47**)
Michelangelo, *Drawing copy of Masaccio's Saint Peter* (**15.18**)
Michelangelo, *Pietà* (**15.19**)
Leonardo, *Church plan drawing* (**15.3**)
Leonardo, *The Last Supper* (**15.15**)
Gentile Bellini, *Procession of the Reliquary of the Cross in Piazza San Marco* (**15.45–15.46**)

Spain finances voyage of Columbus to the New World (1492)
François Rabelais, French author (1494–1553)
Imperial Diet opens in Worms (1495)
Severe famine in Florence (1497)
Savonarola burned at the stake in Florence (1498)
Vasco da Gama discovers sea route to India (1498)

**Gentile Bellini,
*Sultan Mehmet II***

1500

1500–1510

Leonardo, *Mona Lisa*

Leonardo, *Self-portrait* (**15.40**)
Giovanni Bellini, *Doge Leonardo Loredan* (**15.48**)
Michelangelo, *David* (**15.20**)
Giorgione, *Portrait of an Old Woman* (**15.51**)
Bramante, *Tempietto* (**15.4**), Rome
Leonardo, *Madonna and Child with Saint Anne* (**15.16**)
Jacopo Bellini, *Christ Before Pilate* (**15.42**)
Leonardo, *Mona Lisa* (**15.17**)
Raphael, *Betrothal of the Virgin* (**15.7**)
Raphael, *Madonna of the Meadow* (**15.32**)
Giorgione, *Sleeping Venus* (**15.52**)
Giorgione, *The Tempest* (**15.50**)
Caradosso, *Medal of New Saint Peter's* (**15.9**)
Bramante and Michelangelo, *New Saint Peter's* (**15.12**), Rome

Beginnings of African slave trade (c. 1500)
First manufacture of faience (Faenza) and majolica (Majorca) (1500)
Giuliano della Rovere is Pope Julius II (1503–13)
Term "America" used to denote the New World (1507)
Leonardo da Vinci discovers principle of the water turbine (1510)

Michelangelo, *David*

1510–1530

Raphael, *Portrait of Pope Julius II*

Leonardo, *Embryo in the Womb* (**15.13**)
Michelangelo, *Sistine ceiling frescoes* (**15.22–15.23, 15.25–15.27**)
Raphael, *Stanza della Segnatura frescoes* (**15.37–15.39, 15.41**)
 Raphael (attrib.), *Drawing of Pope Julius II* (**15.33**)
 Raphael, *Portrait of Pope Julius II* (**15.34**)
 Raphael, *Galatea* (**15.35–15.36**)
Michelangelo, *Moses* (**15.21**)
Titian, *The Pesaro Madonna* (**15.53**)

Immortality of the soul is pronounced church dogma (1512)
Copernicus states that earth and other planets revolve around sun (1512)
Ponce de Leon establishes Spanish claim to Florida (1513)
Sir Thomas More, *Utopia* (1516)
Martin Luther's 95 Theses; beginning of the Reformation (1517)
Coffee introduced into Europe (1517)
Charles V crowned Holy Roman Emperor (1520)
Sultan Suleiman rules Ottoman Empire (1520–66)
Magellan embarks on circumnavigation of the globe (1520)
Cortez conquers Aztecs, makes Mexico a Spanish colony (1521)
Castiglione, *Book of the Courtier* (1527)
Sack of Rome by troops of Charles V (1527)

1530

1530–1570

Titian, *Allegory of Prudence*

Michelangelo, *The Last Judgment* (**15.28–15.30**)
Titian, *Venus of Urbino* (**15.54**)
Titian, *Charles V at the Battle of Mühlberg* (**15.55**)
Titian, *Rape of Europa* (**15.56**)
Michelangelo, *Rondanini Pietà* (**15.31**)
Titian, *Allegory of Prudence* (**15.57**)

Great ("Halley's") Comet provokes wave of superstition (1531)
Niccolo Machiavelli, *The Prince* (1532)
Henry VIII rejects papal authority, founds Anglican Church (1534)
Founding of Jesuit Order by Ignatius Loyola (1534)
Thomas More refuses oath of the king's supremacy and is executed (1535)
John Calvin, *Institutes of the Christian Religion* (1536)
Beheading of Anne Boleyn (1536)
First Protestants burned at stake by Spanish Inquisition (1543)
Andreas Vesalius produces atlas of human anatomy (1543)
Council of Trent introduces Counter-Reformation policies (1545–63)
Ivan the Terrible rules Russia (1547–84)
Peace of Augsburg (1555)
Tobacco introduced into Spain from America (1555)
Charles V of Spain abdicates in favor of Philip II (1556)
Elizabeth I Queen of England (1558–1603)
Thomas Gresham proposes reform of English currency ("Gresham's Law") (1558)
Giorgio Vasari, *Lives ...* (1564)
Protestant Netherlands rebels against Catholic Spain (1568)

1570

16

Mannerism and the Later Sixteenth Century in Italy

The sixteenth century was a period of intense political and military turmoil from which no Italian artist could remain completely insulated. Charles I of Spain extended his empire to Austria, Germany, the Low Countries, and, finally, Italy. His aggressive tactics culminated in the sack of Rome in 1527. The 1500s were also a period of fundamental religious change. The power of the Catholic Church was challenged, and finally fractured, by the Protestant Reformation (see Box, p. 588).

16.1 Map of leading art centers in Renaissance Italy.

The counter-challenge, or Counter-Reformation, went far in the opposite direction, and religious orthodoxy was strictly enforced by the Inquisition. Established in 1232 by the emperor Frederick II, the Inquisition was a group of state officials dedicated to identifying, converting, and punishing heretics. Pope Gregory IX (d. 1241) appropriated the Inquisition and instituted papal Inquisitors for the same purposes. Their power was increased by Pope Innocent IV (d. 1254), who permitted the use of torture to force confessions from the accused.

During the sixteenth century, in the climate of upheaval within the Church and the Protestant challenges to its authority, humanism seemed to pose a greater threat than it had in the fifteenth century. The humanist primacy of man was replaced by a harsh view of nature. More emphasis was placed on God's role as judge and on the penalties of sin rather than on the possibility of redemption. Besides splitting Europe into two religious camps, the Reformation and Counter-Reformation had fundamental effects on art, artists, and patrons.

Mannerism

After the death of Raphael in 1520, new developments in art began to emerge in Italy (fig. **16.1**). The most significant of these has been called Mannerism. It coexisted with the later styles of Michelangelo and Titian, and remained influential until the end of the sixteenth century. Some scholars see the late work of Michelangelo and Raphael as sharing certain qualities with the Mannerists.

The very term "Mannerism" is ambiguous and has potentially conflicting meanings. Among the several derivations that have been proposed for Mannerism are the Latin word *manus* (meaning "hand"), the French term *manière* (meaning a style or way of doing things), and the Italian *maniera* (an elegant, stylish refinement). In English, too, the term is fraught with possible interpretations. We speak of being "well-mannered" or "mannerly," when we mean that someone behaves according to social convention. "To the manner born" denotes that one is suited by birth to a certain social status. Being "mannered," on the

The Reformation

By the second decade of the sixteenth century, after more than a thousand years of religious unity under the Roman Catholic Church, western Christendom underwent a revolution known as the Reformation. This led to the emergence in large parts of Europe of the Protestant Church.

During the fifteenth century the Church had become increasingly materialistic and corrupt. Particularly offensive was the selling of "indulgences" (a kind of credit against one's sins), which allegedly enabled sinners to buy their way into heaven. In 1517 the German Augustinian monk Martin Luther protested. He nailed to a church door in Wittenberg, Saxony, a manifesto listing ninety-five arguments against indulgences. Luther criticized the basic tenets of the Roman Church. He advocated abolition of the monasteries and restoration of the Bible as the sole source of Christian truth. Luther believed that human salvation depended on individual faith and not on the mediation of the clergy. In 1520 he was excommunicated.

In 1529 Charles V tried to stamp out dissension among German Catholics. Those who protested were called Protestants. In the course of the next several years most of north and west Germany became Protestant. England, Scotland, Denmark, Norway, Sweden, the Netherlands, and Switzerland also espoused Protestantism. For the most part, France, Italy, and Spain remained Catholic. By the end of the sixteenth century, about one-fourth of western Europe was Protestant.

King Henry VIII of England had been a steadfast Catholic, but his wish for a male heir led him to ask the Pope to annul his marriage to Catherine of Aragon, the first of his six wives. The Pope refused, and Henry broke with the Catholic Church. In 1534 the Act of Supremacy made Henry, and all future English kings, head of the Church of England. In 1536 the fundamental doctrines of Protestantism were codified in John Calvin's *Institutes of the Christian Religion*. His teachings became the basis of Presbyterianism.

The Reformation dealt a decisive blow to the authority of the Roman Catholic Church, and the balance of power in western Europe shifted from religious to secular authorities. As a result, the cultural and educational dominance of the Church waned, particularly in the sciences. In the visual arts, the Reformation had a far greater impact in northern Europe than in Italy or Spain, where the Counter-Reformation had an immense influence on the visual arts. Throughout Europe, however, the Reformation marked the beginning of a progressive decline in Christian imagery in the Protestant Church.

cal psychology, which means having bizarre, stylized behavior of an individual nature.

All of these terms apply in some way to the sixteenth-century style called Mannerism. In contrast to the Renaissance interest in studying, imitating, and idealizing nature, Mannerist artists typically took as their models other works of art. The main subject of Mannerism is the human body, which is often elongated, exaggerated, elegant, and arranged in complex, twisted poses. Classical Renaissance symmetry does not apply in Mannerism, which creates a sense of instability in figures and objects. Spaces tend to be compressed and crowded with figures in unlikely or provocative positions, and colors are sometimes jarring. Finally, Classical proportions are rejected and odd juxtapositions of size and space often occur.

In contrast to the dominance of papal patronage in the High Renaissance, Mannerism was a style of the courts. It appealed to an elite, sophisticated audience. Mannerist subjects are often difficult to decipher, and their iconography can be highly complex and obscure, except to the initiated. They may also be self-consciously erotic.

Mannerist Painting

Parmigianino The Mannerist taste for virtuosity and artifice is exemplified by the *Self-portrait in a Convex Mirror* (fig. **16.2**) of Parmigianino (1503–40). He painted it in 1524 at the age of twenty-one with the intention of dazzling the pope, Clement VII, with his skill. According to Vasari, the artist got the idea from seeing his reflection in a barber shop and decided to "counterfeit everything." The painting does indeed replicate the image in a convex mirror and is, in reality, convex. In the background, Parmi-

John Ashbery on Parmigianino

The artifice of Parmigianino's *Self-portrait in a Convex Mirror*, and the mirror as a metaphor for self-portraiture and self-revelation, appealed to the imagination of the contemporary American poet John Ashbery. The following are excerpts from his poem entitled "Self-portrait in a Convex Mirror":

> As Parmigianino did it, the right hand
> Bigger than the head, thrust at the viewer
> And swerving easily away, as though to protect
> What it advertises . . .
> In a movement supporting the face, which swims
> Toward and away like the hand
> Except that it is in repose. It is what is
> Sequestered . . .
> Chiefly his reflection, of which the portrait
> Is the reflection once removed.
> The glass chose to reflect only what he saw
> Which was enough for his purpose: his image
> Glazed, embalmed, projected at a 180-degree angle . . .¹

other hand, suggests a stilted, unnatural style of behavior. "Mannerisms," or seemingly uncontrolled gestures, are considered exaggerated or affected. The nature of Mannerism also inspired the term "manneristic," used in clini-

gianino's studio appears curved by the mirror's surface. The face itself is not distorted because of its distance from the picture plane, while the hand, being close to the picture plane, is enlarged. In these spatial arrangements, Parmigianino has emphasized the hand, making it as important a part of the image as the face. The role of the artist's hand in the artifice is thus an integral part of the picture's iconography (see Box).

Parmigianino's *Madonna and Child with Angels* (fig. **16.3**), also called the *Madonna of the Long Neck*, illustrates the odd spatial juxtapositions and non-Classical proportions that are typical of Mannerism. The foreground figures are short from the waist up, and long from the waist down. The Madonna, in particular, has an elongated neck and tilted head; their movement flows into the spatial twist of the torso and legs, creating a typically Mannerist **figura serpentinata**. Mary's dress, in contrast to the usual blue and red of earlier periods, is a cool metallic color. The man in the distance unrolling a scroll could be an Old Testament prophet. His position between the Madonna and the unfinished column is a logical visual link between pagan antiquity and the Christian era. His improbably small size in relation to both the column and the Madonna, however, is illogical.

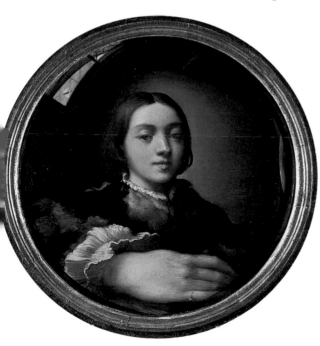

16.2 (above) Parmigianino, *Self-portrait in a Convex Mirror*, 1524. Oil on wood, diameter 9⅝ in (24.4 cm). Kunsthistorisches Museum, Vienna. Il Parmigianino ("The Little Fellow from Parma") was the nickname of Francesco Mazzola, who worked in Parma, Rome, and Bologna. His career was fraught with conflicts and lawsuits, and his interest in pictorial illusionism can be related to his preoccupation with counterfeiting. He was obsessed with alchemy (the science of converting base metal to gold), and eventually he abandoned painting altogether.

16.3 Parmigianino, *Madonna and Child with Angels (Madonna of the Long Neck)*, c. 1535. Oil on panel, approx. 7 ft 1 in × 4 ft 4 in (2.16 × 1.32 m). Galleria degli Uffizi, Florence. Parmigianino's perverse nature is evident in this painting. Its undercurrent of sinister, lascivious eroticism is also consistent with Mannerist tastes. Vasari described him as "unkempt ... melancholy, and eccentric" at the time of his early death, and related that he was, at his own request, buried naked with a cypress cross standing upright on his breast—apparently an expression of his psychotic identification with Christ.

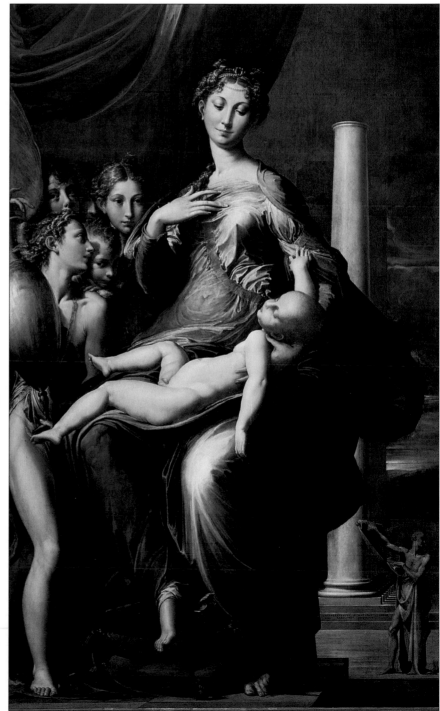

Agnolo Bronzino The allegorical painting of about 1545 by Bronzino (1503–72), traditionally called *Venus, Cupid, Folly, and Time* (fig. **16.4**), illustrates the Mannerist taste for obscure imagery with erotic overtones. The attention to silky textures, jewels, and masks is consistent with Bronzino's courtly, aristocratic patronage. Crowded into a compressed foreground space are several figures whose identities and purpose have been the subject of extensive scholarly discussion. Venus and her son Cupid are easily recognizable as the two figures in the left foreground. Both are nude, and bathed in a white light that creates a porcelain skin texture.

Cupid fondles his mother's breast and kisses her lips. To the right, a nude *putto* with a lascivious expression on his face dances forward and scatters flowers. All three twist in the Mannerist *serpentinata* pose. But only the *putto*'s pose

seems consistent with his action. The undulating forms of Venus and Cupid are rendered for their own sakes rather than to serve the logic of the narrative. A more purposeful gesture is that of Time, the old man who angrily draws aside a curtain to reveal the incestuous transgressions of Venus and Cupid. The identity of the remaining figures is less certain. The hag tearing her own hair has been called Envy, and the creature behind the *putto*, with a serpent's tail, reversed right and left hands, and the rear legs of a lion, Fraud. There is, however, no consensus on their identification or even on the overall meaning of this painting. It was apparently commissioned by Cosimo de' Medici as a gift for Francis I of France. Despite the strictures of the Counter-Reformation as codified by the Council of Trent (see Box), court patronage clearly delighted in playful and erotic, if somewhat obscure, imagery.

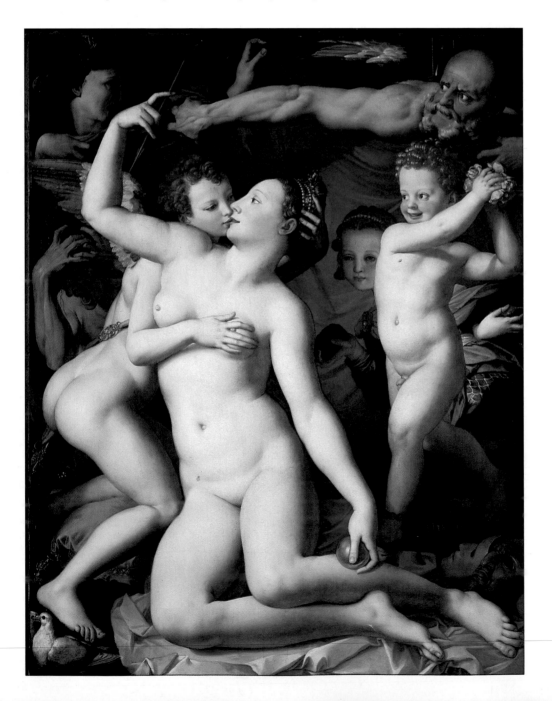

16.4 Agnolo Bronzino, Allegory called *Venus, Cupid, Folly, and Time*, c. 1545. Oil on wood, 5 ft 1 in × 4 ft 8¾ in (1.55 × 1.44 m). National Gallery, London.

The Counter-Reformation

In response to the Reformation, the Roman Catholic Church mounted the Counter-Reformation and tried to eliminate internal corruption. From 1546 to 1564 the Council of Trent was convened at Trento. It denounced Lutheranism and reaffirmed Catholic doctrine. Measures were initiated to improve the education of priests and reassert papal authority beyond Italy. The Council established an Inquisition in Rome to identify heretics and bring them to trial.

In its final session, the Council of Trent restated the Roman Church's view that art should be didactic, ethically correct, decent, and accurate in its treatment of religious subjects. Parallels between the Old and New Testaments were to be emphasized, rather than Classical events. The Council directed that art should appeal to emotion rather than reason—an implicitly anti-humanist stance, which resulted in an increase of miraculous themes. The Roman Inquisition was granted the power to censor works of art that failed to meet the requirements of the Council.

In 1573 the Venetian painter Paolo Veronese (1528–86) was summoned to appear before the Holy Tribunal to defend his monumental High Renaissance painting of *The Last Supper* (fig. **16.5**). The trial transcript, which has been preserved, makes it clear that the Inquisition objected to Veronese's naturalism. The Inquisitors asked Veronese to identify his profession and describe his painting.

"In this Supper," the prosecutor asked, "what is the significance of the man whose nose is bleeding?"

"I intended to represent a servant whose nose was bleeding because of some accident," the artist replied. The Inquisitor asked about the apostle next but one to Peter.

"He has a toothpick and cleans his teeth," said Veronese. The Inquisitor also objected to German soldiers eating and drinking on the stairs, and to the jesters and other figures in the picture. Germany, he declared, no doubt thinking of Martin Luther, was "infected with heresy." Veronese was contrite, admitting he had used artistic license. He said that Christ's Last Supper had taken place in the house of a rich man who might be expected to have visitors, servants, and entertainment. The Inquisitor was not impressed.

"Does it seem fitting at the Last Supper of the Lord to paint buffoons, drunkards, Germans, dwarfs, and similar vulgarities?"

"No, milords."

Veronese was given three months to alter his picture. He merely changed its title to *Christ in the House of Levi*.

In Catholic countries the zeal of the Counter-Reformation led to intolerance, moralizing, and a taste for exaggerated religiosity. Michelangelo came under particular attack. In 1549 a copy of his *Pietà* (see fig. 15.19) was unveiled in Florence. Because of Mary's depiction as an attractive figure, scarcely older than Christ himself, Michelangelo was called an "inventor of filth." In 1545 Pietro Aretino wrote to Michelangelo, criticizing his *Last Judgment* (see figs. 15.28 and 15.29) as suitable for a bathroom but not for a chapel.

It was against this background of political and religious turmoil that sixteenth-century art developed after 1520. One cannot prove that this directly affected the development of Mannerism. Nevertheless, there is, in that style, an undercurrent of anxiety and tension—beneath the refinement and elegance—that is not inconsistent with the times.

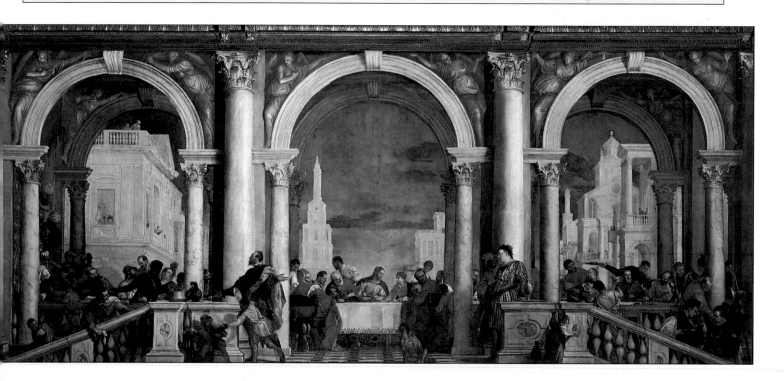

16.5 Paolo Veronese, *The Last Supper*, renamed *Christ in the House of Levi*, 1573. Oil on canvas, 18 ft 3 in × 42 ft (5.56 × 12.8 m). Galleria dell'Accademia, Venice. Paolo Caliari was born in Verona, hence his name, Il Veronese. In 1553 he moved to Venice, where, with Titian and Tintoretto, he dominated 16th-century Venetian painting. This picture illustrates his mastery of *di sotto in sù* (Italian for "looking up from below") perspective. Although Veronese liked to dress luxuriously—in keeping with the taste for pageantry evident in his paintings—he was known for his piety and financial acumen.

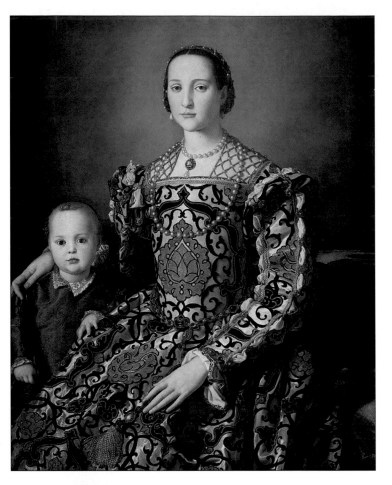

Another type of Mannerist painting can be seen in Bronzino's portrait of *Eleonora of Toledo and her Son Don Giovanni* (fig. **16.6**). In contrast to the nudity of the *Venus, Cupid, Folly, and Time*, these figures are very much attired. Indeed, the portrait is as much about clothing and its significance as about the figures wearing them. Bronzino delights in the carefully ordered patterns of velvet and brocade, and the regularity of Eleonora's curved tiara, which is echoed in the double strands of her pearl necklace. The porcelain skin textures of the Venus and Cupid are translated here to the aloof stares of the sitters. Gazing coldly on the world from a lofty social position, Eleonora and her son exemplify the elite sophistication of the court. Whereas the allegorical painting is about revelation and the exposure of perversion, the portrait depicts figures who are restrained and formal.

Mannerist Sculpture

Cellini Cellini's elaborate gold and enamel *Saltcellar* (fig. **16.7**) illustrates the iconographic complexity and taste for mythological subject-matter that appealed to Mannerist artists and their patrons. Cellini himself gave conflicting

16.6 (left) Agnolo Bronzino, *Eleonora of Toledo and her Son Don Giovanni*, 1545–46. Oil on wood, 3 ft 8 in × 3 ft 1 in (1.11 × 0.93 m). Galleria degli Uffizi, Florence.

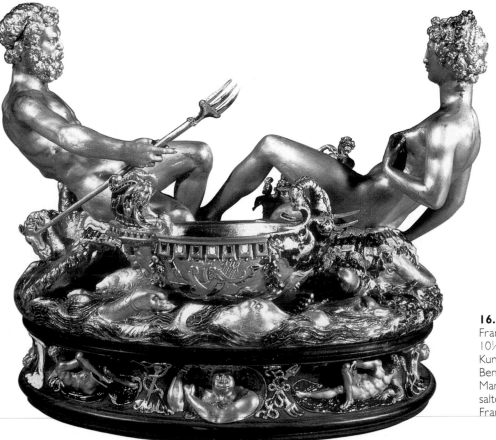

16.7 Benvenuto Cellini, *Saltcellar* of Francis I. Finished 1543. Gold and enamel, 10¼ × 13⅛ in (26 × 33.3 cm). Kunsthistorisches Museum, Vienna. Benvenuto Cellini (1500–71), a versatile Mannerist artist, made this elaborate saltcellar while working in France as Francis I's court goldsmith.

Vasari on Women Artists

In his view of women artists, Vasari was something of a humanist. He included the biography of Madonna Properzia de' Rossi (c. 1490–1530) in his *Lives*, where he has a lot to say about the excellence of women in antiquity. He also names the women of his own day who achieved fame in letters, but elaborates further on the women artists.

Properzia de' Rossi was born in Bologna, where she studied drawing. She received a few public commissions, and did several marble portrait busts. Payment for sculptures on the façade of San Petronio in Bologna is documented, but it is not certain which are by her hand. Vasari describes a panel of *Joseph and Potiphar's Wife*, which has been attributed to Properzia. He relates the subject directly to the artist's life—for she, like Potiphar's wife, conceived an unrequited passion for a young man.

The scene itself (fig. **16.8**) is quite complex, for Potiphar's wife turns in three-quarter view toward the viewer, while reaching back to grab Joseph's cloak. Joseph turns to leave, and seems to rush from the plane of the relief. Properzia has conveyed the erotic passion of Potiphar's wife—and Joseph's flight from it—by the agitated swirls of drapery, and the open, inviting flaps of the tent. The technical skill of this panel is consistent with Vasari's admiration of Properzia's carvings made from peach stones: "they were singular and marvellous to behold."[2]

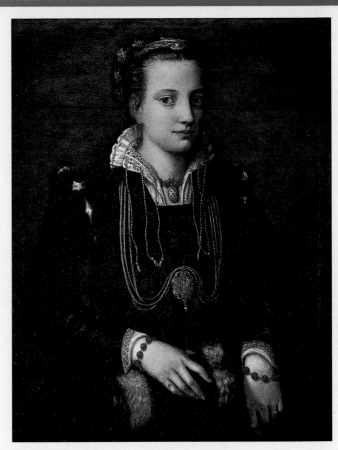

16.9 Sofonisba Anguissola, *The Artist's Sister Minerva*, c. 1559. Oil on canvas, 33½ × 26 in (85 × 66 cm). Milwaukee Art Museum. Gift of the family of Mrs. Fred Vogel, Jr.

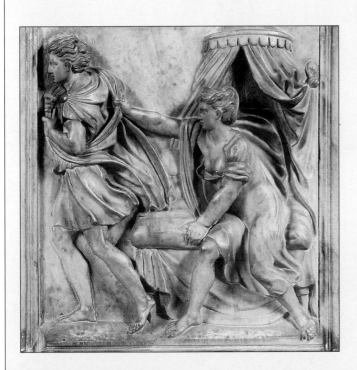

16.8 Properzia de' Rossi (attrib.), *Joseph and Potiphar's Wife*, c. 1520. Marble relief panel, 19 ft ¼ in × 18 ft ⅛ in (5.86 × 15.55 m). Museo di San Petronio, Bologna.

According to Vasari, there were many other women whose talent in drawing and painting equalled Properzia's in carving. Among these was Sofonisba Anguissola (1532/5–1625). Her success brought her to the attention of Philip II of Spain, at whose court she spent many years. She had five sisters who were also artists, and was married twice—first to a Sicilian lord, and then to a ship's captain.

Sofonisba was an accomplished portrait painter. Her portrait of her sister Minerva (fig. **16.9**) captures a rather wistful expression, and emphasizes the textured variation of the dress. She wears coral and gold jewelry, lace, and fur, which, like her features, are delicately rendered. Her pendant depicts the Roman Minerva, goddess of the art of weaving as well as of war and wisdom.

The style of Properzia's relief falls fairly well within the Renaissance tradition, although there is some Mannerist flavor in the draperies, and in the slightly contorted pose of Potiphar's wife. Sofonisba's *Minerva*, however, has affinities with Bronzino's *Eleonora of Toledo* (see fig. 16.6).

accounts of the object's meaning. Perhaps he simply forgot—but the ambiguity is nevertheless consistent with Cellini's ambivalent lifestyle (see Box). What is clear is that the two main nude figures represent the bearded Neptune, holding a trident and surrounded by seahorses, next to a ship, and the Earth goddess, holding a cornucopia, next to an Ionic temple. According to Cellini's description of the *Saltcellar*, Neptune's ship was designed to contain the salt, and Earth's temple the pepper. Other figures include personifications of winds, seasons, and times of day. The style and poses of the figures are clearly Mannerist, some being appropriated from sculptures by Michelangelo. They are elegantly proportioned and arranged to form spatial twists that result in impossible poses. Both Neptune and Earth, whose legs are intertwined, lean so far back that in reality they would topple over. The absence of any visible means of support reinforces their uneasy equilibrium, and the movement inherent in their elaborate poses and surface patterns is enhanced by the high polish of the gold itself.

From around 1545, Cellini was back in Florence working for Cosimo de' Medici. During that time, he carved several marble statues, larger in scale than the *Saltcellar*, that deal with openly homosexual themes from Greek mythology. About 1548, he carved the *Narcissus* (fig. **16.10**) from a block of marble provided by Cosimo. Here, Cellini has used the Mannerist *figura serpentinata* in the service of Narcissus's homoerotic character. He is a slim, slightly effete, adolescent, who raises his arm in the seductive gesture of Giorgione's *Sleeping Venus* (see fig. 15.52). Cellini's Narcissus does not lean forward to stare at his reflection in a pool of water (as he does in Greek myth). Rather, he twists around, looking backwards and to the side, as if the pool is behind him. In so doing, he exposes the front of his torso, and invites the observer's admiration, while he simultaneously admires himself. The implication of Narcissus's pose is that Cellini intended the work for a homosexual audience.

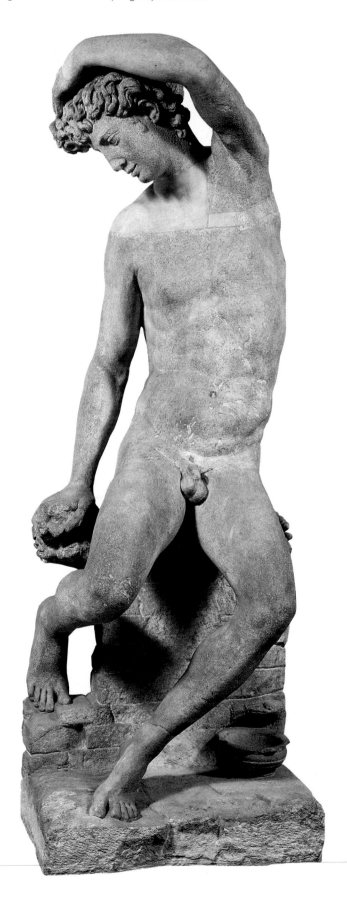

16.10 Benvenuto Cellini, *Narcissus*, c. 1548. Marble, 4 ft 9 in (1.49 m) high. Museo Nazionale (Bargello), Florence.

Benvenuto Cellini: A Mannerist Lifestyle

Benvenuto Cellini (1500–71) could be described as a Mannerist personality. Although trained as a goldsmith, he was equally comfortable as a sculptor in marble, architect, and author. His celebrated autobiography was written when he was fifty-eight, and under house arrest for sodomy. Cellini was restive, moving from place to place, often to avoid lawsuits. He was continually in trouble—he was charged with two murders in Rome in 1529—and had a reputation for violence. His flamboyant lifestyle, which he describes in his autobiography, included overt homosexuality, bisexuality, and episodes of transvestism. In 1558 he took preliminary vows for the priesthood, but later renounced them and married the mother of his two children. His autobiography was published posthumously in 1728, and Berlioz based an opera on it.

Giambologna Although Mannerism was primarily an Italian style, Jean de Boulogne (1529–1608)—known as Giovanni Bologna, or Giambologna in Italy—was born in Flanders, and became a leading Mannerist sculptor. His bronze *Mercury* (fig. **16.11**) of around 1576 shows the increasing importance of open space in Mannerism. The

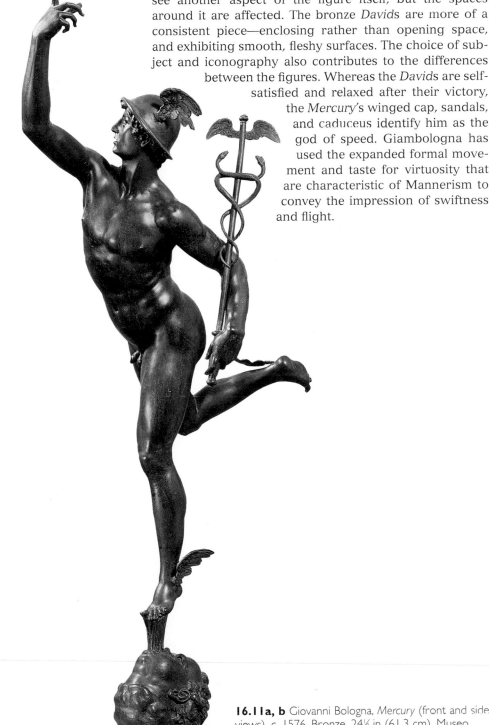

figure runs forward and stretches upward, opening up a variety of spaces bounded by curves and diagonals which enhance the sense of motion. The forms are thin and elongated, and the rippled surface of the bronze creates a pattern of reflected light.

Compared with the bronze *David*s of Donatello and Verrocchio (see figs. 14.34 and 14.44), the *Mercury* offers multiple viewpoints, for the difference between the front view and the side view is considerable. Not only do we see another aspect of the figure itself, but the spaces around it are affected. The bronze *David*s are more of a consistent piece—enclosing rather than opening space, and exhibiting smooth, fleshy surfaces. The choice of subject and iconography also contributes to the differences between the figures. Whereas the *David*s are self-satisfied and relaxed after their victory, the *Mercury*'s winged cap, sandals, and caduceus identify him as the god of speed. Giambologna has used the expanded formal movement and taste for virtuosity that are characteristic of Mannerism to convey the impression of swiftness and flight.

16.11a, b Giovanni Bologna, *Mercury* (front and side views), c. 1576. Bronze, 24⅛ in (61.3 cm). Museo Nazionale del Bargello, Florence.

Giulio Romano: The Palazzo del Tè

Giulio Romano (1492/9–1546) created in the Palazzo del Tè, in Mantua, a Mannerist environment that combined architectural humor with painted illusionism. He had been Raphael's chief assistant on the Vatican *stanze*, and when Raphael died in 1520, Giulio completed many of his unfinished works. Four years later, Federigo Gonzaga commissioned a villa for a week-end getaway, a place of entertainment and festivity, and a horse farm. From 1525 to 1535, Giulio Romano worked on the project. The plan (fig. **16.12**) shows the square courtyard, to which three wings were added.

In the design of the courtyard façades (fig. **16.13**), Giulio frequently subverted the classicizing forms recommended by Alberti. The effect is a more animated surface, and a disruption of Classical proportions. For example, the **rustication** is heavier, and the bulky Tuscan Doric columns support an architrave that seems too thin for the frieze above it. The central **triglyphs** push down into the architrave, and drop below its lower edge. The bases of the pediments over the blind windows are missing, leaving them unsupported except for stone brackets at the corners. **Keystones**, the structural function of which is to lock in the **voussoirs**, seem to pop forward, as if being pushed from behind. In these variations on the Classical Order, Giulio Romano mocks traditional forms of Western architecture—which he nevertheless retains—by slight alterations in placement and proportion.

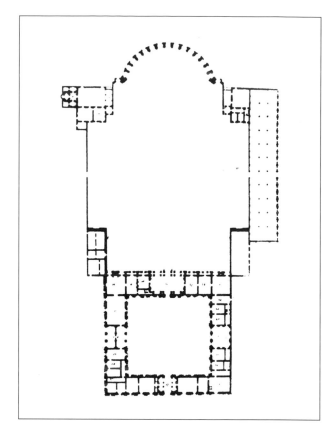

16.12 Giulio Romano, Palazzo del Tè, plan, Mantua, 1525–35.

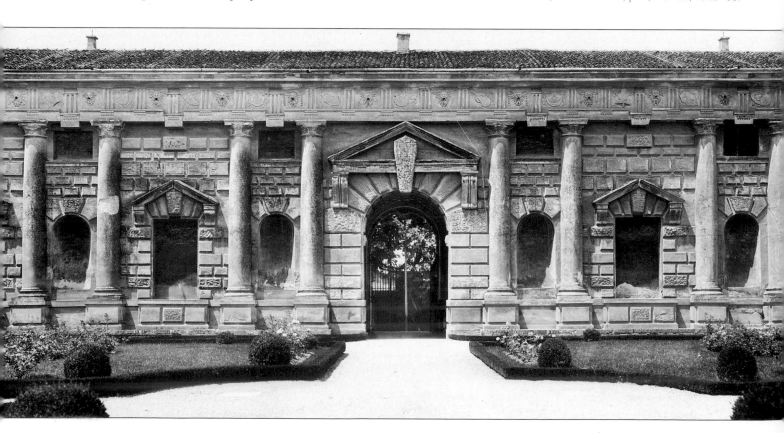

16.13 Giulio Romano, court façade of the Palazzo del Tè, Mantua, 1525–35.

The most spectacular interior decorations in the Palazzo del Tè are in the Sala dei Giganti (Room of the Giants). Here Giulio Romano has frescoed ceiling and walls (figs. **16.14** and **16.15**) with the cataclysmic battle between the Olympian gods and the Titans. The ceiling is a Mannerist version of Mantegna's oculus (see fig. 14.60), which was also painted in Mantua under Gonzaga patronage. It is covered with a large scene depicting Jupiter's temple, swirling cloud formations, and monumental, twisting figures. The gods surround Jupiter as he hurls thunderbolts at the Titans laying siege to Mount Olympos. Below, the world itself seems to crumble before Jupiter's fury.

On the walls, colossal Titans cower under collapsing buildings, or grasp in vain as columns crack in their arms.

As in Mantegna's *Camera degli Sposi* (see fig. 14.58), the viewer is thrown off balance by the illusionistic blend of real and fictive forms. In the Mannerist conception, however, there is an increased turbulence that animates the surface and deepens the space. The humor in all this is contained in the implicit relationship between the meaning of the Titanic mythological battle, and Giulio Romano's architectural disruptions on the courtyard façades. Both represent a rebellion against the rules of a previous historical era, and the establishment of a new order. In the myth, it is a social and religious order and, in the building itself, an architectural order. It is no accident, therefore, that Romano depicts the Titans' fall in architectural terms, and that the crumbling structures are Classical in style.

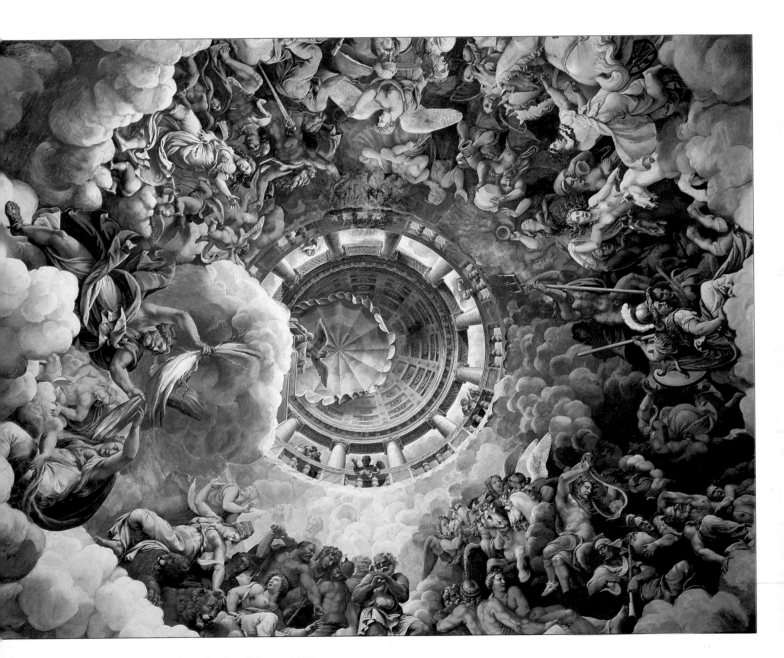

16.14 Giulio Romano, Sala dei Giganti ceiling, Palazzo del Tè.

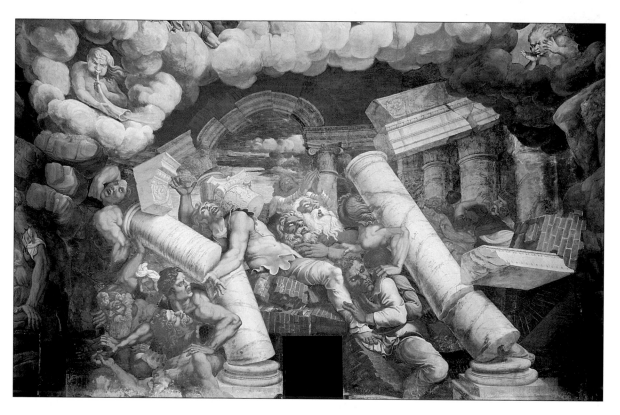

Counter-Reformation Painting

Tintoretto

The impact of the Council of Trent and the Counter-Reformation on the visual arts is most evident from the second half of the sixteenth century. Tintoretto (1518–94), for example, a leading Venetian painter (see Box), and a contemporary of Veronese, painted a *Last Supper* (fig. **16.16**) in 1592–4 that conformed well to Counter-Reformation requirements. The choice of the moment represented, when Christ demonstrates the symbolic meaning of the bread as his body and the wine as his blood, lends itself to mystical interpretation.

In Tintoretto's *Last Supper*, in contrast to those by Veronese (fig. 16.5) and Leonardo (see fig. 15.15), the picture space is divided diagonally. The table is no longer parallel to the picture plane but recedes into the background, and the figures are not evenly lit from a single direction. Humanist interest in psychology and observation of nature has been subordinated to mystical melodrama. To the right of the table, in deep shadow, are servants, going about their business and apparently unaware of the significant event taking place. On the left of the table are the apostles, some in exaggerated poses, illuminated by a mystical light that is consistent with official Counter-Reformation taste. Toward the center of the table, Christ distributes bread to the apostles. Light radiates from his head, so that he is depicted literally as "the light of the world." On the other side of the table, brooding, isolated, and in relative darkness, sits Judas. At the upper right, outlined in glowing light, is a choir of angels.

16.15 Giulio Romano, Sala dei Giganti wall view showing *The Fall of the Giants*, Palazzo del Tè.

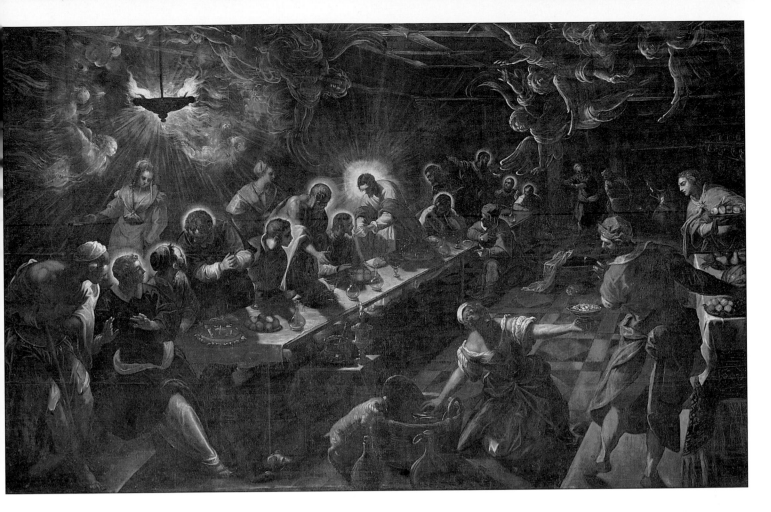

16.16 Jacopo Tintoretto, *The Last Supper*, 1592–4. Oil on canvas, 12 ft × 18 ft 8 in (3.66 × 5.69 m). Chancel, San Giorgio Maggiore, Venice. Jacopo Robusti (1518–94) was nicknamed Tintoretto ("Little Dyer" in Italian) because of his father's profession as a wool dyer. He worked for most of his life in Venice and succeeded Titian as official painter to the republic. He was very prolific and employed many assistants, including two sons and a daughter, Marietta.

El Greco

El Greco (Domenikos Theotokopoulos, 1541–1614) was even more directly a painter of the Counter-Reformation. He worked in Spain from 1577 onwards, when Counter-Reformation influence was at its strongest. In his paintings virtually all traces of High Renaissance style and Classical subject-matter have disappeared. Although he spent time in Titian's workshop, El Greco's style was more affected by the Byzantine influence he encountered in Venice than by Titian's humanism. He was also more in tune with the mystical fervor and religious zeal that predominated in Catholic Spain (see Box). In his late *Resurrection*

Loyola and the *Spiritual Exercises*

Saint Ignatius Loyola (1491/5–1556) was born to a noble Spanish family, and entered military service as a young man. He was wounded, and during his convalescence decided to become a Christian solider. He renounced the material world, lived the life of a beggar, and underwent numerous mystical experiences. In response to Martin Luther and the Protestant Reformation, Ignatius decided to reform the Church from within. He founded the Society of Jesus, which Pope Paul III sanctioned in 1540, and wrote the *Spiritual Exercises* to instruct his followers in meditation.

His system was calculated to conquer fears and passions by a form of empathetic identification practiced in advance of an experience. For example, in the meditation on the "Agony of Death," Ignatius recommends contemplating four things: (1) the dim light and familiar objects in the death room; (2) the people you leave behind; (3) the disintegration of your own body as death approaches; and (4) devils and angels fighting for your soul. His technique was for potential sufferers to create a mental picture, through which trauma would be experienced in advance, and to prepare themselves for the worst. Contemplate, he writes, the "sound of the clock which measures your last hours ... your painful labored breathing ... your face ... covered with cold sweat."[3] And after death has come, imagine yourself "enclosed in a coffin," and the "open grave where they are laying your body." Contemplate your tombstone, months later, "blackened by time ... the worms [that] devour the remains of putrid flesh ... this mass of corruption." And finally, "ask yourself what are health, fortune, friendship of the world, pleasures of the senses, life itself: 'vanity of vanities, all is vanity' (Eccles. 1:2)."

Mystic Saints

Saint Teresa Avila (1515–82) and Saint John of the Cross (1542–91) were full-fledged mystics caught up in Spanish Counter-Reformation zeal. In 1555, at the age of thirty-nine, Teresa converted to the spiritual life while praying to an image of the flagellated Christ. She established the Discalced ('barefoot') communities of Carmelites, so-called because members wore sandals. In addition to Spain, Teresa had missions in the Middle East and Africa. She was aided in her efforts at spiritual reform by Saint John of the Cross. He too joined the Carmelites, and wrote poems and a treatise on the journey of the soul from the world of the senses to God.

Saint Teresa wrote *The Way of Perfection* to instruct her nuns, and an autobiography, which recounts her visions and mystical experiences. In "Completely Afire with a Great Love for God," from the *Life*, she describes her vision of an angel:

> He was not tall, but short, and very beautiful, his face so aflame that he appeared to be one of the highest types of angel who seem to be all afire ... they do not tell me their names.... In his hands I saw a long golden spear and at the end of the iron tip I seemed to see a point of fire. With this he seemed to pierce my heart several times.... When he drew it out ... he left me completely afire with a great love for God ... so excessive was the sweetness caused me by this intense pain that one can never wish to lose it ...[4]

(fig. **16.17**), Mannerism has been placed squarely in the service of Christian mysticism—especially in the depiction of light. Christ rises in light against a dark background, his halo forming a diamond shape. The Roman soldiers reveal their agitation in their twisting, unstable poses. Some are blinded by the divine light of Christ. One soldier falls backwards, toward the picture plane. The surface is animated throughout by flickering flames of light, and three-dimensional space is radically decreased.

Late Sixteenth-Century Architecture

Andrea Palladio

The greatest architect of late sixteenth-century Italy was Andrea Palladio (1508–80), who synthesized elements of Mannerism with the ideals of the High Renaissance. His use of ancient sources, particularly Vitruvius, was inspired by a humanist education (see Box).

From 1566 to 1570, Palladio built the *Villa Rotonda* (figs. **16.18**, **16.19** and **16.20**), near the northern Italian city of Vicenza, for a Venetian cleric. The façade replicates the

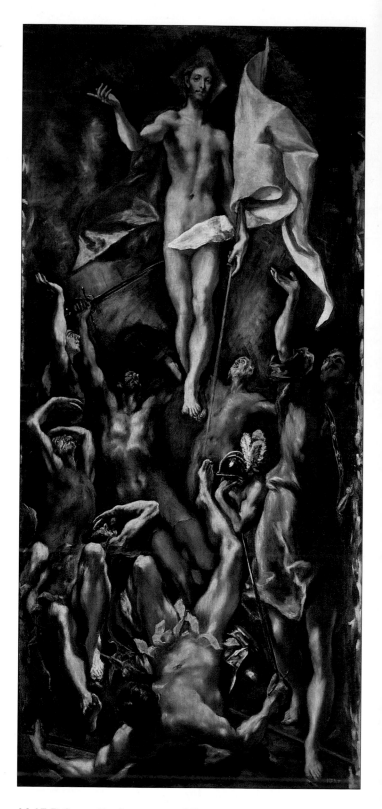

16.17 El Greco, *The Resurrection of Christ*, c. 1597–1610. Oil on canvas, 9 ft ¼ in × 4 ft 2 in (2.75 × 1.27 m). Prado, Madrid. Domenikos Theotokopoulos was born in Crete and subsequently nicknamed El Greco (Spanish for "The Greek"). Most of his work was executed for the Church rather than the court, and has a strongly spiritual quality. Of the leading Mannerist painters, El Greco was the most mystical, and was therefore well suited to the fervent religious atmosphere of Counter-Reformation Spain.

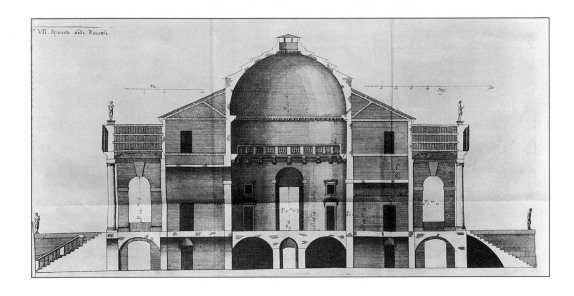

16.18 Section of the *Villa Rotonda* (from the *Quattro libri dell'architettura*, 1570). 18th-century engraving, Bibliothèque de l'Arsenal, Paris.

Plan legend:
1 Column
2 Steps
3 Portico
4 Central domed space

The *Four Books of Architecture*

Four Books of Architecture (*I quattro libri dell'architettura*) by Palladio is the first Western architectural treatise that deals with the work of its author, in addition to ancient architecture. Palladio studied the Roman ruins and published an illustrated edition of Vitruvius in 1556. His own *Four Books*, which were published in 1570, reveal his interest in the Pythagorean philosophy relating musical ratios to the harmony of the universe. In the Renaissance, architectural harmony was also linked with the structures and intervals of music. Palladio illustrated the Classical Orders together with his own plans, elevations, and **cross-sections** of buildings, thereby claiming his own place in the genealogy of Western architects. In 1715 the *Four Books* were translated into English. As a result, Palladio had many architectural descendants, including the eighteenth-century English designer Lord Burlington and, in America, Thomas Jefferson.

16.19 (above) Plan of the *Villa Rotonda*.

16.20 Andrea Palladio, *Villa Rotonda*, Vicenza. Begun 1567–9. Andrea di Pietro Gondola was renamed Palladio (after Pallas Athena) by Count Trissino, a humanist scholar and poet who supervised his education and career. Palladio is known to have been involved in over 140 building projects, of which no more than about thirty-five survive. He also published *L'Antichità di Roma*, the first Italian guidebook, in 1554.

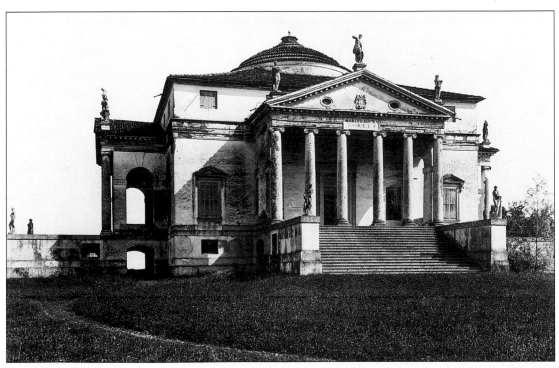

Classical temple portico—Ionic columns supporting an entablature crowned by a pediment—in the context of domestic architecture. There are four porticos, all in the same style and one on each side of the square plan. In Palladio's view, the Classical entrance endowed the building with an air of dignity and grandeur. The strict symmetry was both a Classical and a Renaissance characteristic. Such features recalled ancient Rome, where the villa had originated as an architectural type.

The square plan of the *Villa Rotonda* is typical of Palladio's villas. Passages radiate from the domed central chamber to each of the four exterior porticos. They, in turn, offer views of the surrounding landscape in four different directions. At the sides, each portico is enclosed by a wall pierced by an arch, thereby providing shelter as well as ventilation.

In figure 16.20 some of the classically inspired statues at each angle of the pediments are visible. Others decorate the projecting walls flanking each side of the steps. Since the *Villa Rotonda* was a purely recreational building, used exclusively for entertaining, it did not have the functional additions found in Palladio's other villas.

From 1570 Palladio worked mainly in Venice, particularly on church design. His church of San Giorgio Maggiore (figs. **16.21** and **16.22**), begun in 1566 but not completed until 1592, stands on an island facing the Grand Canal. In this building, Palladio solved the problem of relating the façade to an interior with a high central nave and lower side aisles—the same problem that Alberti had confronted in the Tempio Malatestiano and Sant'Andrea in Mantua (see figs. 14.39 and 14.41). He did so by superimposing a tall Classical façade with engaged Corinthian columns and a high pediment on a shorter, wider façade with shorter columns and a low pediment. The former corresponded to the elevation of the nave, and the latter to that of the side aisles. This relationship between the façade

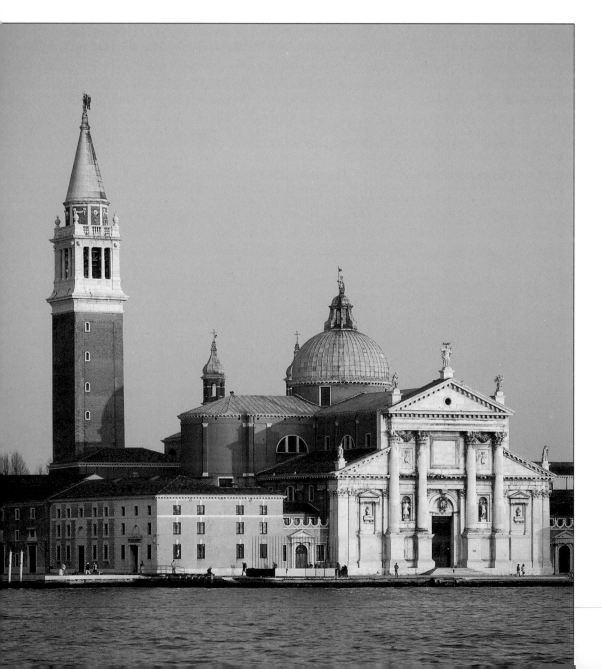

16.21 Andrea Palladio, San Giorgio Maggiore, Venice. Begun 1565.

and the nave and side aisles unified the exterior and interior of the church in a new way (although Alberti had achieved a similar solution in the later fifteenth century in Florence). They are further unified by the repetition of Corinthian columns along the nave and of the shorter pilasters on the side aisles.

In these solutions, Palladio incorporates Classical elements into religious as well as domestic architecture. Nevertheless, the order and the relationship of the elements are not strictly Classical. It would be difficult to demonstrate that his works are Mannerist, but they share with Mannerism the tendency to juxtapose form and space in a way that is inconsistent with Classical arrangements. For example, Palladio breaks, or interrupts, one pediment in imposing another over it. This feature, called a **broken pediment**, becomes a characteristic aspect of Baroque architecture in the seventeenth century (see Chapter 18). In superimposing larger and smaller façades, as in San Giorgio Maggiore, and combining a temple portico with a domestic villa, Palladio recalls certain unexpected juxtapositions and combinations found in Mannerist painting.

Palladio was the single most important architect of his generation, and his influence on subsequent generations of Western architects was extensive. His style was revived in England and America in the eighteenth century, and his palaces and villas are still imitated today.

Vignola and Il Gesù

There developed in the late sixteenth century a new conception of church design that would exert a profound influence on the Baroque architecture of the seventeenth century. This was brought about when the Jesuit order founded by Saint Ignatius decided to build a new mother church, the Church of Il Gesù, for its headquarters in Rome. The powerful Roman cardinal Alessandro Farnese became the patron of the Jesuits in 1565, and he eventually gave the commission for the construction of the church to Giacomo da Vignola (1507–73). In contrast to the classicizing architecture of Palladio, Vignola's design was intended to reflect Counter-Reformation concerns and to satisfy the requirements of the Council of Trent.

Figure **16.23** shows the plan of the Gesù, based on a Latin cross to accommodate large congregations, rather than on the centralized Greek cross preferred in the Renaissance. The transepts are short and, instead of side aisles to permit circulation

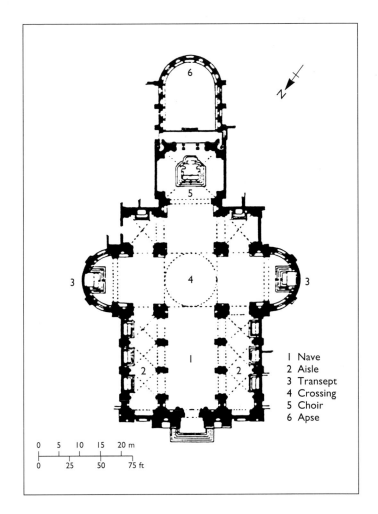

1 Nave
2 Aisle
3 Transept
4 Crossing
5 Choir
6 Apse

16.22 (above) Plan of San Giorgio Maggiore, Venice.

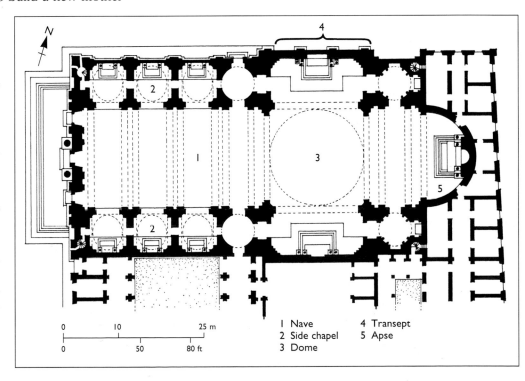

1 Nave 4 Transept
2 Side chapel 5 Apse
3 Dome

16.23 Giacomo da Vignola, plan of the Church of Il Gesù, 1565–73, Rome.

around the nave, Vignola designed side chapels for individual prayer. The bulk of the worshipers were thus channeled into the large, barrel-vaulted nave, and their attention was focused on the priest and the altar. At the same time, the choir was distinctly separate from the nave to accentuate the hierarchical distinction between the clergy and the public. Also emphasizing this distinction was the lengthened route from the sacristy, where the priest prepares for Mass, to the altar, where he performs the Mass. This increased the time it took the priest to reach the altar and heightened worshipers' sense of anticipation

before the Mass began. Most of the interior light came from the windows of the dome and was thus concentrated on the **crossing** below, creating a mystical effect of the sort encouraged by the Council of Trent.

Vignola died before completing the Gesù, and the dome and façade were finished by Giacomo della Porta (1532/3–1602) in 1573. Figure **16.24** shows the façade as Vignola designed it, preserved in a sixteenth-century engraving, and figure **16.25** is the existing façade by della Porta. The façade as conceived by Vignola was influenced by Alberti's architecture and has some similarities to that

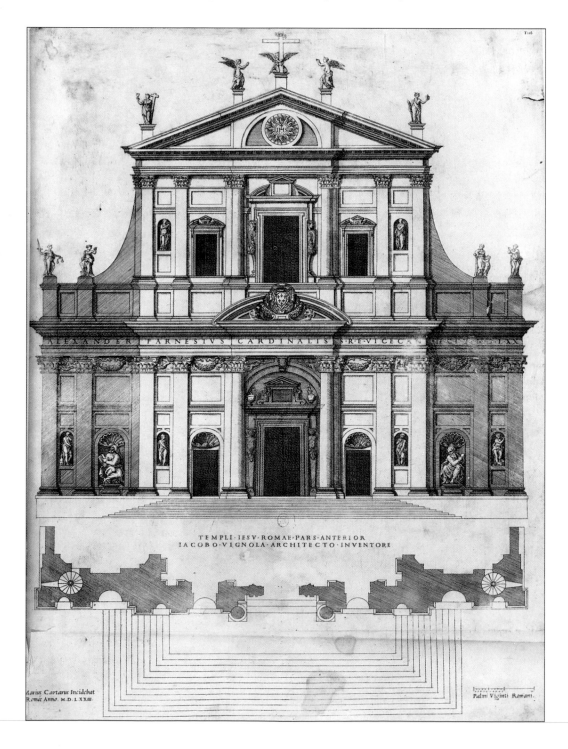

16.24 Church of Il Gesù, Rome. Engraving of Vignola's design for the façade, late 16th century.

of Palladio's San Giorgio Maggiore, but the superimposed Greek portico of San Giorgio has been eliminated. Instead of colossal Orders of engaged half-columns supported on large bases that overlap the ground floor and the pediment, the Gesù has two sets of double columns, one on each story. As a result, the Gesù appears to be more imposing and taller than San Giorgio, which was a quality that appealed to the Jesuits.

Vignola originally planned the interior with simplicity in mind, which would have conformed to the style of other early Jesuit churches. But della Porta increased its complexity, integrating sculpture into the wall surface of the façade and adding **volutes**. He also used two sets of half-columns, one set on each level, as well as several pairs of pilasters. The final product was more complex, and had more surface movement and formal animation, than most Renaissance churches. The Gesù was enormously influential. Its complexity would be taken up by Baroque architects and carried by Jesuit missionaries throughout the world.

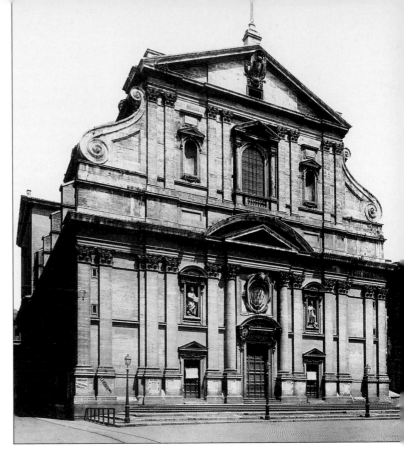

16.25 Giacomo da Vignola and Giacomo della Porta, façade of the Church of Il Gesù, Rome, c. 1575–84.

	Style/Period	Works of Art	Cultural/Historical Developments
1520	MANNERISM AND LATE 16TH-CENTURY ITALY 1520–1540	Parmigianino, *Self-portrait in a Convex Mirror* (**16.2**) Romano, Palazzo del Tè (**16.13–16.15**), Mantua Parmigianino, *Madonna and Child with Angels* (**16.3**) de' Rossi (attrib.), *Joseph and Potiphar's Wife* (**16.8**)	**Parmigianino, Self-portrait**
	1540–1550	Cellini, *Saltcellar* of Francis I (**16.7**) Bronzino, *Venus, Cupid, Folly, and Time* (**16.4**) Bronzino, *Eleonora of Toledo and her Son Don Giovanni* (**16.6**) Cellini, *Narcissus* (**16.10**) **Cellini, Salt-cellar**	Council of Trent introduces Counter-Reformation policies (1545–63) **Bronzino, Eleonora of Toledo and her Son Don Giovanni**
1550	1550–1570 **Palladio, San Giorgio Maggiore**	Anguissola, *The Artist's Sister Minerva* (**16.9**) Palladio, San Giorgio Maggiore (**16.21**), Venice Vignola and della Porta, Church of Il Gesù (**16.24–16.25**), Rome Palladio, *Villa Rotonda* (**16.18, 16.20**), Vicenza	Sir Philip Sidney, English poet and soldier (1554–86) Francis Bacon, English philosopher and statesman (1561–1626) Vasari, *Lives ...* (1564) Pierre de Ronsard, *Elegies* (1565)
1600	1570–1600 **Giambologna, Mercury**	Veronese, *Christ in the House of Levi* (**16.15**) Giambologna, *Mercury* (**16.11**) Tintoretto, *The Last Supper* (**16.16**) El Greco, *The Resurrection of Christ* (**16.17**)	Turkish fleet defeated at Lepanto (1571) Francis Drake starts circumnavigation of world via Cape Horn (1577) Catacombs discovered in Rome (1578) Mary, Queen of Scots, executed (1587) Monteverdi's first book of madrigals (1587) Christopher Marlowe, *Dr. Faustus* (1588) English fleet defeats Spanish Armada (1588) Galileo Galilei, *De Motu*, describing experiments on falling bodies (1590) Edict of Nantes establishes religious toleration (1598) William Shakespeare, *Hamlet* (1600)

17

Sixteenth-Century Painting in Northern Europe

As in the fifteenth century, northern Europe in the sixteenth century underwent many of the same developments as the south (fig. **17.1**). The most important northern artists were the painters of Germany and the Netherlands, several of whom traveled to Italy and were influenced by humanism. Nevertheless, the north was always less comfortable with Classical forms in art than was Italy. The elegant linear qualities, rich colors, and crisp edges of International Gothic forms persist in Netherlandish and German painting. Northern artists were also less interested than the Italians in the subtleties of *chiaroscuro* and modeling, and the textured, painterly qualities of the late Venetian Renaissance do not often appear in the north.

The north did, however, produce some of Europe's most distinguished humanists, including the prolific writer and scholar Erasmus of Rotterdam (see Box). Germany was the home of Martin Luther (see Box), whose views launched the Protestant Reformation. Humanism, as well as Protestantism, clashed with the Inquisition, and religious strife continued to intensify from the late fifteenth century. The opposition of the Church to both the humanists and the

17.1 Map of northern and central Europe in the Renaissance.

Erasmus

Desiderius Erasmus of Rotterdam (c. 1466–1536) was a Roman Catholic reformer and one of the greatest Renaissance humanists in northern Europe. The illegitimate son of a priest, Erasmus was ordained in 1492 and then studied Classics in Paris. Among his most important works is *Moriae encomium* ("The Praise of Folly") of c. 1511, in which he satirizes greed, superstition, and the corruption and ignorance of the clergy. He argues that piety depends on spiritual substance rather than on the observance of religious ceremony.

Erasmus's satirical inclinations were well suited to the northern interest in proverbs as a way of revealing human folly. His *Adagia* ("Adages"), published in 1500, is a compendium of sayings that contain hidden or double meanings. In 1513, he published a satire on Julius II in which the pope is excluded from heaven. Julius announces himself

to Saint Peter as "P.M." (meaning *Pontifex Maximus*, or "Highest Priest"), but Saint Peter takes "P.M." to mean *Pestis Maxima*—"the Biggest Plague." Through the personage of Saint Peter, Erasmus objects to Julius II as an arrogant lush tainted by political and military ambition.

Erasmus' knowledge of Classical languages is evident in his publication of the first edition of the New Testament in Greek (1516); he also published a Latin translation of it. He believed that Latin would bridge the gap between divergent cultures, and thus be a force for unification.

Erasmus was a moderate in an age of extremism. But his tolerance and reason limited his influence as compared with that of Martin Luther. He opposed the Reformation, fearing the destructive effects of partisan religious strife. Attacked by Catholics and Protestants alike, Erasmus remained committed to reconciliation and unity.

Protestants was often virulent and excessive. One striking expression of the work of the Inquisition was its opposition to alleged witchcraft. In 1487, two German Inquisitors—Heinrich Kramer (d. 1500) and James Sprenger (d. 1494), both of whom were members of the Dominican order—had published *The Witches' Hammer*. In it, they described the characteristics of witches and recommended methods of torture for extracting confessions from them.

In a more humanist vein, northern Europe, like Italy, displayed an interest in artists' biography, which was revived as part of the Classical tradition and was consistent with the rise in the social status of the artist. In 1604 Karel van Mander (1548–1606) of Haarlem, Holland, published *Het Schilderboeck* (*The Painter's Book*), describing the lives of northern artists. Like Vasari's *Lives*, it has become an important source for the history of Renaissance art.

One of the most prevalent humanist expressions in the north was the proverb. Humanists such as Erasmus collected proverbs, many of which were Classical in origin, as a way of educating people and arousing interest in antiquity. Whereas the Italian humanists concentrated on reviving Classical forms and the texts on which they were based, the northerners used proverbs to connect the Classical past with the present. They explained the proverbs, placing them in their historical context, and also showed their relevance to contemporary life. This development was consistent with the northern tradition of depicting bourgeois genre scenes (scenes of everyday life).

The Netherlands

Hieronymous Bosch

The Seven Deadly Sins and the Four Last Things Corruption in the Catholic Church, which led to the Reformation, and the follies of humanity became popular subjects in the north. Religious and social satire inspired writers and artists, especially in the Netherlands and Germany. In the visual arts, this inspired iconographic themes containing moral messages. A satirical, moralizing tone is evident in the paintings of Hieronymus Bosch (c. 1450–1516). Little is known of Bosch's artistic development, but he created some of the most original and puzzling imagery in Western art. *The Seven Deadly Sins and the Four Last Things* (fig. **17.2**) has been dated early in Bosch's career by some scholars, and late by others. Some question the attribution to Bosch, but it is generally accepted as either his work or his conception. Painted on a table top, it expresses the medieval view that life on earth is a mere reflection, or mirror, of heavenly perfection. God, according to this view, is both the creator and the "eye." He watches, remembers, and in the end punishes or rewards, according to one's merits while on earth.

The large central circle of the painting is a metaphor in which the eye is a mirror. It is a variation on the convex mirror in van Eyck's *Arnolfini Wedding Portrait* (see fig. 14.74), which, according to the traditional iconographic reading, reflects the artist and also symbolizes God's presence. In *The Seven Deadly Sins*, the resurrected Christ occupies the center of a dark circle, with rays of light extending from it—a visual metaphor for the pupil in an eye. Inscribed in Latin under the figure of Christ is, in Gothic letters, *Cave cave Dus* [an abbreviation of *Dominus*] *videt* ("Beware beware, the Lord sees").

On the outermost ring of the circle are seven scenes from daily life illustrating the Seven Deadly Sins. They are no longer represented as medieval personifications, but

17.2 Attributed to Hieronymus Bosch, *The Seven Deadly Sins and the Four Last Things*, painted table top. Oil on wood, 3 ft 11¼ in × 4 ft 11 in (1.2 × 1.5 m). Prado, Madrid. None of Bosch's pictures has a documented date. This painting is variously regarded as an early (c. 1475) or a late (1505–15) work. All that is known of Bosch is that he lived in the small Dutch town of Hertogenbosch (from which his name is derived) and was a member of a religious fraternity, the Brotherhood of Our Lady. He believed in the pervasiveness of sin, usually of a sensual nature, and his works illustrate the torments of hell in vivid detail.

instead are integrated into the routines of daily life. *Superbia* (Pride, fig. **17.3**) is represented as a vain, bourgeois woman admiring herself in a mirror. A box of jewels, symbolizing the vanity of the world, lies open on the floor. The figure occupies an orderly, middle-class room, decorated with elegant jugs and vases, that reveals pride in her house. Reaching around from behind the chest, and holding up the mirror, is a devil—a moral warning against self-love and the vanity of appearances.

To the left of Pride is *Ira* (Anger), shown as a street fight between neighbors, and *Invidia* (Envy), the next scene to the left, is a verbal quarrel, the acrimony of which is

enhanced by barking dogs with bared teeth. The dog on the left looks up at a large bone, while the other glares enviously at him. Neither dog seems interested in the two available bones between them on the ground. Like envious people, the dogs are never satisfied with what they have, but only want what the other one has. *Avaritia* (Avarice) is represented as a rich man taking money from a poor man while bribing a judge. The remaining scenes represent *Gula* (Gluttony), *Accidia* (Sloth) and *Luxuria* (Lust). This combination of Christian moralizing with scenes of daily life mixed with humor is characteristic of late Renaissance painting in the Netherlands.

Saint Peter greets the saved, and a fiery hell. Heaven is an orderly, harmonious court illuminated by divine light. Hell is dark, disordered, and fraught with torture and destruction.

The Garden of Earthly Delights The meaning of Bosch's huge, complex, and controversial triptych known as *The Garden of Earthly Delights* (fig. **17.4**), now generally dated c. 1510–15, is more obscure than the images on the painted table top. Documents suggest that the *Garden* was a secular commission for the stateroom of the House of Nassau in Brussels, although this is debated by scholars. The work has been interpreted in a number of ways—as a satire on lust, as an alchemical vision (see Box), and as a dream world revealing unconscious impulses. But there are also a number of traditional Christian features in the triptych, which argues for a religious commission, and some scholars identify the primary source of the iconography as the Bible. The Garden of Eden is represented in the left panel. In the foreground, God presents the newly created Eve to a reclining Adam. The prickly tree behind Adam is the Tree of Life. In the middle ground, a curious fountain—the *fons vitae*—stands in a pool of water, and in the background wild animals exist in a state of apparent tameness.

Even in Paradise, however, Bosch's taste for biting satire is evident in certain details that prefigure the Fall. In the foreground, for example, a self-satisfied cat strolls off with a dead mouse in its mouth. At the upper right, a lion eats a deer, while a boar pursues a fantastic animal. Ravens, which can symbolize death, perch on the fountain of life, and the owl in the opening of the fountain could denote the nocturnal activities of witches and devils. Eve's role as the primal seductress is clear from Adam's response to her. He is not the traditional, languid or sleeping figure of Michelangelo (see fig. 15.25), but is alert and wide awake. He literally "sits up and takes notice" of the creature to whom he is being introduced. His reaction is all the more significant in the presence of the serpent coiling itself around the Tree of Life.

17.3 Hieronymus Bosch, *Superbia* (detail of fig. 17.2).

The four corners of the table top illustrate the Four Last Things, a reminder of mortality and the rewards or punishments that follow. In the deathbed scene at the upper left, a dying man receives the last rites. The angel and devil at the head of the bed wait to see which will take his soul. In the corner, members of his family continue their lives, more engaged in the game they are playing than in the deathbed scene. At the upper right, Christ presides over the Last Judgment, and the dead rise from their graves. In the lower right and left, respectively, are heaven, where

Alchemy

Alchemy is the process by which base metals are believed capable of being changed into gold, and it was practiced by several well-known historical figures, including Leonardo da Vinci. The practice of alchemy in both eastern and western cultures had symbolic, as well as financial, meanings that are extremely complex and elusive. (The unreal and obsessive qualities of alchemy were satirized by moralists such as Bruegel—see *The Alchemist*, fig. 17.8) Alchemy could symbolize the cosmos and the quest for immortality, the spiritual evolution of the individual, and the recovery of a state of perfection that existed before the Fall of Man. Of the numerous symbolic constructs in alchemy, two of the most prominent are the Philosopher's Stone and the Philosopher's Egg. The former makes possible regeneration and spiritual fulfilment, while the latter embodies the source of birth and, therefore, of spiritual rebirth.

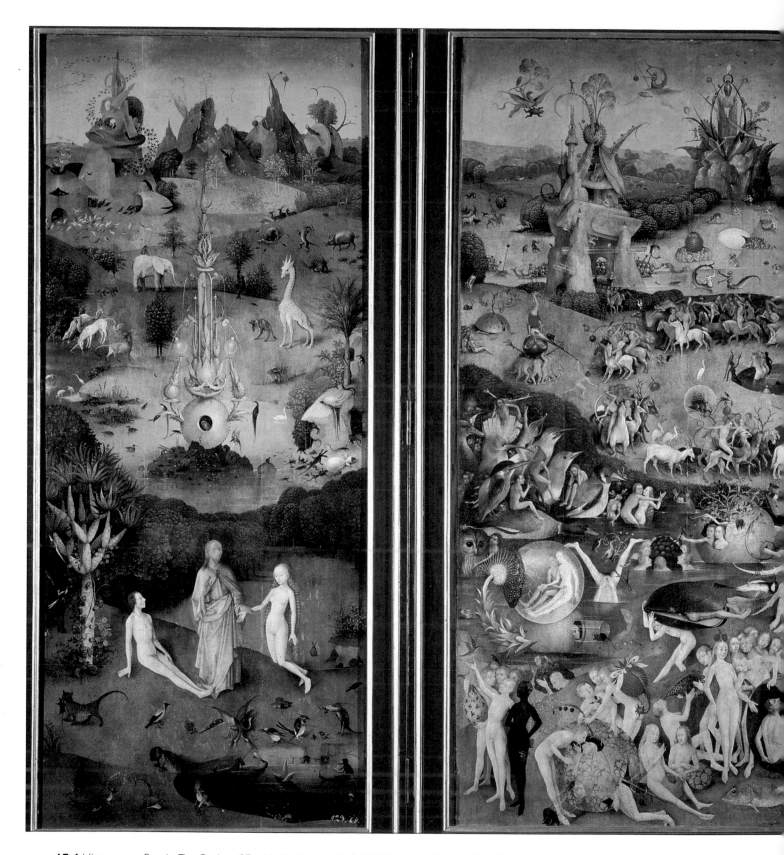

17.4 Hieronymus Bosch, *The Garden of Earthly Delights*, c. 1510–15. Triptych: left panel *The Garden of Eden*, center panel *The World Before the Flood*, right panel *Hell*. Oil on wood, left and right panels 7 ft 2 in × 3 ft (2.18 × 0.91 m); center panel 7 ft 2 in × 6 ft 4 in (2.18 × 1.93 m). Museo del Prado, Madrid.

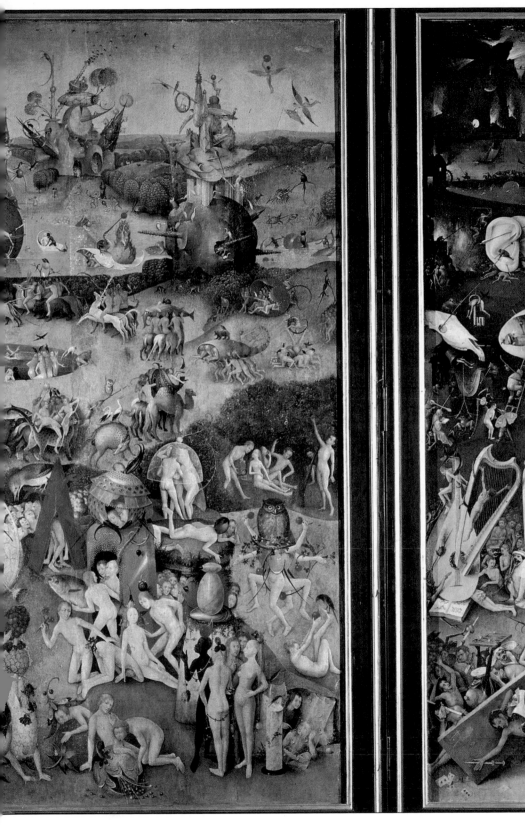
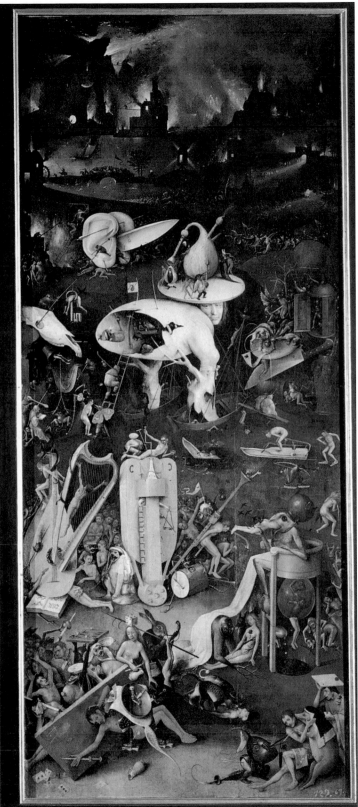

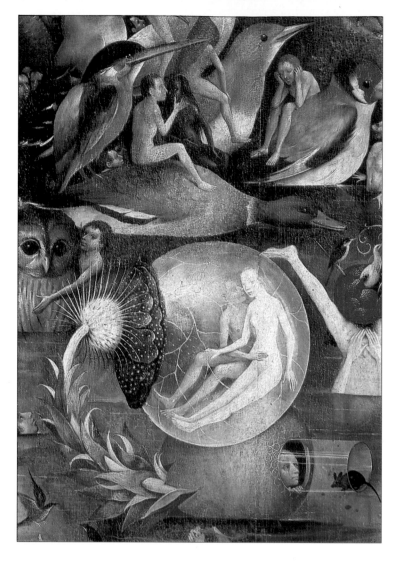

17.5 Hieronymus Bosch, Couple in the transparent globe (detail of fig. 17.4).

The human figures in the large central panel seem largely engaged in sexual pursuits. The amorous couple enclosed in a transparent globe, a reference to the transience of lust (fig. **17.5**) illustrates the proverb: "Happiness is like glass, both are soon gone." The upper regions of the central panel depict what is generally identified as a Tower of Adultresses in the Pool of Lust. It is decorated with horns and filled with cuckolded husbands. Four so-called castles of vanity stand at the pool's edge. In the middle ground, a procession of frenzied human figures mounted on animals endlessly circles a Pool of Youth. The human figures are small in relation to the strange plant and animal forms that populate the picture's space. Some are enclosed in transparent globular shapes that suggest alchemical vessels. The illogical juxtapositions of size, together with the strange symbolic details, such as the enlarged strawberries, have led some scholars to think that Bosch is depicting an inner, dreamlike world. Consistent with Christian tradition, however, is the conventional opposition of the era before the Fall on the left and Hell on the right. The sinister aura of the central panels suggests moralizing on the artist's part, which may refer to the decadence of humanity that led God to unleash the Flood.

In Hell, buildings burn in the distance. The scene is filled with elaborate tortures and dismembered body parts taking on a life of their own. Musical instruments that cause pain rather than pleasure reflect the medieval notion that music was the work of Satan. One figure is crucified on the strings of a harp, and another is impaled on a long flute. A seated monster, probably Satan himself, swallows one soul and simultaneously expels another through a transparent globe. A pair of ears with no head is pierced by an arrow.

At the center of this vision of hell is a monster whose body resembles a broken egg (fig. **17.6**), possibly a reference to the alchemical egg. He is supported by tree trunk legs, each of which stands in a boat. His egglike body is cracked open to reveal a witch serving a table of sinners. On his head, the eggman balances a disk with a bagpipe, which is a traditional symbol of lust in Western art. Peering out from under the disk, and seemingly weighed down by it, is an individualized face, which could be Bosch's self-portrait. The specific nature of the face and its self-conscious appeal to the observer are conventional aspects of artists' self-portraits when they are incorporated into larger narratives. Like the fantastic complexity and tantalizing obscurity of Bosch's images in this work, however, the meaning of the face remains unexplained.

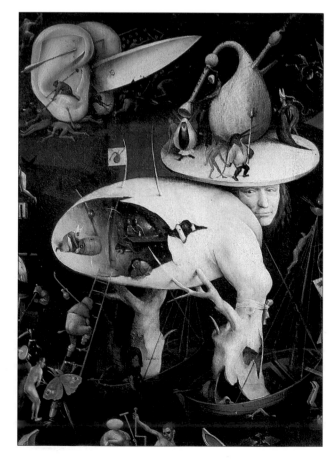

17.6 Hieronymus Bosch, Monster with an egglike body (detail of fig. 17.4).

Pieter Bruegel the Elder

The foremost sixteenth-century painter of the Netherlands, and a follower of Bosch, was Pieter Bruegel the Elder (c. 1525–69). Early in his career, Bruegel worked in the port city of Antwerp, in modern Belgium, an international center of commerce and finance. Bruegel trained in a printing concern, which accounts for his prolific graphic output. In 1551 he became a master in the painters' guild, and the following year departed for Italy. His trip influenced his work considerably, in particular his taste for landscape. While in Italy he made many drawings of the landscape, especially the Alps and the southern seacoast, but he made virtually no sketches of the Roman sculpture and architecture that appealed to Italian Renaissance artists. Bruegel's passion for landscape reflects his belief that nature is the source of all life, a notion that can be related to the contemporary interest in explorations of the globe and is also derived from Petrarch's humanism.

In his *Landscape with the Fall of Icarus* (fig. **17.7**), Bruegel expresses his love of landscape for its own sake, for much of the picture plane is dominated by a seascape including boats, rocks, and a distant horizon. Bruegel's vision of humanity in nature is shown by the intense relationship between the peasant pushing his plowshare and the land. The folds of the peasant's tunic repeat the furrows of the plowed earth beneath him, formally uniting him with the land. The most outstanding feature of this figure is his bright red sleeve, which contrasts with the subdued tones of the scene. Below the peasant, a shepherd tends his flock, while a third man leans over the edge of the sea. The shepherd rests on his crook, and gazes up at the sky. In the context of the myth (see caption), it is likely that he is watching the flight of Daedalus, but he does not notice the drowning Icarus. The other two figures are so absorbed in their tasks that they fail to observe the mythical event taking place. Bruegel's philosophy as expressed in this painting conforms to the German proverb: "No plow stops for a dying man." (See Box on p. 614.)

To the humanist integration of antiquity with contemporary concerns, Bruegel adds the Christian moralizing tradition of northern Europe. The *Fall of Icarus* implies that it is wiser to till the land than to brave the skies, which was also the message of his *Tower of Babel* (see fig. 1.5; 1.7

17.7 Pieter Bruegel the Elder, *Landscape with the Fall of Icarus*, c. 1554–5. Oil on panel (transferred to canvas), 2 ft 5 in × 3 ft 8⅛ in (0.74 × 1.12 m). Musées Royaux des Beaux-Arts de Belgique, Brussels. Although famous for his peasant scenes and known as "Peasant Bruegel," Bruegel was a townsman and a humanist. Here he combines the theme of man's unity with landscape with the Classical myth of Icarus. Daedalus, the father of Icarus, fashioned a pair of wings out of feathers held together by wax, and warned his son not to fly too near the sun. Icarus disobeyed, the sun melted his wings, and he drowned in the Aegean Sea. In the painting, Icarus can be seen flailing around in the water just below the large ship on the right.

17.8 Pieter Bruegel the Elder, *The Alchemist*, 1558. Drawing, 12 × 17¾ in (30.5 × 45 cm). Kupferstichkabinett, Staatliche Museen, Berlin. After 1563, according to van Mander's biography of him, Bruegel's mother-in-law insisted he move to Brussels and end the relationship with his mistress in Antwerp. While in Brussels, he received commissions from the city council as well as from private patrons.

in the Combined Volume). There, too, though in a biblical setting, Bruegel depicts the dangers of unrealistic ambition, as the tower seems to crumble and fall like Icarus. For Bruegel, therefore, what the Greeks called *hubris* (a concept encompassing "pride" and "unrealistic ambition") corresponds to the Netherlandish notion of human folly, a persistent theme in his paintings. Folly, in Bruegel's view, turns things upside-down, just as Icarus has landed head first with his feet flailing in the air. To avoid such a fall, according to Bruegel's imagery, one is advised to concentrate on work. Even in our own age of air travel and space programs, popular wisdom considers it a virtue and a sign of mental stability to "have one's feet planted firmly on the

ground." People who "fly too high" are considered overly ambitious and destined for a fall.

Bruegel's drawing of *The Alchemist* (fig. **17.8**) is another visual parable about the folly of irrational ambition. The alchemist spurns real work and, instead of earning money for his family, tries to make gold from a spurious formula. Bruegel indicates the obsessive nature of alchemy by the alchemist's intense concentration, and the lab equipment filling his home. The results of his obsession are evident in his wife and children leaving the house to beg. The irony of the family going begging while the father pursues a fantasy of gold contributes to the biting satire of Bruegel's drawing.

The following year, 1559, Bruegel painted *Netherlandish Proverbs* (fig. **17.9**), which is the visual equivalent of Erasmus's *Adagia* (see Box on p. 606). It is an outdoor scene filled with about one hundred figures, each of whose activities exemplify a moral principle. But every instance fulfills the proverb in the negative, creating the "world upside-down" that stood for Bruegel's view of human folly. The predominant colors are yellows and browns, which are accented throughout by blues and reds—blue denoting cheating and foolishness, and red, sin and arrogance. The painting is also called *The Blue Cloak* from the detail in which a woman in a sinful red dress puts a blue cloak on her foolish husband (fig. **17.10**). The pointed hood is an allusion to the horns of the cuckold.

17.9 (above) Pieter Bruegel the Elder, *Netherlandish Proverbs*, 1559. Panel, 3 ft 10 in × 5 ft 4½ in (1.17 × 1.63 m). Staatliche Museen, Berlin

17.10 (below) Pieter Bruegel the Elder, *Netherlandish Proverbs* (detail of fig. 17.9).

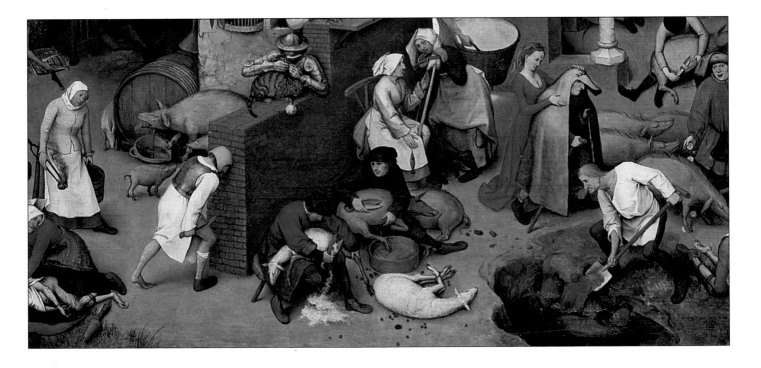

The large number of scenes in this painting makes it difficult to discern the individual proverbs in a small reproduction, but we can identify a few of them in the detail. A woman carries a bucket of water in her left hand, and a burning firepoker in her right ("the right hand doesn't know what the left is doing"). At the left, a man sits on the ground between two stools ("to fall between two stools"). At the lower right, a man whose calf has already drowned is filling the well ("closing the barn door after the horse has gone"), and roses are scattered around a pig ("to cast pearls before swine"). Gossip is represented as two women, one spinning and the other holding the distaff (they literally "spin tales"). Other proverbs illustrated in the picture include "to hold an eel by the tail" (the man at the right in the hut on the water is holding a large eel), "big fish eat little fish" (in the water), "jumping from ox to ass," or "from the frying pan into the fire" (the man by the door of the castle tower), and at the lower left another man "beats his head against a brick wall."

Entirely different in mood, but nevertheless moralizing, is Bruegel's *Peasant Dance* (fig. **17.11**) of c. 1567, which represents the celebration of a feast day of the church. In contrast to the workaday peasants in *The Fall of Icarus*, these indulge the enjoyments of dancing, eating, drinking, music-making, and lust. On the right, two peasants literally "kicking up their heels" seem to dance their way into the picture plane. The dancers in the background give way to even greater abandon. On the left, the bagpipe provides a formal echo of the rotund figures. The slow, deliberate peasants who occupied the landscape near Icarus's fall

have become energetic, filled with vitality and rhythm. Their folly, according to Bruegel's iconography, is that they ignore the distant church and the image of the Virgin and Child attached to the tree at the right.

Bruegel lived during the tense years of the Reformation and the Counter-Reformation, which coincided with Spanish rule of the Netherlands. Nothing is known for certain of his personal response to these events, although it is clear that he was a well-educated humanist. In his art, Bruegel creates a synthesis of Christian genre and Classical imagery, which is at once moralizing and satirical.

Germany

Albrecht Dürer

The German taste for linear quality in painting is especially striking in the work of Albrecht Dürer (1471–1528). He was first apprenticed to his father, who ran a goldsmith's shop. Then he worked under a painter in Nuremberg, which was a center of humanism, and in 1494 and 1505 he traveled to Italy. He absorbed the revival of Classical form and copied Italian Renaissance paintings and sculptures, which he translated into a more rugged, linear northern style. He also drew the Italian landscape, studied Italian theories of proportion, and read Alberti. Like Piero della Francesca and Leonardo, Dürer wrote a book of advice to artists—the *Four Books of Human Proportion* (*Vier Bücher von menschlichen Proportion*).

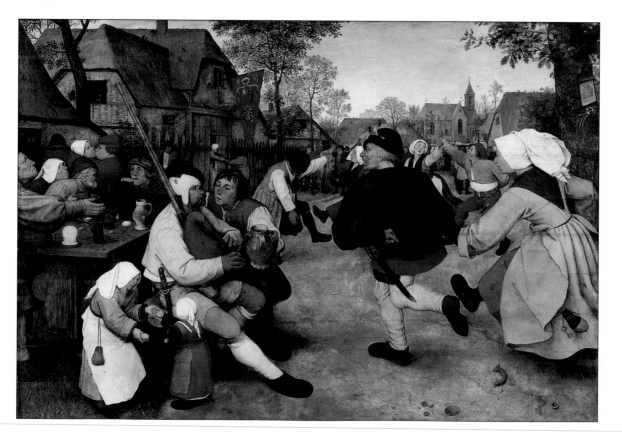

17.11 Pieter Bruegel the Elder, *The Peasant Dance*, c. 1567. Oil on wood, approx. 3 ft 9 in × 5 ft 5 in (1.14 × 1.65 m). Kunsthistorisches Museum, Vienna. Bruegel moralizes through a kind of visual irony. As in fig. 17.7, the peasants are oblivious to the moral message that lies right before their eyes. They do not see, for example, the church in the distant background that overlooks the scene—an architectural version of the all-seeing God in the table top (fig. 17.2). Equally ignored, a little picture of the Madonna hangs on the tree at the far right.

German satirical poet Sebastian Brant (1457–1521) had published *The Ship of Fools* (*Narrenschiff*) in Basel, Switzerland. This was a moralizing metaphor of life's foolishness, and reflected the humanist atmosphere of parts of northern Europe. Like Erasmus and Bruegel, Brant collected proverbs that exemplify human folly, and Dürer's woodcuts illustrate some of Brant's assembled "fools."

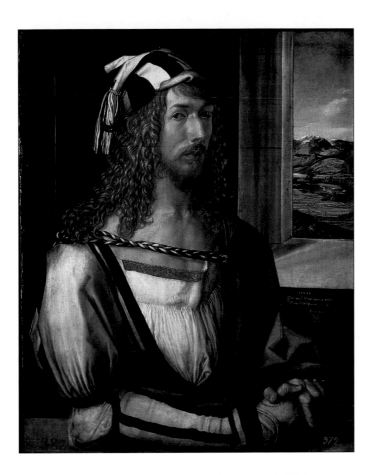

17.12 Albrecht Dürer, *Self-portrait*, 1498. Oil on panel, 20½ × 16 in (52 × 40.6 cm). Prado, Madrid. Dürer was born in Nuremberg, Germany, to a family of goldsmiths. He was trained as a metalworker and painter and in his twenties traveled in Italy. Young German artists traditionally spent a *Wanderjahr*, or year of travel, visiting different parts of Europe and studying art. From 1512, as court painter to the Holy Roman Emperor, Dürer became the most important figure in the transition from late Gothic to Renaissance style in northern Europe.

The *Self-portrait* (fig. **17.12**) of 1498 reveals the influence of Leonardo, whom Dürer greatly admired, in the figure's three-quarter view and the distant landscape. Although set in a three-dimensional cubic space, according to the laws of fifteenth-century perspective, and consistently illuminated from the left, Dürer's figure is painted with a crispness of edge that would be unusual in Italy. The attention to patterning in the long curls and in the details of costume also reveal Dürer's interest in line for its own sake. Particularly prominent in this and other works by the artist is his signature monogram—a D within an A—which is accompanied here by an inscription. The lettering, as well as expressing linearity, is the artist's statement of his own role in creating the image. Dürer's confident sense of himself is conveyed by his upright posture, firmly clasped hands, and elegant costume; it is also a reflection of the social status he had achieved in Nuremberg.

Dürer's interest in line is most apparent in his work as a **woodcut** artist and engraver (see Box). In 1494, the

The Development of Printmaking

Printmaking is the generic term for a number of processes, of which **engraving** and woodcut are two prime examples. **Prints** are made by pressing a sheet of paper (or other material) against an image-bearing surface (the **print matrix**) to which ink has been applied. When the paper is removed, the image adheres to it, but in reverse.

The woodcut had been used in China from the fifth century A.D. for applying patterns to textiles, but was not introduced into Europe until the fourteenth century. First it was used for textile decoration and then for printing on paper. Woodcuts are created by a relief process. First, the artist takes a block of wood sawn parallel to the grain, covers it with a white ground, and draws the image in ink. The background is then carved away, leaving the design area slightly raised. The woodblock is inked, and the ink adheres to the raised image. It is then transferred to damp paper either by hand or with a printing press.

Engraving, which grew out of the goldsmith's art, originated in Germany and northern Italy in the middle of the fifteenth century. It is an **intaglio** process (from the Italian *intagliare*, "to carve"). The image is incised into a highly polished metal **plate**, usually of copper, with a cutting instrument, or **burin**. The artist then inks the plate and wipes it clean so that some of the ink remains in the incised grooves. An impression is made on damp paper in a printing press, with sufficient pressure being applied so that the paper picks up the ink.

Both woodcut and engraving have distinctive characteristics. Dürer's engraving in figure 17.16, for example, shows how this technique lends itself to subtle modeling and shading through the use of fine lines. Hatching and cross-hatching determine the degree of light and shade in a print. Woodcuts, as in figure 17.14, tend to be more linear, with sharper contrasts between light and dark, and hence more vigorous.

Printmaking is well suited to the production of multiple images. A set of multiples is called an **edition**. Both methods described here can yield several hundred good quality prints before the original block or plate begins to show signs of wear. Mass production of prints in the sixteenth century made images available, at a lower cost, to a much broader public than before. Printmaking played a vital role in northern Renaissance culture, particularly in disseminating knowledge, expanding social consciousness, and in the transmission of artistic styles.

In *The Folly of Astrology* (fig. **17.13**), the Fool is dressed as a peasant and wears a "foolscap," with the ears of an ass and bells. He lectures on astrology to a man wearing the robes of a scholar, who listens attentively and is taken in by the foolish discourse. In the upper corners of the woodcut are the astrological signs of the sun and the crescent moon—the sun with a full face, and the moon with a profile.

Three or four years later, around the time of the *Self-portrait*, Dürer produced *The Apocalypse*. This was the first book to be designed and published by a single artist. In it Dürer included the full text of the Book of Revelation in Latin and German editions, which he illustrated. In *The Four Horsemen of the Apocalypse* (fig. **17.14**), the aged and withered figure of Death rides the skeletal foreground horse, trampling a bishop whose head is in the jaws of a monster. Cowering before the horse are figures awaiting destruction. Next to Death, and the most prominent of the four, rides Famine, carrying a scale. War brandishes a sword, which is parallel to the angel above. Plague, riding the background horse, prepares to shoot his bow and arrow, whose wounds were associated with the sores caused by the plague. Finally, the presence of God as the ultimate motivating force behind the four horsemen is implied by the rays of light that enter the picture plane from the upper left corner.

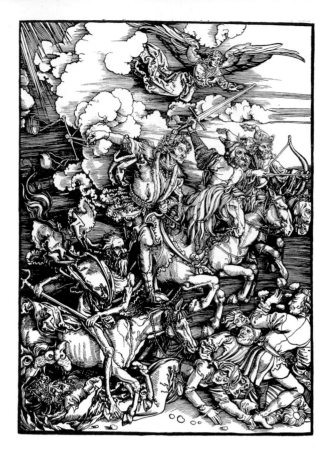

17.14 Albrecht Dürer, *The Four Horsemen of the Apocalypse*, c. 1497–8. Woodcut, approx. 15⅖ × 11 in (39.2 × 27.9 cm). Metropolitan Museum of Art, New York. Gift of Junius S. Morgan, 1919. This is one of a series of fifteen woodcuts from the late 1490s illustrating the Apocalypse. They are based on descriptions of the end of the world in the last book of the Bible.

In this image, Dürer took evident delight in the graphic and psychological expressiveness of line. The powerful left to right motion of the horses and their riders is created by their diagonal sweep across the width of the picture space. The less forceful, zigzag lines of the cowering figures reveal their panic in the face of the relenting and inevitable advance of the horsemen.

Dürer's copper engraving of *Melencolia* (fig. **17.15**), or Melancholy, signed and dated 1514, is an early example of the tradition of portraying artists as having saturnine, or melancholic, personalities (see Box). That the female winged genius is meant to represent Dürer himself is suggested by the location of his monogram underneath her bench. She leans on her elbow in the pose of melancholy that had been conventional since antiquity.

Dürer's Melancholy is an idle, uninspired creator, an unemployed "genius," looking inward for inspiration and not finding it. She is in the grip of obsessive thinking and therefore cannot act. Idle tools, including a bell that does not ring, empty scales, and a ladder leading nowhere, reflect her state of mind. The winged child conveys a sense of anxiety that probably mirrors the anxiety felt by the uninspired artist. Other details, such as the hourglass above the genius, refer to the passing of time. In the upper left, a squeaking bat displays a banner with MELENCOLIA I written on it. The bat, associated with melancholy because of its isolation in dark places, comes out only at night. By combining the bat with the darkened sky pierced by rays

17.13 Albrecht Dürer, *The Folly of Astrology*. Woodcut, 4⅝ × 3⅜ in (11.7 × 8.6 cm), from Sebastian Brant, *The Ship of Fools*, Basel, 1494, fol. liv. (436b).

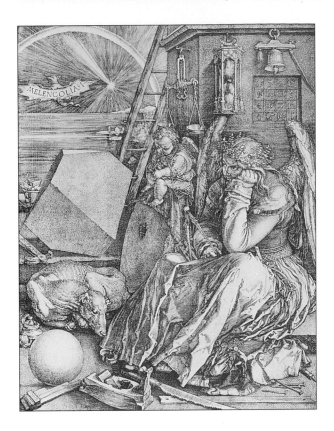

17.15 Albrecht Dürer, *Melencolia I*, 1514. Engraving, approx. 9⅜ × 6⅝ in (23.8 × 16.8 cm).

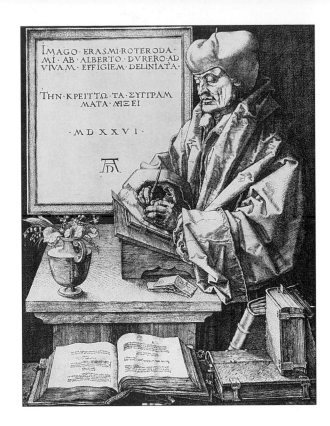

17.16 Albrecht Dürer, *Erasmus*, 1526. Engraving, 9⅞ × 7⅝ in (24.9 × 19.3 cm). B. 107 (214). When Erasmus wrote on Dürer, he was inspired by Pliny's praise of Apelles. But Dürer, according to Erasmus, surpassed Apelles because he could do solely with lines what his Classical predecessor had done with line plus color. And indeed, the massive sleeves and their bulky, angular folds exemplify Renaissance naturalism.

of light, Dürer seems to be making a visual play on the contrasting mental states of black melancholy and the light of inspiration.

In 1526, Dürer engraved a portrait of Erasmus writing in his study, surrounded by the books that denote his substantial intellect and scholarship (fig. **17.16**). The vase of lilies refers to his "purity" of mind and soul, while the prominent Classical inscriptions are signs of his humanism. The Latin reads: "This image of Erasmus of

Rotterdam was drawn from life by Albrecht Dürer," and the Greek, below: "His writings will show what is better." Signed with Dürer's monogram, and dated in Roman numerals, the engraving also reflects the humanist character of the artist.

The Myth of the Mad Artist

Artists, particularly melancholic artists, have traditionally been considered "different" (from the general population) to the point of madness. Aristotle made the first known connection between melancholy—derived from the Greek *melas*, meaning "black" and *cholos*, meaning "bile" or "wrath"—and genius. The melancholic was thought to have an excess of black bile (one of the four bodily humors) in his system, an idea revived in the Renaissance.

Marsilio Ficino believed that melancholics were born under the astrological sign of Saturn, an ancient Roman god known for his moody temperament, and hence shared this particular aspect of Saturn's personality. Consistent with his Neoplatonic philosophy, Ficino combined his astrological theories with Plato's notion that artistic genius was a gift of the gods, who inspired artists with a creative *mania* (Greek for "madness" or "frenzy"). Thus, from the Renaissance onwards, artists and other creative people have been thought to be saturnine (in the sense of temperamental), melancholic, and eccentric.

Saturn, who was also identified with Kronos, one of the Greek Titans, was a god of agriculture, which was associated with geometry (literally, "measurement of the earth"). Artists, farmers, and geometricians alike used measuring instruments in their work, as seen in the compass in the hand of Dürer's Melancholy (see fig. 17.15).

The pose of Dürer's uninspired genius echoes that of Raphael's Heraklitos–Michelangelo in *The School of Athens* (see fig. 15.38) and of Michelangelo's *Jeremiah* (see fig. 15.27) on the Sistine Chapel ceiling. But Dürer's engraving is the earliest representation of the *idea* of melancholy as an artistic image in its own right. It influenced the view of the artist as a divinely inspired, melancholic genius, who suffered bouts of creative frenzy and gloomy idleness. Both Dürer and Michelangelo identified with that image, which declined in popularity in the seventeenth century, but was revived by the nineteenth-century Romantics (see Chapter 24).

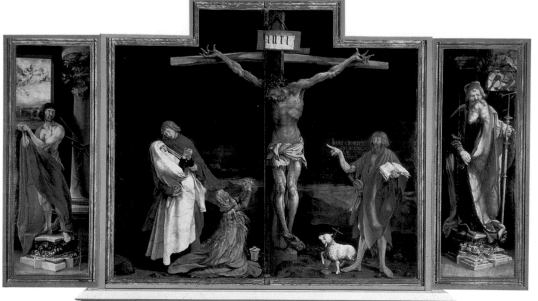

17.17 (left) Matthias Grünewald, *Crucifixion* with *Saint Sebastian* (left), *Saint Anthony* (right), and *Lamentation* (below), the Isenheim Altarpiece, closed, c. 1510–15. Oil on panel (with frame), side panels 8 ft 2½ in × 3 ft ½ in (2.5 × 0.93 m), central panel 9 ft 9½ in × 10 ft 9 in (2.98 × 3.28 m), base 2 ft 5½ in × 11 ft 2 in (0.75 × 3.4 m). Musée d'Unterlinden, Colmar, France.

17.18 (below) Matthias Grünewald, *Annunciation, Virgin and Child with Angels*, and *Resurrection*, the Isenheim Altarpiece, opened.

Matthias Grünewald

Nearly contemporary with Dürer's engraving of Erasmus is the Isenheim Altarpiece (figs. **17.17** and **17.18**), a monumental polyptych by the German artist Matthias Grünewald (d. 1528). It was commissioned for the hospital chapel of the monastery of Saint Anthony in Isenheim. The hospital specialized in the treatment of skin diseases, par-

ticularly ergotism, known as "Saint Anthony's Fire." The altarpiece was a form popular in Germany between 1450 and 1525. It typically consisted of a central corpus, or body, containing sculpted figures, and was enclosed by doors (wings) painted on the outside and carved in low relief inside. In the Isenheim Altarpiece, it is the base, not the corpus, that contains the sculptures; but sculpted

figures of Saints Anthony, Jerome, and Augustine are located in the central corpus behind the *Virgin and Child with Angels*—they are revealed when the two panels of this scene are opened.

The exterior of the doors depicts the *Crucifixion*; its emphasis on physical suffering and the wounds of Christ was related to healing. This is enhanced by Grünewald's revolutionary use of color—for example, the greenish flesh (suggesting gangrene), the grey-black sky, and the rich reds of the drapery that echo the red of Christ's blood—to accentuate the overwhelming effect of the scene. The Cross is made of two logs tied together, its arms bowed from Christ's weight. In contrast to the idealized, relaxed Christ of Michelangelo's *Pietà* in Rome (see fig. 15.19), in Grünewald's Christ *rigor mortis* has already set in. The Crown of Thorns, a visual echo of the contorted fingers, causes blood to drip from Christ's scalp, and his loin cloth is torn and ragged.

Grünewald's depiction of Christ has been related to some fourteenth-century mystical writings, notably the *Revelations* of the Swedish saint Bridget. "The crown of thorns," she wrote, "was impressed on his head; it was firmly pushed down covering half his forehead, the blood, gushing forth from the prickling of thorns.... The color of death spread through his flesh.... His knees ... contracted ... His feet were cramped and twisted.... The cramped fingers and arms were stretched out painfully."[4]

John the Baptist, on Christ's left, points to Christ. The Latin inscription, written in blood red, which John seems to be speaking, reads "He must increase and I must decrease." At John's feet, holding a small cross, is the sacrificial Lamb, whose blood drips into a chalice that prefigures the Eucharist. On Christ's right, Mary Magdalen wrings her hands in anguish. The curve of her arms continues backward towards the swooning Virgin and John the Evangelist supporting her. The darkening sky recalls the biblical account of the sun's eclipse and nature's death at the time of Christ's Crucifixion. On the base of the closed altarpiece, Grünewald has depicted the *Lamentation*, or mourning over Christ after he has been taken down from the Cross. It is set against a snowy, alpine background with barren trees, both being natural metaphors of Christ's death.

The wings of the closed altarpiece depict Saint Anthony, who was associated with healing the sick, on the right, and Saint Sebastian, known as a plague saint because his sores from being shot through with arrows were likened to those of the bubonic plague,

on the left. The altarpiece was generally kept in the closed position. Patients prayed before it to atone for their sins, and to effect a cure. On Sundays and feast days, however, the altarpiece was opened to reveal an interior transformed by bright colors (see fig. 17.18). In the right panel, Christ attains a new, spiritual plane of existence beyond the pull of gravity. His body, defined by curvilinear forms, floats upward into a fiery orb. Christ-as-sun is juxtaposed with the Roman soldiers, whose sinful ignorance causes them to stumble in a rocky darkness.

Lucas Cranach

Lucas Cranach the Elder (1472–1553) was a German humanist and admirer of Martin Luther. In his early work, he primarily depicted landscapes, an interest that continued in some of his later mythological pictures. In *The Judgment of Paris* (fig. **17.19**), Cranach sets the Greek myth (see caption) in sixteenth-century Germany, with a

17.19 Lucas Cranach the Elder, *The Judgment of Paris*, 1530. Panel, 13½ × 8¾ in (34.4 × 22.2 cm). Staatliche Kunsthalle, Karlsruhe, Germany. According to Greek myth, the Trojan prince Paris judged a beauty contest between the goddesses Athena, Hera, and Aphrodite. He awarded the prize of a golden apple to Aphrodite, who had promised him the most beautiful woman in the world. The woman was Helen of Troy.

Saxon castle on a distant hill. An aged, bearded Hermes presents the three goddesses to Paris. Both male figures wear the armor of Saxon knights. The women pose coquettishly, in a way that is reminiscent of the conventional arrangement of the three Classical Graces—the one in the center is seen from the back, and the two on the side from the front. A comparison of *The Judgment of Paris* with the first-century A.D. Roman fresco of *The Three Graces* (fig. **17.20**) illustrates the extent to which Cranach has altered the character of the women to suit his patrons at the court of Saxony. The figure of the horse to the left of the tree adds a touch of humor to the scene, for its gaze is riveted by the unexpected sight of the nudes. The horse's raised leg reveals his erotic excitement, and contrasts with the relaxed, indifferent pose of Paris, who casually converses with Hermes.

Cranach was best known for his portraits. His *Martin Luther* (fig. **17.21**) is as austere as *The Judgment of Paris* is delicate and decorative. The figure is set against a solid green background, eliminating the sense of a natural context. Luther's dark robe is also unmodulated, so that the only three-dimensional form is the head. In the emphasis on the stubble of Luther's beard, Cranach makes his subject seem above the concerns of daily grooming. He is rendered as a man of vision, staring out of the picture plane with an air of inner resolution.

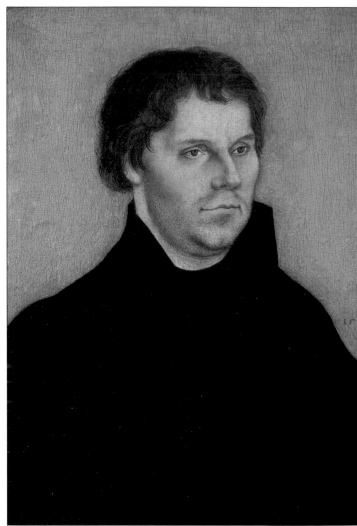

17.21 Lucas Cranach the Elder, *Martin Luther*, 1533. Panel, 8 × 5¾ in (20.5 × 14.5 cm). City of Bristol Museum and Art Gallery, England.

17.20 *The Three Graces*, 1st century A.D. Fresco, from Pompeii. National Archaelogical Museum, Naples.

Hans Holbein

The last great German painter of the High Renaissance was Hans Holbein the Younger (c. 1497–1543). He synthesized German linear technique with the fifteenth-century Flemish taste for elaborately detailed surface textures and rich color patterns. Perhaps his greatest achievements were his portraits.

Holbein's family came from the southern German city of Augsberg, which, like Antwerp, was a center of international trade. At the age of eighteen, Holbein traveled to Basel, where he met Erasmus and painted his portrait (fig. **17.22**). In contrast to the assertive and slightly unkempt character of Cranach's Luther, Holbein's Erasmus is a scholarly gentleman. He is well-groomed, neat, and wears a fur-lined coat. Like Dürer's engraving of Erasmus (see fig. 17.16), Holbein's painting places the figure in a three-dimensional room. Erasmus rests his hands on a book

with the inscription "The Labors of Herakles" (in Greek) facing the picture plane. Erasmus is thus depicted as a man of his own era, whose thought has been formed by the Renaissance synthesis of Christianity with Classical antiquity. The pilaster with its Classical motifs shows the influence of artists such as Giovanni Bellini and Mantegna.

Holbein left Basel in 1526 and sought the patronage of the humanist Sir Thomas More in England, on the recommendation of Erasmus. On a second trip in 1532, Holbein became the court painter to Henry VIII. Holbein's portrait of Henry (fig. **17.23**) of about 1540 evokes the overpowering force of the King's personality. Henry's proverbial bulk dominates the picture plane as he stares directly out at the observer. In contrast to the *Erasmus*, Henry's forceful character is unrelieved by a spatial setting, or by objects in the surrounding space. But the fine textures and minute patterns of his costume create a surface lustre that is reminiscent of van Eyck; they also appear in areas

17.23 Hans Holbein the Younger, *Henry VIII*, c. 1540. Oil on panel, 34¾ × 29½ in (88.3 × 74.9 cm). Galleria Nazionale d'Arte Antica, Rome.

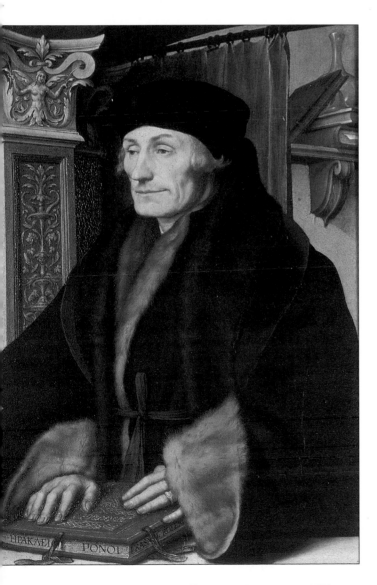

17.22 Hans Holbein the Younger, *Erasmus of Rotterdam*, c. 1523. Panel, 30 × 20¼ in (76.2 × 51.4 cm). Private collection.

of the *Erasmus*. Henry's bent right arm is posed so that the elbow is thrust forward, emphasizing the elaborate sleeves. From the neck down, the King's body forms a rectangle filling the lower two-thirds of the picture. His head seems directly placed on his shoulders, creating a small, almost cubic shape. The hat, by contrast, forms a slightly curved diagonal, echoing the curved chain across his chest and also softening the monumental force of Henry's body and gesture.

The main source of variety in this picture is in the material quality of the surface patterns. Their richness is calculated to remind viewers of Henry's wealth, just as his pose exudes power, self-confidence, and determination, while his face reflects his intelligence and political acumen. In this image, therefore, Holbein has fused formal character with a specific personality, creating a Henry VIII who is "every inch a king."

After Holbein's death, no major artists emerged in Germany during the sixteenth century. By 1600 the conflicts between Protestant and Catholic, Reformation and Counter-Reformation, mysticism and humanism, though hardly at an end, had at least become familiar. Their effects on art would continue, though to a lesser degree, into the seventeenth century.

Style/Period	Works of Art	Cultural/Historical Developments

1490

NORTHERN EUROPE
16TH CENTURY

1490–1500

1st century A.D.:
Pompeii fresco (*The Three Graces*) (**17.20**)

Dürer, *The Folly of Astrology* (**17.13**)
Dürer, *The Four Horsemen of the Apocalypse* (**17.14**)
Dürer, *Self-portrait* (**17.12**)
Bosch (attrib.), *The Seven Deadly Sins and the Four Last Things* (**17.2–17.3**)

Heinrich Kramer and James Sprenger, *The Witches' Hammer* (1487)
Sebastian Brant, *Narrenschiff* (*The Ship of Fools*) (1494)

Dürer, *Self-portrait*

1520

1500–1530

Bosch, *The Garden of Earthly Delights*

Bosch, *The Garden of Earthly Delights* (**17.4–17.6**)
Grünewald, Isenheim Altarpiece (**17.17–17.18**)
Dürer, *Melencolia I* (**17.15**)
Holbein the Younger, *Erasmus of Rotterdam* (**17.22**)
Dürer, *Erasmus* (**17.16**)

Erasmus of Rotterdam, *In Praise of Folly* (1514)
Martin Luther's 95 Theses; beginning of the Reformation (1517)
Martin Luther excommunicated (1521)
Peasants' Revolt in Germany (1524–5)

1530–1570

Holbein the Younger, *Henry VIII*

Cranach the Elder, *The Judgment of Paris* (**17.19**)
Cranach the Elder, *Martin Luther* (**17.21**)
Holbein the Younger, *Henry VIII* (**17.23**)
Bruegel the Elder, *Landscape with the Fall of Icarus* (**17.7**)

Bruegel, *Landscape with the Fall of Icarus*

Bruegel the Elder, *The Alchemist* (**17.8**)
Bruegel the Elder, *Netherlandish Proverbs* (**17.9–17.10**)
Bruegel the Elder, *The Peasant Dance* (**17.11**)

Hans Holbein the Younger becomes court painter to Henry VIII (1532)
Henry VIII rejects papal authority, founds Anglican Church (1534)
John Calvin, *Institutes of the Christian Religion* (1536)
Council of Trent introduces Counter-Reformation policies (1545–63)
Wars of Lutheran vs. Catholic princes in Germany; Peace of Augsburg (1555)
Elizabeth I of England (1558–1603)
Alexander Knox founds Presbyterian Church (1560)
Protestant Netherlands rebels against Catholic Spain (1568)
Karel van Mander, *Het Schilderboeck* (*The Painters' Book*) (1604)

Cranach the Elder, *The Judgment of Paris*

1570

18

The Baroque Style in Western Europe

The Baroque style corresponds roughly to the closing years of the sixteenth century, overlapping Mannerism and lasting, in some areas, as late as 1750. Politically the seventeenth century was a period of crisis and conflict. Religious tensions continued to escalate, while at the same time great strides were made in science. These developments are reflected in the painting, sculpture, and architecture of the time.

Developments in Politics and Science

Although Europe (fig. **18.1**) had rarely been free of war in the sixteenth century, in 1618 the smoldering hostilities between Catholics and Protestants erupted into the Thirty Years War (1618–48). This was one of the most devastating conflicts in European history. Beginning with a revolt of the Bohemians against Austrian rule, the war spread throughout the entire continent, drawing in France, Spain, and many small principalities that were part of the Holy Roman Empire. Aided by the French, the Southern Netherlands rebelled against the Catholic domination of Philip II and Philip IV of Spain (both Hapsburg monarchs) and overthrew forty years of Spanish rule.

When the Treaty of Westphalia was signed in 1648, the war formally ended. But none of the religious differences had been settled. Nevertheless, the principle of national sovereignty was established, and each country had control of its lands and population. A general redistribution of territory also took place, with France receiving most of Alsace, and Sweden annexing provinces on the Baltic Sea. The Netherlands split into Protestant Holland and Catholic Flanders (roughly equivalent to modern Belgium). The authority of the Holy Roman Emperor over Germany was severely weakened, and Germany itself was ravaged by mercenaries.

Politically the seventeenth century is known as the Age of Absolutism, because of certain rulers who exercised absolute power over their countries. According to the principle of the divine right of kings, rulers derived their authority directly from God. The prime example of this principle, the absolute monarch Louis XIV of France (1643–1715), who centralized all national authority into his own hands, ruled in his own right for fifty-four years.

In England, another absolute monarch, Charles I (1625–49), succeeded his father, the first Stuart king, James I. His persecutions of the Puritans (English Calvinists who favored substituting a presbyterian form of church government for the episcopal system) drove them to join with other anti-royalist factions; the English Civil War led to the execution of the King. For eleven years after the death of Charles I, England became a Free Commonwealth under Oliver Cromwell (1599–1658) as Protector. In 1660, Charles's son, Charles II, was restored to the throne.

A reaction to absolutism emerged in the course of the seventeenth century in the first serious study since Plato of the rights of citizens. Political philosophers, notably Thomas Hobbes (1588–1679) and John Locke (1632–1704), argued that government is based on a social contract. Hobbes believed that ultimate power rested with the monarch, while Locke maintained that governments derive their authority from the consent of the governed, who may overthrow any ruler threatening their fundamental rights.

The geographic discoveries of the fifteenth century had been spearheaded by navigators from Spain and Portugal. In 1494, these two countries signed the Treaty of Tordesillas, in which they divided up the non-European world among themselves. Their confidence, however, was misplaced, and by the beginning of the seventeenth century the commercial map of Europe had been redrawn. Venice had declined to the status of a regional market, and the Dutch had overtaken the Hanseatic League (a confederation of north German cities) to become the leading trading nation of the Western world. For most of the 1600s Amsterdam was the financial and trade center of Europe, although Seville, in Spain, was also an important port. The English, who had begun to erode the Spanish empire in the Americas, presented the only serious challenge to the Dutch, for England had the advantage of surplus citizens with which to populate overseas settlements. By the early 1700s, the Dutch had yielded naval superiority to the

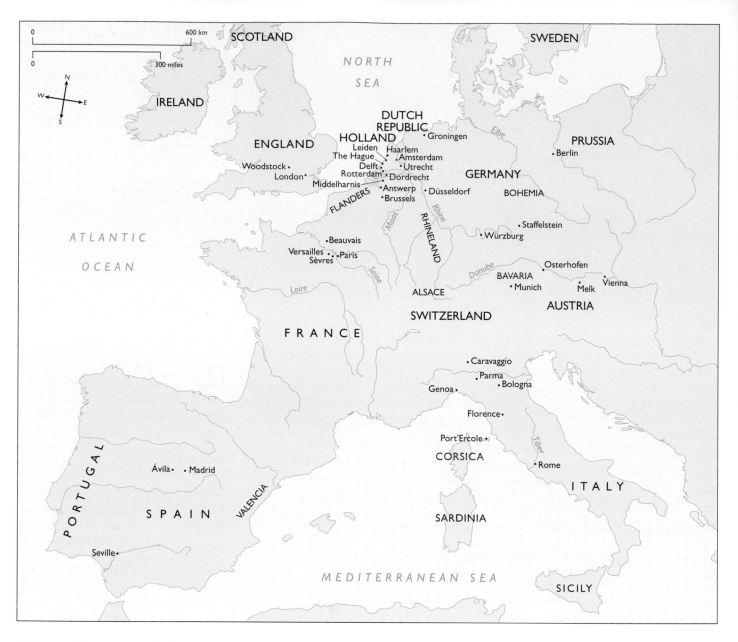

18.1 Map of Europe during the Baroque period.

English who, together with the French, emerged as the leading colonial and commercial power of Europe.

The period 1600 to 1750 was a time of enormous progress in scientific experimentation and observation. Although religious tensions ran high, fundamentalism and superstition increased, and executions for heresy and witchcraft multiplied, scientists began to view the universe as a system with natural and predictable laws.

In 1543 Nicolas Copernicus (1473–1543), a Polish physician and astronomer, had published *De revolutionibus orbium coelestium* (*On the Revolution of the Heavenly Spheres*), in which he hypothesized that the sun, rather than the earth, was the center of the universe and that the planets revolved around it. This heliocentric theory was confirmed by Johan Kepler (1571–1630), a German mathematician who measured the movement of the five known planets and showed that they orbited the sun in elliptical paths. The Italian astronomer Galileo Galilei (1564–1642) proved that bodies of unequal weight fall with the same

speed, impelled by gravity. Galileo also improved the recently invented telescope, which permitted him to see the satellites of the planets and led him to accept the system of Copernicus.

These discoveries flew in the face of Catholic doctrine, which held that the universe was an extension of God's will, that the earth was the center of the universe, and that mankind was central to that system. In 1616 Copernicus's writings were banned by the Church, and in 1632 Galileo was forced by the Inquisition to recant his views. These setbacks notwithstanding, scientific progress was an important feature of the Baroque period. The empirical method, with its emphasis on the direct experience, measurement, and analysis of natural phenomena, culminated in the work of the English natural philosopher Isaac Newton (1642–1727). Newton's laws of motion and theory of gravity (which held that every object in the universe exerts its own gravitational pull) formed the basis of physics until the end of the nineteenth century.

Baroque Style

The term "Baroque" is applied to diverse styles, a fact that highlights the approximate character of art historical categories. Like Gothic, Baroque was originally a pejorative term. It is a French variant of the Portuguese *barroco*, meaning an irregular, and therefore imperfect, pearl. The Italians used the word *barocco* to describe an academic and convoluted medieval style of logic. Although Classical themes and subject-matter continued to appeal to artists and their patrons, Baroque painting and sculpture tended to be relatively unrestrained, overtly emotional, and more energetic than earlier styles.

Baroque artists rejected aspects of Mannerist virtuosity and stylization, while absorbing its taste for *chiaroscuro* and theatrical effects. They were more likely than Mannerist artists to pursue the study of nature directly. As a result, Baroque art achieves a new kind of naturalism that reflects some of the scientific advances of the period. There is also a new taste for dramatic action and violent narrative scenes, and the representation of emotion is given a wide range of expression—a departure from the Renaissance adherence to Classical restraint. Baroque color and light are dramatically contrasted and surfaces are richly textured. Baroque space is usually asymmetrical and lacks the appearance of controlled linear perspective; sharply diagonal planes generally replace the predominant verticals and horizontals of Renaissance compositions. Landscape, genre, and still life, which had originated as separate, but minor, categories of painting in the sixteenth century, gained new status in the seventeenth. Allegory also takes on a new significance in Baroque art, and is no longer found primarily in a biblical context. Portraiture, too, develops in new directions, as artists depict character and psychology along with the physical presence of their subjects.

The considerable variety within the Baroque style is partly a function of national and cultural distinctions. Baroque art began in Italy, particularly Rome, whose position as the center of western European art had been established during the High Renaissance by papal patronage and Rome's links with antiquity. At the end of the Baroque period, however, Paris would emerge as the artistic center of Europe, a position it retained until World War II. Two major Baroque architectural achievements, the completion of Saint Peter's in Rome and the sumptuous court of the French monarch Louis XIV at Versailles, reflect the enormous resources that were devoted to the arts in seventeenth-century Europe.

Architecture

Italy

The rebuilding of Saint Peter's Cathedral, which began when Julius II became pope in 1503, was finally completed during the Baroque period. Its interior decoration and

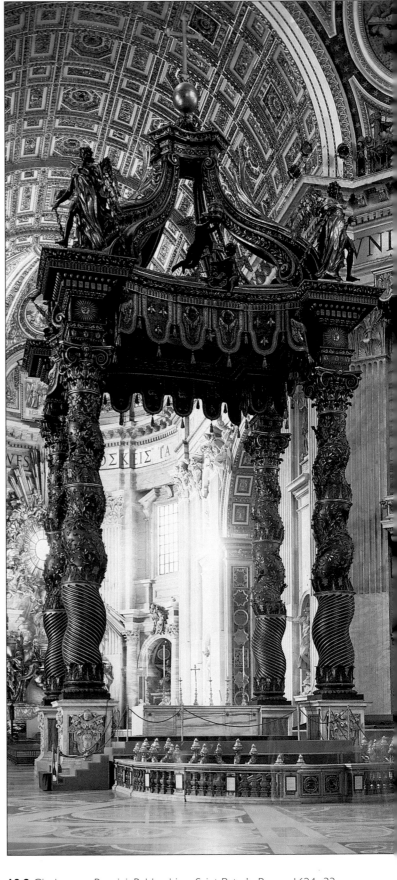

18.2 Gianlorenzo Bernini, Baldacchino, Saint Peter's, Rome, 1624–33. Gilded bronze, approx. 95 ft (28.96 m) high. The baldacchino's height is about one-third the distance from the floor of Saint Peter's to the base of its lantern. Although small in relation to the dome, it is the size of a modern nine-storey building, and its foundations reach deep into the floor of the old Constantinian basilica.

18.3 Gianlorenzo Bernini, *Cathedra Petri* (Throne of Saint Peter). Saint Peter's, Rome, 1656–66. Gilded bronze, marble, stucco, and stained glass. The reliquary is surrounded at its base by the figures of four Doctors of the Church—Saints Ambrose, Athanasius, Augustine, and John Chrysostom. Although it appears that the four Church Doctors are holding up the throne, it is actually **cantilevered** out from the wall. The illusory physical support is a metaphor for supporting the spiritual doctrine of the faith in the early days of Christianity.

spatial design, however, still required attention. Pope Urban VIII (papacy 1623–44) appointed Gianlorenzo Bernini (1598–1680) to the task, and he remained the official architect of Saint Peter's until his death. One of Bernini's intentions was to reduce the space at the crossing so that worshipers would be drawn to the altar. He did so by erecting the bronze **baldacchino** (fig. **18.2**), or canopy, over the high altar above Saint Peter's tomb.

Four twisted columns, decorated with vinescrolls and surmounted by angels, support a bronze valance resembling the tasseled cloth canopy used in religious processions. At the top, a gilded cross stands on an orb. The twisted column motif did not originate with Bernini. In the fourth century, Constantine was thought to have taken spiral columns from Solomon's Temple in Jerusalem and used them at Old Saint Peter's. Eight of these columns were incorporated into the pier niches of New Saint Peter's—two of them are visible in figure 18.2. Bernini's columns seem to pulsate as if in response to some internal pressure or tension. The dark bronze, accented with gilt,

stands out against the lighter marble of the nave and apse. Such contrasts of light and dark, like the organic quality of the undulating columns, are characteristic Baroque expressions.

In the western apse of Saint Peter's, framed by the columns of the baldacchino, is Bernini's distinctive *Cathedra Petri*, or Throne of Saint Peter (fig. **18.3**). This structure is an elaborate reliquary built around an ivory and wooden chair, once believed to have been Saint Peter's original papal throne but actually an early medieval work. Above the throne, the Holy Spirit is framed by a stained glass

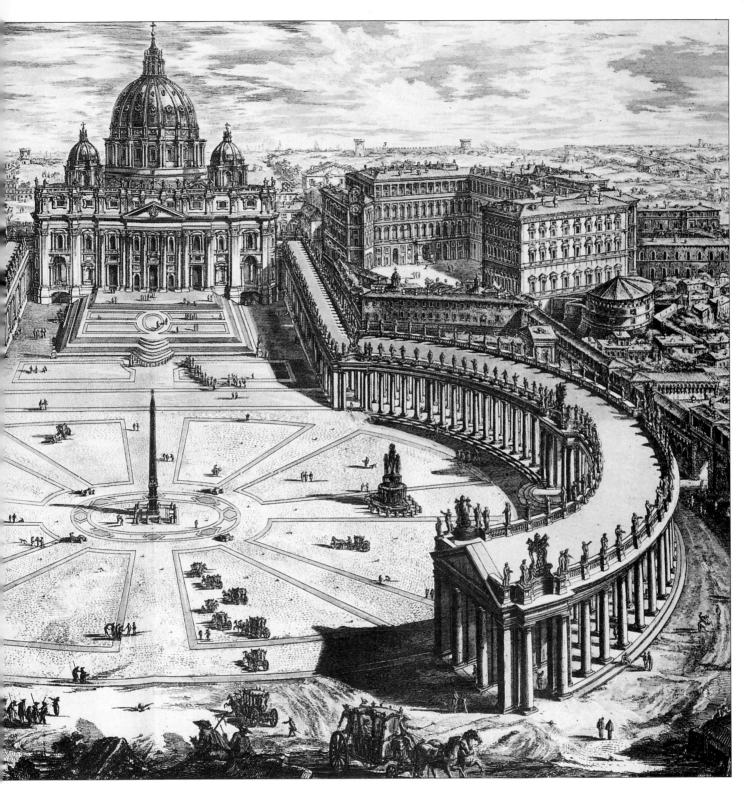

18.4 Gianlorenzo Bernini, Aerial view of colonnade and Piazza of Saint Peter's, Rome, begun 1656. Travertine, longitudinal axis approx. 800 ft (243.8 m). Copper engraving by Giovanni Piranesi, 1750. Kunstbibliothek, Berlin. The enormous piazza in front of the east façade of Saint Peter's can accommodate over 250,000 people.

window. Because the building is oriented to the west, the window catches the afternoon sun, which reflects from the gilded rods, representing divine light.

In 1656 Bernini began work on the exterior of Saint Peter's. His goal was to provide an impressive approach to the church and, in so doing, to define the Piazza San Pietro. The piazza, or public square (fig. **18.4**), is the place where the faithful gather on Christian festivals to hear the pope's message and receive his blessing. Bernini conceived of the piazza as a large open space, organized into elliptical and trapezoidal shapes (in contrast to the Renaissance circle and square). He placed different Orders within the same structure, and combined the Classical Orders with statues of Christian saints.

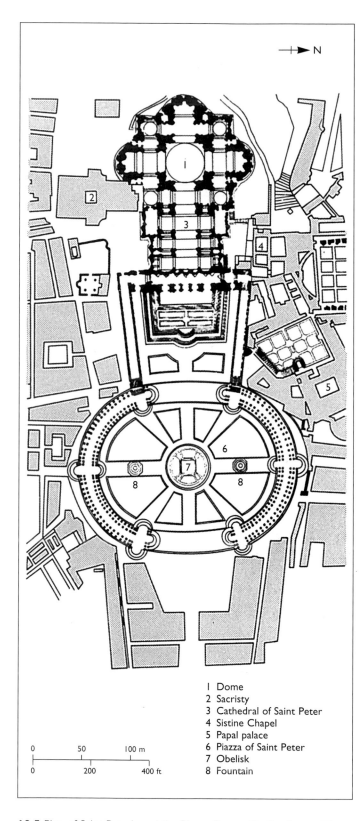

1 Dome
2 Sacristy
3 Cathedral of Saint Peter
4 Sistine Chapel
5 Papal palace
6 Piazza of Saint Peter
7 Obelisk
8 Fountain

18.5 Plan of Saint Peter's and the Piazza, Rome. On the floor of the oval a radial pattern converges at the obelisk. The shape and width of the oval—approx. 800 ft (244 m)—and the location of a fountain within each of its semicircular sections help to establish a stronger north–south axis. That axis is perpendicular to the direction in which most visitors move, namely along the east–west axis of the nave and dome.

18.6 Francesco Borromini, façade of San Carlo alle Quattro Fontane, Rome, 1665–7. Born in Lombardy, Borromini was the son of an architect. In 1621 he moved to Rome and worked under both Maderno and Bernini. Borromini and Bernini were intense rivals of very different temperaments. Borromini resented living and working in Bernini's shadow. Moody and constantly dissatisfied, he eventually committed suicide.

He divided the piazza into two parts (fig. **18.5**). The first section has the approximate shape of an oval, or ellipse, and at its center is an obelisk 83 feet (25.3 m) high, imported from Egypt during the Roman Empire. Around the curved sides of the oval, Bernini designed two colonnades, consisting of 284 **travertine** columns in the Tuscan Order, each one 39 feet (11.89 m) high. The columns are four deep, and the colonnades end in temple fronts on either side of a large opening. Crowds can thus convene and disperse easily; they are enclosed, but not confined. Bernini wrote that the curved colonnades were like the

18.7 Francesco Borromini, interior dome of San Carlo alle Quattro Fontane, Rome. The dome is illuminated on the interior by windows at its base, and contains coffers in the shape of hexagons, octagons, and crosses. At the center of the dome, an oval oculus contains a triangle, a geometric symbol of the Trinity and emblem of the Trinitarian Order that commissioned the church.

arms of Saint Peter's, the Mother Church, spread out to embrace the faithful and confirm their faith, to recall heretics to the true faith, and to light the way of infidels.

The second part of the piazza is a trapezoidal area connecting the oval with the church façade. The trapezoid lies on an upward gradient and the visitor approaches the portals of Saint Peter's by a series of steps. As a result, the walls defining the north and south sides of the trapezoid become shorter toward the façade. This enhances the verticality of the façade and offsets the horizontal emphasis produced by the incomplete flanking towers. The two sections of the piazza are tied together by an Ionic entablature that extends all the way around the sides of both the oval and the trapezoid, and the entablature is crowned by 140 marble statues of saints. The integration of the architecture with the participating crowds reflects the Baroque taste for involving audiences in a created space, in particular a processional space leading to the high altar.

Bernini's greatest professional rival in Rome was Francesco Borromini (1599–1667). They collaborated on the baldacchino, but their interests diverged immediately afterward. From about 1634 to his death, Borromini worked on the Trinitarian monastery of San Carlo alle Quattro Fontane (Saint Charles of the Four Fountains) in Rome (figs. **18.6**, **18.7**, and **18.8**), named after the fountains at the four corners of the street intersection. The small monastery church is Borromini's best-known building, which established his reputation for daring innovation in Rome and abroad.

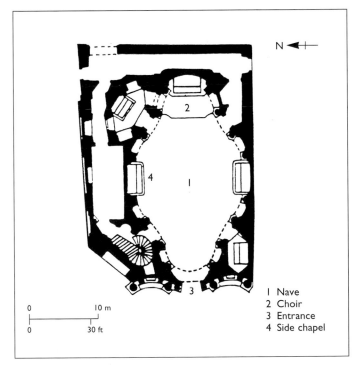

18.8 Francesco Borromini, plan of San Carlo alle Quattro Fontane, Rome, 1638–41. The church plan is shaped like a pinched and distended oval. Its main altar and entrance are set opposite each other on the short sides of the oval, and the walls are a series of convexities and concavities. Side chapels, which seem to be parts of smaller ovals, bulge out from the walls.

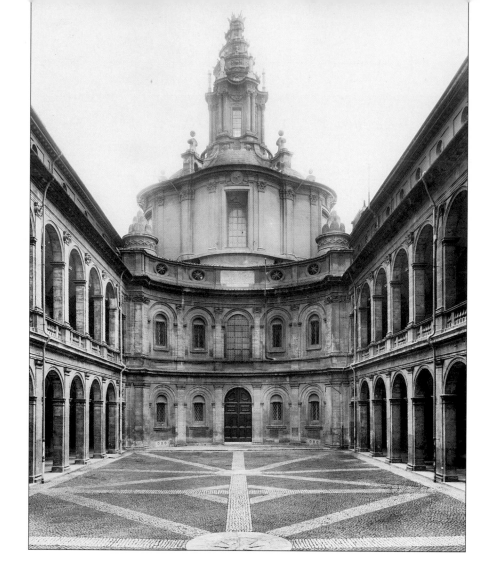

18.9 Francesco Borromini, Collegiate Church of Sant'Ivo della Sapienza, Rome, 1642–60. In 1632, Borromini was appointed the official architect of Rome University by Pope Urban VIII.

The alternation of convex and concave in the façade of San Carlo is repeated with variations in the walls. At the ground level there are three bays—concave, convex, concave. At the upper level the bays are all concave, although a small **aedicule** (niche) and a balustrade fill the central bay, echoing the convex shape of the level below. Borromini's undulating walls, like the twisted columns of Bernini's baldacchino, are characteristic of the plasticity of Italian Baroque architecture.

Above the door of the church, a statue of San Carlo stands in a niche, surmounted by a pointed **gable**. A large painted medallion of the saint, crowned with a gable that echoes the lower one, has been placed above the top level, in alignment with the statue. The corner of the building is bevelled and contains one of the four fountains. Above the entablature are **pendentives** supporting an oval drum, which is not visible from the street. The drum, in turn, supports an oval dome. In figure 18.7 we are inside the church looking up at the interior of the dome. Here Borromini expresses the Baroque concern for lightening architectural volume, just as Bernini did in the *Cathedra Petri*. The appearance of increased height, and of actual upward motion, is enhanced by coffers that decrease in size as they approach the center of the dome.

From 1642 to 1660, Borromini worked on the church of Sant'Ivo della Sapienza (Wisdom), which is another pro-

duct of his unique architectural imagination. Its concave façade (fig. **18.9**) blends into the surrounding buildings of Rome University. The crowning features of this church are particularly innovative—for example, the stepped, pyramidal form supporting the lantern, which is surmounted by a spiral ramp leading to a stone laurel wreath. This feature is decorated with carved flames, and supports an iron cage upholding an orb with a cross. The sources of these motifs, and their unusual combinations, are difficult to identify, but they appear to have been inspired by the ancient Near Eastern **ziggurat**.

The plan of Sant'Ivo (fig. **18.10**) is formed by two equilateral triangles superimposed to form the shape of the six-pointed star of Wisdom. The center is hexagonal, with a bay at each side. Three of the angles end in semicircular apses, and three in pointed apses. The walls of the latter are convex, and seem to push in toward the center of the plan. As a result, there is an organic quality in Borromini's conception that is enhanced by continual tension in the relationship of the walls to the space.

A comparison of the interior view of Sant'Ivo's dome (fig. **18.11**) with that of San Carlo (fig. 18.7) shows the greater complexity of the former. Here the alternation of curves over the semicircular apses with the convex apse walls is clear. The effect is to increase the variation of shapes and spaces, which seem to radiate from the central

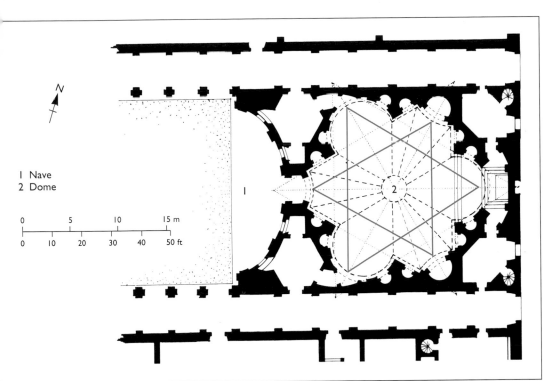

1 Nave
2 Dome

18.11 (below) Francesco Borromini, interior of dome, Collegiate Church of Sant'Ivo della Sapienza.

circle. At San Carlo, on the other hand, the sides of the dome appear to have been pushed inward, toward the center, to create its oval form. The interior illumination of Sant'Ivo's dome enhances the impression of a large, architectural star, which evokes the celestial associations of domed buildings in a new and original way. Being in the form of a star of David, the dome refers to the typological tradition relating Old Testament kings with Christ, and specifically to Christ's descent from the House of David. As such, the dome also links the genealogical sense of David's House with the architectural metaphor in which the church building as Mary is the House of Christ.

France

French seventeenth-century architecture was elegant, ordered, rational, and restrained, recalling the Classical esthetic. France rejected the exuberance of Italian Baroque, preferring a strictly **rectilinear** approach to Borromini's curving walls and the open, activated spaces of Bernini. Geometric regularity was also more in keeping with the French political system—namely, absolute monarchy personified by Louis XIV.

Louis ascended the throne in 1643 at the age of five and ruled from 1661, when he came of age, until his death in 1715. His shrewd policies and talented ministers made France the most powerful, and most populous, nation in

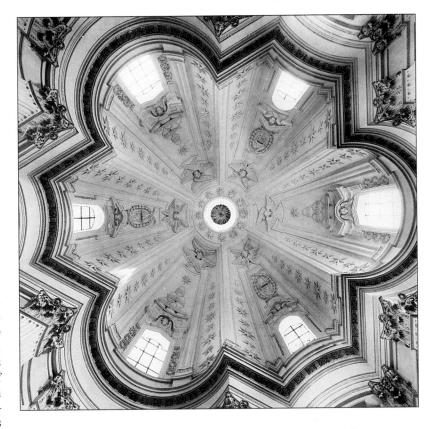

Europe. His chief minister, Jean-Baptiste Colbert, organized the arts in the service of the monarchy. Their purpose was to glorify Louis's achievements and enhance his power and splendor in the eyes of the world. To this end, the building industry and the crafts guilds were subjected

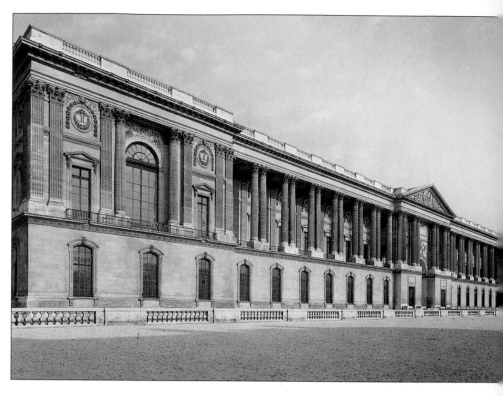

18.12 Claude Perrault, Louis le Vau, and Charles Le Brun, east façade of the Louvre, Paris, 1667–70. A colonnade of paired, two-story columns separates the windows and is linked by a continuous entablature. The flat roof is hidden by a surrounding balustrade, which accents the horizontality of the building. The central pavilion, resembling a Roman temple front, is crowned by a pediment, which is echoed by the small individual pediments above the windows. The main floor rests on a ground floor presented as a **podium**. It is lightly rusticated—the blocks of masonry have roughened surfaces and sunken joints.

to a central authority. An **Academy** was established to create a national style which would reflect the glory of France and its king (see Box).

The first task of Louis and Colbert was to complete the rebuilding of the Louvre (fig. **18.12**) in Paris. Now the city's principal art museum, the Louvre was then a royal palace. Bernini submitted a series of proposals and was summoned to work on the Louvre project. His final proposal was rejected, however, on the grounds that it did not match the existing structure or conform to French taste. The eventual design for the east façade was the work of three men—the painter Charles Le Brun (Director of the French Academy), the architect Louis Le Vau, and Claude Perrault, a physician. The restrained, classicizing symmetry of the façade, in contrast to Bernini's plan for a curved wall, occupies a

long horizontal plane, and set the style for French seventeenth-century architecture.

In 1667 Louis XIV decided to move his court to Versailles, a small town about 15 miles (24 km) southwest of Paris. This involved moving not only the vast royal household but also the whole apparatus of government. Versailles was the site of a hunting lodge built in 1624 by Louis's father, Louis XIII, and enlarged from 1631 to 1636. His son had visited this modest twenty-room **château** as a child. The lodge was at the center of a radiating landscape design and formed the nucleus of the new palace, which

The French Academy (Académie Royale de Peinture et de Sculpture)

Louis XIV extended his notion of the monarch's absolute power to the arts. In 1648, his minister Jean-Baptiste Colbert founded the Royal Academy of Painting and Sculpture with a view to manipulating imagery for political advantage. The philosophy and organization of the Academy was as hierarchical as Louis's state. Artists were trained according to the principle that tradition and convention had to be studied and understood. Art students drew from plaster casts, and copied the old masters. They were steeped in the history of art and of their own culture.

Another issue of philosophical importance to the Academy was the role of nature in the concept of the "ideal." Artists, if properly trained, should be able to produce the ideal in their work. The representation of emotion through physiognomy, expression, and gesture was also discussed at length by Charles Le Brun, who headed the Academy for twenty years. All such considerations were subjected to a system of rules, which was derived partly from Platonic and Renaissance theory, and partly from the French interest in the creation of an esthetic order.

The subject-matter of art was also organized according to a hierarchy. At the top were the Christian Sacraments, followed by history painting. In these two categories, the philosophy of the Academy supported the religious and political hierarchy imposed by Louis XIV. Next in line were portraiture, genre (scenes of daily life), landscape (with or without animals), and, lowest on the scale, still life.

With all the Academic emphasis on systems and rules, a number of artistic "quarrels" were prevalent in the seventeenth century. The High Renaissance arguments over the merits of line and color (*disegno* and *colorito*) continued in the Baroque period, now exemplified by Poussin and Rubens. The *Rubénistes* championed color, while the *Poussinistes* preferred line. A parallel quarrel between the "Ancients" and "Moderns" arose: this concerned the question of which was the best authority for artists to follow. The Ancients were more traditional, and tended to be allied with the proponents of *disegno* and Poussin. Line was considered rational, controlled, and Apollonian. Color, which was allied with Rubens and the Moderns, was emotional, exuberant, and related to Dionysiac expression.

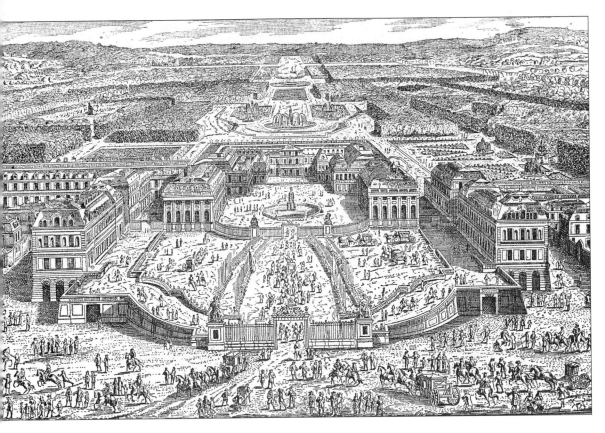

18.13 Aerial view of the park, palace, and town of Versailles, after a 17th-century engraving by G. Pérelle. Versailles was the epitome of the French château (meaning "castle," "mansion," or "country house"), which had been established in the 16th century as the centerpiece of lavish country estates. A small town grew up at the eastern end of the palace, planned in grid formation around three broad boulevards. These radiated out from the palace and funneled visitors into the courtyard, or Court of Honor.

was built under Louis XIV (fig. **18.13**). From 1661 to 1708 the building underwent a series of enlargements, the earlier ones under the direction of Le Brun and Le Vau. The landscape architect, André Le Nôtre (1613–1700), designed the elaborate gardens with pools and fountains—typical Baroque features. By 1678 the new palace was large enough for the court to move to Versailles, which then became the seat of government, including the Treasury and the diplomatic corps. The palace contained hundreds of rooms and served over 20,000 people. Four thousand servants lived inside the palace and 9000 soldiers were billeted nearby.

Unprecedented in scale and grandeur, the palace at Versailles was intended to glorify the power of the French monarch, and so was its iconography. The latter was supervised by Le Brun, who portrayed Louis as the *Roi Soleil* (Sun King), an appellation designed to bolster his divine right to rule. The unrivalled splendor and life-giving force of the King was proclaimed throughout the lavish interior of the palace.

18.14 Jules Hardouin-Mansart and Charles Le Brun, *Galerie des Glaces* (Hall of Mirrors), Palace of Versailles, c. 1680. The reflected sunlight in the Hall of Mirrors was only one of the many solar allusions at Versailles. The Salon d'Apollon, named after Apollo, the sun god, was the throne room. The gardens are laid out along axes that radiate like the sun's rays from a central hub. They are adorned with sculptures illustrating Apollonian myths.

A second stage in the construction of Versailles lasted from 1678 to 1688, and included the great *Galerie des Glaces*, or Hall of Mirrors (fig. **18.14**), which was added by Jules Hardouin-Mansart. The *Galerie* has seventeen large arched mirrors, which constituted a literal wall of glass. They multiplied the sunlight entering the windows opposite, and reflected the glittering splendor of Louis and his court. At each end of the Hall of Mirrors are the Salons of War and Peace, decorated with the relevant symbols. Foreign ambassadors were received in the appropriate salon to learn Louis' political intentions.

Above the main entrance, at the center of the palace, was the King's bedroom. Here, Louis enacted his daily ceremonies of *lever* (getting up) and *coucher* (going to bed),

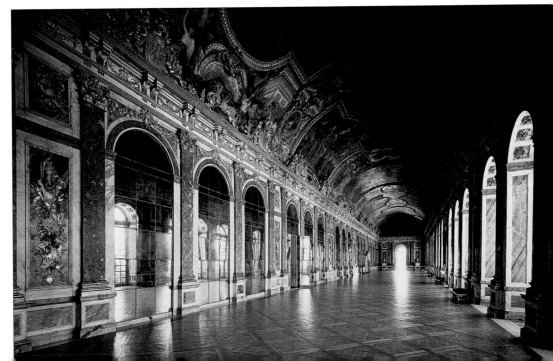

which identified him directly with the rising and setting sun. Bernini's marble, lifesize bust of Louis XIV (fig. **18.15**), which is still in the King's bedroom, contains subtle allusions to Louis's role as the Sun King. The smooth surface of Louis's face, in contrast to the luxurious curls framing it, suggests the sun radiating as a central force through the clouds. With the sharp turn of Louis's head, as if something has suddenly caught his attention, and his wide-eyed, energetic gaze, the bust is also reminiscent of the Hellenistic head of Alexander the Great (see Vol. I, fig. 6.69). Bernini creates the impression that Louis is both of this world—as a king and warrior, a worthy successor to Alexander the Great—and destined for apotheosis.

England

Baroque was also the architectural style of seventeenth-century England. Its greatest exponent was undoubtedly Sir Christopher Wren (1632–1723). Following the Great

18.15 (above) Gianlorenzo Bernini, Bust of Louis XIV, 1665. Marble, lifesize. Versailles.

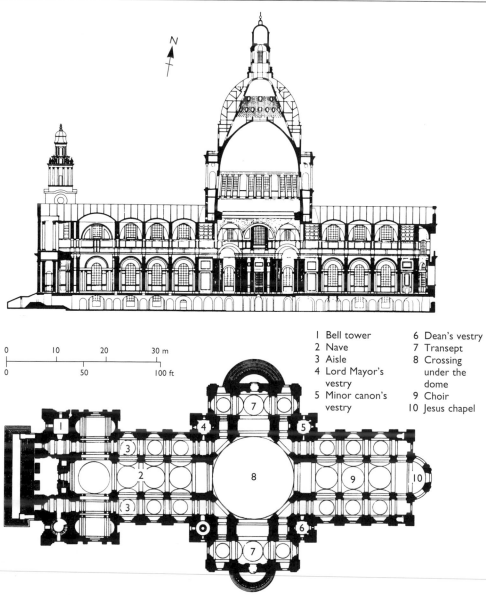

1 Bell tower
2 Nave
3 Aisle
4 Lord Mayor's vestry
5 Minor canon's vestry
6 Dean's vestry
7 Transept
8 Crossing under the dome
9 Choir
10 Jesus chapel

18.16 Longitudinal **section** and plan of Saint Paul's Cathedral, London. An invisible conical brick structure supports the lantern and the lead-faced, wooden framework of the outer dome. Extra support is supplied by flying buttresses which are masked by the upper parts of the side aisle walls.

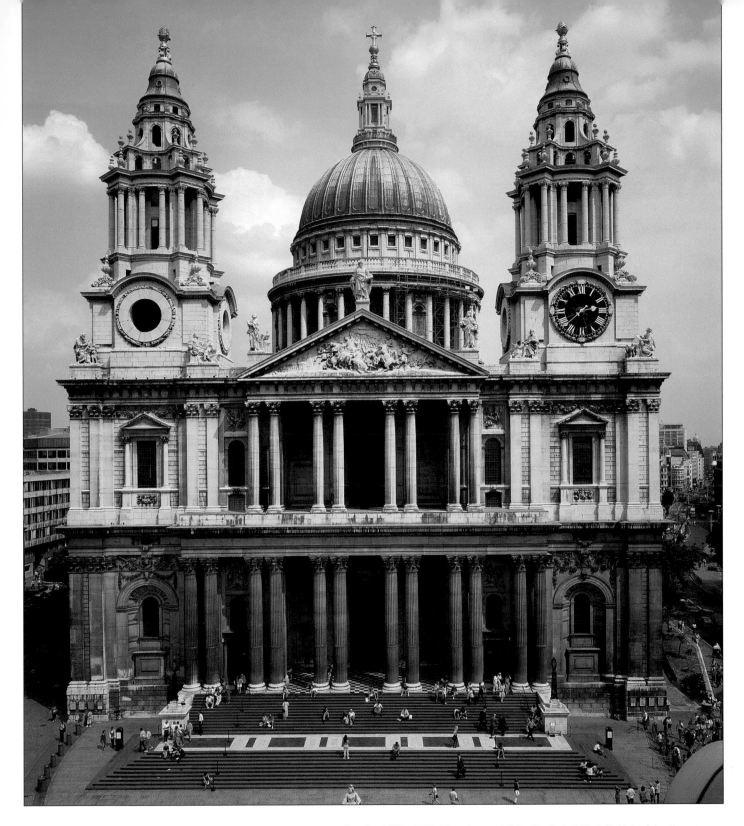

18.17 Christopher Wren, Saint Paul's Cathedral, London, western façade. 1675–1710. The dome of Saint Paul's is 112 ft (34.14 m) in diameter and 300 ft (91.44 m) high, second in size only to Saint Peter's in Rome. Even today, the dome dominates the London skyline, though the lower façade is easily visible only from nearby.

Fire (1666), which destroyed over two-thirds of the old walled City of London, Wren was appointed the King's Surveyor of Works. From 1670 to 1700 he took part in redesigning fifty-one of the churches that had burned down. Wren's priority during this period, however, was Saint Paul's, the first cathedral to be built for the Protestant Church of England.

The plan and longitudinal section (fig. **18.16**) blended elements from several styles. The formal arrangement (although not the style) of nave, side aisles, and **clerestory** is Early Christian. The western façade (fig. **18.17**), with its paired columns and central pediment, is reminiscent of the Louvre. Two flanking towers, although similar in conception to Gothic cathedral towers, are more Baroque in their

execution. They combine round and triangular pediments on the two lower stories, while curved walls appear at the bases of the spires. On the two stories of the façade between the towers, like the façade of the Louvre, paired Corinthian columns support an entablature. Both are also crowned by a triangular pediment. The dome, which rises over the crossing and spans both nave and aisles, is originally a Renaissance feature.

It took forty years to complete Saint Paul's under Wren's supervision. The result is a successful synthesis of French and Italian Baroque, with elements of Renaissance and Gothic.

Sculpture

Gianlorenzo Bernini

By far the most important sculptor of the Baroque style in Rome was Gianlorenzo Bernini. His over-lifesize sculpture *Pluto and Proserpina* (fig. **18.18**) represents the most violent moment in the Greek myth designed to explain the change in seasons—namely, the abduction of Proserpina, daughter of Ceres, the goddess of agriculture. A muscular Pluto, the Roman god of the Underworld, who wants Proserpina for his wife, grabs hold of her, his fingers convincingly digging into her flesh. She, in turn, pushes Pluto's head away from her as she assumes a version of the Mannerist *figura serpentinata* and squirms to escape his grasp. Here, however, the pose is in the service of a violent narrative moment rather than being a virtuoso Mannerist exercise. Both figures are in strong *contrapposto*, leaning backwards at the waist. Flowing hair and beard echo the rippling motion of the body surfaces and reinforce the sense of action. Seated next to Pluto is Cerberus, the three-headed dog who guards the Underworld. One head eyes the abduction intently, while another howls behind Proserpina's foot.

Bernini creates erotic tension between Pluto and Proserpina by a combination of pose and gesture that is characteristic of the Baroque style. Although Proserpina struggles against Pluto, she also turns toward him. In pushing away Pluto's head, her fingers curl around a peak of his crown, while he in turn leers amorously at her. The exuberant back-and-forth motion of the figures echoes

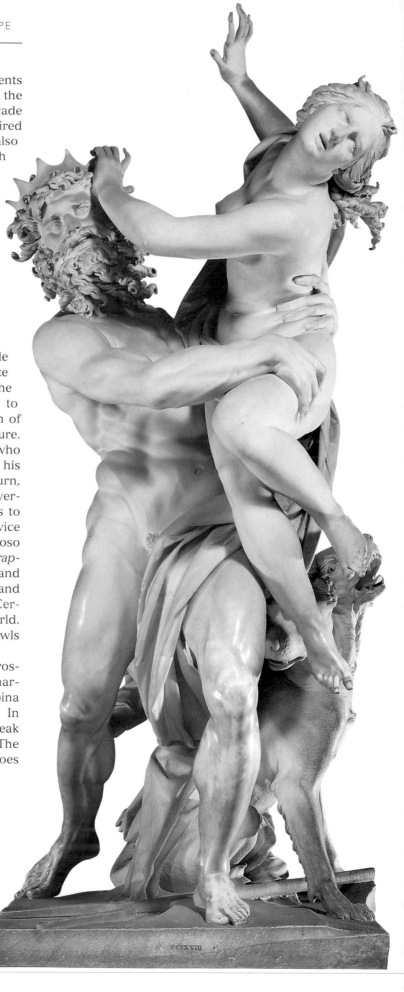

18.18 Gianlorenzo Bernini, *Pluto and Proserpina*, 1621–2. Marble, over-lifesize. Galleria Borghese, Rome. In Greek mythology, Pluto's abduction of Persephone (Proserpina in Latin) explained the seasonal changes. When Proserpina's mother, Ceres, went in search of her daughter, vegetation ceased to grow and winter fell. Ceres found Proserpina in Pluto's Underworld. Because her daughter had eaten six seeds from Pluto's pomegranate, she was doomed to spend half the year in his domain. During the six months of fall and winter, Ceres mourns and nature dies. Spring and summer return when Proserpina rejoins her mother.

the movement of Cerberus's two visible heads. The rhythm of the struggle can be related to the myth itself, for Proserpina is committed to Pluto for one half of the year (corresponding to winter and fall) and to her mother for the other half (spring and summer).

In the lifesize marble sculpture of *David* of 1623 (fig. **18.19**), all trace of Mannerism has disappeared. Once again Bernini has chosen to represent a narrative moment requiring action. David leans to his right and stretches the sling, while turning his head to look over his shoulder at Goliath. In contrast to Donatello's relaxed and self-satisfied bronze *David* (see fig. 14.34), who has already killed Goliath, and Michelangelo's (see fig. 15.20), who tensely sights his adversary, Bernini's is in the throes of the action.

The vertical plane of the Renaissance *David*s has become, in the Baroque style, a dynamic diagonal extending from the head to the left foot. That diagonal is countered by the left arm, the twist of the head, and the drapery. Unlike the *Pluto and Proserpina*, Bernini's *David* is a single figure. Nevertheless, his portrayal assumes the presence of Goliath, thereby expanding the space—psychologically as well as formally—beyond the immediate boundaries of the sculpture. Such spatial extensions are a characteristic, rather theatrical, Baroque technique for involving the spectator in the work (compare the way in which Bernini's church architecture involves the worshipers).

Even more theatrical in character is Bernini's "environmental" approach to the chapel of the Cornaro family (fig. **18.20**) in the church of Santa Maria della Vittoria. This was the funerary chapel of Cardinal Federico Cornaro, who came to Rome from Venice in 1644. The main event over the altar is *The Ecstasy of Saint Teresa* (fig. **18.21**), representing the visionary world of the mystic saint. Lifesize figures are set in a typically Baroque niche with paired Corinthian columns and a broken pediment over a curved entablature. As in the *David* and *Pluto and Proserpina*, Bernini represents a moment of heightened emotion—the transport of ecstasy. The angel prepares to pierce Saint Teresa with a spear as he gently pulls aside her drapery. His own delicate drapery flutters slightly as if he has just arrived. Although Teresa appears elevated from the ground, she is actually supported by a formation of billowing clouds. Leaning back in a long, slowly curving diagonal plane, she closes her eyes and opens her mouth slightly, as if in a trance. Her inner excitement contrasts with the relaxed state of her body and is revealed by the elaborate, energetic drapery folds, which blend with the clouds. Behind Saint Teresa and the

angel are gilded rods, representing rays of divine light. They seem to descend from the infinite realm of heaven and enter the niche behind the altar.

This scene synthesizes the Baroque taste for inner emotion with Counter-Reformation mysticism. Only a sculptor as great as Bernini could combine the powerful religious content of this scene with its erotic implications in a way that would satisfy the Church. Also characteristic of the Baroque style is Bernini's ability to draw the observer into

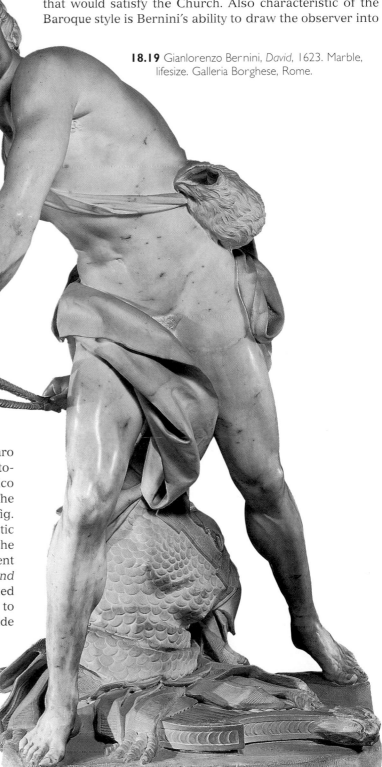

18.19 Gianlorenzo Bernini, *David*, 1623. Marble, lifesize. Galleria Borghese, Rome.

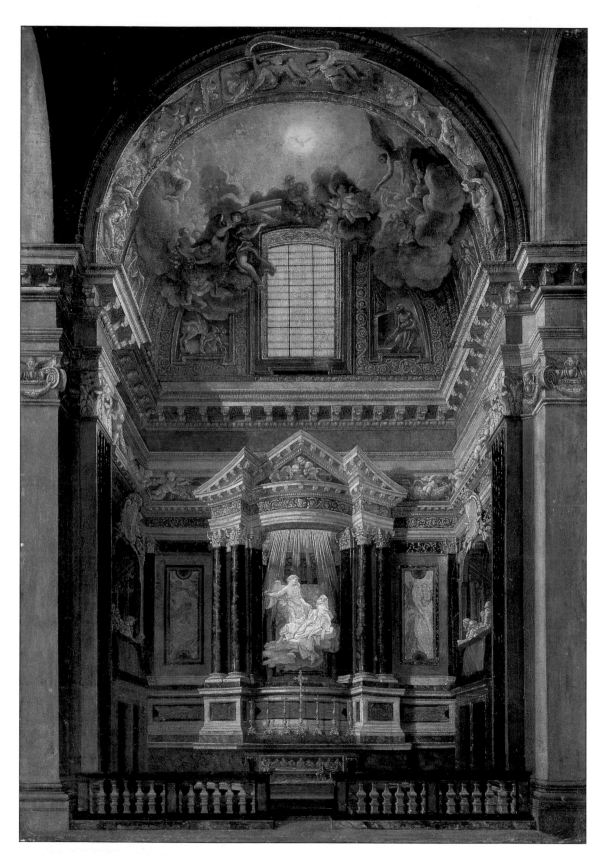

18.20 Anonymous, *Cornaro Chapel*, ca. 1644. Oil on canvas, 5 ft 6¼ in × 3 ft 11¼ in (1.68 × 1.20 m). Staatliches Museum, Schwerin, Germany. The Cornaro Chapel illustrates Bernini's skill in integrating the arts in a single project. Here he uses the chapel as if it were a little theater. Directly opposite the worshiper, the altar wall opens onto the dramatic encounter of Saint Teresa and the angel. Joining the worshiper in witnessing the miracle are members of the Cornaro family, who are sculptured in illusionistic balconies on the side walls, as can be seen in this contemporary painting.

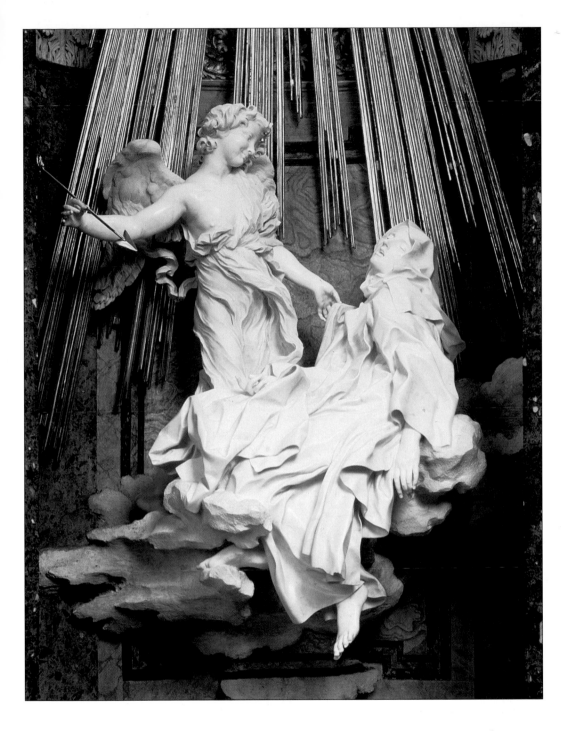

18.21 Gianlorenzo Bernini, *The Ecstasy of Saint Teresa*, Cornaro Chapel, Santa Maria della Vittoria, Rome. Marble, 11 ft 6 in (3.51 m) high. Saint Teresa was born in Avila, Spain, in 1515. She was a Carmelite nun who described the mystical experience depicted here. An angel from heaven pierced her heart with a flaming golden spear. Pleasure and pain merged, and she felt as if God were "caressing her soul." She was canonized in 1622.

the event, which is reinforced by the theatrical arrangement of the chapel itself. Sculptures of the Cornaro family on the side walls occupy an illusionistic architectural space combining the Ionic Order with a barrel-vaulted ceiling and a broken pediment. Some of the onlookers witness and discuss Saint Teresa's mystical experience just like theater-goers watching a play. All except the Cardinal were, in fact, deceased at the time of the commission. They represent the earthly, material world of the donor and his family, while two skeletons inlaid on the marble floor occupy Purgatory—one prays for redemption and the other raises his hands in despair.

Italian Baroque Painting

The two leading painters in Rome at the start of the seventeenth century were Annibale Carracci (1560–1609) and Michelangelo Merisi da Caravaggio (1573–1610). Both had the Church and the nobility as patrons, and both effected a development from High Renaissance—especially from Raphael and Michelangelo—to Baroque style. Carracci turned the late sixteenth-century Mannerist trends back to classicism, while infusing his images with exuberant Baroque drama. Caravaggio pursued a new kind of realism. Ceiling frescoes in churches and palaces

became particularly elaborate in this period, using illusionism to glorify the message of the Catholic Church and its patrons. Two of the most impressive creators of these were Pietro da Cortona (1596–1669), who painted the ceiling of the Barberini Palace, and Giovanni Battista Gaulli, called Baciccio (1639–1709), who decorated the ceiling of Il Gesù (see figs. 16.24 and 16.25), both in the grand Baroque manner.

Annibale Carracci

Annibale was the most important of the Carracci family of artists from the northern Italian city of Bologna (see Box). In 1597, Cardinal Odoardo Farnese commissioned him to decorate the Grand Gallery of his Roman palace in celebration of the marriage of a Farnese duke. The subject of the frescoes, the loves of the gods (fig. **18.22**), was in keeping with the wedding of an aristocratic Roman family. It also reflects Annibale's attraction to Classical iconography, which he infused with the formal elements of Baroque.

18.22 Annibale Carracci, ceiling frescoes in the Grand Gallery, 1597–1601, Farnese Palace, Rome. Altogether there are eleven scenes. Clearly visible in this view is *The Cyclops Polyphemos* in the far lunette, and the large ceiling panel of *The Triumph of Bacchus*. The ceiling panel next to this shows an airborne Mercury approaching Paris.

Giovanni Pietro Bellori's (1613–96) *Lives* of Annibale and Agostino Carracci are from his *Lives of Modern Painters, Sculptors, and Architects*. This work continues Giorgio Vasari's biographical approach to art and artists. Bellori was appointed Antiquarian of Rome by Pope Clement X, and also worked as librarian (in Rome) and art advisor to Queen Christina of Sweden. He wrote the *Lives* from the point of view of a francophile and a classicist. As a result, he approved the classicism of Raphael and Annibale Carracci, as well as of his friend Poussin. Of Caravaggio, however, Bellori was critical. He objected to what he saw as Caravaggio's lack of Classical idealization and to his taste for sometimes unrestrained and unattractive realism.

Bellori was in close contact with Le Brun and the Royal Academy of Painting and Sculpture in Paris, which became affiliated with the French Academy in Rome in 1676. He dedicated the *Lives* to Louis XIV's minister Colbert, and was made an honorary member of the Royal Academy. His art theory was consistent with the Academy's view that artists should select from nature in order to create the "ideal," which in turn reflected the Divine. In this, Bellori drew on Raphael's Platonic description of how to paint a beautiful woman. He praised Carracci for his historical and mythological paintings; just as Giotto had steered the art of painting out of the Byzantine past, according to Bellori, so Annibale Carracci rescued it from the decline of Mannerism. Of Carracci's Farnese frescoes, Bellori wrote: "Altogether the sight leaves a rich measure of its infinite beauty."[1]

The ceiling is a curved vault, on which Annibale painted monumental, imitation caryatid reliefs with picture frames dividing the narrative scenes. The colors are lively, and reflect the amorous exuberance of the content. Although the subject-matter is mythological, certain motifs such as the male figures seated in strong *contrapposto* are inspired by those in the Sistine ceiling. Implicit in the theme of the gods' loves is also a Christian subtext, in which divine love is moralized as a unifying force that leads to salvation. Another theme can be seen in the fresco to the left of the one-eyed Cyclops Polyphemos, which represents Venus and her mortal lover Anchises (fig. **18.23**). As the parents of Aeneas, Venus and Anchises refer to the founding of Rome, and by implication to the antiquity of the Farnese family. They thus link the Farnese Palace and its ecclesiastical patron with the mythological past.

Pietro da Cortona

Pietro da Cortona's *Glorification of the Reign of Urban VIII* of 1633–9 on the ceiling of the great hall of the Palazzo Barberini also links moralized allegories using

18.23 Annibale Carracci, Venus and Anchises (detail of fig. 18.22).

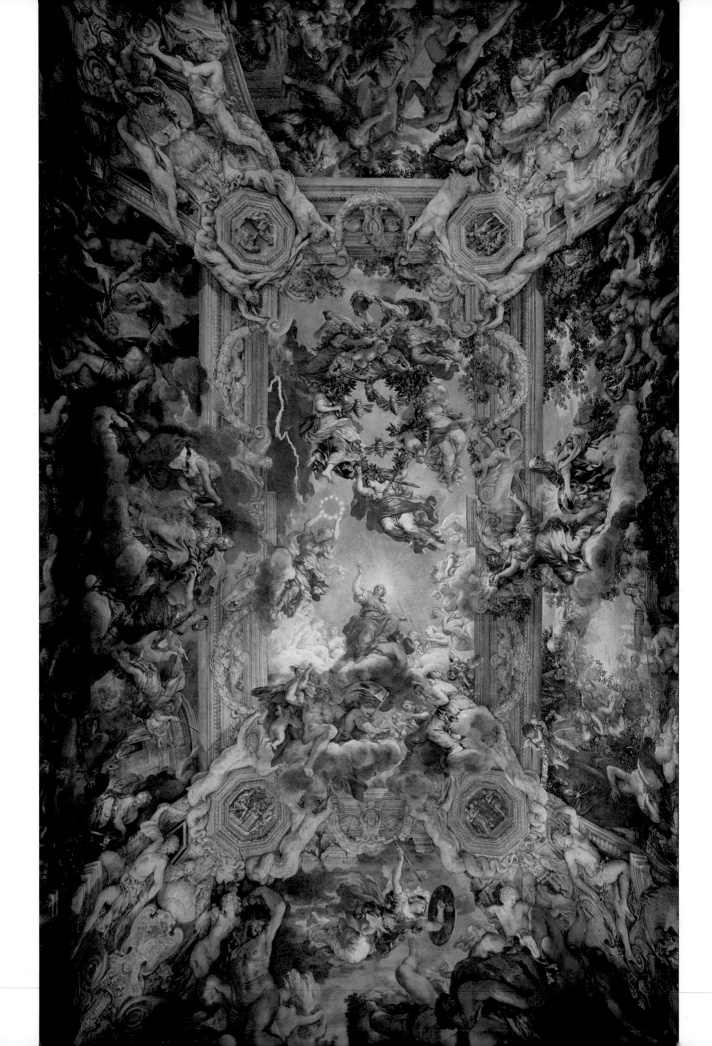

mythological figures with the exaltation of the Catholic Church (fig. **18.24**). Formally, the vigorous spatial shifts, illusionistic architecture, and variations of pose, color, and light animate and dissolve the surface of the walls and ceiling. The central field of the painted ceiling, in keeping with the traditional association of church ceilings and the heavens, is depicted as the sky. It is defined by an illusionistic, rectangular frame, with corner octagons containing simulated bronze reliefs and simulated sculptures below each corner. The curvilinear billows of the clouds are formal echoes of the twisted, dynamic poses of the figures.

The iconography incorporates the family and achievements of Maffeo Barberini (1568–1644), who was elected Pope Urban VIII in 1623. He was a zealous church reformer (Galileo's second condemnation occurred during his papacy), a classicist who published poems in Latin, and Bernini's most powerful patron. At the lower section of the center rectangle (from the point of view illustrated here), the figure in orange draperies holding a scepter personifies Divine Providence. This is reflected in the fact that the whitest light surrounds her head. Her upraised right hand directs the viewer to the figure of Immortality carrying a crown of stars upwards, toward the Barberini arms.

Above Immortality are three huge bees encircled by a laurel wreath, which is held aloft by Faith, Hope, and Charity. The three bees are Barberini devices that Bernini would later depict in relief on Urban VIII's tomb. There they refer to the sweet odor of sanctity believed to have emanated from his body after death. Their juxtaposition with laurel on the Barberini ceiling links the Pope with the grandeur of ancient Rome, while the little *putto* underneath the laurel refers to Urban as a poet. Surmounting the laurel are personifications of Religion with the keys to the Church and the papal tiara.

At the sides of the heavenly realm, but depicted as below it, are mythological subjects connected in some way with the overall themes of the fresco. The side figures are consistently shown in relative darkness, emphasizing their role as precursors, or forerunners, of the Christian faith. Athena, for example, battles the pre-Greek Giants, a scene which was read in the seventeenth century as an allusion to Urban VIII's efforts to eradicate heresy. Below Divine Providence are the three Fates and Saturn (the Roman counterpart of Kronos) devouring his children. This juxtaposition of mythological figures associated with time— Kronos the god of time, and the Fates who control the lifespan of mortals—alludes, by contrast, to the Christian concept of future eternity at the end of time.

Giovanni Battista Gaulli

One of the most spectacular of the seventeenth-century ceiling paintings in Rome is Giovanni Battista Gaulli's fresco of the *Triumph of the Name of Jesus* in the barrel vault of Il Gesù (fig. **18.25**). The artist had worked with the

devoutly Catholic Bernini in Rome, and eventually surpassed him in illusionistic effects. Despite Vignola's plan for a simple interior of the Gesù (see fig. 16.23), a new General of the Jesuit order, Padre Giovanni Paolo Oliva, elected in 1664, had a more elaborate program in mind.

In a large oval space framed illusionistically by architectural features and writhing figures, Gaulli painted the IHS, the first two and last letters of "Jesus" in Greek, as a dramatic source of formal and spiritual light. The scene is actually a Last Judgment, with the Saved rising toward the light of Christ's name, and the Damned, depicted in shadow, plummeting toward the nave below. Worshipers thus appear to be on the same material plane as the sinners, while the vault of heaven and of the mother church of the Jesuit order merge in a blaze of light.

Michelangelo Merisi Caravaggio

Michelangelo Merisi was born in the small northern Italian town of Caravaggio, the name by which he is known. When he was eleven, his father, a stonemason, apprenticed him to a painter in Milan. In about 1590 Caravaggio moved to Rome, where his propensity for violence repeatedly landed him in trouble. During his relatively short life, and despite the interruptions to his career caused by his falling foul of the law, Caravaggio worked in an innovative style and used new techniques that influenced painters in Italy, Spain, and northern Europe. In contrast to Annibale Carracci, Caravaggio painted in oil directly on the canvas, and made no preliminary drawings. Although Carracci worked in the faster medium of fresco, he did many drawing studies and thus appeared to his contemporaries to be a more deliberate, restrained artist than the flamboyant Caravaggio.

Karel van Mander, the Flemish biographer of artists and the first art theoretician in the Netherlands, wrote perceptively about Caravaggio. Van Mander admired the artist for his talent and for the fact that he had risen to fame from humble beginnings. His view that Caravaggio studied nature closely and painted realistically reflected the artist's general reputation. Van Mander also shared the theoretical bias—influenced by Neoplatonism—of Giovanni Bellori and the French Academy, when he wrote that "one should distinguish the most beautiful of life's beauties and select it." In that sentiment, van Mander echoes Raphael's assertion, in turn based on Plato, that to paint his idea of a beautiful woman, he combined the most beautiful parts of several women. But van Mander also understood the effect of Caravaggio's self-destructive lifestyle on his art:

> ... he does not study his art constantly, so that after two weeks of work he will sally forth for two months together with his rapier at his side and his servant-boy after him, going from one tennis court to another, always ready to argue or fight, so that he is impossible to get along with. This is totally foreign to art; for Mars and Minerva have never been good friends.[2]

18.24 (opposite) Pietro da Cortona, *Glorification of the Reign of Urban VIII*, 1633–9. Ceiling fresco. Palazzo Barberini, Rome.

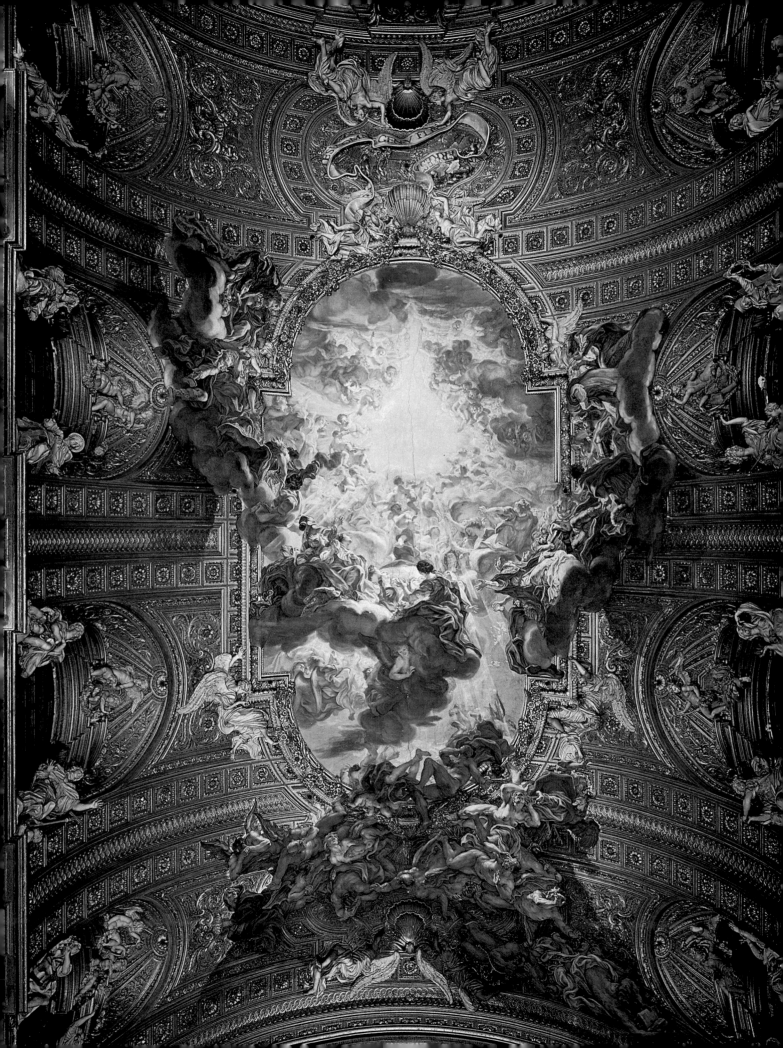

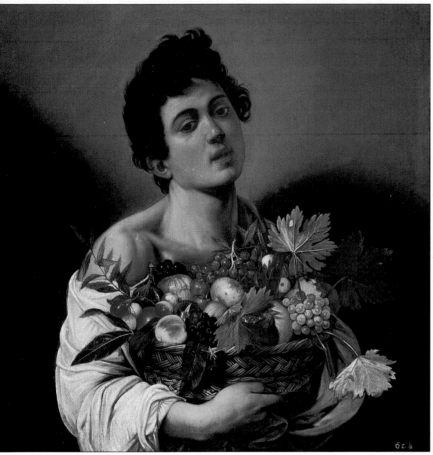

ally has erotic connotations, creates another transition between the observer and the boy. For example, the bright red and yellow peach at the front of the basket is a visual echo of the bare shoulder. Both have a slight cleft, repeated in the boy's chin, as if to suggest that the boy is as edible as the fruit. The wilting leaf at the right, which droops from the basket, is a reference to time. Together with the yellow piece of fruit turning brown in the center of the basket, the leaf calls on the viewer to enjoy life's pleasures—of the palate as well as of the flesh—before they become rotten with age.

Caravaggio's *Medusa* (fig. **18.27**) has the opposite effect: it repels rather than attracts the observer. Painted on a round tournament shield, the head exemplifies the artist's fascination with violence and decapitation. With its snaky hair, the head is highlighted against a dark background. Caravaggio thus focuses our attention on the very source of repulsion. The writhing snakes, whose skins reflect light, seem to squirm in response to the dangers of beheading. Likewise, the face itself looks down,

18.25 (opposite) Giovanni Battista Gaulli, *Triumph of the Name of Jesus*, 1676–79. Ceiling fresco with stucco figures in the vault of the Church of Il Gesù, Rome.

18.26 (above) Caravaggio (Michelangelo Merisi), *Boy with a Basket of Fruit*, c. 1594. Oil on canvas, 27½ × 26⅓ in (70 × 67 cm). Borghese Gallery, Rome.

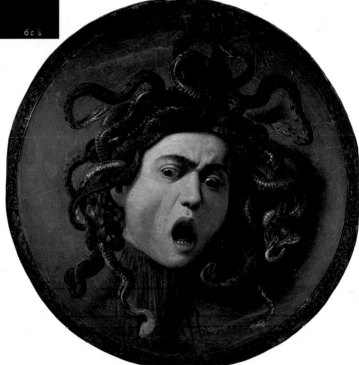

18.27 Caravaggio, *Medusa*, c. 1597. Oil on a shield. Florence, Uffizi. According to a contemporary source, the *Medusa* was commissioned by Cardinal del Monte as a wedding present for the Grand Duke of Tuscany. It is a play on the western tradition of putting the gorgoneion (the representation of Medusa's head) on shields and armor, recalling the similar decoration on the aegis of the goddess Athena.

Van Mander's comments are consistent with Caravaggio's artistic style and iconography as well as with his lifestyle. His attention to realistic natural detail can be seen in his early painting, *Boy with a Basket of Fruit* (fig. **18.26**). The convincing rendition of the fruit leaves no doubt about Caravaggio's close study of nature. Details such as the points of light on the grapes and the veins in the leaves contribute to the realistic effect. The boy stands out against a plain background, which is divided by irregular illumination, characteristic of the Baroque style. He may be a fruit vendor, but he offers himself as well as the fruit to the observer.

In contrast to the Renaissance view of painting as the natural world made visible through the window of the picture plane, Baroque artists draw the observer into the picture by means other than Brunelleschian linear perspective. In this painting, Caravaggio attracts us through the diagonal planes of the boy's right arm and the tilt of his head. His seductive nature is reinforced by the theatrical quality of the spotlight on him. The fruit, which tradition-

as if at its own severed body, and cries out in horror as the fresh blood spurts from the neck.

According to a contemporary source, Caravaggio, like Bernini, studied his own grimacing reflection in a mirror. It was also rumored that he used his own features for Medusa's face. If so, then Caravaggio represented himself as an androgynous, monstrous, mythological female, who is simultaneously dead and alive. The transitional state between life and death recurs in some of the artist's other decapitated heads and is also implied in the rotting fruit and wilting leaf of the *Boy with a Basket of Fruit*. In this unique iconography, Caravaggio expresses his personal ambivalence, oscillating between male and female, self-destructive criminal and creative artist, life and death, and, as van Mander noted, between the war-like Mars and the wise, creative goddess, Minerva.

The oppositions that are characteristic of Caravaggio's iconographic choices—and their relation to the nature of his patronage—can be seen in a comparison of his *Calling of Saint Matthew* (fig. **18.28**), which was an ecclesiastical commission, with his *Amor Vincit Omnia* (fig. **18.29**). *The Calling of Saint Matthew*, based on the biblical account of Christ summoning the tax collector Matthew to his service, exemplifies Caravaggio's innovative approach to Christian subject-matter. Christ and Saint Peter approach a group of older men and youths who are seated at a table counting money: clearly, they are gambling. Christ points to Matthew with a gesture that is a visual quotation from Michelangelo's *Creation of Adam* (see fig. 15.25), as if to say "Come with me." This iconography implicitly parallels Adam's original creation with Matthew's *re-creation* through Christ. Because the pointing gesture of Christ repeats that of Michelangelo's Adam, we can conclude that Caravaggio intended a typological meaning. Christ is here represented as the Second Adam and redeemer of Adam's sins—just as he redeems Matthew. By setting the scene in a contemporary context—the figures wear seventeenth-century Italian dress—Caravaggio appeals to all classes of society rather than only to the elite. The coin in Matthew's hatband underscores his present preoccupation with money, but his gesture echoes Christ's and indicates that his future will be dedicated to the service of Christ.

In *The Calling of Saint Matthew*, Caravaggio's **tenebrism** (freely translated as "dark manner") enhances the Christian message. Christ enters the picture plan from the right, along with a diagonal shaft of light that penetrates the darkness surrounding the gamblers. Night-time and

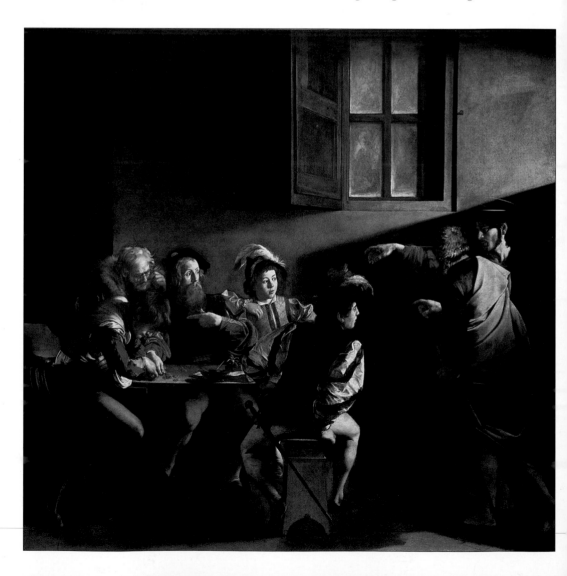

18.28 Caravaggio, *The Calling of Saint Matthew*, Contarelli Chapel, San Luigi dei Francesi, Rome, 1599–1600. Oil on canvas, 10 ft 6¾ in × 11 ft 1⅞ in (3.22 × 3.4 m). Caravaggio's criminal behavior and his acquaintance with Roman street life clearly contributed to the character of this picture. In 1608 Caravaggio fled Rome after killing a man in a dispute over a tennis match. He died of a fever in 1610 before news of the pope's pardon had reached him.

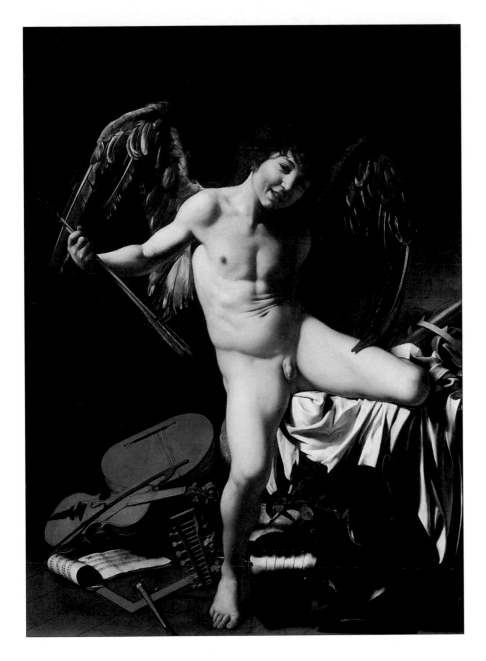

18.29 Caravaggio, *Amor Vincit Omnia*, c. 1602. Oil on canvas, 5 ft ⅝ in × 3 ft 7⅜ in (1.54 × 1.1 m). Gemäldegalerie, Staatliche Museen, Berlin. Caravaggio painted this picture for the Marchese Vincenzo Giustiniani, a wealthy Roman patron. Homosexual references pervade Caravaggio's religious pictures, but never so overtly as in his secular works. Soon after arriving in Rome, Caravaggio joined the homosexual household of Cardinal del Monte, a leading patron of the arts. Despite his personal proclivities and criminal record, Caravaggio's talent was recognized and fostered by ecclesiastical patronage.

the illicit activities of night are suddenly illuminated by Christ's miraculous light. The young man who does not see Christ because he is focusing intently on money is covered in shadow. The old man leaning over him peers through his spectacles. But, in his myopia, he sees only the money and remains oblivious to the significance of the event taking place right beside him.

Caravaggio's *Amor Vincit Omnia* ("Love Conquers All") of about 1602 is a picture totally devoid of Christian content, and it is perhaps his most overtly homosexual painting. Like the *Boy with a Basket of Fruit*, this was commissioned by a private homosexual patron and was designed to appeal to a homosexual audience. The Cupid slips from the edge of a rumpled bed, coquettishly mocking the world. His tilted head and the *contrapposto* of his torso create a series of Baroque diagonals that are

accented by light. The wings appear live and the edges of the feathers, like the *Medusa*'s snakes, catch the light. Records indicate that Caravaggio kept such wings in his studio in Rome in order to enhance the realism of his pictures. The anal erotic implications of the curved tip of the left wing are clear and direct. They simultaneously challenge, and attempt to seduce, the observer.

In *The Calling of Saint Matthew*, light and dark are used symbolically as Christian metaphors. In the *Amor*, light illuminates the erotic figure of the boy and highlights the objects in the room. On the bed are a crown and scepter. Instruments of geometry and music, a manuscript and a quill pen, and pieces of armor are strewn about on the floor. Behind Cupid's right thigh is a starry globe, possibly representing astronomy. The message of this painting is that love, and specifically homosexual love, conquers all.

Artemisia Gentileschi

Caravaggio's lifestyle did not lend itself to the maintenance of a workshop or the employment of apprentices. Nevertheless, he had a major influence on Western art. Among his followers, known as the *Caravaggisti*, was Artemisia Gentileschi (1593–1652/3), one of the first women artists to emerge as a significant personality in Europe (see Box).

Artemisia's *Judith Slaying Holofernes* (fig. **18.30**), which exhibits the Baroque taste for violence, illustrates an event from the Book of Judith in the Old Testament Apocrypha. The Assyrian ruler Nebuchadnezzar has sent his general Holofernes to lay waste the land of Judah. A Hebrew widow of Bethulia, Judith, pretending to be a deserter, goes with her maidservant to the camp of Holofernes and flirts with him. Arranging to spend the evening alone with him, Judith plies him with liquor until he falls into a stupor, and she uses his own sword to cut off his head. She places the head in a bag and returns home; the head is exhibited from the city walls and the Assyrians disperse. Artemisia depicts the moment at which Judith plunges the blade through Holofernes' neck. The violence of the scene is enhanced by the dramatic, Caravaggiesque shifts of light and dark and by the energetic draperies.

Baroque Painting in Northern Europe

Italian patronage continued to be ecclesiastical, as well as private, in the seventeenth century, while in France the state-sponsored Academy set the artistic style. In Flanders the Catholic Church was the primary patron of the arts, while in Protestant Holland the development of a bourgeois economy and a free commercial art market resulted in a significant change in the kind of art produced. For the first time artists were able to support themselves by specializing in a category such as portraiture, still life of various kinds, genre, or landscape. Art dealers sold works to middle-class citizens, who often purchased as much for investment and resale as for esthetic pleasure.

Women as Artists: From Antiquity to the Seventeenth Century

Over the past quarter-century, art historians have researched and re-evaluated the role of women artists in Western art. As a result, women's achievements in the visual arts, and the obstacles they have had to overcome, are much better understood.

Pliny's *Natural History* lists the names of five women in ancient Greece and Rome, together with their works, although nothing else is known of them. From the Roman period through the end of the fourteenth century, there are relatively few records of any individual artists, men or women. During the Middle Ages, women played a major role in the production of embroidery and tapestry—more so in northern Europe than in Italy. They were also active in the illumination of manuscripts, although this was largely confined to the daughters of wealthier families. Until the late thirteenth century, illumination was done by nuns, and a woman needed a dowry to enter a convent.

The bylaws of the Company of Saint Luke, a confraternity of artists in Florence, founded in 1361, mention dues to be paid by women members. However, no women's names are found in the Company records. From the fifteenth century onwards, beginning in Italy, women artists emerge from obscurity. There is evidence, for example, that a woman submitted a model for the lantern of Brunelleschi's dome over Florence Cathedral, but her name is unknown. Previously, women artists in Italy had usually been nuns, women of education and talent, but their work had been limited through their isolation from the wider artistic community. An exception was Sofonisba Anguissola, who worked for Philip II of Spain. Artemisia Gentileschi was the first woman to join the Company's successor, the Accademia del Disegno (Academy of Design), in 1616.

The elevated status of the artist in the Renaissance was largely the result of a new humanist educational curriculum. For the first time, artists mixed socially with the princes of the Church and the nobility, as intellectual equals rather than as artisans and craftsmen. Gradually, the new educational standards were extended, especially among the ruling classes, to women. They were encouraged to engage in a wider range of activities, including poetry, music, and art (in that order). By the sixteenth century it was generally agreed that the daughters of the middle classes should be educated. Women who wanted to become artists had to be trained in the workshops of established masters; many were the daughters, sisters, or wives of artists. The courts of fifteenth- and sixteenth-century Italy produced women who were outstanding cultural patrons, as well as having significant artistic accomplishments in their own right. Nevertheless, attributions are always a problem with women, for works by women were likely to have been delivered under the name of the male head of the workshop.

Despite the advances made by women in the Renaissance, however, practical obstacles remained. Marriage, usually followed by continuous childbearing, interfered with some promising careers. Nevertheless, Artemisia Gentileschi did marry and have children. Women were also barred from drawing from live models, which prevented competition on equal terms with men. Artemisia Gentileschi drew from female models, but familiarity with the male nude was important for monumental works. It is thus no accident that, until recently, it was in the fields of portraiture and still life that women tended to achieve distinction.

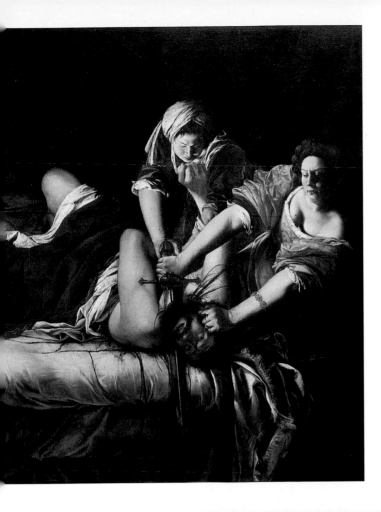

Peter Paul Rubens

The Flemish artist Peter Paul Rubens (1577–1640) was one of the most productive of the seventeenth century. He has left a wealth of paintings covering a wide range of iconography, and his patronage was as varied as his subject-matter. He worked for the Church, the nobility, private citizens, and for himself. Rubens ran a successful workshop with many apprentices, dealt shrewdly in the art market, and undertook important diplomatic missions for Flanders. He was also the court painter to the Spanish governors of Flanders. Isabella, daughter of a Spanish king and regent of the Spanish Netherlands, was a close friend of Rubens and an avid collector of his paintings. In the late 1620s Rubens spent several months at the Spanish court of Philip IV, where he influenced Velázquez (see p. 668).

Rubens's mythological paintings, such as *Venus and Adonis* (fig. **18.31**), celebrate the sensual side of life and seem unaffected by the Counter-Reformation. They also reflect Rubens's Classical education. In this work, Venus tries to prevent her handsome, young, mortal lover Adonis from departing. His hunting dogs wait impatiently as he tries to disengage from the goddess and her son Cupid, who has placed his bow and arrow on the ground and tugs at Adonis's leg. Venus clings to his arm,

18.30 (above) Artemisia Gentileschi, *Judith Slaying Holofernes*, c. 1614–20. Oil on canvas, 6 ft 6⅓ in × 5 ft 4 in (1.99 × 1.63 m). Galleria degli Uffizi, Florence. Artemisia learned painting from her father Orazio. In 1611 Orazio hired Agostino Tassi to teach her drawing and perspective. Tassi raped Artemisia and then refused to marry her. When Orazio sued Tassi, Artemisia was tortured with thumbscrews to test her veracity before Tassi was convicted. Undoubtedly affected by this experience, Artemisia is known for her pictures of heroic women and of violent scenes.

18.31 (right) Peter Paul Rubens, *Venus and Adonis*, c. 1635. Oil on canvas, 6 ft 5½ in × 7 ft 11¼ in (1.97 × 2.42 m). Metropolitan Museum of Art, New York (Gift of Harry Payne Bingham, 1937).

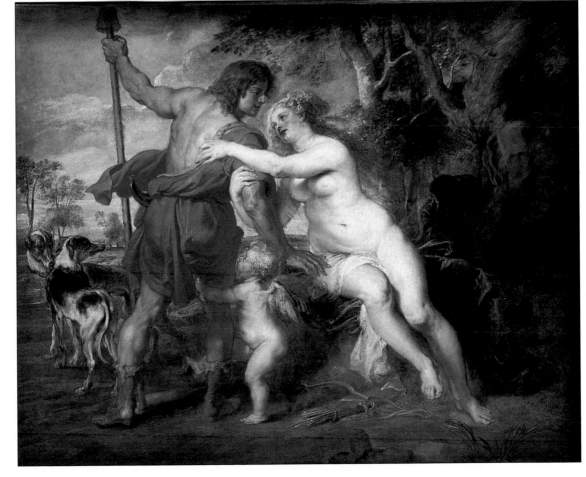

as he turns and allows his right hand to linger seductively on her thigh. The ambivalence of Adonis's pose, forming a long diagonal, reveals his inner struggle between staying and leaving.

Venus herself forms a counter-diagonal, her fleshy, highlighted body a variation on the traditional reclining nude. In contrast to Classical and Renaissance reclining nudes, Rubens's figure is actively, rather than passively, seductive. Venus's more active role in this scene is consistent both with the particular myth and with the moment represented, in which she attempts to control and dominate her lover. Her proportions have also ventured some distance from those of Classical antiquity, for Rubens has emphasized her generous breasts and rippling, dimpled flesh in a way that is frankly sensuous. It is likely that, for Rubens, such full figures reflected, among other things, the Flemish equation of fleshiness with prosperity.

In the so-called *Straw Hat* (fig. **18.32**), Rubens gives free reign to his taste for lusty women. The figure is Susanna Fourment, the artist's future sister-in-law. She peers at the

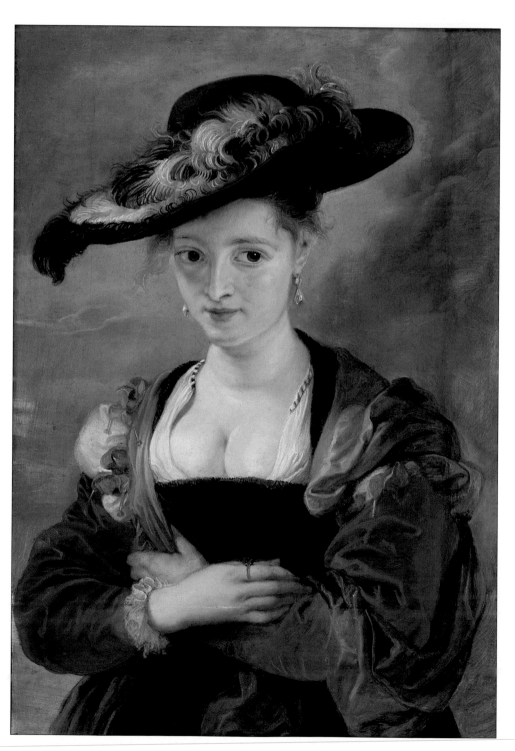

18.32 Peter Paul Rubens, *The Straw Hat* (Susanna Fourment), c. 1620–25. Oil on wood, 31⅛ in × 21½ in (79 × 54.6 cm). National Gallery, London.

observer from beneath a hat set on a diagonal and adorned with feathers. Her proportions are voluptuous: the snug fit of her dress pushes her breasts upward, and her ring squeezes the flesh of her forefinger. The strong contrasts of white light and rich blacks accentuate the textual differences between the soft flesh and the silky sleeves. Their swirling folds and bulky proportions echo the voluminous clouds, and their blackness is repeated in the dress, eyes, and hat. Such striking shifts of light and dark emphasize the increased planar movement of Baroque painting in comparison with Renaissance style.

Rubens's *Martyrdom of Saint Lieven* (fig. **18.33**) was destined for the high altar of the Jesuit church in Ghent. In contrast to the mythological pictures and portraits such as *The Straw Hat*, this work is very much affected by Counter-Reformation concerns, in this case the demand that the viewer be encouraged to identify with Christian suffering and redemption. The combined violence and ecstasy of Rubens's interpretation of the gruesome subject-matter is reflected in the formal excitement of the painting. Crowds of human figures in contorted poses either participate in the crime against Saint Lieven or turn upward toward the light from heaven. Horses rear, and angels appear in a swirl of cloud formations. At the lower right, a soldier turns in a dancelike motion, as if arrested by his recognition of light (and implicitly by enlightenment). The shifts from light to dark, and from color to color, enhance the motion of the poses and gestures, creating a feeling of intense urgency. It is the Baroque technique of involving the observer directly in the picture's space, and therefore in its narrative, that results in this sense of immediacy.

Anthony van Dyck

Rubens's student, Anthony van Dyck (1599–1641), was born in Antwerp, but reached the height of his career as the court portrait painter to the Stuart king Charles I. As such, van Dyck set a standard for portraiture that influenced successive generations of English painters. His portrait of *Charles I on Horseback* (fig. **18.34**) memorializes the ten years when Charles ruled England as an absolute monarch—the so-called Period of Personal Rule after he had dissolved Parliament in 1629.

Van Dyck depicts Charles in the tradition of equestrian portraiture, exemplified by the bronze *Marcus Aurelius* in Rome (see Vol. I, fig. 8.52). The monumental horse, Charles's shiny armor and baton of rule, and the King surveying the landscape, create an image of imperial power. Like Rubens, van Dyck conveys a sense of painterly texture in rendering materials and creates an atmospheric sky. Behind the horse is a page in rich red silk who holds the King's helmet. Charles's melancholy, watery-eyed expression is characteristic of van Dyck's portraits and would later be related to the King's tragic end. Otherwise there is nothing in the painting to suggest the reality of the political situation in England at the time. The inscription on the plaque attached to the tree reads *Charles I, King of Great Britain*. Like the painting itself, the inscription reflects the degree to which Charles was out of touch with the dissatisfied and rebellious mood of his subjects.

Rembrandt van Rijn

Rembrandt van Rijn (1606–69) was born in Leiden, in Protestant Holland. He quickly became a successful painter and moved to Amsterdam. Unlike Rubens, Rembrandt worked largely for Protestant patrons. However, he ran his own commercial enterprise as free as possible from the influence of patronage, preferring that his works be valued as "Rembrandts" rather than as the products of a contractual agreement. With this attitude Rembrandt virtually invented the modern art market. He also reflected the seventeenth-century rise in Dutch capitalism, which through the East India Company had become international in scope (see Box).

The Dutch East India Company: Seventeenth-Century Capitalism

Holland was a small country, not blessed with natural resources and constantly on the defensive against the inroads of the North Sea. Among its more important industries were commercial fisheries (mainly herring) and the production of linen and other cloths. During the seventeenth century Dutch fortunes benefited from an expansion in world trade. The East India Company, established in 1602 by a group of Dutch merchants and sea captains, exemplified the capitalist trends of the period.

The purpose of the Company was to corner the market in products imported from India. Fleets of Dutch ships brought commodities such as spices, silks, and metals from India to the Company's headquarters in the Netherlands. Competitors, principally the English and the Portuguese, were driven out of the market by various stratagems. Prices were set below actual cost. By keeping large stores of goods in warehouses, the Dutch maintained a continuous stock of merchandise and could raise prices when their competitors ran out of supplies. Surplus cargo was occasionally destroyed but, more often, was used to undersell the competition and put rivals out of business. Production was in the hands of Dutch settlers in India, who relied on slave labor. The profits from these enterprises, which were distributed to the shareholders of the Company, could be enormous and helped to swell the prosperity of the Dutch merchant class.

By combining their resources and channeling their efforts through the Company, the Dutch had secured a monopoly of the spice market (cinnamon, cloves, nutmeg, pepper) by the second half of the seventeenth century, as well as a strong position in cotton, porcelain, and silk.

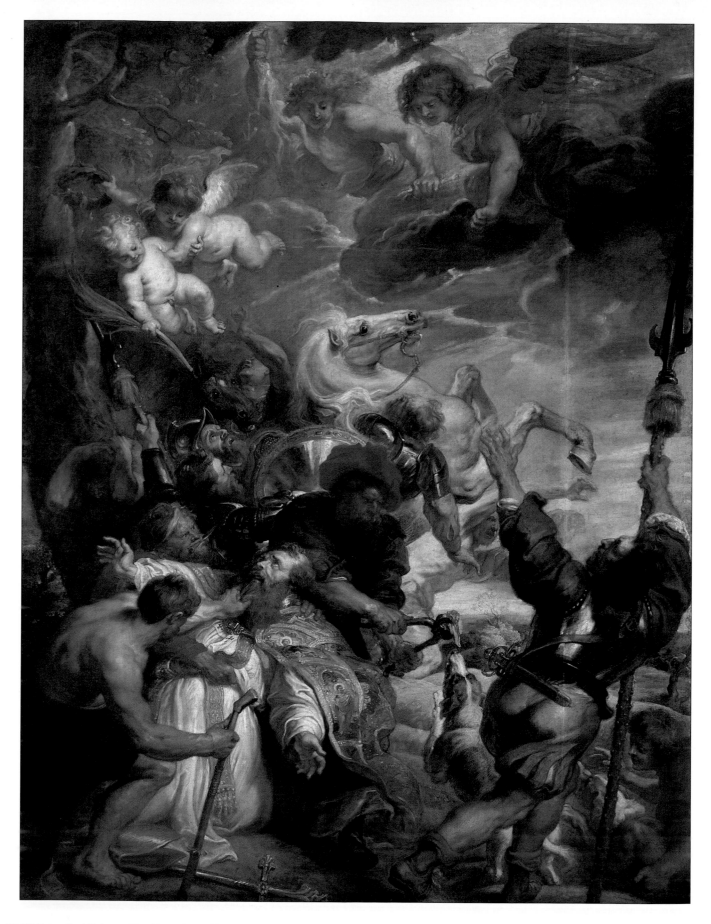

18.33 Peter Paul Rubens, *The Martyrdom of Saint Lieven*, c. 1633. Oil on canvas, 14 ft 9⅛ in × 10 ft 11⅞ in (4.5 × 3.35 m). Musées Royaux des Beaux-Arts de Belgique, Brussels. Saint Lieven was a bishop of Ghent who was waylaid and murdered by robbers. They cut out his tongue and fed it to the dogs. At the center of this picture, one of the robbers holds the tongue in a pair of tongs and offers it to an eager dog. Just below the robber, the saint is depicted as if ecstatically transported by his suffering.

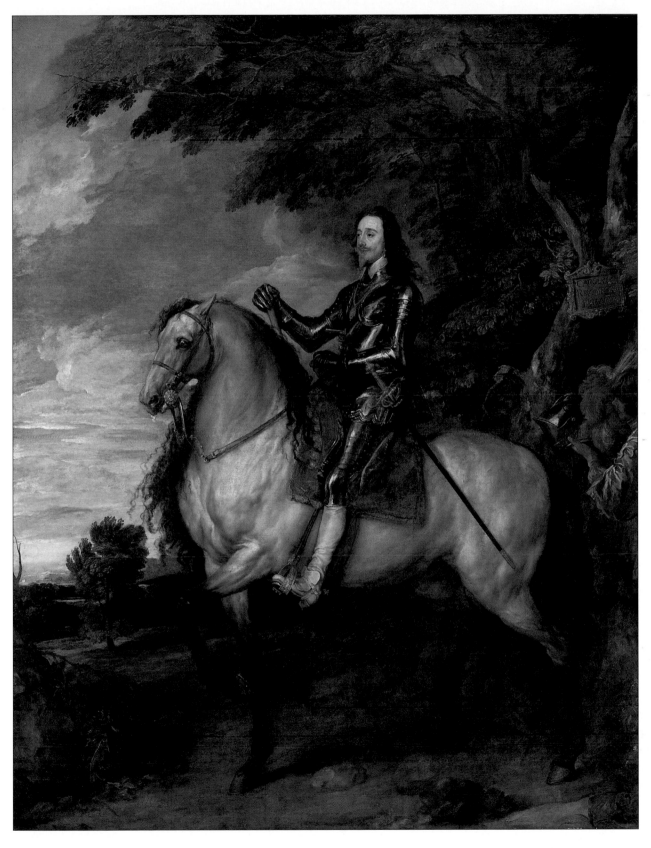

18.34 Anthony van Dyck, *Charles I on Horseback*, c. 1638. Oil on canvas, 12 ft × 9 ft 7 in (3.66 × 2.92 m). National Gallery, London.

Mughal Art and the Baroque

The sixteenth-century age of exploration led to colonization, missionary activity, and trade with the Americas and the Far East. In Holland, many Chinese and Japanese objects were imported through the Dutch East India Company. Although by and large any real understanding of these distant regions on the part of Europeans was minimal, Eastern motifs began to influence furniture design, and a general taste for the exotic emerged in Europe. These cultural exchanges were most meaningful in contacts with Mughal painters of seventeenth-century India (fig. **18.35**). Rembrandt copied Mughal miniatures, and Rubens drew figures from the Mughal court.

The Mughal school of painting in India was known in Europe largely through the enlightened patronage of three emperors: Akbar (1555–1603), Jahangir (1603–27), and Shah Jehan (1627–66). Descended from Genghis Khan, Akbar's Persian grandfather founded the Mughal dynasty in India. He brought with him Persian artists, with whom Akbar studied as a child. Although raised as a Muslim, Akbar did not subscribe to the Islamic prohibition against figurative art. He therefore had Hindu artists working at his court, and they painted in a naturalistic tradition.

Akbar wished to unite Hinduism with Islam and to synthesize both with Christianity. He endorsed the progressive notion that the divine status of a ruler depended on a just and fair administration. His advanced religious views and desire for political unity inspired him to collect European art.

Akbar's European collection influenced Mughal artists, who began to introduce Western perspective into their own work. The **miniature** of *Akbar Viewing a Wild Elephant Captured near Malwa* (fig. **18.36**) combines Hindu shading, which forms the elephant's bulk, Islamic patterning, and elements of Western perspective. For example, the oblique angle of the castle's middle wall creates a three-dimensional effect. Reinforcing this is the depiction of the ground as convincingly supporting elephants, riders, and trees.

Although orthodox Muslims in India objected to Akbar's patronage of figurative art, his son Jahangir continued to encourage artists to study nature and European painting. In the *Allegorical Representation of the Emperor Jahangir Seated on an Hourglass Throne* (fig. **18.37**) the Baroque interest in the theme of time (the hourglass) is incorporated into an Islamic setting. The border designs, **calligraphic** lettering, and elaborate carpet that flattens the space are the result of Persian influence. The figures and hourglass, on the other hand, are rendered three-dimensionally and are shaded. Jahangir, surrounded by a double sun and moon halo, greets four personages, who reveal his international outlook: a Muslim divine in a long white beard, a Muslim prince with a black beard, a European delegate in Western dress, and an artist holding up a picture. Two little angels copied from a European painting play by the hourglass. Above and to the left, a Cupid carries a bow and arrow. To the right is another Cupid who covers his eyes, a reference to the Western notion of blind love.

The masterpiece of Mughal architecture combines Hindu and Islamic features. The Taj Mahal (literally "crown of buildings"; fig. **18.38**) was commissioned by Jahangir's

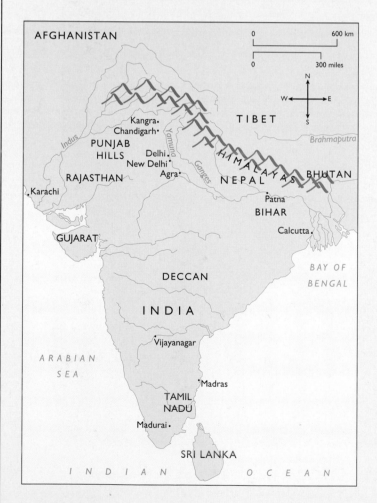

18.35 Map of India in the 17th century.

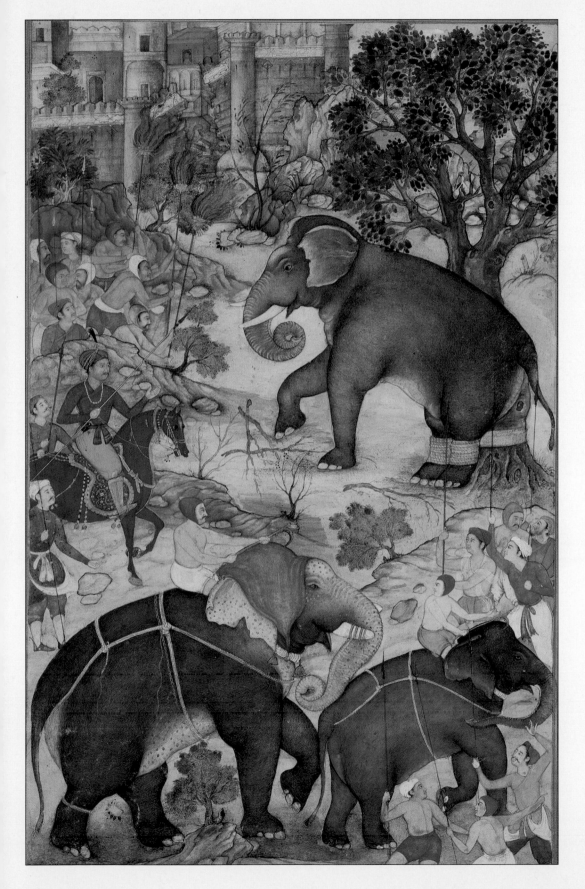

18.36 Lal and Sanwah, *Akbar Viewing a Wild Elephant Captured near Malwa,* 1600. Gouache on paper, 13⅛ in (33.4 cm) high. Victoria and Albert Museum, London.

son, Shah Jehan, as a memorial to his wife, Mumtaz Mahal, who died in 1631. The jewel-like building is set in a garden and approached by four waterways, its ensemble signifying Paradise and its four rivers. The **mausoleum** itself has a large, cusped arch over a deep recess, and stands on a podium with four domed **minarets**, one at each corner. On either side of the mausoleum are two identical structures—a mosque and a secular building. Balancing the large central onion dome, which is a characteristic feature of Mughal architecture, are two smaller *chattris*—the parasol-shaped elements that are derived from the *chattras* on early **stupas** (see Vol. I, fig. 8.L). The entire structure is perfectly symmetrical, which contributes to its calm, imposing impression. Elaborate curvilinear designs of inlaid, semiprecious stones enhance the marble surface of the Taj Mahal.

18.37 (right) Bichtir, *Allegorical Representation of the Emperor Jahangir Seated on an Hourglass Throne*, early 17th century. Color and gold on paper, 10⅞ in (27.6 cm) high. Courtesy of the Freer Gallery, Smithsonian Institution, Washington, D.C. (42.15V).

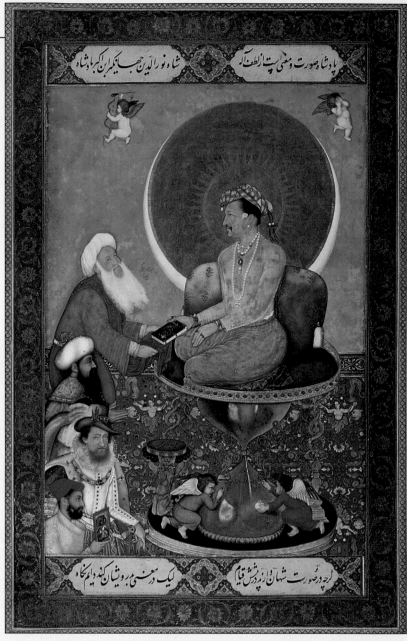

18.38 (below) Taj Mahal, 1634, Agra, India.

The subject-matter of Rembrandt's paintings includes biblical and mythological scenes, landscapes, and portraits. Like Caravaggio, Rembrandt was attracted to the dramatic effects of light and dark, but he used them as much to create the character of his figures as their backgrounds. His *Blinding of Samson* (fig. **18.39**) shows the most dramatic moment in the story told in the Book of Judges (16:20–21). The Philistines have pinned down Samson and are chaining his hand as he struggles fiercely. Rembrandt draws the viewer into the picture plane through the strong, silhouetted diagonals of the man in red who directs his lance at Samson. Leaning over Samson is the armored soldier plunging a dagger into his eye. Delilah, who is a portrait of Rembrandt's wife Saskia, runs away, carrying the hair that was the source of Samson's strength and the scissors she used to cut it. At the upper right is a figure with a raised sword, who is nevertheless appalled at the blinding, a theme that had enormous significance for Rembrandt. It recurs throughout his work, but this is its most violent expression. As a painter, Rembrandt would have identified with the horror of a man blinded and his right hand immobilized. Here, the sharp

contrasts of light and dark emphasize the effect of blindness, and the violence is accentuated by the force of diagonal, planar thrusts.

In the Old Testament scene of *Belshazzar's Feast* (fig. **18.40**), Rembrandt emphasizes the mystical light required by the text. Belshazzar, the son of the regent of Babylon in the sixth century B.C., sees a great light on the wall during a feast. Beside the light a hand appears with a cryptic message, which Daniel interprets as "You have been weighed in the balance and found wanting." The same night, Belshazzar is killed, fulfilling the sense of menace that is still popularly associated with "writing on the wall."

In Rembrandt's image, Belshazzar rises from the table and turns to face the mysterious light. He spreads out his arms in a sweeping diagonal, displaying the elaborate gold embroidery of his cloak. Light is also concentrated on his face, jewelry, turban, and crown, contrasting these reflections of his material wealth with the illumination of inner fear and awe in the faces of the two figures on Belshazzar's right (our left), and with the light from heaven appearing on the wall. This painting is primarily rendered in warm brown tones, with a prominent color shift in the

18.39 Rembrandt van Rijn, *The Blinding of Samson* (*The Triumph of Delilah*), 1636. Oil on canvas, 6 ft 8¾ in × 8 ft 11 in (2.05 × 2.72 m). Städelsches Kunstinstitut, Frankfurt.

18.40 Rembrandt van Rijn, *Belshazzar's Feast*, c. 1635. Oil on canvas, 5 ft 5 ¾ in × 6 ft 9½ in (1.67 × 2.07 m). National Gallery, London. Rembrandt shared the Baroque interest in naturalism. For his Old Testament scenes, he liked to frequent the Jewish quarter of Amsterdam for inspiration and models.

18.41 Rembrandt van Rijn, *The Militia Company of Captain Frans Banning Cocq* (known as *The Night Watch*), 1642. Oil on canvas, 12 ft 2 in × 14 ft 4 in (3.7 × 4.37 m). Rijksmuseum, Amsterdam. This was originally located in the headquarters of the Amsterdam Civic Guard. In 1975, a cook who had been fired from the Dutch navy slashed *The Night Watch*. This painting is so identified with the Dutch nation that the sailor believed he was taking revenge on Holland itself.

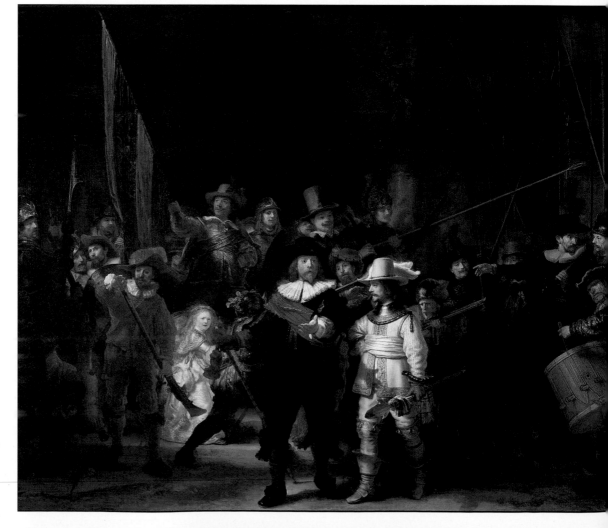

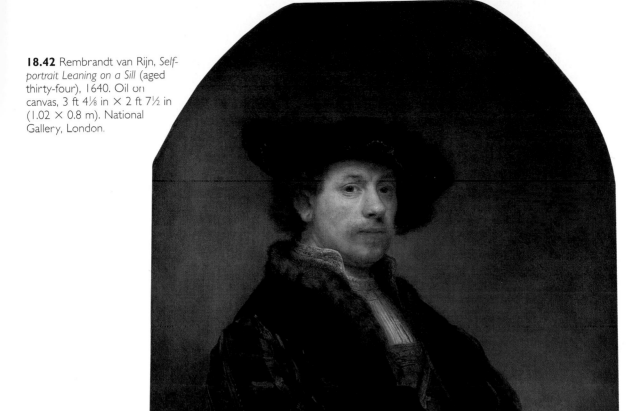

18.42 Rembrandt van Rijn, *Self-portrait Leaning on a Sill* (aged thirty-four), 1640. Oil on canvas, 3 ft 4⅛ in × 2 ft 7½ in (1.02 × 0.8 m). National Gallery, London.

red-orange of the woman at the lower right corner. She withdraws in fear from the light and spills her drink. In so doing, she helps to draw the observer into the picture plane by virtue of her forceful diagonal movement.

By mid-career, Rembrandt was Amsterdam's most esteemed portrait painter. As Church patronage began to wane in western Europe, especially in the Protestant countries, secular groups began to commission works of art. Rembrandt's *Night Watch* (fig. **18.41**) is a group portrait which depicts a militia company, led by Captain Banning Cocq, leaving Amsterdam for a shooting expedition. The city wall, pierced by an arch in the background, evokes the triumphal arches of ancient Rome; it also reminded viewers that the Dutch had overthrown their Spanish conquerors and were now a free people.

The two men striding into the foreground form a diagonal link between the observer and the company. The captain extends his left hand as if to invite us into the scene. Light falls on to his hand from above, and casts a shadow across the yellow jacket of his companion. As a result, the shadow continues the line of the captain's red sash—a formal interplay of lights, darks, and colors that is typical

of the Baroque style. The remainder of the crowd is animated by highlights of light and color, by strong, **silhouetted** contrasts, and by the shifting diagonals of the spears, guns, and flags. A barking dog at the lower right responds to the sound of the drum.

The faces are dramatically characterized by light and dark defining their features. Each figure appears to be a portrait. Included in the crowd is a young woman who resembles Rembrandt's wife Saskia. She is highlighted in yellow behind the soldier in red. Hanging from her belt is a bird, whose claws were the emblem of the militia. Peering out over the shoulder of the flag-bearer is Rembrandt's own face, and possibly his most unassuming self-portrait.

Rembrandt painted more self-portraits than any other artist before the seventeenth century. Including paintings, etchings, and drawings, Rembrandt produced at least seventy-five self-portraits, all of which constitute a visual autobiography. They chronicle Rembrandt's changing fortunes and moods and, above all, his journey through life from youth to old age. If we compare two painted self-portraits, one from 1640 (fig. **18.42**) and one from 1661

(fig. **18.43**), we can see the development of Rembrandt's self-image over a twenty-one-year period.

At the age of thirty-four, Rembrandt is dressed in velvet and fur, resting his arm on a window sill in the manner of portraits by Raphael and Titian. He looks optimistically out on the world. In the facial shading, Rembrandt creates a sense of inner character visible through the "window" of the eyes, just as the picture itself is a "window" on the figure. By 1661, after several personal tragedies, Rembrandt is an older and more sorrowful figure. He is no longer the prosperous, bourgeois artist, confident of his future. Now he is a "Saint Paul," humbled and saddened; his pose is less assertive, and he seems weighed down by his own body. He looks up from the rather worn pages he is reading, as if shrugging his shoulders at the twists of fate. The slight tilt of his head and the loose brushwork

emphasize the sagging cheeks. The raised eyebrows create a pattern of wrinkles on his forehead, and his hair has turned gray. As in the earlier pictures, Rembrandt highlights the face and hand, leaving a darkened surrounding space from which the figure seems to emerge.

The medium of etching (see Box) was suited to Rembrandt's genius for manipulating light and dark. Although etching had been invented in the sixteenth century, it was Rembrandt alone who perfected the technique during the seventeenth century. The three little self-portrait etchings reproduced here illustrate his use of black and white, or pure dark and pure light, to convey character.

The earliest figure (fig. **18.44**) is the twenty-four-year-old Rembrandt in a cap. His youthful vigor is indicated by the short, wavy lines of hair and the sharp twist of the head. Something seems suddenly to have caught his

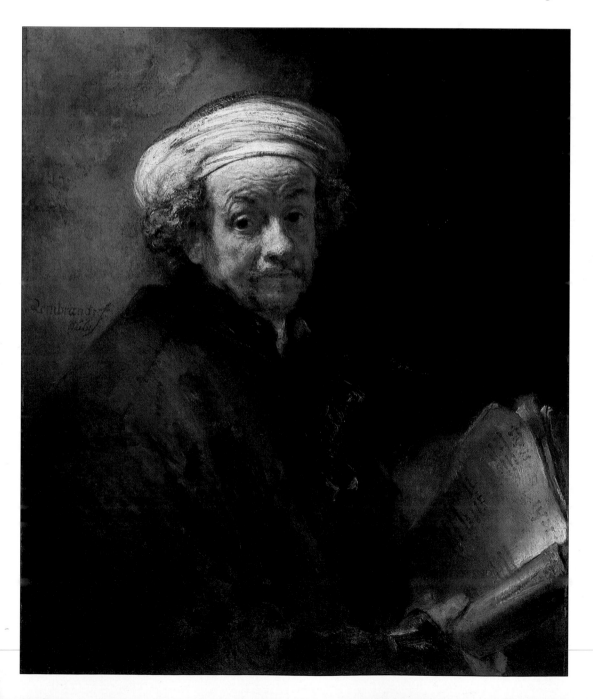

18.43 Rembrandt van Rijn, *Self-portrait as Saint Paul* (aged fifty-five), 1661. Oil on canvas, 35⅞ × 30⅜ in (91 × 77 cm). Rijksmuseum, Amsterdam.

attention, for his eyes are round with wonder and his mouth slightly open as if he is about to speak. Figure **18.45**, in which the artist is a few years older, shows him grimacing. Like Caravaggio and Bernini, Rembrandt studied his own facial expressions in a mirror, which he used in self-portraits and biblical scenes. The third etching (fig. **18.46**), was executed in 1639, not long before the painted self-portrait in figure 18.42, to which it is related. A well-dressed Rembrandt, his hat perched rakishly on his head, exudes the self-confidence of success. His inner artistic energy seems to shine forth from the illumination of his face.

Etching

Etching, like engraving, is an intaglio method of producing multiple images from a metal (usually copper) plate. In etching, the artist covers the plate with a resinous, acid-resistant substance (the **etching ground**). A pointed metal instrument, or **stylus**, is then used to scratch through the ground and create an image on the plate. When the plate is dipped in acid, or some other corrosive chemical, the acid eats away the exposed metal. In so doing, it creates grooves where the ground was scratched through by the stylus. The ground is then wiped off, the plate inked, and impressions taken just as in engraving. The result, however, is different. Whereas in engraving the artist pushes the burin to cut into the metal surface, the etching stylus moves more easily through the ground, allowing for more delicate marks and greater freedom of action. The result is a more convincing sense of spontaneity in the image and a blurred, atmospheric quality (see, for example, the sleeves of fig. 18.46).

Rembrandt also used the intaglio **drypoint** method, in which the image is scratched directly on to the plate. "Dry" signifies that acid is not used. The incisions on the plate make metal grooves with raised edges, called the **burr**. When the drypoint plate is inked, the burr collects the ink and produces a soft, rich quality in the darker areas of the image.

In both etching and drypoint, the burin can also be used for emphasis. It is possible to combine the two techniques in one image, as Rembrandt did. It is also possible to make alterations to an engraved plate and then produce additional prints. One can see the artist's changes by studying in order the different **states**, or subsequent versions, of the same image.

18.44 (right) Rembrandt van Rijn, *Self-portrait in a Cap, Openmouthed and Staring*, 1630. Etching, 2 × 1⅞ in (5.1 × 4.6 cm). Rijksmuseum, Amsterdam.

18.45 (below) Rembrandt van Rijn, *Self-portrait Grimacing*, 1630s. Etching, 3¼ × 2⅞ in (8.3 × 7.2 cm). Staatliche Museen, Berlin.

18.46 (below right) Rembrandt van Rijn, *Self-portrait Leaning on a Stone Sill*, 1639. Etching and drypoint, state 2, 8⅛ × 6½ in (20.5 × 16.4 cm). Rembrandt House Museum, Amsterdam.

Frans Hals

Frans Hals (c. 1581–1666) worked mainly in the small Dutch town of Haarlem. Known primarily for his portraits and group portraits, he did not have as wide a range of subject-matter as Rembrandt. His portraits, such as *The Laughing Cavalier* (fig. **18.47**), convey a sense of exuberance and immediacy, which is enhanced by the sitter's pose, character, and proximity to the picture plane. The cavalier, a courtly soldier, is set at an oblique angle. His left arm forms two diagonals, simultaneously leading in and out of the picture space, which are repeated in the torso and the tilted hat. He does not actually laugh, but the upturned curves of his mustache and his direct gaze create that impression. Hals's evident delight in the textural variations of the portrait add to its cheerful effect. The hat is virtually flat in contrast to the ruddy complexion and slightly fleshy face. The intricate lace and embroidery of the costume is interrupted, and relieved, by the broad brushstrokes defining the black silk shawl.

18.47 (below) Frans Hals, *The Laughing Cavalier*, 1624. Oil on canvas, 33¾ × 27 in (86 × 69 cm). Reproduced by permission of the Trustees, The Wallace Collection, London.

18.48 (above) Judith Leyster, *The Last Drop* (*The Gay Cavalier*), c. 1628–29, after conservation. Oil on canvas, 35⅛ × 29 in (89.3 × 73.7 cm). Philadelphia Museum of Art (The John G. Johnson Collection). Leyster was the daughter of a brewer in Haarlem. She married a painter of genre scenes, and had five children. In 1635 she successfully sued Frans Hals for taking one of her students as his apprentice.

Judith Leyster

Judith Leyster (1609–90) also worked in Haarlem, where she was the only woman elected to the painters' guild. Her figures, like Hals's *Laughing Cavalier*, are vital and energetic. Her genre painting *The Last Drop* (formerly known as *The Gay Cavalier*) (fig. **18.48**) provides an instructive contrast to the Hals and shows the influence of Caravaggio's tenebrism. In *The Last Drop*, exuberance is created, as in the Hals, by broad, hearty gestures and strong diagonals. This is accentuated by Leyster's dramatic contrasts of light and dark, the flickering candle, and the rich red costume. Whereas Hals's figure is right up against the picture plane, Leyster's two youths are set back further in space. They are thus less monumental in their impact, and do not confront the viewer directly. Instead, the drinker engages us by his absorption in the wine cask, and the smoker by his graceful, dancelike motion.

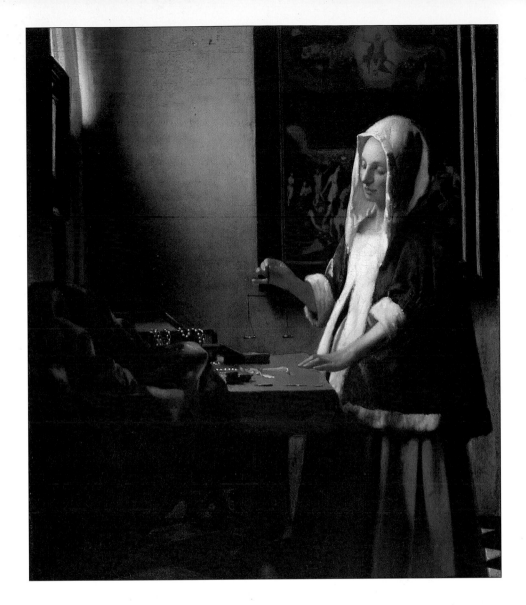

Johannes Vermeer

Johannes Vermeer (1632–75) left a very small number of pictures—no more than thirty-five in all. Like Rembrandt, he was a master of light, though in a completely different way. Most of his paintings are interior genre scenes, many with allegorical meanings. His canvases are generally small and his subjects, as well as their treatment, are intimate. Outdoor light is typically reflected on interior surfaces according to the quality of their textures.

Vermeer's *Woman Holding a Balance* (fig. **18.49**) combines genre with allegory. At first glance, the scene appears to be a typical domestic interior, conveyed with Vermeer's characteristically subtle effects of light. To achieve such effects, he used mirrors and the **camera obscura**, an ancestor of the modern camera which was also used by Leonardo da Vinci. The camera obscura, a dark box which projects an image through a tiny hole on to a flat surface, allowed Vermeer literally to "stage" his painted settings, and also to render precisely the small reflective details that are characteristic of his style. The room in the *Woman Holding a Balance* is illuminated by a morning glow, which filters through the window, highlighting the white borders of the woman's jacket and head covering. The light catches the edge of the delicate scale she is holding, and reflects from each individual stringed pearl. Her meditative gaze matches the stillness of the interior and seems to have arrested her action. In contrast to the variations of light, the large area in the lower left of the picture is darkened, its obscured forms consistent with Baroque style.

Vermeer's picture has been interpreted in a number of different ways, none of them conclusive. It had been assumed that the woman was weighing pearls, but microscopic examination reveals that the scales are empty. Another view suggested that the woman was pregnant, weighing pearls to determine the gender of her baby. She has also been associated with the Virgin, because of her illumination through the window, recalling Flemish scenes of the Annunciation. Furthermore, her position between the viewer and the slightly blurred picture of the Last Judgment on the wall evokes Mary's role as intercessor. The pearls themselves have been read as references to vice and pride, as well as to the purity of the Virgin. Since there is nothing on the scales, it is possible that the woman is contemplating moral balance, and is thus related to the Last Judgment, in which Christ is "weighing" the fate of human souls.

Vermeer's largest canvas, the *View of Delft* (fig. **18.50**), a particularly striking example of the Dutch taste for landscapes, is unique among his known works. Vermeer has combined an atmospheric sky with houses and water in a way that illustrates his genius for conveying jewel-like areas of light. Despite the large size of the canvas, Vermeer's attention to meticulous detail creates a feeling of intimacy.

The shifting lights and darks of the clouds and the delicately colored buildings are reflected in the water. Standing on the shore in the foreground are a few small human figures, who seem insignificant compared with the vast sky and the implied continuation of the scene beyond the picture's frame. Their staunch vertical forms anchor the church spires, the towers of the drawbridge, and the reflections of these shapes in the water. Silvers, blues, and grays alternate in the sky, as yellow sunlight filters through the clouds. The sparkle of the sunlight, as it catches details of the houses or glimmers on the water, shows Vermeer's concern for naturalistic effects, and creates a glowing, textured surface motion that was entirely new in western European art.

18.50 Johannes Vermeer, *View of Delft* (after restoration), c. 1660–61. Oil on canvas, 3 ft 2 in × 3 ft 9½ in (0.97 × 1.16 m). Mauritshuis, The Hague.

Jacob van Ruisdael

The landscapes of Jacob van Ruisdael (c. 1628–82) extend the vistas further toward the horizon than Vermeer does in the *View of Delft*. Much of Holland's landscape was artificially created by the dikes that held back the sea. Ruisdael's subjects, therefore, resonate with the very survival of Holland and its economy. His panoramic view in *Extensive Landscape with Ruins* (fig. **18.51**), for example, seems to encompass a vast space, which is expanded by the broad, horizontal sweep of earth, water, and sky. Together these natural features produce a sense of atmospheric intensity enhanced by the rumbling clouds that menace the calm water and land.

The strong vertical accent provided by the church tower serves to anchor the painting and to emphasize the flatness of the surrounding landscape. It also proclaims the transitional character of religious architecture as it mediates between earth and sky. Painterly atmospheric effects and imagery that shows the smallness of human creations (the church) in relation to the vastness of nature took on a moralizing quality in seventeenth-century Holland. The ruins show the deterioration over time of man-made works, in contrast to the seasonal renewal of nature. In the nineteenth century, these themes are integrated into the Romantic esthetic (see Chapter 21).

18.51 Jacob van Ruisdael, *Extensive Landscape with Ruins*. Oil on canvas, 13⅓ × 15¾ in (34 × 40 cm). National Gallery, London.

Harmen Steenwyck

The moralizing trends in Dutch art are perhaps clearest in the Baroque **vanitas** still lifes of the seventeenth century. In contrast to the macrocosmic views of Dutch landscape, the still lifes reflect the microcosm. Both illustrate the scientific concerns of northern Europe. In the *Vanitas* of Harmen Steenwyck (1612–after 1664), painted in 1660 (fig. **18.52**), a typical Baroque diagonal of light illuminates some of the objects on the table, leaving others in obscurity. Every object, however, has a double meaning. On the one hand, the convincing portrayal of their material textures appeals to the senses, while on the other it signifies the deceptions of materialism. Contrasted with the sensual pleasures are the references to time—a standard feature of Baroque *vanitas* iconography. A watch, for example, reminds the viewer that time passes. The results of the passage of time are indicated by the smoke that lingers around the shiny metal oil lamp, as if its flame has just been blown out. The extinguished flame, like the skull, symbolizes death. The hard, curved, highlighted surface of Steenwyck's skull echoes the shell, lamp, and jug, all of which are now empty containers. Such direct confrontation between observer and skull combines the Baroque taste for dramatic involvement in the picture with a reflection of what lies in store for everyone.

18.52 Harmen Steenwyck, *Vanitas*, 1660. Oil on canvas, 15½ × 20 in (39.2 × 50.7 cm). National Gallery, London. *Vanitas* is the Latin word for "emptiness," or "untruth," from which comes the English word "vanity." Such pictures appear to show random objects, but in fact have an underlying moral message—usually about the fleeting nature of physical reality. The open book, for example, may stand for human learning, as opposed to higher "moral" truth. A sword implies strength and power, a rare shell stands for earthly values and wealth, and the recorder and horn represent music and the arts.

Spanish Baroque Painting

Diego Velázquez

The paintings of the leading Baroque artist in seventeenth-century, Counter-Reformation Spain, Diego Velázquez (1599–1660), covered a broad spectrum of subject-matter. His genius was nurtured by his Classical education, stimulated by his admiration for Titian, and spurred by his competition with Rubens.

Velázquez's *Crucifixion* (fig. **18.53**), probably painted in the 1630s, is thought to have been commissioned for a Benedictine order of nuns in Madrid. The work would certainly have satisfied the Counter-Reformation view that observers should identify with Christ's Passion. Christ's illuminated body stands out against a darkened background, which may refer to the tradition that the sky went black at the time of the Crucifixion, and also shows the influence of Caravaggio's tenebrism. The softly textured hair falls forward over Christ's face, and the curved glow of light surrounding his head is reflected in the crown of thorns. Velázquez's taste for realistic detail is indicated by the blood dripping from Christ's wounds, and the grain and knots of the Cross's wood. The precision of such details recurs in the lettering on the plaque at the top of the Cross. Clearly written in Greek, Hebrew, and Latin is: "Jesus of Nazareth, King of the Jews."

Despite the mystic quality of the light, Christ is actually supported by the platform beneath his feet. The slight *contrapposto* that results from the weight-bearing right leg and the bent left knee evokes the relaxed Classical pose of Polykleitos's *Spearbearer* (see Vol. I, fig. 6.26). In thus synthesizing the formal elements of Baroque style with a Classical pose, Velázquez conforms to Counter-Reformation ideology, according to which physical suffering leads to moral repose.

For Philip IV, his most constant patron, Velázquez painted numerous pictures. The equestrian portrait *Philip IV on Horseback* (fig. **18.54**) was commissioned for the Hall of Realms in Philip's Buen Retiro Palace. It was one of several equestrian portraits of Philip and members of his family, which, like van Dyck's *Charles I on Horseback* (see fig. 18.34) and Titian's *Charles V at the Battle of Mühlberg* (see fig. 15.55), served a dynastic as well as a political purpose. Philip's exalted pose is a Baroque version of the mounted Roman emperor, which implicitly connects him to the glory of ancient Rome. Philip controls the horse with apparent ease as he executes a *levade*—a difficult Spanish Riding School maneuver, in which the rider uses one hand to control a rearing horse. Despite the skill required for this exercise, Philip remains calm and in control. His upright posture contrasts with the diagonal plane of the horse, the slanting ground below, and the horizontal expanse of the sky. The blues and yellows spreading across the sky, the metal sheen of Philip's armor, and the rendering of the horse are all testimony to Velázquez's remarkable command of color and texture.

In addition to equestrian portraits, Philip's Hall of Realms was decorated with battle scenes intended to project the image of Spain's military superiority. But in *The Surrender of Breda* (fig. **18.55**), Velázquez depicted Spanish moral superiority by departing from the traditional approach—portraying the domination of the vanquished by the victor. Rather than show Spinola, the victorious general, on horseback, Velázquez places him on the ground, and at the right. He is therefore on an equal footing—although his head is higher—with Nassau, the defeated Dutch commander, on the left. In a gesture of friendship and compassion, Spinola restrains Nassau from kneeling. Nevertheless, Velázquez makes clear that the Spaniards are militarily as well as morally superior. The greater number of lances on the Spanish side are signs of military superiority. They are aligned in an orderly formation, and the well-groomed soldiers are

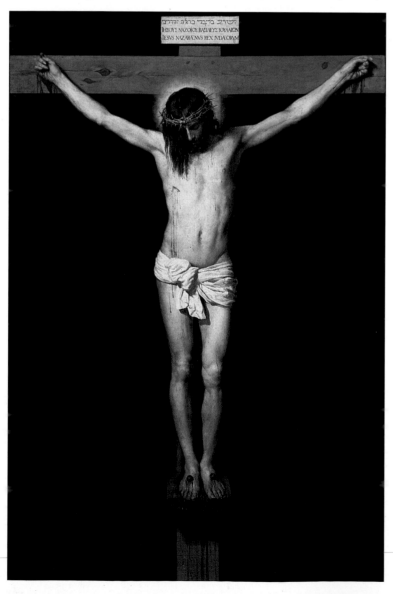

18.53 Diego Velázquez, *The Crucifixion*, 1630s. Oil on canvas, 8 ft ⅛ in × 5 ft 5 in (2.48 × 1.69 m). Prado, Madrid.

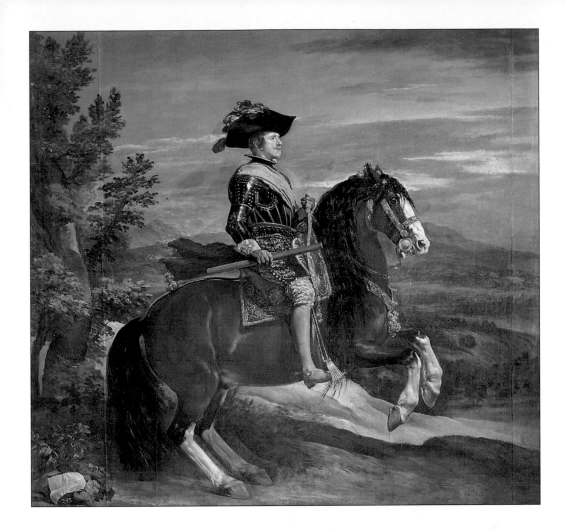

18.54 (left) Diego Velázquez, *Philip IV on Horseback*, 1629–30. Oil on canvas, 9 ft 10½ in × 10 ft 5¼ in (3.01 × 3.18 m). Prado, Madrid. Velázquez became court painter to Philip IV early in his career. He followed the humanist leanings of his teacher, Francisco Pacheco, who later became his father-in-law. Like Titian, Velázquez worked for the elevation of painting to the status of a liberal art, alongside music and astronomy. In Spain, painting and sculpture were still considered mere crafts because artists worked with their hands.

18.55 (right) Diego Velázquez, *The Surrender of Breda*, c. 1635. Oil on canvas, 10 ft × 12 ft ⅛ in (3.07 × 3.7 m). Prado, Madrid. From 1624 to 1625, Spanish troops led by General Ambrogio Spinola laid siege to the city of Breda, in Holland. Spain allowed the Dutch to surrender and withdraw gracefully, which they did. Here the Dutch leader, Justin of Nassau, hands over the keys to his fortress to Spinola—an event that did not actually occur. Two years later, the Dutch retook Breda from Spain.

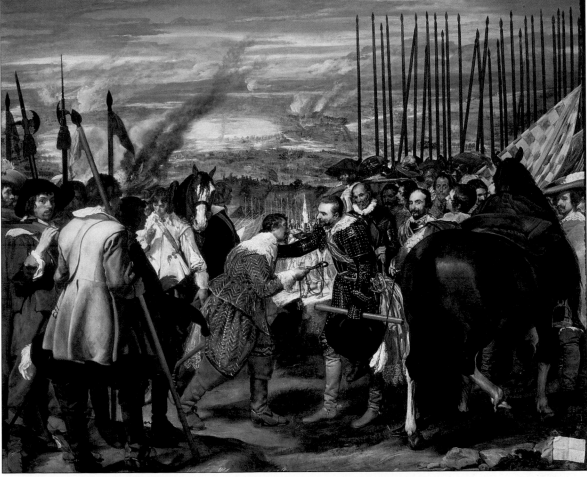

elegantly costumed. The Dutch, on the other hand, are dishevelled and their clothing is torn. Behind their weapons, smoke and fire indicate the after-effects of battle, while the landscape beyond the Spanish side is peaceful. Also conveying Spanish power is the monumental form of the partly foreshortened horse, from which Spinola has dismounted, and the clean diagonal of the checkered flag.

In contrast to his political pictures, the *Venus with a Mirror* (fig. **18.56**), known as *The Rokeby Venus* after the nineteenth-century family that owned it, was designed for private viewing. Its patron may have been the Marquis of Eliche, who was well known as both a libertine and a collector of Velázquez's works. The painting obscures the identity of the model by turning her away from the viewer and blurring her features in the mirror. Cupid's presence hints at, but does not specifically identify, the amorous content of the scene, which is enhanced by the painterly textures and rich colors. Seen in rear view, the nude is a long series of curves, which are repeated in the grand sweep of the silky curtain. Likewise the reds and pinks in the curtain recur in the nude's cheeks and Cupid's cloth. The rarity of the female nude in seventeenth-century Spain

makes this painting all the more unusual. It clearly reflects the influence of reclining Venuses by Giorgione (see fig. 15.52) and Titian (see fig. 15.54), which Velázquez had studied during his two trips to Italy.

Velázquez's unqualified masterpiece is the monumental *Las Meninas* of 1656 (fig. **18.57**). This work is not only a tribute to the artist's talent as a painter, but it is about the very art of painting. The setting is a vast room in Philip's palace, and the five-year-old infanta, or princess, Margharita is the visual focus of the picture. She is attended by her maids (*meninas*) and accompanied by a midget, a dwarf, and a dog. The elaborate costumes of the Spanish court are painted in such a way that the brush-strokes highlight the textures depicted.

Certain forms, such as the infanta and the doorway, are emphasized by light. Other areas of the picture—the paintings on the side wall, for example—are unclear. Most obscure of all is the huge canvas at the left, on which Velázquez himself is working. It is seen, like the *Venus with a Mirror*, from the back. Velázquez's variations of light and dark, which combine clarity and obscurity, are characteristic of the Baroque style.

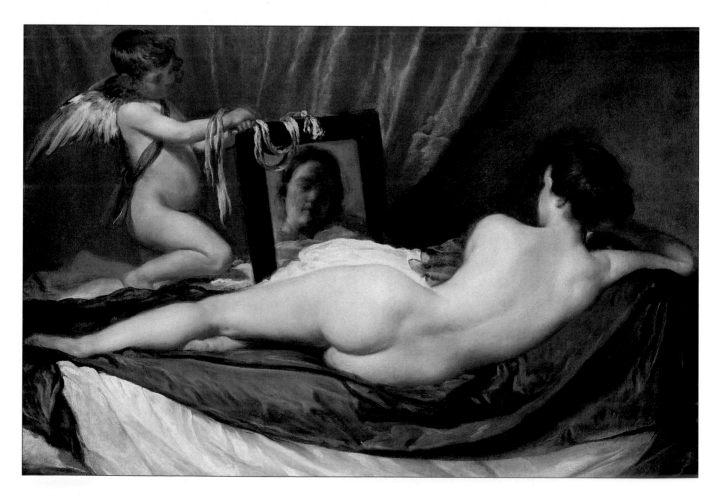

18.56 Diego Velázquez, *Venus with a Mirror* (*The Rokeby Venus*), c. 1648. Oil on canvas, 4 ft ⅜ in × 5 ft 9⅝ in (1.23 × 1.77 m). National Gallery, London. The existence of this painting demonstrates that it was acceptable, even in Counter-Reformation Spain, to paint the female nude—provided it was for a private patron. Even so, Velázquez has erred on the side of modesty by showing only the face of the model in the mirror. A stricter application of the laws of physics might have shown another part of her body.

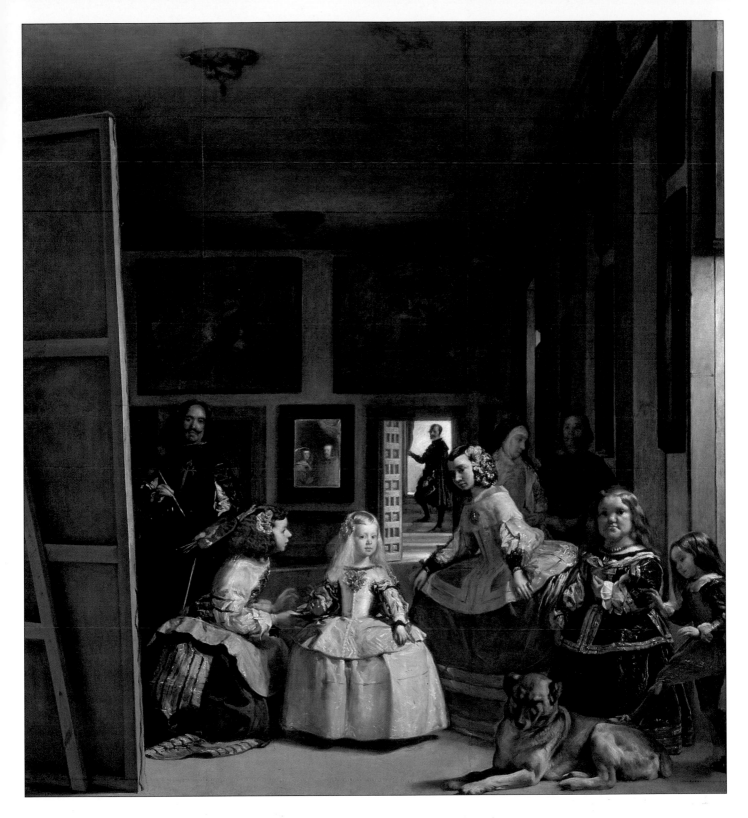

18.57 Diego Velázquez, *Las Meninas* (after cleaning), 1656. Oil on canvas, 10 ft 7 in × 9 ft ½ in (3.23 × 2.76 m). Prado, Madrid. Velázquez's personal pride in his own status—as a "divine" artist and member of the royal circle—is evident in his self-confident stance and raised paintbrush. The red cross on his black tunic is the emblem of the Order of Santiago, of which Velázquez became a knight in 1659. Since the painting was completed in 1656, the cross must have been a later addition.

Below the mythological pictures on the back wall, depicting contests between gods and mortals (inevitably won by the gods), is a mirror, which has been the subject of extensive scholarly discussion. King Philip IV and Queen Mariana, the parents of the infanta, are visible in the mirror. Does their image mean that they are actually standing in front of their daughter, that they are the subjects of Velázquez's canvas? Or is this perhaps not a reflection at all, but rather a painted portrait? These are among the questions most often posed about the

unusual iconography. We have seen that mirror images occur in paintings for a variety of reasons (see figs. 14.74 and 16.2). The mirror in *Las Meninas* may have an intentional ambiguity which, judging from the *Venus with a Mirror*, would probably correspond to Velázquez's personal taste, possibly to that of his patrons, and certainly to the Baroque style as a whole.

Another issue to which Velázquez almost certainly refers in *Las Meninas* is the status of the art of painting in seventeenth-century Spain. It was not considered a liberal art as it was in Italy, but rather a handicraft. By placing himself in royal company—including the King and Queen through their reflections—it is likely that Velázquez was making a plea for elevating the status of painting as well as that of the artist (see caption).

French Baroque Painting

Nicolas Poussin

Although Nicolas Poussin (1594–1665) was a French painter, born in Normandy, he lived most of his adult life in Rome. He studied the Italian Renaissance and was drawn to Classical as well as biblical subjects. Poussin represents the most Classical phase of the Baroque style, particularly in those of his works that depict ancient subject-matter (see Box).

In his *Assumption of the Virgin* (fig. **18.58**), painted some time before 1638, Poussin's attraction to antique forms is already apparent. Large fluted

18.58 Nicolas Poussin, *Assumption of the Virgin*, c. 1626. Oil on canvas, 4 ft 4 ⅞ in × 3 ft 2⅝ in (1.34 × 0.98 m). National Gallery, Washington, D.C. (Ailsa Mellon Bruce Fund)

columns frame the scene asymmetrically, and cherubs fill a sarcophagus with flowers. The Virgin rises in an exuberant swirl of blue drapery, which echoes the cloud formations, as excited cherubs celebrate their joy at her ascent to heaven. The contrast of the carefully arranged white drapery with the dark stone of the sarcophagus continues the zigzag motion of the dark clouds right down to the lower edge of the picture plane. At the ground, the short diagonal of the drapery invites us into the scene and sends our vision soaring upwards with the Virgin.

Entirely different in its somber, stoic, and elegiac mood is Poussin's *Ashes of Phokion* (fig. **18.59**). Despite Baroque lighting, everything seems ordered and rational, in keeping with the Classical restraint that characterizes his later style. The Classical temple façade is set off by the dark landscape forms, and tiny figures stroll calmly in the clearing between foreground and background. Closest to the picture plane, and highlighted by a white headscarf and sleeve, is Phokion's widow. Ignored by the other figures,

Poussin's Theory of Artistic Modes

This was one expression of the seventeenth-century French pursuit of an ordered system for conveying emotions in art. It was based on ancient Greek musical theory and Greek modes, from which the modern "keys" of music are derived. Modes were associated with different emotions. The Dorian mode, which was steady, solemn, and severe, corresponded to intellectual gravity and wisdom. The subtle modulations of the Phrygian mode made possible strong and violent effects. The Lydian mode was elegiac, the Hypolydian evoked sweetness and divinity, and the Ionian was cheerful and joyous.

Each mode was considered suited to a particular category of subject. Dorian was for Classical histories, Phrygian for representations of war, Lydian for funerals, Hypolydian for scenes of Paradise, and Ionian for celebrations, dancing, and feasting. Of Poussin's three paintings illustrated in this chapter, *The Assumption* is in the Hypolydian mode, *The Ashes of Phokion* corresponds to the Dorian mode, and *The Dance of Human Life* to the Ionian.

18.59 Nicolas Poussin, *The Ashes of Phokion*, 1648. Oil on canvas, 3 ft 9¾ in × 5 ft 9¼ in (1.16 × 1.76 m). Walker Art Gallery, Liverpool. Phokion was a 4th-century B.C. Athenian politician. Although elected general forty-five times, he consistently opposed the war against Macedon because he believed that Athenian military supremacy had come to an end. As a result, he was convicted of treason and executed, and his ashes were buried outside the city limits. The Greek author Plutarch included Phokion in his *Lives* as a model of Stoic virtue.

she collects her husband's ashes, evoking the *vanitas* theme of "ashes to ashes, and dust to dust." A related theme is evident in Poussin's combination of buildings from different historical periods. Buildings and nature, he suggests, may last; human beings do not.

In *The Dance of Human Life*, also called *Dance to the Music of Time* (fig. **18.60**), Poussin uses mythology in the service of Christian allegory in the context of a scene symbolizing *vanitas*. Three women and one man in Classical dress join hands and dance in a circle. They represent Luxury, Wealth, Poverty, and Industry—four states of human existence—locked in never-ending circular movement. Time himself, the old winged man at the right, is the musician. Apollo drives his chariot across the sky, symbolizing the passage from day to night. Leading the chariot is Aurora, the dawn goddess, and following behind are the Horai (the four seasons). The twin heads of Janus—the god of gateways who sees past and future simultaneously—adorn the top of an antique stone pedestal. Two children, one with an hourglass and the other blowing bubbles, are reminders, like Steenwyck's still life (see fig. 18.52), that life is fleeting and insubstantial.

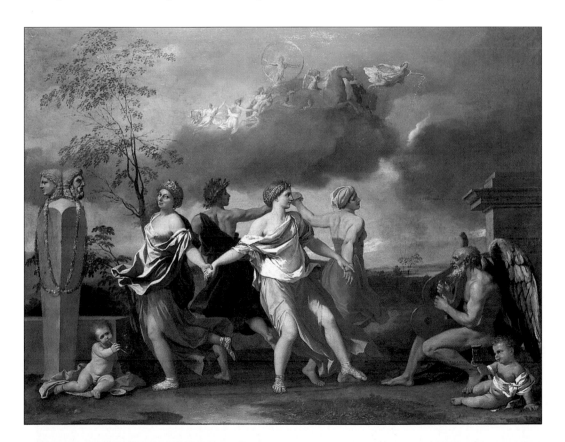

18.60 Nicolas Poussin, *The Dance of Human Life*, c. 1638–40. Oil on canvas, 2 ft 8⅝ in × 3 ft 8⅝ in (0.83 × 1.05 m). The Wallace Collection, London. By 1624 Poussin was in Rome, working for influential patrons. Ironically, his reputation was at its highest with the French Academy, but he preferred to live in Rome, where his restrained classicizing style was out of tune with the more exuberant Roman Baroque. This painting was executed for Pope Clement IX (then still a cardinal), who suggested the subject to Poussin.

	Style/Period	Works of Art	Cultural/Historical Developments
1580	BAROQUE WESTERN EUROPE 1580–1600	Caravaggio, *Boy with a Basket of Fruit* (**18.26**) Caravaggio, *Medusa* (**18.27**) Annibale Carracci, Farnese ceiling frescoes (**18.22–18.23**) Caravaggio, *The Calling of Saint Matthew* (**18.28**) Lal and Sanwah, *Akbar Viewing a Wild Elephant Captured Near Malwa* (**18.36**)	Death of Saint Theresa of Avila (1582) English East India Company founded (1600) **Caravaggio, The Calling of Saint Matthew**
1600	1600–1630 **Bernini, David**	Bichtir, *Allegorical Representation of the Emperor Jahangir Seated on an Hourglass Throne* (**18.37**) Caravaggio, *Amor Vincit Omnia* (**18.29**) Gentileschi, *Judith Slaying Holofernes* (**18.30**) Rubens, *The Straw Hat* (**18.32**) Bernini, *Pluto and Proserpina* (**18.18**) Bernini, *David* (**18.19**) Hals, *The Laughing Cavalier* (**18.47**) Bernini, Baldacchino, Saint Peter's (**18.2**), Rome Poussin, *Assumption of the Virgin* (**18.58**) Leyster, *The Last Drop* (**18.48**) van Ruisdael, *Extensive Landscape with Ruins* (**18.51**) Velázquez, *Philip IV on Horseback* (**18.54**)	Dutch East India Company founded (1602) Bodleian Library, Oxford, opened (1602) Cervantes, *Don Quixote* (1605) William Shakespeare, *King Lear* (1605) First permanent English settlement at Jamestown, Virginia (1607) Johannes Kepler postulates planetary system (1609) Publication of King James Bible (1611) First use of Manhattan by the Dutch as a fur-trading center (1612) Thirty Years' War (1618–48) Puritans reach New England (1620) Molière (Jean-Baptiste Poquelin), French dramatist (1622–73) Cardinal Richelieu adviser to Louis XIII of France (1624–42) William Harvey describes circulation of the blood (1628) Great migration to America begins (1630)
1630	1630–1640 **Rembrandt, Self-portrait**	Rembrandt, *Self-portrait in a Cap* (**18.44**) Rembrandt, *Self-portrait Grimacing* (**18.45**) Velázquez, *The Crucifixion* (**18.53**) Velázquez, *The Surrender of Breda* (**18.55**) da Cortona, *Glorification of the Reign of Urban VIII* (**18.24**) Rubens, *The Martyrdom of Saint Lieven* (**18.33**) Artist unknown, *Taj Mahal* (**18.38**), Agra Rubens, *Venus and Adonis* (**18.31**) Rembrandt, *Belshazzar's Feast* (**18.40**) Rembrandt, *The Blinding of Samson* (**18.39**) van Dyck, *Charles I on Horseback* (**18.34**) Poussin, *The Dance of Human Life* (**18.60**) Borromini, San Carlo alle Quattro Fontane (**18.6–18.7**), Rome Rembrandt, *Self-portrait Leaning on a Sill* (etching) (**18.46**)	Galileo forced to recant by the Inquisition (1633) John Donne, *Poems* (1633) Harvard College founded (1636) René Descartes, *Discourse on Method* (1637) Collapse of Dutch tulip market (1637) **Velázquez, The Surrender of Breda**
1640	1640–1650 **Rembrandt, Self-portrait**	Poussin, *The Ashes of Phokion* (**18.59**) Rembrandt, *Self-portrait Leaning on a Sill* (**18.42**) Rembrandt, *The Night Watch* (**18.41**) Borromini, Sant'Ivo della Sapienza (**18.9**, **18.11**), Rome Bernini, Cornaro Chapel (**18.20–18.21**), Rome Velázquez, *Venus with a Mirror* (**18.56**)	Louis XIV succeeds to French throne (1643) Battle of Rocroi ends Spanish ascendancy in Europe (1643) Treaty of Westphalia ends Thirty Years' War (1648) French Royal Academy founded, Paris (1648) Charles I beheaded; England declared a Commonwealth (1649)
1650 **1710**	1650–1710 **Vermeer, View of Delft**	Velázquez, *Las Meninas* (**18.57**) Bernini, Piazza of Saint Peter's (**18.4**), Rome Bernini, Throne of Saint Peter (**18.3**) Steenwyck, *Vanitas* (**18.52**) Rembrandt, *Self-portrait as Saint Paul* (**18.43**) Vermeer, *View of Delft* (**18.50**) Vermeer, *Woman Holding a Balance* (**18.49**) Bernini, Bust of Louis XIV (**18.15**) Perrault, Le Vau, Le Brun, East façade of the Louvre (**18.12**), Paris Le Brun, Le Vau, Le Notre, Versailles (**18.13**) Wren, Saint Paul's Cathedral (**18.17**), London Gaulli, *Triumph of the Name of Jesus* (**18.25**) Hardouin-Mansart and Le Brun, Hall of Mirrors (**18.14**), Versailles	Thomas Hobbes, *Leviathan*, a defense of absolute monarchy (1651) Oliver Cromwell becomes Lord Protector of England (1653) Restoration of Stuart monarchy in England under Charles II (1662) Plague in London (1665) Great Fire of London (1666) John Milton, *Paradise Lost* (1667) Antonio Vivaldi, Italian composer (1675–1741) Racine, *Phèdre* (1677) John Bunyan, *Pilgrim's Progress* (1678) Versailles becomes residence of French kings (1682) Isaac Newton, *Philosophiae Naturalis Principia Mathematica* (1687) John Locke, *An Essay Concerning Human Understanding* (1690) Witchcraft trials in Salem, Massachusetts (1692)

19

Rococo and the Eighteenth Century

The eighteenth century, particularly its latter half, was a complex patchwork of several different artistic trends (fig. **19.1**). Two of these, the Neoclassical and the Romantic, overlap each other in time and often converge in a single work. They continue into the nineteenth century, and are covered more completely in Chapters 20 and 21. The most distinctive eighteenth-century style, which flourished from about 1700 to 1775, is called Rococo, apparently coined from the French *rocaille* and *coquille* (meaning, respectively, "rock" and "shell"—the formations used to decorate Baroque gardens). Scholars are divided over whether Rococo was an independent style or merely a final flowering and refinement of Baroque.

Rococo style is above all an expression of wit and frivolity, although at its best there are more serious, somber, and satirical undercurrents. On the surface, the typical Rococo picture depicts members of the aristocracy gathered in parks and gardens, while Cupids frolic among would-be lovers. Classical gods and goddesses engage in amorous pursuits. The world of Rococo is a world of fantasy and grace, which also includes a taste for the exotic, as well as for satire. One extreme expression of this taste in the eighteenth century was the fad for **chinoiserie**. From about 1720, an interest in Chinese imagery developed in France and England. This included garden design, architectural follies, costumes, and decorative motifs in general. In 1761, Sir William Chambers built a **pagoda** in Kew Gardens, Middlesex, on the outskirts of London (fig. **19.2**). The fanciful, unlikely appearance of a Chinese pagoda in an English garden appealed to the Rococo esthetic. Furthermore, individual details of Chinese architecture, such as the curved roofs, dragons holding wind chimes, gilded finials, and the delicate balustrades at each story, were consistent with Rococo elegance. Several decades later, chinoiserie was to become part of the Romantic nostalgia for the past and longing for the exotic.

Rococo began after the turn of the century in the courtly atmosphere of Versailles. After the death of Louis XIV in 1715 and a subsequent decline in royal patronage, the center of taste shifted from the court to the Paris *hôtel* (elegant townhouse), and to the salon (see Box). The source of patronage also shifted from being the exclusive province of the French aristocracy to include the upper middle class and the bourgeoisie. In other capitals of Europe, especially in Germany, the Rococo style was quickly taken up by rulers and their courts.

Although Rococo was the primary artistic style of the eighteenth century, Classicism remained a potent force. Excitement over the discovery of the buried Roman cities of Herculaneum (in 1709) and Pompeii (in 1748) fueled the interest in antiquity. The German scholar Johann Winckelmann introduced a historical approach to the study of ancient Greek and Roman art (see Box on p. 677). At the same time, Neo-Gothic and Palladian styles developed—the former especially in England, the latter in both England and America. Toward the end of the century, Romanticism arose in opposition to the Classical esthetic of the European "Academies."

Salons and *Salonnières*

In the eighteenth century, the salon became the center of Parisian society and taste. The typical salon was the creation of a charming, financially comfortable, well-educated, and witty hostess (the *salonnière*) in her forties. She provided good food, a well-set table, and music for people of achievement in different fields who visited her *hôtel*. The guests engaged in the arts of conversation, and in social and intellectual interchange.

In the seventeenth century, the most important salon had been that of Madame de Rambouillet, who wished to exert a "civilizing" influence on society. By the next century, the salon was a fact of Paris social life, and one in which women played the dominant role. Among the *salonnières* were women of significant accomplishments in addition to hostessing. These included writers (Madames de LaFayette, de Sévigné, and de Staël, and Mademoiselle de Scudéry), a scientist (Madame de Châtelet), and the painter Élisabeth Vigée-Lebrun.

Political and Cultural Background

In contrast to the surface frivolity of Rococo, serious advances were taking place in other fields. The world of music could boast Antonio Vivaldi, Johann Sebastian Bach, Franz Joseph Haydn, and Wolfgang Amadeus Mozart. In science, Gottfried Leibniz developed calculus, Joseph Priestly discovered oxygen, and Edmund Halley identified the comet that bears his name. Technological developments, such as mechanized spinning and James Watt's steam engine, laid the foundations for the Industrial Revolution. Satire, which is a feature of certain Rococo artists, had as its leading literary exponents Jonathan Swift in England and François-Marie Arouet (Voltaire) in France.

Important political changes also occurred in eighteenth-century Europe. Frederick the Great turned Prussia into an aggressive military power, and France and Austria united against him. This new alignment resulted in the Seven Years' War (1756–63), which was won by the

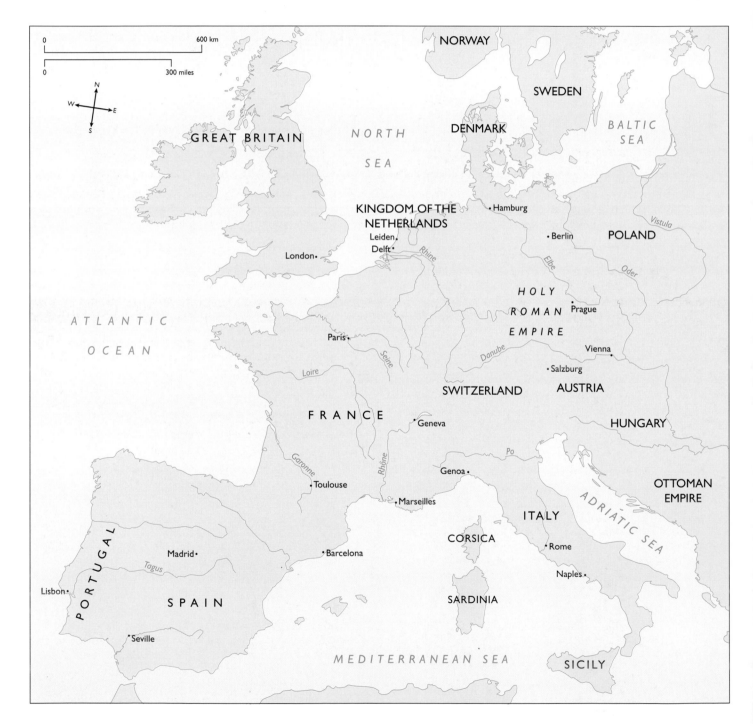

19.1 Map of western Europe, c. 1740.

19.2 Sir William Chambers, *Pagoda*, Kew Gardens, England, 1761. Engraving by William Woollett after J. Kirby, hand-colored by Heath. Victoria and Albert Museum, London.

Art Theory and the Beginnings of Art History

The eighteenth century, particularly the latter half, saw the beginning of modern art theory and art history. The very term "esthetic" is an eighteenth-century invention.

Johann Joachim Winckelmann (1719–68) was born in Berlin, and became a librarian near Dresden. There he met artists and visited museums. In the 1760s he moved to Rome, where he was appointed Superintendent of Antiquities, and oversaw excavations at Herculaneum and Pompeii. Based on his publication in 1764 of *The History of Ancient Art*, Winckelmann has been called the father of art history, because he believed that styles of art were determined by their cultures. He thus expanded the study of art beyond the more biographical approach of Vasari and the Classical tradition, and beyond the philosophical views of Plato and Aristotle. Beauty, for Winckelmann, was a matter of intuition and spirit, and the height of esthetic beauty had been attained by Greece in the fifth and fourth centuries B.C. Roman art, he said, was derivative of Greek art, which was noble, restrained, and ideal. The Renaissance, in his view, was a revival not of Roman, but of Greek art. Winckelmann classified ancient art into four phases: Archaic, Phidian, the fourth century B.C. and the period from the third century B.C. through the fall of the Roman Empire. These categories became a model for later art historical divisions.

A different approach to art theory was espoused by the German philosopher Immanuel Kant (1724–1804). In 1750, he published his *Critique of Judgment*, in which he advanced the notion of esthetic assessment of, and response to, both nature and art. Beauty, for Kant, resided in the interplay between the viewer and what was viewed. Kant thus accorded to the esthetic response a significant and independent role in the human experience of the world.

In the early decades of the nineteenth century, G. W. F. Hegel (1770–1831) combined elements of Winckelmann and Kant in his theoretical lectures. Hegel addressed the spiritual connection between art and religion, and also identified the historical evolution of style. This evolution, according to Hegel, was inevitable and could be perceived and understood in retrospect. Artistic expression for Hegel symbolized an idea, and therefore had a more rational underpinning than in Kant's system. Hegel's belief that art revealed its culture and was a historical artifact conformed to Winckelmann's ideas, but Hegel's historical stages differed. The first, Symbolic stage, was pre-Classical, and included ancient Egypt. In the second stage, the fifth- and fourth-century-B.C. Greeks produced the Classical ideal, in which the soul is revealed by the formal perfection of the body. The third and last stage was Hegel's own Romantic period, in which the spiritual and the religious converged

Prussians. England, whose international influence was based largely on the strength of its navy, consolidated its position in the eighteenth century and took the lead in European industrialization. England's position of economic and naval primacy extended to the New World and to India.

Developments in America mirrored the shifts in European power. The North American colonies belonged mainly to England. The exceptions were in the south, in the Louisiana territory, and in Canada, where the English did not dislodge the French until 1763. Spain controlled the whole of Central and South America (with the exception of Brazil), Mexico, Texas, parts of California, and most of Florida (which it ceded to England in 1763).

The Age of Enlightenment

The eighteenth century has been called the "Age of Enlightenment." This complex concept derives from certain philosophical ideas that were translated into political movements. The rationalism of the French philosopher René Descartes—"Cogito, ergo sum" ("I think, therefore I am")—in the previous century continued to appeal to

Scientific Experiments in the Enlightenment

Joseph Wright (1734–97) painted two scenes of scientific experimentation. These placed him firmly in the tradition of the Enlightenment and its interest in scientific reasoning. In addition, he was particularly intrigued by the dramatic effects of artificial light, and this led him into industrial workshops and other settings where he could study figures silhouetted against the glow of forges.

In 1768 Wright exhibited *An Experiment on a Bird in the Air Pump* (fig. **19.3**). The experiment in this picture consisted of putting an animal or bird into a glass container which was connected to a pump. The demonstrator then pumped out the air in order to show the effect on the creature. Here the victim is a white cockatoo, which in reality was too valuable a bird to risk; it was probably chosen for its dramatic effect. In the picture, the air has already been pumped out and the bird has subsided to the bottom of the container. The left hand of the demonstrator is raised to the valve of the pump which, if turned in time, will restore the air flow and save the bird.

On the table stands a large glass jar containing an opaque liquid and what appears to be a skull, silhouetted by a candle standing behind the jar. Both candle and skull are traditional components of a *vanitas* scene—the candle signifying the passage of time, the skull its inevitable result. The man seated in profile to the left of the pump holds a watch, ostensibly to clock the experiment, but also as a further reminder that time is passing.

19.3 Joseph Wright, *An Experiment on a Bird in the Air Pump*, 1768. Oil on canvas, 28⅓ × 37¾ ft (72 × 96 cm). National Gallery, London. Wright was a British portraitist and landscape painter who spent most of his life in Derby, in the heartland of England. He became known as Wright of Derby to distinguish him from other contemporary artists of the same name.

European and American thinkers. In England, John Locke advanced the notion of "empiricism," the belief that all knowledge of matters of fact derives from experience. This became the basis of the scientific method (see Box). Seventeenth-century improvements in microscopes and telescopes lent credence to Locke's ideas. And in France, Denis Diderot and the *encyclopédistes* classified the various branches of knowledge on a scientific basis. Diderot's pursuit of scientific observation carried over into his views on art training. In contrast to the study of tradition advocated by the French Academy, Diderot advised art students to leave the studio and observe real life.

In political philosophy, the concept of a secular "social contract" developed. Locke's *Two Treatises of Civil Government*, published in 1690, argued against the divine right of kings. In Locke's view, government was based on a contract between the ruler and the ruled, who have a right to rebel when their freedom is threatened. In 1762, Jean Jacques Rousseau went a step further in his *Social Contract*. For him, the political "contract" was not between people and government, but among the people themselves. The practical and ultimate effect of such reasoning can be seen in Thomas Jefferson's Bill of Rights and the American Constitution (see p. 710). The American Revolution (1775–83) ended the oppression of the colonies by the English king George III, and was followed a few years later by the French Revolution (1789–99). These two revolutions essentially broke the time-honored belief in the divine right of kings throughout most of western Europe.

Traditionally, the image of light, associated with the power of the sun, had been used for political ends. In ancient Egypt the pharaoh was thought of as the sun god Ra on earth, while the entire court of Louis XIV revolved around his self-image as the Sun King. Likewise, throughout the history of Christian art, Christ is paralleled with the sun as the "light of the world." With the inroads made by non-Christian philosophies, and the consequent decline in the influence of the Church, the notion of "light" became increasingly secular. In the eighteenth century, it became associated with a "rational," empirical outlook. The light in En*light*enment referred to the primacy of reason and intellect, in contrast to the unquestioning acceptance of divine power. This bias was profoundly optimistic,

because it encouraged a spirit of inquiry, and a belief in progress and in the human ability to control nature.

While these were the most dominant eighteenth-century views, countercurrents persisted. The prevalence of irony and satire, for example, implied an awareness that darker forces underlay the optimistic view of nature and the surface levity of Rococo. In Germany, the reaction was even more pronounced, particularly in the esthetic of the so-called *Sturm und Drang* ("storm and stress") movement, which was a manifestation of early Romanticism. According to that more pessimistic outlook, nature had ultimate power over reason. As in Johann Wolfgang von Goethe's play *Faust*, human life was seen as a constant—and losing—battle for control over the evil forces of nature.

Rococo Painting

Antoine Watteau

The leading Rococo painter, Antoine Watteau (1684–1721), was born in Flanders, but spent most of his professional life in France. He worked in the painterly, colorist tradition

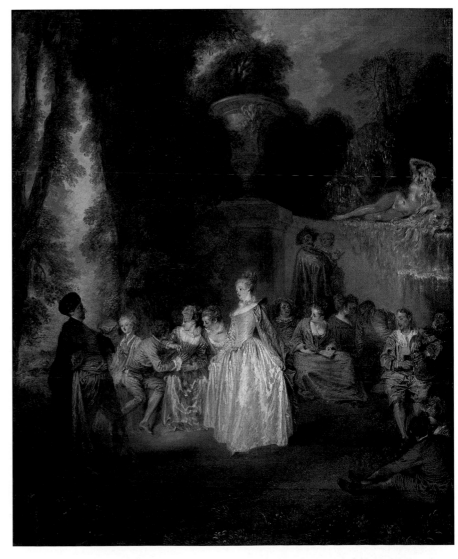

19.4 Antoine Watteau, *The Dance* (*Les Fêtes Vénitiennes*), c. 1718. Oil on canvas, 21½ × 17¾ in (54.6 × 45.1 cm). National Gallery of Scotland, Edinburgh. The figure on the right playing the bagpipes is the self-portrait of Watteau, who was acquainted with the dancing couple. The woman was an actress, while the man (who exchanges a glance with Watteau) was a fellow painter and friend.

of his compatriot Rubens, whose interest in voluptuous nudes and richly textured materials he shared. Nevertheless, the thin, graceful proportions of Watteau's figures, and his subject-matter, are more consistent with Rococo style. He is best known for his "fêtes galantes," paintings of festive gatherings, in which elegant aristocrats relax in outdoor settings. *The Dance* (fig. **19.4**) of around 1718 depicts a semicircular group of figures conversing, flirting, and playing music by a garden wall. The wall creates an enclosure, so that the figures are at once distinct from, and yet related to, their natural surroundings. One couple has detached itself from the group. They point their toes to begin a dance. The theme of courtship predominates, but it is kept on a frivolous plane. The lighthearted, theatrical effect is enhanced by the colorful, silky, shimmering textures of the costumes.

The irony that often underlies Watteau's playful surfaces is suggested here by the more serious tone of the large, Classical, stone **krater** on the edge of the garden wall. On the one hand, the use of such motifs reflects the contemporary fad for Italianate settings and, on the other, the choice of motif can

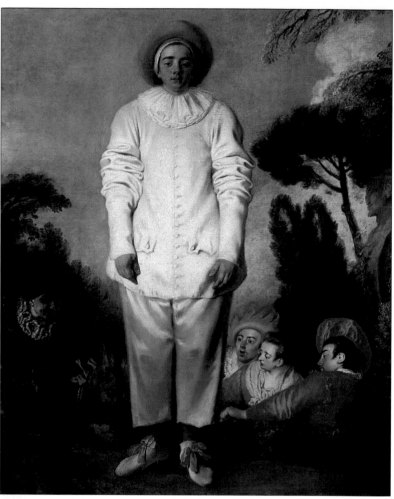

19.5 (below) Antoine Watteau, *A Lady at her Toilet*, c. 1716. Oil on canvas, 17½ × 14½ in (44 × 37 cm). The Wallace Collection, London.

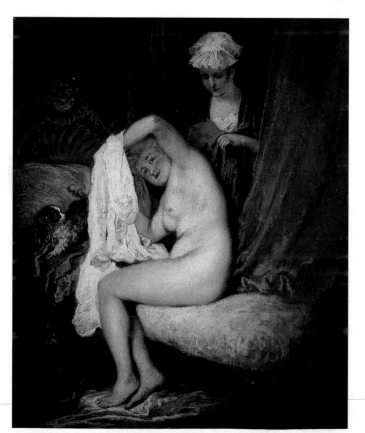

19.6 Antoine Watteau, *Gilles*, undated. Oil on canvas, 6 ft ⅝ in × 4 ft 10¾ in (1.84 × 1.49 m). Louvre, Paris.

have a particular iconographical significance. Carved in relief under its lip, and staring down at the assembled figures, for example, is a ram's head—a traditional symbol of lust. Also classically inspired is the stone reclining nude that seems to be watching the group at her leisure. She raises her arm languidly over her head in a conventional gesture of seduction (cf. Giorgione's *Sleeping Venus*, fig. 15.52). Both the nude and the krater are of stone, and are thus, like the Classical tradition itself, enduring. Their juxtaposition with themes of courtship, music, and dance—all of which are transitory pleasures—is the ultimate source of Watteau's irony in this picture.

The flirtatious gaze is directly represented in Watteau's *A Lady at her Toilet* (fig. **19.5**), which is an intimate bedroom scene rather than an outdoor social gathering. The maid who peers through the curtains joins us in gazing at the nude. Like the reclining nude of stone in the *Dance*, the lady at her toilet raises her arm as if issuing a seductive invitation to the viewer. Also observing her are the excited little dog and the Cupid leaning over the carved scallop shell above the pillow. Watteau thus combines several

traditional erotic motifs (the dog, the Cupid, the raised arm) with Rococo levity. Unlike the *Dance*, however, figures in *A Lady at her Toilet* do not interact with each other as if in a play. Rather, the objects of the nude's gaze are the viewers, as she is theirs.

The more wistful side of Watteau can be seen in his undated *Gilles* (fig. **19.6**), the sad Harlequin. The actor, in this case a comic lover, wears his costume, but does not perform. His pose is frontal, and his arms hang limply at his sides. His melancholy expression betrays his mood, and is at odds with the silk costume and pink ribbons on his shoes. Presently between roles, this actor is "all dressed up with nowhere to go." The blue-gray sky echoes the figure's mood, as do the sunset-colored clouds. End of day, which is indicated by the sunset, corresponds to the sense that Gilles is at a loss about what to do next. His lonely isolation is accentuated by the four figures around him, who seem engaged in animated conversation.

François Boucher

François Boucher's (1703–70) "Rubenist" brand of Rococo is evident in the playful *Venus Consoling Love* (fig. **19.7**), which is devoid of Watteau's undercurrent of irony and melancholy. A powder-pink Venus, in a lightly erotic pose, tries to console a pouting, flustered Cupid, whose arrow-filled quiver hangs from his shoulder. Reclining on Venus's couch and watching from the trees are two more Cupids, whose intent gazes draw the viewer toward the central characters. The two white doves—"love birds"—echo the amorous text of this scene. The predominance of pinks, the curly blond heads of the Cupids, and the silky, feathery textures contribute to the cheerful, material richness of Boucher's work.

19.7 François Boucher, *Venus Consoling Love*, 1751. Oil on canvas, 3 ft 6⅛ in × 2 ft 9⅜ in (1.07 × 0.85 m). National Gallery, Washington, D.C. (Chester Dale Collection). 1751 was also the year that Madame de Pompadour, Louis XV's mistress, moved to the north wing of Versailles and lived there until her death. Throughout her tenure at court, Boucher was her favorite artist.

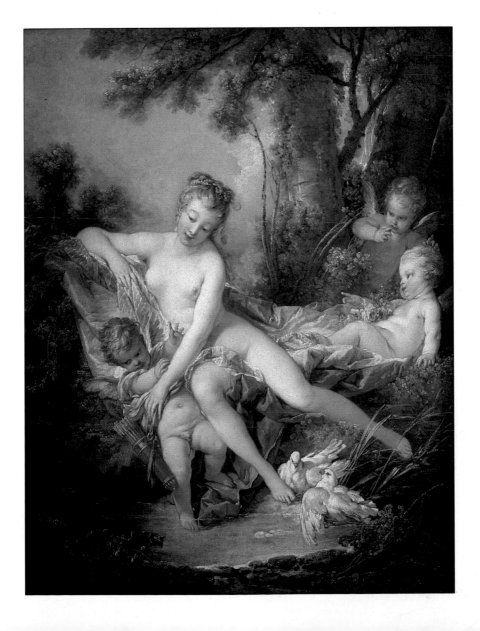

Jean-Honoré Fragonard

The last significant Rococo painter was Jean-Honoré Fragonard (1732–1806). In *The Swing* (fig. **19.8**) he enlivens nearly the entire picture plane with frilly patterns. The lacy ruffles in the dress of the girl swinging are repeated in the illuminated leaves, the twisting branches, and the scalloped edges of the fluffy clouds. It is as if the entire design is animated by the erotic play of the figures.

At the right of the painting, an elderly cleric pushes the swing, while a voyeuristic suitor hides in the bushes and gazes up under the girl's skirts. His hat and her shoe are sexual references in this context—the former a phallic symbol and the latter a vaginal one. They complement the setting: an enclosed yet open garden, where amorous games are played. The stone statues also deepen the erotic implications of the scene. On the left, a winged god—probably Cupid—calls for secrecy and silence by putting his finger to his lips. Between the swing and the old man, two more Cupids cling to a dolphin. Like Watteau, Fragonard calls on Classical imagery to provide a serious underpinning of frivolous erotic themes.

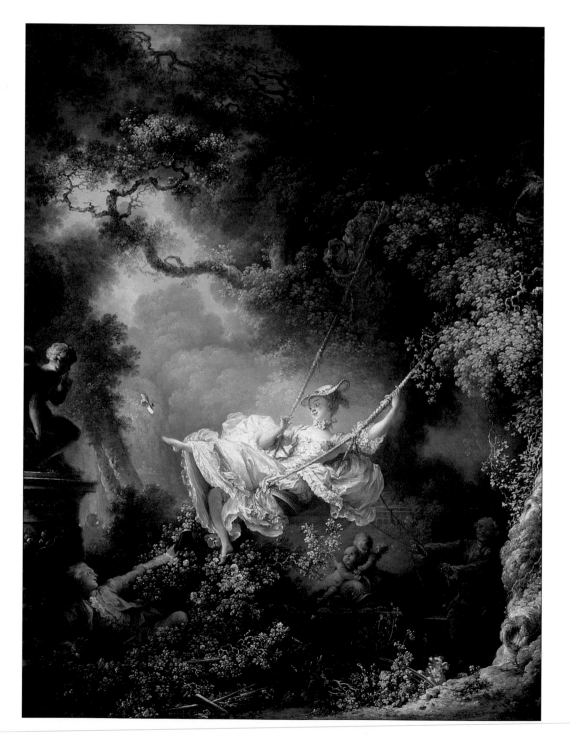

19.8 Jean-Honoré Fragonard, *The Swing*, 1766. Oil on canvas, 35 × 32 in (88.9 × 81.3 cm). Wallace Collection, London. *The Swing* was commissioned by the Baron de Saint-Julien, who specified that Fragonard should paint his (the Baron's) mistress on the swing, with himself as her observer. Fragonard emphasizes the erotic associations of "swinging" by highlighting the shimmering texture and swirling curves of the dress. Swinging has some of the same connotations today—compare the "swinging sixties."

19.9 Hyacinthe Rigaud, *Louis XIV*, 1701. Oil on canvas, 9 ft 2 in × 7 ft 10¾ in (2.79 × 2.4 m). Louvre, Paris.

Royal Portraiture

Hyacinthe Rigaud A comparison of the late Baroque, large-scale portrait of *Louis XIV* (fig. **19.9**) by the French artist Hyacinthe Rigaud (1659–1743) with two other royal portraits of the later eighteenth century reflects different artistic trends. Rigaud's Louis XIV stands majestically in an elaborate costume of ermine and blue velvet with gold **fleurs-de-lys** signifying French royalty. Louis' silk stockings show off his shapely legs, while his high-heeled shoes compensate for his short stature. He is framed by the folds of a rich red silk curtain and surrounded by the accoutrements of kingship and power—a scepter and sword. The column, with the classicizing relief on its podium, is an echo of Louis himself, and associates his personal iconography with the Classical past. It is also an architectural metaphor for Louis' role as the structure and support of France itself. Rigaud's figure is very much a king, not surprisingly the monarch who declared "L'etat, c'est moi" ("I am the state"), merging his identity with that of France.

Rosalba Carriera Rosalba Carriera (1675–1757) was born in Venice, and worked mainly in Italy and France as a portraitist. Her success won her election to the French Academy. In 1721, she painted a portrait of the ten-year-old King Louis XV, son of Louis XIV (fig. **19.10**). By this time, the Sun King had been dead for six years, a regency had been established, and the court had moved to Paris. There, Rosalba's reputation for quick, flattering portraits earned her extensive aristocratic patronage. In the portrait of Louis XV (see Box), the shimmering pastel quality of the costume, with its prominent gold medal, matches the soft curls of the powdered wig. Compared to the stately portrait of his father, Louis XV seems vapid and devoid of a distinctive personality. This impression is probably a combination of Rosalba's slightly saccharine Rococo efforts to flatter and Louis XV's own ineffectual character.

Élisabeth Vigée-Lebrun The other major eighteenth-century portrait painter to the aristocracy in France was Élisabeth Vigée-Lebrun (1755–1842). She painted several portraits of Marie Antoinette, the Austrian-born queen of Louis XVI. Like Rosalba Carriera, Vigée-Lebrun befriended monarchs and their families, and benefited from their patronage. Her 1788 portrait of *Marie Antoinette and her Children* (fig. **19.11**) depicts the Queen of France in an elegant, regal setting, oblivious to the social, political, and economic unrest among her subjects that would erupt the following year and culminate in the French Revolution (see Box). The variety of rich textures—

Pastel

Pastels are chalky crayons made of compressed pigments, which are bound with water and a gum substance. Artists using pastels build up color as they would in a painting. The colors are usually pale, but the higher the proportion of pigment chalk, the deeper the tone. The pastels are applied to pastel paper, which is fibrous and therefore allows the color to adhere to the surface.

Pastels had been used for centuries for drawing studies in red, black, and white, but from the fifteenth century artists began to draw in a wider range of colors. Works in pastel, as they were made in the eighteenth century, are called paintings, rather than drawings, because they are not as linear; they increased the speed with which a painting could be made and permitted a luminous surface texture that appealed to Rococo tastes. Rosalba Carriera was instrumental in the growing popularity of pastels.

silks, laces, and brocades, and Marie Antoinette's enormous feathered hat—emphasize the wealth and position of the sitters. At the same time, aloof and poised as she appears, the Queen shows her ease with motherhood. One daughter nestles against her shoulder and the toddler squirms on her lap. The boy introduces a somber note as he pulls aside the crib cover to reveal the empty bed, denoting the death of one of Marie Antoinette's children.

19.10 Rosalba Carriera, *Louis XV*, 1751. Pastel on paper, 18½ × 15¾ in (47 × 40 cm). Museum of Fine Arts, Boston. Rosalba's father was a government official, her mother worked as a lacemaker, and her grandfather was a painter. She never married, and devoted herself to her two sisters, to whom she taught art. Rosalba was enormously successful as a portrait painter to eighteenth-century European royalty.

19.11 Élisabeth Vigée-Lebrun, *Marie Antoinette and her Children*, 1788. Oil on canvas, 8 ft 10¾ in × 6 ft 4¾ in (2.71 × 1.95 m). Musée National du Château de Versailles, France.

Prelude to the French Revolution

Louis XV died in 1774. Both he and his successor Louis XVI were ineffectual rulers. For political reasons, Louis XVI helped the American colonies in their fight against the English king (see p. 710). He encountered internal economic problems when, in 1787, the French nobility and the Church refused to pay taxes. This marked the beginning of an aristocratic revolt against absolute monarchy in France and, with the American example before them, led to the demand for a written constitution. In 1789 on July 14 (now known as "Bastille Day"), angry crowds stormed the Bastille (a prison in Paris). The common people generally supported France's National Constituent Assembly; composed of members of the middle class as well as of the nobility, it backed the idea of a constitution.

Four major developments culminated in the Revolution. In 1789, the Assembly abolished the feudal system, and imposed a tax on certain aristocratic privileges. The Declaration of the Rights of Man and the Citizen guaranteed new freedoms: the press, speech, religion, equality before the law, the right to own property, and a graduated income tax. By 1791, a new constitution had been introduced. It asserted that legitimate government authority rested with the Assembly; the king had the power of veto, but could only use it to delay a decision, not to nullify it. Finally, the clergy was declared subject to civil law, which angered the pope whom Louis XVI supported.

In June 1791, Louis and Marie Antoinette fled with their children. They were captured at Varennes, not far from the French–German border. A year and a half later, in January 1793, the King and Queen of France were executed, two of the thousands of victims of the guillotine.

Thomas Gainsborough

Nature and portraiture, which predominated in French Rococo, were also an important aspect of the style in England. Thomas Gainsborough (1727–88), who was influenced by van Dyck and best known for his full-length portraits, liked to set his figures in landscape. In his portrait of *Mrs. Richard Brinsley Sheridan* (fig. **19.12**), for example, the sitter assumes a slightly self-conscious pose, and gazes out of the picture plane. The shiny, silky textures of her dress and the light filtering through the background trees evoke the materials and garden settings of French Rococo. Here, however, the amorous frivolity has been subdued. Mrs. Sheridan is at once enclosed by nature and distinct from it. She is sedate, aristocratic, and surrounded by a landscape as orderly and controlled as herself.

William Hogarth

A different expression of English Rococo is found in the witty, biting commentary of William Hogarth (1697–1764). Influenced in part by Flemish and Dutch genre paintings, he took contemporary manners and social conventions as the subjects of his satire. His series of six paintings entitled *Marriage à la Mode* from the 1740s pokes fun at hypocritical commitments to the marriage contract. A print of the second scene of the series (fig. **19.13**) is illustrated here, in which the husband, a young aristocrat, has returned home exhausted from carousing. An excited dog sniffs the woman's hat still in the husband's pocket, thus drawing the viewer's attention to his master's sexual exploits. A black mark on the side of the man's neck indicates that he has already contracted syphilis.

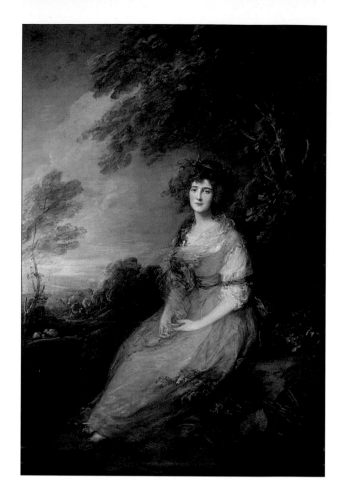

19.12 (above) Thomas Gainsborough, *Mrs. Richard Brinsley Sheridan*, 1785–7. Oil on canvas, 7 ft 2½ in × 5 ft ½ in (2.2 × 1.54 m). National Gallery of Art (Andrew W. Mellon Collection), Washington, D.C. Gainsborough's patrons included the English royalty and aristocracy, but he also painted portraits of his musical and theatrical friends and their families. Mrs. Sheridan was the wife of Richard Brinsley Sheridan, author of the satirical comedies *The Rivals* and *School for Scandal.*

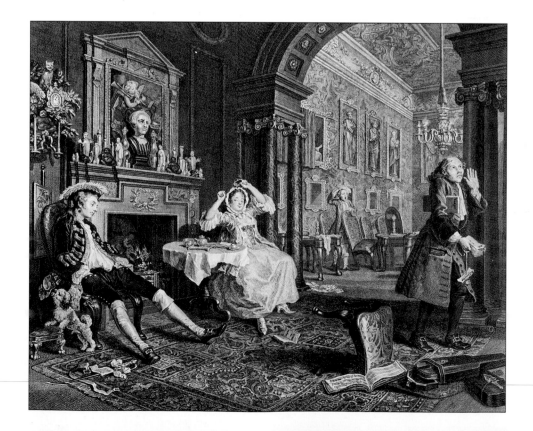

19.13 William Hogarth, *Marriage à la Mode II*, 1745. Engraving by B. Baron after an oil painting of 1743. British Museum, London.

The wife, meanwhile, seems to have indulged in some illicit behavior of her own. She leans back in one chair, while a fallen chair in the foreground suggests that someone, perhaps her music teacher, has just made a speedy exit. The architecture reflects the Neoclassical Palladian style of eighteenth century England, but Rococo details fill the interior. The costume frills, for example, echo the French version of the style. The elaborate chandelier and the wall designs are characteristic of Rococo fussiness. On the mantelpiece, the bric-à-brac of chinoiserie reflects the eighteenth-century interest in Far Eastern exotic objects, as well as referring to a frivolous lifestyle. They are contrasted with the august pictures of saints in the next room.

The device of paintings within paintings performs the same function as the stone statues in the Watteau and Fragonard discussed above. The saints stand in the background room, isolated from the living, who ignore them. Cupid, on the other hand, is depicted blowing the bag-pipes, which, as in Bruegel's *Peasant Dance* (see fig. 17.11), signify lust. The dangers of sexual excess, which Hogarth satirizes, are underscored by locating Cupid among ruins, foreshadowing the inevitable ruin of the marriage. As in French Rococo, Hogarth calls on traditional figures from Classical antiquity for the purpose of playful, but telling, satirical warnings. Also like French Rococo, which typically represents aristocrats, Hogarth's pictures deal with identifiable social and professional classes. But they lack the air of theatrical fantasy that pervades French examples of the style.

Hogarth's satirical imagery included comments on taste and fraud in the art world. In 1761, he produced the etching in figure **19.14**, *Time Smoking a Picture*, in which the motif of the picture within a picture plays a central role. An aged Father Time literally "smokes" a painting in order to make it seem older than it is. He sits on a broken plaster cast, which denotes Hogarth's preference for new, clean, modern art rather than for old master paintings (see

19.14 William Hogarth, *Time Smoking a Picture*, 1761. Etching and mezzotint, 8 × 6¹¹⁄₁₆ in (20.32 × 17 cm). Hogarth's House, London. Hogarth's father was a teacher, from whom his son learned Latin and Greek (as is evident from this etching). He also opened a Latin-speaking coffee house that went bankrupt. As a result, he spent three years in debtors' prison, until Parliament passed an Act freeing all debtors. This experience contributed to the artist's fierce opposition to social injustice and hypocrisy. In 1752, Hogarth published his views on art in *Analysis of Beauty*, which, like the etching, states his anti-Academic position. In the couplet at the bottom of the print, he urges people to look at nature and to themselves, rather than to the plaster casts of traditional art schools, for "what to feel."

caption). Time's scythe cuts through the canvas, the top frame of which is inscribed in Greek: "Time is not a clever craftsman, for he makes everything more obscure." At the left, the jar marked VARNISH refers to the technique of varnishing pictures to age them artificially. The purpose of Time's activity is to increase the value of the painting, as is indicated by the phrase at the lower right: "As Statues moulder into Worth." Hogarth depicts Time as a fraudulent art dealer, more interested in profit than in paintings, and willing to destroy art in order to make money.

Rococo Architecture

Several divergent architectural trends can be identified in the eighteenth century, but the most original new style was Rococo. In architecture, as in painting, Rococo emerged from late Baroque Classicism, which it both elaborated and refined. In northern Italy and Central Europe, Baroque had been the preferred style for palaces and hunting lodges. Particularly in the countries along the Danube—Austria, Bohemia, and southern Germany—

19.15 (above) Balthasar Neumann, the Residenz, Würzburg, Germany, 1719–53.

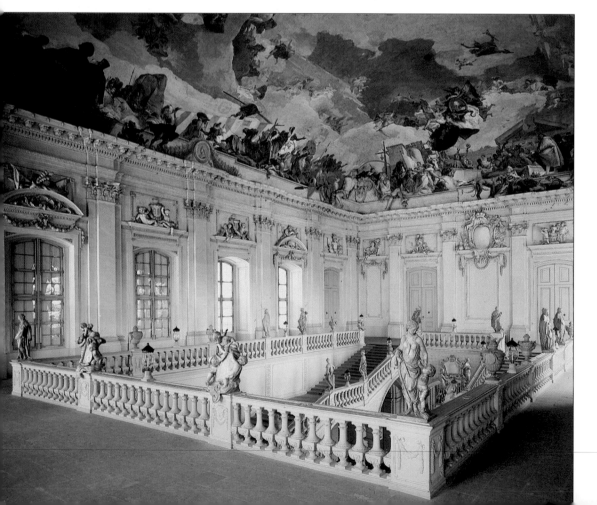

19.16 Staircase of the Residenz showing the ceiling fresco of Giovanni Battista Tiepolo, 1752–3.

a distinct regional style developed, which was a blend of Italian Baroque and French Rococo.

Balthasar Neumann

A leading exponent of this movement was the German architect Balthasar Neumann (1687–1753). He created one of the most ornate Rococo buildings, the Residenz (fig. **19.15)**, or Episcopal Palace, in Würzburg, Bavaria, in southwest Germany. Begun in 1719 and not finished until 1753, the Residenz was an enormous edifice built for the hereditary prince-bishops of the Schönborn family. It was designed around a large entrance court, and the side wings, reminiscent of the plan at Versailles, had interior courtyards of their own. Although elements of the Classical Orders remain in the columns and pilasters on the façade of the Würzburg Residenz, the spaces in the pediments are largely taken up by elaborate curvilinear designs.

The principal feature of the interior of the Residenz is its magnificent staircase, which ascends to a first landing. It then divides, reverses direction, and rises to the upper level (fig. **19.16)**. The hall containing the staircase is the largest room—nearly 100 by 60 feet (30 by 18 meters)—in the Residenz. The bannister and balustrade are decorated with statues and stone kraters, while Cupids lounge on the entablatures over the doorways. Each door is framed by large, triple Corinthian pilasters, which support another entablature that continues around the entire room. The ceiling fresco was painted by the Italian Rococo artist Giovanni Tiepolo (1696–1770), and is believed to be the largest in the world. Its portrayal of Apollo and the Prince-Bishop, the seasons, the zodiac, and the continents of Africa, America, Asia, and Europe is a grand statement of the far-reaching influence of the Schönborns.

The Kaisersaal, or Imperial Room, of the Residenz is a two-story octagonal chamber. Painted in white, gold, and pastel colors, it rises to a vaulted oval ceiling pierced by oval windows. The frescoes are again by Tiepolo. Engaged Corinthian columns with gilt capitals and bases and the entablature above them are made of **stucco**, or fine plaster, painted to resemble marble. The edges of the windows and other architectural features are traced with delicate thin **moldings**, like designs made of spun sugar. The white surfaces of the vault are covered with ornament. Most striking of all are the giant, illusionistic gilded curtains that are drawn apart by a pair of white Cupids to reveal *The Investiture of Bishop Harold* (fig. **19.17)**. Other *trompe l'oeil* devices make the viewer wonder where the ceiling ends and exterior space begins. A dog sits on top of a column, and other figures appear to be half-in and half-out of the picture frame. Such playful illusions, combined with ornate decoration, are characteristic of the painted spaces of Rococo architecture.

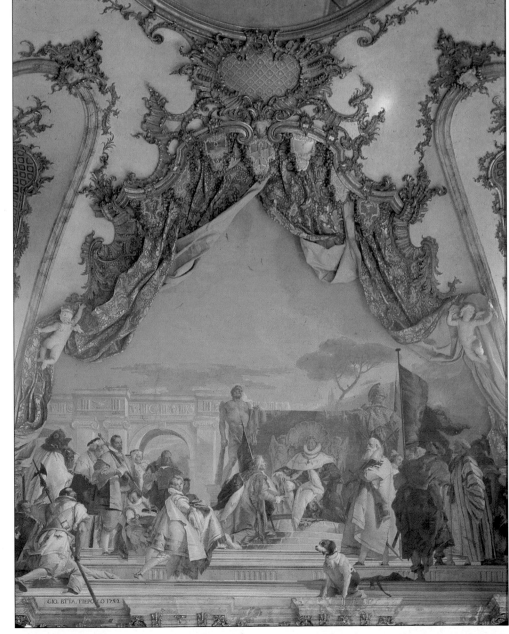

19.17 Giovanni Battista Tiepolo, *The Investiture of Bishop Harold*, a detail of the ceiling frescoes in the Kaisersaal, the Residenz, 1751–2. Born and trained in Venice, by the 1730s Tiepolo had established himself throughout northern Italy as a master of monumental fresco decoration. He was known for his technical skill, command of perspective, and fondness for illusionistic architecture. He spent three years in Würzburg decorating the Residenz, and in 1762 he was invited to Spain by Charles II to work on the royal palace.

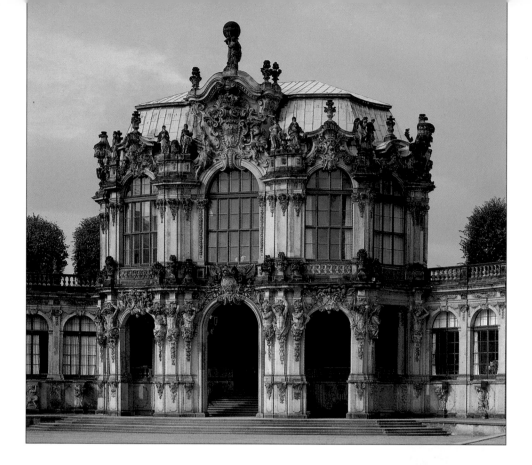

19.18 (left) Matthäus Daniel Pöppelmann, Wallpavillon, the Zwinger, Dresden, Germany, 1711–22. Pöppelmann was trained as a sculptor, but became court architect to Augustus the Strong, Elector of Saxony and King of Poland. Augustus sent Pöppelmann to Rome, Vienna, Paris, and Versailles (the capitals of Rococo taste) to gather ideas for his palace in Dresden. Finally, only the Zwinger was built. It was gutted during World War II, but has been accurately reconstructed.

19.19 (below) Dominikus Zimmermann, Wieskirche, Bavaria, 1745–54. The nave is a Rococo development of Borromini's oval church plans in Baroque Rome. The Wieskirche's longitudinal axis is emphasized by the deep, oblong chancel. Eight freestanding pairs of columns with shadow edges (square corners or ridges that accentuate light and shadow) support the ceiling. The ambulatory, which continues the side aisles, lies outside the columns.

Matthäus Daniel Pöppelmann

The ultimate in German Rococo architecture is the Zwinger, built in Dresden in 1711–22 (fig. **19.18**). The Zwinger (German for "enclosure," or "courtyard") is a series of galleries and pavilions commissioned by Augustus the Strong, King of Poland and Elector of Saxony. Arranged around an enclosed courtyard, it serves as an open-air theater for tournaments and other spectacles. The section illustrated here is the Wallpavillon, one of the pavilions situated at the corners of the courtyard, to which it is connected by glass-covered arcades. All of these structures were designed to provide shelter for the spectators. The architect, Matthäus Daniel Pöppelmann (1662–1736), claimed that his design was based on Vitruvian proportions. He even included elements that are Classical in origin, such as the statue of Hercules with the world on his shoulders—a reference to Augustus himself—at the top, and satyrs emerging from the bunched pilasters. But the Classical elements are freely rearranged so that the overall intricate effect is far from Classical in spirit. So elaborate, in fact, is the surface decoration that the wall seems to dissolve into ornate detail.

Dominikus Zimmermann

Rococo church architecture is well illustrated by Zimmermann's Wieskirche, or "Church of the Meadow," which is located in open country, as its name implies (figs. **19.19** and **19.20**). It is a pilgrimage church near Oberammergau in the foothills of the Bavarian Alps. From the plan, it is clear that Zimmermann was influenced by Borromini's elliptical architectural shapes in Rome. The exterior is relatively plain, but the interior is typical of

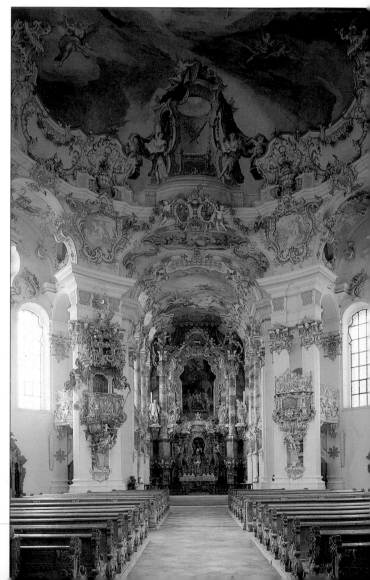

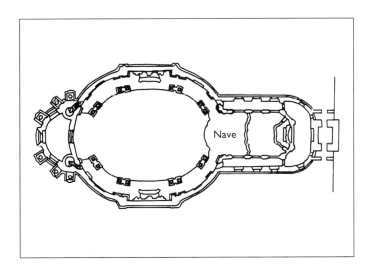

19.20 Plan of the Wieskirche.

though there are accents of pink throughout. As one approaches the **chancel**, the colors deepen. Gilt and brown predominate, but the columns flanking the altar are of pink marble, while the statues and other decorations are white. The decoration of the ceiling is entirely Rococo, in that it unites the painted surfaces with the architecture through ornate illusionism.

Architectural Revivals

Palladian Style: Lord Burlington and Robert Adam

In England, the Baroque style—and especially Rococo, with all its frills—was rejected in the eighteenth century in favor of renewed interest in the ordered, classicizing appearance of Palladian architecture. Palladio's *Four Books of Architecture* (see p. 601) was published in an English translation in 1715, and exerted widespread influence. An early example of English Palladian style is Chiswick House (figs. **19.21** and **19.22**) on the southwestern outskirts of London, which Lord Burlington (1695–1753) began in 1725 as a library and place for entertainments.

German Rococo church interiors, which were designed to give visitors a sense of spiritual loftiness and a glimpse of heaven. The nave is mainly white and the decoration (including the elaborate pulpit on the left) is largely gold,

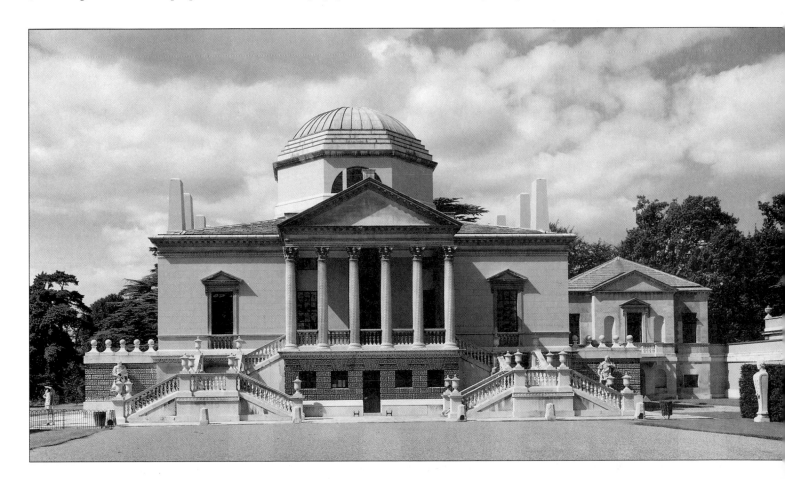

19.21 Richard Boyle (Earl of Burlington), Chiswick House, near London, begun 1725. Lord Burlington was one of a powerful coterie of Whigs and supporters of the House of Hanover (George I and his family). He took a Grand Tour of Europe in 1714 to 1715 and returned to Italy in 1719 to revisit Palladio's buildings. On his return to England, he became an accomplished architect in the tradition of Palladio.

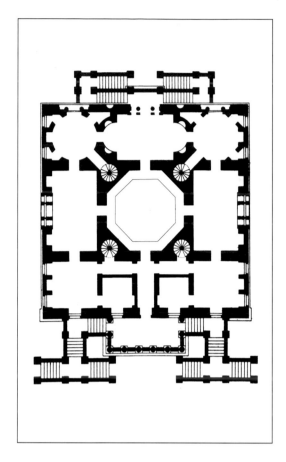

19.22 (above) Plan of Chiswick House.

Burlington based Chiswick House loosely on Palladio's Villa Rotonda (see fig. 16.20), although it is on a smaller scale, and there are some significant differences in the plans (figs. 19.22 and 16.19). Unlike the Villa Rotonda, Chiswick House did not need four porticos. Instead, it has one, which is approached by lateral double staircases on each side. The arrangement of the rooms around a central octagon rather than a circle is also different, and the columns are Corinthian rather than Ionic as in the Villa Rotonda. There are no gable sculptures, and the roof is decorated on each side by a row of obelisks, which function as chimney flues. The dome is shallower than that of the Villa Rotonda, and rests on an octagonal drum, allowing more light into the central chamber. Despite such differences, however, the proportions and spirit of Chiswick are unmistakably Palladian.

Another leader of the Classical revival in England, particularly in the field of interior design, was Robert Adam (1728–92). Interest in Classical antiquity had been heightened by the excavations at Herculaneum and Pompeii. Discoveries from these sites provided the first concrete examples of imperial Roman domestic architecture since the eruption of Mt. Vesuvius in A.D. 79. Publications about Classical archaeology followed. Not only was Adam influenced by these, but he was himself an enthusiastic amateur archaeologist. He had travelled to Rome and made drawings of the ruins, which informed much of his own work. In a fireplace niche in the entrance hall of Osterley Park House near London (fig. **19.23**), which Adam began to remodel in 1761, he recreated the atmosphere of a

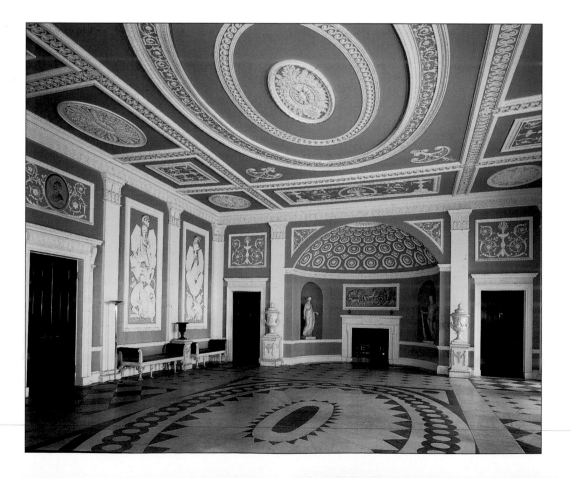

19.23 Robert Adam, fireplace niche, Osterley Park House, Middlesex, England, begun 1761. The ornamentation— including pilasters, entablature, moldings, relief over the fireplace, coffered semi-dome, and sculptures in the smaller niches—was all based on Classical precedent.

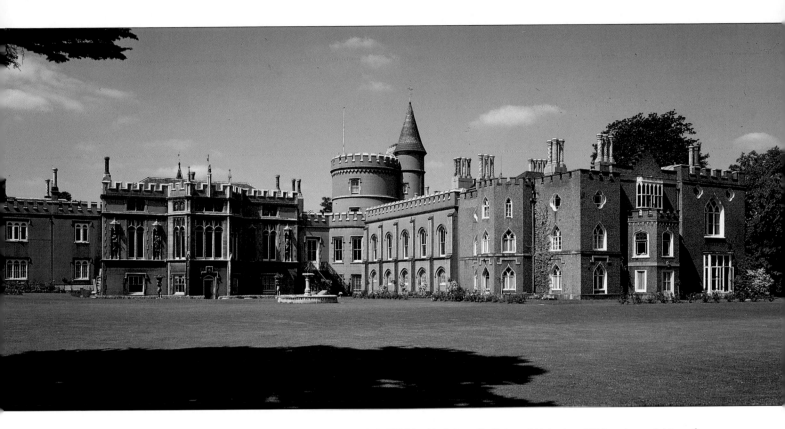

19.24 Horace Walpole, Strawberry Hill, Twickenham, near London, 1749–77. Like his father, Sir Robert Walpole, a Whig prime minister of England, Horace Walpole also sat in Parliament as a Whig. His novel *The Castle of Otranto* started a fashion for Gothic tales of terror. Walpole's prolific correspondence is a valuable record of eighteenth-century manners and tastes and, through it, he elevated letter writing to an art form.

Roman villa. Although there is still an element of Rococo delicacy, especially in the pastel color schemes of certain rooms, it is now a much more austere setting. The principal characteristics of this later style are axial symmetry and geometrical regularity, both of which reflect Neoclassical taste.

Gothic Revival: Horace Walpole

Contemporary with German Rococo architecture and the Palladian movement was a renewed interest in Gothic style. The revival of Gothic—which never completely died out in England—began around 1750. It must be seen in relation to the late eighteenth-century Romantic movement, which is discussed in Chapter 21.

In its most general form, Romanticism rejected established beliefs, styles, and tastes—particularly the Classical ideals of clarity and perfection of form. It fostered the dominance of imagination over reason. The term Romanticism comes from the highly colored medieval literature about heroes such as Charlemagne and King Arthur, or ancient themes such as the fall of Troy, which became popular in the later eighteenth century. These works—part fiction, part history—were called "romances," not because of their subject-matter but because they were originally written in one of the Romance languages (French, Italian, Spanish, and Portuguese). In the context of eighteenth-

century architecture, Romanticism was a reaction against Neoclassical trends (see Chapter 20), with their emphasis on order and symmetry. At the same time, however, to the extent that it evoked the Classical past, Romanticism shared certain aspects of the Neoclassical style.

One of the earliest non-Classical manifestations of Romanticism in England was the use (from the 1740s) of imitation Gothic ruins and other medievally inspired objects in garden design. This was followed by the more radical activity of Horace Walpole (1717–97), a prominent figure in politics and the arts. Walpole and a group of friends spent over twenty-five years enlarging and "gothicizing" a small villa in Twickenham, just outside London. The result, renamed Strawberry Hill (fig. **19.24**), was widely admired at the time. It is a large, sprawling structure, which has none of the soaring grandeur of traditional Gothic buildings. Nevertheless, Strawberry Hill contains an interesting jumble of Gothic features, including battlements, buttresses, and tracery. There are turrets on the outside and vaulting in the interior. We have no reason to doubt the seriousness with which Walpole undertook the project, but it is difficult to resist the thought that the revived Gothic—or Gothick, as it was sometimes called—had a somewhat tongue-in-cheek quality. Strawberry Hill also reflected the serious nostalgia with which the British viewed the Middle Ages, associated with a lost sense of community.

European Painting

Bourgeois Realism: Jean-Baptiste Chardin

The French Enlightenment *encyclopédiste* Diderot praised Jean-Baptiste Chardin (1699–1779) as a realist painter. In contrast to the fashionable, aristocratic elegance of his Rococo contemporaries, Chardin's subjects, especially still life and genre, are in the tradition of Netherlandish painting. His down-to-earth *La Fontaine* (fig. **19.25**) illustrates the artist's interest in household work. Simple tasks are raised above the level of the ordinary by the conviction and intense concentration of the figures. Work, rather than play—as in Rococo—is Chardin's subject. In the very application of paint to canvas, Chardin conveys his own focus and intensity. The large copper vat at the center of *La Fontaine*, for example, is painted with thick, almost **impasto**, brushstrokes, creating the impression of a shiny metal surface. The wooden bucket, the tiled floor, and the draperies hanging at the left reflect Chardin's attention to the rustic textures of the country kitchen. The woman her-self carries out her chores with determination. She wears plain household attire, in contrast to Rococo silks and laces. In the background, another woman talks to a little girl, as if to instill in her the "bourgeois" values of work. These figures gaze neither at one another nor at the observer. Unlike the flirtatious character and fanciful settings of Rococo, in which time is spent primarily in leisure pursuits, Chardin's scenes extol the moral virtues of work and study in "realistic," everyday surroundings.

Chardin's still lifes, such as *Pipe and Jug* (fig. **19.26**), eliminate human figures, while assuring the observer of their presence. He also endows his objects with distinctive shapes and textures which contribute to their character. The objects seem to have been arranged by an absent person who might return at any moment. The box itself is a sturdy container, solid and reliable like the woman in *La Fontaine*. It seems as if it has just been opened, and the pipe casually propped against it until its owner comes back. A prominent white jug, illuminated from the window at the left, presides over the smaller objects. It seems to dominate the space—like a woman with her hand on her

19.25 Jean-Baptiste Siméon Chardin, *La Fontaine*, first exhibited 1733. Oil on canvas, 15 × 16½ in (38.1 × 41.9 cm). National Museum, Stockholm.

19.26 Jean-Baptiste Siméon Chardin, *Pipe and Jug*, undated. Oil on canvas, 12½ × 16½ in (31.7 × 41.9 cm). Louvre, Paris.

hip. The thick impasto of the jug contrasts with the shiny surfaces of the smaller, more delicate, and less imposing objects. As in *La Fontaine*, Chardin's focused attention, and the visible care lavished on the application of the paint, herald the nineteenth-century still lifes of Manet and Cézanne (see Chapters 23 and 24).

Neoclassicism: Angelica Kauffmann

Angelica Kauffmann (1741–1807) was a child prodigy who became one of the most important and prolific Neoclassical painters. Her *Pliny the Younger and his Mother at Misenum, A.D. 79* (fig. **19.27**) illustrates the late eighteenth-century interest in Classical form and content, as well as the degree to which different styles can overlap each other

19.27 Angelica Kauffmann, *Pliny the Younger and his Mother at Misenum, A.D. 79*, 1785. Oil on canvas, 3 ft 4½ in × 4 ft 2½ in (1.03 × 1.28 m). The Art Museum, Princeton University (Museum Purchase, Gift of Franklin H. Kissner). Kauffmann was a member of the Accademia di San Luca in Rome from 1765, but, as a woman, was excluded from figure drawing classes. In 1766 she went to England, where she helped to found the Royal Academy of Art.

within the same period. Although the content is Classical, the mood is created by the Romantic theme of man versus the violence of nature. Figures in Classical dress observe the eruption of Mt. Vesuvius from across the Bay of Naples. Pliny the Younger, who wrote a description of the eruption, sits with a pen poised over a scroll on his lap. He listens, as an excited eyewitness gesticulates toward Pompeii. His mother turns away in fear, pulling her veil as if to shield her eyes. The architectural setting, with its round arch, triangular pediment, pilasters, and columns, conforms to ancient Rome, while clarity, order, simplicity, and the elimination of Rococo frills reflect a return to Classical taste.

American Painting

John Singleton Copley

Across the Atlantic, on the North American continent (fig. **19.28**), artists of the late eighteenth century were affected by European styles. A leading painter of the Colonial period was John Singleton Copley (1738–1815). He did not sympathize with the American Revolution, and in 1775

19.29 John Singleton Copley, *Paul Revere*, c. 1768–70. Oil on canvas, 35 × 28½ in (88.9 × 72.3 cm). Courtesy, Museum of Fine Arts, Boston (Gift of Joseph W., William B., and Edward H. R. Revere). Copley grew up in Boston, the son of Irish emigrants. He was trained by his stepfather, an engraver of mezzotint portraits, and then became a portrait painter.

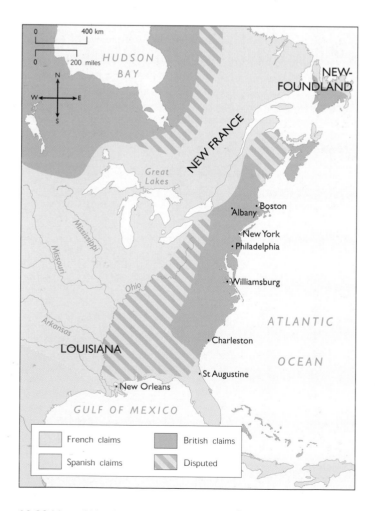

19.28 Map of North American settlements in the 18th century.

emigrated to England, where, under the influence of European Rococo, his work became more ornate.

Before his departure, Copley painted a portrait of Paul Revere (fig. **19.29**), which is typical of his earlier, more direct realist style. Despite the apparent simplicity of the picture, however, there are unmistakable elements of Baroque and Rococo. The figure looks directly out of the picture plane, inviting the viewer into its space as many Baroque figures do. The way in which the sharply focused, illuminated figure is set against a dark background is reminiscent of Baroque portraiture. Likewise, the attention to surface shine (for example, the silver teapot and highly polished table top with engraving tools) occurs frequently in both Baroque and Rococo. In contrast to those styles, however—and particularly to the latter—Copley's Paul Revere is not idealized; he wears a simple shirt and a plain vest. His solid, squarish bulk is emphasized, and the weight of his head is indicated by his stern expression and the thumb pushing up against his jaw.

Benjamin West

Benjamin West (1738–1820), another important late eighteenth-century American artist, came from Pennsylvania Quaker stock, and began painting at the age of six. Like Copley, West settled in England, where he became known for his pictures of Classical and historical subjects. In 1772, he was appointed historical painter to King George III, and was President of the Royal Academy from 1792 to 1805, and from 1807 to 1820. Many young American artists visiting London, including Copley, trained at his studio.

In *The Death of General Wolfe* (fig. **19.30**), West caused consternation among conservative elements by his choice of contemporary, rather than Neoclassical, dress. King George III was not alone in feeling that modern dress was vulgar. It was generally thought that West's figures should have worn togas so that the picture would convey a universal message. But despite such criticism, the work was enormously popular. Its appeal to the past, with a suggestion of nostalgia, became characteristic of nineteenth-century Romanticism. Although West rejected Classical costume, his training in the Classical tradition is evident.

The Indian in the foreground kneels in the traditional pose of death and mourning. At the same time, however, the use of light and the melodramatic gestures are reminiscent of the Baroque style.

In eighteenth-century America as well as Europe, different trends in artistic style persisted alongside the Palladian movement, the Gothic revival, and the beginnings of Romantic and Realist developments. By the end of the eighteenth century, Rococo was a style of the past. The Neoclassical, Romantic, and Realist movements would at various times emerge to dominate nineteenth-century taste.

19.30 Benjamin West, *The Death of General Wolfe*, c. 1770. Oil on canvas, 4 ft 11½ in × 7 ft ¼ in (1.51 × 2.13 m). National Gallery of Canada, Ottawa (Gift of the 2nd Duke of Westminster, 1918). James Wolfe, the subject of this painting, was the young general who led the British troops to victory over a much larger French force in Quebec in 1759. His success obliged France to concede Canada to England. At the decisive moment of battle, Wolfe was wounded and died in the arms of his officers.

Style/Period	Works of Art	Cultural/Historical Developments

1700

ROCOCO AND THE 18TH CENTURY

1700–1740

Watteau, *Gilles*

Rigaud, *Louis XIV* (**19.9**)
Pöppelmann, the Zwinger (**19.18**), Dresden
Watteau, *A Lady at her Toilet* (**19.5**)
Watteau, *The Dance* (**19.4**)
Watteau, *Gilles* (**19.6**)
Neumann, Residenz (**19.15**), Würzburg
Boyle, Chiswick House (**19.21**), nr. London
Chardin, *La Fontaine* (**19.25**)
Chardin, *Pipe and Jug* (**19.26**)

Chardin, *Pipe and Jug*

Peter the Great founds Saint Petersburg (1703)
Union of England and Scotland as Great Britain (1707)
Alexander Pope, *Rape of the Lock* (1712)
Death of Louis XIV of France (1715)
Daniel Defoe, *Robinson Crusoe* (1719)
Spain occupies Texas (1720–22)
South Sea Bubble (English speculative craze) bursts (1720)
Johann Sebastian Bach, Brandenburg Concertos (1721)
Establishment of cabinet government in England; Robert Walpole first prime minister (1721)
Regular postal service established between London and New York (1721)
Jonathan Swift, *Gulliver's Travels* (1726)
John Gay, *The Beggar's Opera* (1728)
Methodist movement founded by John and Charles Wesley (1730)
Discovery of Herculaneum and Pompeii (1738–48)
David Hume, *A Treatise of Human Nature* (1739)

1740

1740–1760

Hogarth, *Marriage à la Mode II* (**19.13**)
Zimmermann, Wieskirche (**19.19**), Bavaria
Walpole, Strawberry Hill (**19.24**), Twickenham
Boucher, *Venus Consoling Love* (**19.7**)
Carriera, *Louis XV* (**19.10**)
Tiepolo, Residenz frescoes (**19.16–19.17**)

Hogarth, *Marriage à la Mode II*

George Frederick Handel, *The Messiah* (1741)

Benjamin Franklin invents the lightning conductor (1752)
Samuel Johnson begins *Dictionary of the English Language* (1755)
Voltaire, *Candide* (1759)

1760

1760–1770

Copley, *Paul Revere*

Adam, Osterley Park House (**19.23**), Middlesex
Hogarth, *Time Smoking a Picture* (**19.14**)
Chambers, Pagoda (**19.2**), Kew
Fragonard, *The Swing* (**19.8**)
Wright, *An Experiment on a Bird in the Air Pump* (**19.3**)
Copley, *Paul Revere* (**19.29**)
West, *The Death of General Wolfe* (**19.30**)

Jean Jacques Rousseau, *Social Contract* (1762)
Spain cedes Florida to England
England defeats France at Battle of Quebec and gains control of Canada (1763)
Wolfgang Amadeus Mozart writes his first symphony (1764)
Johann Winckelmann, *History of Ancient Art* (1764)
James Watt invents steam engine (1769)
Capt. James Cook lands at Botany Bay, Australia (1770)

1770

1770–1800

Kauffmann, *Pliny the Younger and his Mother at Misenum, A.D. 79* (**19.27**)
Gainsborough, *Mrs. Richard Brinsley Sheridan* (**19.12**)
Vigée-Lebrun, *Marie Antoinette and her Children* (**19.11**)

Vigée-Lebrun, *Marie Antoinette and her Children*

Denis Diderot completes his encyclopedia (1772)
Boston Tea Party in protest against tea duty (1773)
American Declaration of Independence (1776)
Adams Smith, *Wealth of Nations* (1776)
Lavoisier proves that air is composed mainly of oxygen and nitrogen (1777)
Richard Brinsley Sheridan, *The School for Scandal* (1777)
Immanuel Kant, *Critique of Pure Reason* (1781)
Beginning of the French Revolution (1789)
William Blake, *Songs of Innocence* (1789)
Execution of Louis XVI and Marie Antoinette (1793)
Eli Whitney invents the cotton gin (1793)
Edward Jenner introduces vaccination against smallpox (1796)
Napoleon Bonaparte appointed First Consul of France (1799)

1800

20

Neoclassicism: The Late Eighteenth and Early Nineteenth Centuries

During the late eighteenth and early nineteenth centuries in western Europe, several styles competed for primacy. Paris had become the undisputed center of the Western art world, but Rome was still a significant artistic force. In France, the "True Style," later

called the Neoclassical style, was a reaction against the levity of Rococo. French Baroque, especially under Louis XIV, had had a pronounced Classical flavor; from it evolved the Neoclassical style, which was adopted by the leaders of the French Revolution. Neoclassical then became the style most closely associated with the revolutionary movements of the period (see Box).

Chronology of the French Revolution and the Reign of Napoleon

1789	The storming of the Bastille prison in Paris, followed by the Reign of Terror. Many associated with the *ancien régime* ("old regime") and the hereditary monarchy are killed.
1793	Louis XVI and his wife Marie Antoinette are beheaded by the guillotine.
1795–9	The *Directoire* period, or Directory—rule by the middle class.
1799	Napoleon becomes First Consul.
1803	The Napoleonic Law Code is issued.
1804	Napoleon is crowned emperor.
1806	Napoleon begins a building campaign in Paris with the intention of creating a new Rome. He takes Julius Caesar, who was also a consul before becoming dictator, as his model. Like Caesar, Napoleon adopts the eagle for his military emblem and the laurel wreath for his crown.
1812	Napoleon attacks Russia, but is forced to retreat.
1814	Napoleon abdicates. The monarchy is restored under Louis XVII.
1815	Napoleon is defeated in the Battle of Waterloo. The Congress of Vienna establishes the borders of European countries, which last until World War I (1914–18).
1821	Napoleon dies in exile.

The Neoclassical Style in France

The contrast between Rococo and Neoclassical style can be illustrated by comparing two sculptures of a similar subject—an embrace—taken from two different episodes in Classical mythology. The **terracotta** *Intoxication of Wine* (fig. **20.1**) by Clodion (1738–1814) exemplifies the amorous frivolity of Rococo. The *Cupid and Psyche* (fig. **20.2**) of Antonio Canova (1757–1822), on the other hand, displays the sweeping grandeur and idealization of Neoclassical.

In the Clodion, a lusty **satyr** (see Box on p. 700) leans backward, drawing a nude bacchante towards him. She pours wine into his mouth while embracing him and straddling his thigh. The satyr's excitement is revealed by his raised right leg, which echoes the bacchante's left leg. The figures seem prevented from toppling over only by the satyr's hand resting on the rock. Their twisted poses and diagonal planes animate and open the space, pointing outward from the core of the statue toward the viewer. The surface motion created by the satyr's rippling muscles and the rough textures of his shaggy hair underline the orgiastic nature of the encounter.

Canova's *Cupid and Psyche* portrays an embrace of another kind. Its subject is the ill-fated romance between Cupid and Psyche (also the Greek word for "soul"). It is a tale that contains the seeds of tragedy, and so this sculpture rises above the frivolous anonymity of the Clodion. The Canova is reminiscent of classical ballet, with its smooth surfaces, broad poses, and gestures encompassing and enclosing a space beyond the embrace itself. Cupid leans over, his wings spreading out in an eloquent V-shape. Their formal upward motion suggests the rising of

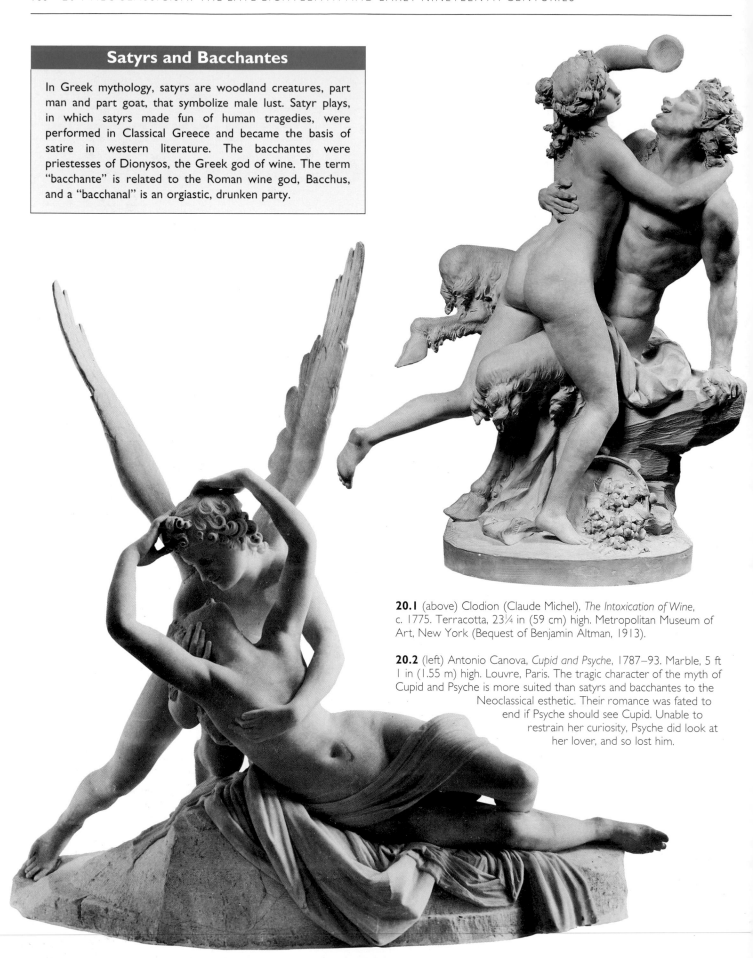

Satyrs and Bacchantes

In Greek mythology, satyrs are woodland creatures, part man and part goat, that symbolize male lust. Satyr plays, in which satyrs made fun of human tragedies, were performed in Classical Greece and became the basis of satire in western literature. The bacchantes were priestesses of Dionysos, the Greek god of wine. The term "bacchante" is related to the Roman wine god, Bacchus, and a "bacchanal" is an orgiastic, drunken party.

20.1 (above) Clodion (Claude Michel), *The Intoxication of Wine*, c. 1775. Terracotta, 23¼ in (59 cm) high. Metropolitan Museum of Art, New York (Bequest of Benjamin Altman, 1913).

20.2 (left) Antonio Canova, *Cupid and Psyche*, 1787–93. Marble, 5 ft 1 in (1.55 m) high. Louvre, Paris. The tragic character of the myth of Cupid and Psyche is more suited than satyrs and bacchantes to the Neoclassical esthetic. Their romance was fated to end if Psyche should see Cupid. Unable to restrain her curiosity, Psyche did look at her lover, and so lost him.

the soul and the lofty nature of true love. Psyche lies back, in a pose that recalls the traditional reclining nude, and curves her arms about Cupid's head in a gesture that is at once open and closed. It is the lofty, tragic dimension of Canova's sculpture that allies it with the Neoclassical style, in contrast to the "satirical" Rococo revelry of Clodion.

Art in the Service of the State: Jacques-Louis David

The political aspects of the Neoclassical style derived from its associations with heroic subject-matter, formal clarity, and the impression of stability and solidity. It also contained implicit references to Athenian democracy and the Roman Republic. In artistic terms, the Neoclassical style was a reaction against Rococo. However, the political preoccupations of the Neoclassical style arose directly from the questioning stance that had so strongly characterized eighteenth-century Enlightenment thought. Increasing

popular resentment of the abuses of the monarchy was a logical development of the Enlightenment, which championed the right of the individual within the state. After the French Revolution, Napoleon Bonaparte adopted the Neoclassical style, and used its association with the austerity and virtue of the ancient Roman Republic to create and sustain his political image—first as general and consul, and later as emperor.

The leading Neoclassical painter, Jacques-Louis David (1748–1825), appealed to the republican sentiments that derived from Classical antiquity. His *Oath of the Horatii* (fig. **20.3**), first exhibited in 1785, illustrates an event from Roman tradition in which honor and self-sacrifice prevailed (see caption). The figures wear Roman dress and the scene takes place in a Roman architectural setting, before three round arches resting on a form of Doric column. Framed by the center arch, Horatius raises his sons' three swords, on which they swear an oath of allegiance to Rome. Within a rectangular space composed of clear

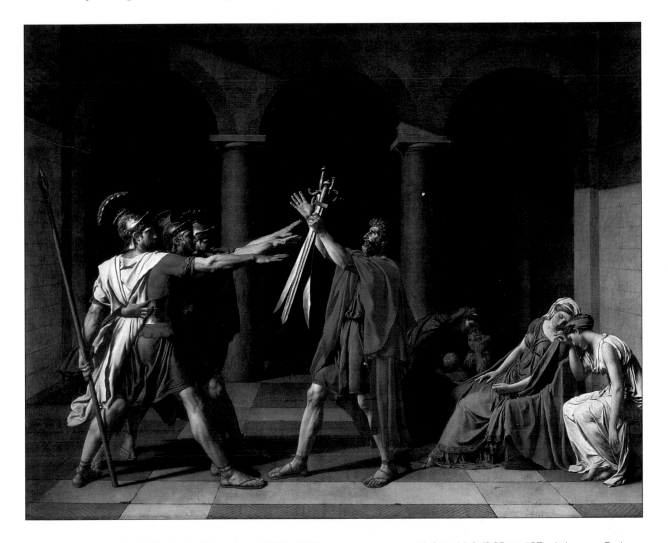

20.3 Jacques-Louis David, *The Oath of the Horatii*, 1784–5. Oil on canvas, approx. 11 ft × 14 ft (3.35 × 4.27 m). Louvre, Paris. Although the event is not described in Classical sources, the story of the Horatii was known from a tragedy by Pierre Corneille, the 17th-century French dramatist. Rome and Alba Longa had agreed to settle their differences by "triple" combat between two sets of triplets—the Horatii of Rome and the Curiatii of Alba—rather than by all-out war.

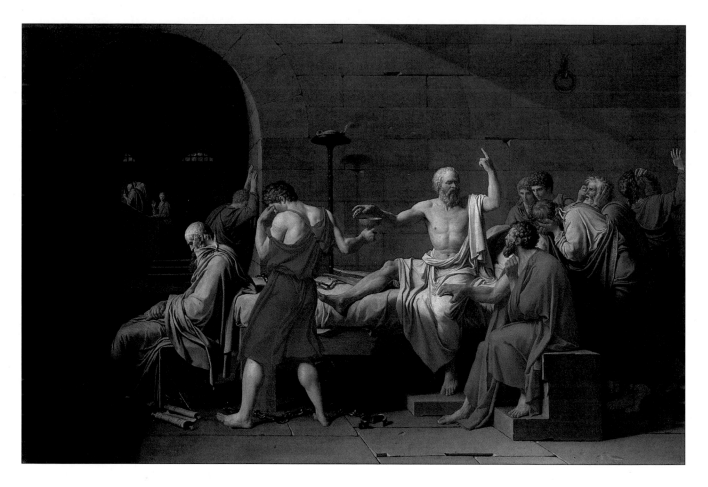

20.4 Jacques-Louis David, *The Death of Socrates*, 1787. Oil on canvas, 4 ft 3 in × 6 ft 5¼ in (1.29 × 1.96 m). Metropolitan Museum of Art, New York (Wolfe Fund, 1931, Catherine Lorillard Wolfe Collection).

vertical and horizontal planes, and subdued by muted color, the gestures of the soldiers are vigorous, determined, and somewhat theatrical. They express a fervor that links Roman patriotism of the past to the contemporary passions of the French—first for reform and later for revolution. The women and children, in contrast, collapse at the right in a series of fluid, rhythmic curves, which reflect their more emotional nature. They include the sisters of the Horatii, one of whom is engaged to an enemy combatant and is overcome by her tragic destiny. In the shadows, the wife of Horatius comforts her grandchildren.

The painting was commissioned by Louis XVI as part of a program aimed at the moral improvement of France. Although the modern viewer tends to see it as a piece of overtly revolutionary propaganda, the ideals embodied in Neoclassical painting were in fact appealing to both the royalist establishment and its republican opponents. The irony of the political subtext was apparently lost on Louis' minister for the arts, who approved the painting.

In *The Death of Socrates* (fig. **20.4**), painted in 1787, David used a subject from Greek history to exemplify individual heroism and self-sacrifice in the service of intellectual freedom. The Athenians objected to Socrates' teaching, and condemned him for corrupting the youth of their city. He was offered a choice of exile or death, but, as recorded by Plato in *The Apology*, refused to abandon his principles and chose to die. David portrays the last moments of Socrates, who continues teaching to the very end. One disciple turns away as he hands him the goblet of poison hemlock. Others wearing Classical dress gather at the right and listen intently to Socrates' words.

The architecture of the prison, with its round arch, is depicted with the same clarity and box-like construction as *The Oath of the Horatii*. Not only is the subject itself drawn from antiquity, but the specific gesture of Socrates—his hand raised and his finger pointing upwards as if toward a higher truth—is a visual quotation from Raphael's Plato in *The School of Athens* (see fig. 15.38). Since Raphael's Plato is a portrait of Leonardo, the gesture of David's Socrates pays tribute to his great High Renaissance predecessors as well as to the intellectual integrity of philosophers Plato and Socrates. The high moral tone of David's *Oath of the Horatii* and *The Death of Socrates*, the former patriotic and the latter intellectual in appeal, made them exemplary images for a France on the verge of revolution. In 1789, two years after David painted *The Death of Socrates*, the angry mobs of Paris stormed the Bastille and ignited the Revolution.

In *The Death of Marat* (fig. **20.5**), commissioned during the Reign of Terror, David used the principles of the Neoclassical style explicitly in the service of contemporary political events (see caption). Both David and Marat were members of the Jacobin movement, a group of revolutionary extremists, and the patrons of David's painting. David himself was elected to the National Convention and voted to send Louis XVI to the guillotine. When Robespierre, the minister who presided over the Reign of Terror, fell, David was imprisoned twice. But he regained favor under Napoleon, who appointed him his imperial painter and granted him a barony. After Napoleon's exile, David left France, and died in Brussels in 1825.

The painting, which is set in a clear cubic space, like the *Horatii* and the *Socrates*, depicts a recent, rather than a Classical event. David's *Marat* has affinities with Christian art, particularly images of the dead Christ, which emphasizes Marat's role as a political martyr. The influence of Caravaggio can be seen in the darkened background, from which the figure of Marat emerges into light. In both form and content, therefore, David's *Marat* represents intellectual and political enlightenment.

David has idealized Marat in Classical fashion, for his body was in fact ravaged by a skin disease. He found relief from this by soaking in the bath. At the same time, however, the stab wound is visible, and the red bath water has stained the sheet. Marat has placed a writing surface over the tub, and he holds the letter sent by his killer, which reads: "*Il suffit que je sois bien malheureuse pour avoir droit à votre bienveillance,*" meaning "I just have to be unhappy to merit your goodwill."

Marat was the victim of a deceitful woman, and David displays her deceit for all the world to see as political propaganda. The knife that Charlotte Corday has dropped on the floor beside the tub is contrasted ironically with the quill pen still in Marat's limp hand. The instrument of violence and death is thus opposed to the pen, which is associated in this picture with revolutionary political writing. That Marat the revolutionary was stabbed by a member of a more conservative party enhances the tragic irony of David's picture.

Napoleon as Patron

From 1799, David created images for his new patron, Napoleon Bonaparte, who was First Consul of France (fig. **20.6**). His *Napoleon at Saint Bernard Pass* of 1800 (fig. **20.7**), which depicts Napoleon crossing the Alps, is clearly in the tradition of Roman equestrian portraits. Napoleon wears full military regalia and sits proudly astride a splendid, rearing white charger. The textures of his uniform and the horse trappings are rendered in precise detail. The wind blows at their backs, whipping forward the horse's tail and mane. Napoleon points ahead, toward the peak of the mountain, and simultaneously looks down at the observer. His dramatic gesture and the horse's pose are intimations of early Romanticism. David's idealized glorification of his patron is evident from the fact that on this occasion Napoleon actually rode a mule. The convention of idealizing the ruler-patron is known as early as ancient Egypt, and continues in western Europe and the United States to the present. David, however, probably drew on Pliny's example of Apelles as the official painter to Alexander the Great.

David's Neoclassicism is used here in the interests of the new political regime in France. Napoleon's charger looms up and dominates the picture plane, in contrast to the distant soldiers, who struggle with their cannons and are obscured by the misty sky. David relates Napoleon to his illustrious imperial predecessors by the inscriptions CAROLUS MAGNUS (Charlemagne) and HANNIBAL carved in stone under BONAPARTE in the left foreground.

When Napoleon was crowned emperor in 1804, he set about commissioning monuments throughout Paris with a view to recreating the grandeur of imperial Rome. To

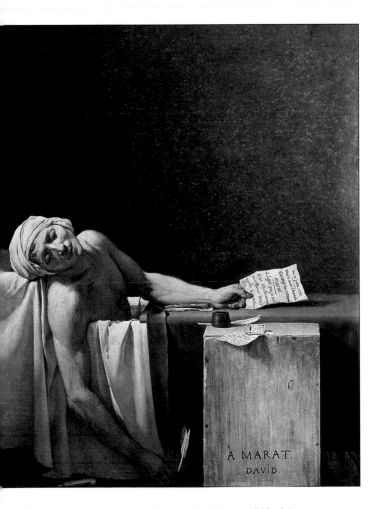

20.5 Jacques-Louis David, *The Death of Marat*, 1793. Oil on canvas, approx. 5 ft 3 in × 4 ft 1 in (1.6 × 1.25 m). Musées Royaux des Beaux-Arts de Belgique, Brussels. On July 13, 1793 Marat was stabbed in his bathtub by Charlotte Corday, a supporter of the conservative Girondin group. Inscribed on the crate supporting Marat's inkwell, pen, and papers is a combined personal and political message. David dedicates the painting À MARAT, DAVID ("To Marat, from David") and dates it L'AN DEUX ("The Year Two"), the second year of the French revolutionary calendar.

commemorate his military successes, he conceived the idea of constructing an Arc de Triomphe, or Arch of Triumph (fig. **20.8**), which would be based on the triumphal arches of ancient Rome. From these, the architect adopted the relief sculptures on the upper piers, the decorative cornices, and the row of **metopes** and **triglyphs** below the upper cornice. There were no columns or pilasters on the Arc de Triomphe, and the design was enhanced later by adding sculptures to the lower parts of the piers. The arch was commissioned in 1806, but only completed in 1836,

twenty-one years after Napoleon's defeat at Waterloo in 1815 (he was exiled to the island of St. Helena the following year). At 164 feet (50 m) high, it was the largest arch ever built; it stands at a busy intersection in the Place Charles de Gaulle (formerly named the Place de l'Etoile).

Napoleon also commissioned a monumental Doric column of marble, surmounted by a statue of himself, for the Place Vendôme in Paris (fig. **20.9**). Decorated with the spiral reliefs depicting events from his campaign of 1805, it was directly inspired by the Column of Trajan in Rome

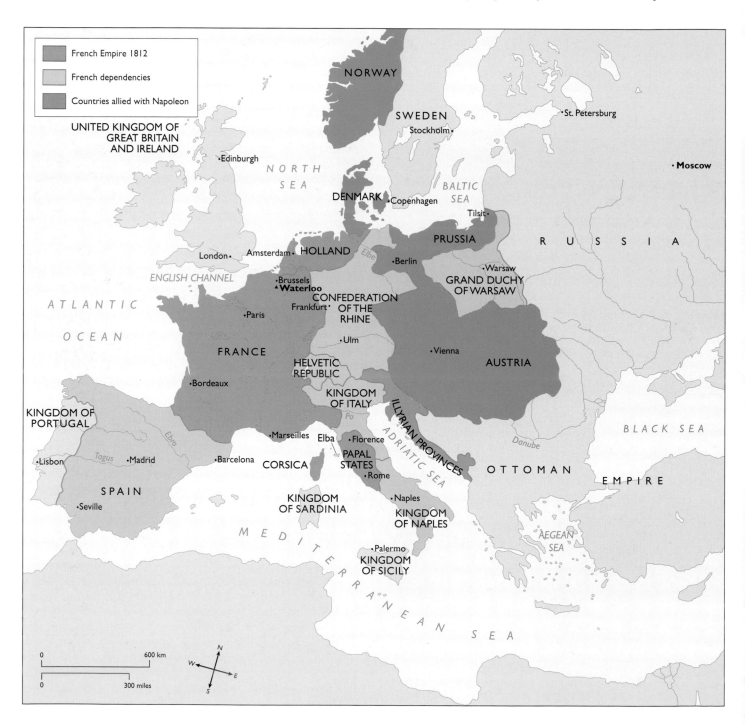

20.6 Map of the Napoleonic Empire, 1812.

20.7 (left) Jacques-Louis David, *Napoleon at Saint Bernard Pass*, 1800. Oil on canvas, 8 ft × 7 ft 7 in (2.44 × 2.31 m). Musée National du Château de Versailles.

20.8 (below) Jean-François-Thérèse Chalgrin et al., Arc de Triomphe, Paris, 1806–36. 164 ft (50 m) high.

20.9 (above) Charles Percier and Pierre F. L. Fontaine, Place Vendôme Column, Paris, 1810. Marble, with bronze spiral frieze.

(see Vol. I, fig. 8.36). The bronze from which the frieze was made had been melted down from the captured artillery of the Austrian and Prussian armies. In the column, as in the Arc de Triomphe, Napoleon expressed his view that architecture and sculpture derived from ancient Rome would enhance both his claim to the throne of France and his image as heir of the Roman emperors.

With a similar purpose, Napoleon brought the sculptor Canova to Paris from Rome, and in 1808 commissioned Canova to carve the lifesize marble sculpture of his sister Pauline (fig. **20.10**). Like David's Socrates, Pauline's proportions are Classical and she is nude from the waist up. Although she lounges on an Empire-style divan, her pose recalls that of the traditional reclining Venus.

Napoleon also enlisted the services of Marie-Guillemine Benoist (1768–1826), who painted several portraits of him. She studied with David, whose influence is readily apparent in her *Portrait of a Negress* of 1800 (fig. **20.11**). Like Canova's *Pauline*, the Negress is partly nude from the waist up, and is in the tradition of the reclining nude female. She thus combines aspects of Classicism and Romanticism in a way that attests the overlap of the two styles in the late eighteenth and early nineteenth centuries. The figure stands out against a plain background, and the dark brown skin contrasts sharply with the classicizing white drapery. At the same time, Benoist has included a hint of the figure's exotic, Romantic character in the turban and the gold earring. But the clear edges, the smooth texture of the paint, and the Neoclassical drapery enhance the unexpected impact made by a black woman set in a conventional European tradition.

Jean-Auguste-Dominique Ingres

The career of another of David's students who worked for Napoleon, Jean-Auguste-Dominique Ingres (1780–1867), also embodies the interplay of Neoclassicism and Romanticism. There are already hints of Romantic taste for the exotic in Benoist's *Negress*, but Ingres' work also retains traces of Mannerist elegance. His portrait of *Madame Rivière* (fig. **20.12**), painted in 1805, five years after the *Negress*, continues the tradition of formal clarity, interest in rich detail, and smooth texture that he learned in David's studio. Placed in an oval frame, Madame Rivière

20.10 Antonio Canova, *Maria Paolina Borghese as Venus*, 1808. Marble, 5 ft 2⅞ in × 6 ft 6¾ in (1.6 × 2.0 m), including divan. Borghese Gallery, Rome.

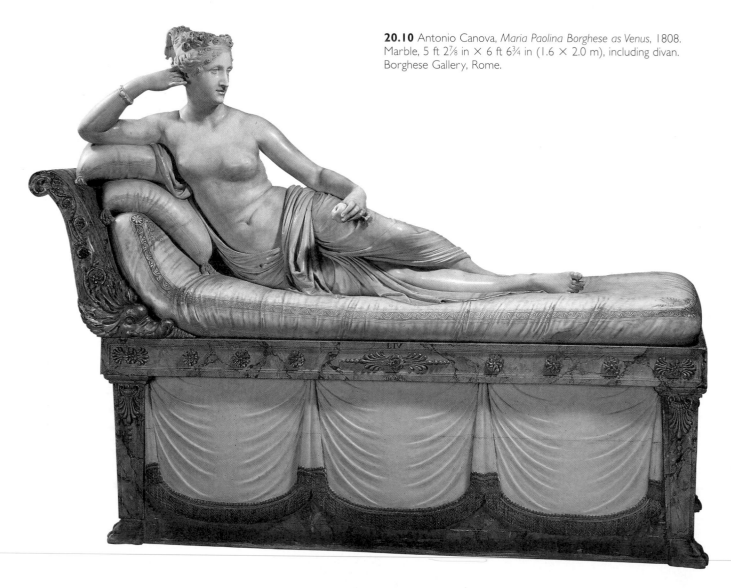

ing a large V. The grand, halo-like golden arc of his throne echoes the arc of his laurel wreath, and mirrors the curves of his collar, necklace, and ermine. Also denoting his imperial status are the eagles that adorn the columns forming the sides of his throne. Another large eagle is outlined in the weave of the carpet in the foreground. Everywhere, the brushstrokes are submerged to enhance the illusion of texture. Ingres' smooth, highly finished surfaces were characteristic of Academic painting rather than of Romanticism (see Chapter 21), which stressed the material quality of the media. Ingres' fondness for rich textures is expressed in the red velvet (red was the color of Roman emperors), ermine, and gold, all of which finally overwhelm the Emperor.

Drawing on Greek mythology, Ingres painted an *Oedipus and the Sphinx* (fig. **20.14**) in 1808. Oedipus (see Box on p. 709) is shown solving the riddle of the Sphinx, while a frightened Theban rushes off toward the Greek city in the background. Oedipus's head, particularly his profile, recalls Greek statuary, but his muscular torso seems distant from the Classical ideal. The bones and the foot in the lower left corner, which are the remains

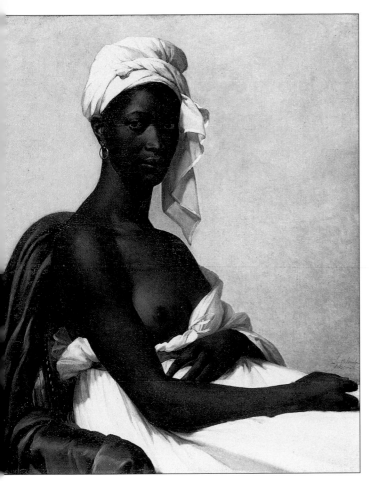

20.11 Marie-Guillemine Benoist, *Portrait of a Negress*, 1800. Oil on canvas, 31⅝ in × 25⅝ in (80.33 × 65.1 cm). Louvre, Paris. Benoist was the daughter of a government official. She studied with Vigée-Lebrun and began her career as a portraitist in pastel. Later she studied with David, and in 1791 exhibited two history paintings. When she married a royalist, her career declined, and she was in constant danger under the Reign of Terror. Napoleon awarded her an annual pension.

reclines on velvet cushions, which are draped with an elaborately patterned shawl. Its blues echo the velvet, while a slightly diaphanous white veil flutters from behind her head. Her black, piercing eyes repeat the curls, which are derived from Ingres' study of Greek vase painting. The soft shading of her flesh is consistent with the soft material textures and her relaxed, somewhat languid pose. She is an elaborate painted version of Canova's *Pauline*, a modern Venus turned toward the viewer and clothed in the garb of early nineteenth-century French aristocracy.

Ingres' portrait of 1806, depicting Napoleon as a deified Roman emperor in all his imperial splendor (fig. **20.13**), recalls the fussiness of Rococo and the exaggeration of Mannerism. On the other hand, the clarity and precision of the details are characteristic of the Neoclassical style. Napoleon exhibits the accoutrements of kingship and deity, his scepter and staff pointing heavenward and form-

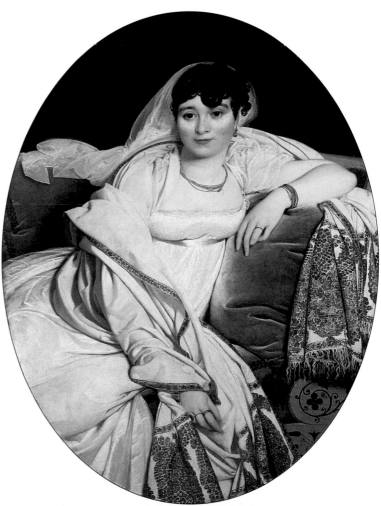

20.12 Jean-Auguste-Dominique Ingres, *Madame Rivière*, 1805. Oil on canvas, 3 ft 9 in × 3 ft (1.16 × 0.90 m). Louvre, Paris.

of the Sphinx's victims, and the Sphinx herself, are also unclassical because they impart a disturbing sense of mystery. Ingres thus combines themes and motifs from Classical antiquity with certain characteristics that heralded the nineteenth-century Romantic movement.

It was in his "Odalisques" that Ingres achieved his most successful synthesis of Neoclassical clarity, rich, aristocratic textures, and a Romantic taste for the exotic. (An odalisque is a harem girl, from *oda*, meaning a room in a Turkish harem.) Ingres' *Grande Odalisque* (fig. **20.15**), exhibited in 1814 (the year of Napoleon's abdication), is the best example. The idealized, reclining nude is seen from the back, as is Vélazquez's *Venus with a Mirror* (see fig. 18.56). But here the figure turns to gaze at the observer. In contrast to the painterliness that obscures the Venus, Ingres' nude has precise edges and a clear form. At the

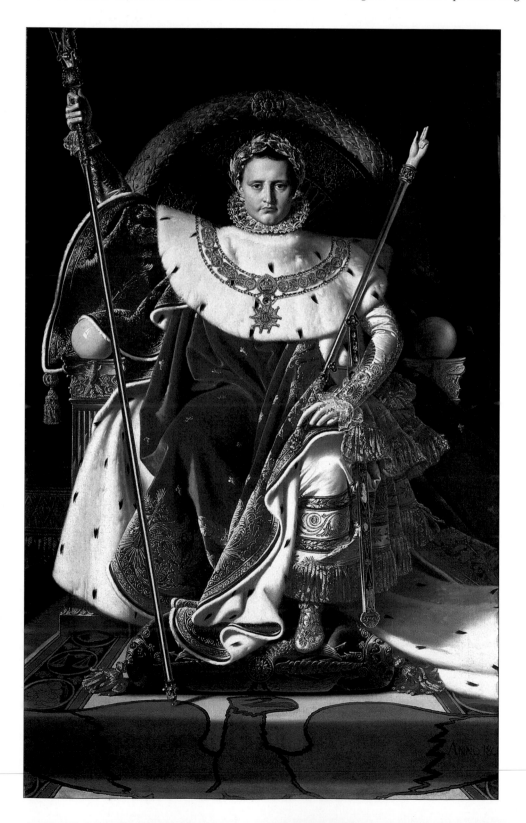

20.13 Jean-Auguste-Dominique Ingres, *Napoleon Enthroned*, 1806. Oil on canvas, 8 ft 8 in × 5 ft 5¼ in (2.59 × 1.55 m). Musée de l'Armée, Paris.

Oedipus

The myth of Oedipus is given its definitive literary form in Sophokles' play *Oidipos Tyrannos* (*Oedipus the King*). Oedipus's father, King Laios of Thebes had been warned by the oracle that his son would kill him. He therefore drove a stake through his son's foot and left him to die on a mountain. A shepherd couple discovered Oedipus, and raised him as their own son. Later, Oedipus learned from the oracle that he was destined to kill his father and marry his mother. To avoid this fate, Oedipus left home. Nearing the city of Thebes, he came to a fork in the road where he encountered a man who refused to let him pass. Oedipus killed the man and continued on his way. He met the Sphinx on the outskirts of Thebes, and solved her riddle: "What walks on four legs in the morning, two legs in the afternoon, and three legs in the evening?" The answer: "Man." (As a baby he crawls on all fours, then he walks on two legs, and finally he walks with a cane.) The prominent foot in the lower left corner of Ingres' painting refers both to the name "Oedipus" (which means "swollen foot" in Greek) and to the riddle's emphasis on walking.

The Thebans rejoiced at the destruction of the Sphinx and gave their widowed queen, Jocasta, to Oedipus in marrriage. Years later, as King of Thebes and the father of four children by Jocasta, Oedipus is told that he is the cause of a plague ravaging the city. On learning that he has committed patricide and incest—for Laios was the man at the crossroads, and Jocasta his mother—Oedipus blinds himself.

This myth has been taken up in various forms by artists and writers ever since. In the early twentieth century, Sigmund Freud named the Oedipus Complex after it, believing it to be the core of child development and the nucleus of every neurosis.

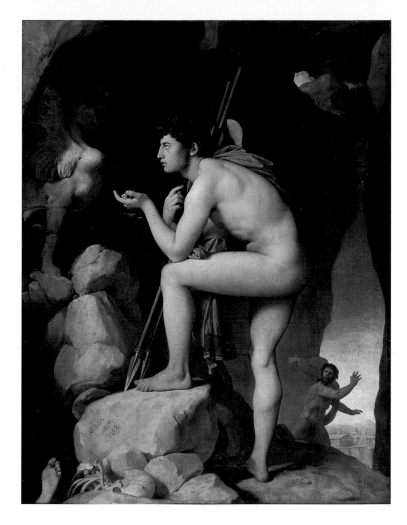

20.14 (above) Jean-Auguste-Dominique Ingres, *Oedipus and the Sphinx*, 1808. Oil on canvas, 6 ft 2⅜ in × 4 ft 8⅝ in (1.9 × 1.4 m). Louvre, Paris.

20.15 Jean-Auguste-Dominique Ingres, *Grande Odalisque*, 1814. Oil on canvas, approx. 2 ft 11¼ in × 5 ft 4¾ in (0.89 × 1.65 m). Louvre, Paris.

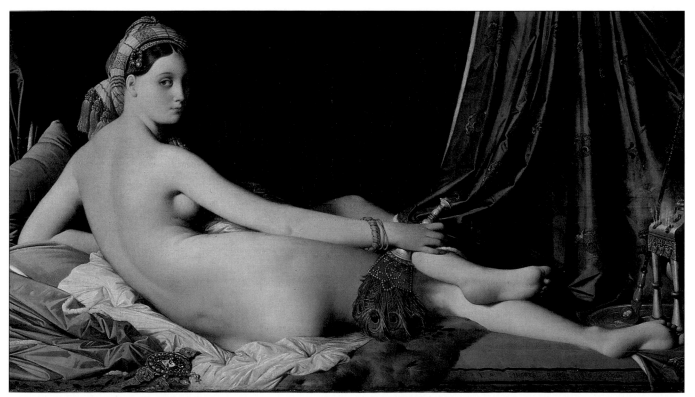

same time, however, the odalisque remains aloof and somewhat distant by comparison with the Baroque Venus. She is removed from everyday contemporary French experience by an exotic setting filled with illusionistic textures—the silk curtain and sheets, the peacock feathers of the fan, the fur bed covering, the headdress, and the hookah (a Turkish pipe in which the smoke is cooled by passing through water). The *Grande Odalisque* well illustrates Ingres' love of clarity, which he associated with line—hence his Academic motto that "drawing is the probity of art." Nevertheless, he, more than the purely Neoclassical David, was attracted to the more Romantic elements of sensuality and color.

Developments in America

The American Revolution preceded the French Revolution by only a few years (see Box). As in France, the intent of the American Revolution was liberation from monarchy. But the additional factor of throwing off the yoke of a foreign ruler made the Revolution in America somewhat different from its French counterpart. Once liberated from the English throne, which was then occupied by King George III, America abandoned monarchy completely. The system designed by Jefferson and the other framers of the Constitution resulted in a smoother transition of power than in France and a more stable form of government (see Box).

In America, the Revolution not only signified a political break with its colonial origins; it also marked a departure from the dominant pre-Revolutionary style of architecture. This was the so-called "Colonial Georgian" style, named after the English King. Just as republican Rome was the political model to which the newly independent colonies aspired, so Roman architecture was more closely imitated in the early period of independence. Since this period (c. 1780–1810) coincided with the establishment of many United States government institutions, the style is referred to as the Federal style.

Chronology of the American Campaign for Independence

1776 Declaration of Independence. The colonies declare independence from England, marking the beginning of the American Revolution.

1787 The Constitution of the United States is signed.

1789 George Washington is inaugurated as first President of the United States.

1790 Washington, D.C., is founded as the nation's capital.

1801 Thomas Jefferson is inaugurated as the third president.

The Architecture of Thomas Jefferson

No single American embodied the principles of Neoclassicism more than Thomas Jefferson (1743–1826). In 1789, the leading French sculptor, Jean-Antoine Houdon (1741–1828), carved a marble portrait bust of Jefferson (fig. **20.16**) during his stay in France as United States Minister to that country (1785–9). Houdon has captured an air of kindly self-confidence, and suggested his sitter's profound intellect. Details such as the indentation by the side of Jefferson's jutting chin, his smile, and the slight

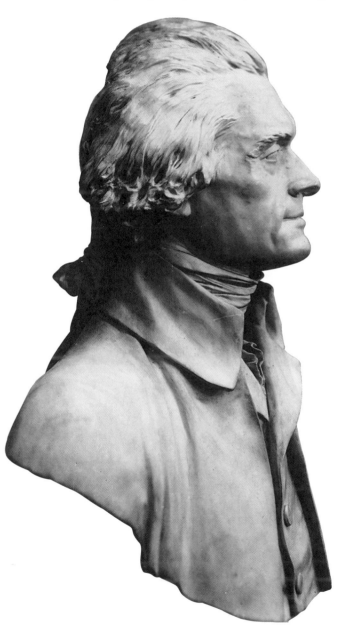

20.16 Jean-Antoine Houdon, *Thomas Jefferson*, 1789. Marble, 21½ in (54.6 cm) high. Library of Congress, Washington, D.C. Jefferson was a member of the Continental Congress of 1775–6 and was principally responsible for drafting the Declaration of Independence. He was governor of Virginia 1779–81, U.S. minister in France 1785–9, secretary of state under George Washington 1789–93, vice-president 1796–1801, and president 1801–9.

John Trumbull's *Declaration of Independence*

In 1817, President James Madison commissioned John Trumbull to paint four pictures illustrating American Independence for the Rotunda of the Capitol building in Washington, D.C. One of these was *The Declaration of Independence* (fig. **20.17**). The Declaration was a product of Enlightenment philosophy and of the belief that reason could impose an intelligent order on human society. According to Trumbull's autobiography, he was given advice on the composition by Jefferson himself.

All the signers are present in the painting, in which the solemn dignity of the occasion is portrayed. Formally, it is a construction of rectangular space, with simple doors and an unadorned Doric frieze. The furniture is austere, and the figures wear plain, contemporary American dress.

Contrasting with the overall austerity are the sweeping—and slightly more colorful—diagonals of the flags and the drum on the far wall. These refer to the battles that had made it possible to achieve the aims of the Declaration. Visually, the flags unite the long diagonal of mostly seated figures at the left with the central group in front of the desk, and the seated figures at the right. The tallest figure, distinguished by a long red vest, is Jefferson. He hands a copy of the Declaration to John Hancock of Massachusetts. Standing to Jefferson's left is the stocky Benjamin Franklin of Pennsylvania, and at the left in the foreground is John Adams of Massachusetts. Between Adams and Jefferson are Roger Sherman and Robert Livingston, both of New York.

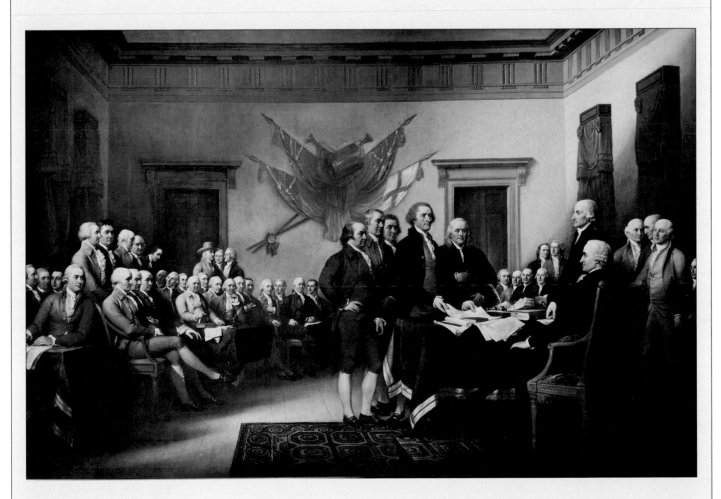

20.17 John Trumbull, *The Declaration of Independence*, 1818. Oil on canvas, 12 × 18 ft (3.66 × 5.49 m). U.S. Capitol Rotunda, Washington, D.C. Trumbull came from a Calvinist family of Connecticut. He fought in the Revolution, and was educated at Harvard. In 1780 he went to London and studied with Benjamin West, who influenced his history paintings. He also painted many portraits.

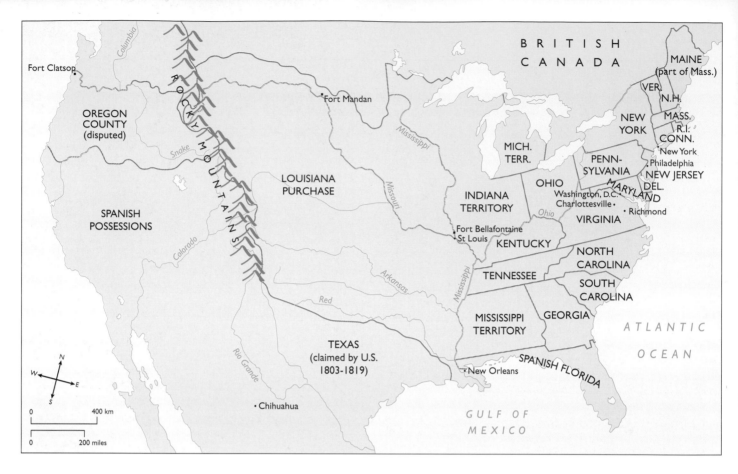

20.18 Map of the United States during Jefferson's presidency, c. 1803.

furrow of his brow, convey the impression of a composed, thoughtful individual. The portrait bust itself was a type of sculpture derived from ancient Rome, and therefore further reflects the Neoclassical tastes of both Houdon and Jefferson.

Jefferson's views on contemporary architecture also reveal his Classical education and humanist outlook. Although Jefferson was a native of Virginia, which was then the wealthiest and most populous of the states (fig. **20.18**), he disliked the houses of Virginia, and wrote that they were "very rarely constructed of stone and brick ... It is impossible to devise things more ugly, uncomfortable, and happily more perishable." He described the buildings of colonial Williamsburg, which he knew from his student days at the College of William and Mary, as "rude, mis-shapen piles, which, but that they have roofs, would be taken for brick-kilns."[1] In addition to his other accomplishments, Jefferson studied Classical and Palladian architectural theory, and owned the first copy of Palladio's *Four Books on Architecture* in America. His work as an architect produced three of the finest Neoclassical buildings in America.

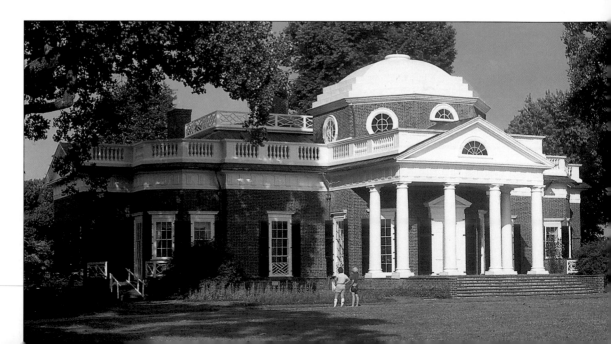

20.19 Thomas Jefferson, Monticello, near Charlottesville, Virginia, 1769–84 (rebuilt 1794–1809).

Jefferson began construction on his own home, Monticello (Italian for "Little Mountain"), in 1769 (fig. **20.19**). It is located on a hilltop outside Charlottesville, Virginia. Jefferson designed Monticello himself and, despite frequent absences, supervised its construction over a period of more than forty years. The house was planned and built in two distinct stages. At first (1769–84) it was designed as a building with a double **portico**, two stories high. On the east façade, a second-story Ionic Order was to be superimposed on a ground-floor Doric, a concept which Jefferson borrowed from Palladio. In the event, this striking feature was never completed and was superseded in the subsequent design.

During his time in France, Jefferson had a chance to study at first hand what he had previously known only from books. He became familiar with the elegant Paris *hôtels* and other French Neoclassical architecture of the period. He also visited the remains of the Roman occupation of Gaul, and saw the so-called Maison Carrée at Nîmes in southern France. This was a small, well-preserved Roman temple, similar to the temple of Portunus (see Vol. I, fig. 8.26). Jefferson used it as the model for a new State Capitol of Virginia in Richmond. Figure **20.20** shows the projecting Ionic portico, surmounted by a Classical pediment.

In 1789, Jefferson returned to America with new plans for enlarging and remodelling Monticello, which he began to put into effect in 1794, soon after his resignation as Secretary of State. Since Palladio's most admired designs had

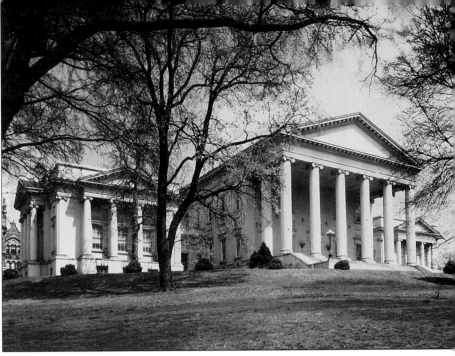

20.20 Thomas Jefferson, State Capitol, Richmond, Virginia, 1785–9.

a single story, Jefferson decided that he too wanted a house that would appear to be one-story. The final result was a building that seemed to have only one, high-ceilinged floor. In fact, however, the entablature and balustrade conceal a second and a third floor, both containing bedrooms. The windows for these rooms are near floor level, and on the east façade they look from the outside like the top sashes of the ground-floor windows.

The remodelling of the ground floor can be seen from the plan (fig. **20.21**), where the shaded areas represent the old floor plan. The new plan, which is more than twice the size of the old, includes a large entrance hall with a gallery, a suite of rooms (bedroom, library, and study) on the south side of the house for Jefferson's personal use, and a corresponding set of public rooms on the north side. The house itself is connected to two small pavilions by a wooden boardwalk. Located underneath the boardwalk, and below the level of the lawn, were the service areas of the house—the kitchen, cellar, icehouse, stables, and so forth. The symmetry of these side extensions, or "dependencies" as they were called, is another feature that Jefferson borowed from Palladio's country estates. Jefferson's design for Monticello, in particular the dome and the two entrances, was also influenced by that of Chiswick House (see fig. 19.21).

Monticello's individual rooms, its dome, and central drum are octagons, which was a favorite shape of Jefferson's. The octagon tended to broaden the corners of a building, and expand the interior spaces. Roman influence is evident in the dome and east portico, which is colonnaded in the Doric Order. Just as republican Rome represented Jefferson's political ideal, so Monticello fulfilled the Classical ideal which he missed in the previous domestic architecture of colonial America.

The pride and joy of Jefferson's later years was the University of Virginia, the first state-supported educational establishment, located just a few miles from Monticello. Its

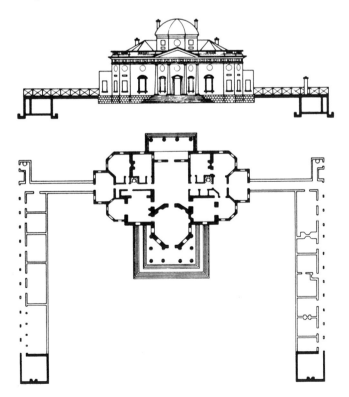

20.21 Plan and elevation of Monticello. (From W. Blaser)

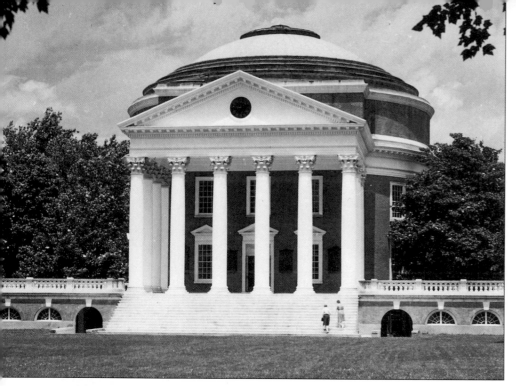

20.22 Thomas Jefferson, Rotunda, University of Virginia, Charlottesville, 1817–26. Jefferson was the first rector of the university and described himself on his tombstone as "Father of the University." Both the curriculum and the architectural conception were a tribute to Jeffersonian humanist principles. In the quality of its individual parts and the harmony of the whole environment, Jefferson's "academical village," as he called it, is a masterpiece of the Federal style.

centerpiece is the Rotunda (figs. **20.22** and **20.23**), which served as the original university library. Although its proportions are somewhat taller, its inspiration is clearly the Pantheon in Rome (see Vol. I, fig. 8.30). Among the purely Jeffersonian features are an entablature encircling the building and two layers of windows (pedimented on the ground floor, plain on the second).

On either side of the Rotunda, framing the central lawn, are two symmetrical rows of low, colonnaded buildings, which were (and still are) student quarters. These link a series of pavilions, built in the form of Roman temples. Each pavilion faithfully reproduces an architectural order according to a Classical prototype. The pavilions also housed the academic departments, with classrooms on the ground floor and living quarters for the professors on the upper floor.

Greenough's *George Washington*

Shortly after the University of Virginia was completed, the United States Congress decided to erect a statue to

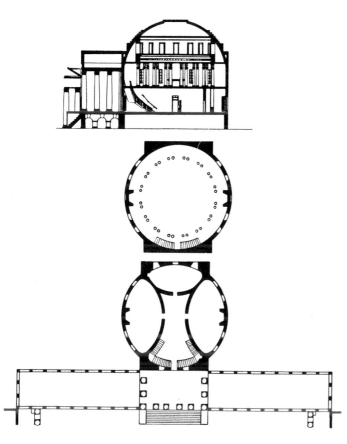

20.23 Thomas Jefferson, plan and section of the Rotunda, University of Virginia, Charlottesville. (From W. Blaser)

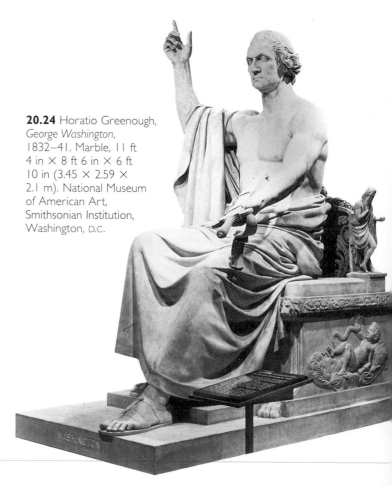

20.24 Horatio Greenough, *George Washington*, 1832–41. Marble, 11 ft 4 in × 8 ft 6 in × 6 ft 10 in (3.45 × 2.59 × 2.1 m). National Museum of American Art, Smithsonian Institution, Washington, D.C.

commemorate George Washington in a grand manner. In 1832, the commission was given to Horatio Greenough (1805–52), America's first professional sculptor, then living in Italy. The colossal marble statue that he produced (fig. **20.24**) was inspired by Phidias's Early Classical sculpture of Zeus in the temple at Olympia (see Vol. I, fig. 6.35). Although this work, one of the Seven Wonders of the ancient world, was lost, it was known from ancient descriptions and from representations on coins. The imposing presence, monumental scale, and grand gestures of the *Washington* also have a Romantic quality. Nude from the waist up, the figure points upwards in the manner of David's Socrates (see fig. 20.4) and Raphael's Plato (see fig. 15.39). The left hand, extending forward and holding a sword, repeats the movement of the left leg. The statue embodies the various guises of Washington—

man of action, political philosopher, ruler, and general. A frontal pose and imposing presence, combined with a lion throne, create the impression of a powerful leader. Unfortunately, the statue did not reach America until 1841, by which time tastes had changed. The Neoclassical style was no longer in fashion, and the statue was criticized for its partial nudity. It was placed outside the Capitol building in Washington, D.C., where it began to erode; today it sits unceremoniously inside the rotunda of the National Museum of American Art, part of the Smithsonian Institution.

In the United States, as in western Europe, the purity of Neoclassicism gave way to Romanticism. In its own way, the Romantic movement, like the Neoclassical, had political, cultural, and literary significance, much of which is reflected in the visual arts.

Style/Period	Works of Art	Cultural/Historical Developments
NEOCLASSICAL 1730–1800 Jefferson, Monticello	Jefferson, Monticello (**20.19**), Charlottesville Clodion, *The Intoxication of Wine* (**20.1**) Jefferson, State Capitol, Richmond (**20.20**) Canova, *Cupid and Psyche* (**20.2**) David, *The Oath of the Horatii* (**20.3**) David, *The Death of Socrates* (**20.4**) Houdon, *Thomas Jefferson* (**20.16**) David, *The Death of Marat* (**20.5**) David, *The Death of Marat*	Lord Burlington promotes Neoclassical architecture in England (1725–50) James Watt perfects invention of the steam engine (1775) American Declaration of Independence (1776) American Revolutionary War (1776–84) Gibbon, *Decline and Fall of the Roman Empire* (1776–87) French Revolution begins (1789) Thomas Paine, *The Rights of Man* (1790) Mozart, *The Magic Flute* (1790)
1800–1810 David, *Napolean at Saint Bernard Pass*	Benoist, *Portrait of a Negress* (**20.11**) David, *Napoleon at Saint Bernard Pass* (**20.7**) Ingres, *Madame Rivière* (**20.12**) Ingres, *Napoleon Enthroned* (**20.13**) Chalgrin et al., Arc de Triomphe (**20.8**), Paris Canova, *Maria Paolina Borghese as Venus* (**20.10**) Ingres, *Oedipus and the Sphinx* (**20.14**) Percier and Fontaine, Place Vendôme Column (**20.9**), Paris	Thomas Jefferson negotiates Louisiana Purchase (1803) Expedition to the Pacific Coast by Lewis and Clark (1803–6) Napoleon proclaimed Emperor of France (1804) Beethoven, the Eroica Symphony (1804) Nelson defeats French fleet at Trafalgar (1805)
1810–1840 Jefferson, Rotunda, University of Virginia	Ingres, *Grande Odalisque* (**20.15**) Jefferson, Rotunda, University of Virginia (**20.22**), Charlottesville Trumbull, *The Declaration of Independence* (**20.17**) Greenough, *George Washington* (**20.24**) Ingres, *Grande Odalisque*	Goethe, *Faust* (1808–32) Napoleon retreats from Russia (1812) Lord Elgin brings sculptures from Parthenon to England (1812) Jane Austen, *Pride and Prejudice* (1813) Stephenson's first steam locomotive (1814) Congress of Vienna (1814–15) Napoleon defeated at Waterloo; exiled to Saint Helena (1815) University of Virginia founded by Thomas Jefferson (1817) Greece declares independence from Turkey (1822) James Fenimore Cooper, *The Last of the Mohicans* (1826) Alexandre Dumas, *The Three Musketeers* (1828) July Revolution; Louis Philippe King of France (1830) Stendhal, *The Red and The Black* (1830) Alfred Lord Tennyson, *The Lady of Shalott* (1832) Honoré de Balzac, *La Comédie Humaine* (1832–50) Charles Dickens, *Oliver Twist* (1838)

1730 / 1800 / 1810 / 1840

<div align="center">

21

</div>

Romanticism: The Late Eighteenth and Early Nineteenth Centuries

The Romantic Movement

The Romantic movement, like Neoclassicism, swept through both western Europe and the United States. The term "Romantic" is derived from the Romance languages (French, Italian, Spanish, Portuguese, and Rumanian), and more particularly from the medieval tales of chivalry and adventure written in those languages, such as the *Chanson de Roland* (Song of Roland). Romantic literature shares with the so-called "Gothic" novels and poems by English writers of the late eighteenth and early nineteenth centuries a nostalgia for the past, which contributes to its haunting character. The Romantic esthetic of "long ago" and "far away" is conveyed in works with locales and settings that indicate the passage of time, such as ruined buildings and broken sculptures. To the extent that Neoclassicism expresses a nostalgia for antiquity, it too may be said to have a "Romantic" quality.

Whereas Neoclassicism has its roots in antiquity, the origins of Romanticism are no older than the eighteenth century. They can be found especially in the work of the French philosopher Jean Jacques Rousseau (see Box). The effect of the Romantic movement on early nineteenth-century culture is evident not only in the visual arts, but also in politics, social philosophy, music, and literature (see Box). These different fields were more closely interrelated in the Romantic period than they had been previously.

It is impossible to assign precise dates to the Romantic movement. Historians generally agree, however, that the *Lyrical Ballads* of Wordsworth and Coleridge, which were published in 1798, are a seminal work, that the July Revolution of 1830 in France (see Box) marks the high point in Romantic influence on politics, and that by 1848 enthusiasm for Romanticism was in decline.

Romanticism comprised a wide range of subject-matter, which offered more thematic possibilities than Neoclassicism. In contrast to the Neoclassical virtues of order and clarity, the Romantics believed in emotional expression and sentiment, and instead of encouraging heroism on behalf of an abstract ideal in the Neoclassical manner, the Romantics were often partisan supporters of contemporary causes, such as the individual's struggle against the state.

Chronology of Events in France

1814 Napoleon abdicates and the Bourbon monarchy is restored under Louis XVII (the Restoration).

1824 Charles X becomes King of France.

1830 The July Revolution. The Bourbons are overthrown and Louis Philippe becomes "citizen-king" with limited powers. More citizens are given the right to vote for the legislature.

1848 The February Revolution. Louis Philippe is overthrown and the Second Republic begins. Napoleon's nephew, Louis Napoleon, is elected President.

1852 Louis Napoleon is proclaimed Emperor (Napoleon III); the Second Empire begins.

1870 Louis Napoleon abdicates following France's defeat in the Franco-Prussian War; the Third Republic begins.

Rousseau and the Return to Nature

Jean Jacques Rousseau (1712–78) was a leading eighteenth-century French philosopher. His writings inspired the French Revolution, and also provided the philosophical underpinning of the Romantic movement. The artists and writers who subscribed to Rousseau's views are known as the "Romantics." Rousseau advocated a "return to nature." He believed in the concept of the "noble savage"—that humanity was born to live harmoniously with nature, free from vice, but had been corrupted by civilization and progress. Such ideas led to the political belief that the people themselves should rule. In his fiction, Rousseau created elaborate descriptions of natural beauty which were consistent with the Romantic esthetic.

In addition to their nostalgia for the past, and willingness to become active participants in current events, the Romantics developed an interest in the mind as the site of mysterious, unexplained, and possibly dangerous phenomena. For the first time in Western art, dreams and nightmares were depicted as internal events, with their source in the individual imagination, rather than as external, supernatural happenings. States of mind, including insanity, began to interest artists, whose studies anticipated Freud's theories of psychoanalysis at the end of the nineteenth century and the development of modern psychology in the twentieth.

Architecture

In architecture, the Romantic movement was marked by revivals of historical styles. The Gothic revival had begun in the late eighteenth century with such buildings as Horace Walpole's Strawberry Hill (see fig. 19.24) evoking the English past. Likewise, the Neoclassicism of Jefferson was a revival of ancient Greek and Roman forms, which were ideologically appropriate for a newly founded democracy.

The first important nineteenth-century public buildings in the Gothic style were the new Houses of Parliament in

Romanticism in Music and Poetry

The various strains of Romanticism that are evident in the visual arts are also found in nineteenth-century music and poetry. In Romantic music, the expression of mood and feeling takes precedence over form and structure. Its antithesis is classical music, in which classical form and proportion predominate over emotional expression.

Romantic music was often based on literary themes, and literary or geographical references evoked various moods. Some of Hector Berlioz's overtures, for example, are based on Sir Walter Scott's historical novels, which are set in the Middle Ages. Felix Mendelssohn's "Italian" and "Scottish" Symphonies are based on the composer's travels in Italy and Scotland. The Polish mazurkas of Frédéric Chopin and the Hungarian rhapsodies of Franz Liszt reflect the strong nationalistic strains of Romanticism. In opera, the emotional and nationalistic intensity of the Romantic movement found its fullest expression in the works of Richard Wagner.

In English poetry, the leaders of Romanticism were William Wordsworth (1770–1850) and Samuel Taylor Coleridge (1772–1834). In 1798 they jointly published a collection of poems, *Lyrical Ballads*, the introduction to which served as a manifesto for the English Romantics.

Wordsworth's "The Solitary Reaper" conveys a sense of the melancholy oneness of humanity with an all-encompassing nature. The reaper is alone in a vast expanse of land when seen by the poet:

> Behold her, single in the field,
> Yon solitary Highland Lass!
> Reaping and singing by herself;
> Stop here, or gently pass!
> Alone she cuts and binds the grain,
> And sings a melancholy strain;
> O listen! for the Vale profound
> Is overflowing with the sound. (Stanza I)

Other English poets of the Romantic movement included Lord Byron (1788–1824), Percy Bysshe Shelley (1792–1822), and John Keats (1795–1821). Byron's nostalgic yearning for ancient Greece is evident in much of his poetry:

> The isles of Greece, the isles of Greece!
> Where burning Sappho loved and sung,
> Where grew the arts of war and peace,
> Where Delos rose, and Phoebus sprung!
> Eternal summer gilds them yet,
> But all, except their sun, is set. ("Don Juan" III, lxxxvi)

Shelley's "Ozymandias" evokes the attraction of exotic locales and explores our ability to communicate with the past through time-worn artifacts:

> I met a traveller from an antique land
> Who said: "Two vast and trunkless legs of stone
> Stand in the desert ..."
> And on the pedestal these words appear:
> "My name is Ozymandias, king of kings:
> Look on my works, ye Mighty, and despair!"
> Nothing beside remains. Round the decay
> Of that colossal wreck, boundless and bare
> The lone and level sands stretch far away.

In 1819 Shelley visited the Uffizi Gallery in Florence, where he saw a painting of Medusa's head, then attributed to Leonardo da Vinci. The head lies on the ground, crawling with lizards, insects, and snakes. Shelley's poem expresses the Romantic taste for the macabre, the appeal of death, and the theme of the aloof, unattainable woman:

> It lieth, gazing on the midnight sky,
> Upon the cloudy mountain-peak supine;
> Below, far lands are seen tremblingly;
> Its horror and its beauty are divine.
> ("On the Medusa of Leonardo da Vinci in the
> Florentine Gallery," lines 1–4)

The aloof and unattainable woman, seen by the Romantics as cold and deathlike but nevertheless fascinating, is celebrated with a medieval flavor in Keats's "La Belle Dame sans Merci:"

> I saw pale kings and princes too,
> Pale warriors, death-pale were they all;
> They cried—"La Belle Dame sans Merci
> Hath thee in thrall!" (lines 38–41)

21.1 Sir Charles Barry and Augustus W. N. Pugin, Houses of Parliament, London, 1836–70. The competition for this commission was won by Sir Charles Barry (1795–1860), one of the most established English architects. His collaborator was Augustus Pugin (1812–52), who was responsible for the decoration and details. A Catholic convert and almost a cult figure in early Victorian England, Pugin was the most vocal crusader for the Gothic style; he proclaimed its moral and religious superiority as the "only correct expression of the faith, wants, and climate" of England. In his book *Contrasts*, Pugin discusses architecture as a reflection of its society, and in *The True Principles of Pointed or Christian Architecture* he wrote that architecture should be judged by the highest standards of Christian morality.

London (fig. **21.1**). These were constructed from 1836 to 1870 to replace the old Palace of Westminster, which had been destroyed by fire in 1834 (see fig. 21.21). There was considerable debate over whether the new Houses should be in the Classical or the Gothic style. In the end, Gothic prevailed, because it was regarded as both the national style and the more Christian style. In addition, it would stand as a reminder that the parliamentary system of government had been established in the Middle Ages.

The result was a functional building with Gothic decoration and fixtures, but which retained formal symmetry. (The overall result reportedly disappointed the designer, Augustus Pugin, who thought it too "Greek.") Despite the strong vertical accent of the Victoria Tower in the southwest corner and the clock-tower of Big Ben at the north, the Houses of Parliament lack the soaring quality of the Gothic cathedrals. Instead, when seen from a distance they give an impression of low horizontality.

Architects in America as well as Europe were influenced by the Gothic revival. Richard Upjohn (1802–78), an English immigrant to America, built over forty Gothic revival churches. He is best known for Trinity Church, which he built in the pure Perpendicular Gothic style, at the intersection of Wall Street and Broadway in New York City (fig. **21.2**). Its vaulting is of plaster, and the rest of the construction is stone. The deep chancel and elevated altar reflected the liturgical views of the High Church Anglican, or Episcopalian, movement, to which Upjohn belonged.

21.2 Richard Upjohn, Trinity Church, New York, 1841–52.

Trinity Church served a wealthy, urban parish, but Upjohn also designed churches built entirely of timber for poorer, rural communities. *Upjohn's Rural Architecture*, published in 1852, was an illustrated handbook for the construction of inexpensive churches, chapels, and houses. These were largely of wood and provided the origin of the term "carpenter's Gothic."

In addition to revivals of historical styles, some Romantic architects based their work on visions of exotic foreign buildings. The Far East had become a particularly rich source for such visions in the eighteenth century, such as the Kew Gardens Pagoda (see fig. 19.2). In 1815 the Prince Regent (later to become George IV of England) commissioned the expansion and remodelling of the Royal Pavilion (fig. **21.3**) at Brighton, a fashionable seaside resort on the south coast. The architect, John Nash (1752–1835), used the so-called Indian Gothic style, which was borrowed from Islamic architecture. Its mixture of minarets and onion domes, constructed over a cast-iron framework, is reminiscent of the Taj Mahal (see fig. 18.38). The interior decoration of the Royal Pavilion was also inspired by oriental forms. Similar Eastern elements attracted the nineteenth-century poet Coleridge, whose "Kubla Khan" had appeared in the *Lyrical Ballads*. It incorporated the exotic sounds of faraway places and the Romantic taste for endless time and infinite space:

> In Xanadu did Kubla Khan
> A stately pleasure-dome decree;
> Where Alph, the sacred river, ran
> Through caverns measureless to man
> Down to a sunless sea. (lines 1–5)

Sculpture

Romantic sculptors were generally less prominent than poets, painters, and architects. One of the finer examples of sculpture inspired by Romantic ideals is François Rude's (1784–1855) stone relief of 1833–6 (fig. **21.4**). Originally titled *The Departure of the Volunteers of 1792*, it is commonly known as *La Marseillaise* and was one of four reliefs added to the Arc de Triomphe in Paris (see fig. 20.8). Twenty-five years had passed since Napoleon commissioned the arch. Its original purpose had been to commemorate his military successes, but in the intervening period the political mood had changed and *La Marseillaise* conveys a rather different political message.

The relief shows a group of volunteers answering the call to arms in defense of France against foreign enemies. They seem caught up in the "romance" of their enthusiasm, as the rhythmic energy of their motion echoes the imaginary beat of military music (see caption). Rude's soldiers range from youths to old men, who are either nude or equipped with Classical armor. But unlike the sedate, ordered, and individualized world of Neoclassical patriotism (see p. 703), Rude's volunteers seem carried away by the force of the crowd. Vigorously striding above the volunteers, and driving them on, is an allegory of Liberty. She is a nineteenth-century revolutionary version of the traditional winged Victory (cf. Vol. I, fig. 6.71).

21.3 John Nash, Royal Pavilion, Brighton, England, 1815–18. Nash had to leave London because of bankruptcy in 1793. By the end of the decade, his affairs were in order, and he returned to become a member of the Prince Regent's circle. He then made a fortune in real estate, especially from the development of Regent's Park and Regent Street, named after the title of his royal patron.

21.4 François Rude, *The Departure of the Vounteers of 1792* (*La Marseillaise*), 1833–6. Limestone, approx. 42 ft (12.8 m) high. Arc de Triomphe, Paris. The "Marseillaise," the French national anthem, was composed in 1792 by an army officer called Rouget de Lisle. Volunteers from the port of Marseille, who led the storming of the Tuilleries, brought the song to Paris.

Watercolor

In **watercolor**, powdered pigments are mixed with water, often with gum arabic used as a **binder** and drying agent. Watercolor is transparent, and so one color overlaid on another can create a **wash** effect. The most common **ground** for watercolor is paper. Because the medium is transparent, the natural color of the paper also contributes to the image.

Watercolor had been known in China as early as the third century A.D., but was only occasionally used in Europe before the late eighteenth and early nineteenth centuries. At that point it became popular, particularly with English artists such as Constable and Turner, for landscape paintings on a small scale. In the second half of the nineteenth century, watercolor also became popular among American artists. It was favored by those who preferred to paint directly from nature rather than in a studio, and needed a more portable, quickly drying medium.

Gouache is a watercolor paint which, when dry, becomes opaque. It is commonly used on its own or in combination with transparent watercolor.

Figural Painting

William Blake

There was a strong Christian strain in Romanticism. This was associated with the longing for a form of religious mysticism, which, from the Reformation onward, had been on the wane in western Europe. This longing can be seen in the work of the English visionary artist and poet William Blake (1757–1827). Though trained in the Neoclassical style, he was more of a Romantic by temperament.

From 1793 to 1796 Blake illuminated a group of so-called *Prophetic Books* dealing with visionary biblical themes. His watercolor and gouache (see Box) design of *God Creating the Universe* (fig. **21.5**), also called the The *Ancient of Days*, shows God organizing the world with

21.5 William Blake, *God Creating the Universe* (*Ancient of Days*), frontispiece of *Europe: A Prophecy*, 1794. Metal relief etching, hand-colored with watercolor and gouache, 12¼ × 9½ in (31.1 × 24.1 cm). British Museum, London. Blake was an engraver, painter, and poet, whose work was little known until about a century after his death. In this image, Blake's God is almost entirely enclosed in a circle. The light extending from each side of his hand forms the arms of a compass. The precision of the circle and triangle contrasts with the looser painting of clouds and light, and the frenetic quality of God's long, white hair, blown sideways by an unseen wind.

21.6 Théodore Géricault, sketch for the *Charging Cuirassier*, 1812. Oil on canvas, 9 ft 7 in × 6 ft 4½ in (2.9 × 1.9 m). Musée des Beaux-Arts, Rouen. Géricault grew up in Napoleonic France. He admired the soldiers, especially the cavaliers, who fought with Napoleon. He himself was an avid rider; his death in 1824 was due to a fall from his horse. A comparison of this study with David's *Napoleon at Saint Bernard Pass* (see fig. 20.7), which also glorifies equestrian courage, shows the difference between the idealized clarity of Neoclassicism and the energetic textures of Romanticism.

a compass (cf. fig. 1.4; 1.6 in the Combined Volume). Blake's nostalgic combination of medieval iconography and a Michelangelo-style God with a revival of mysticism is characteristic of the Romantic movement. His passionate yearning for a past (and largely imaginary) form of Christianity appears in his poems as well as in his pictures. It is exemplified by the opening lines of his hymn "Jerusalem:"

> And did those feet in ancient time
> Walk upon England's mountains green?
> And was the holy Lamb of God
> On England's pleasant pastures seen?

Théodore Géricault

Théodore Géricault (1791–1824) died at the age of only thirty-three, but his work was crucial to the development of Romantic painting, especially in France. His

sketch for the *Charging Cuirassier* (fig. **21.6**), exhibited in 1812, when Gericault was only twenty-one, shows the early expression of his prodigious talent. It is a *tour de force* illustrating the Romantic theme of man against nature. The officer turns sharply as he tries to control the rearing charger, on which he depends for his life. The turbulent sky, and the indications of battle in the distance, enhance the dramatic effect of the scene. Thick, impasto patches of paint add to the motion created by the vigorous diagonals, and the variety of surface textures. Géricault has synthesized the energetic character of the medium with his subject-matter. As an image of a lone man, battling the forces of nature, this work typifies the Romantic esthetic.

Géricault's scientific interest in human psychology is evident in his studies of the insane, which he executed from 1822 to 1823. In these works he captured the mental disturbance of his subjects through pose and physiognomy. In the *Mad Woman with a Mania of Envy* (fig. **21.7**),

21.7 Théodore Géricault, *Mad Woman with a Mania of Envy*, 1822–3. Oil on canvas, 28⅜ × 22⅘ in (72 × 58 cm). Musée des Beaux-Arts, Lyons. Géricault was a man of paradoxes—a fashionable society figure, but a political and social liberal, who was active in exposing injustice. The subject of this portrait, which is also known as *L'Hyène de la Salpêtrière*, was a child-murderess. La Salpêtrière was a mental hospital in Paris where Freud studied under the celebrated neuropathologist Jean-Martin Charcot and learned that hypnosis could temporarily relieve the symptoms of hysteria.

for example, the figure hunches forward and stares suspiciously off to the left, as if aware of some potential menace. The raising of one eyebrow and the lowering of the other, combined with the slight shift in the planes of her face, indicate the wariness of paranoia.

Géricault's loose brushstrokes create the textures of the woman's face, which is accentuated by light and framed by the ruffle of her cap. By virtue of the conscious organization of light, color, and the visibility of his brushwork, Géricault unifies the composition both formally and psychologically. The sweeping, light brown curve below the collar echoes the more tightly drawn curve of the mouth. Reds around the eyes and mouth are repeated in the collar, and the white of the cap ruffle recurs in the small triangle of the white undergarment. The untied cap laces and the few dishevelled strands of her hair are a subtle metaphor for the woman's emotional

state, as if she is "coming apart" and "unravelling" physically as well as mentally.

Géricault used the cause of social justice in the service of Romanticism in his acknowledged masterpiece, *The Raft of the "Medusa"* (fig. **21.8**), which he began in 1818

The Salon

The Salon refers to the official art exhibitions sponsored by the French authorities. The term is derived from the Salon d'Apollon in the Louvre Palace. It was here, in 1667, that Louis XIV sponsored an exhibition of works by members of the Académie Royale de Peinture et de Sculpture (Royal Academy of Painting and Sculpture). From 1737 the Salon was an annual event, and in 1748 selection by jury was introduced. Throughout the eighteenth century, the Salons were the only important exhibitions at which works of art could be shown. This made acceptance by the Salon jury crucial to an artist's career.

During the eighteenth century the influence of the Salon was largely beneficial and progressive. By the nineteenth century, however, despite the fact that during the Revolution the Salon was officially opened to all French artists, it was in effect controlled by Academicians, whose conservative taste resisted innovation of any sort.

21.8 Théodore Géricault, *The Raft of the "Medusa,"* 1819. Oil on canvas, 16 ft × 23 ft 6 in (4.88 × 7.16 m). Louvre, Paris. The mood of this painting is evoked by lines from "The Rime of the Ancient Mariner" by Coleridge, the English Romantic poet: "I looked upon the rotting deck and there the dead men lay." To ensure authenticity, Géricault spoke with survivors and made studies of the dead and dying in morgues and hospitals before executing the final painting.

21.9 Eugène Delacroix, *The Bark of Dante*, 1822. Oil on canvas, 6 ft 2⅞ in × 8 ft ⅞ in (1.88 × 2.46 m). Louvre, Paris.

and exhibited at the Salon (see Box) the following year. This picture commemorates a contemporary disaster at sea rather than a heroic example of Neoclassical patriotism. On July 2, 1816 the French frigate *Medusa* hit a reef off the west coast of Africa. The captain and senior officers boarded six lifeboats, saving themselves and some of the passengers. The 149 remaining passengers and crew were crammed on to a wooden raft, which the captain cut loose from a lifeboat. During the thirteen-day voyage that followed, the raft became a floating hell of death, disease, mutiny, starvation, and cannibalism. Only fifteen people survived.

The episode became a national scandal when it was discovered that the ship's captain owed his appointment to his monarchist sympathies rather than to merit. Furthermore, the French government had tried to cover up the worst details of the incident. It was not until the ship's surgeon, one of the survivors from the raft, published his account of the disaster that the full extent of the tragedy became known. Géricault took up the cause of the individuals against social injustice and translated it into a struggle of humanity against the elements.

The writhing forms, which are reminiscent of Michelangelo's Sistine Chapel figures in the scene of the Flood, echo the turbulence of sea and sky. In the foreground a father mourns his dead son. Other corpses hang over the edge of the raft, while in the background, to the right, frantic survivors wave hopefully at a distant ship. The raft itself tilts upward on the swell of a wave, and the sail billows in the wind. As a result, the viewer looks down on the raft, directly confronting the corpses. The gaze gradually moves upward, following the diagonals of the central figures, and finally reaches the waving drapery of the man standing upright. In this painting Géricault incorporates the Romantic taste for adventure and

individual freedom into an actual event, in which victims of injustice fight to survive the primal forces of nature.

Eugène Delacroix

The most prominent figure in French Romantic painting was Eugène Delacroix (1798–1863), who outlived Géricault by nearly forty years. Delacroix was rumored to be the illegitimate son of the French statesman Charles Talleyrand (whom he resembled physically), but he was brought up in the family of a French government official. His celebrated *Journal*, which reveals his talent for writing, is a useful source of information on the social context of his life, as well as on his philosophy of art.

In painting, Delacroix stood for color just as Ingres, his contemporary and rival, championed line. In this theoretical opposition, Delacroix and Ingres transformed the traditional esthetic quarrel between *colorito* and *disegno*, the Rubenists and the Poussinists, the Moderns and the Ancients, into Romanticism versus Classicism. Delacroix's paintings are characterized by broad sweeps of color, lively patterns, and energetic figural groups. His thick brushstrokes, like Géricault's, contribute to the character of the image as well as to the surface textures of the canvas. They are in direct contrast to the precise edges and smooth surfaces of Neoclassical painting. Just as in literature Delacroix's contemporary, Victor Hugo (see Box on p. 724), broke with the classically inspired rules of seventeenth-century French drama, so Delacroix continued and developed Géricault's taste for emotional expression, a wider range of textures, and freer outlines.

In an early work, *The Bark of Dante* (fig. **21.9**), exhibited in 1822, Delacroix reflects the Romantic revival of interest in Dante's *Inferno* (see p. 452). Dante and his guide Virgil are in the lake around the infernal city of Dis, the burning

Victor Hugo

Victor Hugo (1802–85), a prolific author of novels, plays, and poems, led the French Romantic movement in literature, especially in the 1820s and 1830s. Since his father was a general in Napoleon's army, his family was on close terms with the Emperor. This gave Hugo an overview of French society, which he chronicled in his novels. He equated artistic with political and social freedom, and championed all three. His novel *Les Misérables* deals with social injustice, and his poem "Written After July 1830"—like Delacroix's *Liberty*—supported the July 1830 Revolution:

> Too long by tyrant hand restrain'd,
> Too long in slavery enchain'd,
> Paris awoke—and in his breast,

Each his ideas at once confest:
"Vainly may despots not essay
To lead a mighty race astray;
True to themselves, the French shall bring
Such treason home unto the king."

Hugo also defended the cause of Greek emancipation from Turkey, which is the subject of Delacroix's *Massacre at Chios*. His play *Hernani*, performed in 1830, led to a quarrel between conservative "Classicists," who favored order, rules, and restraint, and the proponents of a more "Romantic" emotional style. Like the other Romantics, Victor Hugo was drawn to subjective expression, and to exotic, nostalgic, and melancholic themes.

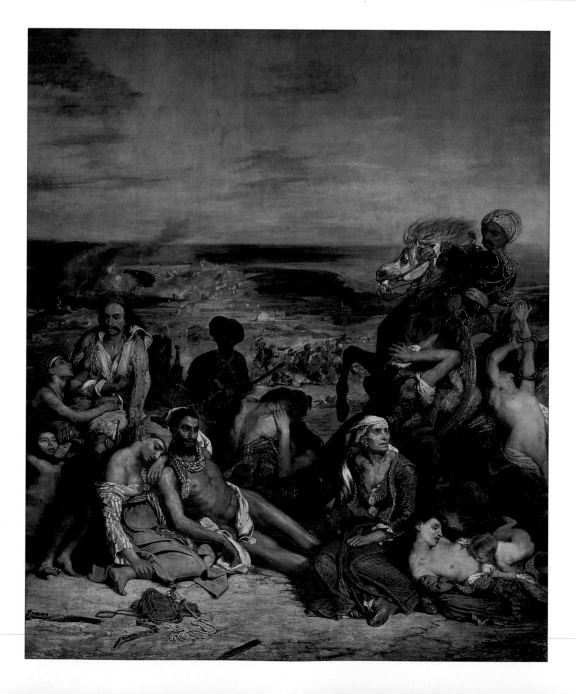

21.10 Eugène Delacroix, *The Massacre at Chios*, 1822–4. Oil on canvas, 13 ft 10 in × 11 ft 7 in (4.22 × 3.53 m). Louvre, Paris.

towers of which are visible in the background. The bark lists precariously as the damned souls rise up from the turbulent water to grasp hold of its sides. At the left, a terrified soul bites into the wooden rim of the boat. Dante reveals his own terror by raising his right hand in alarm to maintain his balance. In contrast, the figure of Virgil, clad in a heavy robe and a Classical laurel wreath, is calm. Leaning over and rendered in back view is Charon, the boatman of Hades.

In *The Massacre at Chios* (fig. **21.10**) of 1822–4, Delacroix satisfied the Romantic taste for distant places and the belief in political freedom. In this he shared the views of Byron (see p. 717), who died in 1824 fighting for Greek independence from Turkey. Delacroix enlists the viewer's sympathy for Greece by showing the suffering and death of its people in the foreground. They are individualized, and thus elicit identification with their plight. At the same time, Delacroix has concentrated attention on the details of their exotic dress. Two Turks—one holding a gun, and the other on a rearing horse—threaten the Greeks, while scenes of burning villages and massacre are depicted in the distance.

Delacroix's *Liberty Leading the People* (fig. **21.11**), executed in 1830, applies Romantic principles to the revolutionary ideal. In contrast to Rude's *Marseillaise* on the Arc de Triomphe (see fig. 21.4), whose figures are in side view, Delacroix's rebels march directly toward the viewer. Delacroix "romanticizes" the uprising by implying that the populace has spontaneously taken up arms, united in yearning for liberty (see caption). The figures emerge from a haze of smoke—a symbol of France's political emergence from the shackles of tyranny to enlightened republicanism. Visible in the distance is the Paris skyline with the towers of Notre-Dame Cathedral. From here the rebels will fly the tricolor (the red, white, and blue French flag).

As in *The Raft of Medusa*, Delacroix's corpses lie in contorted poses in the foreground. The diagonal of the kneeling boy leads upward to Liberty, whose raised hand,

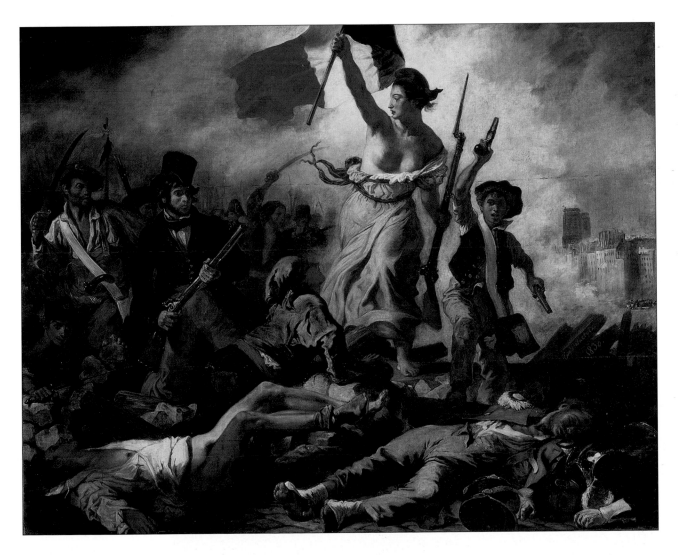

21.11 Eugène Delacroix, *Liberty Leading the People*, 1830. Oil on canvas, 8 ft 6 in × 10 ft 7 in (2.59 × 3.23 m). Louvre, Paris. This painting refers to the July 1830 uprising against the Bourbon king Charles X, which led to his abdication. Louis Philippe, the "citizen-king," was installed in his place, though his powers were strictly limited.

holding the flag aloft, forms the apex of a pyramidal composition. Her Greek profile and bare breasts recall ancient statuary, while her towering form and costume confirm her allegorical role. By incorporating antiquity into his figure of Liberty, Delacroix makes a nostalgic, "Romantic" appeal to Roman republican sentiment. Among Liberty's followers are representatives of different social classes, who are united by their common cause. In their determined march forward, they trample the corpses beneath them. They are willing to die themselves, secure in the knowledge that others will arise to take their place.

A colorist in the tradition of Rubens, Delacroix integrates color with the painting's message. In an image that is primarily composed of brown tones and blacks, the colors that appear most vividly on the flag are repeated with more or less intensity throughout the picture plane. Whites are more freely distributed. In the sky, reds and blues are muted. Denser blues are repeated in the blue stocking of the fallen man at the left and the shirt of the kneeling boy. His scarf and belt, like the small ribbon of the corpse at the right, are accents of red. In echoing the colors of the flag, which is at once a symbol of Liberty and of French republicanism, Delacroix paints a political manifesto.

In 1832, Delacroix traveled to North Africa. The exotic, Moorish character of the region appealed to his Romantic taste. Although he continued to paint scenes of violence, including battles and animal hunts, he was also attracted by more tranquil scenes. A comparison of the *Women of Algiers* (fig. **21.12**) of 1834 with Ingres's *Grande Odalisque* (fig. 20.15) highlights Delacroix's rejection of the precise edges and smooth surface texture of Neoclassicism. His figures are redolent of the exotic, perfumed, and probably drugged harem atmosphere, whereas Ingres' odalisque is alert and clear. In contrast to the three seated harem girls, the black African woman on the right of the Delacroix seems in full possession of her faculties. She turns in a dancelike motion, as if something has caught her attention. The figure on the far left leaning against a large pillow is a Moorish version of the traditional reclining nude. It is quite at odds with the pictorial principles of Ingres' odalisque.

One year before his death in 1863, at the age of sixty-five, Delacroix painted a haunting *Medea* (fig. **21.13**). In Greek mythology, Medea is a sorceress who kills her children because her husband, Jason, has deserted her to marry a princess. Medea's apprehension and the terror of her two children reveal Delacroix's attraction to the same primal forces of insanity that appealed to Géricault. Medea dominates the picture plane—a mythological version of Géricault's *Mad Woman*, who was also a child-murderess. Like Géricault's figure, Medea seems distracted by something outside the picture space. But she is more in control, for she grasps the dagger and restrains her struggling children. The violent, writhing *contrapposto* of all three figures and the picture's dynamic color accentuate the ten-

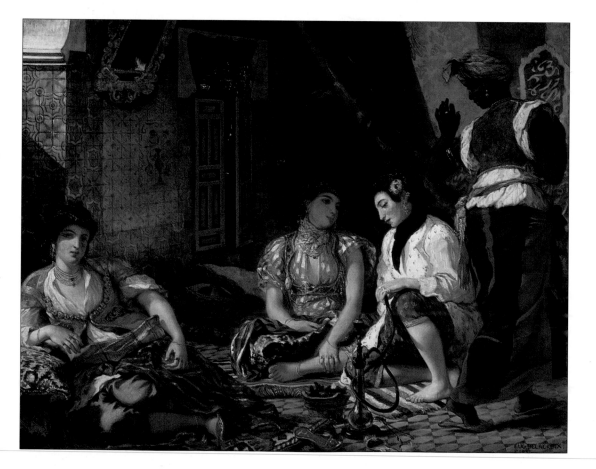

21.12 Eugène Delacroix, *Women of Algiers*, 1834. Oil on canvas, 5 ft 10⅞ in × 7 ft 6⅛ in (1.8 × 2.29 m). Louvre, Paris. After a visit to a harem, Delacroix became fascinated by the lively patterns of Moorish costume and interior decor. Here he combines the relaxed, languorous poses of the harem women with the formal motion of surface design. Throughout the picture plane, the arabesques of Islamic lettering are reflected in pose and gesture, as well as in the designs themselves.

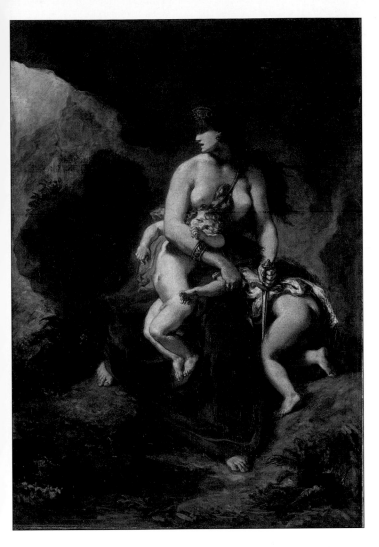

21.13 Eugène Delacroix, *Medea*, 1862. Oil on canvas, 48 × 33¼ in (122.5 × 84.5 cm). Louvre, Paris.

sion of the scene. Delacroix's Medea is the tragic counterpart to Liberty leading the people. Both are barebreasted, and loom up to form the apex of a pyramidal composition.

Francisco de Goya y Lucientes

The leading Spanish painter of the late eighteenth and early nineteenth centuries, Francisco de Goya (1746–1828), was attracted by several Romantic themes. His compelling images reflect his remarkable psychological insights, and many also display his support for the causes of intellectual and political freedom. He enriched his artistic training by studying the works of Rembrandt and Velázquez, both for their painterly techniques and for their genius for penetrating psychological character studies. Goya's affinity for Rembrandt's etchings is evident in his own prolific work in that medium.

In 1799, Goya published *Los Caprichos* (The Caprices), a series of etchings combined with the new medium of aquatint (see Box). In this series, he depicts psychological phenomena, often juxtaposing them with an educational or social message. In Plate 3 (fig. **21.14**), for example, the title of which may be translated as "The Bogeyman is Coming," Goya illustrates the night-time fears of child-

> ### Aquatint
>
> Although etching was not new to the nineteenth century, its use in combination with **aquatint** was. In aquatint, the artist covers the spaces between etched lines with a layer of **rosin** (a form of powdered resin). This partially protects against the effects of the acid bath. Since the rosin is porous, the acid can penetrate to the metal, but the artist controls the acid's effect on the plate by treating the plate with varnish. This technique expands the range of grainy tones in finished prints. Aquatint thus combines the principles of engraving with the effects of a watercolor or wash drawing.

hood. The mother's gaze is riveted on the unseen face of the Bogeyman, while her children cringe in fear. Their terrified faces, contrasted with the anonymity of the apparition, accentuate the uncanny character of the Bogeyman. Goya takes full advantage of the dramatic possibilities of the blacks and whites that are characteristic of the

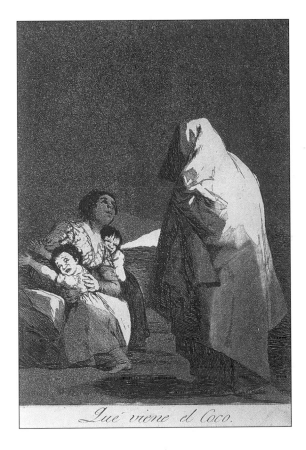

21.14 Francisco de Goya y Lucientes, *Los Caprichos*, Plate 3, published 1799. Etching and aquatint. Metropolitan Museum of Art, New York (Gift of M. Knoedler and Co., 1918). Inscribed on the plate is Goya's warning against instilling needless fears into children: "Bad education. To bring up a child to fear a Bogeyman more than his own father is to make him afraid of something that does not exist."

medium. The Bogeyman's sharply contrasting light and dark—his "dark side" turned toward the children, whose white faces and black features accentuate their terror—is a metaphor for his two-sided nature. An inscription on the plate confirms Goya's enlightened view of child development, consistent with the philosophy of Jean Jacques Rousseau, which was unusual in a country still haunted by the shadow of the Inquisition.

The Witches' Sabbath (fig. **21.15**) of 1798–9 satirizes the irrational belief in witchcraft by exaggerating the primitive quality of such thinking. In this, Goya indirectly attacks the Inquisition, which opposed the principles of

21.15 Francisco de Goya y Lucientes, *The Witches' Sabbath*, 1798–9. Oil on canvas, 17¼ × 12¼ in (44 × 31 cm). Museo Lázaro Galdiano, Madrid.

the Enlightenment. He depicts the widespread fantasy that witches were old, ugly, deformed women, who sucked the blood of children and fed infants to Satan. His witches form a circle around a devil in the guise of a goat, and one witch offers him a bloodless, skeletal infant. The lascivious implications of the goat and the bacchanalian grape leaves on his horns refer to popular notions of the witches' sabbath as an orgiastic, cannibalistic ritual.

In 1786, Charles III of Spain appointed Goya his court painter, and his successor Charles IV promoted the artist to the position of Principal Painter. In his monumental portrait *The Family of Charles IV* of 1800 (fig. **21.16**), Goya left a satirical record of three generations of Spanish royalty. The pompous poses, glittering costumes, and blank stares highlight the unappealing character of the royal family. Such grandiose self-display conforms to the setting—the palace picture gallery—that had served the political image of Spanish royalty for centuries.

Goya's irony is enhanced by the insertion of his self-portrait at the left. In a humorous quotation from Velázquez's *Las Meninas* (see fig. 18.57), Goya faces a large canvas of which only part of the back is visible to the observer. In contrast to the dynamic poses of Velázquez's picture, however, Goya's are stiff, rather like stuffed dolls. Instead of being drawn into the space of the picture as in *Las Meninas*, Goya's space comes to an abrupt halt in the shallow depth of the hall. The family of Charles IV is arrayed in a horizontal plane, and seems to compete for visibility, like a group posing for a photograph. Whereas Velázquez stands proudly among his royal "peers," displaying his palette and brush for all to see, Goya portrays himself as diffidently fading into the background.

In his images of war Goya champions Enlightenment views of individual freedom against political oppression. In *The Executions of the Third of May, 1808* (fig. **21.17**) he dramatically juxtaposes the visible faces of the victims with the covered faces of the executioners. The firing squad is an anonymous, but deadly, force, whose regular, repeated rhythms and dark mass contrast with the highlighted, disorderly victims. The emotional poses and gestures, accentuated by thick brushstrokes, and the stress on individual reactions to the "blind," brute force of the firing squad, are characteristic of Goya's Romanticism. The raised arms of the central, illuminated victim about to be shot recall Christ's death. His pose and gesture, in turn, are repeated by the foremost corpse. The lessons of Christ's Crucifixion, Goya seems to be saying, are still unlearned. By mingling reds and browns in this section of the picture, Goya creates the impression that blood is flowing into the earth. Somewhat muted by the night sky, a church rises in the background and towers over the scene.

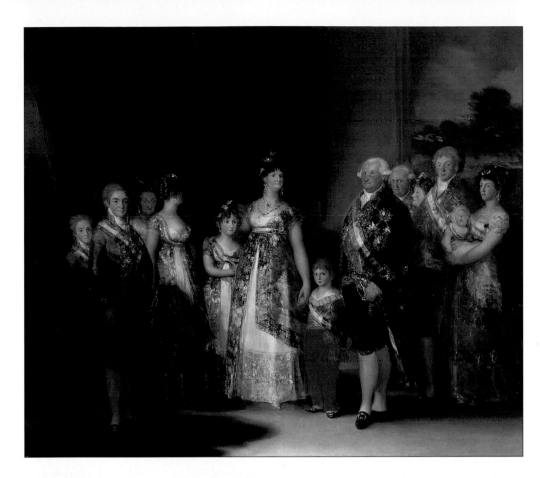

21.16 (left) Francisco de Goya y Lucientes, *The Family of Charles IV*, 1800. Oil on canvas, 9 ft 2 in × 11 ft (2.79 × 3.35 m). Prado, Madrid.

21.17 (below) Francisco de Goya y Lucientes, *The Executions of the Third of May, 1808*, 1814. Oil on canvas, 8 ft 9 in × 11 ft 4 in (2.67 × 3.45 m). Prado, Madrid. This painting depicts the aftermath of events that occurred on May 2 and 3, 1808. Two Spanish rebels had fired on fifteen French soldiers from Napoleon's army. In response, the French troops rounded up and executed close to a thousand inhabitants of Madrid and other Spanish towns. Six years later, after the French had been ousted, the liberal government of Spain commissioned a pair of paintings, of which this is one, to commemorate the atrocity.

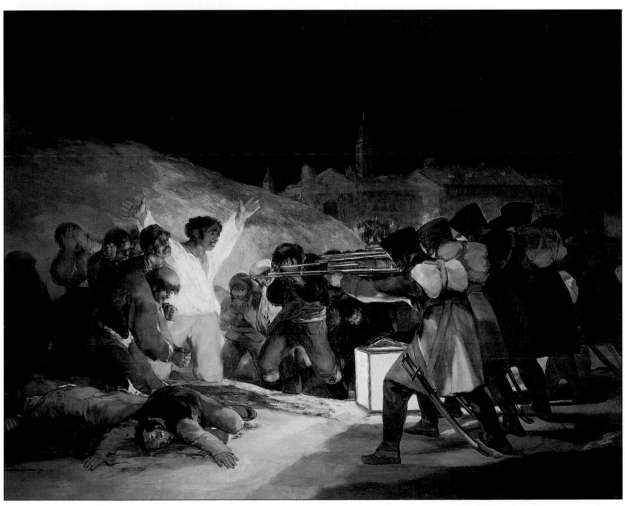

When he was in his seventies, Goya painted a series of so-called "black paintings." Since they were not commissioned and were therefore painted for Goya's own satisfaction, these late pictures reveal some of the artist's most intimate preoccupations. *Kronos Devouring One of his Children* (fig. **21.18**), of c. 1820–22, is a disturbing indictment of man's bestial nature. The figure of Kronos stares wildly out of the picture plane, his gaping mouth tearing off a piece of the child's body. Goya depicts the Titan as a crazed, wide-eyed cannibal, who is barely contained by the picture space. The loose brushstrokes, especially in the long hair and body, reinforce his bestial nature. In this frenzied, unclassical image of a father destroying his child, Goya combines several themes that preoccupied him throughout his life. In particular, as in the "Bogeyman," he deals with the image of a terrifying father who destroys his vulnerable children, psychologically in the former and physically in the *Kronos*. Goya confronts humanity with an example of its "blackest," most primitive forms of behavior—infanticide and cannibalism. It is ironic that Goya's most anti-Classical image should ultimately project a humanistic message.

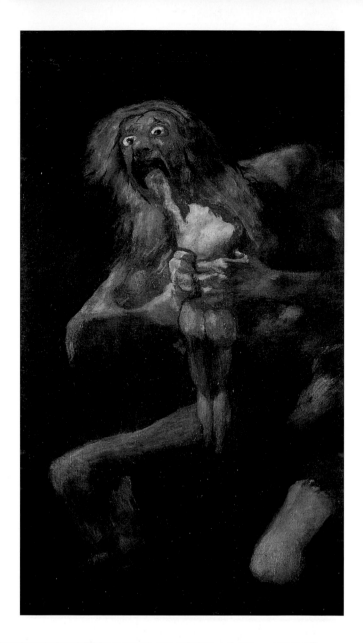

21.18 Francisco de Goya y Lucientes, *Kronos Devouring One of his Children*, c. 1820–22. Wall painting in oil detached on canvas, 4 ft 9⅞ in × 2 ft 8⅝ in (1.47 × 0.83 m). Prado, Madrid. According to Greek myth, Kronos devoured his children to thwart the prophecy that they would overthrow him. But the children were gods and therefore immortal. They survived to fulfill their destiny, and became the twelve Olympians. Goya's Kronos, on the other hand, destroys the child, crushing its torso like a flimsy doll and tearing away its arms and head. His savagery is accented by the red highlight outlining the upper torso and flowing across his hands.

The Esthetic of the Sublime

In 1757, the British philosopher Edmund Burke (1729–97) published *A Philosophical Enquiry into the Origin of our Ideas of the Sublime and the Beautiful*. Certain artists and writers of the late eighteenth and early nineteenth centuries took up his views on the sublime, which reflect the ambivalent character of the Romantic esthetic. According to Burke, the passions and the irrational exert a powerful, awesome force on people. These, he believed, explain the subjective reaction to art. Burke's esthetic system describes the "irrational" attraction to fear, pain, ugliness, loss, hatred, and death (all of which comprise the notion of the sublime) on the one hand, and to beauty, pleasure, joy, and love on the other. (Some one hundred and fifty years later, Freud would show the co-existence of these oppositions in the unconscious and relate their dynamics to child development. Freud's essay of 1919 entitled "The Uncanny," which is his only work on esthetics, has affinities with both the writing of Burke and the psychological paintings of Goya.) Pain and danger, according to Burke, "are the most powerful" passions. Life and health, in contrast, make less of an impression on people. (These notions were to resurface in Freud's theory of the life and death instincts.)

A summation of Burke's esthetic is reflected in Shelley's "Medusa," whose "horror and beauty are divine." Of the paintings illustrated in this chapter, several can be related to Burke's ideas. Revolutionary zeal that elevates the passions to new heights appears in Rude's *Marseillaise* and Delacroix's *Liberty Leading the People*. Géricault's *Madwoman*, Delacroix's *Medea*, and Goya's *Kronos* evoke the terror of being killed or devoured by one's parents. Irrational fears are aroused in Goya's *Bogeyman* and *Witches' Sabbath*. And nature, as in Friedrich's *Moonrise over the Sea*, has a quality of beauty, but it also threatens to envelop and outlast humanity with its infinite vastness. Friedrich's two men gazing at the sea evoke Burke's view that "the ocean is an object of no small terror. Indeed terror is in all cases whatsoever, either more openly or latently, the ruling principle of the sublime."[1]

Landscape Painting

Romantic themes often focused on the longing to return to nature and on the insignificance of the individual in relation to nature's vastness. The varying moods of nature were seen as a reflection of states of mind. Such themes led to an expansion of landscape painting in the nineteenth century. Romantic landscape often evoked a sense of the sublime (see Box), which included an uncanny quality of terror.

Germany: Caspar David Friedrich

In Germany (see Box), which otherwise lacked major artists in this period, the poetic landscapes of Caspar David Friedrich (1774–1840) express these Romantic trends. His *Moonrise over the Sea* (fig. **21.19**) exemplifies the Romantic merging of human form and mood with nature. The scene is barren and the vastness of the landscape is suggested by its implied continuation beyond the borders of the picture. The two men have no individual identity beyond their relationship to the landscape and their medieval dress, which reflects Romantic nostalgia for the past. Their forms are pure silhouettes, and provide vertical accents cutting through the horizon line. As a result, they seem transitory and ghostly in contrast to the permanence of nature, and this contributes to the sense of awe and the sublime.

> ## German *Sturm und Drang*
>
> In Germany, the *Sturm und Drang* movement of the late eighteenth century marked an early phase of Romanticism. A reaction against the domination of French Classical taste, it was a literary movement that exalted individualism and nature. It placed emotion, instinct, and originality above rational and scientific thought. As young men, the playwrights Johann Wolfgang von Goethe (1749–1832), whose *Faust* was illustrated by Delacroix, and Johann Christoph Friedrich von Schiller (1759–1805) were among its principal exponents. Another major figure was Johann Gottfried von Herder (1744–1803), an influential critic who "rediscovered" ancient German literature. His views reflected the nationalist strain of German Romanticism. For Herder, the virtues of natural feeling and emotion prized by the Romantics resided in old German folk songs and sagas, rather than in Greek and Roman antiquity or in French Classicism.

21.19 Caspar David Friedrich, *Moonrise over the Sea*, 1817. Oil on canvas, 20 × 26 in (51 × 66 cm). Nationalgalerie, Berlin.

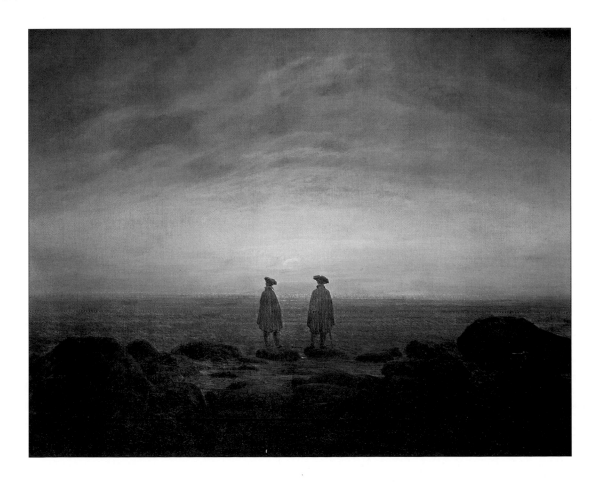

England: John Constable and Joseph Mallord William Turner

In England, the two greatest Romantic landscape painters, John Constable (1776–1837) and Joseph Mallord William Turner (1775–1851), approached their subjects quite differently. Whereas Constable's images are clear and tend to focus on the details of English country life, Turner's are apt to become swept up in the paint.

In Constable's *Salisbury Cathedral from the Bishop's Garden* (fig. **21.20**), for example, cows graze in the foreground, while couples stroll calmly along pathways. The cathedral is framed by trees that echo its vertical spire. Nostalgia for the past is evident in the juxtaposition of the day-to-day activities of the present with the Gothic cathedral. Humanity, like the cathedral, is at one with nature, and there is no hint of the industrialization that in reality was encroaching on the pastoral landscape of nineteenth-

century England. (This is discussed further in Chapter 22.) The atmosphere of this painting is echoed in the poems of Wordsworth, who wanted to break away from eighteenth-century literary forms and return to nature, to a "humble and rustic life." In "Tintern Abbey," Wordsworth evokes the Romantic sense of the sublime that is achieved by oneness with nature:

> … And I have felt
> A presence that disturbs me with the joy
> Of elevated thoughts; a sense sublime
> Of something far more deeply interfused,
> Whose dwelling is the light of setting suns,
> And the round ocean and the living air,
> And the blue sky, and in the mind of man …
> (lines 93–9)

In contrast to the calm landscapes of Constable, Turner's approach to Romanticism is characterized by

21.20 John Constable, *Salisbury Cathedral from the Bishop's Garden*, 1820. Oil on canvas, 2 ft 10⅝ in × 3 ft 8 in (0.91 × 1.12 m). Metropolitan Museum of Art, New York (Bequest of Mary Stillman Harkness, 1950). (See also Vol. I, figs. 12.51–12.53.)

dynamic, sweeping brushstrokes, and vivid colors that blur the forms. His *Burning of the Houses of Lords and Commons* (fig. **21.21**) is a whirlwind of flame, water, and sky, structured mainly by the dark diagonal pier at the lower right, the bridge, and the barely visible towers of Parliament across the Thames. The luminous reds, yellows, and oranges of the fire dominate the sky and are reflected in the water below. In this work, architectural structure is in the process of dissolution, enveloped by the blazing lights and colors of the fire. The forces of nature let loose and their destruction of man-made structures are the primary theme of this painting. In Constable, on the other hand, nature is under control, and in harmony with human creations.

The contrast between these two artists can be seen by comparing their watercolors of Stonehenge (see Vol. I, fig. 2.27). Its ruined and mysterious character was ideally suited to the Romantic imagination. In Constable's version (fig. **21.22**), tiny figures walk quietly among the **monoliths**. The clouds are streaked with light, emphasizing the connection between stones, earth, and sky. Thin, almost transparent waterpaint textures create a veil, which enhances the impression of looking back in time to a Neolithic past.

The exuberance of the brushstrokes in Turner's *Stonehenge* (fig. **21.23**) creates a haze that softens the stones. Grazing in the foreground are sheep which echo the structure itself—some stand upright and others lie flat. Shifts of light and dark on the sheep are repeated on the stones and in the turbulent sky. Contrasts in the Turner are more accentuated than in the Constable. For example, in the former the silver-tipped clouds separate and allow sunlight to pour down on the circle of stones. At the same time, the sky imparts a typically Romantic impression of menace, to which the sheep respond with agitation.

21.21 Joseph Mallord William Turner, *The Burning of the Houses of Lords and Commons, October 16, 1834*, 1835. Oil on canvas, 3 ft ¼ in × 4 ft ½ in (0.92 × 1.23 m). Cleveland Museum of Art (Bequest of John L. Severance, 42.647). The painting is based on an actual fire of 1834. Turner spent the entire night sketching the scene. After the fire the new Houses of Parliament (still standing today) were built in the Gothic revival style, which was inspired by Romantic nostalgia for a medieval Christian past (see fig. 21.1).

21.22 John Constable, *Stonehenge*, 1835. Watercolor, 15¼ × 23¼ in (38.7 × 59.1 cm). Victoria and Albert Museum, London. (See also Vol. I, figs. 2.27, 2.28, and 2.31.)

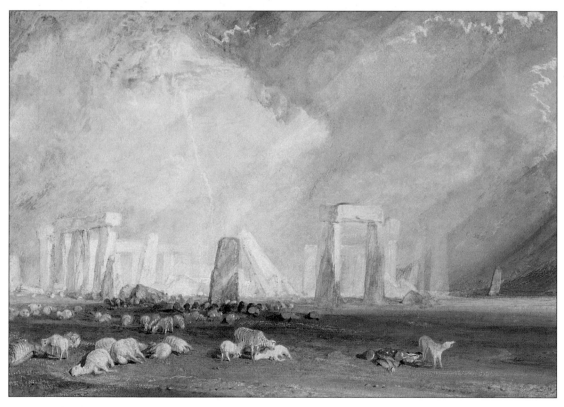

21.23 Joseph Mallord William Turner, *Stonehenge*, 1828. Watercolor, 11 in × 16 in (28 × 40.6 cm). Salisbury and South Wiltshire Museum.

America

In the United States as well as Europe, the Romantic movement infiltrated both art and literature (see Box). The landscape of different parts of the country inspired artists, individually and in groups, to produce works that were often monumental in size and breathtaking in effect.

Thomas Cole One such painting is *The Oxbow* (fig. **21.24**) by Thomas Cole (1801–48), which depicts a bend in the Connecticut River, near Northampton. ("Oxbow" is the term used to describe the crescent-chaped, almost circular, course of a river caused by its meandering.) One is struck by the abrupt contrast between the two sides of the painting. On the left is wilderness, where two blasted trees in the foreground bear witness to the power of the elements. A thunderstorm, an example of nature's dramatic, changing moods characteristic of the Romantic esthetic, is passing over. Torrents of rain still fall from the dark clouds. The direction of the rain indicates that the storm is moving away to the left and that it has already

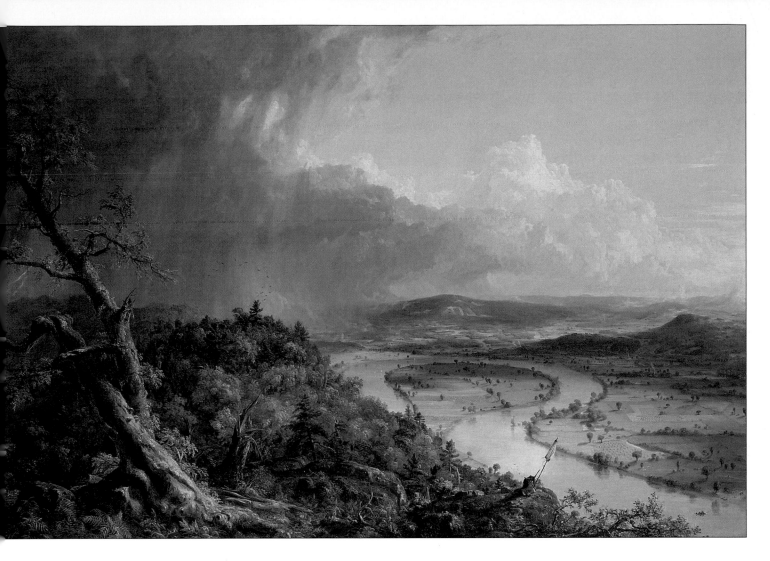

21.24 Thomas Cole, *View from Mount Holyoke, Northampton, Massachusetts, after a Thunderstorm* (*The Oxbow*), 1836. Oil on canvas, 4 ft 3½ in × 6 ft 4 in (1.31 × 1.93 m). Metropolitan Museum of Art, New York (Gift of Mrs. Russell Sage, 1908). Cole was born in England and emigrated to America with his family at the age of seventeen. In 1825 his work came to the attention of John Trumbull (see p. 711), then President of the American Academy, who is quoted as saying: "This youth has done at once, and without instruction, what I cannot do after fifty years' practice." This story, whether anecdotal or not, places Cole squarely in the tradition of other "boy wonders" such as Giotto and Picasso.

American Romantic Writers

Nineteenth-century America produced many important Romantic works of literature. The historical adventures of James Fenimore Cooper (1789–1851), particularly *The Last of the Mohicans* (1826), extol the American Indian as an example of the "noble savage." The supernatural poems and tales of Edgar Allan Poe (1809–49) contain uncanny portrayals of death and terror. Likewise, the Gothic novels and short stories of Nathaniel Hawthorne (1804–64) create a haunted, medieval atmosphere in which super-natural phenomena abound.

A characteristic American Romantic philosophy emerged in the Transcendentalism of Ralph Waldo Emerson (1803–82) and Henry David Thoreau (1817–62), a doctrine that stressed the presence of God within the human soul as a source of truth and a moral guide. After a trip to England (where he met Coleridge and Wordsworth), Emerson became a spokesman for Romantic individualism, which he expressed in poems and essays. A more personal form of natural philosophy can be seen in Thoreau's experimental return to nature. He lived alone for two years in a hut at the edge of Walden Pond in Massachusetts, and recorded his experience in *Walden; or Life in the Woods* (1854).

passed the farmland to the right, which now lies serene and sunlit. A landscape of neatly arranged fields, dotted with haystacks, sheep, and other signs of cultivation, extends into the distance. Boats ply the river and plumes of smoke rise from farmhouses. Barely visible in the fore-

ground, just right of center, is a single figure, the artist at work before his easel. On a jutting rock are his umbrella and folding stool and, leaning against them, a portfolio with the name T. Cole on its cover. Both artist and viewer have a panoramic view from the top of the mountain, a

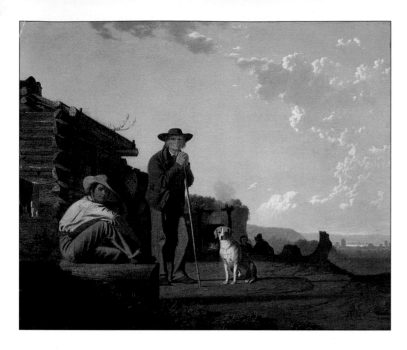

21.25 George Caleb Bingham, *The Squatters*, 1850. Oil on canvas, 25 × 30 in (63.5 × 76.2 cm). Museum of Fine Arts, Boston (Bequest of Henry L. Shattuck in memory of Ralph W. Gray).

feature that became typical of the Hudson River School of painting, of which Cole was the acknowledged leader.

It was Cole's habit to journey on foot through the northeastern states, making pencil sketches of the landscape. He would then develop them into finished paintings during the winter, and this was the case with *The Oxbow*. It is likely that Cole never actually witnessed the storm in the way he depicts it, and that there is a large element of the artist's imagination at work. If so, why did Cole choose this particular image? An untitled poem which he wrote in January 1835, a year before he completed *The Oxbow*, begins as follows:

> I sigh not for a stormless clime,
> Where drowsy quiet ever dwells,
> Where purling waters changeless chime
> Through soft and green unwinter'd dells—
>
> For storms bring beauty in their train;
> The hills that roar'd beneath the blast,
> The woods that welter'd in the rain
> Rejoice whene'er the tempest's past.

Cole's affinity for storms has been interpreted by some scholars as a metaphor for his inner life, symbolic of some unresolved conflict or of inner peace following a period of stress. It is also possible to see the painting as an allegory of civilization (the right) versus savagery (the left), which is certainly consistent with Cole's own outlook. For although he made his reputation primarily as a landscape artist, Cole always aspired to a "higher style of landscape," a mode of painting that contained some additional moral or religious significance. At approximately the same time as *The Oxbow*, he produced a series of five allegorical paintings entitled *The Course of Empire*, which trace the cycle of historical development from savagery through civilization to decay. Others believe that Cole was commenting on the paradoxes of life in early nineteenth-century America —a nation still predominantly rural and at odds with the accelerating pace of industrialization; a society that valued individual opportunity, but denied women and blacks the right to vote; a period of prosperity for the upper classes, but insecurity and hardship for the majority.

George Bingham In the latter half of the eighteenth century, most rural communities consisted of clusters of largely self-sufficient family-owned farms. Over the next fifty years, population growth and the increasing demand for new land made it hard for this system to survive. The building of canals and railroads commercialized the farm sector and stimulated competition between regions, all vying to sell the same crops into the same markets. Cole's country, the Hudson Valley and the Catskills, faced new competition from the Midwest and the Great Lakes. Agriculture became subject to the laws of the market-place, vulnerable to changes in prices, government policies, and credit conditions. Some farmers prospered, while those who were unable to adjust to changing conditions became marginalized by progress. Many immigrants, who had come to America in search of opportunity, never managed to rise above the bottom rung of the economic ladder.

21.26 Edward Hicks, *The Peaceable Kingdom*, c. 1834. Oil on canvas, 29⅜ × 35½ in (74.8 × 90.2 cm). National Gallery of Art, Washington, D.C. (Gift of Edgar William and Bernice Chrysler Garbisch).

This darker side of American rural life is illustrated in *The Squatters* (fig. **21.25**) by George Caleb Bingham (1811–79), who combined a career in Missouri politics with a vocation as a painter. His image of a poor rural family outside a log cabin reminds us that there were many agricultural workers who, unable to compete in a market economy and having perhaps lost their land through overmortgaging, led a hand-to-mouth existence as tenants, wage laborers, or squatters.

Folk Art: Edward Hicks Another, more direct view of nature in nineteenth-century American painting can be found in folk art. Folk artists are typically not academically trained; their forms are usually flattened, their proportions unrealistic, and their imagery without reference to the Classical tradition. As a result, their works tend to have a spontaneous quality that can be refreshing compared to the more "finished" appearance of works by artists who have had formal training.

One example of this genre that embodies the Romantic ideal of a return to nature is *The Peaceable Kingdom* (fig. **21.26**) by Edward Hicks (1780–1849), who during his lifetime was celebrated more as a Quaker preacher than as an artist. Hicks based this painting on a passage from the

Artists Quote Art: Horace Pippin

In 1945, one year before his death, the American self-taught artist Horace Pippin (1888–1946) painted one of three versions of *The Holy Mountain* (fig. **21.27**). His inspiration was Hicks's *Peaceable Kingdom*, which he combined with his own interest in war and peace—he was himself a veteran of World War I—and with his experience as a black man in America. As in *The Peaceable Kingdom*, Pippin shows carefree children and tame wild animals, both existing in an idyllic state of nature, surrounded by lush vegetation.

The first of Pippin's series is signed with the date of D-Day (the start of the Allied invasion of France)—June 6, 1944. The second is signed December 7, 1944—the date of Japan's attack on Pearl Harbor. August 9, which appears on the example illustrated here, refers to the Allied bombing of Nagasaki. In all three cases, Pippin creates a kind of war memorial by juxtaposing significant events of World War II with a peaceful setting that evokes the Garden of Eden. The red-cross flowers distributed over the grass, and the white T-shapes clustered among the central trees, recall the vast military graveyards of World War II.

Presiding at the center of the scene is a black shepherd in a white robe. (In the first version this figure is a self-portrait.) This feature has been compared to "de Lawd" in Marc Connelly's *Green Pastures*—a play (1930) and movie (1936) about an all-black heaven.

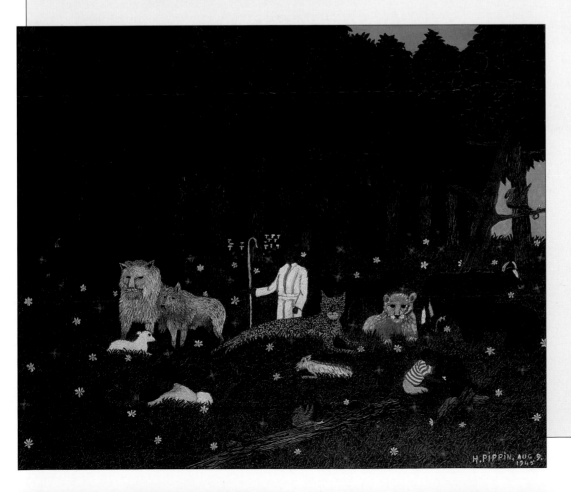

21.27 Horace Pippin, *The Holy Mountain III*, 1945. Oil on canvas, 25¼ × 30¼ in (63.5 × 76.8 cm). Hirshhorn Museum and Sculpture Garden, Smithsonian Institution, Washington, D.C. (Gift of Joseph H. Hirshhorn, 1966).

Book of Isaiah (11: 6–9): "The wolf also shall dwell with the lamb, and the leopard shall lie down with the kid; and the calf and the young lion and the fatling together; and a little child shall lead them." Rather than being drawn into a vast space, the viewer experiences an immediate confrontation with the image, especially the wild cats. Its impact is enhanced by the close-up view of wild animals coexisting peacefully with humans. Their careful, almost staged arrangement and immobile frontality endow them with a static quality that is consistent with the folk art preference for inanimate objects. *The Peaceable Kingdom* merges the natural landscape with a utopian ideal related to the notion of a Garden of Eden. The background scene, also utopian, is a visual quotation of a scene in Benjamin West's *Penn's Treaty with the Indians*. In contrast to the capricious, dangerous, and constantly changing eruptions of nature that are captured in the work of Turner and Cole, Hicks's conception seems frozen in time (see Box on p. 737).

Style/Period	Works of Art	Cultural/Historical Developments
ROMANTICISM **1790–1800** *(1790)*	Blake, *Ancient of Days* (**21.5**) Goya, *The Witches' Sabbath* (**21.15**)	Samuel Taylor Coleridge, *Kubla Khan* (1797) Wordsworth and Coleridge, *Lyrical Ballads* (1798) Romantic literary movement (1798–1850)
1800–1820 *(1800)*	Goya, *The Family of Charles IV* (**21.16**) Géricault, Sketch for *The Charging Cuirassier* (**21.6**) Goya, *The Executions of the Third of May, 1808* (**21.17**) Nash, *Royal Pavilion* (**21.3**), Brighton Goya, *Los Caprichos* (**21.14**) Géricault, *The Raft of the "Medusa"* (**21.8**) **Nash, Royal Pavilion**	French army under Napoleon occupies Spain (1808) John Keats, *Endymion* (1818) Lord Byron, *Don Juan* (1819) **Géricault, Sketch for *The Charging Cuirassier***
1820–1830 *(1820)*	Goya, *Kronos Devouring One of his Children* (**21.18**) Constable, *Salisbury Cathedral from the Bishop's Garden* (**21.20**) Delacroix, *The Bark of Dante* (**21.9**) Géricault, *Mad Woman with a Mania of Envy* (**21.7**) Delacroix, *The Massacre at Chios* (**21.10**) Turner, *Stonehenge* (**21.23**) **Goya, *Kronos Devouring One of his Children***	Percy Bysshe Shelley, *Adonais* (1821) Walter Scott, *Waverley* novels (1821–5) Beethoven, *Choral Symphony* (1824) John James Audubon, *Birds of North America* (1827) **Turner, Stonehenge**
1830–1840 *(1830)*	Friedrich, *Moonrise over the Sea* (**21.19**) Delacroix, *Liberty Leading the People* (**21.11**) Rude, *La Marseillaise* (**21.4**) Hicks, *The Peaceable Kingdom* (**21.26**) Delacroix, *Women of Algiers* (**21.12**) Turner, *The Burning of the Houses of Lords and Commons* (**21.21**) Constable, *Stonehenge* (**21.22**) Barry and Pugin, *Houses of Parliament* (**21.1**), London Cole, *The Oxbow* (**21.24**)	Charles Darwin begins *Beagle* voyage (1831) Hector Berlioz, *Symphonie Fantastique* (1832) End of slavery in British Empire (1834) William Wordsworth, *Poems* (1835) Victoria, Queen of England (1837–1901) **Delacroix, *Liberty Leading the People***
1840–1850 *(1840)* *(1850)*	Upjohn, *Trinity Church* (**21.2**), New York Bingham, *The Squatters* (**21.25**) Delacroix, *Medea* (**21.13**) 1945: Pippin, *The Holy Mountain III* (**21.27**)	John Ruskin, *Modern Painters I* (1843) Edgar Allen Poe, *The Raven and Other Poems* (1845) Irish famine leads to mass emigration (1845) Richard Wagner, *Tannhäuser* (1845) Pre-Raphaelite Brotherhood founded in England (1848) California gold rush begins (1848) John Ruskin, *The Seven Lamps of Architecture* (1849) Nathaniel Hawthorne, *The Scarlet Letter* (1850)

22

Nineteenth-Century Realism

Cultural and Political Context

The nineteenth century was an age of revolutions—economic, social, and political—and these, like contemporary ideas about human rights, can be traced to the eighteenth-century Enlightenment. Resulting conflicts between different classes of society were often implicit in works of art—usually depicted from the viewpoint of those rebelling against political oppression.

A major force in polarizing social classes was the Industrial Revolution, which began in England, transforming the economies, first of western Europe (fig. 22.1), then of the United States and other parts of the world, from an agricultural to a primarily industrial base. Once started, the process of industrialization continued at breakneck speed. Inventions such as the steam engine, and new materials such as iron and steel, made manufacturing possible. The iron industry was transformed by the substitution of coke for charcoal in the smelting process. The greater availability of iron as a building material, in addition to its strength and resistance to fire, made it preferable to wood. By the third quarter of the nineteenth century, new processes led to the manufacture of inexpensive steel (an alloy of low-carbon iron and other metals), which by 1875 had begun to replace iron in the building and industrial sectors.

Factories were established, mainly in urban areas, and people moved to the cities in search of work. New social class divisions arose between factory owners and workers. Demands for individual freedom and citizens' rights were accompanied in many European countries by social and political movements for workers' rights. In 1848 Karl Marx and Friedrich Engels (see Box) published the most influential of all political tracts on behalf of workers —the Communist Manifesto. The same year, the first convention for women's rights was held in New York.

French and English literature of the nineteenth century is imbued with the currents of reform inspired by a new social consciousness. Novelists such as Charles Dickens, Honoré de Balzac, Gustave Flaubert, and Émile Zola

The Communist Manifesto

The political theory of communism was set out by Karl Marx (1818–83) and Friedrich Engels (1820–95) in the Communist Manifesto, published in England in 1848.

Marxism views history as a struggle to master the laws of nature and apply them to humanity. The Manifesto outlines the stages of human evolution, from primitive society to feudalism and to capitalism, each phase being superseded by a higher one.

Marxists believed that bourgeois society had reached a period of decline; it was now time for the working class (or "proletariat") to seize power from the capitalist class and organize society in the interests of the majority. The next stage would be socialism under the rule of the working class majority ("dictatorship of the proletariat"). This, in turn, would be followed by true communism, in which the guiding principle "from each according to his ability, to each according to his needs" would be realized. Part-analysis, part-rhetoric, the Manifesto ends: "The proletarians have nothing to lose but their chains. They have a world to win. Working men of all countries, unite!"

Marx wrote very little about art, but he did discuss it briefly in his Introduction to the Critique of Political Economy (1857–9). He believed that art is linked to its cultural context, and thus should not be regarded in a purely esthetic light. His primary interest was in the relationship of art production to the proletarian base of society, and its exploitation by the superstructure (the bourgeoisie). For Marx, the arts were part of the superstructure, which comprises the patrons of art, while the artists were "workers." As a result, he argued, artists, like other members of the working class, had become alienated from their own productions. His view of the class struggle has led to various so-called "Marxist" theories of art history, in which art is interpreted as a reflection of conflict between proletariat and bourgeoisie.

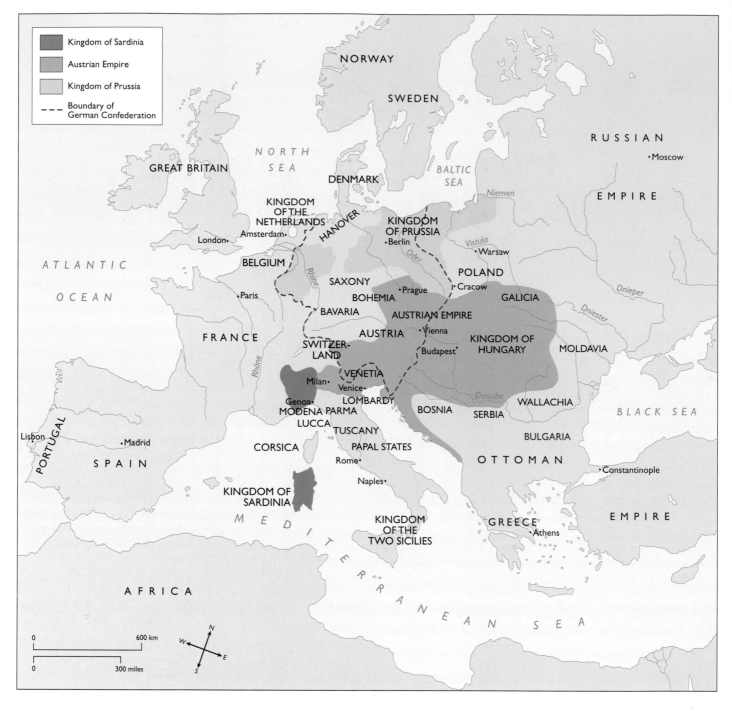

22.1 Map of industrialized Europe in the 19th century.

described the broad panorama of society, as well as the psychological motivation of their characters (see Box). In science, too, the observation of nature led to new theories about the human species and its origin. In 1859, for example, the naturalist Charles Darwin (1809–92) published the *Origin of Species by Means of Natural Selection,* written after a five-year sea voyage aboard the *Beagle,* which included a period of scientific observation in the Galapagos Islands.

Newspapers and magazines reported scientific discoveries, and also carried **cartoons** and **caricatures** satirizing political leaders, the professions, actors, and artists. The proliferation of newspapers reflected the expanding communications technology that resulted from the Industrial

Revolution. Advances in printing and photography made articles and images ever more accessible to a wider public. Inventions such as the telegraph (1837) and telephone (1876) increased the speed with which messages and news could be delivered, and thus the efficiency of organized activity. Travel was also accelerated; the first passenger railroad, powered by steam, went into service in 1830.

Paralleling the more general social changes in the nineteenth century was the change in the social and economic structure of the art world that had begun in the previous century. Crafts were replaced by manufactured goods. Guilds were no longer important to an artist's training, status, or economic well-being. A new figure on the art scene was the critic, whose opinions, published in news-

papers and journals, influenced buyers. Patronage became mainly the province of dealers, museums, and private collectors. Both the art gallery and the museum as they exist today originated in the nineteenth century.

In the visual arts, the style that corresponded best to the new social awareness is called Realism. The term was coined in 1840, although the style itself appeared well before that date. Direct observation of society and nature, and political and social satire, are the primary concerns of the Realist movement in art.

French Realism

Jean-François Millet

The Gleaners (fig. **22.2**), by Jean-François Millet (1814–75), illustrates the mid-century transition between Romanticism and Realism in painting. The dramatic, heroic depiction of the three peasants in the foreground and their focus on their tasks recall the Romantic sense of "oneness with nature." Two peasants in particular are monumentalized by the large scale of their foreshortened forms, which convey a sense of powerful energy. Contrasted with the laborers gleaning the remains of the harvest is the prosperous farm in the background. The emphasis on class distinctions—the hard, physical labor of the poor as opposed to the comfortable lifestyle of the wealthy—is characteristic of Realism. In addition to social observation, Millet records the natural atmosphere of the scene, showing the slightly overcast sky. The farm is illuminated in a golden glow of sunlight, while the three foreground figures and the earth from which they glean are in shadow.

Rosa Bonheur

Another approach to nature in which Realism and Romanticism are combined is found in the work of Rosa Bonheur (1822–99). Her painting of *The Horse Fair* (fig. **22.3**) shows her close study of the anatomy and movement of horses galloping, rearing, and parading. Consistent with Realist interest in scientific observation, Bonheur dissected animals from butcher shops and slaughterhouses; she also visited horse fairs such as this one, and cattle markets. In addition to the Realist qualities of *The Horse Fair*, the thundering energy of the horses, and the efforts of their grooms to keep them under control, are reminiscent of Géricault's *Charging Cuirassier* (see fig. 21.6). As in the Géricault, Bonheur's turbulent sky echoes the dramatic (and Romantic) dynamism of the struggle between humanity and the untamed forces of nature.

Gustave Courbet

The painter most directly associated with Realism was Gustave Courbet (1819–77), who believed that artists could accurately represent only their own experience. He rejected historical painting, as well as the Romantic depiction of exotic locales and revivals of the past. Although he had studied the history of art, he claimed to have drawn from it only a greater sense of himself and his own experience in the present. In 1861, he wrote that art could not be taught. One needed individual inspiration, he believed, fueled by study and observation. Gustave Courbet's Realist approach to his subject-matter is expressed in the statement in his Manifesto: "Show me an angel and I'll paint one."

Realism in Literature

The current of Realism and its related "-ism," Naturalism, flows through nineteenth-century literature, science, and arts. In England, Charles Dickens (1812–70) described the dismal conditions of lower-class life. He drew on direct observation and personal experience, for as a boy he had worked in a factory while his father was in debtors' prison. His opening sentence of *A Tale of Two Cities* reflects the ambivalence with which the new industrial society was viewed: "It was the best of times, it was the worst of times, it was the age of wisdom, it was the age of foolishness, it was the epoch of belief, it was the epoch of incredulity, it was the season of Light, it was the season of Darkness."

In France, Honoré de Balzac (1799–1850) wrote eighty novels, comprising the *Comédie Humaine* (*Human Comedy*) —a sweeping panorama of nineteenth-century French life. The novelists Gustave Flaubert (1821–80) and Emile Zola (1840–92) also focused on society and personality. In 1857 Flaubert published *Madame Bovary*, the story of the unfaithful wife of a French country doctor. The description of her suicide by arsenic poisoning is a classic example of naturalistic observation. Zola's *Thérèse Raquin* (1871) details a particular state of mind—namely remorse—while his *Nana*, the story of a prostitute, has broader social connotations. Zola not only championed a Realist approach to the arts; he was also a staunch defender of political and social justice.

Charles Baudelaire (1821–67) published his first book of verse, *Les Fleurs du Mal* (*The Flowers of Evil*), in 1857. Both he and the printer were fined and censored for endangering French morals, a condemnation that was not lifted until 1949. He was obsessed with the beauty of evil and decadence, but he was also a Realist in depicting the specific details of perversion.

Realist theater can be found throughout Europe. In France, Alexandre Dumas the Younger's (1824–95) novel *La Dame aux Camélias* (1849) was turned into a play. Its description of Camille's death from tuberculosis has become a classic. In Norway, Henrik Ibsen (1828–1906) carefully detailed the psychological motives of his characters. In England, George Bernard Shaw (1856–1950) portrayed both the inevitability and the absurdity of class distinctions.

22.2 (above) Jean-François Millet, *The Gleaners*, 1857. Oil on canvas, approx. 2 ft 9 in × 3 ft 8 in (0.84 × 1.12 m). Musée d'Orsay, Paris. Because of their powerful paintings of rural labor, Millet and his contemporary Courbet were suspected of harboring anarchist views. Both were members of the Barbizon School, a group of French artists who settled in the village of that name in the Fontainebleau Forest. They painted directly from nature, producing landscapes tinged with nostalgia for the countryside, which was receding before the advance of the Industrial Revolution.

22.3 Rosa Bonheur, *The Horse Fair*, 1853. Oil on canvas, 8 ft ¼ in × 16 ft 7½ in (2.44 × 5.07 m). Metropolitan Museum of Art, New York (Gift of Cornelius Vanderbilt, 1887). Rosa Bonheur regularly exhibited in the Salons of the 1840s, and achieved international renown as an animal painter. In 1894, she was named the first woman artist of the Legion of Honor. Her father was a landscape painter, and a Saint-Simon socialist who favored women's rights and believed in a future female Messiah. Rosa made a point of imitating the dress and behavior of men and lived only with women. In order to wear men's clothes in Paris—they were especially practical when she made sketches in slaughterhouses—she had to have a police permit, which was renewable every six months. *The Horse Fair* toured England, and was privately exhibited in Windsor Castle at the behest of Queen Victoria. In 1887, Cornelius Vanderbilt donated it to the Metropolitan Museum of Art. When Buffalo Bill took his Wild West show to France, he brought Bonheur a gift of two mustangs from Wyoming.

22.4 Gustave Courbet, *The Interior of My Studio: A Real Allegory Summing up Seven Years of My Life as an Artist from 1848 to 1855*, 1855. Oil on canvas, 11 ft 10 in × 19 ft 7¾ in (3.61 × 5.99 m). Musée d'Orsay, Paris.

Courbet's huge and complex *Interior of My Studio: A Real Allegory Summing up Seven Years of My Life as an Artist from 1848 to 1855* (fig. **22.4**) can be considered a "manifesto" in its own right. The seven-year period cited in the title begins with the February Revolution of 1848, and the proclamation of the Second Republic. Over this period, Courbet struggled to free himself from the style of his Romantic predecessors. He wanted to embark on a new artistic phase, in which his subject-matter would reflect the reality of French society.

The *Studio* reflects Courbet's broad view of society on the one hand, and his relationship to the art of painting on the other. In his own words, the painting showed "society at its best, its worse, and its average" ("la société dans son haut, dans son bas, dans son milieu"). While working on the *Studio*, Courbet described the figures on the right as his friends—workers and art collectors. Those on the left were both the wealthy and the poor; that is, people whose existence depended on class struggle and therefore the vagaries of society rather than their own work and talent.

The thirty figures portrayed cover the spectrum of society, from the intelligentsia to the lower classes. The group on the left are types rather than individuals, reflecting the anonymity of working-class life. They consist mainly of country folk, and include laborers, an old soldier with a begging bag, a Jew, a peddler, a fairground strongman, a clown, and a woman sprawled on the ground, suckling a child. On the floor are the paraphernalia of Romanticism—a dagger, a guitar, a plumed hat. A skull rests on a newspaper, symbolizing the death of journalism. Behind the easel, as if invisible to the artist, is a nude male figure whose pose is in the tradition of Academic art.

On the right, and more brightly illuminated, are portraits of friends, members of Courbet's own artistic and literary coterie, an art collector and his fashionable wife, and a pair of lovers. Many of these are recognizable, including Courbet's patron, J. L. Alfred Bruyas, who financed the

Realist exhibition (see below). Seated at the far right and reading a book is the poet Charles Baudelaire, who was a champion of Realism at the time. Echoing Baudelaire's absorption in his book is a boy lying on the floor sketching, who has been interpreted as an allusion to Courbet himself as a child, as well as to the ideal of freedom in learning.

The central group (fig. **22.5**) illustrates Courbet's conception of himself as an artist, and his place in the history of western European painting. Having come from a provincial background himself, Courbet identifies the group on the left with his past. Those on the right refer to

22.5 Detail of fig. 22.4.

his present and future role in the sophisticated world of Parisian society. He himself is at work on a rural landscape, characteristically building up the paint with brushes and a **palette knife** in order to create the material textures of "reality." He displays the unformed paint by tilting his **palette** toward the observer, while also extending his arm to place a daub of paint on the landscape. In this gesture, he has appropriated the creative hand of Michelangelo's God in *The Creation of Adam* (see fig. 15.25). As such, Courbet shows himself in the act of observing nature and then *re*-creating it with his brush and colors. The creative hand of the artist, echoing an ancient tradition, is a metaphor for the creating hand of God.

In planning the *Studio*, Courbet also had in mind Velázquez's *Las Meninas* (see fig. 18.57) and Goya's *Family of Charles IV* (see fig. 21.16), in which the artist paints in company. Whereas Velázquez and Goya place themselves in the same room as the royal family, but off to one side, Courbet places himself at the center of the picture within the spectrum of society, midway between the workers and the intellectual elite. In contrast to his Spanish predecessors, whose canvases are unseen by the viewer, Courbet the artist is "enthroned" before his canvas. A nude woman inspires the painter-king. She is a kind of artistic "power behind the throne," or muse. In this role, she fulfills Courbet's stated relationship to earlier art—that is, he studies and absorbs it, but then transforms it according to his inspiration in the "real," present world. The further significance in the woman's placement behind Courbet is that the artist "turns his back" on her, rejecting the Academic tradition in the form of a Classical nude. The metaphorical link between the woman and the landscape is conveyed by the drapery above the canvas, which has been pulled back to reveal the view, just as she has revealed herself.

A small boy stands at Courbet's knee and stares raptly at his work, perhaps personifying the untrained, child-like admiration that Courbet hoped to arouse in his public. The boy has no socks, and wears *sabots*, or clogs, to indicate his rural origin. To the boy's right is a white cat which seems to be playing with the nude's falling drapery. But it turns its head and looks up at Courbet, recalling the sixteenth-century saying, "A cat may look at a king." The adage as represented here is a subtle combination of Courbet's egalitarian "socialism" and his self-portrait as an artist-king.

The *Studio* was offered to the International Exhibition of 1855, but was rejected by the jury. Courbet rented an exhibition space nearby, where he hung forty of his own paintings—the first one-man show in the history of art. The sign over the entrance read "Realism, G. Courbet." The public ignored the show, and most critics derided it. Courbet took the picture back to his studio, and exhibited it only twice more. It remained unsold until after his death.

Honoré Daumier

Honoré Daumier (1808–79), one of the most direct portrayers of social injustice, has been called both a Romantic and a Realist. In this chapter he is discussed in the context of Realism. A juxtaposition of his *Third-class Carriage* (fig. **22.6**) with *Interior of a First-class Carriage* (fig. **22.7**) illustrates his attention to Realist concerns. In both works, Daumier's characteristically dark, sketchy outlines and textured surfaces remind the viewer of his media. In both, a section of society seems to have been framed unawares. Strong contrasts of light and dark, notably in the silhouetted top hats, create clear edges, in opposition to the looser brushwork elsewhere. The very setting, the interior of a railroad car, exemplifies the new industrial subject-matter of nineteenth-century painting.

Although Daumier had painted for much of his life, he was not recognized as a painter before his first one-man show at the age of seventy. He earned his living by selling satirical drawings and cartoons to the Paris press and reproducing them in large numbers by **lithography** (see Box). His works usually appeared in *La Caricature*, a weekly paper founded in 1830 and suppressed by the government in 1835, and *La Charivari*, a daily paper started in 1832. Daumier satirized the corruption of political life, the legal system, judges, lawyers, doctors, businessmen, actors, bourgeois hypocrisy, and even the king himself (see Box on p. 746).

Lithography

A lithograph, literally a "stone (*lith*) writing or drawing (*graph*)," is a print technique first used at the end of the eighteenth century in France. In the nineteenth century, lithography became the most widely used print medium for illustrating books, periodicals, and newspapers, and for reproducing posters.

To create a lithograph, the artist makes a picture with a grease crayon on a limestone surface. Alternatively, a pen or brush is used to apply ink to the stone. Since limestone is porous, it "holds" the image. The artist then adds water, which adheres only to the non-greased areas of the stone, because the greasy texture of the image repels the moisture.

The entire stone is rolled with a greasy ink that sticks only to the image. When a layer of damp paper is placed over the stone and both are pressed together, the image is transferred from the stone to the paper, thereby creating the lithograph. This original print can then be reproduced relatively cheaply and quickly, making it suitable for mass distribution. Since the stone does not wear out in the printing process, an almost unlimited number of impressions can be taken from it.

In transfer lithography, a variant used by Daumier, the artist draws the image on paper, and fixes it to the stone before printing. This retains the texture of the paper in the print and is more convenient for mass production.

22.6 (above) Honoré Daumier, *Third-class Carriage*, c. 1862. Oil on canvas, 25¾ × 35½ in (65.4 × 90.2 cm). Metropolitan Museum of Art, New York (Bequest of Mrs. H. O. Havemeyer, 1929). Lower-class figures crowd together in a dark, confined space. The three drably dressed passengers in the foreground slump slightly on a hard, wooden bench. They seem resigned to their status, and turn inward, as if to retreat from harsh economic reality. Their psychological isolation defends them from the crowded conditions in which they live.

22.7 Honoré Daumier, *Interior of a First-class Carriage*, 1864. Crayon and watercolor, 8¹⁄₁₆ × 11¾ in (20.5 × 30 cm). Walters Art Gallery, Baltimore. Four well-dressed and comfortably seated passengers occupy the first-class car. One woman looks out of the window, as if alert to the landscape and not destined for a life of crowded confinement. The elegant dress and upright, neatly arranged poses of all these figures reveal their higher social position, compared with the rough dress and peasant-like proportions of their counterparts in the third class.

Gargantua

Gargantua, a good-natured giant in French folklore, became the main character in the classic work by Rabelais (c. 1494–1553) on monastic and educational reform, *La Vie Très Horrifique du Grand Gargantua* (*The Very Horrific Life of the Great Gargantua*). Rabelais's Gargantua is a gigantic prince with an equally enormous appetite. (The root word "garg" is related to "gargle" and "gorge," which is also French for "throat." In Greek, the word *gargar* means "a lot" or "heaps," and in English one who loves to eat is sometimes referred to as having a "gargantuan" appetite.)

In Daumier's print (fig. **22.8**), a gigantic Louis Philippe, the French king (1830–48), is seated on a throne before a starving crowd. A poverty-stricken woman tries to feed her infant, while a man in rags is forced to drop his last few coins into a basket. The coins are then carried up a ramp and fed to the King. Underneath the ramp, a crowd of greedy but well-dressed figures grasps at falling coins. A group in front of the Chamber of Deputies, the French parliament, applauds Louis Philippe. The message of this caricature is clear: a never-satisfied king exploits his subjects and grows fat at their expense. Daumier explicitly identified Louis Philippe as Gargantua in the title of the print. In 1832 Daumier, along with his publisher and printer, was charged with inciting contempt and hatred for the French government and with insulting the person of the King. He was sentenced to six months in jail and fined one hundred francs.

22.8 Honoré Daumier, *Louis Philippe as Gargantua*, 1831. Lithograph, 8⅜ × 12 in (21.4 × 30.5 cm). Private collection, Paris.

22.9 Honoré Daumier, *The Freedom of the Press: Don't Meddle with It (Ne Vous y Frottez Pas)*, 1834. Lithograph, 12 × 17 in (30.5 × 43.2 cm). Private collection, France. The implication of this image is that the power of the press is ultimately greater than that of a king. Daumier's depiction of dress according to class distinctions is characteristic of 19th-century Realist social observation.

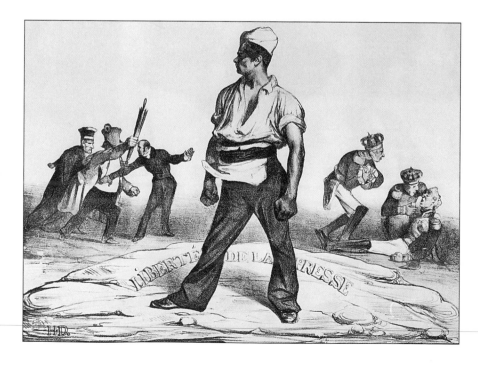

Photography means literally "drawing with light" (from the Greek *phos*, meaning "light" and *graphe*, meaning "drawing" or "writing"). The basic principles may have been known in China as early as the fifth century B.C. The first recorded account of the **camera obscura** (fig. **22.10**), literally a "dark room," is by Leonardo da Vinci. He described how, when light is admitted through a small hole into a darkened room, an inverted image appears on the opposite wall or on any surface (for example, a piece of paper) interposed between the wall and the opening. In the early seventeenth century, the astronomer Johannes Kepler devised a portable camera obscura, resembling a tent. It has since been refined and reduced to create the modern camera, the operation of which matches the principles of the original "dark room."

From the eighteenth century, discoveries in photo-chemistry accelerated the development of modern photography. It was found that silver salts, for example, were sensitive to light, and that an image could therefore be made with light on a surface coated with silver. In the 1820s a Frenchman, Joseph-Nicéphore Niépce (1765–1833), discovered a way to make the image remain on the surface. This

22.10 Diagram of a camera obscura. Here the camera obscura has been reduced to a large box. Light reflected from the object (1) enters the camera through the lens (2) and is reflected by the mirror (3) onto the glass ground (4), where it is traced onto paper by the artist/photographer.

process was called **fixing** the image; however, the need for a long exposure time (eight hours) made it impractical.

In the late 1830s another Frenchman, Louis Daguerre (1789–1851), discovered a procedure that reduced the exposure time to fifteen minutes. He inserted a copper plate coated with silver and chemicals into a camera obscura and focused through a lens onto a subject. The plate was then placed in a chemical solution (or "bath"), which "fixed" the image. Daguerre's photographs, called **daguerreotypes**, could not be reproduced, and each one was therefore unique. The final image reversed the real subject, however, and also contained a glare from the reflected light. In 1839 the French state purchased Daguerre's process and made the technical details public.

Improvements and refinements quickly followed. Con-temporaneously with the development of the daguerreo-type, the English photographer William Henry Fox Talbot (1800–77) invented "negative" film, which permitted multiple prints. The negative also solved the problem of Daguerre's reversed print image: since the negative was reversed, reprinting the negative onto light-sensitive paper reversed the image back again. By 1858 a shortened exposure time made it possible to capture motion in a still picture.

During the twentieth century, color photography dev-eloped. Still photography inspired the invention of "movies," first in black and white and then in color. Today, photo-graphy and the cinema have achieved the status of an art form in their own right.

From its inception, photography has influenced artists. Italian Renaissance artists used the camera obscura to study perspective. Later artists, including Vermeer, are thought to have used it to enhance their treatment of light. In the mid-nineteenth century, artists such as Ingres and Delacroix used photographs to reduce the sitting time for portraits. Eakins was an expert photographer who used photographic ex-periments to clarify the nature of locomotion.

Black-and-white photography has an abstract character quite distinct from painting, which, like nature itself, usually has color. The black-and-white photograph creates an image with tonal ranges of gray rather than line or color. Certain photographic genres, such as the close-up, the candid shot, and the aerial view, have influenced painting considerably.

In 1834, *La Caricature* published Daumier's protest against censorship, entitled *The Freedom of the Press: Don't Meddle with It* (fig. **22.9**). The foreground figure in working-class dress is Daumier's hero. He stands firm, with clenched fists and a set determined jaw. Behind him FREEDOM OF THE PRESS is inscribed like raised print-type on a rocky terrain. He is flanked in the background by two groups of three social and political types, who are the tar-gets of Daumier's caricature. On the left, members of the bourgeoisie feebly brandish an umbrella. On the right, the dethroned and crownless figure of Charles X receives inef-fectual aid from two other monarchs in a configuration that recalls West's *Death of General Wolfe* (see fig. 19.30).

So great was the impact of Daumier's caricatures that in 1835 France passed a law limiting freedom of the press to verbal rather than pictorial expression. The French auth-orities apparently felt that drawings were more apt to incite rebellion than words. Such laws, which are reminis-cent of the ninth-century Iconoclastic Controversy (see Vol. I, p. 301), are another reflection of the power of images. Clearly, the nineteenth-century French censors felt more threatened by the proverbial "picture" than by the "thousand words."

Photography

Another method of creating multiple images—and one that struggled to become an art form in its own right in the nineteenth century—was photography (see Box). It

achieved great popularity, and its potential use for both portraiture and journalism was widely recognized. Many painters were also photographers and, from the nineteenth century to the present, the mutual influence of photography and painting has grown steadily.

At first, photography was primarily a medium of portraiture. As such, it served several purposes. One of its most commercial successes was the *carte de visite*, or calling card, bearing the likeness of the sender. Heads of state, such as Queen Victoria and the French emperor Napoleon III, soon realized the potential of photography for political imagery. Eventually photography would be used to identify criminals, to capture the physiognomy, gestures, and postures of the insane, to record cultural groups and monuments throughout the world, and to document social conditions of all kinds.

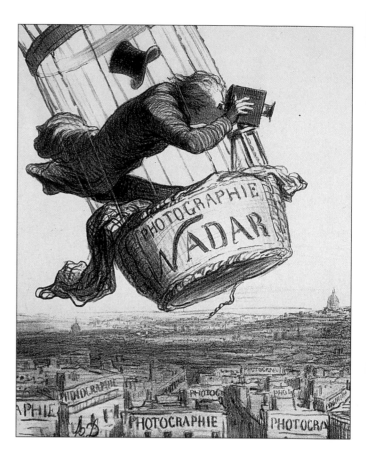

22.12 Honoré Daumier, *Nadar Elevating Photography to the Height of Art*, 1862. Lithograph, 10¾ × 8¾ in (27.2 × 22.2 cm). Museum of Fine Arts, Boston.

France: Nadar

In France, the photographic portraits taken by the novelist and caricaturist Gaspard-Félix Tournachon, known as Nadar (1820–1910), were particularly insightful. In 1853, he opened a studio, which was frequented by the celebrities of his generation. In contrast to most of his contemporaries, Nadar photographed his sitters against a plain, dark backdrop, focusing attention solely on the subjects themselves. His portrait of Sarah Bernhardt (fig. **22.11**), the renowned French actress, illustrates the subtle gradations of light and dark that are possible in the photographic medium. Nadar has captured Bernhardt in a pensive mood. Her dark, piercing eyes stare at nothing in particular, but seem capable of deep penetration.

In addition to portraiture, Nadar was a pioneer of aerial photography. He took the first pictures from a balloon in 1856, which demonstrated the potential of photography for creating panoramic vistas and new viewpoints. Nadar then built his own balloon, one of the largest in the world, which he named *Le Géant* (The Giant). In 1870, when France declared war on Prussia, Nadar helped organize the Paris balloon service for military observation.

From 1850 a new "quarrel" arose in the French art world over the status of photography. "Is it ART?" became

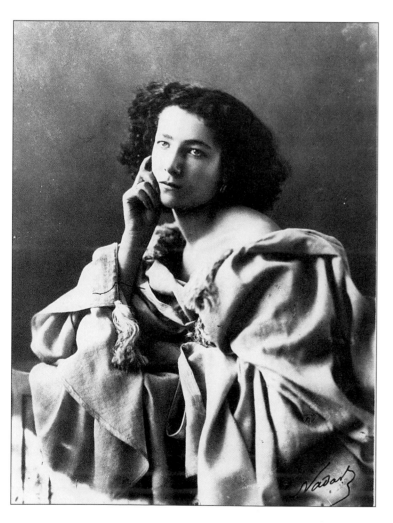

22.11 Gaspard-Félix Tournachon (Nadar), *Sarah Bernhardt*, c. 1864. Photograph from a collodion negative. Bibliothèque Nationale, Paris. In 1854 Nadar published *Le Panthéon Nadar*, a collection of his best works. The portrait of Bernhardt (at age fifteen) emphasizes her delicate features and quiet pose, in contrast to the large, voluminous, tasseled drapery folds.

22.13 Julia Margaret Cameron, *Mrs. Herbert Duckworth*, 1867. Photograph. Collection B. and N. Newhall, Rochester, New York. Mrs. Duckworth, later Mrs. Leslie Stephen, was the mother of the English author Virginia Woolf.

a controversial issue, with the "Nays" arguing that its mechanical technology made it an automatic, rather than an artistic, process. Because the artist's hand did not create the image directly, it was not "ART." Many adherents of this point of view did not, however, object to the use of photography for commerce, industry, journalism, or science. The exhibition of photography also became an issue, which was exemplified by the International Exhibition of 1855 in Paris. On the one hand, photography was brought before a wide public, and its advantages were

recognized. But on the other hand, because it was not shown in the Palais des Beaux-Arts (the Palace of Fine Arts), photography was allied with industry and science rather than with the arts. In 1859, the French Photographic Society negotiated an exhibition scheduled at the same time, and in the same building, as the Salon. But the two exhibitions were held in separate sections of the building.

In the 1860s, several books were published which argued that photography should be accorded artistic status. To some extent, this debate continues even today. Its irony can be seen in the light of the sixteenth- and seventeenth-century quarrels—in Venice and Spain, respectively—over the status of painting as a liberal art. In those instances, because the artist's hand *did* create the work, it was considered a craft, and not an art. With photography, the *absence* of the hand is used as an argument against artistic status.

This on-going quarrel did not escape Daumier's penchant for satire. In 1862 he executed the caricature of *Nadar Elevating Photography to the Height of Art* (fig. **22.12**), showing Nadar inside the *Géant*, photographing the rooftops of Paris. Each roof is inscribed with the word PHOTOGRAPHIE. Daumier emphasizes Nadar's precarious position by a series of sharp diagonals—from his hat to his camera lens, which is parallel to his legs, and the line of his back which repeats the basket and rim of the balloon. The force of the wind is indicated by the flying drapery, flowing hair, and hat about to be blown away. Height, in this image, is satirically equated with the lofty aspirations of photography to the status of ART.

England: Julia Margaret Cameron

In England, the portrait photographer Julia Margaret Cameron (1815–79) insisted on the esthetic qualities of photography. She manipulated techniques in order to achieve certain effects, preferring blurred edges and a dreamy atmosphere to precise outlines. Her 1867 portrait of Mrs. Herbert Duckworth (fig. **22.13**) illustrates these preferences. The softness of the face and collar, which emerge gradually from the darkness, seem literally "painted in light." Cameron conceived of photography almost with reverence, as a means to elicit the inner character of a talented sitter. She described this in her autobiography, *Annals of My Glass House*, as follows: "When I have had such men before my camera, my whole soul has endeavored to do its duty towards them in recording faithfully the greatness of the inner as well as the features of the outer man. The photograph thus taken has been almost the embodiment of a prayer."[1]

America: Mathew Brady

In the United States, the photographs of Mathew Brady (c. 1822–96) combine portraiture with on-the-spot journalistic reportage. In his "Cooper Union" portrait of Lincoln (fig. **22.14**), Brady depicts the president as a thoughtful, determined man. Lincoln's straightforward stare, as if gazing firmly down on the viewer, creates a very different impression from the dreamy, introspective characters of Nadar's *Sarah Bernhardt* and Cameron's *Mrs. Duckworth*. Lincoln stands before a column, which is both a standard studio "prop" and a reference to his sense of history. To foster the union of North and South, Lincoln cited the biblical metaphor "A house divided against itself cannot stand." His hand rests on a pile of books, evoking his profound commitment to literature and intellectual truth. Of the one hundred or so known photographs of Lincoln, more than one third were taken by Brady.

In April 1865, Brady photographed General Robert E. Lee, who led the Confederate troops in the American Civil War (fig. **22.15**). He portrayed the formally dressed and neatly groomed Lee as proud and dignified, despite defeat. Only a few creases in his clothing and under his eyes betray the years of suffering he has witnessed. His house in Richmond, like Lee himself, is shown still standing at the

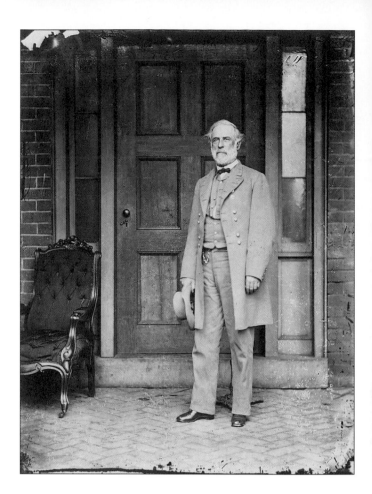

22.15 Mathew B. Brady, *Robert E. Lee*, 1865. Photograph. Library of Congress.

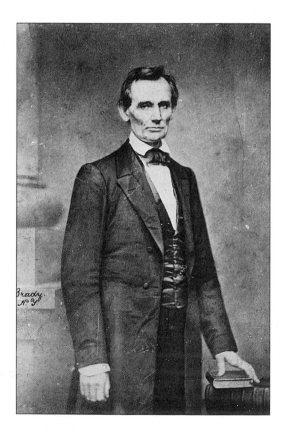

22.14 Mathew B. Brady, *Lincoln "Cooper Union" Portrait*, 1860. Photograph. Library of Congress. Brady took this photograph on February 27 at the Tenth Street Gallery in New York City. Lincoln had just delivered his Cooper Union Speech to the members of the Young Men's Republican Club.

end of the war—he is framed by the rectangle of his back door. The elegant, upholstered chair, half out of the picture plane, is a memento of the passing civilization for which he fought.

Differing from the varied tones that characterize the Lincoln and Lee portraits are the sharp contrasts of *The Ruins of Gallego Flour Mills, Richmond* (fig. **22.16**). The remains of the flour mills, burned when the Union army drove Confederate troops from Richmond, Virginia, stand—like the portrait of Robert E. Lee—as testimony to a dying civilization. The dark architectural skeleton, arranged as a stark horizontal, is silhouetted against a light sky with only a few intervening grays.

English Realism: The Pre-Raphaelites

An altogether different current of Realism developed in England with the Pre-Raphaelite Brotherhood, founded in 1848. It was the conception of three young London painters, William Holman Hunt (1827–1910), Dante Gabriel Rossetti (1828–82), and John Everett Millais (1829–96), and soon grew to include others. The three founders called themselves Pre-Raphaelites because of their belief that the aim of artists since (and including) Raphael had been to achieve beauty through idealization. They considered this esthetic artificial and sentimental, rather than natural and

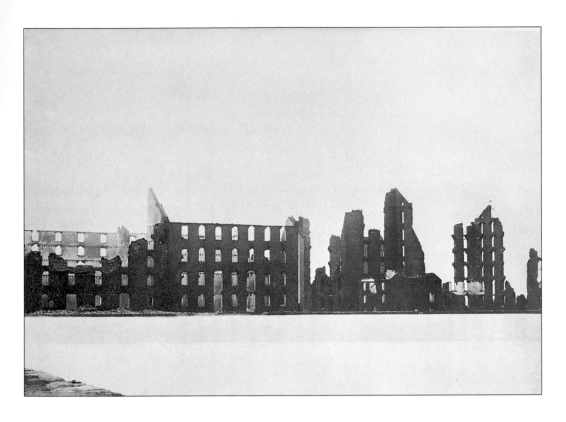

22.16 Studio of Matthew B. Brady, *Ruins of Gallego Flour Mills, Richmond*, 1863–5. Albumen-silver print from a glass negative, 6 × 8³⁄₁₆ in (15.2 × 20.8 cm). Museum of Modern Art, New York (purchase). When the Civil War broke out in 1861, Brady organized a group of cameramen into a "photographic corps" to record the events of the war. The project was a great artistic and historical success, but proved a financial disaster for Brady.

sincere. They therefore decided that their own inspiration would be drawn from the "truthful" crafts tradition that predated Raphael. In thus looking to the past, the Pre-Raphaelite movement had a Romantic quality.

Although the Pre-Raphaelites also followed Turner's ideal of truth to nature, their pictorial style is quite distinct from his. In contrast to the impressionistic quality of Turner's work, in which forms often dissolve into the paint, Pre-Raphaelite paintings are figurative, with clear edges and smooth surfaces often covered with precise patterns. Whereas Turner's color tended to be pastel, Pre-Raphaelite color is pure and vivid, and its subject-matter is wide ranging. It included portraiture, contemporary, mythological, medieval, and Christian themes.

Dante Gabriel Rossetti

Rossetti's *Ecce Ancilla Domini* ("Behold the Handmaid of the Lord"), also known as *The Annunciation* (fig. **22.17**), was exhibited in 1850. It infuses youthful emotional tension into the traditional religious scene. The Virgin, who was modeled on the artist's sister, is sullen and withdrawn. She cringes on her bed as a tall, thin, weightless, and somewhat effete Gabriel floats into her room with yellow flames at his feet. Rossetti represents the Virgin according to his idea of her "truth," that is, as a frightened adolescent in a sexually equivocal situation. He combines her inner disturbance with an oddly mystical atmosphere, accentuated by the conventional lilies, haloes, candle, and open window. Rossetti also depicts the nineteenth-century awareness of conflict between external appearance and internal, psychic reality.

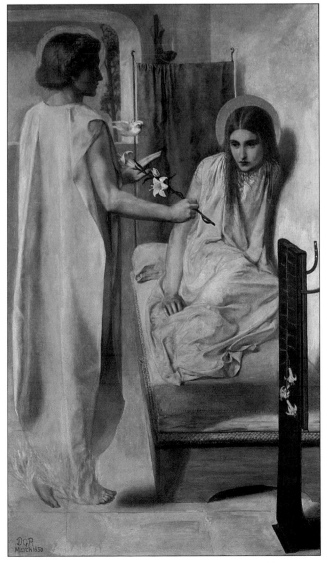

22.17 Dante Gabriel Rossetti, *Ecce Ancilla Domini* (*The Annunciation*), 1850. Oil on canvas, 28½ × 16½ in (72.4 × 41.9 cm). Tate Gallery, London.

John Everett Millais

One of the most glaring examples of the opposition between social propriety and hidden emotional turmoil is Millais' portrait of John Ruskin (fig. **22.18**). While the artist was working on the picture in 1854, he fell in love with Ruskin's wife Euphemia (Effie) Gray. Although Ruskin had been an ardent suitor, he was a disappointment as a husband; in 1855 the Ruskins' marriage was annulled on grounds of non-consummation. Effie literally escaped from Ruskin, married Millais, and subsequently had six children.

In his five-volume *Modern Painters*, a work of art criticism that he wrote in defense of Turner, Ruskin had advocated truth to nature. Millais' portrait is partly a tribute to Ruskin's vision of nature, which is evident in the landscape. The intricate details of rock formations and leaves reflect Ruskin's own passion for geology and botany as well as the Pre-Raphaelite attention to meticulous detail. Ruskin stands calmly, the quintessential picture of a Victorian gentleman in control of himself and his surroundings. His ruddy complexion and pale blue eyes are set against the darker background, while his black clothing contrasts with the light foreground rocks and the whites, yellows, and light blues of the water. He carries a walking stick, which suggests that he had climbed to the edge of the waterfall and stopped to contemplate nature. Ruskin's outward calm, in contrast to the rushing water, is an ironic and tragic image of England's greatest living art critic. Despite his genius for describing works of art and his extraordinary writings on many other subjects, Ruskin concealed and denied his emotional conflicts and repeated bouts of psychosis.

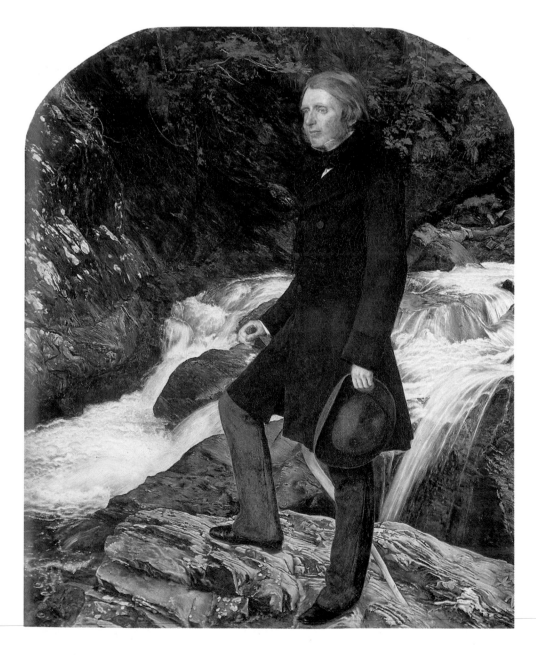

22.18 John Everett Millais, *John Ruskin*, 1854. Oil on canvas, 31 × 26¾ in (79 × 68 cm). Collection of Lady Gibson. John Ruskin (1819–1900), the son of a wealthy sherry merchant, grew up in a materially pampered but psychologically isolated and abusive home. When he went to Oxford University, his mother went too. The sadistic character of his upbringing is described in his autobiography, *Praeterita* ("From the Past"). In 1843, at the age of twenty-four, Ruskin published the first volume of *Modern Painters*. In 1849 he published *The Seven Lamps of Architecture*, and in 1851 *The Stones of Venice*. These books established his reputation as the leading English art critic of his generation. In the 1860s he wrote on economic and social matters, defending esthetic, humanitarian, and environmental values against free-market capitalism. In 1885, because of declining mental health, Ruskin had to resign his Slade Professorship at Oxford and retire to his family home in Coniston, in the Lake District. Throughout his life, he kept detailed diaries, some of which describe his psychotic episodes, including his dreams and hallucinations.

American Realism

Thomas Eakins

One of the landmarks of Realist painting in America was *The Gross Clinic* (fig. **22.19**) by Thomas Eakins (1844–1916). It depicts a team of doctors led by Dr. Samuel D. Gross, an eminent surgeon and professor at the Jefferson Medical College in Philadelphia. They are performing an operation dressed in street clothes, as was the custom in the nineteenth century. Dr. Gross holds a scalpel and comments on the operation to the audience in the amphitheater.

Eakins uses atmospheric perspective (see p. 500), and highlights the surgical procedure. In his choice of subject, as well as his lighting, Eakins echoes Rembrandt, who had painted a well-known scene of a doctor dissecting a cadaver. Here, however, the patient is alive, and a female relative, probably his mother, sits at the left and hides her face. In addition to using light to highlight the surgery, Eakins endows it with symbolic meaning. The illumination on Gross's forehead and hand accentuates his "enlightened" mind and his manual skill.

In the early 1870s Eakins had painted several oils of rowing, a sport he greatly enjoyed. He also translated this subject into watercolor. *John Biglen in a Single Scull* (fig. **22.20**) is one of a series showing the well-known rower with his oars poised above the water. Eakins' watercolors are deliberately executed, and were exhibited as finished pictures. This example juxtaposes the calm, undisturbed water, and the rower's tension as he awaits the signal to begin. The contrast is reinforced by the horizontals of the water, the horizon, and the body of the scull set against the diagonals of Biglen's outstretched arms, curved back, bent knees, and the long oar.

22.19 (above) Thomas Cowperthwait Eakins, *The Gross Clinic*, 1875–6. India ink and watercolor on cardboard, 23¾ × 19¼ in (60.4 × 49.1 cm). Metropolitan Museum of Art, New York (Rogers Fund, 1923). As an art teacher, Eakins emphasized the study of anatomy, dissection, and scientific perspective. He clashed with the authorities of the Pennsylvania Academy over his policy that women art students draw from the nude.

22.20 (left) Thomas Cowperthwait Eakins, *John Biglen in a Single Scull*, 1873. Watercolor on off-white wove paper, 19⁵⁄₁₆ × 24⅞ in (49.2 × 63.2 cm). Metropolitan Museum of Art, New York (Fletcher Fund, 1924).

22.21 Henry Ossawa Tanner, *Annunciation*, 1898. Oil on canvas, 4 ft 9 in × 5 ft 11½ in (1.45 × 1.82 m). Philadelphia Museum of Art (W. P. Wilstach Collection). Tanner's mother was born a slave, and remained so until her father was given his freedom. She moved to Pittsburgh, attended school, and eventually married the Reverend Benjamin Tucker Tanner, who became a bishop. Tanner's parents admired the abolitionist John Brown; they gave their son the middle name Ossawa after Osawatomie, Kansas, where John Brown killed several vigilantes who were fighting to preserve slavery.

Henry Ossawa Tanner

Eakins' student Henry Ossawa Tanner (1859–1937) moved to Paris, where he was the first African-American to exhibit at the Paris Salon. Under Eakins' influence, he painted Realist scenes of African-American life in the United States. Later he used his religious faith to express what he believed were the universal emotions—the essential reality—in biblical stories. In that approach, Tanner can be compared with certain of the Pre-Raphaelites. He traveled to the Middle East in January 1897, and absorbed the atmosphere that would provide the setting for his biblical pictures.

The next year, Tanner exhibited his *Annunciation* (fig. **22.21**) at the Salon. He shows Mary having just awakened and sitting up in bed. She tilts her head to stare at the appearance of a gold rectangle of light, which signifies a divine presence. The attention to realistic details such as Mary's dress, the stone floor, and Near Eastern rug, is combined—as in Rossetti's *Ecce Ancilla Domini*—with mystical qualities of light. Tanner shares with Rossetti the depiction of Mary's inner reality as an apprehensive participant in a miraculous event.

French Realism in the 1860s

Edouard Manet's *Déjeuner sur l'Herbe*

The work of Edouard Manet (1832–83) in Paris formed a transition from Realism to Impressionism (which is the subject of the next chapter). By and large, Manet's paintings of the 1860s are consistent with the principles of Realism, whereas in the 1870s and early 1880s he adopted a more Impressionist style.

In 1863, Manet shocked the French public by exhibiting his *Déjeuner sur l'Herbe* ("Luncheon on the Grass") (fig. **22.22**). It is not a Realist painting in the social or political sense of Daumier, but it is a statement in favor of the artist's individual freedom, and challenges the viewer on several grounds. The shock value of a nude woman casually lunching with two fully dressed men, which was an affront to the propriety of the time, was accentuated by the recognizability of the figures. The nude, Manet's model Victorine Meurend, stares directly at the viewer. The two men are Manet's brother Gustave and his future brother-in-law, Ferdinand Leenhoff. In the background, a lightly clad woman wades in a stream.

Although Manet's *Déjeuner* contains several art historical echoes in references to well-known Renaissance pictures by Raphael and Titian, they have been transformed in a way that was unacceptable to the nineteenth-century French public. The figures were not sufficiently Classical, or even close enough to their Renaissance prototypes, to pass muster with the prevailing taste. Certain details such as the bottom of Victorine's bare foot, and the unidealized rolls of fat around her waist, aroused the hostility of the critics. The seemingly cavalier application of paint also annoyed viewers, with one complaining, "I see fingers without bones and heads without skulls. I see sideburns painted like two strips of black cloth glued on the cheeks."

Manet's *Olympia*

Manet created an even more direct visual impact in the *Olympia* (fig. **22.23**), which also caused a scandal when first exhibited in 1865. Here again, Manet is inspired by the past—most obviously by Giorgione's *Sleeping Venus* (see fig. 15.52) and Titian's *Venus of Urbino* (see fig. 15.54). But

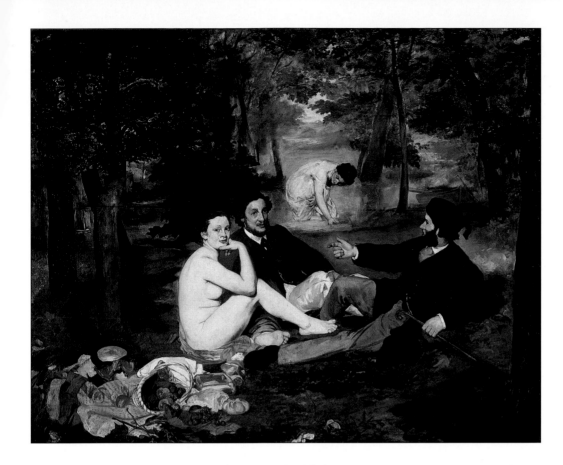

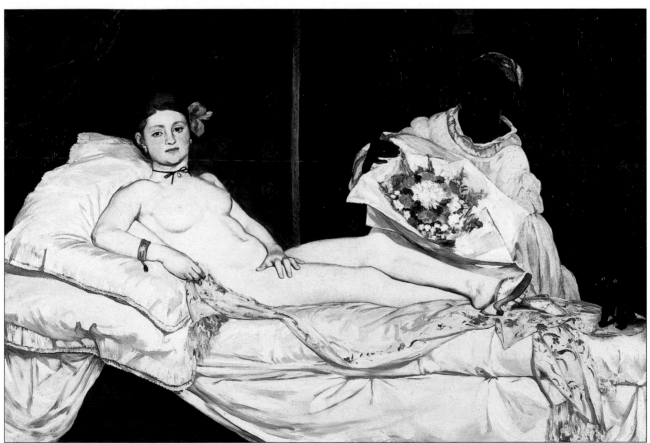

22.23 Edouard Manet, *Olympia*, 1865. Oil on canvas, 4 ft 3 in × 6 ft 3 in (1.3 × 1.9 m). Musée d'Orsay, Paris. Olympia is naked rather than nude, an impression emphasized by her bony, unclassical proportions. The sheets are slightly rumpled, suggesting sexual activity. The flowers that her maid delivers have clearly been sent by a client. Olympia's shoes may refer to "streetwalking," and the alert black cat is a symbol of sexuality, no doubt because of the popular reputation of the alley cat. The term "cat house" is commonly used for a brothel.

whereas the Italian Renaissance nudes are psychologically "distanced" from the viewer's everyday experience by their designation as Classical deities, Manet's figure (the same Victorine who posed for the *Déjeuner*) was widely assumed to represent a prostitute. As such, she raised the specter of venereal disease, which was rampant in Paris at the time. The reference to "Olympia" in such a context only served to accentuate the contrast between the social "reality" of nineteenth-century Paris and the more comfortably removed Classical ideal. Titian had also relieved the viewer's confrontation with his Venus by constructing a space that receded into depth. In the *Olympia*, however, the back wall of the room approaches the picture plane, separated from it only by the bed and the black servant. Olympia is harshly illuminated in contrast to the soft light and gradual, sensual shading of Titian's Venus. Furthermore, she shows none of the traditional signs of modesty, but instead stares boldly at the viewer.

The Salon (see p. 722), biased as it was toward Academic art, had always been uncomfortable with "modern" works. It did not know what to make of Manet. In 1863 it rejected his *Déjeuner*, but two years later accepted the *Olympia*. It is impossible to overestimate not only the depth of feeling that surrounded the decisions of the Salon juries, but also the hostile criticism that generally greeted **avant-garde**, or modernist, works. In 1863 there was an outcry following the rejection of over 4000 canvases by the Salon jury. This prompted Napoleon III to authorize a special exhibition, the "Salon des Refusés," for the rejected works. Among the "rejected" were Manet, Camille Pissarro, Paul Cézanne (only one of whose works was ever shown in an official Salon during his lifetime), and James Abbott McNeill Whistler—all of whom subsequently gained international recognition.

It is interesting that Manet's *Olympia* caused dissension even among the ranks of the so-called Realists. Not only was it considered an affront by the Academic artists and the bourgeois public, but it also offended Courbet, author of the "Realist Manifesto," who pronounced it "as flat as a playing card."

Courbet's *Woman with a Parrot*

In 1866, a year after Manet exhibited *Olympia*, Courbet exhibited his *Woman with a Parrot* (fig. **22.24**). Courbet's woman is set in a deeper space than Olympia, and does not confront the viewer as directly. Her head falls back on the bed, and her self-consciously wavy hair corresponds to the ripples of the bedcover. Courbet softens her impact on the viewer by turning her face toward the parrot perched on her hand. Her sexuality was seen as less threatening than Olympia's because she is somewhat idealized and turns from the viewer. The woman with the parrot is voluptuous, her shading more gradual than Olympia's. She is nude rather than naked.

Architecture and Sculpture

By and large, nineteenth-century architects were not quick to adopt iron and steel, both of which had been recently developed, as building materials. At first they did not regard them as suitable for such use. Accordingly, the first

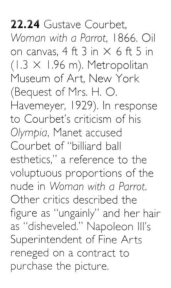

22.24 Gustave Courbet, *Woman with a Parrot*, 1866. Oil on canvas, 4 ft 3 in × 6 ft 5 in (1.3 × 1.96 m). Metropolitan Museum of Art, New York (Bequest of Mrs. H. O. Havemeyer, 1929). In response to Courbet's criticism of his *Olympia*, Manet accused Courbet of "billiard ball esthetics," a reference to the voluptuous proportions of the nude in *Woman with a Parrot*. Other critics described the figure as "ungainly" and her hair as "disheveled." Napoleon III's Superintendent of Fine Arts reneged on a contract to purchase the picture.

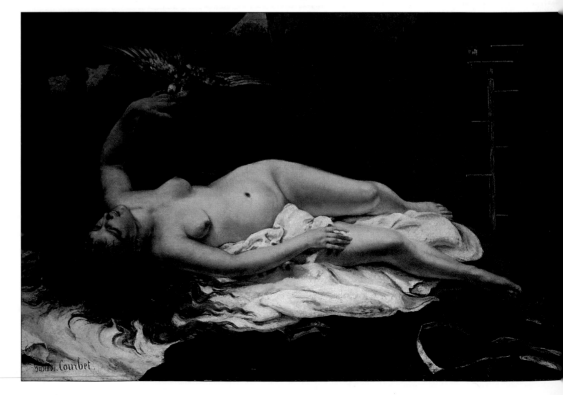

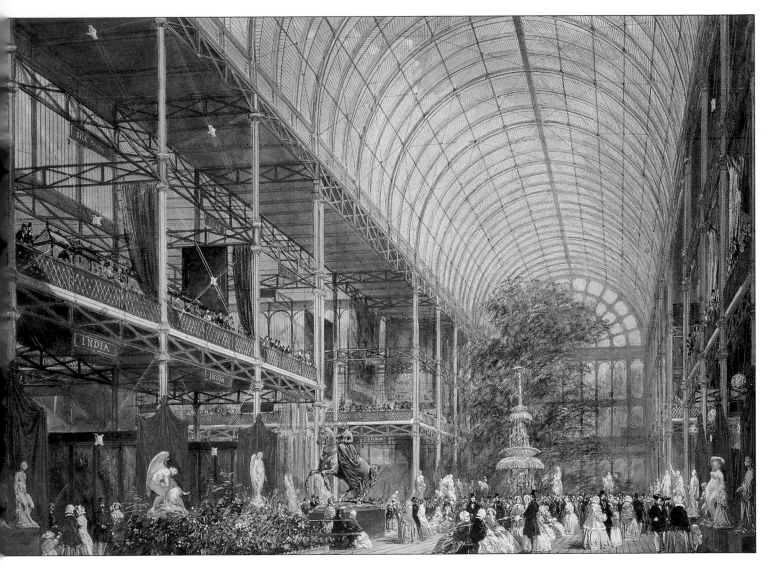

22.25 Joseph Paxton, Crystal Palace, London, 1850–51. Cast iron, wrought iron, and glass. Engraving (R. P. Cuff after W. B. Brounger). Drawings Collection, Royal Institute of British Architects, London. The Crystal Palace was 1850 ft (563.88 m) long (perhaps an architect's pun on the year in which it was built) and 400 ft (121.92 m) wide. It covered an area of 18 acres (7.3 ha), enclosed 33 million cubic feet (934,000 m³) of space (the largest enclosed space up to that time), and contained more than 10,000 exhibits of technology and handicrafts from all over the world.

major project making extensive use of iron was considered a utilitarian structure rather than a work of art.

Joseph Paxton: The Crystal Palace

In 1851 the "Great Exhibition of the Works of Industry of All Nations" was held in London. This was the first in a series of Universal, or International, Expositions ("Expos") and World's Fairs which continue to this day. Architects were invited to submit designs for a building in Hyde Park to house the exhibition.

When Joseph Paxton submitted his proposal, 245 designs had already been received and rejected. Paxton had started his career as a landscape gardener, and had built large conservatories and greenhouses from iron and glass. Not only was his proposal less expensive than the other designs, but it could be completed within the nine-month deadline. The design was subdivided into a limited number of components and subcontracted out. The individual components were thus "prefabricated," or made in advance and assembled on the actual site. Because of its extensive use of glass, the structure was dubbed the Crystal Palace (fig. **22.25**).

There were many advantages to this construction method. Above all, prefabrication meant that the structure could be treated as a temporary one. After the exhibition had ended, the building was taken apart and reassembled on a site in the south of London. But one alleged advantage of iron and glass—that they were fireproof—proved to be illusory. In 1936 the Crystal Palace was destroyed in a fire, the framework buckling and collapsing in the intense heat.

Bridges: The Roeblings

The industrializing countries, particularly the United States with its great distances, urgently needed better systems of transportation to keep up with the advances in communication and commerce. Rivers and ravines had to be crossed by roads and railroads, and this led to new developments in nineteenth-century bridge construction. Until the 1850s bridges had been designed according to the **truss** method of construction, which utilized short components joined together to form a longer, rigid framework. Wooden truss bridges used by the Romans to cross the River Danube, for example, are illustrated on Trajan's Column (see fig. 8.36). By the 1840s, metal began to replace wood as the preferred material for such bridges.

The principle of the **suspension bridge** had been known for centuries, from the bridges of twisted ropes or vines that had been used to cross ravines in Asia and South America. The superior span and height of the suspension bridge were appropriate for deep chasms or wide stretches of navigable water. Modern suspension bridges were built from the early 1800s using iron chains, but by the middle of the century engineers had begun to see the advantages of using flexible cable made of steel wire.

The greatest American bridge builders of the nineteenth century were J. A. Roebling (1806–65) and his son, W. A. Roebling (1837–1926), who were responsible for the Brooklyn Bridge (fig. **22.26**). Two massive towers of granite were constructed at either end of the bridge. They were linked by four huge parallel cables, each containing over 5000 strands of steel wire. The steel, which was spun on the site, supported the roadways and pedestrian walkways. It was the first time that steel had been used for this purpose. Ironically, however, in deference to architectural tradition, the shape of the arches in the masonry was a return to the Gothic style.

22.26 John A. and W. A. Roebling, Brooklyn Bridge, New York, 1869–83. Stone piers with steel cables, 1595 ft (486 m) span. This suspension bridge spanned the East River to connect Manhattan (New York City) and Brooklyn. Like the Crystal Palace, the Brooklyn Bridge was regarded as a work of engineering rather than of architecture.

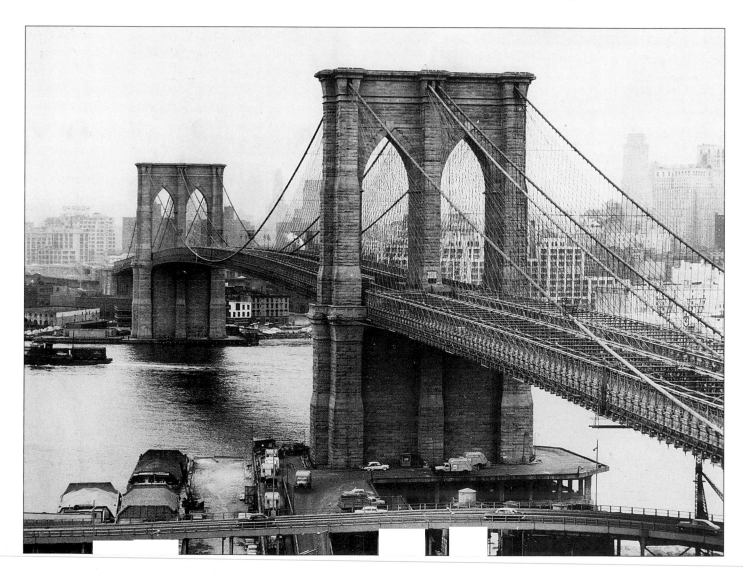

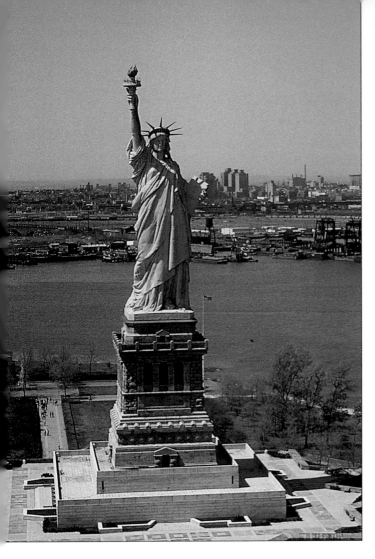

22.27 Auguste Bartholdi and Alexandre-Gustave Eiffel, Statue of Liberty, New York, 1875–84. Copper plate on a steel and wrought-iron framework, 151 ft 6 in (46.2 m) high.

The Statue of Liberty

Shortly after the American Civil War a French intellectual, Edouard de Laboulaye, thought of presenting the United States with a monument to commemorate French assistance to America in the Revolutionary War. For the next ten years, funds were raised from France by public subscription and the monument was constructed from 1875 to 1884.

Originally called *Liberty Enlightening the World*, but popularly known as the Statue of Liberty, the monument is a massive statue (fig. **22.27**) of a classically clothed woman raising the torch of liberty. In her left hand she holds a tablet bearing the starting date of the American Revolution, July 4, 1776. She steps forward in a traditional *contrapposto* pose, and looks slightly to her right. The statue's weight (225 tons) and height (151 ft 6 in (46.2 m)), and the fact that it was destined for a site where it would be constantly exposed to strong winds, required the skills of both a sculptor and a structural engineer.

The sculptor was Auguste Bartholdi (1834–1904), who had been influenced by colossal Egyptian sculptures and had established himself in France as a sculptor on a

massive scale. He fashioned the statue by hammering thin copper sheets into the required shape and then attaching them with iron straps to a supporting framework. The frame (fig. **22.28**) was built of steel and wrought iron by Alexandre-Gustave Eiffel (1832–1923).

In 1885 the completed statue was disassembled and shipped to America. It was reassembled on Bedloe's Island (later renamed Liberty Island), which guards the entrance to New York Harbor. The pedestal on which the statue stands, approximately the same height as the statue itself, was financed by the American public. The statue's proximity to Ellis Island, the most important entry port for immigration to America, made it one of the first sights greeting millions of immigrants. As such, its very concept is consistent with the nineteenth-century theme of struggle for social, political, and artistic freedom. It has become an icon of liberty, symbolizing opportunity for Americans and non-Americans alike.

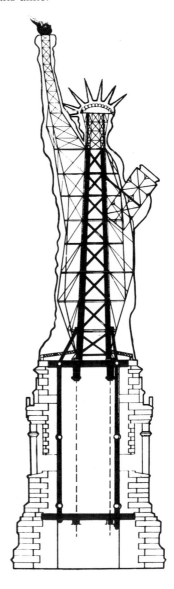

22.28 Gustav Eiffel, diagram of the construction of the Statue of Liberty.

The Eiffel Tower

Like the Crystal Palace, the Eiffel Tower in Paris (fig. 22.29) was built as a temporary structure. It was designed as a landmark for the Universal Exposition of 1889, celebrating the centenary of the French Revolution. From the third and highest platform of the tower, visitors could enjoy a spectacular panorama of Paris, covering a radius of about fifty miles (80 km).

Named for its designer, the same Eiffel who engineered the framework for the Statue of Liberty, the tower was a

22.29 (below) Alexandre-Gustave Eiffel, Eiffel Tower, Paris, 1887–9. Wrought-iron superstructure on a reinforced concrete base, 984 ft (300 m) high; 1052 ft (320 m) including television mast. The Eiffel Tower was so controversial that a petition demanding its demolition was circulated. When the Exposition ended in 1909, the tower was saved because of its value as a radio antenna. Its original height, before the addition of a television mast, was twice that of the dome of Saint Peter's or the Great Pyramid at Giza. Until the Empire State Building was built in New York in 1932, the Eiffel Tower was the highest man-made structure in the world.

22.30 (above) Louis Sullivan, Wainwright Building, St. Louis, Missouri, 1890–91. Photograph © Wayne Andrews/Esto.

metal truss construction on a base of reinforced concrete. Through the curves of the elevation and the four semicircular curves of the base—all executed in open-lattice wrought iron—Eiffel transformed an engineering feat into an elegant architectural monument. An unusual feature of the Tower was the design of its elevators (by the American Elisha Otis), which at the lowest level had to ascend in a curve. In 1889 elevators were still something of a novelty, although they would become a staple of commercial and residential architecture within the next generation.

Origins of the Skyscraper: Louis Sullivan

By the second half of the nineteenth century, a new type of construction was needed to make more economical use of land. One of the drawbacks of masonry or brick construction is that the higher the building, the thicker the supporting walls have to be at the base. This increases the cost of materials, the overall weight of the structure, and the area that it occupies. The new materials of structural steel and concrete reinforced with steel wire or mesh were stronger than the traditional materials. Their **tensile strength** (ability to withstand longitudinal stress) was also much greater, allowing flexibility in reaction to wind and other pressures. The power-driven electric elevator, invented by Elisha Otis in the latter half of the century, was another necessity for highrise construction. All of the ingredients for the skyscraper were now in place. Skyscrapers could be used as apartment houses, office buildings, multi-story factories, department stores, auditoriums, and other facilities for mass entertainment.

The Wainwright Building in St. Louis (fig. **22.30**), a nine-story office building built in 1890–91, is one of the finest examples of early highrise building. It is based on the **steel frame** method of construction, in which steel girders are joined horizontally and vertically to form a grid. The framework is strong enough for the outer and inner walls to be suspended from it without themselves performing any supporting function. Architectural features which had been used since Classical antiquity and the Gothic era—post-and-lintel, arch, vault, buttress—were now functionally superfluous.

The architect, Louis Sullivan, used a Classical motif to stress the verticality of the building and to disguise the fact that it was basically a rectangular block with nine similar horizontals superimposed on one another. He treated the first and second floors as a horizontal base. The next seven floors were punctuated vertically by transforming the wall areas between the windows into slender pilasters (every second one corresponding to a vertical steel beam), extending from the third to the ninth floor. The top floor, which contained the water tanks, elevator plant, and other functional units, was made into an overhanging cornice, with small circular windows blending into the ornamental reliefs. The Renaissance impression of the building is heightened by the brick, red granite, and terracotta facing. Although the Wainwright Building is not tall by contemporary standards, Sullivan's use of Classical features makes it seem taller than it actually is.

	Style/Period	Works of Art	Cultural/Historical Developments
1830	REALISM 1830–1850	Daumier, *Louis Philippe as Gargantua* (**22.8**) Daumier, *The Freedom of the Press* (**22.9**) **Daumier, *Louis Philippe as Gargantua***	John Ruskin, *Modern Painters* (1843) John Stuart Mill, *Principles of Political Economy* (1848) Karl Marx and Friedrich Engels, *The Communist Manifesto* (1848) Alexandre Dumas the Younger, *La Dame aux Camelias* (1849)
1850	1850–1860 	Rossetti, *The Annunciation* (**22.17**) Paxton, Crystal Palace (**22.25**), London Bonheur, *The Horse Fair* (**22.3**) Millais, *John Ruskin* (**22.18**) Courbet, *The Interior of my Studio* (**22.4–22.5**) Millet, *The Gleaners* (**22.2**) **Courbet, *The Interior of my Studio***	Herman Melville, *Moby Dick* (1851) Harriet Beecher Stowe, *Uncle Tom's Cabin* (1851) Crimean War (1853–6) Haussmann begins reconstruction of Paris boulevards (1853) Henry David Thoreau, *Walden* (1854) Walt Whitman, *Leaves of Grass* (1855) Gustave Flaubert, *Madame Bovary* (1857) Charles Baudelaire, *Les Fleurs du Mal* (1857) First transatlantic cable laid (1858–66) Charles Darwin, *Origin of Species* (1859)
1860	1860–1870 **Manet, *Le Déjeuner sur l'Herbe***	Brady, *Lincoln "Cooper Union" Portrait* (**22.14**) Daumier, *Third-class Carriage* (**22.6**) Nadar, *Sarah Bernhardt* (**22.11**) Brady, *Ruins of Gallego Flour Mills* (**22.16**) Daumier, *Nadar Elevating Photography to the Height of Art* (**22.12**) Manet, *Le Déjeuner sur l'Herbe* (**22.22**) Daumier, *Interior of a First-class Carriage* (**22.7**) Manet, *Olympia* (**22.23**) Brady, *Robert E. Lee* (**22.15**) Courbet, *Woman with a Parrot* (**22.24**) Cameron, *Mrs. Herbert Duckworth* (**22.13**)	William Morris founds Arts and Crafts movement in England (1860s) Charles Dickens, *Great Expectations* (1861) American Civil War (1861–5) Victor Hugo, *Les Miserables* (1862) Le Salon des Refusés, Paris (1863) Leo Tolstoy, *War and Peace* (1864–9) Assassination of Abraham Lincoln (1865) Lewis Carroll, *Alice's Adventures in Wonderland* (1865) Gregor Mendel formulates laws of genetics (1865) Fyodor Dostoevsky, *Crime and Punishment* (1866) Russia sells Alaska to U.S.A. (1867) Louisa M. Alcott, *Little Women* (1868) Opening of Suez Canal (1869) U.S. transcontinental railroad completed (1869) **Brady, *Ruins of Gallego Flour Mills***
1870 / **1900**	1870–1900 **Roebling, Brooklyn Bridge**	Roebling, Brooklyn Bridge (**22.26**), New York Eakins, *John Biglin in a Single Scull* (**22.20**) Eakins, *The Gross Clinic* (**22.19**) Bartholdi and Eiffel, Statue of Liberty (**22.27**), New York Eiffel, Eiffel Tower (**22.29**), Paris Sullivan, Wainwright Building (**22.30**), St. Louis Tanner, *Annunciation* (**22.21**)	Franco-Prussian War; Bismarck becomes Chancellor of Germany (1870–71) Heinrich Schliemann begins excavations at Troy (1870) Émile Zola, *Thérèse Raquin* (1871) Samuel Butler, *Erewhon* (1872) Thomas Hardy, *Far from the Madding Crowd* (1874)

23
Nineteenth-Century Impressionism

The Impressionist style evolved in Paris in the 1860s and continued into the early twentieth century. Unlike Realism, Impressionism responded rarely to political events. The devastating effects of France's defeat in the Franco-Prussian War in 1871, for example, had virtually no impact on Impressionist imagery. Impressionist painters preferred genre subjects, especially scenes of leisure activities, entertainment, and landscape, and Impressionism was more influenced by Japanese prints and new developments in photography than by politics.

Despite the changing focus of its content, Impressionism was in some ways a logical development of Realism. But Impressionists were more concerned with optical than with social realism. In their concern with political commentary, the Realists had emphasized social observation, while the Impressionists were concerned with the natural properties of light. As optical realists, they studied changes in light and color caused by weather conditions, times of day, and seasons, making shadows and reflections important features of their iconography. Impressionists also studied the effects of interior, artificial lighting, such as theater spotlights and café lanterns. Nevertheless, these formal concerns did not entirely eliminate the interest in observing society, and the changes brought about by growing industrialization; subject-matter included canals and barges, factories with smoking chimneys, and railway stations.

To a large extent, the Impressionist painters formed a distinct community. Although many were from bourgeois families, they liked to exchange ideas in more bohemian surroundings, notably the Café Guerbois in the Montmartre district of Paris, where Manet, Degas, and their circle used to congregate. Because their paintings were initially, and vociferously, rejected by the French Academy, as well as by the French public at large, the Impressionists became a group apart and held eight exhibitions dedicated to their own work between 1874 and 1886, the first of which was held at the studio of the photographer Nadar (see p. 748). Ironically, despite the contemporary rejection of Impressionism, it had a greater international impact in the long run than previous styles that France readily accepted.

Urban Renewal during the Second Empire

In 1852, after a coup the previous year, Napoleon Bonaparte's nephew, Napoleon III, had himself proclaimed ruler of the Second Empire. For political as well as esthetic reasons, he decided to modernize Paris. He wanted Paris to be the center of European culture, adapting industrial developments to improve the lifestyle of the general population. New housing would eliminate slums, and wide boulevards would replace the old, narrow, medieval streets. Modern amenities such as drainage and sewer systems, clean water supplies, bridges, lamplighting along the streets, outdoor fountains, and public parks would engage the citizens of Paris in renewed civic pride. The Emperor believed that these renovations would discourage revolutionary activity and prevent uprisings of the kind that swept Europe in 1848. With this in mind, in 1853 he commissioned Baron Georges-Eugène Haussmann (1809–91) to plan and supervise the new urban design.

Baron Georges-Eugène Haussmann

Haussmann was inspired by the Baroque grandeur of Bernini's Square of Saint Peter's (see fig. 18.4) and the layout of Versailles (see fig. 18.13). His plan was to focus on important buildings, on which the boulevards converged (or from which they radiated). Figure 23.1 shows the Place de l'Étoile (Square of the Star) with the Arc de Triomphe (cf. fig. 20.8) at the center of a traffic circle. This design facilitated the movement of vehicles and crowds, while also emphasizing the political significance of the triumphal arch.

Jean-Louis-Charles Garnier

One of the architects hired to work on the renovation was Jean-Louis-Charles Garnier (1825–98). He created the greatest of the new buildings, the Paris Opéra, from 1862 to 1875. Figure 23.2 is an aerial view of the Opéra and the arrangement of the boulevards in relation to it. The façade

23.1 Aerial view of the Place de l'Étoile, Paris, seen from the west. From the Place de l'Étoile, the Avenue des Champs-Elysées leads eastward to the Jardin des Tuileries and, beyond that, to the Louvre.

23.2 Aerial view of the Place de l'Opéra, Paris.

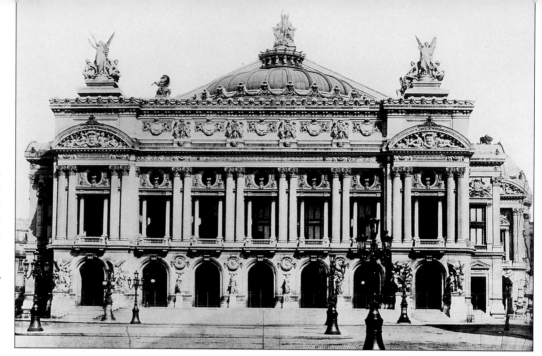

23.3 Jean-Louis-Charles Garnier, façade of the Opéra, Paris, 1862–75.

(fig. **23.3**) is clearly Baroque in conception, reflecting the opulence of Second Empire taste as well as the fact that opera itself is a Baroque form. The interior view of the Grand Staircase (fig. **23.4**) exemplifies the character of this neo-Baroque splendor, with its colossal Ionic columns, the broken pediment at the head of the stairs, the upper story balustrade surmounted by undulating arches, and the ornate frescoes on the ceiling. Like the Galerie des Glaces at Versailles (see fig. 18.14), mirrors adorned the Opéra walls. This feature, together with the vast open space around the stairway, created a "stage" on which the operagoers circulated. Seeing and being seen, as much as the performance itself, enhanced the excitement of attending the opera.

The plan (fig. **23.5**) shows Garnier's organization of the entrances, which corresponded to the social rank of the audience. The Emperor would have had a private entrance accessible by a ramp, had he not fallen from power before its completion. Everyone else was divided according to whether they arrived by carriage (at the side entrance) or on foot (through the main entrance), and whether they already had tickets or intended to buy them at the box office.

Painting

Edouard Manet

At first Manet remained separate from the core of Impressionist painters, who were his contemporaries. He did not adopt their interest in bright color and the study of light until the 1870s. From around 1866, he was championed by the novelist Émile Zola, who wrote art criticism for the Paris weekly *L'Événement*. Zola argued in favor of Manet's challenge to Academic taste on the grounds that artists should be free to pursue their own esthetic inclinations.

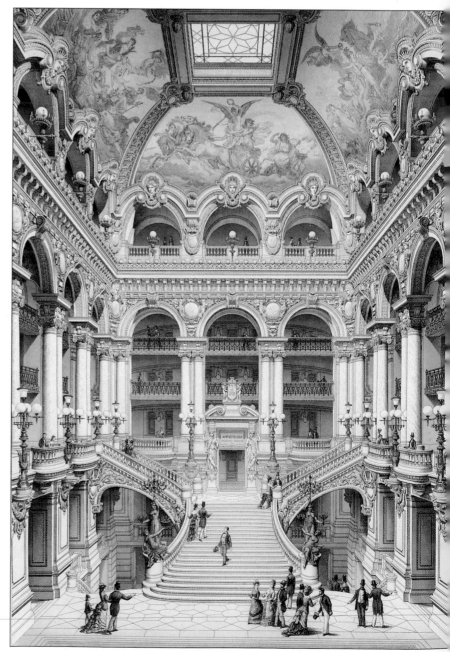

23.4 Grand Staircase of the Opéra, Paris. Engraving, 1880.

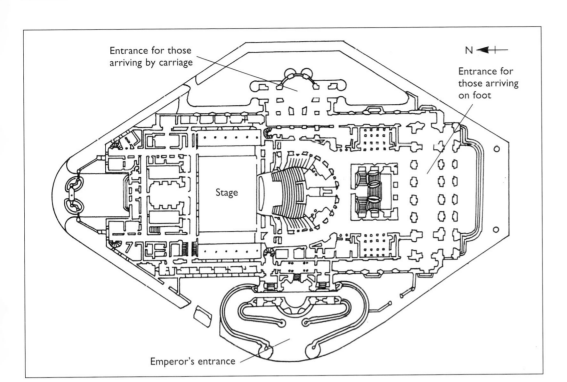

Entrance for those
arriving by carriage

N

Entrance for
those arriving
on foot

Stage

Emperor's entrance

Zola When Manet exhibited his portrait of Zola (fig. **23.6**) in 1868, it was not popular. As with the *Olympia* (see fig. 22.23), Manet's *Zola* occupies a narrow space and is right up against the picture plane. Even at this early date, the *Zola* reveals elements that would become characteristic of Impressionism. The figure's studied casualness, for example, and the close-up view create the impression of an unposed snapshot. Zola's manuscripts are piled up in front of his books, so that his review of Manet's work is visible on top of the pile. The textured paint, in contrast to Neoclassical clarity of edge and smoothness of surface, shows sympathy with the Impressionist esthetic. At the left is a Japanese screen; its pattern of white flowers is repeated in the gold upholstery nails on the chair and reflects the influence of the new *japonisme* on nineteenth-century painting.

In addition to the Japanese screen, Manet uses the device of pictures within pictures as a kind of visual autobiography, showing the sources for Zola's portrait. A reproduction of his *Olympia* overlaps an etching by Goya of Velázquez's *The Drinkers* and a Japanese print of a wrestler. The juxtaposition of Goya with Velázquez reflects Manet's affinity for Spanish art. Velázquez had, at times, painted in strong contrasts of light and dark, while Goya's late series of black paintings appealed to Manet's early interest in black tones. *Olympia*'s placement on top of reproductions of Manet's predecessors is a temporal metaphor, accentuating the fact that Manet is the more "modern," in the sense of "recent," artist. The Japanese print is only slightly overlapped by the *Olympia*, indicating its contemporariness. Both the print and the *Olympia* make use of flattened form and areas of dark silhouettes, characteristics that recur in the *Zola*.

23.6 Edouard Manet, *Zola*, exhibited 1868. Oil on canvas, 57 × 45 in (144.8 × 114.3 cm). Louvre, Paris.

Japanese Woodblock Prints

From 1853 to 1854 Commodore Matthew Perry, a United States naval officer, led an expedition that forced Japan (fig. **23.7**) to end its policy of isolation. This opened up trade with the Far East and set the stage for cultural exchange. In the Paris Universal Exposition of 1867, many Japanese woodblock prints were on view. As a result, so-called *japonisme*, the French term for the Japanese esthetic, became popular in fashionable Parisian circles. Japanese prints exerted considerable influence on Impressionist painters in France, the United States, and elsewhere.

Woodblock printing had begun in China in the fourth century A.D. In the sixth century, Buddhist missionaries brought the technique to Japan. At first it was used for printing words, and only in the sixteenth century did artists begin to make woodblock images to illustrate texts. Originally the images were confined to black and white, but in the seventeenth century color was introduced. In order to create a woodblock print in color, the artist makes a separate block for each color and prints each block separately. The raised portions differ in each block and correspond to a different color in the final print. It is important, therefore, that the outlines of each block correspond exactly, so that there is no unplanned overlapping or empty space between forms.

The prints that most influenced the Impressionist painters were made during the Edo period (1600–1868). In the seventeenth century, Edo (the former name of Tokyo) became an urban center of feudalism in Japan. It was also the primary residence of the emperor, whose power was nearly absolute. Nevertheless, a merchant class developed which produced the main patrons of literature and the visual arts. Woodblock prints provided multiple images, which could be sold to a wide audience. As a result, publishers commissioned artists to prepare preliminary designs, and then supervised the engraving, printing, and sale of the final works.

Japanese art students were apprenticed to master artists, just as in western Europe during the Renaissance. The signatures on the prints reflect this system, for the artist had a chosen name (or *go*) as well as an apprentice name. The former was framed by a **cartouche** (cf. Vol. I, fig. 4.5), while the latter was usually unframed and placed at the bottom of the page. A publisher's mark might also be stamped on the print. At the top of the page are the titles of the individual texts, or series of texts, that are illustrated. If the subject is an actor, his name or role is sometimes added.

From 1790 to 1874, the Japanese government made several unsuccessful attempts to censor certain types of imagery—especially erotica—so there is sometimes an official seal and a date printed on the page. The standard dimensions (*oban*) of a woodblock print were 15 by 10½ inches (38 × 26 cm). Smaller works were reduced proportionally, and subjects demanding larger sizes or several episodes were printed, like polyptychs, in attached sections.

23.7 Map of Japan in the 19th century.

Ukiyo-e The so-called Golden Age of Japanese wood-block was the Ukiyo-e school of painting, which was founded around the middle of the seventeenth century. It lasted until the end of the Edo period in 1868. The term *ukiyo-e* means "floating world," and refers to the transience of material existence. The most popular subjects were theater, dance, and various kinds of female services ranging from outright erotica to the high-class courtesan. Respectable, middle-class women performing daily tasks were also depicted, but mythological and historical scenes were less popular, and landscape was used only as background until the nineteenth century. Both the stylistic techniques used in woodblock prints and their subject-matter—leisure genre scenes, entertainment, courtesans, landscape and cityscape, aerial views, and so forth—have close affinities with French Impressionism.

Utagawa Kinisada The actor in figure **23.8** by Utagawa Kinisada (1786–1865), for example, is presented in a close-up view. The monumental impact of the print is created by the broad forms that seem barely contained by the frame. The actor's stylized facial expression—its exaggerated, masklike quality—conforms to the stylization of the *kabuki* theater. (*Kabuki* is a type of Japanese theater derived from sixteenth-century songs and dances which were originally performed by women, and later only by men. The typical *kabuki* play lasts many hours and has many parts. There is a great deal of action in the plot, actors change costume on stage, and props are numerous. Costumes are elaborate, poses and gestures are stylized, and the actors' voices are trained according to strictly defined systems of modulation. Music and sound effects are created by a banjo, drums, bells, and clappers.) The triptych (fig. **23.9**) of

23.8 (above) Utagawa Kunisada, *The Actor Seki Sanjuro in the Role of Kiogoku Takumi*, 1860. Woodblock print with *gauffrage* (blindprinting) and burnishing. Collection Hotei, Netherlands.

23.9 Utagawa Kunisada, *Scene from Sukeroku*, c. 1835. Woodblock print, 8½ × 22½ in (21.6 × 57.2 cm). Victoria and Albert Museum, London.

around 1835 shows an episode from a *kabuki* play. Here stylization affects the interaction between characters: the figures assume contorted, *contrapposto* poses that constrict and monumentalize their space. At the same time, the elaborate patterning of the costumes carries the observer's gaze across the picture plane and accentuates the flatness of the surface.

Utagawa Toyokuni Utagawa Toyokuni's (1769–1825) actor portrait (fig. **23.10**) shows Onoe Matsusuke as a villain. Its lively color and expressive character were qualities that contributed to Toyokuni's reputation as the best artist of his generation. In this work, the figure's full body is represented, but the face, despite its small size, is the focus of attention. The picture plane is dominated by the geometric patterns of the costume, from which the villain's face emerges. The downward curve of his mouth and long, pointed nose accentuate his villainous intent. This, in turn, is reinforced by the upward sweep of his sword's sheath, which repeats the curved eyebrows and headdress. Both of these actor portraits convey an intensity of pose, gesture, and facial grimace that is typical of *kabuki*.

23.11 Kitagawa Utamaro, *Young Woman with Blackened Teeth Examining her Features in a Mirror*, from the series *Ten Facial Types of Women*, c. 1792–3. Woodblock print, 14⅔ × 9⅔ in (36.5 × 24.6 cm). British Museum, London.

23.10 Utagawa Toyokuni, *Portrait of the Actor Onoe Matsusuke as the Villain Kudo Suketsune*, 1800. Woodblock print, 14⅝ × 9⅝ in (37.2 × 24.6 cm). Victoria and Albert Museum, London.

Kitagawa Utamaro The Ukiyo-e images of beautiful women (*bijin*) reflect a new expressiveness of mood and personality. The late eighteenth-century example by Kitagawa Utamaro (1753–1806) illustrated here (fig. **23.11**) is from a series entitled *Ten Facial Types of Women*. It reveals some of the differences between Western and Japanese portraiture. At first glance, the stylization of the *Young Woman with Blackened Teeth Examining her Features in a Mirror* appears to eliminate the specificity of Western portraits. The depiction of the features recurs in many of Utamaro's female portraits: the brushed eyebrows form two raised curves, thin oval eyes contain a black pupil, the nose is purely linear, and the small lips are slightly parted. A sense of three-dimensional space is created by contours almost entirely without shading. As in Kunisada's *Actor*, it is by the foreshortening of the forms and the arrangement of curved outlines—especially of the drapery folds—that Utamaro conveys the illusion of depth. The flat background was originally coated with powdered mica, most

of which has since worn away. But its shine made the figure stand out, enhancing its three-dimensional quality and creating a reflective, mirror-like surface.

Two aspects of this print can be related to the prevailing concerns of Impressionism. The intimate, close-up view, in which one sees the woman in a private moment of self-absorption, became an Impressionist theme. She is unaware of being observed, for she is locked in the gaze of her own reflection. The flat blackness of the mirror repeats the other blacks—hair, pupils, teeth, and the official stamps and signatures in the upper right. Silhouettes of this kind appealed to the Impressionist taste for the effects of black-and-white photography. Furthermore, the back of the mirror—its form as well as its black tone—makes us aware of our exclusion from the intimate interchange between the woman and her reflection. This, too, is characteristic of certain Impressionist works. But it is also a device familiar to us from Velázquez's *Las Meninas* (see fig. 18.57) and Goya's *The Family of Charles IV* (see fig. 21.16), where, in both cases, we are prevented from seeing the canvases.

Keisei Eisen The print of the *Oiran on Parade* (fig. **23.12**) by Utamaro's pupil Keisei Eisen (1790–1848) illustrates a different type of *bijin*. This is one of the Edo period's high-ranking courtesans, and she is decked out in full regalia for public viewing. Her lofty position is reflected by her height, her massive proportions, and the attention to the design of her costume. Two birds embroidered in the kimono echo the woman herself: the bird at the left repeats the kimono's lower curve, and the other echoes her strutting posture. Utamaro's influence is evident in the depiction of the face, and the unmodeled, empty background, but not in the abundance of patterning. This feature, the repetition of orange and blue, and the subject itself have affinities with the chromatic unity of Impressionism. The Prussian blue, which is used here, was a recent import from the West, and attests the contacts between the East and Europe even before 1853.

23.12 Keisei Eisen, *Oiran on Parade*, c. 1830. Woodblock print, 29 × 9¾ in (73.7 × 24.8 cm). An *oiran* is the highest ranking courtesan. Victoria and Albert Museum, London.

Utagawa Kuniyoshi *Tairano Koremochi Waking up from a Drunken Sleep* (fig. **23.13**) by Utagawa Kuniyoshi (1797–1861) illustrates a scene from the *Tale of Genji*, an epic Japanese romance of the eleventh century, which is attributed to the aristocratic Lady Murasaki Shikibu. It chronicles the life of its hero, Genji, and continues into the generation of his grandchildren. In this episode, a man sees a woman reflected in a *sake* cup as a demon. In contrast to the portraits, this print has a sense of place. Scattered leaves and the *sake* cup appear to be on the ground, and the tree branch identifies the outdoor setting. The detailed attention to the layers of patterned drapery correspond to the elaborate descriptions of sartorial minutiae that is a feature of the *Tale of Genji*.

Katsushika Hokusai The two greatest woodblock artists who accorded a prominent role to landscape were Katsushika Hokusai (1760–1849) and Utagawa Hiroshige (1797–1858). Hokusai's *Great Wave of Kanagawa* (fig. **23.14**) is from a series entitled *Thirty-six Views of Mt. Fuji*. Such series of scenes, in particular different views of the same place, or similar views of the same place at different times of day and in different seasons, were also taken up by the Impressionists. The use of Prussian blue in this print enhances the wave's naturalism, but it is the dramatic rise of the wave and its nearness to the picture plane that creates its impressive effect. It is a convincing portrayal of the rhythmic power of a swelling wave, even though the wave's flat, patternistic quality seems to arrest its movement. In the distance, the sacred Mt. Fuji is small and insignificant by comparison. When the Impressionists first saw this print in the late nineteenth century, they were astounded by it. According to Debussy, this image inspired his famous composition *La Mer* (see Box).

Hokusai's *Horsetail Gatherer* (fig. **23.15**) of about 1840 uses landscape to create an atmosphere of stillness. As in *The Great Wave*, the artist depicts the scene from a bird's-eye view. It is from a Noh play, another type of Japanese theater. In contrast to *kabuki*, Noh plays are austere, usually consisting of one main actor conveying a specific

23.13 Utagawa Kuniyoshi, *Tairano Koremochi Waking up from a Drunken Sleep*, 1843. Woodblock print. Collection J. Asselbergs, Netherlands.

Music and Art

The French composer Claude Achille Debussy (1862–1918) was influenced by Impressionism and Symbolism (see p. 809). He created suggestive moods in his compositions, rather than precise statements. Like Impressionist painting, his work is evocative: it conveys light, color, and atmosphere, in contrast to clear delineation. Debussy was an admirer of Whistler, whose own musical titles reflected the abstraction of his paintings. Debussy's *La Mer*, an orchestral suite composed in 1905, consists of three "symphonic sketches"—From Dawn to Noon on the Sea (*De l'aube à midi sur la mer*), The Play of the Waves (*Jeux de vagues*), and Dialogue between the Wind and the Sea (*Dialogue du vent et de la mer*).

23.14 Katsushika Hokusai, *The Great Wave of Kanagawa*, from the series *Thirty-six Views of Mt. Fuji*, 1831. Woodblock print, 9⅞ × 14⅝ in (25 × 37.1 cm). Victoria and Albert Museum, London.

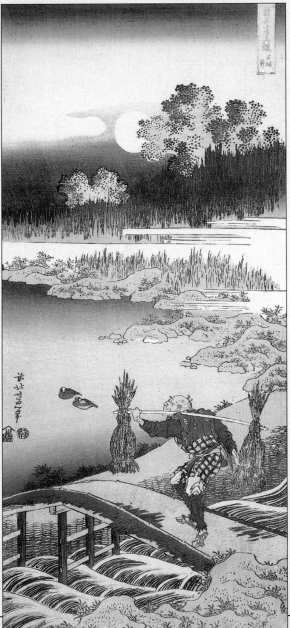

23.15 Katsushika Hokusai, *The Horsetail Gatherer*, c. 1840. Woodblock print, 19⅟₁₆ × 9 in (50 × 23 cm). British Museum, London.

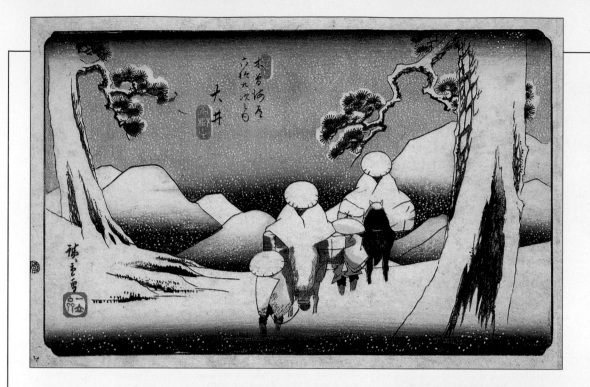

23.16 Utagawa Hiroshige, *Travelers in the Snow at Oi*, late 1830s. Woodblock print, 10¼ × 14½ in (26 × 36.8 cm). British Museum, London.

emotion. Hokusai's print shows an old man searching the woods and mountains for his lost child. In the print, the moon moves from behind the distant trees, as if to light the man's way. But although it is night-time, the landscape is brightly illuminated. Its stillness is broken only by the flowing water under the bridge. The curves of the stream form a sharp contrast to the smooth, glass-like water on which two ducks have settled. Their peacefulness highlights the man's anxious search, which, in turn, is echoed in the rushing stream beneath him.

Utagawa Hiroshige Travel, which became a popular subject in nineteenth-century France—for example, Daumier's *Third-class* and *First-class Carriage* (see figs. 22.6 and 22.7)—is also found in Japanese woodblock prints. Hiroshige produced several travel series, which established his reputation. *Travelers in the Snow at Oi* (fig. **23.16**) is from the *Sixty-nine Stations of the Kisokaida* of the late 1830s. Hiroshige, like the Impressionists, Bruegel, and other artists, conveys a sense of the season. The abundance of white, the heads bowed and arms folded to ward off the falling snow, express the coldness of winter. This impression is enhanced by the minimal color, the stark geometric quality of the round hats, and the predominance of flattened forms.

Hiroshige's last series was entitled *One Hundred Views of Edo*. The *Saruwaka-cho Theater* of 1856 (fig. **23.17**) shows a busy theater street at night. It is rendered in linear perspective, with the moon causing the figures to cast gray shadows. At the left, theater touts are trying to lure customers. The sense of a busy street, seen from an elevated vantage point, appeals to the same esthetic as Renoir's *Pont-Neuf* (see fig. 23.32) and Pissarro's *Place du Théâtre Français* (see fig. 23.33). It reflects the fact that just as the Impressionists were influenced by Japanese prints, so some of the Japanese artists, notably Hiroshige, were influenced by Western art.

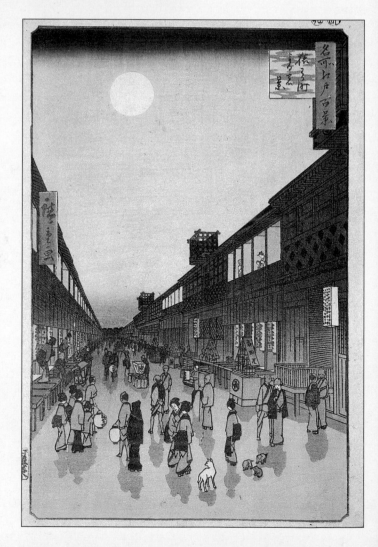

23.17 Utagawa Hiroshige, *Saruwaka-cho Theater*, 1856. Woodblock print, 14⅛ × 9¾ in (35.9 × 24.8 cm). Whitworth Art Gallery, University of Manchester.

A Bar at the Folies-Bergère Manet's *A Bar at the Folies-Bergère* (fig. **23.18**) of 1881–2 keeps the figure close to the picture plane, and reveals the artist's adoption of Impressionist color, light, and brushwork. By the device of the mirror in the background, Manet simultaneously maintains a narrow space and also expands it. The mirror reflects the back of the barmaid, her customer, and the interior of the music hall, which is both in front of her and behind the viewer.

The bright oranges in the glass bowl are the strongest color accent in the picture. The bowl, like the green and brown bottles, is a reflective surface. Daubs of white paint on these objects create the impression of sparkling light. In contrast, the round lightbulbs on the reflected pilasters seem flat because there is no tonal variation. Absorbing the light, on the other hand, is the smoke that rises from the audience, blocking out part of the pilaster's edge and obstructing our view. This detail exemplifies the Impressionist observation of the effect of atmospheric pollution—a feature of the industrial era—on light, color, and form.

23.18 Edouard Manet, *A Bar at the Folies-Bergère*, 1881–2. Oil on canvas, 3 ft 1½ in × 4 ft 3 in (0.95 × 1.3 m). Courtauld Institute Galleries, London. The Folies-Bergère is a Paris music hall, which opened in 1869. Today it is a tourist attraction offering lavish spectacles featuring a great deal of nudity. In Manet's day its program consisted of light opera, pantomime, and similar forms of entertainment.

A third kind of light can be seen in the chandeliers, the blurred outlines of which create a sense of movement. The depiction of blurring is one aspect of Impressionism that can be related to photography, as well as to the ways in which we see. When a photographic subject moves, a blur results. In Manet's painting, the figures reflected in the mirror are blurred, indicating that the members of the audience are milling around.

The formal opposite of blurred edges—the silhouette— is also an important feature of the Impressionist style. In its purest form, a silhouette is a flat, precisely outlined image, black on white or vice versa, as in the black ribbon around the barmaid's neck. Other, more muted silhouettes occur in the contrast of the round lightbulbs and the brown pilasters, the gold champagne foil against the dark green bottles, or the woman with the white blouse and yellow gloves in the audience on the left. Such juxtapositions, whether of pure black and white or of less contrasting lights and darks, also occur in certain Realist pictures, notably those by Daumier. They reflect the contrasts that are possible in black-and-white photography.

The impression that the image is one section of a larger scene—a "slice of life," or cropped view—is another characteristic of Impressionism that is related to photography. In Manet's painting, the customer is cut by the frame, as is the trapeze artist, whose legs and feet are visible in the upper left corner of the picture plane. The marble surface of the bar is also cut, and appears to continue indefinitely to the right and left of the observer.

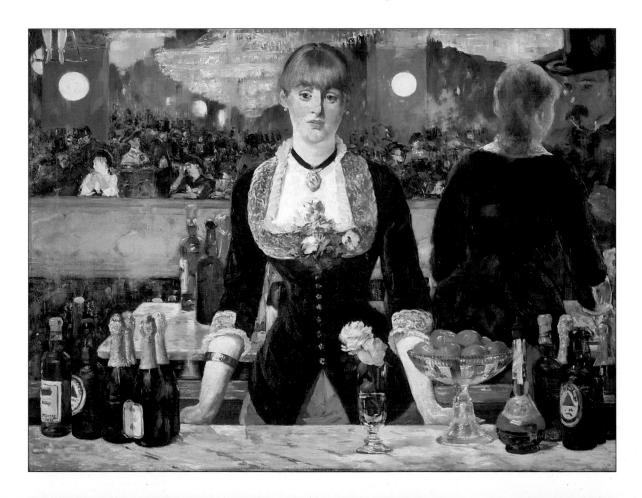

In addition to the many formal innovations of Impressionism in Manet's *Bar*, the imagery of the painting is also significant. The structural fragmentation of the picture corresponds to the mood of the barmaid. In contrast to the energy and motion in the audience, the members of which interact with each other—or the gazes of which are riveted on the trapeze artist—the barmaid stares dully into space. Her immobility is accentuated by the clarity and sharp focus of her edges compared with those of the audience. Nor does she seem interested in the male customer approaching at the right. There the viewpoint shifts, and the two figures are seen as if from an angle, whereas the barmaid and the mirror are seen from the front.

This image has evoked art historical interpretation from several methodological viewpoints. As a social comment, Manet makes a distinction between the monotony of serving at a bar and the bourgeoisie enjoying leisure time. This effect continues the concerns of Courbet and the Realists. The dulled quality of the barmaid's expression is also consistent with the observation of one art historian that Manet's source for her pose is an Italian image of the Dead Christ as the Man of Sorrows.

Another way of reading this image is through its sexual subtext. When seen from the back, the girl seems engaged in conversation with the man. But from the front she is alienated—bored and vacant—and aligned with the objects on the bar. She herself becomes an object to be consumed, along with the fruit and the alcoholic beverages. The flowers on her lace collar, like those on the counter, may be read as *vanitas* symbols. Her corsage is roughly triangular, and is echoed by the more precise gray triangle below her jacket. The sexual connotations of this triangle are fairly straightforward, and they reinforce the implication that the customer is propositioning the barmaid.

Edgar Degas

Absinthe (fig. **23.19**), painted by Edgar Degas (1834–1917) in 1876, also represents a "slice of life," the boundaries of which are determined by the seemingly arbitrary placement of the frame. The zigzag construction of the composition creates a slanted viewpoint, rather like that of a candid photograph. It is as if the photographer had taken the picture without aligning the camera with the space being photographed. The two figures are "stoned"—the white liqueur in the woman's glass is absinthe—and, like Manet's barmaid, stare fixedly at nothing in particular. The poses and gestures convey psychological isolation and physical inertia.

Degas depicted another type of immobility in his painting of the American Impressionist Mary Cassatt before a painting in the Louvre (fig. **23.20**). As in *Absinthe*, Degas uses the device of a tilted floor to create a candid impression—itself a play on the gaze. Here, it is the sight of a painting that immobilizes the figure, rather than an alcoholic stupor. Both Cassatt and the woman on the right, possibly

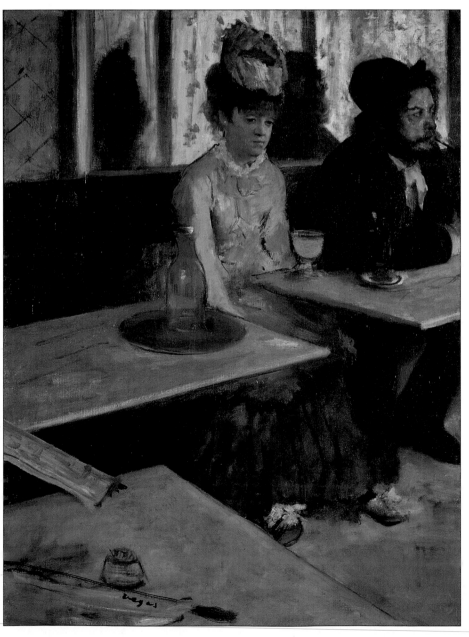

23.19 Hilaire Germain Edgar Degas, *Absinthe*, 1876. Oil on canvas, 36¼ × 26¾ in (92.1 × 67.9 cm). Musée d'Orsay, Paris. Degas, the son of a wealthy Parisian banker, joined the Impressionist circle around 1865 and exhibited in seven of their eight exhibitions between 1874 and 1886.

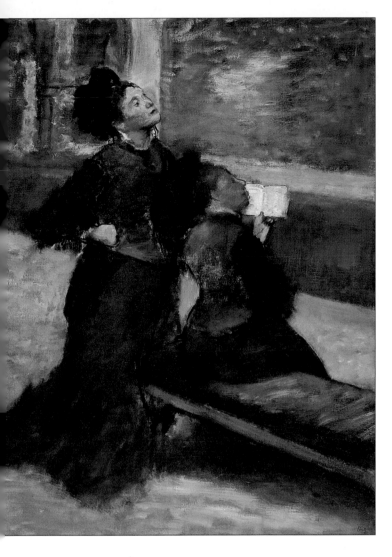

her sister, are riveted by the sight of an "impressionistic" picture. The seated figure looks up from the written text of her open book, as her focus is preempted by the image. Finally, Degas draws in the observer, who, in looking at *his* picture, also watches the painted viewers gazing at a painting.

In his ballet pictures, Degas expresses a wide range of movement. His dancers rest, stretch, exercise, and perform. *The Dancing Lesson* (fig. **23.21**) of 1883–5, which, like *Absinthe*, is set at an oblique angle, shows a series of ballerinas in various poses and stages of motion or rest. Illuminating the interior is outdoor light, which enters the rehearsal room through three windows. The figures are unified by the repeated blue of their costumes, each accented by a sash of a different color. Blue, yellow, and reddish orange—the three main colors of the costumes—are assembled in the open fan held by the central girl. The repetition of colors throughout the composition creates a chromatic unity that is a characteristic innovation of the Impressionist style. It also reflects the flat color patterns that are typical of Japanese woodblock prints.

23.20 (left) Hilaire Germain Edgar Degas, *Visit to a Museum*, c. 1885. Oil on canvas, 36⅛ × 26¾ in (91.8 × 68 cm). Gift of Mr and Mrs John McAndrew. Courtesy, Museum of Fine Arts, Boston.

23.21 (below) Hilaire Germain Edgar Degas, *The Dancing Lesson*, 1883–5. Oil on canvas, 15½ × 34¾ in (39.4 × 88.4 cm). Sterling and Francine Clark Art Institute, Williamstown, Massachusetts. Degas is best known for his ballet pictures. He sketched ballerinas from the wings of the theater and in ballet studios such as this one. His interest in depicting forms moving through space led him to paint horseraces, acrobats, and other entertainers.

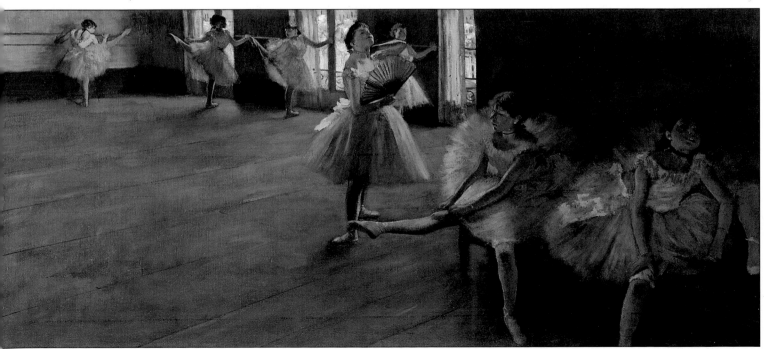

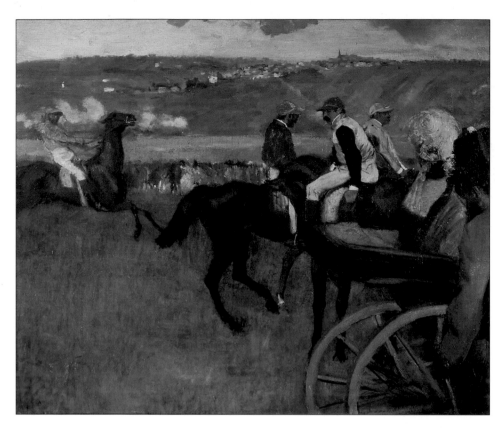

23.22 Hilaire Germain Edgar Degas, *At the Races*, 1887–80. Oil on canvas, 26 × 31⅞ in (66 × 81 cm). Musée d'Orsay, Paris.

In *At the Races* (fig. **23.22**), Degas depicts figures in a state of restlessness before the event. At the right, three mounted jockeys wearing shiny silk vests face in different directions as if impatient for the race to begin. Patches of color that blur the waiting crowd enhance the sense of restless expectation. The woman in the carriage and the man in the top hat also prepare for the race. At the left, a single horse gallops into the picture plane as his jockey reins him in. The arrested movement of the galloping horse draws attention to the distant train that continues on. In this detail, Degas refers to the contrast between mechanized and natural movement, and to the changing modes of transportation created by the Industrial Revolution.

Degas was a devoted amateur photographer, and his passion for depicting forms moving through space can be related to his photographic interests. Other nineteenth-century photographers also explored the nature of motion. In 1878, for example, the American photographer Eadweard Muybridge (1830–1904) recorded for the first time the actual movements of a galloping horse (fig. **23.23**). To do so, he set up along the side of a race track twelve cameras, the shutters of which were triggered as the horses passed. Muybridge discovered that all four feet are off the ground only when they are directly underneath the horse (as in the second and third frames), and not when they are stretched out, as in Degas's galloping horses, or in the prehistoric running bulls from Lascaux (see Vol. I, fig. 2.10).

23.23 Eadweard Muybridge, *Galloping Horse*, 1878. Albumen print. Eadweard Muybridge Collection, Kingston Museum.

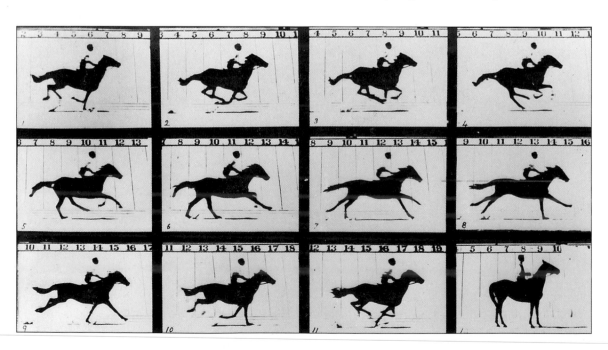

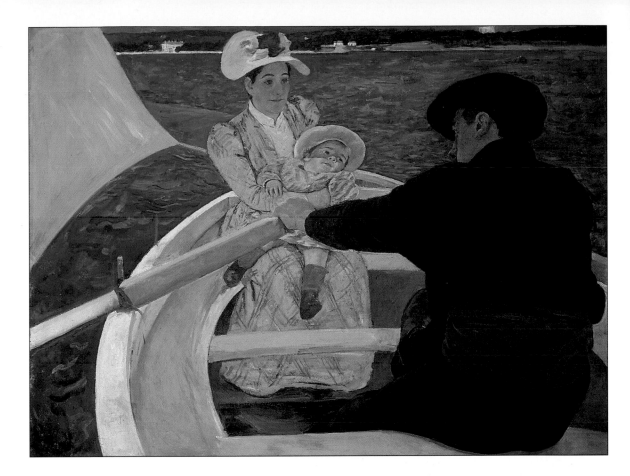

23.24 Mary Cassatt, *The Boating Party*, 1893–4. Oil on canvas, 2 ft 11½ in × 3 ft 10⅛ in (0.9 × 1.17 m). National Gallery of Art, Washington, D.C. (Chester Dale Collection). Cassatt was from a well-to-do Pennsylvania family. For most of her career she lived in France, where she exhibited with the Impressionists and was a close friend of Degas. She fostered American interest in the Impressionists by urging her relatives and friends—particularly the Havemeyer family—to buy their works at a time when they were still unpopular.

Mary Cassatt

In *The Boating Party* (fig. **23.24**) of 1893–4, Mary Cassatt (1845–1926) uses the Impressionist "close-up," another pictorial device inspired by photography. She combines it with a slanting viewpoint to emphasize the intimacy between mother and child. The rower, on the other hand, is depicted in back view as a strong silhouette. More individualized are the mother and child, who gaze at the rower, and are contrasted with his anonymity. Cassatt intensifies the tension between the three figures by flattening the space, and foreshortening both child and rower. The compact forms create an image of powerful monumentality. Cassatt's bold planes of color, sharp outlines, and compressed spaces, as well as the *obi* (wide sash) worn by the rower, exemplify the influence of Japanese woodblocks on the Impressionist painters.

A different kind of intimacy characterizes Cassatt's *The Letter* (fig. **23.25**). It contains a single figure, whose relationship to another person is implied by the letter. She hunches forward, concentrating on sealing the envelope and oblivious of being observed. Her apprehensive air is given formal expression in the agitated surface patterns. The observer looks in on a private moment, just as when viewing Utamaro's *Young Woman with Blackened Teeth* (see fig. 23.11). Cassatt's skill as a printmaker reinforced her attraction to the Japanese woodblocks, the flat patterns of which recur in *The Letter*.

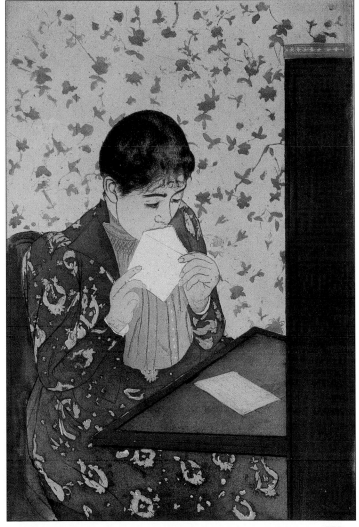

23.25 Mary Cassatt, *The Letter*, 1891. Etching and aquatint, 17 × 11⅞ in (43.2 × 30.2 cm). Philadelphia Museum of Art (Louis E. Stern Collection).

Berthe Morisot

As in the work of Cassatt, Berthe Morisot's (1841–95) *The Cradle* of 1873 (fig. **23.26**) explores the theme of intimacy through a close-up. She does not, however, use oblique spatial shifts. Instead she sets her figures on a horizontal surface, within a rectangular composition. Curves and diagonals reinforce the interaction between mother and child. For example, the mother's left arm connects her face with the baby's arm, which is bent back behind her head. The line of the mother's gaze, intently focused on the baby,

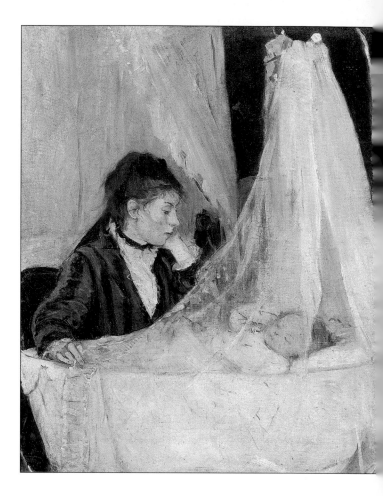

23.26 (right) Berthe Morisot, *The Cradle*, 1873. Oil on canvas, 22½ × 18½ in (57 × 47 cm). Louvre, Paris. Morisot was one of five sisters, all of whom learned to paint. She married Eugene Manet, the brother of the artist, and had one daughter whom she frequently used as a model in her paintings.

23.27 (below) Claude Monet, *Terrace at Sainte-Adresse*, c. 1866–7. Oil on canvas, 3 ft 2⅝ in × 4 ft 3⅛ in (0.98 × 1.3 m). Metropolitan Museum of Art, New York. In his youth Monet lived at Le Havre, a port town on the Normandy coast. It was here that he first became familiar with rapid changes in light and weather. In 1874 he exhibited in the show that launched the Impressionist movement. Until the 1880s his work was poorly received and he lived in extreme poverty.

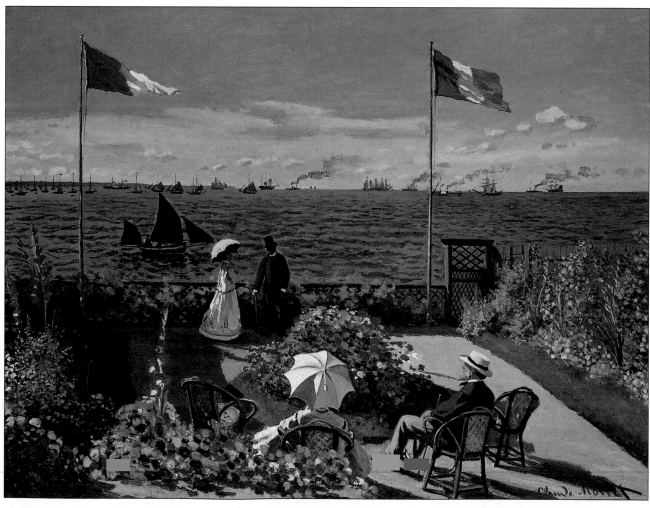

is repeated by the diagonal curtain. On the left, the mother's right arm curves toward the picture plane and is counteracted by the slow curve of the baby's cradle-covering from top right to lower left. The baby's left arm also curves, so that the unity of mother and child is here indicated by a series of formal repetitions in which both participate.

The loose brushwork, for which Morisot and her Impressionist colleagues were often criticized, is particularly apparent in the lighter areas of the painting. The translucent muslin invites the viewer to "look through" the material at the infant. Looking is also implied by the window and curtain, although in fact nothing is visible through the window. In these lighter areas, as in the edges of the mother's dress, the individual white brushstrokes seem to catch the available light and reflect it. Contrasting with the whites are the dark, silhouetted areas such as the wall, chair, and the ribbon around the mother's neck. A transitional area is provided by the mother's dress, which, though dark, contains light highlights that create a shiny surface texture.

Claude Monet

The work of Claude Monet (1840–1926), more than any other nineteenth-century artist, embodied the technical principles of Impressionism. He was above all a painter of landscape, who studied light and color with great intensity. Unlike the Academic artists, Monet did much of his painting outdoors, in the presence of natural landscape, rather than in the studio. As a result, he and the Impressionists were sometimes called *plein air*, or "open air," painters.

From the 1860s, early in his career, Monet worked with a wide range of color. A comparison of an early and a late work by Monet illustrates the development of the Impressionist style. The *Terrace at Sainte-Adresse* (fig. **23.27**) of about 1866–7 is a leisure genre scene. In the distance, sail boats and steam ships hint at the Industrial Revolution and the changing times. The *Bassin des Nymphéas*, or "Waterlily Pond," of 1904 (fig. **23.28**) illustrates Monet's style nearly forty years later.

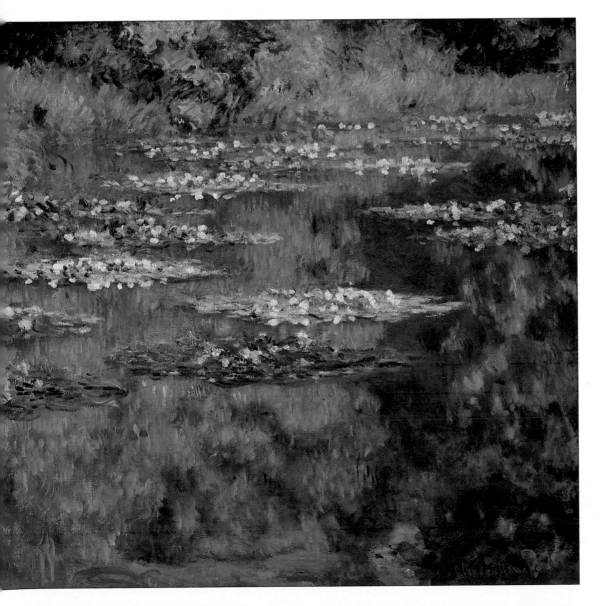

23.28 Claude Monet, *Bassin des Nymphéas (Waterlily Pond)*, 1901. Oil on canvas, 34½ × 35¾ in (87.6 × 90.8 cm). Denver Art Museum. In 1883 Monet moved to Giverny, a village about 50 miles (80 km) west of Paris, where he spent his later years. He built a water garden that inspired numerous "waterscape" paintings, including this one and a series of large waterlily murals.

Both pictures reflect Monet's concern with the direct observation of nature and both are the result of his habit of painting outdoors with nature itself as his "model." The water is painted using the Impressionist technique of "broken color;" instead of using a solid, "unbroken" color for the water, Monet breaks it up into light and dark. In the *Terrace*, light and dark blue-green brushstrokes alternate to create the illusion that the water is moving. In the *Waterlily Pond*, the lack of motion is indicated by the more vertical arrangement of the broken colors—greens, blues, yellows, and purples—that comprise the water's surface. Monet's method here reflects the way light strikes the eye—in patterns of color rather than in the relatively sharp focus of the *Terrace*. In the *Waterlily Pond* the observer's point of view is the same as in the *Terrace*, but the field of vision is much narrower.

These paintings also illustrate Monet's fidelity to optical experience through the depiction of colored shadows and reflections. In the *Terrace*, the shadows on the pavement are dark gray, and the creases in the flags are darker tones of their actual colors—red, yellow, and blue. Likewise, the reflection in the water of the large dark gray sail boat is composed of more densely distributed dark green brushstrokes than the rest of the water. In the *Waterlily Pond*, the reflected foliage is transformed into relatively form-less patches of color. Without the lily pads and the shore, there would be no recognizable objects at all, and no way for viewers to orient themselves in space.

Although even in late Impressionism there is never a complete absence of recognizable content and form, the comparison of these two pictures indicates a progressive dissolution of painted edges. The brushstrokes and the paint begin to assume an unprecedented prominence. As a result, instead of accepting a canvas as a convincing representation of reality, the viewer is forced to take account of the technique and medium in experiencing the picture. This is consistent with Monet's recommendation that artists focus on the color, form, and light of an object rather than its iconography. In that suggestion, Monet emphasized the essence of a painted object as an abstract form, and not as a replica of the thing itself. In other words, a painted "tree" is not a tree at all, but a vertical accent on a flat surface.

In studying the natural effects of light and color on surfaces, Monet—like the Japanese artists Hokusai and Hiroshige—painted several series of pictures representing one locale under different atmospheric conditions. In 1895 he exhibited eighteen canvases of Rouen Cathedral. A comparison of *Rouen Cathedral, West Façade, Sunlight* of 1894 (fig. **23.29**) with the *Rouen Cathedral* in figure **23.30** shows the changes in the façade according to the time of day. In both paintings, the myriad details of a Gothic cathedral dissolve into light and shadow, which are indicated by individual patches of color. The blue sky in figure

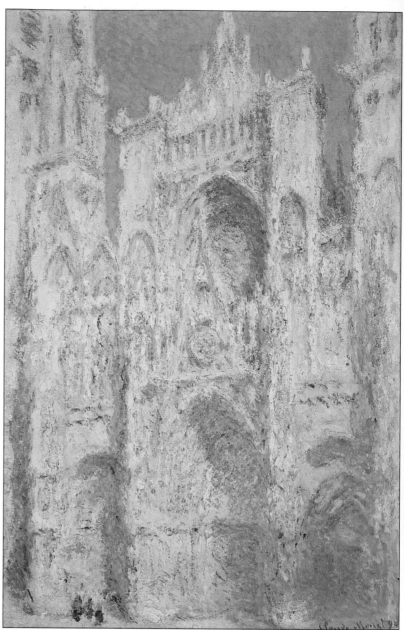

23.29 Claude Monet, *Rouen Cathedral, West Façade, Sunlight*, 1894. Oil on canvas, 39½ × 26 in (1.0 × 0.66 m). National Gallery of Art, Washington, D.C. (Chester Dale Collection).

23.29 results in a cream-colored façade, the dark areas of which repeat the sky blue combined with yellows and oranges. In figure 23.30, on the other hand, the gray, early-morning sky casts a lavender hue on the light sections of the façade, while darker blues and purples fall on the shaded areas. A slight yellow glow from the sun pervades the sky, and is visible on the tower. Here, as in the *Waterlily Pond*, viewers are made aware of the medium as much as of the subject-matter. They are also reminded that our normal vision lacks sharp focus.

Auguste Renoir

The *Torso of a Woman in the Sun* (fig. **23.31**) of about 1875–6 by Auguste Renoir (1841–1919) is composed of patches of broken color and reflections of light. The soft-

23.30 Claude Monet, *Rouen Cathedral, the Portal and the Tower of Albane, the Morning*, 1894. Oil on canvas, 42 × 29 in (1.07 × 0.74 m). Galerie Beyeler, Basel.

ness of the brushstrokes creates a silky texture on the flesh as well as in the surrounding foliage. The woman seems to emerge from the very brushstrokes that define the landscape. Although her proportions are not quite Classical, the gesture of her right hand evokes the traditional *Venus Pudica* gesture of the *Medici Venus* (see fig. 14.28), Giorgione's *Sleeping Venus* (see fig. 15.52), and Titian's *Venus of Urbino* (see fig. 15.54).

Renoir evokes a type of Classical and Renaissance Venus in the anonymous torso. But like Manet's *Olympia* (see fig. 22.23), the Renoir combines traditional content with a new formal idiom. Although the figure is part of a continuing theme in Western art, the style in which she is painted corresponds to the Impressionist interest in effects of outdoor light and color on different kinds of surfaces. Like the *Olympia* and Titian's *Venus*, Renoir's figure is not completely nude. Her bracelet and ring accentuate the absence of clothing. The identity of Renoir's model is known (her name was Anna Leboeuf), but this is not a portrait. Her facial features convey a general idea rather than a specific individual.

In Renoir's *Pont-Neuf* (fig. **23.32**) of 1872, the influence of photography can be seen in the somewhat elevated vantage point. The rhythms of the city, which became a favorite Impressionist subject, are indicated by the variety of human activity. The scene is a "slice" of a city street, but Renoir also presents a condensed panorama of different social classes. Mothers stroll with children, youths lean against the side of the bridge, some people carry bundles and push carts, and others walk their dogs or ride in carriages. Soldiers and policemen are among the crowd. At the far side of the bridge the familiar buildings of the left bank are visible. Because the sky is blue, the forms—like the day—are relatively clear, and figures cast dark shadows on the pavement. Their patterns, as well as the general view of a busy street, is reminiscent of Hiroshige's *Saruwaka-cho Theater* (see fig. 23.17). Hiroshige's print, in turn, reflects the influence of Western one-point perspective.

23.31 Pierre-Auguste Renoir, *Torso of a Woman in the Sun*, c. 1875–6. Oil on canvas, 31½ × 24 in (80 × 61 cm). Musée d'Orsay, Paris. Renoir suffered years of financial hardship before gaining critical acclaim. When he exhibited this painting in 1876, one conservative critic (Albert Wolff) called the figure a "heap of decomposing flesh covered with green and purple patches, which are the sign of advanced putrefaction in a corpse."

23.32 Pierre-Auguste Renoir, *The Pont-Neuf*, 1872. Oil on canvas, 29⅝ × 36⅞ in (75 × 93.7 cm). National Gallery of Art, Washington, D.C. (Ailsa Mellon Bruce Collection).

23.33 Camille Pissarro, *Place du Théâtre Français*, 1898. Oil on canvas, 29 × 36 in (73.7 × 91.4 cm). Minneapolis Institute of Arts (William Hood Dunwoody Fund).

23.34 Hilaire Germain Edgar Degas, *Fourth Position Front, on the Left Leg,* c. 1880s. Bronze, 16 in (40.6 cm) high. Musée d'Orsay, Paris.

Camille Pissarro

The viewpoint of Camille Pissarro's (1830-1903) *Place du Théâtre Français* of 1898 (fig. **23.33**) is higher than that of Renoir's *Pont-Neuf*. In contrast to the Renoir, this picture depicts a rainy day, and the figures are in softer focus, which blurs their forms. Also blurred is the façade of Garnier's Opéra at the end of the long Boulevard de l'Opéra. They are rendered as patches of color, and create dark accents against the lighter pavement. The effect of the gray sky is to drain the color from the street and dull it. At the same time, however, the street's surface is enlivened by visible brushstrokes and reflective shadows. Impressionist cityscapes offered artists an opportunity to explore the effects of outdoor light on the color and textures of the city. They also record the momentary and fugitive aspects of Haussmann's boulevards in ways that even photographs could not.

23.35 Auguste Rodin, *The Thinker*, 1879–89. Bronze, 27½ in (69.8 cm) high. Metropolitan Museum of Art, New York (Gift of Thomas F. Ryan, 1910).

Sculpture

Edgar Degas

The term Impressionism is more applicable to painting than to sculpture. Degas exhibited only one sculpture in his lifetime, and most remained as wax models until his death. About half of these were cast in bronze in the 1920s. Degas' *Fourth Position Front, on the Left Leg* (fig. **23.34**), which was probably modeled during the 1880s, illustrates his ability to capture motion in space in sculpture as well as in painting. The dancer seems as if she is about to spring up and twist around to her right.

Since Degas apparently did not intend to cast such wax figures, they may be considered as preliminary studies for his paintings. As such, they provide a glimpse into his working methods. The textured surface of this bronze, which retains evidence of the medium, recalls the prominence of Impressionist brushstrokes. The observer is made aware of the dynamic modeling process just as the dancer herself shows the process of physical "working out" in preparing for the finished performance.

Auguste Rodin

The acknowledged giant of nineteenth-century sculpture was Auguste Rodin (1840–1917). Rodin's influence on twentieth-century sculpture parallels the impact of the Impressionists on the development of painting. Like Degas, Rodin built up forms in clay or wax before **casting** them. His characteristic medium was bronze, but he also made casts of plaster. *The Thinker* of 1879–89 (fig. **23.35**) reveals the influence of Italian Renaissance sculpture on Rodin's con-

ception of the monumental human figure. The work actually evolved from what Rodin originally planned to be a representation of Dante. Its introspective power and large, muscular body, reminiscent of Michelangelo's *Jeremiah* (see fig. 15.27) and Dürer's *Melencolia* (see fig. 17.15), are created by the figure's formal tension and sense of contained energy. Both the *Jeremiah* and *Melencolia* are meditative figures—Jeremiah the Old Testament prophet who "sees" the future, and the idled melancholic genius of Dürer—who have affinities with Rodin's introspective, immobilized *Thinker* (see Box).

In 1891 Zola asked Rodin to take over a commission from the French Society of Men of Letters for a monumental statue of the French novelist Honoré de Balzac. Rodin spent the last seven years of his life on the work, which was not cast until after his death. He called it the sum of his whole life. A comparison of the plaster and bronze versions of Rodin's *Balzac* (figs. **23.37** and **23.38**) demonstrates his interest in conveying the dynamic, experimental *process* of making sculpture, rather than in the finished work. In the plaster statue, the great novelist looms upward like a ghostly specter wrapped in a white robe. The bronze is less spectral, but more reflective. In both versions, the nature of the medium defines the sur-

face texture of the work. The rough, unfinished surface of the plaster recalls the unpolished, often incomplete, marble sculptures of Michelangelo. In the bronze, the reflecting light activates the surface and energizes it.

Both statues have the Impressionist quality of accentuating the surface texture of the artist's material, and also convey an impression of raw power and primal thrust that is characteristic of Rodin. Their surface motion creates a blurred effect similar to the prominence of Impressionist brushwork, and mirrors Balzac's own dynamic spirit. The figure seems to be in an unfinished state—a not-quite-human character in transition between unformed and formed. Since Balzac's literary output was prodigious, his representation as a monumental, creative power evokes the timeless energy of his own work. Edward Steichen, who photographed the *Balzac* as well as *The Thinker*, responded in this way to a news photo of the *Balzac*: "It was not just a statue of a man; it was the very embodiment of a tribute to genius."

In 1898, when the plaster version of the *Balzac* was first exhibited, the public disliked it, and so did the Society of Men of Letters that had commissioned it. Rodin himself never cast the work in bronze, and it is not known whether he ever intended to do so (see Box).

Artists Quote Art: Steichen

In 1902 Edward Steichen photographed Rodin. He had spent the previous year observing the artist in his studio, which was crowded with marble blocks and sculptures in progress. Figure **23.36** is Steichen's photograph of Rodin facing *The Thinker*. Both the artist and his bronze are silhouetted against Rodin's white marble of the *Monument to Victor Hugo*, author of *Les Misérables*. By combining two negatives, Steichen has arranged the three figures in a continuum of light, with Rodin at the left in almost total darkness. Only a small part of his head—alluding to the light of artistic inspiration—is illuminated. The shiny bronze surface of *The Thinker*, which Rodin faces as he would his own mirror image, reflects curves of light on the upper torso, arms, and head. The white marble *Monument* seems to look down from the lofty heights of literary genius on the sculptor and his sculpture. By juxtaposing whites and blacks as he does, Steichen incorporates the photographic medium into the artistic message of his image.

23.36 Edward Steichen, *Rodin—The Thinker*, 1902. Gum bichromate print, 15⅝ × 19 in (39.6 × 48.3 cm).

23.37 (right) Auguste Rodin, *Balzac*, 1892–7. Plaster, 9 ft 10 in (3 m) high. Musée Rodin, Paris.

23.38 (far right) Auguste Rodin, *Balzac*, 1893–7. Bronze, 9 ft 3 in (2.82 m) high. Boulevard Raspail, Paris.

23.37, **23.38** Rodin's revolutionary methods of working included the use of nonprofessional models in nontraditional poses. Apart from portrait busts, Rodin was the first major sculptor to create work consisting of less than the whole body—a headless torso, for example.

Artists Quote Art: Beauford Delaney

In the 1960s, Beauford Delaney (1901–79), an African-American artist living in Paris, painted a small tribute to Rodin entitled *Balzac by Rodin* (fig. **23.39**), in which he transported the statue from the Boulevard Raspail to an anonymous landscape setting. He has retained the looming, gigantic aspect of Rodin's sculpture, its sense of process, and the green hue of aged bronze. But he has endowed the work with his own unique white light, which, according to the American author James Baldwin, "held the power to illuminate, even to redeem and reconcile and heal."[1] Henry Miller described Delaney's picture as "saturated with color and light."[2] White light fills the areas of the *Balzac* that in reality are darkened, thus reversing the relationship of light and dark on a sculptured surface. The entire sky is white, except for the blue patch over the *Balzac*'s head, a reversal of the expected, for the blue becomes cloud-like and the naturally blue sky is whitened.

23.39 Beauford Delaney, *Balzac By Rodin*, 1960s. Oil on canvas, 24 × 19½ in (61 × 50 cm), whereabouts unknown. Beauford Delaney was the son of a minister in Knoxville, Tennessee. He studied art, and went to New York in 1929 at the end of the Harlem Renaissance. In 1954 he moved to Paris, where he painted portraits of the French playwright Jean Genet and the American novelists Henry Miller, James Baldwin, and James Jones.

American Painting at the Turn of the Century

Several important late nineteenth-century American artists correspond chronologically with French Impressionism. Some, such as Cassatt, lived as expatriates in Europe and worked in the Impressionist style. Others stayed in America and continued in a more Realist vein.

Winslow Homer

Winslow Homer (1836–1910), for example, visited Paris before the heyday of Impressionism and his work can be regarded as transitional between Realism and Impressionism. In *Breezing Up* (fig. **23.40**) of 1876, Homer's interest in revealing the American identity of his subjects and their place in society is evident. At the same time, however, he has clearly been influenced by the Impressionist interest in weather conditions and their effect on light and color. The sea, churned up by the wind, is rendered as broken color with visible brushstrokes. By tilting the boat in the foreground, Homer creates a slanted "floor" that is related to Degas's compositional technique. The interruption of the diagonal sail by the frame, the oblique viewpoint, and the sailors' apparent indifference to the observer, suggest a fleeting moment captured by the camera.

John Singer Sargent

John Singer Sargent (1856–1925), who lived in Paris in the early 1880s, espoused Impressionism wholeheartedly. But even though Sargent is sometimes considered an Impressionist, he did not allow form to dissolve into light, as did the French Impressionists. After his death, and with the advent of modernism, Sargent was dismissed as a painter of elegant, superficial portraits, which emphasized the rich materials worn by his society patrons. But *The Daughters of Edward Darley Boit* (fig. **23.41**), exhibited in the Salon of 1883, reveals the inner tensions of four young sisters, despite their comfortable lifestyle.

The girls occupy a fashionable room decorated with elements of *japonisme*, notably the large vases and the rug. The mirror, which recalls Velázquez's *Las Meninas* (see fig. 18.57), complicates the spatial relationships within the picture, while the oblique view sets the figures above the observer. The cropped rug and vase evoke the Impressionist "slice of life," and the subjects seem frozen in time. Three gaze at the viewer, and one leans introspectively against a vase. Two are close together and two, echoing the vases, are apart. The spaces separating the figures convey psychological tension and create the impression of an internal subtext.

Maurice Prendergast

The style of the American painter Maurice Prendergast (1859–1924) more clearly evolved from Impressionism than that of Sargent. Prendergast was born in Newfoundland, but spent most of his life in Boston and New York. Active in the late 1800s and during the first two decades of the twentieth century, he was far in advance of his American contemporaries. In *Bathers* (fig. **23.42**), he creates a mosaic effect with short, patchy brushstrokes. Despite the prominence of the brushwork, however, the color patterns maintain their distinctive character. They seem to have little in common with fidelity to optical experiences as shown by Monet, Renoir, and Pissarro.

23.40 Winslow Homer, *Breezing Up (A Fair Wind)*, 1873-76. Oil on canvas, 24⅛ × 38⅛ in (61.5 × 97 cm). National Gallery of Art, Washington, D.C. (Gift of the W. L. and May T. Mellon Foundation). Homer, a largely self-taught artist from Boston, worked as a magazine illustrator. At the outbreak of the Civil War, he was sent by *Harper's Weekly* to do drawings at the front. After the war, he spent a year in France. From 1873 he worked in watercolor, which became as important a medium for him as oil.

23.41 John Singer Sargent, *The Daughters of Edward Darley Boit*, 1882. Oil on canvas, 7 ft 3 in × 7 ft 3 in (2.21 × 2.21 m). Courtesy, Museum of Fine Arts, Boston (Gift of Mary Louisa Boit, Florence D. Boit, Jane Hubbard Boit, and Julia Overing Boit, in memory of their father, Edward Darley Boit).

23.42 Maurice Prendergast, *Bathers*, c. 1912. Oil on canvas, 22 × 34 in (55.9 × 86.4 cm). Photo courtesy of Adelson Galleries, New York. This canvas was painted in 1912, the year in which the artist returned from Europe. He was asked in that same year to be on both the foreign and the American selection committees for the forthcoming Armory Show.

23.43 James Abbott McNeill Whistler, *Nocturne in Black and Gold (The Falling Rocket)*, c. 1875. Oil on oak panel, 23⅝ × 18½ in (60 × 47 cm). Detroit Institute of Arts (Gift of Dexter M. Ferry, Jr.). Whistler, born in Lowell, Massachusetts, moved with his family to Russia, where his father designed the Moscow–St. Petersburg railroad. He set up art studios in Paris and London, finally settling in Chelsea. The author of *The Gentle Art of Making Enemies*, Whistler was known for his distinctive personality and biting wit. He dressed as a dandy, wearing pink ribbons on his tight, patent leather shoes and carrying two umbrellas in defiance of the inclement London weather.

"Art for Art's Sake"

In Paris, widespread public and critical condemnation made it difficult for the Impressionists to sell their work. In London as well, there were esthetic quarrels. One of these erupted into the celebrated libel trial between the American painter James McNeill Whistler (1834–1903) and the English art critic John Ruskin. In 1877 Ruskin published a scathing review of Whistler's *Nocturne in Black and Gold (The Falling Rocket)* (fig. **23.43**), painted some two years earlier. The picture was on view at London's Grosvenor Gallery, and it threw Ruskin into a rage. He accused Whistler of flinging "a pot of paint ... in the public's face." Whistler himself, Ruskin added, was a "coxcomb," guilty of "Cockney impudence" and "wilful imposture."

Whistler sued Ruskin for libel, and the case went to trial in November 1878. Ruskin, who was in the throes of a psychotic breakdown, could not appear in court, but his views were presented by his attorney. According to Ruskin, Whistler's picture was outrageously overpriced at 200 guineas, quickly and sloppily executed, technically "unfinished," and devoid of recognizable form. Several of Whistler's other paintings were introduced as exhibits and declared equally "unfinished." In particular, the opposing side pointed out, Whistler did not paint like Titian, whose works *were* "finished." Ruskin also objected to Whistler's musical titles (in this case "Nocturne") as pandering to the contemporary fad for the incomprehensible. The paintings themselves were not, he insisted, serious works of art. In his opening statement, the Attorney General, acting for Ruskin, had this to say about musical titles:

> In the present mania for art it had become a kind of fashion among some people to admire the incomprehensible, to look upon the fantastic conceits of an artist like Mr. Whistler, his "nocturnes," "symphonies," "arrangements," and "harmonies," with delight and admiration; but the fact was that such productions were not worthy of the name of great works of art. This was not a mania that should be encouraged; and if that was the view of Mr. Ruskin, he had a right as an art critic to fearlessly express it to the public.

On cross-examination, Whistler was questioned about his subject-matter:

> "What is the subject of the *Nocturne in Black and Gold*?"
> "It is a night piece," Whistler replied, "and represents the fireworks at Cremorne."
> "Not a view of Cremorne?"
> "If it were a view of Cremorne, it would certainly bring about nothing but disappointment on the part of the beholders. It is an artistic arrangement.... It is as impossible for me to explain to you the beauty of that picture as it would be for a musician to explain to you the beauty of a harmony in a particular piece of music if you have no ear for music."

Ironically, Ruskin had once used his critical genius to further the public reception of Turner, himself a rather "Impressionistic" artist. Equally ironic, Whistler was quite capable of producing clear and precise images as he did in his etchings, as well as in some of his portraits. The famous portrait of Whistler's mother (see fig. 1.8; 1.9 in the Combined Volume), which has a combined musical and artistic title—*Arrangement in Gray and Black*—is a remarkable psychological portrait and also satisfies Ruskin's requirement that a painting appear "finished." It conveys her dour, puritanical character, reflected in the assertion by one of Whistler's friends that she lived on the top floor of his London house in order to be closer to God.

Whistler's two stylistic tendencies—linear and atmospheric—mirrored his own psychological conflicts, as well as the traditional quarrels between *disegno* and *colorito*, the *Poussinistes* and the *Rubénistes*, Classical art and modernism. In the Impressionist period, the Academy stood for traditional "clarity," and opposed the atmospheric effects of works by Whistler and Debussy. Whistler internalized these quarrels according to his own struggle between male and female forces within himself. He wrote, for example, that "Color is vice ... When controlled by a firm hand, well-guided by her master, Drawing, Color is then like a splendid woman with a mate worthy of her ... the most magnificent mistress possible. But when united with uncertainty, with a weak drawing ..., Color becomes a bold whore, makes fun of her little fellow, isn't it so?"[3]

In court, Whistler countered Ruskin's position by stating what was essentially the formalist "art for art's sake" view of art, namely that art did not necessarily serve a utilitarian purpose. Although designated a painting of fireworks on the Thames, Whistler's *Nocturne* was actually a study in light, color, and form. The atmospheric effects of the cloudy night sky are contrasted with gold spots of light from the exploded rocket. When questioned about the identity of the black patch in the lower right corner, Whistler replied that it was a vertical, placed there for purely formal reasons. In that response, he echoed Monet's view that a painted "tree" is not a tree, but a vertical daub of paint. On the subject of money, Whistler testified that he had spent only a day and a half painting the *Nocturne*, but was charging for a lifetime of experience.

The jury followed the judge's instructions and decided in Whistler's favor, but awarded him only a farthing in damages. When it was over, the trial was extensively ridiculed in the English and American press. A *New York Times* critic complained (December 15, 1878) that "the world has been much afflicted of late with these slapdash productions of the paint-pot." In his view, musical titles were "exasperating nomenclature," and the "shadowy and unseen presences" of modern art were confusing. "Ordinary men and women in a state of health," he concluded, "prefer to have their pictures made for them." The London *Times* suggested that Whistler might take his "brush" to Ruskin's "pen" and paint a caricature of Ruskin as an "arrangement in black and white." The tragic irony of this notion is that when, at the end of his life, Ruskin

descended into his final madness, he went around muttering "everything black . . . everything white."

The trial was also the subject of the cartoon in figure **23.44**, which appeared in the English humorous magazine *Punch* on December 7, 1878. In it the judge holds up a giant farthing, which he offers to Whistler, who has a large ear on top of his head—his "ear for musical titles." Whistler stands on flute-legs, which refer not only to his musical titles, but also to his father, whose nickname was "Pipes," as he was a keen amateur flautist. At the right, the balloon over the jury reads: "No symphony [for "sympathy"] with the defendant."

Below the jury, Ruskin is represented as an "Old Pelican in the Wilderness of Art," his head bowed as if in shame at having lost the case. The box in front of the judge reads DAMAGES, and has a slot large enough to accommodate the farthing. Slithering along the floor are two serpents emerging from the bottomless pit of court costs. In fact, Whistler went bankrupt as a result of the trial, and was forced to sell his house in Chelsea. A fellow artist called the bankruptcy petition an "arrangement in black and white." Nearly seventy years after the trial, *Art Digest* reported that the Detroit Institute of Arts paid $12,000 for the infamous "pot of paint."

The significance of this absurd trial is its function as a window on esthetic conflict in the late nineteenth century. It also proves the adage that one cannot legislate taste. Whistler later called the trial a conflict between the "brush" and the "pen." It exemplified the rise of the critic as a potent force in the nineteenth-century art world. Although Ruskin had shown foresight when dealing with his own innovative contemporaries—notably Turner and the Pre-Raphaelites, whose causes he had championed—he did not have the same vision about the younger generation of artists. And he was not alone. The French public also notably failed to recognize the merits of avant-garde nineteenth-century art and, as a result, many important French paintings were bought by foreign collectors and are now in collections outside France.

We have seen that the history of Western art is fraught with esthetic quarrels, but passions rose to new heights during the latter half of the nineteenth century. For the first time, the material of art became itself a subject of art, and content yielded to style. More than anything else, it was the dissolution of form that seems to have caused the most intense critical outrage. But this was the very development that would prove to have the most lasting impact on Western art.

23.44 *Whistler versus Ruskin: An Appeal to the Law,* from *Punch,* December 7, 1878, p. 254.

Style/Period	Works of Art	Cultural/Historical Developments
1790 IMPRESSIONISM 1790–1800	Utamaro, *Young Woman with Blackened Teeth Examining her Features in a Mirror* (**23.11**) Toyokuni, *Portrait of the Actor Onoe Matsusuke as the Villain Kudo Suketsune* (**23.10**)	
1800 1800–1870	Eisen, *Oiran on Parade* (**23.12**) Hokusai, *The Great Wave of Kanagawa* (**23.14**) Kunisada, *Scene from Sukeroku* (**23.9**) Hiroshige, *Travelers in the Snow at Oi* (**23.16**) Hokusai, *The Horsetail Gatherer* (**23.15**) Kuniyoshi, *Tairano Koremochi Waking up from a Drunken Sleep* (**23.13**) Hiroshige, *Saruwaka-cho Theater* (**23.17**) Kunisada, *The Actor Seki Sanjuro in the Role of Kiogoku Takumi* (**23.8**) Garnier, *Opéra* (**23.3–23.4**), Paris Monet, *Terrace at Sainte-Adresse* (**23.27**) Manet, *Zola* (**23.6**) **Manet, Zola**	Restoration of Meiji dynasty in Japan (1868) **Hiroshige, Saruwaka-cho Theater**
1870 1870–1880	Renoir, *The Pont-Neuf* (**23.32**) Morisot, *The Cradle* (**23.26**) Whistler, *Nocturne in Black and Gold* (**23.43**) Renoir, *Torso of a Woman in the Sun* (**23.31**) Homer, *Breezing Up* (**23.40**) Degas, *Absinthe* (**23.19**) Muybridge, *Galloping Horse* (**23.23**) Degas, *Visit to a Museum* (**23.20**) Rodin, *The Thinker* (**23.35**) Whistler versus Ruskin (**23.44**) **Muybridge, Galloping Horse**	Richard Wagner, *Die Walküre* (1870) Giuseppe Verdi, *Aida* (1871) First Impressionist art exhibition in Paris (1874) Mark Twain, *The Adventures of Tom Sawyer* (1875) Georges Bizet, *Carmen* (1875) Alexander Graham Bell invents the telephone (1876) U.S. National Baseball League founded (1876) First lawn tennis championship played at Wimbledon (1877) Henrik Ibsen, *A Doll's House* (1879) Thomas Edison invents phonograph and electric light bulb (1879–80)
1880 1880–1890	Degas, *Fourth Position Front, on the Left Leg* (**23.34**) Manet, *A Bar at the Folies-Bergère* (**23.18**) Sargent, *The Daughters of Edward Darley Boit* (**23.41**) Degas, *The Dancing Lesson* (**23.21**) Degas, *At the Races* (**23.22**) **Degas, At the Races**	European colonization of Africa begins (1880s) Pasteur discovers a chicken cholera vaccine (1880) Andrew Carnegie develops first large steel furnace (1880) Fyodor Dostoevsky, *The Brothers Karamazov* (1880) Henry James, *Washington Square* (1881) Brahms, *Academic Festival Overture* (1881) Brooklyn Bridge opened to traffic (1883) Nietzsche, *Thus Spake Zarathustra* (1883) Gilbert and Sullivan, *The Mikado* (1885) First steam turbine engine invented (1884) Walter Pater, *Marius the Epicurean* (1885) American Federation of Labor founded (1886) Robert Louis Stevenson, *Dr. Jekyll and Mr. Hyde* (1886) Karl Marx, *Das Kapital* published in English (1886) Arthur Conan Doyle, *A Study in Scarlet* (1887) Dunlop invents pneumatic tire (1888) Rimsky-Korsakov, *Scheherazade* (1888) George Eastman develops Kodak box camera (1888)
1890 1890–1900	Cassatt, *The Letter* (**23.25**) Rodin, *Balzac* (**23.37–23.38**) Cassatt, *The Boating Party* (**23.24**) Monet, *Rouen Cathedral, West Façade, Sunlight* (**23.29**) Monet, *Rouen Cathedral, the Portal and the Tower of Albane, the Morning* (**23.30**) Pissarro, *Place du Théâtre Français, Rain* (**23.33**) **Monet, Rouen Cathedral** **Rodin, Balzac**	James G. Frazer, *The Golden Bough* (1890–1915) Rachmaninoff, Piano Concerto No. 1 (1891) Bernard Shaw, *Mrs. Warren's Profession* (1892) F. H. Bradley, *Appearance and Reality* (1893) Dvorak, *New World* Symphony (1893) Beginning of the Dreyfus Affair in France (1894) Sibelius, *Finlandia* (1894) Rudyard Kipling, *Jungle Books* (1894–5) Tchaikovsky, *Swan Lake* ballet (1895) Discovery of X-rays by Wilhelm Roentgen (1895) H. G. Wells, *The Invisible Man* (1897) Edmond Rostand, *Cyrano de Bergerac* (1897) Edward Elgar, *Enigma Variations* (1899) Oscar Wilde, *The Importance of Being Ernest* (1899) Rutherford discovers alpha and beta rays in radioactive atoms (1899) Boxer Rebellion in China against Western interests (1899–1900)
1900 1900–1920	Steichen, *Rodin – The Thinker* (**23.36**) Monet, *Waterlily Pond* (**23.28**) Prendergast, *Bathers* (**23.42**)	
1920	1960s: Delaney, *Balzac by Rodin* (**23.39**)	

24
Post-Impressionism and the Late Nineteenth Century

The term Post-Impressionism, meaning "After Impressionism," is used to designate the work of a group of important late nineteenth-century painters. Although their styles are quite diverse, they are united by the fact that nearly all were influenced by Impressionism. Like the Impressionists, the Post-Impressionists were drawn to bright color and visible, distinctive brushstrokes. Despite the prominent brushwork, however, Post-Impressionist forms do not dissolve into the medium as they do in the late works of Monet. The edges in Post-Impressionist works, whether outlined or defined by sharp color separations, are usually relatively clear.

Within Post-Impressionism two important trends evolved. These are exemplified on the one hand by Cézanne and Seurat, who reassert formal and structural values, and, on the other, by Gauguin and van Gogh, who explore emotional content. Both trends set the stage for the major directions of early twentieth-century art. Certain Post-Impressionist artists were also influenced by the late nineteenth-century Symbolist movement (see p. 809).

Post-Impressionist Painting

Henri de Toulouse-Lautrec

Henri de Toulouse-Lautrec (1864–1901), who was inspired by Degas, based his most characteristic work on the Paris nightlife. He frequented dance halls, nightclubs, cafés, and bordellos in search of subject-matter. The loose, sketchy brushwork, which is contained within clearly defined color areas, contributes to a sense of dynamic motion in his paintings. In the *Quadrille at the Moulin Rouge* (fig. **24.1**), the woman facing the viewer exudes an air of determined, barely contained energy about to erupt in dance. Her stance is the opening position of a quadrille, and a challenge to the other figures. Like Degas, Toulouse-Lautrec favored partial, oblique views, which suggest photographic cropping. He was also, like Degas, influenced by Japanese prints, using strong silhouettes, which offset the more textured areas of his painted surfaces.

In contrast to the textured surfaces of his paintings,

Toulouse-Lautrec's lithograph posters consist of flat, unmodeled areas of color. The poster—which Lautrec popularized at the end of the nineteenth century—was not only an art form. Like the print techniques used by the

24.1 Henri de Toulouse-Lautrec, *Quadrille at the Moulin Rouge*, 1892. Oil on cardboard, 31⅓ × 31½ in (80 × 80.01 cm). National Gallery of Art, Washington, D.C. (Chester Dale Collection). The Moulin Rouge was (and still is) a popular music hall in Montmartre. It was here, in the artistic and entertainment center of Paris, that Toulouse-Lautrec lived and worked. He was descended from the counts of Toulouse and, although his family disapproved of his lifestyle, his wealth saved him from the poverty suffered by many artists of his generation. He died at age thirty-seven from the effects of alcoholism.

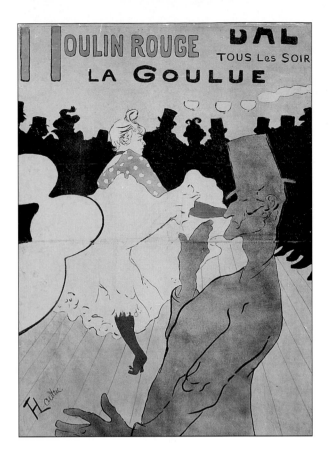

24.2 (above) Henri de Toulouse-Lautrec, *La Goulue at the Moulin Rouge*, 1891. Lithograph, 5 ft 5 in × 3 ft 10 in (1.65 × 1.17 m). Philadelphia Museum of Art (Gift of Mr. and Mrs. R. Sturgis Ingersoll). At fifteen, two accidents left Toulouse-Lautrec with permanently stunted legs. Perhaps because of this, dancers had a particular attraction for him. La Goulue was one of the professional dancers who, along with singers, circus performers, and prostitutes, were among his favorite subjects.

Realists for social and political ends, posters disseminated information—for example, *La Goulue at the Moulin Rouge* (fig. **24.2**). Because the purpose of a poster is to advertise an event, words necessarily form part of the message. In *La Goulue*, the letters are integrated with the composition by repetition of the lines and colors of the printed text within the image. The blacks of BAL ("dance") and LA GOULUE recur in the silhouetted background crowd and the stockings of the dancer. The flat red-orange of MOULIN ROUGE is echoed in the dress. And the thin, dark lines of TOUS LES SOIRS ("every evening") are repeated in the floorboards and the outlines of the figures.

Paul Cézanne

The Post-Impressionist who was to have the most powerful impact on the development of Western painting was Paul Cézanne (1839–1906). He, more than any artist before him, transformed paint into a visible structure. Cézanne's early pictures were predominantly black and obsessed with erotic or violent themes. *The Temptation of Saint Anthony* (fig. **24.3**) of about 1870 depicts an erotic theme that preoccupied Cézanne for many years. Related to a book of the same title by Zola, whom Cézanne had known since childhood, the painting shows the hermit saint at the upper left. He recoils from a nude exposing herself to him. The two figures at the right have an androgynous quality, but appear to be male. The seated figure broods in the manner of Dürer's *Melencolia* (see fig. 17.15), while also reclining in a traditional female pose. The ambivalence of the standing figure lies in the fact that his gaze is riveted to

24.3 Paul Cézanne, *The Temptation of Saint Anthony*, c. 1870. Oil on canvas, 22⅜ × 30 in (57 × 76 cm). Buhrle Collection, Zürich.

the kneeling woman, while he turns as if to escape the sexual dangers that she represents. The erotic conflicts dramatized in this *Temptation* are Cézanne's own, and they are characteristic of his early imagery.

Cézanne's *Self-portrait* (fig. **24.4**) of around 1872 depicts a man of intense vitality. Although the colors remain dark, the background landscape conveys Impressionist ideas. The thickly applied paint accentuates each brushstroke—short and determined—like the bricks of an architectural structure. The arched eyebrows frame diamond-shaped eye sockets, and the curved brushstrokes of the hair and beard create an impression of wavy, slightly unruly motion.

Cézanne exhibited with the Impressionists in 1873 and 1877 and, under the influence of Pissarro, his palette became brighter, and his subject-matter more restricted. In the *Still Life with Apples* (fig. **24.5**), of c. 1875–7, painted at the height of his Impressionist period, Cézanne subordinates narrative to form. He condenses the rich thematic associations of the apple in Western imagery with a new, structured abstraction. Cézanne's punning assertion that he wanted to "astonish Paris with an apple" (see Box) is nowhere more evident than in this work. Seven brightly colored apples are set on a slightly darker surface. Each is a sphere, outlined in black and built up with patches of color—reds, greens, yellows, and oranges—like the many facets of a crystal. Light and dark, as well as color, are created by the arrangement of the brushstrokes in rectangular shapes. The structural quality of the apples seems to echo Cézanne's assertion that the natural world can be "reduced to a cone, a sphere, and a cylinder."

24.4 Paul Cézanne, *Self-portrait*, c. 1872. Oil on canvas, 25¼ × 20½ in (64 × 52 cm). Musée d'Orsay, Paris. Cézanne was born and lived most of his life in Provence, in the south of France. He studied law before becoming a painter. In 1869 he began living with Hortense Fiquet, by whom he had a son in 1872. They married in 1886, the year his father died.

24.5 Paul Cézanne, *Still Life with Apples*, c. 1875–7. Oil on canvas, 7½ × 10¾ in (19.1 × 27.3 cm). By kind permission of the Provost and Fellows of King's College, Cambridge, England (Keynes Collection).

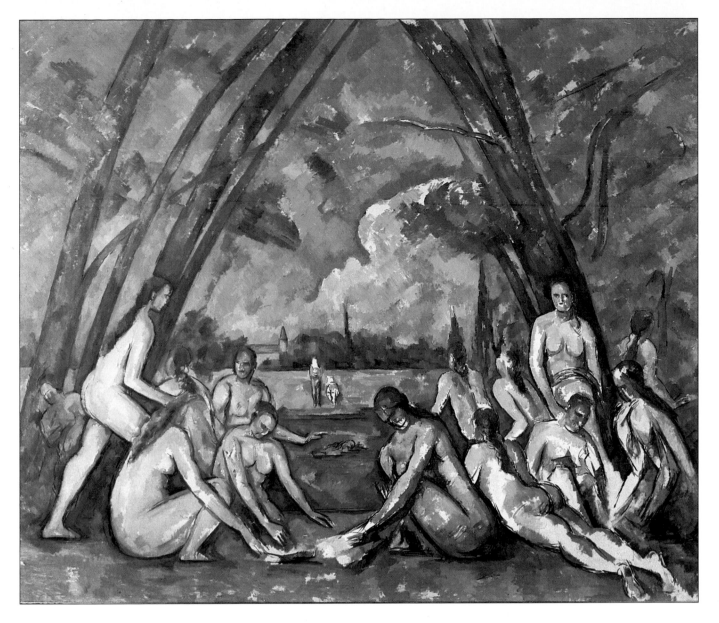

24.6 Paul Cézanne, *The Great Bathers*, 1898–1905. Oil on canvas, 6 ft 10 in × 8 ft 3 in (2.08 × 2.52 m). Philadelphia Museum of Art (W. P. Wilstach Collection).

An Apple a Day . . .

Since its portrayal as the "forbidden fruit" in the Garden of Eden, the apple has had a prominent place in the Western imagination. The traditional associations of the apple with health ("an apple a day keeps the doctor away") and love ("the apple of one's eye") are still apparent in popular expressions. In Greek mythology, one of the Labors of Herakles (the Roman Hercules) required that he steal the Golden Apples of the Hesperides. The role of the golden apple in the Trojan War was illustrated in the sixteenth century by Cranach, who depicted Paris, the Trojan prince, judging the beauty contest between Hera, Athena, and Aphrodite (see fig. 17.19).

Cézanne's pun condenses the Paris of Greek myth with Paris, the capital city of France. In astonishing "Paris" (in the latter sense), Cézanne wins the beauty contest, and becomes a Hercules among painters.

The apples are endowed with a life of their own. Each seems to be jockeying for position, as if it has not quite settled in relation to its neighbors. The shifting, animated quality of these apples creates dynamic tension, as does the crystalline structure of the brushstrokes. Nor is it entirely clear just what the apples are resting on, for the unidentified surface beneath them also shifts. As a result, the very space of the picture is ambiguous, and the image has an abstract, iconic power.

In 1887 Cézanne's active involvement with the Impressionists in Paris ended, and he returned to his native Provence in the south of France. Having integrated Impressionism with his own objectives, he now focused most of his energy on the pursuit of a new pictorial approach. In *The Great Bathers* (fig. **24.6**), painted toward the end of his life, Cézanne achieved a remarkable synthesis of a traditional subject with his innovative technique of spatial construction.

As in the *Still Life with Apples*, there is no readily identifiable narrative in *The Great Bathers*. A group of nude women occupy the foreground, blending with the landscape through pose and similarity of construction, rather than through Impressionist dissolution of form. They correspond to the base of a towering pyramidal arrangement, which is carried upward by the arching trees. Two smaller figures visible across a river repeat the distant verticals.

Cézanne's new conception of space is evident in the relationship of the sky and trees. He depicts air and space, as well as solid form, as a "construction." Through his technique of organizing the brushstrokes into rectangular shapes, his surfaces, such as the sky, become multi-faceted patchworks of shifting color. In certain areas—the tree on the left, for example—patches of sky overlap the solid forms. This results in spatial ambiguity, and the abandonment of the traditional distinctions between foreground and background. In this breakdown of the spatial conventions of Western art, Cézanne created a revolution in the painter's approach to the picture plane. It was a revolution whose formal precedents can be found in the Post-Impressionist combination of prominent brushstrokes with clear edges.

Georges Seurat

In his own brand of Post-Impressionism, short-lived though it was, Georges Seurat (1851–91) combined Cézanne's interest in volume and structure with Impressionist subject-matter. His most famous painting, *Sunday Afternoon on the Island of La Grande Jatte* (fig. **24.7**), monumentalizes a scene of leisure by filling the space with solid, rigid, iconic forms. Human figures, animals, and trees are frozen in time and space. Motion is created formally, by contrasts of color, silhouettes, and repetition, rather than by the figures.

Seurat has been called a Neo-Impressionist and a Pointillist, after his process of building up color through

24.7 Georges Seurat, *Sunday Afternoon on the Island of La Grande Jatte*, 1884–6. Oil on canvas, 6 ft 9 in × 10 ft ⅜ in (2.08 × 3.08 m). Art Institute of Chicago (Helen Birch Bartlett Memorial Collection). La Grande Jatte is an island in the River Seine that was popular with Parisians for weekend outings. Seurat's painstaking and systematic technique reflected his scientific approach to painting. For two years he made many small outdoor studies before painting the large final canvas of *La Grande Jatte* in his studio. In 1886 it was unveiled for the last Impressionist Exhibition.

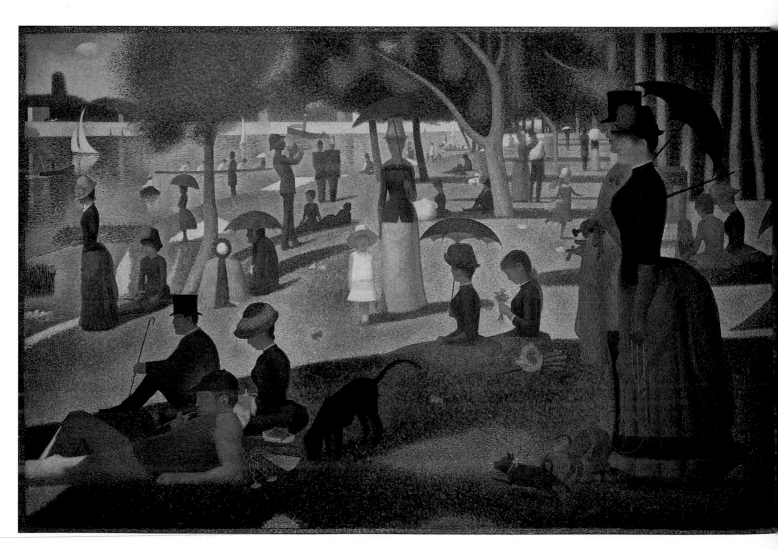

24.8 Detail of 24.7.

dots, or points, of pure color; Seurat himself called this technique "divisionism." In contrast to Cézanne's outlined forms, Seurat's are separated from each other by the grouping of dots according to their color. In the detail of

the girl holding the spray of flowers (fig. **24.8**), the individual dots are quite clear.

Seurat's divisionism was based on two relatively new theories of color. The first was that placing two colors side by side intensified the hues of each. There is in *La Grande Jatte* a shimmering quality in the areas of light and bright color, which tends to support this theory. The other theory, which is only partly confirmed by experience, asserted that the eye causes contiguous dots to merge into their combined color. Blue dots next to yellow dots, according to this theory, would merge and be perceived as vivid green. If the painting is viewed from a distance or through half-closed eyes, this may be true. It is certainly not true if the viewer examines the picture closely, as the illustration of the detail confirms. True or not, such theories are characteristic of the search by nineteenth-century artists for new approaches to light and color, based on scientific analysis.

Vincent van Gogh

Vincent van Gogh (1853–90), the greatest Dutch artist since the Baroque period, devoted only the last ten years of his short life to painting. He began with a dark palette and subjects that reflected a social consciousness reminiscent of nineteenth-century Realism. *The Potato Eaters* (fig. **24.9**)

24.9 Vincent van Gogh, *The Potato Eaters*, 1885. Oil on canvas, 2 ft 8¼ in × 3 ft 9 in (0.82 × 1.14 m). Vincent van Gogh Foundation. Rijksmuseum Vincent van Gogh, Amsterdam.

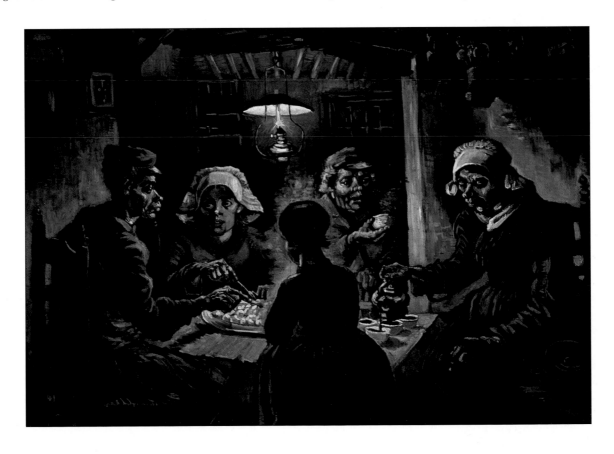

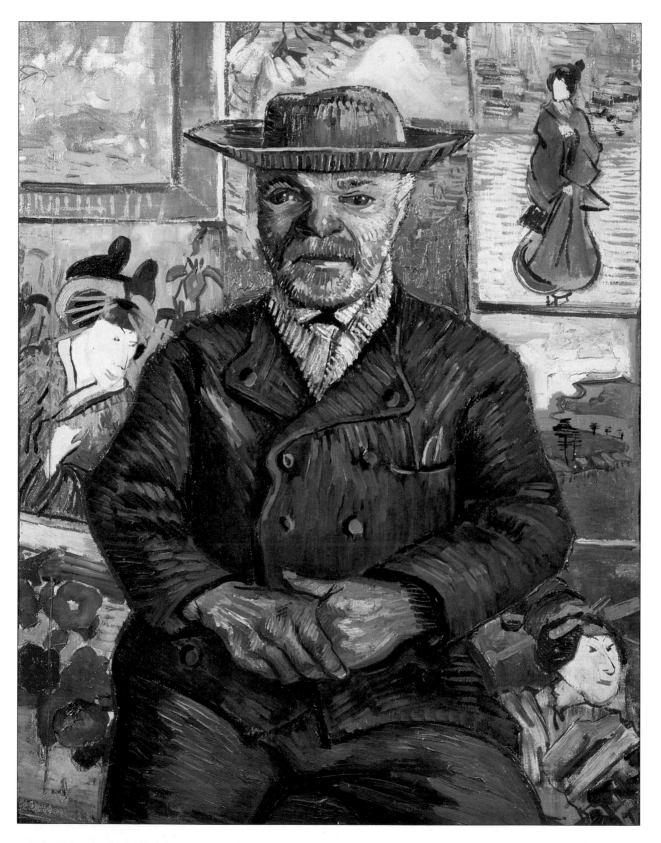

24.10 Vincent van Gogh, *Portrait of Père Tanguy*, 1887. Oil on canvas, 25½ × 20 in (64.8 × 50.8 cm). Private collection. Unable to sell his paintings, van Gogh relied on his brother Theo, an art dealer in Paris, for most of his financial support. Père Tanguy was a Paris dealer in art supplies who helped the artist by showing his canvases in his shop window. In a letter to Theo, Vincent compared Tanguy with Socrates, and expressed the wish to be like him. Tanguy's frontal pose, hands crossed in front of him, is reminiscent of Buddha, who was also admired by van Gogh.

of 1885 exemplifies van Gogh's empathy with the poverty of the coal miners he knew in the Borinage region of southern Belgium. It shows four family members around a crude wooden table; their meal consists only of potatoes and coffee. In the foreground, a girl rendered in back view is silhouetted against the rising steam. The rather heavy, ponderous character of all the figures is enhanced by a thick, impasto paint texture.

More than many artists, van Gogh painted unequivo cally autobiographical scenes. His signature, "Vincent," on the back of the chair in the left corner of *The Potato Eaters*, implies his identification with the young man. Tension created by his personal sense of isolation pervades the painting. Although united by their spatial proximity, none of these figures communicates with anyone. The dark interior is warmed solely by the light above the table, which, given van Gogh's strict religious upbringing, might refer to the presence of God in the miners' humble house.

The following year, 1886, van Gogh moved to Paris, where his brother Theo worked as an art dealer (see Box). Under the influence of French Impressionism, van Gogh's paintings became explosions of light and color. In 1887 he painted the *Portrait of Père Tanguy* (fig. **24.10**), in which vibrant color has supplanted the somber tones of his early pictures. The brushstrokes are thick, clear, and separated from one another, creating the surface animation that characterizes van Gogh's work after 1886. The Japanese prints in the background reflect the artist's attraction to their colorful patterns and to their bold contrasts of light and dark. Their partial character—each is cropped by the painting's frame—reflects the Impressionist preference for works of art that represent a "slice of life." Here, however, the cropping also serves to intensify the contrast between the colorful background movement and Père Tanguy's static, iconic character.

Van Gogh's interest in Japanese woodblock prints was consistent with certain features of Impressionism. While living in Paris, van Gogh began to collect such prints, which he had known and admired previously. He wrote to Theo from Antwerp that he had decorated his room with "a number of little Japanese prints." Once in Paris, he encountered personally the new fashion for *japonisme* and its impact on the Impressionists. In *Père Tanguy*, the woodblocks depict geishas and courtesans, as well as landscape (Mt. Fuji is visible above Tanguy's hat). The prevalence of this subject-matter in Japanese prints reflects a pre-occupation of the artist, for throughout his life van Gogh struggled with his attraction to prostitutes. They were the only type of woman with whom he was able to form a relationship. He was drawn to their poverty and suffering, and he empathized with them just as he had with the coal miners represented in *The Potato Eaters*.

In addition to including Japanese prints within his pictures, van Gogh made copies—using his own thick brushstrokes—of several of them. A comparison of his copy of Hiroshige's *Sudden Shower at Ohashi Bridge at Ataka*

"Dear Theo"—The Letters of Vincent van Gogh

Van Gogh's most penetrating exercise in self-portraiture was his correspondence with his younger brother, Theodorus van Gogh, known as Theo. The letters chronicle Vincent's life of poverty and despair, his efforts to find his life's calling, his tortured relationships with women, and his bouts of madness.

Van Gogh's father was a clergyman in Zundert, a small town in Holland. His mother was depressed by the death of her first son, after whom Vincent was named, and who was born on exactly the same day as the second Vincent. Van Gogh grew up with the grave of his older brother, which was located near the family house, a constant presence. As an adult, he took several jobs before devoting himself exclusively to painting. At first, he aspired to follow his father as a minister in the Dutch Reform Church. He was sent by the Church to work with the coal miners at the Borinage district in the south of Belgium. Their poverty inspired *The Potato Eaters*, but van Gogh's religious zeal alarmed the authorities and he was not ordained. He also worked in his uncle's art dealership (Goupil's) in Brussels and London, and taught school in England. He was a prodigious reader, fluent in English and French, as well as in Dutch.

Although van Gogh did not decide to be a painter until about 1884, he had—like most artists—begun drawing as a child. Once he settled on his career, he became dependent on Theo for money and emotional support. Virtually every letter details his expenditures on art supplies, and complains about the cost of living. Often he went without food in order to paint. Aside from a few brief stints in formal art classes, van Gogh comes close to being a self-taught artist. His letters also describe his efforts to learn to draw, to capture a likeness, and his views on art and artists, particularly Delacroix, who exerted a major influence on his development.

After two years in Paris, van Gogh moved to Arles, in the south of France. There he hoped to found a society of artists who would live and work in a communal setting. Gauguin joined him, but these two difficult personalities were destined not to co-exist for long. When van Gogh cut off his earlobe in a fit of jealous despair and was hospitalized, Gauguin left. Van Gogh then suffered several episodes of mental breakdown and on July 27, 1890, he shot himself, dying two days later. Six months after Vincent's death Theo also died.

Van Gogh's clinical diagnosis has never been satisfactorily identified. Theories abound, however, and they range from epilepsy to childhood depression to lead poisoning from paint fumes. Unable to sell his pictures during his lifetime, van Gogh's legacy of paintings went to Theo, and then to Theo's son, also named Vincent. The young Vincent bequeathed the bulk of the collection to Holland, and most are now permanently exhibited in the Vincent van Gogh Museum in Amsterdam.

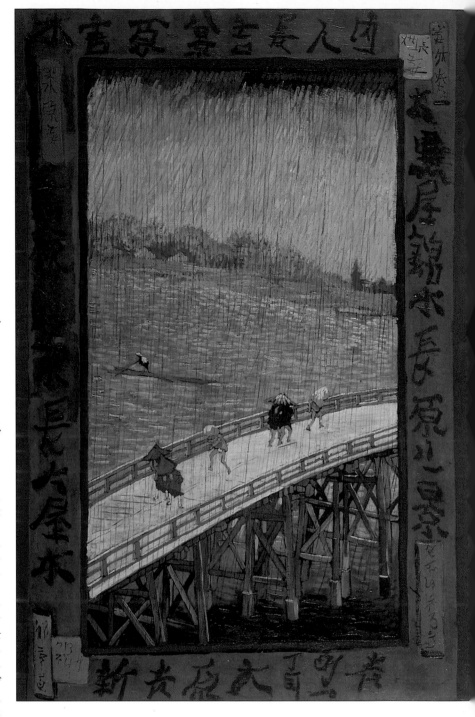

with the original (figs. **24.11** and **24.12**) shows that they share certain formal and iconographic interests with the French Impressionists. The picture planes are divided by strong diagonals—the bridge and the shoreline—into asymmetrical trapezoids. Reminiscent of the candid camera effect of Degas's *Absinthe* (see fig. 23.19), the resulting tilt is stabilized by the silhouetted verticals of the piers supporting the bridge. Hiroshige's portrayal of rain is echoed in the Impressionist studies of weather conditions—for example, Pissarro's *Place du Théâtre Français* (see fig. 23.33). The darkened sky and the huddled figures, which are small and anonymous, are consistent with van Gogh's frequent bouts of depression. Finally, the people in Hiroshige's print are arranged in two sets of pairs and two single figures. A lone boatman, working against the current, drives his boat up the river. Such contrasts between pairs and solitary figures was a continuous theme in van Gogh's work. It reflected his personal struggle with isolation and his unsuccessful attempts to form a lasting relationship with a woman. It also evoked his close—"paired"—relationship with Theo.

In 1888 van Gogh moved from Paris to Arles in the south of France. The following year he painted the famous *Bedroom at Arles* (fig. **24.13**), which is pervaded by isolation and tension. Figures who do not communicate are replaced by an absence of figures. The artist's existence, rather than the artist himself, is indicated by furnishings and clothing. Only the portraits on the wall , one of which is a self-portrait, contain human figures. Like the figures on Hiroshige's bridge, the portraits are arranged as a pair juxtaposed with a single landscape over the clothes rack. Likewise two pillows lie side by side on a single bed. There are two chairs, but they are separated from each other. The same is true of the doors. There are two bottles on the table, and a double window next to a single mirror. Van Gogh's *Bedroom* is thus a psychological self-portrait, which records his efforts to achieve a fulfilling relationship with another person, and his failure to do so.

The tension is reinforced by the color, particularly the intense hue of the red coverlet, which is the only pure color in the painting. In October 1888 Vincent sent Theo a sketch of the *Bedroom* (fig. **24.14**), in order to give him an idea of his work:

I have a new idea in my head and here is a sketch of it.... This time it's simply my bedroom, only here color is to do everything, and giving by its simplification a grander style of things, it is to be suggestive here of *rest*, or of sleep in general. In a word, looking at the picture ought to rest the brain, or rather the imagination.[1]

A description of the color follows:

The walls are pale violet. The floor is of red tiles. The wood of the bed and chairs is the yellow of fresh butter, the sheets and pillows very light greenish citron. The coverlet scarlet. The window green. The toilet table orange, the basin blue. The doors lilac. And that is all—there is nothing in this room with its closed shutters.[2]

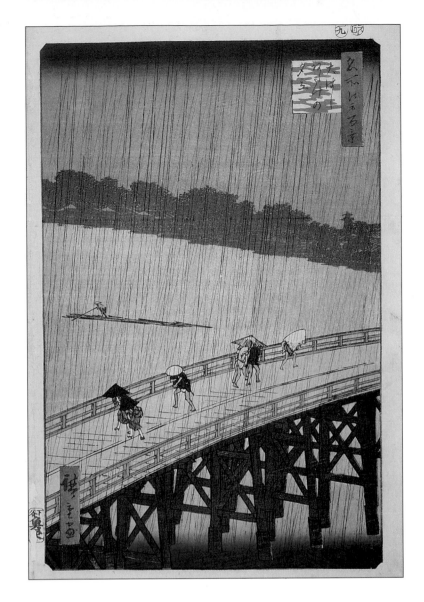

24.12 Utagawa Hiroshige, *Sudden Shower at Ohashi Bridge at Ataka*, from the series *One Hundred Views of Edo*, 1857. Woodblock print, 14⅛ × 9¾ in (35.9 × 24.8 cm). Whitworth Art Gallery, University of Manchester.

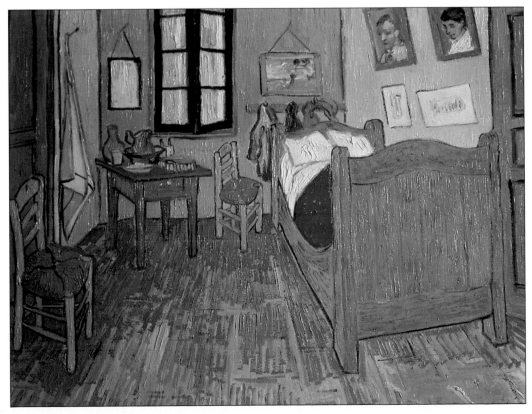

24.13 Vincent van Gogh, *Bedroom at Arles*, 1889. Oil on canvas, 28⅜ × 35⅜ in (72 × 90 cm). Musée d'Orsay, Paris.

24.14 Vincent van Gogh, sketch for *Bedroom at Arles*, 1888. Pen and ink on squared paper, 5¼ × 8⅓ in (13.3 × 21.1 cm). Vincent van Gogh Foundation. Rijksmuseum Vincent van Gogh, Amsterdam.

24.15 Vincent van Gogh, *Wheatfield with Reaper*, 1889. Oil on canvas, 29¼ × 36¼ in (74.3 × 92.1 cm). Vincent van Gogh Foundation/Rijksmuseum Vincent van Gogh, Amsterdam. Van Gogh described the "all yellow, terribly thickly painted" figure as Death, who reaps humanity like a wheat field. The yellow symbolically derives its power from the sun, which is the painting's source of light. Here it determines the color of the entire picture, and its intensity seems to "heat" the scene.

Van Gogh shared the Impressionist passion for land-scape. His *Wheatfield with Reaper* (fig. 24.15) illustrates his genius for intense, vibrant color. The frenzied curves of wheat—actually formed with individual brushstrokes—repeat the curve of the reaper's scythe. But, despite the unforgettable power of van Gogh's brushwork, his forms never dissolve completely. The areas of color are maintained as distinct shapes, and the power of the color exceeds that of Impressionism.

Like Rembrandt, whom he surely studied in his native Holland, van Gogh painted many self-portraits. His drawings show that he studied his own features as intensely as he observed the world around him. The sheet in figure 24.16 depicts different views of his head, which are related

to the *Self-portrait* in figure 24.17. The structural quality of the head is emphasized by the firm outlines and gradual shading. Whereas Rembrandt created physiognomy primarily by variations in lightness and darkness, van Gogh did so with color. Aside from the yellows and oranges of the face and hair, the *Self-portrait* is very nearly mono-chromatic. The main color is a pale blue-green, varying from light to dark in accordance with the individual brush-strokes. The jacket remains distinct from its background by its darkened color and outline.

Although the figure itself is immobile, the pronounced spiralling, wavy brushstrokes undulate over the surface of the picture plane. Yellow—the color associated with Death in *Wheatfield with Reaper*—predominates in the depiction

24.16 Vincent van Gogh, studies for *Self-portrait*, 1889. Pencil and pen drawing, 12⅝ × 9½ in (32 × 24 cm). Rijksmuseum Vincent van Gogh, Amsterdam.

24.17 Vincent van Gogh, *Self-portrait*, 1889. Oil on canvas, 25½ × 21¼ in (64.8 × 54 cm). Musée d'Orsay, Paris.

of van Gogh's head and is a component of both the orange and the blue-green. The intense gaze is also achieved through color, for the whites of the eyes are not white at all, but rather the same blue-green as the background. As a result, the viewer has the impression of looking through van Gogh's skull at eyes set far back inside his head.

Paul Gauguin

Compared to the dynamic character of van Gogh's pictorial surfaces, Paul Gauguin (1848–1903) applied his paint smoothly. Although Gauguin's colors are bright, they are arranged as flat shapes, usually outlined in black. The surfaces of his pictures seem soft and smooth in contrast to the energetic rhythms of van Gogh's thick brushstrokes.

Gauguin began his career under the aegis of the Impressionists—he exhibited with them from 1879 to 1886—and then went on to explore new approaches to style. In *The Yellow Christ* (see fig. **24.19** and Box) of 1889, Gauguin identifies with the Symbolist movement, and a group of painters referred to as the Nabis, meaning "prophets." He sets the Crucifixion in a Breton landscape, and depicts Christ in flattened yellows. Three women in local costume encircle the Cross—a reference to traditional Christian symbolism, in which the circle signifies the Church. In fact, the women of Brittany often prayed at large stone crosses in the countryside. The juxtaposition of the Crucifixion with the late nineteenth-century landscape

of northern France is a temporal and spatial condensation that is characteristic of the dream world depicted by the Symbolists. It is also intended to convey the hallucinatory aspects of prayer, indicating that through meditating on the scene of the Crucifixion the Breton women conjured up an image of the event.

In the *Self-portrait with Halo* (fig. **24.21**) of the same year, a pair of apples is suspended behind Gauguin's head. They, like the serpent rising through his hand, allude to the Fall of Man. The flat, curved plant stems in the foreground repeat the motion of the serpent, the outline of Gauguin's lock of hair, and the painting's date and signature. The clear division of the picture plane into red and yellow depicts the artist's divided sense of himself; his head is caught between the two colors, implying that his soul wavers between the polarities of good and evil. Gauguin combines Symbolist color with traditional motifs to convey this struggle. He is at once the tempted and the tempter, a saint and a sinner, an angel and a devil. An important feature of the *Self-portrait* is Gauguin's contrast between himself as a physical body and the red and yellow areas of the picture plane. His hand and face, as well as the apples, are modeled three-dimensionally, whereas the red and yellow are flat. These methods by which the artist depicted animate and inanimate objects continued to be used throughout his career.

In 1891 Gauguin sold thirty paintings to finance a trip to Tahiti. Apart from an eighteen-month stay in France in

Gauguin's attraction to the brown tones of his Polynesian subjects was foreshadowed by his Symbolist use of color. In a twentieth-century painting of the *Crucifixion* (fig. **24.18**), the American artist Bob Thompson (1937–66) combined the Symbolist color of Gauguin's *Yellow Christ* (fig. 24.19) with the composition of the *Crucifixion* of 1503 (fig. **24.20**) by Cranach.

Thompson was born in Louisville, Kentucky. One of his ancestors was an American Indian; others were slaves. His early death in Rome cut short a promising career. He was influenced by Renaissance painters, particularly Masaccio, Piero della Francesca, and Cranach. In the *Crucifixion*, Thompson merges his self-image as a black artist with the psychology of color, thereby linking contemporary issues of race with nineteenth-century Symbolism. The foreshortened, red, crucified figure on the right corresponds to the placement of Cranach's Christ. The same swirling sky as that in Cranach's *Crucifixion* evokes the tradition of nature's ominous response to the death of Christ. Thompson's red Christ is his self-portrait, just as Gauguin's yellow Christ bears a resemblance to that artist. Thompson places his yellow figure in the role of the good thief (on Christ's right). Both he and Gauguin identified with Christ's suffering— Thompson as a victim of racism (note the colored figures), and Gauguin as the victim of an unsympathetic society.

24.19 Paul Gauguin, *The Yellow Christ*, 1889. Oil on canvas, 36¼ × 28⅞ in (92.1 × 73.3 cm). Albright-Knox Art Gallery, Buffalo, New York.

24.18 Bob Thompson, *Crucifixion*, 1963–4. Oil on canvas, 5 × 4 ft (1.52 × 1.22 m). Private collection. Photo Maggie Nimkin. The blue Mary has red hair, similar to that of Thompson's Caucasian wife, whom she resembles. The painting not only reflects Thompson's concern over racial issues, but also shows the correlation between his personal and artistic identity as a "man of color and of colors."

24.20 Lucas Cranach the Elder, *Crucifixion*, 1503. Oil on panel, 54½ × 43 in (138 × 109.2 cm). Alte Pinakotek, Munich.

24.21 Paul Gauguin, *Self-portrait with Halo*, 1889. Oil on wood, 31⅛ × 20¼ in (79.5 × 51.4 cm). National Gallery of Art, Washington, D.C. (Chester Dale Collection). In 1873 Gauguin married a Danish piano teacher, with whom he led a middle-class life and had five children. In 1882 he became a full-time painter and deserted his family. After a turbulent year with van Gogh in Arles in the south of France, Gauguin returned in 1889 to Brittany, where he was influenced by the Symbolists, and his work assumed a spiritual, self-consciously symbolic quality.

1895–6, he spent the rest of his life in the South Sea Islands. In his Tahitian paintings, Gauguin synthesized the Symbolist taste for dreams and myth with native subjects and traditional Western themes. *Nevermore* (fig. **24.22**), for example, depicts a Tahitian version of the reclining nude. The brightly colored patterns and silhouettes indicate the influence both of Japanese prints and of native designs. They enliven the composition and contrast with the immobility of the figures.

Gauguin has infused the traditional reclining nude with a sense of danger and suspicion. She evidently knows of the danger, since she rolls her eyes as if aware of the two women talking in the background. The title of the picture, spelled out in the upper left corner, echoes the refrain of Edgar Allan Poe's "The Raven," which Gauguin knew from Baudelaire's translation:

> Once upon a midnight dreary, while I pondered, weak and weary,
> Over many a quaint and curious volume of forgotten lore—
> While I nodded, nearly napping, suddenly there came a tapping,
> As of someone gently rapping, rapping at my chamber door.
> "Tis some visitor," I muttered, "tapping at my chamber door—
> Only this and nothing more." . . .
> "Prophet!" said I, "thing of evil! prophet still, if bird or devil!—
> Whether Tempter sent, or whether tempest tossed thee here ashore,
> Desolate yet all undaunted, on this desert land enchanted—
> On this home by Horror haunted—tell me truly, I implore—
> Is there—is there balm in Gilead?—tell me—tell me, I implore!"
> Quoth the Raven, "Nevermore."

In Gauguin's painting, the raven stands on a shelf between the title and the whispering women, and stares at the nude. The juxtaposition of raven, nude, and talking women hints at a silent, but sinister, communication. In this combination of Tahitian imagery and Western themes, self-consciously imbued with a psychic dimension, Gauguin merges his personal brand of Post-Impressionism with a Symbolist quality.

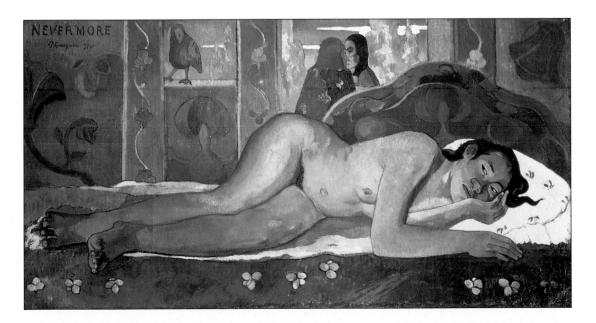

24.22 Paul Gauguin, *Nevermore*, 1897. Oil on canvas, 1 ft 11⅞ × 3 ft 9⅝ in (0.61 × 1.16 m). Courtauld Institute Galleries, University of London. Although Gauguin's style changed little after he left France, Polynesian life and culture became the subjects of his work. Gradually, poverty, alcoholism, and syphilis undermined his health, and he died at age fifty-five, after at least one suicide attempt.

Gauguin and Oceania

Following the eighteenth-century Enlightenment, there developed a new interest in Oceania, which includes Polynesia, Melanesia, Micronesia, and New Guinea (fig. **24.23**). The possibility that man existed there in the utopian state of nature posited by Jean Jacques Rousseau intrigued western Europe. Between 1768 and 1778, Captain Cook made three voyages to the South Seas. Collectors began to focus on Oceanic objects which had been brought back by explorers. Descriptions and drawings of the native populations, their artifacts, dwellings, costumes, and even their tattoos achieved a certain popularity in Europe.

In 1872 Sarah Bernhardt was given a drawing of the monumental statues on Easter Island, waist-high stone figures with huge heads and block-like features. They date from the fifth to the seventeenth century A.D., and are the most impressive Oceanic sculptures (fig. **24.24**). Their frontal poses and impassive gazes endow them with a timeless quality that has fascinated viewers since their discovery. Like the Neolithic monoliths of western Europe (see Vol. I, Chapter 2), by virtue of their size and verticality they connect earth with sky. Some mark burials, but their primary purpose was to embody the divine power of a deceased ruler. As such, they can be related to ancestor cults throughout the world, such as the Cambodian cult of the sun king at Angkor (see Vol. I, p. 444).

By the latter half of the nineteenth century, after the fashion for *japonisme* had been established, ethnology

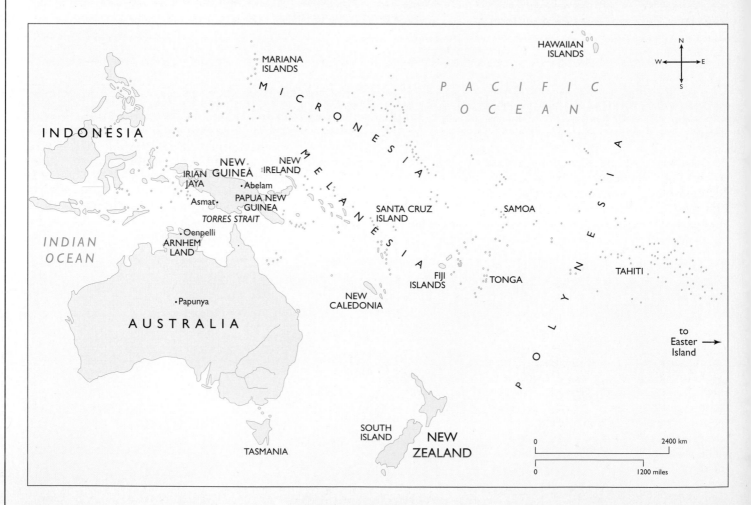

24.23 Map of Oceania.

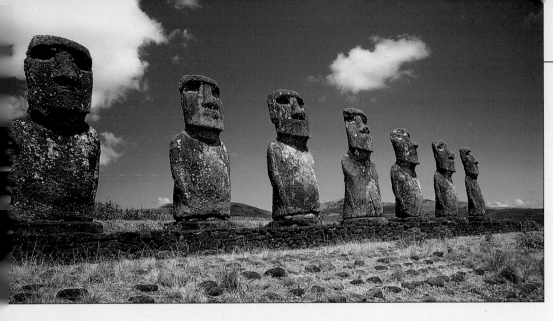

24.24 Stone heads, Easter Island, 5th–17th century.

museums became more numerous and began to mount exhibits of Oceanic art. This development was encouraged by French colonial expansion in Africa and the Far East (especially Indochina) in the 1880s. In 1882 the Musée d'Ethnographie (Musée de l'Homme) opened in Paris, and the arts of Polynesia were well represented. In an effort to provide "context," the Universal Exposition of 1889 exhibited Oceanic objects in reconstructed village settings.

Gauguin was one of the first major artists to become interested in Oceanic culture and to collect its art and artifacts. The European fantasy of a "noble savage" appealed to him, and in 1891 he gave the following account of his intention to live and work in Tahiti:

I am leaving in order to have peace and quiet, to be rid of the influence of civilization. I only want to do simple, very simple art, and to be able to do that, I have to immerse myself in virgin nature, see no one but savages, live their life, with no other thought in mind but to render, the way a child would, the concepts formed in my brain and to do this with the aid of nothing but the primitive means of art, the only means that are good and true.[3]

For Gauguin, Tahiti had many complex associations. It was one aspect of the ambivalent self he depicted in the *Self-portrait* of 1889. He saw Tahiti as a new Eden, an island paradise, where nature took precedence over the corrupt, industrial, "civilized" West, and he described his trip as a return to the "childhood of mankind." The South Seas also fueled the eclectic character of his art. For he never renounced the Western tradition, in which he was deeply immersed. His affinity with late nine-teenth-century European abstraction is evident in his reply to a question about his "red dogs" and "pink skies:"

It's music, if you like! I borrow some subject or other from life or from nature as a pretext, I arrange lines and colors so as to obtain symphonies, harmonies that do not represent a thing that is real, in the vulgar sense of the word, and do not directly express any idea, but are supposed to make you think the way music is supposed to make you think, unaided by ideas or images, simply through the mysterious affinities that exist between our brains and such arrangements of colors and lines.[4]

Gauguin was a prodigious synthesizer of different artistic traditions, including those of western Europe, Japanese woodblock, and the sculpture of Egypt, Oceania, Indonesia, and the Far East. For example, he combined Oceanic mythology with Christian and Buddhist iconography. In the *Idol with the Seashell* (fig. **24.25**) of about 1893 the figure represents Taaroa, who was worshiped on Easter Island as the divine creative force of the universe. The prominent teeth, made of inlaid bone, carry cannibalistic implications. But the idol occupies a traditional pose of Buddha and the rounded, polished shell is reminiscent of the Christian halo. In such works as this, Gauguin helped to correct the popular misunderstanding of the tribal arts as primitive in the sense of regressive. For him, the incorporation of various non-Western forms and motifs into Western art expanded intellectual, as well as esthetic experience.

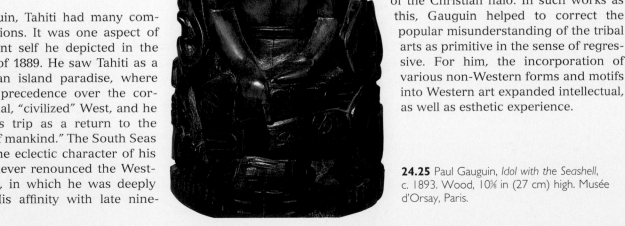

24.25 Paul Gauguin, *Idol with the Seashell*, c. 1893. Wood, 10⅝ in (27 cm) high. Musée d'Orsay, Paris.

Symbolism

The Symbolists (see Box) rejected both the social consciousness of Realism and the Impressionist interest in nature and the outdoors. They were attracted instead by the internal world of the imagination and by images that portrayed the irrational aspects of the human mind. Their interest can be related to Goya's Romantic preoccupation with dream and fantasy and Géricault's studies of the insane. They were drawn to mythological subject-matter because of its affinity with dreaming, but their rendition of myth was neither heroic in character nor Classical in style. Rather, it was disturbed and poetic, and contained more than a hint of perversity.

Gustave Moreau

Gustave Moreau (1826–98) was the leader of the Symbolist movement in France. His *Orpheus* (fig. **24.26**) depicts an imaginary scene from Greek myth—Orpheus was a musician who was killed and torn limb from limb by the maenads, or frenzied female followers of Dionysos. Here, a young woman dressed in rich fabrics gazes down at the decapitated head of Orpheus as it lies across his lyre. Both she and the head are somewhat idealized, and there is a sense of languid passivity in their expressions, enhanced by the soft, yellow light. The idyllic episode at the top of the craggy mountain on the left, together with the peaceful quality of Orpheus and the woman, belie the violence that has preceded the present moment.

24.26 Gustave Moreau, *Orpheus*, 1865. Oil on canvas, 5 ft 1 in × 3 ft 3½ in (1.55 × 1 m). Musée d'Orsay, Paris. This painting was shown in the Paris Universal Exposition of 1867. The two turtles in the lower right corner, an apparently anomalous feature, may refer to the legend that Orpheus made his lyre by stringing a hollow tortoiseshell. To a public that knew the story of Orpheus, this painting must have seemed macabre indeed.

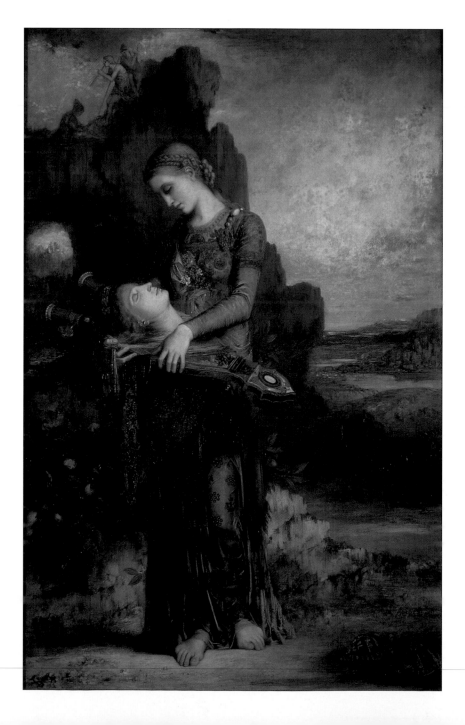

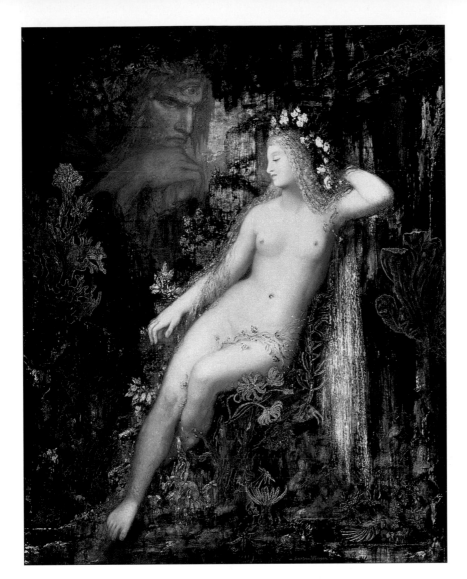

24.27 Gustave Moreau, *Galatea*, 1880–81. Oil on panel, 33⅓ × 26¼ in (85 × 67 cm). Collection M. Robert Lebel, Paris.

In *Galatea* (fig. **24.27**), Moreau reverses the relationship of observer to observed. In *Orpheus*, the woman gazes at the severed head of a man, while in the *Galatea* the man, who is the Cyclops Polyphemos (see Vol. I, p. 130), gazes at the woman—in this case, Galatea. He holds the stone with which he has killed her lover Acis, because of his primitive longing for her. Like the woman in the *Orpheus*, the very idealization of the Cyclops is sinister, for it is at odds with his bestial nature. Both scenes depict tales of unrequited love and passion turned to murder, and both are pervaded by a disturbing calm. As in the *Orpheus*, an eerie, unreal light transports the *Galatea* into the realm of the

The Symbolist Movement

Symbolism was particularly strong in France and Belgium in the late nineteenth century. It began as a literary movement, emphasizing internal, psychological phenomena rather than objective descriptions of nature.

The English word "symbol" comes from the Greek *sumbolon*, or "token." It originally referred to a sign that had been divided in two, and could therefore be identified by virtue of the fact that the two halves fitted together. A symbol thus signifies the matching part, or other half. It is something that stands for something else. Symbols derive from myth, folklore, allegory, dreams, and other unconscious manifestations. The Symbolists believed that, by focusing on the internal world of dreams, it was possible to rise above the here and now of a specific time and place, and arrive at the universal. It is no coincidence that the Symbolist movement in art and literature was contemporary with advances in psychology, most notably psychoanalysis and Sigmund Freud.

In literature, the poets' "Symbolist Manifesto" of 1886 rejected Zola's Naturalism in favor of the Idea and the Self. The French poets Charles Baudelaire, Stéphane Mallarmé, and Paul Verlaine became cult figures for the Symbolists, as did the American writer Edgar Allan Poe and the Swedish philosopher Emanuel Swedenborg. Their literature of decadence, disintegration, and the macabre shares many qualities with Symbolist painting. An erotic subtext, often containing perverse overtones, pervades and haunts the imagery.

imagination: the Cyclops is bathed in orange light, while Galatea is illuminated by white light. Reclining on a bed of mysterious, translucent flowers, her pose recalls the traditional reclining nude, and this enhances the impression of her vulnerability in the presence of Polyphemos.

A comparison of Moreau's *Orpheus* and *Galatea* with other works discussed in this chapter makes it clear that, while the ideas of the Symbolists influenced certain Post-Impressionists, the Symbolist style, or form, did not.

Edvard Munch

The Norwegian artist Edvard Munch (1863–1944) went in 1889 to Paris, where he came into contact with Impressionism and Post-Impressionism. The combination of Symbolist content with Post-Impressionism was particularly well suited to Munch's character. His mental suffering, like van Gogh's, was so openly acknowledged in his imagery and statements that it is unavoidable in considering his work. His pictures conform to Symbolist theory, in that they depict states of mind, emotions, or ideas, rather than observable physical reality. The style in which Munch's mental states are expressed, however, is Post-Impressionist in its expressive distortions of form and its use of non-local color.

In his best-known painting, *The Scream* (fig. **24.28**) of 1893, Munch represents his own sense of disintegration in a figure crossing the bridge over Oslo's Christianafjord. The bright colors—reds, oranges, and yellows—intensify the sunset, with darker blues and pinks defining the water. Both sky and water seem caught up in an endless swirl that echoes the artist's anguish. His fellow pedestrians at the far end of the bridge continue on ahead, while he stops to face the picture plane, simultaneously screaming and holding his ears. The action of blocking out the sound pushes in the sides of his face, so that his head resembles a skull and repeats the landscape curves. Munch described the experience depicted in this painting as follows: "I felt as though a scream went through nature—I thought I heard a scream—I painted this picture—painted the clouds like real blood. The colors were screaming."[5] He thus joins the scream of nature as his form echoes the waving motion of the landscape.

In the related picture, *Anxiety* (fig. **24.29**), painted the following year, the depicted state of mind is named in the title. A woman, who is about to walk out of the picture and thus out of Munch's sight, is followed by a relentless procession of skeletal men in black coats and top hats. Like retribution itself, they seem inevitable and without end. Of *Anxiety*, Munch wrote: "I saw all the people behind their

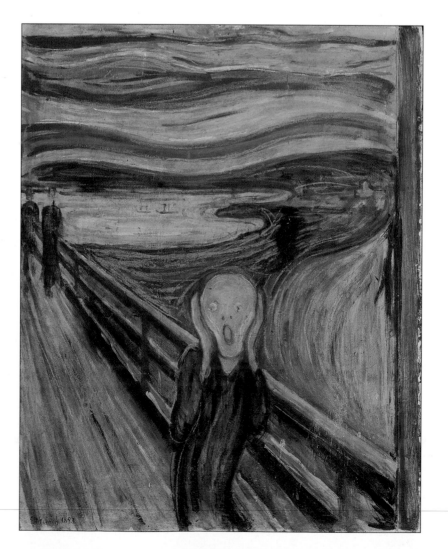

24.28 Edvard Munch, *The Scream*, 1893. Oil, pastel, and casein on cardboard, 35¾ × 29 in (90.8 × 73.7 cm). National Gallery, Oslo.

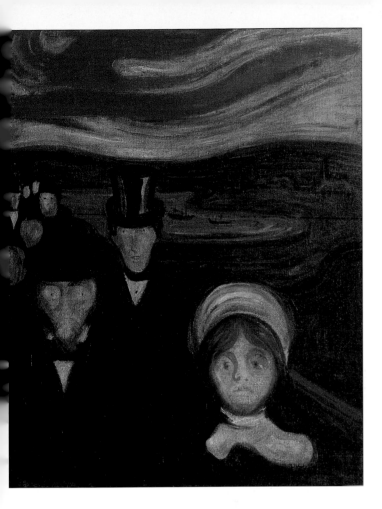

24.29 Edvard Munch, *Anxiety*, 1894. Oil on canvas, 37 × 28¾ in (94 × 73 cm). Munch Museum, Oslo. In 1892 Munch received electric shock treatment for depression and lived thereafter in almost total seclusion. Anxiety is one of Munch's favorite themes, along with death, illness, despair, and other forms of suffering. The woman in this painting is possibly Mrs. Heiberg, Munch's first love, with whom he was obsessed. According to his notes, he saw her in every woman he passed on the street.

masks—smiling, phlegmatic—composed faces—I saw through them and there was suffering—in them all—pale corpses—who without rest ran around—along a twisted road—at the end of which was the grave."[6]

Fin-de-siècle Developments

The last decade of the nineteenth century saw the emergence of several related styles. All signalled a reaction against the revival styles of the earlier part of the century. This period, and a few years on either side of it, is referred to as *fin-de-siècle* (literally "end of century").

Aestheticism

The principal tenet of Aestheticism was that the sole justification of art was its intrinsic beauty. This notion derived from the philosophy of Immanuel Kant, who believed that esthetics should be independent of morality and utility. In France, this became the popular *l'art pour art* ("Art for

art's sake") movement. In England, Whistler had championed this view of art in his lawsuit against Ruskin.

The playwright Oscar Wilde (1854–1900) was also a spokesman for the Aesthetic movement in England. His writings and lifestyle alternately amused and shocked polite society, and in 1895 he was sentenced to prison for homosexual offenses. Aubrey Beardsley (1872–98), the leading illustrator of the decade, created what he called "embellishments" of Wilde's play *Salomé*. (In the Gospel of Matthew (14:1–12) Salomé's mother Herodias persuades her daughter to charm King Herod with her dancing and then to demand the head of John the Baptist as her reward.) Figure **24.30** shows Beardsley's portrayal of Salomé fondling John's severed head. The legend below reads: J'AI BAISÉ TA BOUCHE IOKANAAN/J'AI BAISÉ TA BOUCHE

24.30 Aubrey Beardsley, *Salomé with the Head of John the Baptist*, 1893. Pen drawing, 11 × 6 in (27.9 × 15.2 cm). Princeton University Library.

("I have kissed your mouth, Jokanaan, I have kissed your mouth"). John's Medusa-like hair hangs limply, while Salomé's stands on end. Echoing this contrast at the bottom of the drawing is an open, erect flower beside a drooping bud. The blood from John's neck drips into a dark pool.

Beardsley's use of strong blacks, his emphasis on the unnatural and the macabre, and his taste for sexual metaphors with decadent overtones are characteristic of the *fin-de-siècle* esthetic. So too are the ambiguous features of Salomé and John. Both have an androgynous quality and, were it not clear from the context, it would be difficult to say which was male and which female. This is also a projection of Beardsley himself, for although he was not overtly bisexual, as Wilde was, there is evidence that he engaged in cross-dressing.

Conservative critics denounced Beardsley's work for its decadence. Those who believed that art without morality has no value railed at his thinly disguised eroticism. After the trial and conviction of Oscar Wilde, a general revulsion against Aestheticism set in. Nevertheless, in focusing on the formal, esthetic qualities of art, the movement was partially successful in establishing the independence of art from ethical considerations.

Art Nouveau

Art Nouveau (literally "new art") was an ornamental style composed of curvilinear, organic forms that was a European-wide response against industrialization and the prevalence of the machine. In France, it was known as the Style Moderne, or "Modern Style," in Germany as the

24.31 Victor Horta, staircase of the Maison Tassel, Brussels, 1892.

Jugendstil ("Youthful Style"), and in Italy as the Stile Liberty (after Liberty of London, a store which imported Art Nouveau fabrics). The style is characterized by sinuous, asymmetrical linear patterns, which mainly influenced architecture and the decorative arts—especially glass, furniture, jewelry, and wrought-iron work.

From 1892 to 1893 the Belgian architect Victor Horta (1861–1947) designed a house for the Tassel family of Brussels. His patron, Professor Tassel, typified the new generation that wanted to express its opposition to the tastes of the older aristocracy. Figure **24.31** shows the staircase of the house, which reflects the undulating, organic lines of Art Nouveau. They resemble the natural forms of plant stalks, tendrils, vine scrolls, insect wings, and peacock tails. Here, the ornamental ironwork corresponds to the designs painted on the adjoining wall.

Figure **24.32** is the entrance to a Métropolitain (Métro) subway station in Paris. It was designed in 1900 by Hector Guimard (1867–1942) from prefabricated glass and metal. The tall, thin, curvilinear lamp-posts on either side of the entrance recall certain plant stalks and flowers, and seem to stand on tiptoe. Also reminiscent of floral designs is the elegant ironwork railing that surrounds the opening in the sidewalk. Even the lettering of the sign—METROPOLITAIN—corresponds to the sinuous, linear style of Art Nouveau.

The Vienna Secession

Fin-de-siècle Vienna, the capital of the Austro-Hungarian empire, was a city of contradictions. The Hapsburg monarchy persisted amidst the growth of a liberal bourgeoisie. Technology advanced against a backdrop of conservative nationalism. And Sigmund Freud was formulating a theory of the mind that exploded entrenched philosophical and religious traditions of western Europe.

The resistance to change in Viennese society was nowhere more evident than in its attitude to contemporary art. The visual arts were dominated by two institutions—the Akademie der Bildenden Kunste and the Künstlerhausgenossenschaft. The former was Vienna's teaching academy, the latter a private society that owned the city's only exhibition space. Both were conservative, and in control of all exhibitions in Vienna, as well as of Austrian exhibits abroad.

24.32 Hector Guimard, entrance to a Métro station, Paris, 1900.

In 1897 a group of artists broke away and formed the independent Vereinigung Bildender Künstler Öesterreichs (Secession), known as the "Vienna Secession." This group did not champion any one artistic style, even though the Jugendstil was strongly represented. Its purpose was rather to provide a forum for diverse styles which shared the rejection of Academic naturalism. The leader of the Secession, and its first President, was Gustave Klimt (1862–1918), an established painter in the Academic tradition.

Within eighteen months of its formation, the Secession held two successful exhibitions, and built its own exhibition hall. Klimt designed the poster (fig. **24.33**) and the cover of the catalogue for the first exhibition. The poster shows a scene derived from Greek mythology—a vigorous Theseus about to plunge his sword into the Minotaur. This

symbolizes youth (Theseus), heroically destroying the oppressive forces of conservatism (the Minotaur). Athena, armed as if to defend the wisdom of artistic rebellion, stands at the far right. She is rendered in profile, holding up the Gorgon shield to face the viewer.

In 1894 Klimt was commissioned to paint a series of allegorical murals for the University of Vienna. Their completion was long delayed, and when Klimt produced the first, full-sized version of one of these, it was clear that his style had radically changed. Because of public criticism, he never completed the project. Klimt's mature style is evident in *The Kiss* (fig. **24.34**) of 1908, in which the kneeling, silhouetted forms of a man and a woman—possibly the artist and his mistress— blend into the design. Aside from their heads and limbs, the figures are submerged by the lively, gold surface patterns.

24.33 Gustave Klimt, *Ver Sacrum*, poster for the first Secession exhibition depicting Theseus and the Minotaur, c. 1898. Historisches Museum der Stadt, Vienna.

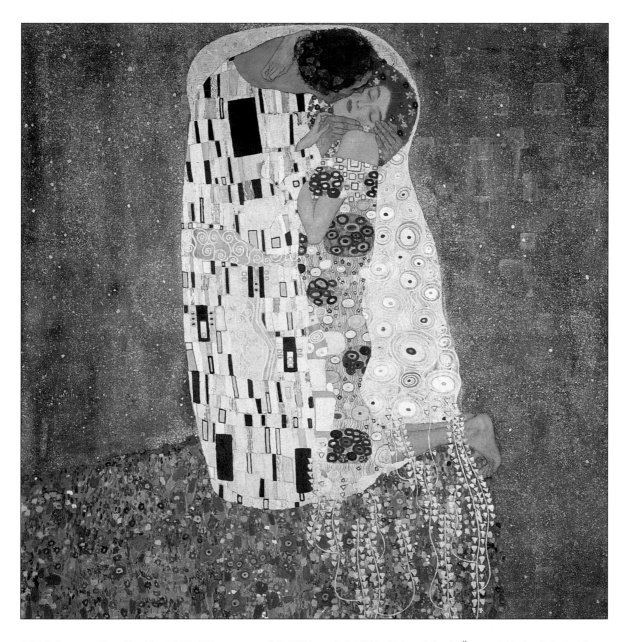

24.34 Gustave Klimt, *The Kiss*, 1908. Oil on canvas, 5 ft 10⅞ in × 5 ft 10⅞ in (1.8 × 1.8 m). Österreichische Galerie, Vienna.

The remainder of this text surveys the major styles of twentieth-century art, which derive from certain nineteenth-century developments. Realism had introduced a new social consciousness into the visual arts, and Impressionism had made artists and viewers alike aware of the potential, expressive power of the medium itself. Post-Impressionists explored various ways in which the individual brushstrokes could enhance and construct images, even to the point where the paint intruded on the subject. At the same time, Symbolism took up the Romantic interest in giving visual form to states of mind. The nineteenth century ended with an artist in whose work both the medium and the imagination were combined as new subjects in Western art.

Henri Rousseau

Although Henri Rousseau (1844–1910) worked largely during the latter part of the nineteenth century, his impact on Western art history must be seen in the context of the first half of the twentieth century. He has been called a **naive** painter because he had no formal training, and spent most of his working life as a customs inspector near Paris—hence his nickname "Le Douanier" ("customs officer"). He painted in his spare time, exhibited at the Salon des Indépendants, and in 1885 retired from his job to become a full-time painter. At first mocked by the critics, Rousseau was later much admired. In 1908 Pablo Picasso (see Chapter 25) held a banquet in his honor at his Montmartre studio.

Rousseau's last great work, *The Dream* (fig. **24.35**), was painted in 1910 shortly before his death, and eleven years after the publication of Freud's *The Interpretation of Dreams* (see Box). The painting shows a nude, reclining but alert, who has been transported on a Victorian couch to a jungle setting, complete with wild animals and abundant flowers and foliage. Emerging from the jungle depths is a dark gray creature, clothed and upright, who is simultaneously animal and human and plays a musical instrument. The bizarre gray of his face and skin contrasts with the bright jungle colors. The daytime sky is at odds with the normal time for dreaming, which is night.

When asked about the unlikely juxtaposition of the couch with the jungle in *The Dream*, Rousseau provided two different answers. In the first, he said that the woman is the dreamer; she is sleeping on the couch, and both have been transported to the jungle. In the second, he said that the couch was there simply because of its red color. In the French journal *Soirées de Paris* (January 15, 1914), Rousseau published the following inscription for the painting:

In a beautiful dream
Yadwigha gently sleeps
Heard the sounds of a pipe
Played by a sympathetic charmer
While the moon reflects
On the rivers and the verdant trees
The serpents attend
The gay tunes of the instrument.

In one sense *The Dream* can be regarded as a synthesis of the two main trends in western European art at the turn of the century. For lack of better terminology, these trends may be described as "subjectivity" (one of the primary characteristics of Romanticism and Symbolism) and "objectivity" (the ideal aspired to by the Realists and Impressionists.) In *The Dream*, Rousseau merges the visionary world of dream and imagination with a detailed depiction of reality. To this end, he made a careful study of leaves and flowers before painting them, although their very "reality" in this painting has an eerie quality. However, *The Dream* is remarkably consistent with Freud's account of the mechanisms of dreaming and, as such, looks forward to twentieth-century Surrealism (see Chapter 27). Rousseau's image combines the dream (the picture) with the dreamer (the nude). Its precise, clear edges serve to contain the wild character of the jungle, which represents the primitive forces revealed in dreams.

24.35 Henri Rousseau, *The Dream*, 1910. Oil on canvas, 6 ft 8½ in × 9 ft 9½ in (2.05 × 2.99 m). Museum of Modern Art, New York (Gift of Nelson A. Rockefeller).

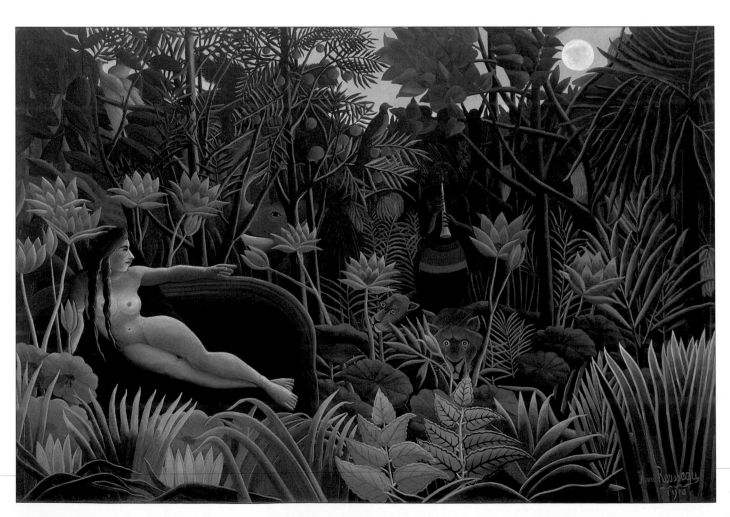

The Mechanisms of Dreaming

In 1899 Sigmund Freud published *The Interpretation of Dreams*. Although initially only a few copies were sold, its impact on Western thought has been enormous. As defined by Freud, there are four mechanisms of dreaming:

1 *Representability* means that an idea or feeling can be changed into a picture. The dream picture is an unconscious regression from words to images, whereas works of art are consciously produced.

2 *Condensation* merges two or more elements into a new, disguised form. In Rousseau's *The Dream*, for example, the jungle is condensed with a European sitting room, and day is condensed with night.

3 *Displacement* means moving an element from its usual setting to another place. The dark musician in *The Dream* is an example, for non-human features have been displaced onto him. Displacement can result in condensation. Geographical condensation is achieved by displacing the couch into the jungle.

4 *Symbolization* is the process of symbol-making. A symbol is something that stands for something else. In *The Dream* the flowers, fruit, serpent, musician, jungle setting, and the nude may be interpreted as symbols of the dreamer's sexual fantasies.

Style/Period	Works of Art	Cultural/Historical Developments
POST-IMPRESSIONISM AND THE EARLY 20TH CENTURY	Stone heads, Easter Island (**24.24**) 1503: Cranach, *Crucifixion* (**24.20**)	
1850 1850–1880 Cézanne, *Still Life with Apples*	Hiroshige, *Sudden Shower at Ohashi Bridge at Ataka* (**24.12**) Moreau, *Orpheus* (**24.26**) Cézanne, *The Temptation of Saint Anthony* (**24.3**) Cézanne, *Self-portrait* (**24.4**) Cézanne, *Still Life with Apples* (**24.5**)	
1880 1880–1890	Moreau, *Galatea* (**24.27**) Seurat, *Sunday Afternoon on the Island of La Grande Jatte* (**24.7–24.8**) van Gogh, *The Potato Eaters* (**24.9**) van Gogh, *Self-portrait* studies (**24.16**) van Gogh, *Portrait of Père Tanguy* (**24.10**) van Gogh, *Japonaiserie: Bridge in the Rain* (**24.11**) van Gogh, *Bedroom at Arles* (**24.13–24.14**) van Gogh, *Wheatfield with Reaper* (**24.15**) van Gogh, *Self-portrait* (**24.17**) Gauguin, *The Yellow Christ* (**24.19**) Gauguin, *Self-portrait with Halo* (**24.21**)	 van Gogh, *Self-portrait*
1890 1890–1900 Gauguin, *Nevermore*	Toulouse-Lautrec, *La Goulue at the Moulin Rouge* (**24.2**) Toulouse-Lautrec, *Quadrille at the Moulin Rouge* (**24.1**) Horta, *Staircase of the Maison Tassel* (**24.31**), Brussels Gauguin, *Idol with the Seashell* (**24.25**) Munch, *The Scream* (**24.28**) Beardsley, *Salomé with the Head of John the Baptist* (**24.30**) Munch, *Anxiety* (**24.29**) Gauguin, *Nevermore* (**24.22**) Klimt, *Ver Sacrum* poster (**24.33**) Cézanne, *The Great Bathers* (**24.6**)	Diesel patents internal combustion engine (1892) Emergence of Art Nouveau in Europe (1893) Cinematograph invented (1894) Sino-Japanese War; Japanese victorious (1894–5) Wireless telegraphy invented by Marconi (1895) Richard Strauss, *Till Eulenspiegel's Merry Pranks* (1895) Puccini, *La Bohème* (1896) The Curies discover radium (1898) Boer War; English defeat South Africans (1899–1902) Munch, *The Scream*
1900 1900–1910	Guimard, *Entrance to a Métro Station* (**24.32**), Paris Klimt, *The Kiss* (**24.34**) Rousseau, *The Dream* (**24.35**)	Sigmund Freud, *The Interpretation of Dreams* (1900) Anton Chekhov, *Uncle Vanya* (1900) Joseph Conrad, *Lord Jim* (1900) Theodore Dreiser, *Sister Carrie* (1900) Max Planck formulates quantum theory (1900) Discovery of Minoan culture in Crete (1900–1909) Wright Brothers' first flight in a powered airplane (1903) G. E. Moore, *Principia Ethica* (1903) Jack London, *The Call of the Wild* (1903) Anton Chekhov, *The Cherry Orchard* (1904) James Barrie, *Peter Pan* (1904) Puccini, *Madame Butterfly* (1904) Edith Wharton, *The House of Mirth* (1905) Emmeline Pankhurst launches Suffragette movement (1906) William James, *Pragmatism* (1907) Baden-Powell founds Boy Scout movement (1907) E. M. Forster, *A Room with a View* (1908) Ford Motor Company produces first Model T car (1908)
1910	Rousseau, *The Dream* 1963–4: Thompson, *Crucifixion* (**24.18**)	

25

Turn of the Century: Early Picasso, Fauvism, Expressionism, and Matisse

Western history is traditionally divided into centuries, and historians tend to see significance in the "turn of a century." Given the span of human history from the Paleolithic era, in which the first known works of art were produced, a century represents a small, almost infinitesimal, fragment of time. Nevertheless, as we consider historical events that are closer to our own era, their significance seems to increase, and time itself to expand. Although we measure the prehistoric era by millennia, and later periods by centuries, we tend to measure our own century by decades—or less. Our perception of time depends upon its relation to ourselves.

From the perspective of the turn of the twentieth century, it seems that rapid changes have occurred in many fields. Technological advances set in motion by the Industrial Revolution speeded up communication and travel to an unprecedented degree. Electric lights have been used from the 1890s, radios from 1895, cars from the early 1900s, televisions and computers from the 1950s. The Wright Brothers flew the first airplane in 1903. Sixty-six years later, in 1969, the United States put the first man on the moon. Great strides were made in medicine, Albert Einstein formulated the theory of relativity, and Freud established psychoanalysis as an internationally accepted, although still debated and evolving, social science.

In politics, too, major changes took place. Lenin led the Russian Revolution in 1917; by 1991 the Soviet Union was dissolved. World War I (1914–18) decimated a generation of European men. Following the Great Depression of 1929, Europe witnessed the rise of Hitler and National Socialism, which culminated in World War II (1939–45). The end of that war ushered in the anxieties of the nuclear era, and new concerns about the future of the environment.

In the arts as well, rapid changes are evident, as styles came and went, often merging into one another. For the purposes of this text, the twentieth century is divided by the marker of World War II. Up to that point, Paris had been the undisputed center of the Western art world. As Gertrude Stein (see p. 835) said, "Paris was where the twentieth century was." Paris exerted a strong pull on artists, who studied in its art schools, and on collectors

and critics, who toured its studios, galleries, and museums. After the war, and partly because of it, many artists—indeed, entire schools of artists—were forced to flee Europe and settle in the United States. As a result, the significant innovations in Western art in the second half of the twentieth century took place largely in the United States, particularly in New York.

In 1900 many works by Impressionist and Post-Impressionist artists were shown at the World's Fair, or International Exhibition, in Paris. These styles had emphasized the primacy of the medium. Building on this innovation, twentieth-century artists expanded into new areas, influenced in part by non-Western cultures. The nineteenth century had developed a taste for *japonisme* as a result of the influence of Japanese woodblock prints. In the early twentieth century, there was a growing interest in African art, the geometric abstraction of which appealed to artists, collectors, and critics.

Whereas the Impressionists extended the range of subject-matter by depicting different social classes than those of Neoclassicism, twentieth-century artists developed a new iconography that included everyday objects. They also began to use new materials, such as plastics, which resulted from advances in technology. New techniques for making art were developed, especially in the second half of the century. Technological developments also encouraged new directions in architecture.

The very idea of "newness" became one of the tenets of modernism. The so-called avant-garde (literally the "vanguard," or leaders, of artistic change) became a prominent force in Western art. Continual striving for avant-garde status contributed to the rapidity with which styles changed in the twentieth century.

Pablo Picasso and Henri Matisse

In painting, two figures dominated the first half of the twentieth century, the Spanish artist Pablo Picasso (1881–1973) and, in France, Henri Matisse (1869–1954). Both made sculptures, but were primarily painters. In contrast to the experience of the Impressionists and Post-Impressionists, the genius of Picasso and Matisse was

25.1 Pablo Picasso, *The Old Guitarist*, 1903. Oil on panel, 4 ft ¾ in × 2 ft 8½ in (1.23 × 0.83 m). Art Institute of Chicago (Helen Birch Bartlett Memorial Collection). Picasso was born in Málaga on the south coast of Spain. His father, José Ruíz Blasco, was an art teacher devoted to furthering his son's career. (Picasso took his mother's family name.) From 1901 to 1904 Picasso moved between Paris, Barcelona, and Madrid, settling permanently in Paris in 1904. The subjects of Picasso's Blue Period were primarily the poor and unfortunate.

Wallace Stevens: "The Man with the Blue Guitar"

The Symbolist quality of Picasso's *Old Guitarist* appealed to the American poet Wallace Stevens (1879–1955), who wrote "The Man with the Blue Guitar" in 1937 in response to it:[1]

> The man bent over his guitar,
> A shearsman of sorts. The day was green.
>
> They said, "You have a blue guitar,
> You do not play things as they are."
>
> The man replied, "Things as they are
> Are changed upon the blue guitar."
>
> And they said then, "But play, you must,
> A tune beyond us, yet ourselves,
>
> A tune upon the blue guitar
> Of things exactly as they are." [Stanza I]
>
> And the color, the overcast blue
> Of the air, in which the blue guitar
>
> Is a form, described but difficult,
> And I am merely a shadow hunched
>
> Above the arrowy, still strings,
> The maker of a thing yet to be made;
>
> The color like a thought that grows
> Out of a mood, the tragic robe
>
> Of the actor, half his gesture, half
> His speech, the dress of his meaning, silk
>
> Sodden with his melancholy words,
> The weather of his stage, himself. [Stanza IX]
>
> Is this picture of Picasso's, this "hoard
> Of destructions," a picture of ourselves,
>
> Now, an image of our society?
> Do I sit, deformed, a naked egg,
>
> Catching at Good-bye, harvest moon,
> Without seeing the harvest or the moon?
>
> Things as they are have been destroyed.
> Have I? Am I a man that is dead
>
> At a table on which the food is cold?
> Is my thought a memory, not alive?
>
> Is the spot on the floor, there, wine or blood
> And whichever it may be, is it mine? [Stanza XV]

recognized relatively early in their careers. Their paths crossed at the Paris apartment of Gertrude Stein, who held regular gatherings of artists and intellectuals from Europe and the United States.

Picasso and Matisse began their careers in the nineteenth century under the influence of Impressionism, Post-Impressionism, and Symbolism. They soon branched out—Picasso earlier than Matisse—and spearheaded the avant-garde, although their styles were quite distinct. Matisse's career followed a more direct line than Picasso's. He began and ended as a colorist, with important evolutions along the way. Picasso, on the other hand, shifted from one style to another, often working in more than one mode at the same time (see Chapter 26). His first individual style was actually Symbolist, and is referred to as his "Blue Period."

Picasso's "Blue Period" Picasso's Blue Period lasted from approximately 1901 to 1904. Consistent with the Symbolist esthetic, his "Blue" paintings depict a mood or state of mind, in this case melancholy and pessimism (note, for example, the expressions "to be in a blue mood," "Blue Monday," "to have the blues"). The predominance of blue as the mood-creating element reflects the liberation of color that had been effected by nineteenth-century Post-Impressionism.

Picasso emphasizes the somber quality of *The Old Guitarist* (fig. **25.1**) by the all-pervasive blue color and the shimmering, silver light (see Box). His long, thin, bony form, tattered clothes, and downward curves convey dejection. The guitarist's inward focus enhances the impression that he is listening intently, absorbed in his music, and also indicates that he is blind. The elongated forms and flickering silver light hark back to the spirituality of El Greco.

African Art and the European Avant-Garde

With the increasing number of ethnological museums at the end of the nineteenth century, non-Western art was becoming an esthetic force in Europe. Against the background of nineteenth-century *japonisme*, the influence of Oceanic art, revivals of interest in Egyptian and Iberian art, and the spatial revolution of Cézanne, the early twentieth-century avant-garde was receptive to new formal ideas. One of the major sources for these was the growing interest in African art.

From about 1906, leading European artists began to notice African works in museums and shops, to discuss them with each other, and to collect them. Artists also traveled outside of Europe more than they had in the past. Despite this geographic and intellectual expansion, the early twentieth-century approach to the visual arts led to certain misconceptions about African art. First, Africa is a huge continent (fig. **25.2**), comprising many different cultures, each with its own history of art. The time span of African art is as vast as that of Europe, ranging from the Stone Age to the present. Second, the understanding of African art is complicated by certain essential differences

between it and other non-Western styles. Unlike Far Eastern art, for example, there is virtually no narrative in African art. African artists did not conceive of their objects as set in a time and space in the way that Western artists had. As a result, much African art has a timeless quality, which was one of the sources of its appeal to the West.

The Fang of Gabon, for example, associate large heads with infancy, an age which was believed to be in a state of greater harmony with the ancestors. According to the Fang, adults lose contact with the power wielded by deceased ancestors and with their own infantile past. Another interpretation of such works is that they symbolize the desire for children. Clearly, African sculptures combining childlike with adult features condense time. In so doing, they seem timeless, because they are essentially out of the chronological sequence of time as people experience it.

Most surviving African art is sculpture, which can only be understood in its cultural context. The cave paintings and **glyptic arts** of Africa were little known to nineteenth- and early twentieth-century European artists, who only rarely had contact with African architecture. To indicate something of the range of African sculpture, four examples of human subjects are illustrated. Each is the product of a distinct cultural group.

Ife The first (fig. **25.3**) is from the city of Ife, founded around A.D. 800 to 900, in southwestern Nigeria. Its surviving art dates from the twelfth and thirteenth centuries A.D., and shows currents of naturalism as well as stylization. This copper mask is a convincing likeness, with a sense of soft flesh around the cheeks and lips, a firm bone structure beneath the nose, organic ears, and a broad, curved forehead. The hair, mustache, and beard were attached through holes which are still visible. The only significantly stylized feature is the outline around the eye. This work shows skill in modeling, as well as in metal-casting technology. It is believed to have been used in royal burials, and was probably worn during funerary ceremonies. There can be little question, however, that it has the quality of a portrait—possibly of a king.

Baule The full-figure Baule ancestor from the Ivory Coast (fig. **25.4**) typifies the African sculptures whose abstraction appealed to the Western avant-garde in the early twentieth century. Its surface is smooth and polished, with relief patterns of scarification on the face, neck, and torso. The hair is made of finely incised parallel lines.

25.2 Map of Africa.

25.3 (above) Copper mask, Ife, Nigeria, 12th–13th century. Lifesize. National Museum, Lagos.

25.4 (right) Baule ancestor, Ivory Coast. Wood, 20½ in (52.1 cm) high. British Museum, London.

A mechanical effect is created by the abrupt, non-organic planar shifts that contrast with Classical proportions. Such objects offered non-Western artists new ways of approaching the human figure. At the same time, however, the proportions of African sculpture have meanings that vary from culture to culture.

Bakota The Bakota of Gabon made a distinctive type of figure, which was generally of wood covered with metal sheets of brass or copper (fig. **25.5**). Their flat geometry struck the European avant-garde as particularly expressive. The oval face, identified as such by the lunette-shape eyes and pyramidal nose, is enhanced by a geometric headdress. The neck is cylindrical and the body abstracted to form a diamond shape framing empty space. It is clear that the Bakota figure, as well as the Baule ancestor, would have appealed esthetically to a generation of Western artists on the verge of Cubism. But here again, the African figure is admired out of context. The actual function of the Bakota statue

was to cover a reliquary containing ancestral bones. Ironically, therefore, traditional works within one society (in this case an African society) became inspirational for artists breaking with tradition in another society (that of western Europe).

Benin Around the turn of the century the art of Benin, a small kingdom to the west of modern Nigeria, attracted the art world's attention. Benin culture had been known since the fifteenth century, when the Portuguese infiltrated the area, sending missionaries, fighting as mercenaries in the Benin armies, and introducing guns to the local population. As traders, the Portuguese were interested in cloth, ivory, pepper, gold, and slaves. Their presence on Benin soil is known from contemporary accounts, and also from bronze Benin sculptures representing Portuguese soldiers. Two centuries later, the Dutch also began trading in Benin. In 1897, a group of British officials went to Benin City during the annual festival honoring royal ancestors. The officials were killed, and Britain sent in a force known as the "Punitive Expedition," which burned the city. The metal and ivory objects that survived were taken to England. Some were sold to the British

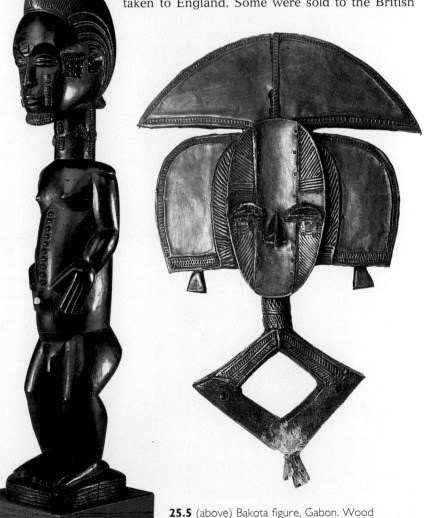

25.5 (above) Bakota figure, Gabon. Wood covered with brass sheeting, 26 in (66 cm) high. British Museum, London.

Museum, others to the Berlin Museum of Folk Art. Several ended up in private collections.

The bronze head in figure **25.6** represents the Oba, or divine king, of Benin. He controls the fate of his subjects through the spiritual power conferred on him by his divine ancestors. According to Benin tradition, which is transmitted orally, the former, celestial kings of Benin had failed their subjects, who sought a new ruler. They turned to the Oni, who ruled the neighboring Ife culture, and he sent his son, Oranmiyan, to Benin. There he became the father of Eweka I by a local princess. The present Oba is the direct descendant of Eweka I, and the undisputed ruler of Benin. He combines the power of earth and sky, and is both feared and loved by his people.

Heads of kings comprise a major iconographic category in Benin art. They reflect the importance of the Oba as a patron, and the fact that most Benin art is connected to the court. The example illustrated here is cast in bronze, a technique introduced in the late 1300s. The face is typically covered by a succession of rings, each denoting a significant achievement and conferring power. The crown is

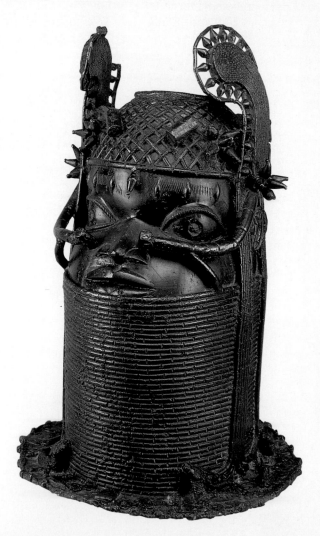

25.6 Bronze Oba head, Benin, mid-19th century. 20⅛ in (51.1 cm) high. British Museum, London.

decorated on either side with curved features. Such works are set on ancestral altars, where they serve a ritual function. The head itself projects the image of beauty and terror, which reflects the king himself, and is seen as the ruler of the body—much as the head of state ruled the "body politic" in Europe.

All four African figures described here are related to ancestor cults, or to kingship. Each belongs to a distinctive group of people, and has a religious function. They also vary in their degree of stylization, abstraction, and naturalism. But together they illustrate some of the qualities that inspired the avant-garde. The following quotations from European artists discussed in this text express the liberating effect of their encounter with African sculpture:

Kirchner (1910) (on the Benin bronzes in the Dresden Ethnology Museum): "A change and a delight."[2]

Nolde (1912): "Why is it that we artists love to see the unsophisticated artifacts of the primitives?"

"It is a sign of our times that every piece of pottery or dress or jewelry, every tool for living has to start with a blueprint—Primitive people begin making things with their fingers, with material in their hands. Their work expresses the pleasure of making. What we enjoy, probably, is the intense and often grotesque expression of energy, of life."[3]

Kandinsky (statement pub. 1930): "the shattering impression made on me by Negro art, which I saw in [1907] in the Ethnographic Museum in Berlin."[4]

Marc (1911): "I was finally caught up, astonished and shocked, by the carvings of the Cameroon people, carvings which can perhaps be surpassed only by the sublime works of the Incas. I find it so self-evident that we should seek the rebirth of our artistic feeling in this cold dawn of artistic intelligence, rather than in cultures that have already gone through a thousand-year cycle like the Japanese or the Italian Renaissance."[5]

Matisse (on African sculptures in a shop on the rue de Rennes in Paris; interview recorded in 1941): "I was astonished to see how they were conceived from the point of view of sculptural language; how it was close to the Egyptians ... compared to European sculpture, which always took its point of departure from musculature and started from the description of the object, these Negro statues were made in terms of their material, according to invented planes and proportions."[6]

Picasso (on African masks): "For me the [tribal] masks were not just sculptures, they were magical objects ... intercessors ... against everything—against unknown, threatening spirits ... They were weapons—to keep people from being ruled by spirits, to help free themselves. ... If we give a form to these spirits, we become free."[7]

Braque: "Negro masks opened a new horizon for me."[8]

Fauvism

In 1905 a new generation of artists exhibited their paintings in Paris at the Salon d'Automne. Bright, vivid colors seemed to burst from their canvases and dominate the exhibition space. Forms were built purely from color, and vigorous patterns and unusual color combinations created startling effects. To a large extent, they were derived from Gauguin's Symbolist use of color. The critic Louis Vauxcelles noticed a single traditional sculpture in the room, and exclaimed, "Donatello parmi les fauves!" ("Donatello among the wild beasts!"), because the color and movement of the paintings reminded him of the jungle. His term stuck, and the style of those pictures is still referred to as "Fauve."

Vauxcelles' observation of the traditional sculpture juxtaposed with the works of the young artists exhibiting in 1905 signalled the latest skirmish in the traditional western European dispute over the primacy of line versus color. Although there was plenty of "line" in Fauve painting, it was the brilliant, non-naturalistic color and emotional exuberance that struck viewers. In contrast, Classical restraint and harmony, which were associated with line, appeared more controlled and, by implication, more civilized.

Henri Matisse: 1902–5

The leading artist of the Fauve group in France was Henri Matisse. His *Notre-Dame in the Late Afternoon* of 1902 (fig. **25.7**) depicts urban spaces as flat planes of color. Although the shapes are clearly defined, as in Post-Impressionism, and the paint texture is visible, Matisse has eliminated detail in favor of the predominance of color. Human figures are silhouettes, and the façade of Notre-Dame contains no reference to the Gothic surface variations on the actual building. Whereas the *Rouen Cathedrals* of

25.7 Henri Matisse, *Notre-Dame in the Late Afternoon*, 1902. Oil on canvas, 28½ × 21½ in (72.4 × 54.6 cm). Albright-Knox Art Gallery, Buffalo, New York (Gift of Seymour H. Knox).

Monet (see figs. 23.29 and 23.30) had subordinated Gothic detail to shifts of light and dark, Matisse's cathedral is reduced to a shape of color. But the color—which is lavender—combines the blues and pinks that are present throughout the picture plane. As a result, the cathedral assumes a position of power, for not only does it dominate the scene by its imposing height, but it unifies the view of modern Paris through color—just as it had once been the social, economic, religious, and artistic focal point of the medieval town.

Three years later, Matisse painted a portrait of his wife in the new style (fig. **25.8**). Here Madame Matisse is a construction in color—a concept that Matisse had learned from Cézanne. He subtitled the work "The Green Line," which refers to the line, beginning at the top of the forehead and continuing down the nose, that divides the face into a subdued ocher on the left and pink on the right. Throughout the picture plane, shading, modeling, and perspective are subordinate to color, which creates the features. The dark blue hair, which lacks organic quality because of its flatness, seems to perch on the head. This inorganic relation of head to hair, like the absence of modeling—for example, in the flat planes of the ears—reveals the influence of African masks on Matisse's style.

The background of *The Green Line* is identified only as patches of color. To the right of Madame Matisse (our left) are two tones of red, clearly separated above her ear. At the opposite side, the background is green. Variations on these reds and greens recur in the face itself, creating a chromatic unity between figure and background.

Expressionism

In Germany, the artists who, like the Fauves, were most interested in the expressive possibilities of color—as derived from Post-Impressionism—were called Expressionists. They formed groups that outlasted the Fauves in France, and styles that persisted until the outbreak of World War I in 1914. Expressionism, like Fauvism, used color to create mood and emotion (see Box), but differed from Fauvism in its greater concern with the emotional

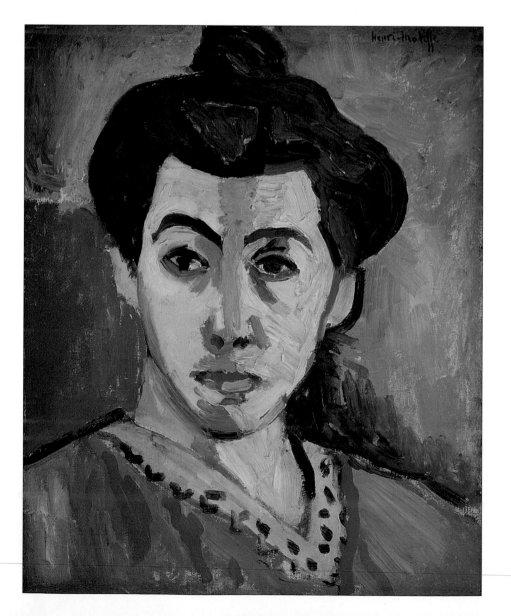

25.8 Henri Matisse, *Madame Matisse (The Green Line)*, 1905. Oil on canvas, 16 × 12¾ in (40.6 × 32.4 cm). Statens Museum for Kunst, Copenhagen. Matisse was born in northern France. He reportedly decided to become a painter when his mother gave him a set of **crayons** while he was recuperating from surgery.

25.9 Ernst Ludwig Kirchner, *The Street*, 1907. Oil on canvas, 4 ft 11¼ in × 6 ft 6⅞ in (1.5 × 2 m). Museum of Modern Art, New York.

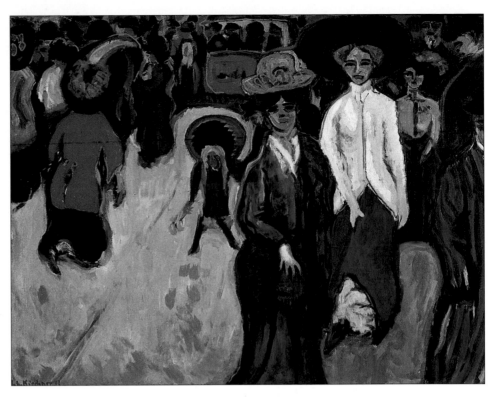

properties of color. Expressionism was also less concerned than the Fauves with the formal and structural composition of color.

The Bridge (*Die Brücke*)

In 1905, the year of the Fauve exhibition in Paris, four German architecture students in Dresden formed *Die Brücke* ("The Bridge"). Joined the following year by two others, this group of artists continued to work together until 1913. The name was inspired by the artists' intention to create a "bridge," or link, between their own art and modern revolutionary ideas, and between what was traditional and what was new in art. They modernized both the spiritual abstraction of medieval art, and the geometric esthetic of African and Oceanic art, by integrating them with the mechanical forms of the city. Expressionist color was typically brilliant and exuberant, and further energized by harsh, angular shapes.

Ernst Ludwig Kirchner The most important founding artist of *Die Brücke* was Ernst Ludwig Kirchner

(1880–1938), who had been trained as an architect before becoming a painter. He had been inspired by the Jugendstil of the Vienna Secession, as well as by Munch, van Gogh, and non-Western art. *The Street* of 1907 (fig. **25.9**), for example, combines exuberant Expressionist color with undulating forms reminiscent of Munch. The flat color areas, on the other hand, can be related to Fauvism.

Art History and Esthetics in Early Twentieth-Century Munich

Two important figures in the Munich art world, Heinrich Wölfflin (1864–1945) and Wilhelm Worringer (1881–1965), were particularly influential. Wölfflin lectured on art history, while Worringer's esthetic theories supported the Expressionist movement.

Wölfflin's most important work, which is still read by art students—*The Principles of Art History*—was first published in German in 1915. He devised a system of determining style by an analysis of its formal elements. Renaissance and Classical styles, for example, were distinguished from Baroque by five pairs of opposing characteristics. The classicizing Renaissance style was, according to Wölfflin, linear, whereas Baroque was painterly. Renaissance planes were constructed according to the verticals and horizontals of linear perspective, while Baroque planes receded diagonally. Space tended to be open in Baroque, and closed in Renaissance. Elements were multiple and clarity was absolute in the Renaissance style. In Baroque, elements were unified and clarity was relative.

What united Wölfflin with Worringer was their mutual emphasis on the viewer's experience of works of art. But whereas Wölfflin focused on past styles, Worringer championed the avant-garde—notably the German Expressionist movement. In 1908 Worringer published his dissertation *Abstraktion und Einfühlung* (*Abstraction and Empathy*); this argued for new forms of expression and was widely read by the young artists of Worringer's generation. Three years later, in *The Historical Development of Modern Art*, Worringer replied to criticism leveled at the Expressionists, defending them against charges reminiscent of those brought against Whistler and the French Impressionists. Expressionist paintings were accused of being decadent, self-indulgent, without form, finish, or depth. Worringer countered by pointing out the limitations of adherence to naturalism. He called for accessibility to new influences as a way of expanding artistic consciousness. Such infusions, particularly from non-European cultures, Worringer believed, would offer a new route to the spiritual core of creativity.

A comparison with a later street scene—*Five Women in the Street* (fig. **25.10**) of 1913—reflects certain stylistic shifts (in this case toward Cubism) of the period. The dreamlike quality of the earlier picture, and its pure, primary hues, ally it with nineteenth-century Symbolism and Post-Impressionism. In the later picture, the color is subdued and limited, which shows the influence of Analytic Cubism (see p. 837). The predominance of dulled greens creates a uniformity that accentuates the impersonal character of the women. Kirchner captures the anxious, frenetic pace of urban life through angular, elongated figures, occupying a shifting perspective. His training in architecture is evident in the tectonic forms of the women. Their high-heeled shoes, for example, create two-dimensional geometric silhouettes against a lighter space, and their fur ruffs form perfect crescents. The distinctions between light and dark in the dresses are crisply defined, creating a sense of solid, crystalline structure rather than of soft material.

Emil Nolde Another artist associated with German Expressionism, Emil Nolde (1867–1956), spent only a year

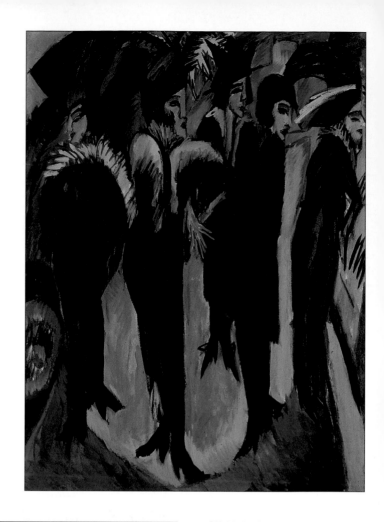

25.10 (right) Ernst Ludwig Kirchner, *Five Women in the Street*, 1913. Oil on canvas, 3 ft 10½ in × 2 ft 11½ in (1.18 × 0.9 m). Museum Ludwig, Cologne (Courtesy, Rheinisches Bildarchiv, Cologne).

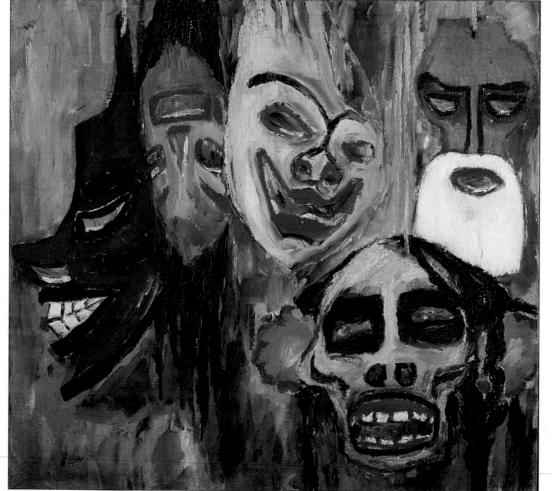

25.11 (left) Emil Nolde, *Still Life with Masks*, 1911. Oil on canvas, 28¾ × 30½ in (73 × 77.5 cm). Nelson-Atkins Museum of Art, Kansas City.

25.12 (above) Emil Nolde, drawing of an Oceanic canoe prow, for left-hand mask in fig. 25.11, 1911. Pencil drawing, 11⅞ × 7⅛ in (30 × 18 cm). Stiftung Seebüll Ada und Emil Nolde.

as a member of The Bridge, leaving in 1907 to work independently. His early pictures depicted religious themes, which were infused with a visionary mood. After spending the year 1899 to 1900 in Paris, Nolde increased his range of color. In addition to the influence of nineteenth-century French styles, his work shows very clearly that non-Western art provided him with a significant source of inspiration.

His *Still Life with Masks* of 1911 (fig. **25.11**) reveals his combination of bright color with thickly applied paint to achieve intense, dynamic effects. The upside-down pink mask and the adjacent yellow one were inspired by northern European carnivals. But the red mask at the far left is based on Nolde's own drawing of an Oceanic canoe prow (fig. **25.12**). The yellow skull, like the mask at the lower right, is also derived from non-Western prototypes—in this case a shrunken head from Brazil, of which Nolde also made sketches. African examples probably inspired the green mask at the upper right, but the combination of a green surface with red outlining the features is an Expressionist use of color. Nolde's non-Western imagery served to express qualities that were finally more in tune with Expressionism than with the cultural or artistic intentions of the non-Western art he studied.

The Blue Rider (*Der Blaue Reiter*)

Another German Expressionist group more drawn to non-figurative abstraction than members of The Bridge was *Der Blaue Reiter* ("The Blue Rider"), established in Munich in 1911. The name of the group, derived from the visionary language of the Book of Revelation (cf. the Four Horsemen of the Apocalypse), was inspired by the millennium and the notion that Moscow would be the new center of the world from 1900—as Rome had once been. "Blue Rider" referred to the emblem of the city of Moscow showing Saint George (the "Rider") killing the dragon.

Vassily Kandinsky The Russian artist Vassily Kandinsky (1866–1944) was among the first to eliminate recognizable objects from his paintings. He identified with the "Blue Rider" as the artist who would ride into the future of a spiritual non-figurative and mystical art. The color blue signified the masculine aspect of spirituality (cf. fig. 25.15). At the age of thirty, Kandinsky left Moscow where he was a law student, and went to Munich to study painting. There he was a founder of the *Neue Künstler Vereinigung* (New Artists' Association), or NKV, the aim of which was rebellion against tradition. A few artists split from the NKV to form the Blue Rider.

For Kandinsky, art was a matter of using rhythmic lines, colors, and shapes, rather than narrative. Like Whistler, Kandinsky gave his works musical titles intended to express their abstract qualities. By eliminating references to material reality, Kandinsky followed the Blue Rider's avoidance of the mundane in order to communicate the spiritual in art. Titles such as *Improvisation* evoked the dynamic spontaneity of creative activity, while the *Compositions* emphasized the organized abstraction of his lines, shapes, and colors.

In 1912 Kandinsky published *Concerning the Spiritual in Art*, in which he explained his philosophy, according to which music was intimately related to art. Kandinsky was, by temperament, drawn to religious and philosophical thinking imbued with strains of mysticism and the occult, which can be related to a millenarian spirit reflected in the Blue Rider emblem. And he believed that art had a spiritual quality, because it was the product of the artist's spirituality. The work of art, in turn, reflected this through the musical harmony of form and color.

Panel for Edwin R. Campbell No. 4 (formerly *Painting Number 201*) of 1914 (fig. **25.13**) was one of four in a series representing the seasons—this one being winter. In it

25.13 Vassily Kandinsky, *Panel for Edwin R. Campbell No. 4* (formerly *Painting Number 201, Winter*), 1914. Oil on canvas, 5 ft 4¼ in × 4 ft ¼ in (1.63 × 1.24 m). Museum of Modern Art, New York (Nelson A. Rockefeller Fund, by exchange).

25.14 Vassily Kandinsky, *Several Circles, Number 323*, 1926. Oil on canvas, 55⅛ × 55⅛ in (140 × 140 cm). Guggenheim Museum, New York.

did so by endowing delicate geometric shapes with a dynamic spatial tension. This is evident in *Several Circles, Number 323* (fig. **25.14**), in which translucent circles float in a swirling brown space. Some of the circles are isolated, others barely touch the edge of adjacent circles, while a few appear to skim over one another, their geometric purity contrasting with the textured background. Kandinsky's image has an "otherworldly" quality, evoking both the minutiae of the invisible molecular world, and the vast distances of a solar system occupied by orbiting moons and planets.

Franz Marc The other major Blue Rider artist was Franz Marc (1880–1916), who joined Kandinsky in editing the *Blue Rider Yearbook* of 1912. This contained discussions of Picasso and Matisse, of The Bridge, The Blue Rider itself, and the new interest in expanding esthetic experience through contact with non-Western art. In contrast to Kandinsky, however, Marc did not entirely eliminate recognizable objects from his work, except in preliminary drawings made shortly before his premature death.

Marc's *Large Blue Horses* of 1911 (fig. **25.15**) combines geometry with rich color. As Gauguin described his "red dogs" and "pink skies" (see p. 807), Marc's animals and their setting can be considered in the abstract terms of musical composition. They are an arrangement in blue, foreshortened forms, which harmonize with the curvilinear, brightly colored landscape. Marc's use of animals reflects his belief that they are better suited than humans to the expression of cosmological ideas. The two gray curves representing slender tree trunks serve as structural

Kandinsky creates a swirling, curvilinear motion, within which there are varied lines and shapes. Lines range from thick to thin, color patches from plain to spotty, and hues from solid to blended. The most striking color is red, which is set off against yellows and softer blues and greens. The strongest accents are blacks, while the sense of winter is suggested primarily by the whites, which occur in pure form and also blend with the colors. Blues become light blues, and reds become pinks, creating an illusion of coldness that is readily associated with winter.

Later, in the 1920s, despite stylistic changes inspired by his association with the Moscow avant-garde, Kandinsky continued to pursue the notion of the spiritual in art. He

25.15 Franz Marc, *The Large Blue Horses*, 1911. Oil on canvas, 3 ft 5⅝ in × 5 ft 11⁵⁄₁₆ in (1 × 1.8 m). Walker Art Center, Minneapolis (Gift of the T. B. Walker Foundation, Gilbert Walker Fund, 1942). Marc shared Kandinsky's spiritual attitude to the formal qualities of painting, especially color. He thought of blue as masculine, yellow as having the calm sensuality of a woman, and red as aggressive. Mixed colors were endowed with additional meaning. For Marc, therefore, color functioned independently of content.

anchors. They also create a sense of confinement, which compresses the space and enhances the monumentality of Marc's horses.

The Blue Rider, in contrast to The Bridge, was international in scope and had a greater influence on Western art. In particular, Kandinsky's non-figurative imagery, which was among the first of its kind, was part of a revolutionary development that would remain an important current in twentieth-century art. Neither Matisse nor Picasso, for all their innovations, ever completely renounced references to nature and to recognizable forms in their imagery.

Käthe Kollwitz

Although Käthe Kollwitz (1867–1945) was not a formal member of any artistic group, her *Whetting the Scythe* (fig. **25.16**) of 1905 conveys the direct emotional confrontation that was characteristic of Expressionism. Her harsh textures and the preponderance of rich blacks enhance her typically depressive themes. The gnarled figure concentrating intently on her task is rendered in close-up, which accentuates the detailed depiction of the woman's wrinkled hands and aged, slightly suspicious face. In the background, the cruciform arrangement of blacks reinforces the morbid associations of the image. The presence of the scythe, an attribute of the Grim Reaper, or Death, conforms to the woman's rather sinister quality. She is a version of van Gogh's Post-Impressionist *Wheatfield with Reaper* (see fig. 24.15) and Wordsworth's Romantic "Solitary Reaper."

25.16 Käthe Kollwitz, *Whetting the Scythe*, 1905. Soft-ground 8th-state etching, 11¹¹⁄₁₆ × 11¹¹⁄₁₆ in (29.7 × 29.7 cm). British Museum, London. Despite being financially comfortable herself, Kollwitz's imagery brings the viewer into contact with the emotional and material struggles of the working classes. This print is from a series published in 1904 to commemorate Germany's 16th-century peasant rebellion.

by line, are more static and geometric. These two tendencies—fluid line and flat color—create a dynamic tension that persists throughout his career.

Harmony in Red In *Harmony in Red* of 1908–9 (fig. **25.17**), Matisse goes beyond the thick, constructive brushstrokes and unusual color juxtapositions of his Fauve period. The actual subject of the painting, a woman

Matisse after Fauvism

Although Fauvism was shortlived, its impact, and that of Expressionism, laid the foundations of twentieth-century abstraction. Matisse reportedly said that "Fauvism is not everything, but it is the beginning of everything."

As Matisse developed, he was influenced by abstraction without embracing it completely. His sense of musical rhythm translated into line creates energetic, curvilinear biomorphic form. On the other hand, the shapes and spaces of Matisse that are determined primarily by color, and only secondarily

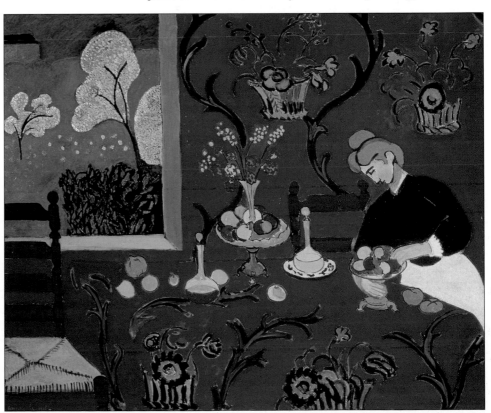

25.17 Henri Matisse, *Harmony in Red*, 1908–9. Oil on canvas, 5 ft 11 in × 8 ft 1 in (1.8 × 2.46 m). State Hermitage Museum, St. Petersburg.

arranging a fruit bowl on a table, seems secondary to its formal arrangement. Within the room, the sense of perspective has been minimized, because the table and wall are of the same red. The demarcation between them is indicated not by a constructed illusion of space, but by a dark outline, and by the bright still life arrangements on the surface of the table. The effect is reinforced by the tilting plates and bowls. Linear perspective is confined to the chair at the left and the window frame behind it. But, despite the flattening of the form by minimal modeling, Matisse endows the woman and the still life objects with a sense of volume.

The landscape, visible through the open window, relieves the confined quality of the close-up, interior view. It is related to the interior by the repetition of energetic black curves, which Matisse referred to as his "arabesques." The inside curves create branch-like forms that animate the table and wall, while those outside form branches and tree trunks. Smaller arabesques define the flower stems and the outline of the woman's hair.

The title *Harmony in Red* evokes the musical abstraction of Matisse's picture. It refers to the predominant color, the flat planes of which "harmonize" the wall and table into a shared space. Matisse builds a second, more animated "movement" in the fluid arabesques harmonizing interior with exterior. Finally, the bright patches on the woman, the still life objects, and the floral designs create a more staccato rhythm composed of individual accented forms. Matisse's ability to harmonize these different formal modes within a static pictorial space represents a synthesis of three artistic currents: the Post-Impressionist liberation of color, the Symbolist creation of mood, and the twentieth-century trend toward abstraction.

Dance I In *Dance I* of 1909 (fig. **25.18**), it is the figures, rather than the arabesques, who dance. The black outlines define the dancers, who twist and turn, jump and stretch. Their rhythmic, circular motion has been compared, in its simplicity, to dancers on the surface of a Greek vase. Although the blue and green background is composed of flat colors, Matisse succeeds in creating a three-dimensional illusion in the dancers themselves. This is enhanced by the warm pinks that make the dancers appear to advance, while the cool background colors recede. Although the individual movements of the dancers vary, together they form a harmonious continuum.

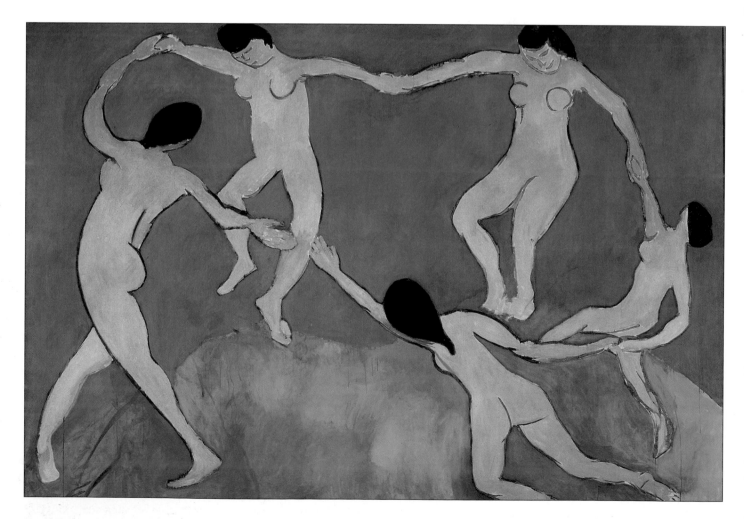

25.18 Henri Matisse, *Dance I*, 1909. Oil on canvas, 8 ft 6½ in × 12 ft 9½ in (2.6 × 3.9 m). Museum of Modern Art, New York (Gift of Nelson A. Rockefeller in honor of Alfred H. Barr, Jr.).

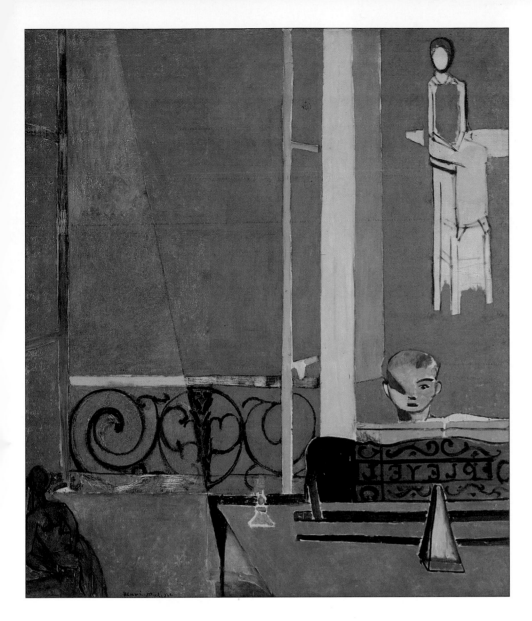

25.19 Henri Matisse, *Piano Lesson*, 1916. Oil on canvas, 8 ft ½ in × 6 ft 11¾ in (2.45 × 2.13 m). Museum of Modern Art, New York (Mrs. Simon Guggenheim Fund).

The Piano Lesson Another painting with a musical subject reflects changes that occurred in Matisse's style over the next decade. The *Piano Lesson* (fig. **25.19**) of 1916 has an autobiographical subtext. It is about the conflict between musical discipline and ambition on the one hand, and erotic pleasure on the other. In contrast to the earlier paintings, the *Piano Lesson* is constructed geometrically from rectangular and trapezoidal shapes that indicate Matisse's willingness to experiment with Cubist form. The seated woman at the right, for example, who could be the boy's mother or teacher, is a rectangular structure with ovals defining her blank face. She is raised up, as if on a throne, implicitly commanding the boy to practice. The boy stares fixedly at his music. His right eye is blocked out by a gray trapezoid that echoes the shape in the window and the metronome.

To the left of the gray window section is a rich green trapezoid. In the lower left corner, a figurine lounges in a seductive pose reminiscent of Titian's *Venus of Urbino* (see fig. 15.54); it is also a quotation of an earlier sculpture by Matisse. The outlines of the figure echo the arabesques in the music stand and the grillwork in the window. Although the boy is boxed in by the rectangle, which he shares with the "enthroned" woman, he is also related to the figurine through their shared tones of orange-brown. Though prevented from "seeing" her by the gray shape over his right eye, he seems to have her literally "on his mind" by virtue of the color of his hair. The same orange-brown is repeated in the illuminated candle, which is positioned between the boy and the figurine. The candle, which can have erotic implications, also denotes the passage of time.

The opposition of the woman as disciplinarian and seductress is evident in the formal structure of the painting, as well as in its iconographic details. The rectilinear organization of the space, like the metronome, corresponds to the "lofty" woman in its sense of ordered logic and measured time. (She is based on an earlier portrait of the wife of a Cubist critic, and can thus be linked with the geometry of Cubism.)

Inscribed across the center bar of the music stand is the word PLEYEL in reverse. This is a reference to the manufacturer of the piano, as well as to the Salle Pleyel, the most distinguished concert-hall of Paris. It therefore combines the present practice of the ambitious young musician with a future that his mother or teacher wishes for him. The *Piano Lesson* can be read as a metaphor for Matisse's

Later Works

Matisse later became interested in the lively, Moorish patterns of North Africa. He traveled to Morocco for the first time in 1911, and painted European models in Moorish settings. In *Decorative Figure in an Oriental Setting* of 1925 (fig. **25.22**), Matisse placed a monumental odalisque in a space crowded with colorful, linear energy. The woman, by contrast, is massive and blocklike. She retains some of the geometry of his earlier figures, with her cylindrical neck, circular breasts, triangular side, and rectangular thigh.

The solidity of her form anchors the picture, which is otherwise filled with the motion of elaborate patterns. The curved drapery creates a transition from the still, restful pose of the odalisque to the tilting floor and profusely animated designs of the carpet, wall, and flower pot. Orange arabesques frame the blue shapes on the wall—a particularly vivid chromatic juxtaposition, because blue

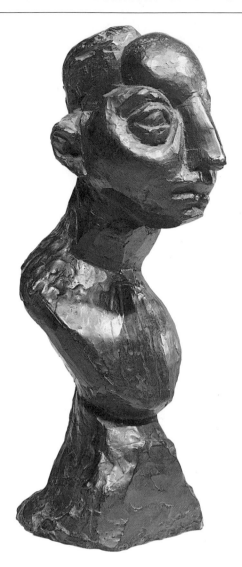

25.20 Henri Matisse, *Jeannette V*, 1916. Bronze, 23 × 7¾ × 11½ in (58.4 × 19.7 × 29.3 cm). Art Gallery of Ontario, Toronto.

relationship to the art of painting. It combines the rules of practice, technique, order, and logic with controlled sexual energy. The role of female inspiration, echoed by the separate implications of metronome and candle, is divided between the two women. In a way, therefore, this picture is to Matisse what the *Studio* (see figs. 22.4–22.5) was to Courbet—a psychological "manifesto" of the painter's art.

Jeannette V The geometric qualities of the *Piano Lesson* recur in a sculpture of the same year that reflects the influence of African art. *Jeannette V* (fig. **25.20**) is a bronze bust organized more according to geometry than to nature; it is the last of a series of heads begun in 1909 that move toward increasingly simplified abstraction. The hair is divided into shifting forms, one of which merges into the long nose, and the neck and body are arranged in three zigzag planes. This work shares an aggressive, angular quality with the seated Bambara figure from Mali (fig. 25.21) that Matisse owned at the time. In both, there is an emphasis on pointed forms, and a vigorous self-assertiveness.

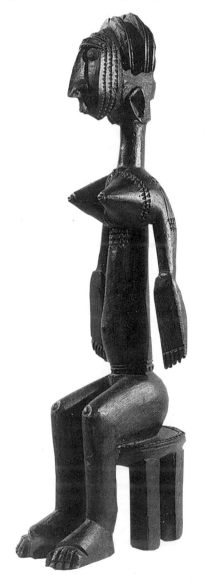

25.21 Seated figure, Bambara, Mali. Wood, 24 in (61 cm) high. Private collection, France.

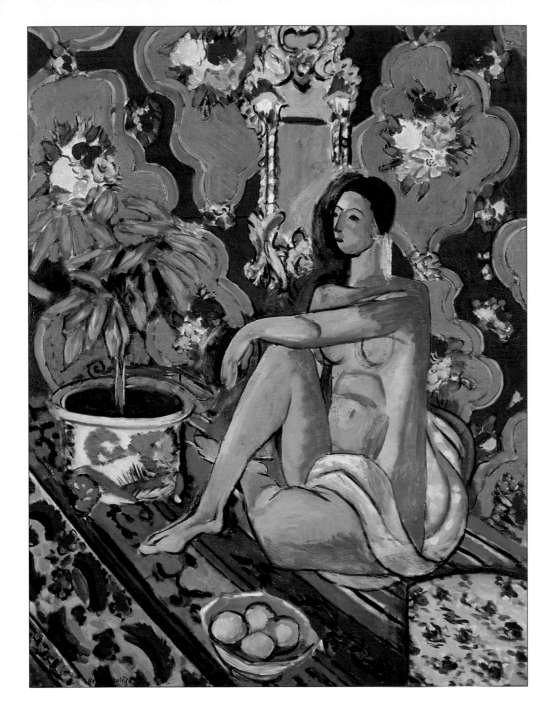

and orange are opposites on the color wheel (see fig. 1.16; 1.18 in the Combined Volume). The blues are further enlivened by the flowers in their midst, especially by the intense reds.

During the last decade of his life, Matisse gave up painting, partly because of cancer. Instead, he grappled directly with the problem of creating a three-dimensional illusion from absolutely flat forms. His medium was the so-called *découpage*, or "cut-out," an image created by pasting pieces of colored paper onto a flat surface. An early series of cut-outs, entitled *Jazz*, indicates Matisse's continuing interest in synthesizing musical with pictorial elements. His cut-out of *Icarus* of

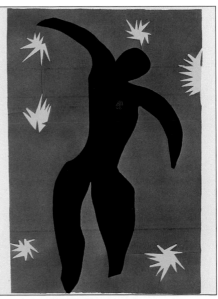

1947 (fig. **25.23**), from the *Jazz* series, combines a subject from Greek mythology with modern style and technique. By curving the edges and expanding or narrowing the forms, Matisse gives the silhouetted Icarus (see Bruegel's *Landscape with the Fall of Icarus*, fig. 17.7) the illusion of three-dimensional volume. His outstretched, winglike arms and tilting head create the impression that, though he is falling through space, he is not plummeting down to the sea, but floating gracefully in slow motion.

Entirely different in character are the zigzagging bright yellow stars that surround Icarus. Their points shoot off in various directions, and their vivid color is far more energetic than the languid figure of Icarus. There are thus two musical "movements" in this cut-out—the slower, curvilinear motion of Icarus, and the rapid, angular motion of the stars. Staccato and adagio are combined against the deep, resonant blue sky.

The drive toward new techniques and media for image-making, which is evident in Matisse's cut-outs, will be seen to characterize many of the innovations of twentieth-century art.

Style/Period	Works of Art	Cultural/Historical Developments
TURN OF THE CENTURY	Ife copper mask (**25.3**) Baule ancestor (**25.4**) Bakota figure (**25.5**) Bambara seated figure (**25.21**) Benin Oba head (**25.6**)	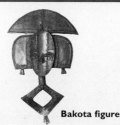 **Bakota figure**
1900 1900–1910 **Picasso, The Old Guitarist**	Matisse, *Notre-Dame in the Late Afternoon* (**25.7**) Picasso, *The Old Guitarist* (**25.1**) Matisse, *Madame Matisse* (**25.8**) Kollwitz, *Whetting the Scythe* (**25.16**) Kirchner, *The Street* (**25.9**) Matisse, *Harmony in Red* (**25.17**) Matisse, *Dance I* (**25.18**) **Matisse, Harmony in Red**	Theodore Roosevelt president of the U.S.A. (1901–9) Foundation of Nobel prizes (1901) August Strindberg, *The Dance of Death* (1901) The hormone adrenalin first isolated (1901) First oil wells drilled in Persia (1901) Maxim Gorky, *Lower Depths* (1902) Anton Chekhov, *Three Sisters* (1902) Aswan Dam opened (1902) Albert Einstein, *Special Theory of Relativity* (1905) Alfred Stieglitz opens the 291 Art Gallery (1905) *Die Brücke* formed in Dresden (1905) Upton Sinclair, *The Jungle* (1906) Pavlov's study of conditioned reflexes (1907)
1910 1910–1920 **Marc, The Large Blue Horses**	Nolde, *Still Life with Masks* (**25.11**) Nolde, *Drawing of an Oceanic Canoe Prow* (**25.12**) Marc, *The Large Blue Horses* (**25.15**) Kirchner, *Five Women in the Street* (**25.10**) Kandinsky, *Painting Number 201* (**25.13**) Matisse, *Jeannette V* (**25.20**) Matisse, *Piano Lesson* (**25.19**) **Kandinsky, Painting Number 201**	Igor Stravinsky, *The Firebird* (1910) *Der Blaue Reiter* formed in Munich (1911) Delius, *On Hearing the First Cuckoo in Spring* (1912) S.S. *Titanic* sinks on maiden voyage (1912) Thomas Mann, *Death in Venice* (1913) First World War (1914–18) W. Somerset Maugham, *Of Human Bondage* (1915) Bolshevik Revolution in Russia (1917) League of Nations established (1919)
1920 **1930** 1920–1930	Matisse, *Decorative Figure in an Oriental Setting* (**25.22**) Kandinsky, *Several Circles, Number 323* (**25.14**) 1947: Matisse, *Icarus* (**25.23**)	

26

Cubism, Futurism, and Related Twentieth-Century Styles

The most influential style of the early twentieth century was Cubism, which, like Fauvism, developed in Paris. Cubism was essentially a revolution in the artist's approach to space, both on the flat surface of the picture and in sculpture. The non-naturalistic colorism of the Fauves can be seen as synthesizing nineteenth-century Impressionism, Post-Impressionism, and Symbolism. Cubism, however, together with the non-figurative innovations of Expressionism, soon became the wave of the artistic future.

The main European impetus for Cubism came from Cézanne's new spatial organization, in which he built up images from constructions of color. Other decisive currents of influence came from so-called "primitive," or tribal, art, and from the art of the Iberian peninsula. These offered European artists unfamiliar, non-Classical ways to represent form and space.

Cubism

Precursors

Picasso's 1906 portrait of Gertrude Stein (fig. **26.1**; see Box) is executed in the dark red hues that mark the end of his Rose Period, which followed the Blue Period discussed in Chapter 25. The emphasis on color is consistent with contemporary Fauve interests, but a comparison with *The Old Guitarist* of the Blue Period (see fig. 25.6) indicates that

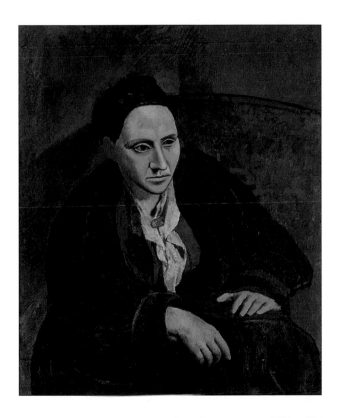

26.1 Pablo Picasso, *Gertrude Stein*, 1906. Oil on canvas, 39⅜ × 32 in (100 × 81.3 cm). Metropolitan Museum of Art, New York (Bequest of Gertrude Stein, 1947). In 1909 Gertrude Stein wrote *Prose Portraits*, the literary parallel of Analytic Cubism. Her unpunctuated cinematic repetition reads like free association. The following is from her *Portrait* of Picasso. "One whom some were certainly following was one working and certain was one bringing something out of himself then and was one who had been all his living had been one having something coming out of him ... This one was one who was working."[1]

Gertrude Stein

Gertrude Stein (1874–1946) was an expatriate American art collector and writer. She moved to Paris in 1903, after studying psychology at Radcliffe and medicine at Johns Hopkins. Her Paris apartment became a salon for the leading intellectuals of the post-World War I era, whom she dubbed the "lost generation." Her most popular book, *The Autobiography of Alice B. Toklas* (Stein's companion), is actually her own autobiography.

Stein and her two brothers were among the earliest collectors of paintings by avant-garde artists. History has vindicated her judgment, for she left an art collection worth several million dollars. Ernest Hemingway, in *A Movable Feast*, wrote that he had been mistaken not to heed Stein's advice to buy Picassos instead of clothes.

more than color has changed. In the *Gertrude Stein*, new spatial and planar shifts occur which herald the beginning of the development of Cubism.

Gertrude Stein's right arm and hand, for example, are organically shaded and contoured. Her left hand, however, seems flatter, and her arm looks as if it were constructed of cardboard. Picasso reportedly needed over eighty sittings to finish the picture, the main stumbling block being the face. In the final result, Gertrude Stein seems to be staring impassively from behind a mask. The hair does not grow organically from the scalp, and the ears are flat. The sharp separations between light and dark at the eyebrows, the black outlines around the eyes, and the disparity in the size of the eyes detract from the impression of a flesh-and-blood face.

Even more like masks are the faces in Picasso's pivotal picture, *Les Demoiselles d'Avignon* (*The Women of Avignon*) of 1907 (fig. **26.2**). With this representation of five nudes and a still life, Picasso launched a spatial revolution. The subject itself was hardly new, and Picasso had adapted traditional poses from earlier periods of Western art. On the far left, for example, the standing figure nearly replicates the pose of ancient Egyptian kings (see Vol. I, Chapter 4). The left leg is forward, the right arm is extended, and the fist is clenched. Also borrowed from Egypt is the pictorial convention of rendering the face in profile and the eye in front view. Picasso's two central figures, whose arms stretch behind their heads, are based on traditional poses of Venus. Of all the figures, the faces of the seated and standing nudes on the far right are most obviously based on African prototypes. The wooden mask from the Congo in figure **26.3**, for example, shares an elongated, geometric quality with the face of the standing figure. Here Picasso has abandoned *chiaroscuro* in favor of the Fauve preference for bold strokes of color. The nose resembles the long, curved, solid wedge of the mask's nose.

In the Mbuya (sickness) mask from Zaire (fig. **26.4**) the natural facial configuration is disrupted. Similarly, the face of Picasso's seated figure defies nature as well as the Classical ideal. In both faces, the nose curves to one side, while the mouth shifts to the other. In the two central

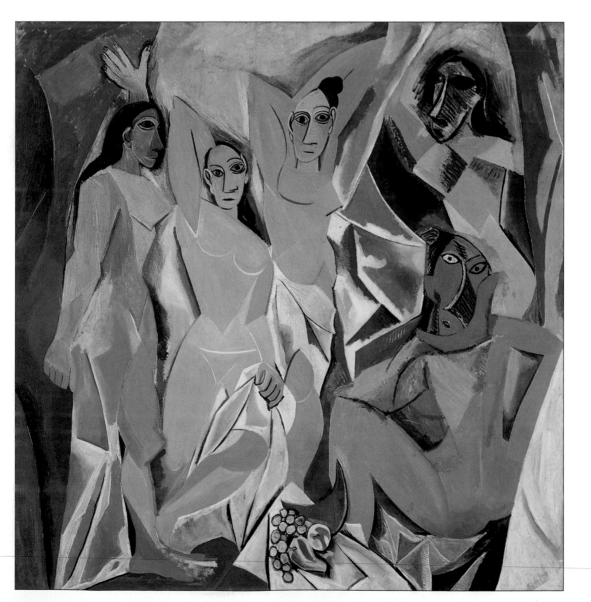

26.2 Pablo Picasso, *Les Demoiselles d'Avignon*. Paris, June to July 1907. Oil on canvas, 8 ft × 7 ft 8 in (2.44 × 2.34 m). Museum of Modern Art, New York (acquired through the Lillie P. Bliss Bequest). This painting was named for a bordello in the Carrer d'Avinyo (Avignon Street), Barcelona's red light district. Earlier versions contained a seated sailor and a medical student carrying a skull. Both were aspects of Picasso himself. By removing them from the final painting, Picasso shifted from a personal narrative to a more powerful mythic image.

26.3 Mask from the Etoumbi region, People's Republic of the Congo. Wood, 14 in (35.6 cm) high. Musée Barbier-Müller, Geneva.

26.4 Mbuya (sickness) mask, Pende, Zaire. Painted wood, fiber, and cloth, 10½ in (26.6 cm) high. Musée Royal de l'Afrique Centrale, Tervuren, Belgium.

nudes as well, the features have not only been simplified, but also distorted, so that one eye is slightly above another, the nose is no longer directly above the mouth, and the ears are asymmetrical. Still more radical is the depiction of the body of the seated figure, the so-called "squatter." She looks toward the picture plane while simultaneously turning her body in the opposite direction, so that her face and back are visible at the same time. In this figure, Picasso has broken from tradition by abandoning the single vantage point of the observer in favor of multiple vantage points along the lines pioneered by Cézanne. The so-called simultaneous view was to become an important visual effect of the new Cubist approach to space.

The figures in the *Demoiselles* are fragmented into solid geometric constructions, with sharp edges and angles. They interact spatially with the background shapes, blurring the distinction between foreground and background, as Cézanne had done. Such distortion of the human figure is particularly startling because it assaults our bodily identity. Light, as well as form, is fragmented into multiple sources, so that the observer's point of view is constantly shifting. Because of its revolutionary approach to space and its psychological power, the *Demoiselles* represented the greatest expressive challenge to the traditional, Classical ideal of beauty and harmony since the Middle Ages.

Analytic Cubism: Pablo Picasso and Georges Braque

In 1907 Picasso met the French painter Georges Braque (1881–1963), who had studied the works of Cézanne and been overwhelmed by the *Demoiselles*. Braque is reported to have declared, when he first saw the *Demoiselles*, that looking at it was like drinking kerosene. For several years Braque worked so closely with Picasso that it can be difficult to distinguish their pictures during the period known as Analytic Cubism. Braque's *Violin and Pitcher* (fig. **26.5**) of 1909–10 is very much like Picasso's works of that time, and will serve as an example of Analytic Cubism.

Both the subject-matter and the expressive possibilities of color—here limited to dark greens and browns—are subordinated to a geometric exploration of three-dimen-

26.5 Georges Braque, *Violin and Pitcher*, 1909–10. Oil on canvas, 3 ft 10 in × 2 ft 4¾ in (1.17 × 0.73 m). Öffentliche Kunstsammlung Basel, Kunstmuseum (Gift of Dr. H. C. Raoul La Roche, 1952). Braque was born in Argenteuil, France, and moved to Paris in 1900. There he joined the Fauves, and established a collaborative friendship with Picasso. They worked closely together until World War I and were jointly responsible for the development of Cubism. In 1908, on seeing a painting by Braque, Matisse reportedly remarked that it had been painted "with little cubes." This was credited with being the origin of the term Cubism.

sional space. The only reminders of space, as we know it, and of the objects that occupy it are the violin and pitcher, a brief reference to the horizontal surface of a table, and a vertical architectural support on the right. Most of the picture plane, including parts of these objects, is rendered as a jumble of fragmented cubes and other solid geometric shapes. What would, in reality, be air space is filled up, in Cubism, with multiple lines, planes, and geometric solids. The sense of three-dimensional form is achieved by combining shading with bold strokes of color. Despite the crisp edges of the individual shapes in Analytic Cubist pictures such as this one, the painted images nevertheless lose parts of their outlines. Whereas in Impressionism edges dissolved into prominent brushstrokes, in Cubism they dissolve into shared geometric shapes. No matter how closely the forms approach dissolution, however, they never completely dissolve.

In 1909 Picasso produced the first

26.6 Pablo Picasso, *Head of a Woman*, 1909. Bronze (cast), 16³⁄₁₆ × 9⅜ × 10½ in (41.1 × 24.5 × 26.7 cm). Collection of the Modern Art Museum of Fort Worth (acquired with a donation from Ruth Carter Stevenson).

Cubist sculpture, a bronze *Head of a Woman* (fig. **26.6**), in which he shifted the natural relationship between head and neck, creating two diagonal planes. The hair, as in Analytic Cubist paintings, is multifaceted, and the facial features are geometric rather than organic.

In 1911 two Cubist exhibitions held in Paris brought the work of avant-garde artists to the attention of the general public. The year 1911 also marked the culmination of Analytic Cubism. Although this phase of Cubism was brief, its impact on Western art was enormous. It stimulated the emergence of new and related styles, along with original techniques of image-making.

Guillaume Apollinaire and Marie Laurencin

Guillaume Apollinaire, the Symbolist poet and critic, was one of the most outspoken advocates of Cubism, particularly that of Picasso. "A man like Picasso," he wrote in 1912, "studies an object as a surgeon dissects a cadaver." According to Apollinaire, modern painters "still look at nature, [but] no longer imitate it ... Real resemblance no longer has any importance, since everything is sacrificed by the artist to truth ... Thus we are moving towards an entirely new art which will stand ... as music stands to literature. It will be pure painting, just as music is pure literature."[2]

Figure **26.7** by Marie Laurencin (1885–1956) shows Apollinaire seated with Picasso (on the left) and his dog Frika, Picasso's mistress Fernande Olivier, and the artist herself on the right. Laurencin typically painted in flat planes of pastel blues, pinks, and grays. Here Picasso's abrupt profile and frontal eye recalls his own use of that distortion, which he had found in Egyptian painting. Fernande's face is divided by color into two planes reminiscent of Cubist construction. Laurencin depicts her self-portrait with the neck characteristically curving sharply into the face, an arrangement that is repeated in the positioning of her left arm and hand.

Laurencin and Apollinaire were inseparable for about five years, from 1909 to 1914. She was accused of being a superficial artist and intellectually inferior until Gertrude Stein bought this painting. The affinities of Laurencin's work with Cubism are evident in this picture, as well as in some of her designs for stage sets. She also illustrated Poe's "The

Raven," which reveals her admiration for the Symbolist poets. In fact, it was partly through her encouragement that Apollinaire wrote in a Symbolist style.

26.7 Marie Laurencin, *Group of Artists*, 1908. Oil on canvas, 27½ × 31⅞ in (64.8 × 81 cm). The Baltimore Museum of Art. The Cone Collection, formed by Dr. Claribel Cone and Miss Etta Cone. BMA 1950.215.

Collage

Picasso's Cubist *Man with a Hat* (fig. **26.8**) of 1912 is an early example of **collage** (see Box), which was a logical outgrowth of Analytic Cubism, and marked the beginning of the shift to Synthetic Cubism (see p. 840). Pieces of colored paper and newspaper are pasted onto paper to form geometric representations of a head and neck, while the remainder of the image is drawn in charcoal. The use of newspaper, which seems textured because of the newsprint, was a common feature of early collages. Words and letters, which are themselves abstract signs, often formed part of the overall design. Collage, like Cubism itself, involved disassembling aspects of the environment—just as one might take apart a machine, break up a piece of writing, or even divide a single word into letters—and then rearranging (or reassembling) the parts to form a new image.

26.8 Pablo Picasso, *Man with a Hat*, after December 3, 1912. Pasted paper, charcoal, and ink, 24½ × 18⅜ in (62.2 × 47.3 cm). Museum of Modern Art, New York (Purchase).

Collage and Assemblage

Collage (from the French *coller*, meaning "to paste" or "to glue") developed in France from 1912. It is a technique that involves pasting lightweight materials or objects, such as newspaper and string, onto a flat surface. A technique related to collage, which developed slightly later, is **assemblage**. Heavier objects are brought together and arranged, or assembled, to form a three-dimensional image. Both techniques make use of **"found objects"** (*objets trouvés*), which are taken from everyday sources and incorporated into works of art.

Picasso's witty 1943 assemblage entitled *Bull's Head* (fig. **26.9**) is a remarkable example of his genius for synthesis. He has fused the ancient motif of the bull and the traditional medium of bronze with modern steel and plastic. He has also conflated the bull's head with African masks, and effected a new spatial juxtaposition, by reversing the direction of the bicycle seat and eliminating the usual space between it and the handlebars. In this work, Picasso simultaneously explores the possibilities of new media, of conflated imagery, and of the spatial shifts introduced by Cubism.

26.9 Pablo Picasso, *Bull's Head*, 1943. Assemblage of bicycle saddle and handlebars, 13¼ × 17⅛ × 7½ in (33.7 × 43.5 × 19 cm). Musée Picasso, Paris. Picasso detached the seat and handlebars of a bicycle, turned the seat around, and attached it to the handlebars. The object was then cast in bronze and hung on a wall. Although the image of a bull's head is clear and convincing, the influence of African masks is also evident.

Synthetic Cubism

Synthetic Cubism marked a return to bright colors. Whereas Analytic Cubism fragmented objects into abstract geometric forms, Synthetic Cubism arranged flat shapes of color to form objects. Picasso's *Three Musicians* (fig. **26.10**)—a clarinetist on the left, a Harlequin playing a guitar in the center, and a monk—is built up from unmodeled shapes of color arranged into tilted planes. In addition, the flat shapes—such as the dog lying under the table—occupy a more traditional space than those of Analytic Cubism, in which air space is filled with solid geometry. The shapes, which here are painted, resemble the flat paper pasted to form a collage. Simultaneity of viewpoint is preserved—for example, in the sheet of music. It is held by the monk and turned toward the viewer, who sees both the musician and what he is reading at the same time.

Picasso's Surrealism

Another stylistic shift in Picasso's work which was influenced by Cubism has been called Surrealism. This term (see Chapter 27) literally means "above real," and denotes a truer reality than that of the visible world. In the *Girl Before a Mirror* (fig. **26.11**) of 1932, Picasso aims at psychological reality. He uses the multiple viewpoint in the service of symbolism, although the precise meaning of this picture has remained elusive, and has been the subject of many interpretive discussions. The girl at the left is rendered in a combined frontal and profile view, but her mirror reflection is in profile. It is also darker than the "real" girl outside the mirror, and torsos do not match.

The device of the mirror to create multiple views is not new. Picasso was certainly familiar with Manet's *Bar at the Folies-Bergères* (see fig. 23.18), Velázquez's *Venus with a Mirror* (see fig. 18.56), and *Las Meninas* (see fig. 18.57), all of which use mirrors to expand the viewer's range of vision. Here, however, the formal differences between the girl and her reflection suggest that outer appearances are contrasted with an inner, psychological state. One French term for "mirror" is *psyché*, which means "soul," and this provides a clue to the picture's significance. It reinforces the notion that Picasso transformed the multiple views of Cubism into multiple psychological views, which simultaneously show the girl's interior psychic reality and exterior appearance.

Picasso's *Guernica*

In his monumental work of 1937, *Guernica* (fig. **26.12**), Picasso combined both Analytic and Synthetic Cubist forms with several traditional motifs, which he juxtaposed in a new Surrealist way. The combination serves the political message of the painting—namely, Picasso's powerful protest against the brutality of war and tyranny (see caption). Consistent with its theme of death and dying, the

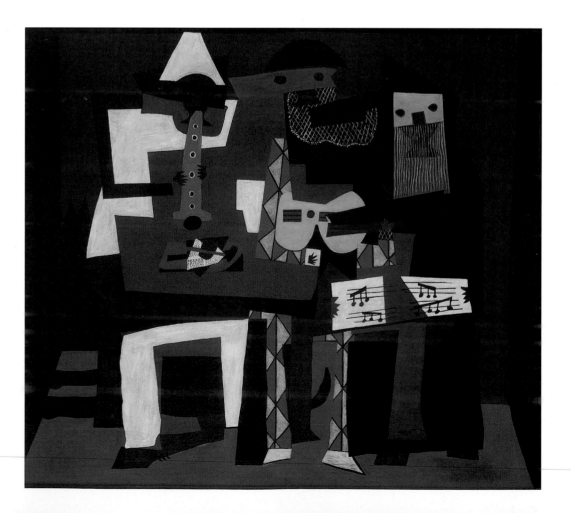

26.10 Pablo Picasso, *Three Musicians*, 1921. Oil on canvas, 6 ft 7 in × 7 ft 3¾ in (2.01 × 2.23 m). Museum of Modern Art, New York (Mrs. Simon Guggenheim Fund).

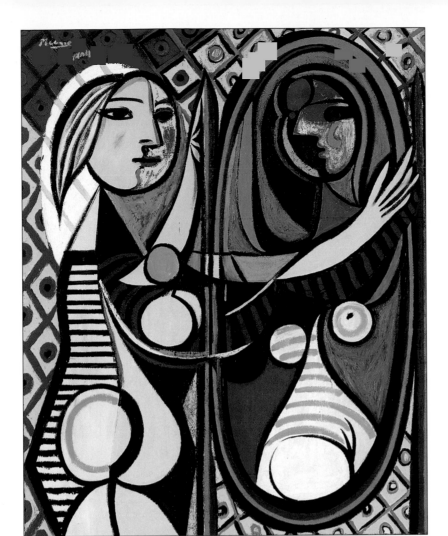

26.11 Pablo Picasso, *Girl Before a Mirror*, 1932. Oil on canvas, 5 ft 4 in × 4 ft 3¼ in (1.62 × 1.3 m). Museum of Modern Art, New York (Gift of Mrs. Simon Guggenheim).

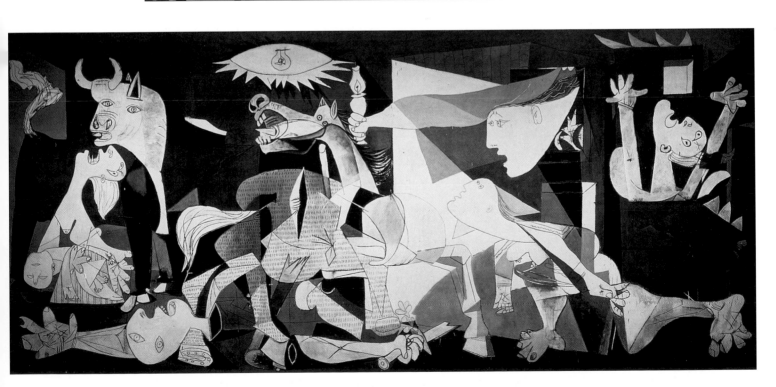

26.12 Pablo Picasso, *Guernica*, 1937. Oil on canvas, 11 ft 5½ in × 25 ft 5¾ in (3.49 × 7.77 m). Prado, Madrid. From 1936 to 1939 there was a civil war between Spanish Republicans and the Fascist army of General Franco. In April 1937 Franco's Nazi allies carried out saturation bombing over the town of Guernica. Picasso painted *Guernica* to protest this atrocity. He loaned it to New York's Museum of Modern Art, stipulating that it remain there until democratic government was restored in Spain. In 1981 *Guernica* was returned to Madrid.

26.13 Pablo Picasso, study for *Guernica*, 1937. Pencil drawing, 9½ × 17⅞ in (24.1 × 45.4 cm). Prado, Madrid.

painting is nearly devoid of color, though there is considerable tonal variation within the range of black to white. The absence of color enhances the journalistic quality of the painting, relating it to the news accounts of the bombing it protests.

Guernica is divided into three sections, a compositional structure that recalls the triptychs of the Middle Ages and Renaissance. There is a central triangle with an approximate rectangle on either side. The base of the triangle extends from the arm of the dismembered and decapitated soldier at the left to the foot of the running woman at the right. The dying horse represents the death of civilization, though it may be rescued by the woman with a lamp (Liberty) rushing toward it. Another expression of hope, as well as of the light of reason, appears in the motif combining the shape of an eye with the sun's rays and a lightbulb just above the horse's head. On the right, the pose and gesture of a falling woman suggest Christ's Crucifixion. On the left, a woman holds a dead baby on her lap in a pose reminiscent of Mary supporting the dead Christ in the traditional *Pietà* scene (see fig. 15.19). Behind the woman looms the specter of the Minotaur, the monstrous tyrant of ancient Crete, whose only human quality is the flattened face and eyes. For Picasso, the Minotaur came to represent modern tyranny, as embodied by the Spanish dictator General Francisco Franco, who collaborated with Adolf Hitler and Benito Mussolini.

These apparently disparate motifs are related by form and gesture, by their shared distortions, and by the power of their message. Cubist geometric shapes and sharp angles pervade the painting. Picasso's characteristic distortions of body and face emphasize the physical destruction of war. Eyes are twisted in and out of their sockets,

ears and noses are slightly out of place, tongues are shaped like daggers, palms and feet are slashed. Although the integrity of the human form is maintained throughout, it is an object of attack and mutilation.

Picasso did forty-five studies for *Guernica*. The one illustrated here (fig. **26.13**) shows the dying horse and the mother with the dead child. They have been changed in the final painting, although they retain their basic character. The Cubist neck of the horse has a stronger curve in the drawing and its protruding teeth seem to hang out of the mouth. The woman howls in despair as in the painting, but in the drawing she crawls on the ground, while the baby flops over like a rag doll. Picasso's spontaneous, dynamic drawing technique is evident in this study, particularly in the horse's mane and the areas of shading. The individualized anguish of the figures in the drawing becomes generalized, and thus—as with the *Demoiselles d'Avignon*—assumes mythic proportions in the final work.

Other Early Twentieth-Century Developments

The City

Cubism and other early twentieth-century movements were well suited to the new artistic awareness of the modern urban landscape. Kirchner's Expressionist *Five Women in the Street* (see fig. 25.10) captured the mechanistic character of the city by using the flattened planes of Cubism.

Futurism

Related to Expressionism was the contemporary movement called Futurism, which originated in Italy. The Futurists were inspired by the dynamic energy of industry and the machine age. They argued for a complete break with the past. In February 1909 a Futurist Manifesto, written by Filippo Marinetti, the editor of a literary magazine in Milan, appeared on the front page of the French newspaper *Le Figaro*. The Manifesto sought to inspire in the general public an enthusiasm for a new artistic language. In all of the arts—the visual arts, music, literature, theater, and film—the old Academic traditions would be abandoned. Libraries and museums would be abolished, and creative energy would be focused on the present and future. Speed, travel, technology, and dynamism would be the subjects of Futurist art.

Marinetti's language was apocalyptic in its determination to slash through the "millennial gloom" of the past. "Time and Space died yesterday," he declared. "We already live in the absolute, because we have created eternal, omnipresent speed. ... We will destroy the museums, libraries, academies of every kind, we will fight moralism, feminism, every opportunistic or utilitarian cowardice." And later in the same tract: "We establish *Futurism*, because we want to free this land from its smelly gangrene of professors, archaeologists, ... and antiquarians." Marinetti equated "admiring an old picture" with "pouring our sensibility into a funerary urn," and he recommended an annual "floral tribute" to the *Mona Lisa*, implying that the artistic past was dead and merited only the briefest remembrance.

Futurism was given plastic form in a 1913 sculpture by Umberto Boccioni (1882–1916) entitled *Unique Forms of Continuity in Space* (fig. **26.14**). It represents a man striding vigorously, as if with a definite goal in mind. The long diagonal from head to foot is thrust forward by the assertive angle of the bent knee. The layered surface planes, related to the fragmented planes of Analytic Cubism, convey the impression of flapping material. Organic flesh and blood are subjugated to a mechanical, robot-like appearance—a vision that corresponds to Boccioni's aims as stated in his *Technical Manifesto of Futurist Sculpture 1912*. Sculpture, he said, must "make objects live by showing their extensions in space" and by revealing the environment as part of the object.

26.14 Umberto Boccioni, *Unique Forms of Continuity in Space*, 1913. Bronze (cast 1931), 43⅞ × 34⅞ × 15¾ in (111.2 × 88.5 × 40 cm). Museum of Modern Art, New York (acquired through the Lillie P. Bliss Bequest). In 1910 Boccioni wrote the *Manifesto of the Futurist Painters*, which encouraged artists to portray the speed and dynamism of contemporary life, as he himself has done in this sculpture. He fought for Italy in World War I and was killed by a fall from a horse in 1916.

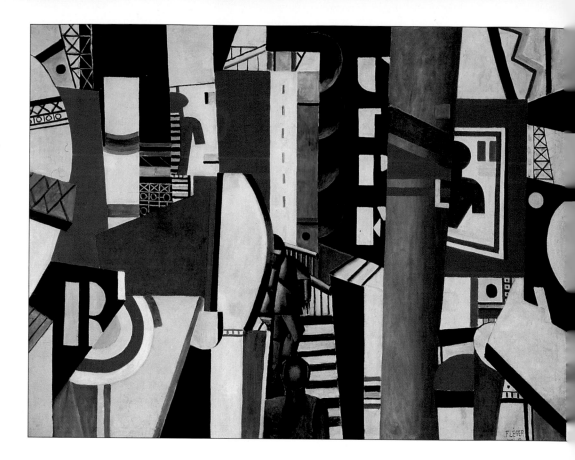

26.15 Fernand Léger, *The City*, 1919. Oil on canvas, 7 ft 7 in × 14 ft 9½ in (2.31 × 4.5 m). Philadelphia Museum of Art (A. E. Gallatin Collection). Léger described the kinship between modern art and the city as follows: "The thing that is imaged does not stay as still ... as it formerly did. ... A modern man registers a hundred times more sensory impressions than an 18th-century artist. ... The condensation of the modern picture ... its breaking up of forms, are the result of all this. It is certain that the evolution of means of locomotion, and their speed, have something to do with the new way of seeing."[3]

Fernand Léger's *The City*

The work of Fernand Léger (1881–1955) is more directly derived from Cubism than Boccioni's sculpture. In *The City* of 1919 (fig. **26.15**), Leger captures the cold, steel surfaces of the urban landscape. Harsh forms, especially cubes and cylinders, evoke the metallic textures of industry. The jumbled girders, poles, high walls, and steps, together with the human silhouettes, create a sense of the anonymous, mechanical movement associated with the fast pace of city life. In this painting, Léger has taken from Analytic Cubism the multiple viewpoint and superimposed solid geometry. His shapes, however, are colorful and recognizable, and there is a greater illusion of distance within the picture plane.

Piet Mondrian

In 1911, the year of the two Cubist exhibitions, Piet Mondrian (1872–1944) came to Paris from Holland. He had begun as a painter of nature, but under the influence of Cubism gradually transformed his imagery to flat rectangles of color. His delicate *Amaryllis* (fig. **26.16**) exemplifies his sensitivity to nature and attention to the subtleties of surface texture. Mondrian gradually abstracted forms

26.16 Piet Mondrian, *Amaryllis*, 1909. Watercolor on paper, 18½ × 13½ in (43.7 × 34.3 cm). Janis Family Collection, New York. Mondrian was an Impressionist and Symbolist painter before helping to found the *De Stijl* movement in 1917. His spiritual attitude toward art was reflected in his belief that perfect esthetic harmony and balance in art are derived from ethical purity and world harmony. The dating of Mondrian's nature studies is controversial. This one has been variously dated from 1909 to the 1920s.

26.17 Piet Mondrian, *Broadway Boogie Woogie*, 1942–3. Oil on canvas, 4 ft 2 in × 4 ft 2 in (1.27 × 1.27 m). Museum of Modern Art, New York. (Given anonymously).

from nature to create flat rectangles bordered by thick, black lines. In these pictures, he plays on the tension, as well as the harmony, between vertical and horizontal. In them, he also rejects curves and diagonals altogether, and expresses his belief in the purity of primary colors. According to Mondrian, chromatic purity, like the simplicity of the rectangle, had a universal character. To illustrate this, he wrote that, since paintings are made of line and color, they must be liberated from the slavish imitation of nature (see the **installation** photograph in fig. 26.28).

Later, while living in New York in the early 1940s as a refugee from World War II, Mondrian painted *Broadway Boogie Woogie* (fig. **26.17**). This was one of a series of pictures that he executed in small squares and rectangles of color, which replaced the large rectangles outlined in black. The title evokes a busy city street and dance music. The grid pattern of the New York streets, the flashing lights of Broadway, and the vertical and horizontal motion of cars and pedestrians are conveyed as flat, colorful shapes. Fast shifts of color and their repetition recall the strong, accented rhythm of Boogie-woogie, a popular form of dance music of the period. In combining musical references with the beat of city life and suggesting these qualities through color and shape, Mondrian synthesized Expressionist exuberance with Cubist order and control.

The Armory Show

The burgeoning styles of the early twentieth century in western Europe did not reach the general American public until 1913. In February of that year, the Armory of the Sixty-ninth Regiment, National Guard, on Lexington Avenue at 25th Street in New York was the site of an international exhibition of modern art. A total of 1200 exhibits, including works by Post-Impressionists, Fauves, and Cubists, as well as by American artists, filled eighteen rooms. This event marked the first widespread American exposure to the European avant-garde.

The Armory Show caused an uproar. Marcel Duchamp (1887–1968) submitted *Nude Descending a Staircase, No. 2* (fig. **26.18**), which was the most scandalous work of all. It was a humorous attack on Futurist proscriptions against traditional, Academic nudity. The image has a kinetic quality consistent with the Futurist interest in speed and motion. At the same time, the figure is a combination of

26.18 Marcel Duchamp, *Nude Descending a Staircase, No. 2*, 1912. Oil on canvas, 4 ft 10 in × 2 ft 11 in (1.47 × 0.89 m). Philadelphia Museum of Art (Louise and Walter Arensberg Collection).

Cubist form and multiple images that indicate the influence of photography. She is shown at different points in her descent, so the painting resembles a series of consecutive movie stills, unframed and superimposed.

Various accounts published at the time ridiculed the *Nude*'s début in the United States. Descriptions by outraged viewers included the following: "disused golf clubs and bags," an "elevated railroad stairway in ruins after an earthquake," "a dynamited suit of Japanese armor," an "orderly heap of broken violins," an "explosion in a shingle factory," and "Rude Descending a Staircase (Rush Hour in the Subway)." Duchamp recorded his own version of the *Nude*'s place in the history of art: "My aim was a static representation of movement—a static composition of indications of various positions taken by a form in movement—with no attempt to give cinema effects through painting."[4]

The influence of Futurism, Cubism, and African sculpture is evident in the style of the Romanian sculptor Constantin Brancusi (1876–1957), who was also represented in the Armory Show. A version of his *Mademoiselle Pogany* (fig. **26.19**), listed for sale at $540, created a stir of its own. Her reductive, essential form was described as a "hard-boiled egg balanced on a cube of sugar." The last stanza of "Lines to a Lady Egg," which appeared in the New York *Evening Sun*, went as follows:

Ladies builded like a bottle,
Carrot, beet, or sweet potato—
Quaint designs that Aristotle
Idly drew to tickle Plato—
Ladies sculptured thus, I beg
You will save your tense emotion;
I am constant in devotion,
O my egg![5]

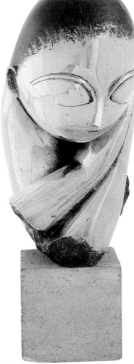

26.19 Constantin Brancusi, *Mademoiselle Pogany*, Version 1 (1913) after a marble of 1912. Bronze, on limestone base: bronze 17¼ × 8½ × 12½ in (43.8 × 21.5 × 31.7 cm); base 5¾ × 6⅛ × 7⅜ in (14.6 × 15.6 × 18.7 cm). Museum of Modern Art, New York (acquired through the Lillie P. Bliss Bequest).

In the Introduction (Chapter I in the Combined Volume), we discussed Brancusi's bronze *Bird in Space* (see fig. 1.2; 1.4 in the Combined Volume), which achieved notoriety in the legal debate over whether it was a work of art or a "lump of manufactured metal." In *Mademoiselle Pogany*, the emphasis on rationalized, or quasi-geometrical, form allies the work with Cubism and related styles. Brancusi's high degree of polish conveys the increased prominence of the medium itself as artistic "subject." The roughness of the unpolished bronze at the top of the head, on the other hand, which contrasts with the polish of the face, creates an impression of hair. In the detachment of *Mademoiselle Pogany*'s hands and head from her torso, she becomes a partial body image that is characteristic of Brancusi's human figures and reflects the influence of Rodin, with whom Brancusi studied briefly in Paris. The partial aspect of Brancusi's sculptures is related to his search for a truthful, Platonic "essence" of nature, rather than a literal and objective depiction of it.

Stuart Davis

Despite—or perhaps because of—the sensation caused by the Armory Show, which also traveled to Chicago and Boston, its impact on American art was permanent. The American artist Stuart Davis (1894–1964), for example, had exhibited several watercolors in the Armory Show while still an art student. Later, in 1921, he painted *Lucky Strike* (fig. **26.20**), in which the flattened cigarette box was clearly influenced by collage. The colorful, unmodeled shapes are reminiscent of Synthetic Cubism, while the words and numbers recall early newspaper collages. The subject itself reflects American consumerism, which advertises a product by its package; the painting was thus an important early forerunner of Pop Art (see Chapter 29).

Aaron Douglas and the Harlem Renaissance

The African-American painter Aaron Douglas (1898–1979) used the principles of Synthetic Cubism to depict the history of his people. Douglas was a leading figure in the Harlem Renaissance of the 1920s. Centered in Harlem, a district of New York City, this was the first significant black American cultural movement. It was primarily a literary movement, but it also included philosophers, performers, political activists, and photographers, as well as painters and sculptors. The philosopher Alain Locke (1886–1954) urged black artists of African descent to reflect their heritage in their works.

Douglas was born in Kansas and studied art in Paris, where he was exposed to the avant-garde. He became interested in the affinities between Cubism and African art, and combined these concerns with black experience in America. In 1934 Douglas painted four murals entitled *Aspects of Negro Life* for the New York Public Library. The second in the series—*From Slavery Through Reconstruction* (fig. **26.21**)—depicts three events following the American Civil War. At the right, there is rejoicing at

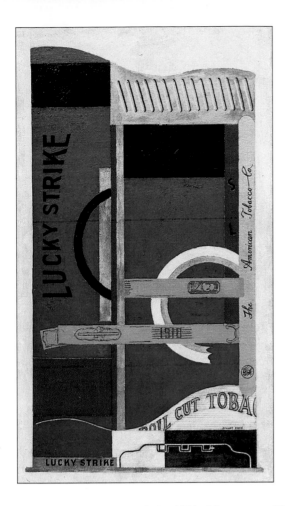

the news of the *Emancipation Proclamation* (of January 1, 1863), which freed the slaves. The man on the soapbox in the center represents the success of the black man, whose voice is now being heard. At the left, the Union army leaves the South, and Reconstruction with its anti-Black backlash follows.

The exuberance of the figures recalls the dynamic energy of jazz, which also appealed to Matisse. Music appears in the subject-matter of the mural—the trumpet and the drums—as well as in the rhythms of its design. The main colors are variations on the hue of rose, while concentric circles of yellow convey a sense of sound traveling through space. At the same time, the unmodeled character of the color allies the work with Synthetic Cubism. The green and white cotton plants in the foreground refer to the work of the American slaves, and create an additional pattern superimposed over the light reds.

Kazimir Malevich and Suprematism

One of the most geometric developments that grew out of Cubism took place in Russia. Kazimir Malevich (1878–1933) was born in Kiev, and in 1904 went to Moscow to study art. Although, as a student, he did not travel outside Russia, he was exposed to the European avant-garde through important collections in Moscow, and in 1908 he saw works exhibited by Cézanne, Gauguin, Matisse, and Braque. As a mature artist, Malevich combined Cubism with Futurism. He considered the proto-Cubism of Cézanne to have been rooted in village life, whereas the later development of the style was urban in character. For Malevich, it was Futurism, the more dynamic form of Cubism, that expressed the fast pace of city life.

26.20 (above) Stuart Davis, *Lucky Strike*, 1921. Oil on canvas, 33¼ × 18 in (84.5 × 45.7 cm). Museum of Modern Art, New York (Gift of the American Tobacco Company, Inc.). Davis designed the first abstract postage stamp for the United States in 1964. He gravitated to abstract forms from objects such as eggbeaters and electric fans. As a lifelong smoker, Davis had a particular fondness for the imagery of smoking.

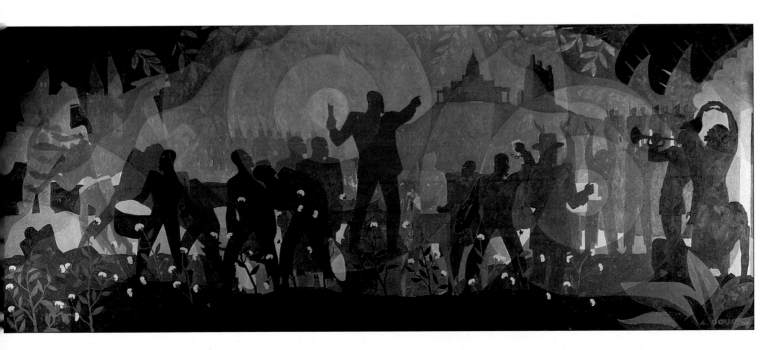

26.21 Aaron Douglas, *From Slavery Through Reconstruction* (from the series *Aspects of Negro Life*), 1934. Oil on canvas, 5 ft × 10 ft 8 in (1.5 × 3.25 m). Schomburg Center for Research in Black Culture, New York Public Library. Astor, Lenox and Tilden Foundations.

His *Composition with the Mona Lisa* (fig. **26.22**) of 1914 is a collage composed of pasted objects such as a thermometer, a postage stamp, and bits of newspaper. The structure of the composition is based on Synthetic Cubism, with the cylindrical shapes suggesting engines and other mechanical devices. Malevich literally "crossed out" the *Mona Lisa*, because, he said, the new version had more value as "the face of the new art." This sentiment reflected his view that the tradition of naturalistic painting had been superseded by avant-garde abstraction.

Following his Cubist-Futurist phase, Malevich created the style he called Suprematism. His first Suprematist painting, exhibited in 1915, in St. Petersburg, Russia, consisted of a black square centered in a white background. The original became damaged, and he subsequently made several additional versions of it (fig. **26.23**). According to Malevich, the black square was an expression of the cosmic, of pure feeling, and the white was the void beyond feeling. His aim was to achieve the mystical through pure form, which embodied pure feeling,

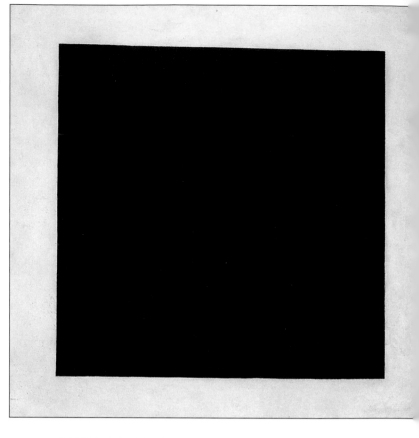

26.22 (below) Kazimir Malevich, *Composition with the Mona Lisa*, 1914. Graphite, oil, and collage on canvas, 24⅜ × 19½ in (61.9 × 49.5 cm). State Russian Museum, St. Petersburg.

26.23 Kazimir Malevich, *Black Square*, 1929. Oil on canvas, 31¼ × 31¼ in (79.4 × 79.4 cm). State Tretiakov Gallery, Moscow.

instead of depicting what is visible and natural. The requirements of society, the state, and religion were subordinated to form. In his book entitled *The Nonobjective World*, Malevich stated that, at the turn of the twentieth century, art "divested itself of the ballast of religious and political ideas." He summed up his philosophy of Suprematism as follows:

> Artists have always been partial to the use of the human face in their representations, for they have seen in it (the versatile, mobile, expressive mimic) the best vehicle with which to convey their feelings. The Suprematists have nevertheless abandoned the representation of the human face (and of natural objects in general) and have found new symbols with which to render direct feelings (rather than externalized reflections of feelings), for *the Suprematist does not observe and does not touch—he feels*.[6]

After the Communist Revolution of 1917, Malevich was appointed Commissar for the Preservation of Monuments and Antiquities. By the late 1920s, the Soviet government under Stalin (d. 1953) was suppressing avant-garde art and asserting state control over all the arts. Sensing that further oppression was to come, Malevich traveled in 1927 to Poland and Germany, where the Bauhaus (see p. 854) published his book in German. He left some of his abstract paintings with German friends in order to protect them from Soviet officials. The Germans, in turn,

would later have to hide them from the Nazis. In 1930, Malevich was arrested by the Soviets for artistic "deviation."

Three years later, he painted his last *Self-portrait* (fig. **26.24**), which reflects his renunciation of the "deviant" avant-garde and his return to naturalism. Ironically, he represented himself as a "Renaissance man." When he died, his white coffin was decorated with one black circle and one black square, and a white cube with a black square on it marked the place where his ashes were buried. In 1936 the Soviets confiscated his remaining pictures; they were not shown publicly again until 1977.

Brancusi's *Gate of the Kiss* and *Endless Column*

In 1935, the year before the Soviet confiscation of Malevich's abstract pictures, Brancusi accepted a commission for his native town of Tirgu Jiu, in Romania. He agreed to design a peace memorial dedicated to those who had died in World War I. In its final form, the memorial consisted of three structures—*The Table of Silence*, *The Gate of the Kiss*, and *The Endless Column*. The central feature, *The Gate of the Kiss* (fig. **26.25**), was derived from a much earlier series of sculptures entitled *The Kiss*, of which the 1912 version is illustrated here in figure **26.26**. The Cubist

26.25 Constantin Brancusi, *The Gate of the Kiss*, 1938. Stone, 17 ft 3½ in × 21 ft 7⅛ in × 6 ft 1½ in (5.27 × 6.58 × 1.84 m). Public Park, Tirgu Jiu, Romania.

26.26 (below) Constantin Brancusi, *The Kiss*, 1912. Stone, 23 in (58.4 cm) high. Philadelphia Museum of Art. The Louise and Walter Arensberg Collection.

26.24 Kazimir Malevich, *Self-portrait*, 1933. Oil on canvas, 28¾ × 26 in (73 × 66 cm). State Russian Museum, St. Petersburg.

quality of *The Kiss* resides in its blocklike form, which Brancusi used to merge the embracing figures. The arms overlap and, as seen from the front, appear shared equally between the couple. The lips are formed into a little cube connecting the rectangular heads. As with many of Picasso's cubist faces after 1906, these can be read simultaneously as a profile and a front view. The focal point of the face is the eye, the placement of which creates the multiple viewpoint, for it is both two eyes rendered in profile and a single eye in a triangular face.

In *The Gate of the Kiss*, Brancusi persists in the use of cubic form, and also endows it with symbolic meaning. The **lintel** is decorated with incised, geometric versions of *The Kiss*, and each supporting post is decorated with four large, round "eyes." The ensemble implies that the notion of a kiss embodies love, which therefore "upholds" peace. The eyes, combined with the rectangular opening, also transform *The Gate* into a large face, which, like Janus of the ancient Roman gateways, watches those who come and those who go with equal attention.

The Endless Column (fig. **26.27**) stands alone, and, like Trajan's Column (see Vol. I, figs. 8.36–8.37), does not function as an architectural support. Instead, it conveys an independent message, which is related to the significance of height. Rather than proclaiming the power of a single leader such as the Roman emperor (compare the column erected under Napoleon in the Place Vendôme in Paris, fig. 20.9), Brancusi's column seems to soar skyward in the manner of his *Bird in Space* (see fig. 1.2; 1.4 in the Combined Volume). It represents the sense of aspiration expressed by the Gothic cathedral towers and, ironically, as in *The Gate of the Kiss*, the ambitious hope for peace in a world on the verge of World War II.

Postscript

The installation photograph in figure **26.28** illustrates the main space of the Sidney Janis Gallery in New York during a landmark exhibition entitled "Brancusi + Mondrian" in the early 1980s. Mounted nearly seventy years after the Armory Show, and over fifty years after Malevich's detention for so-called "deviant" art, the Janis exhibition conveyed the importance of the avante-garde. It also emphasized the formal and historical relationship between Brancusi and Mondrian. In the left corner, a group of highly polished bronzes by Brancusi includes two versions of *Mademoiselle Pogany*. Flanked by Mondrians are a marble and a bronze version of *Bird in Space*. Brancusi's "essences," here composed of graceful curves and rounded,

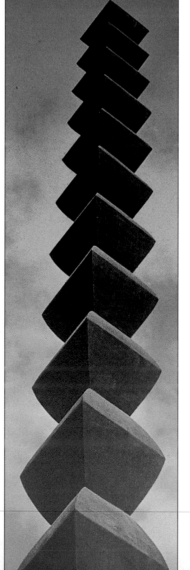

26.27 Constantin Brancusi, *The Endless Column*, 1937. Cast iron, 96 ft 3⅜ in (29.35 m) high, 35⅜ in (0.9 m) wide, 35⅜ in (0.9 m) deep. (Formerly) Public Park, Tirgu Jiu, Romania.

volumetric shapes, are contrasted with Mondrian's pure verticals and horizontals on a flat surface. In this juxtaposition, the viewer confronts the work of two major early twentieth-century artists. Despite their apparent differences, these artists have a remarkable affinity in their pursuit of an "idea," which they render in modern, abstract form.

Early Twentieth-Century Architecture

In the late nineteenth and early twentieth centuries, the most innovative developments in architecture took place in the United States. Following Louis Sullivan, who developed the skyscraper, the next major American architect was Frank Lloyd Wright (1869–1959). Wright had worked in Chicago as Sullivan's assistant before building private houses, mainly in Illinois, in the 1890s and early 1900s. But, whereas Sullivan's skyscrapers addressed the urban need to provide many offices or apartments on a relatively small area of land, Wright launched the Prairie Style, which sought to integrate architecture with the natural landscape.

Frank Lloyd Wright and the Prairie Style

In 1908, Wright wrote that "the Prairie has a beauty of its own and we should recognize and accentuate this natural beauty, its quiet level. Hence ... sheltering overhangs, low terraces and out-reaching walls, sequestering private gardens." In his philosophy, Wright found affinities with Japanese architecture, and its tradition of open internal spaces. He incorporated this tradition into a series of early twentieth-century, midwestern Prairie Style houses.

The best-known example of Wright's early Prairie Style is the Robie House of 1909 (fig. **26.29**) in south Chicago. Its horizontal emphasis, low-pitched roofs with large overhangs, and low boundary walls are related to the flat prairie landscape of the American West and Middle West. At the same time, the predominance of rectangular shapes and shifting, asymmetically arranged horizontal planes is reminiscent of the Cubist esthetic.

The ground floor of the Robie House contained a playroom, garage, and other

26.28 Installation view, "Brancusi + Mondrian" exhibition, December 1982–January 1983. Photo courtesy of Sidney Janis Gallery, New York. The art critic Sidney Geist wrote of this show that "If the century's Modernist struggle seems to have been called in question by recent developments, 'Brancusi + Mondrian' banished all doubt. … We have to do here with two saintly figures—for whom art was a devotion. Their lives and art evolved under the sign of inevitability."[7]

26.29 Frank Lloyd Wright, Robie House, Chicago, 1909. Wright's insistence on creating a total environment inspired him, sometimes against the wishes of his clients, to design the furniture and interior fixtures of his houses. In the case of the Robie House, Wright even designed outfits for Mrs. Robie to wear on formal occasions so that she would blend with his architecture.

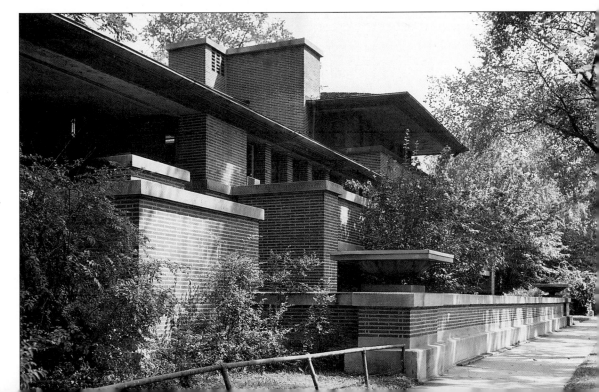

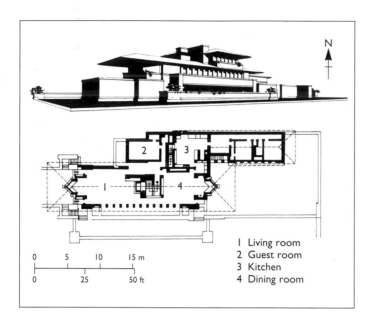

26.30 Perspective drawing and plan of the second floor of the Robie House.

In 1936, on a wooded site at Bear Run, Pennsylvania, Wright built a weekend house (fig. **26.31**) for the Edgar Kaufmann family which was a synthesis of the International Style (see below) and the Prairie Style. It is called Fallingwater because it is perched over a small waterfall. As in the Robie House, there is a large central core, composed here of local masonry. Fallingwater is surrounded by reinforced concrete terraces, which are related to the International Style. Their beige color attempts to blend with the landscape and their cantilevered horizontals repeat the horizontals of the rocky ledges below. Although the smooth texture and light hue of the terraces actually contrast with the darker natural colors of the woods, the natural stone of the chimneys resembles the rocks in the surrounding landscape. In keeping with the Prairie Style, parts of the house are integrated with the landscape and seem to "grow" from it. Glass walls, which make nature a constant visible presence inside the house, further reinforce the association of architecture with landscape. To some extent, therefore, Fallingwater fulfills Wright's pursuit of "organic" architecture.

service areas. The main living area was on the second floor, and the bedrooms were on the third. The second-floor plan (fig. **26.30**) illustrates the massive central core, which doubles as a fireplace and staircase, and is the focal point of the living quarters. Around the central core the living and dining rooms are arranged in an open plan. Verandas extend from the two main rooms. The huge cantilevered (see Box) roof on the second floor shields the windows from sunlight.

26.31 Frank Lloyd Wright, Fallingwater, Bear Run, Pennsylvania, 1936.

Cantilever

The system of **cantilever construction** is one in which a horizontal architectural element, projected in space, has vertical support at one end only. Equilibrium is maintained by a support and counterbalancing weight inside the building. The cantilever requires materials with considerable tensile strength. Wright pioneered the use of **reinforced concrete** and steel girders for cantilever construction in large buildings. In a small house, wooden beams provide adequate support.

26.32 Frank Lloyd Wright, Taliesin West, Arizona.

In 1938 Wright began work on his own house and office, Taliesin West (fig. **26.32**), in the Arizona foothills outside of Phoenix. Its main materials were called "desert concrete" by Wright, because they consist of concrete embedded with local stones and rocks, redwood beams, and canvas awnings. As in most of his designs for private houses, Wright used squares and rectangles as his primary shapes and right angles for beams and other planar juxtapositions.

International Style

From the end of World War I, a new architectural style developed in western Europe. Since it apparently originated in several countries at about the same time, it is known as the International Style.

Holland: De Stijl In Holland, the International Style of architecture began as the De Stijl movement, of which Mondrian was a founder. The primary leader, however, was the artist Theo van Doesburg (1883–1931), whose transformation of a cow into abstract geometric shapes is illustrated in figures 1.21–1.25; 1.23–1.27 in the Combined Volume. Several Dutch architects, attracted by Frank Lloyd Wright's work (which had been exhibited in Germany in 1910), joined Mondrian and van Doesburg in the De Stijl movement. They were idealists searching for an ultimate, or universal, style that would satisfy human needs through mass production. The spiritual goal of world peace, they believed, would also be fostered by the "equilibrium of opposites" that was part of De Stijl's credo.

Typical of this new architecture is the Schroeder House in Utrecht (fig. **26.33**), designed by Gerrit Rietveld (1888–1964). The flat roof and cantilevered balconies are similar to those in Wright's private houses. Whereas Wright emphasized horizontals, however, Rietveld preferred oppositions of horizontals and verticals derived from Cubism, which he integrated with a **skeletal construction**. There is no surface decoration to interrupt the exterior simplicity of the building. The many windows and balconies, with attached rectangular panels that seem to float in mid-air, create a sense of tension, paradoxically combined with weightlessness. Composed of predominantly white, flat planes and right angles, the Schroeder House is the three-dimensional equivalent of one of Mondrian's paintings of rectangles bordered by black outlines.

26.33 Gerrit Rietveld, Schroeder House, Utrecht, The Netherlands, 1923–4. Alfred Barr, Jr., curator of New York's Museum of Modern Art, defined the International Style as follows: "… emphasis upon volume … thin planes … as opposed to … mass and solidity; … regularity as opposed to symmetry … and … dependence upon the intrinsic elegance of materials, perfection, and fine proportions, as opposed to applied ornament." These goals are fulfilled in the Schroeder House.

Germany: The Bauhaus The German expression of the International Style centered on the Bauhaus. In the first decade of the twentieth century, the Deutscher Werkbund ("German Craft Association") was formed. Its aim was to improve the esthetic quality of manufactured goods and industrial architecture, to produce them more cheaply, and make them more widely available. This movement produced a number of important architects and designers, who had enormous international influence through the 1960s. Many who had worked together in Europe later emigrated to the United States to escape Hitler's persecutions during World War II.

The leader of this community was Walter Gropius (1883–1969), who in 1919 became the first director of the Bauhaus, in Weimar. The Bauhaus (from the German *Bau*, meaning "structure" or "building," and *Haus*, meaning "house") combined an arts and crafts college with a school of fine arts. Gropius believed in the integration of art and industry. With that in mind, he set out to create a new institution that would offer courses in design, architecture, and industry.

Vassily Kandinsky was a prominent member of the Bauhaus faculty from 1922, and he remained until 1933 when it was closed by the Nazis. His paintings of that period reflect the geometric angularity he espoused as part of the Russian avant-garde in Moscow at the beginning of World War I. Such forms, which were also characteristic of the Bauhaus esthetic, can be seen, for example, in *Composition 8* (fig. **26.35**). Compared to the exuberant curvilinear forms of his Expressionist *Painting Number 201* (see fig. 25.13), this is measured, constructed, and dominated by dynamic diagonal planes. While at the Bauhaus, Kandinsky published a text book on composition entitled *Point and Line to Plane: Contribution to the Analysis of the*

26.34 Walter Gropius, plan of the Bauhaus, Dessau, Germany, 1925–6.

Pictorial Elements (1926), in which he combined spirituality and mysticism with strict, formal analysis.

In 1926 Gropius relocated the Bauhaus from Weimar to Dessau, and planned its new quarters (fig. **26.34**) according to his International Style philosophy. Three blocklike buildings contained living and working areas, as well as the schools. They were linked by an elevated bridge containing offices. This conception differed radically from previous academic institutions, which were monumental, had a clearly marked entrance within a distinctive façade, and were usually Neoclassical in style.

The workshop wing of the Bauhaus (fig. **26.36**) is typical of the International Style. It is entirely rectilinear, with verticals and horizontals meeting at right angles. The primary material is reinforced concrete, but, apart from two thin white bands at the top and bottom, the viewers see only sheet glass walls from the outside. Structurally, this was a logical extension of the steel skeleton system of construction which, as in the Wainwright Building (see fig. 22.30), relieves the outer walls of any support function. Formal affinities with Cubism are inescapable, although Gropius, like the members of the Dutch De Stijl, was

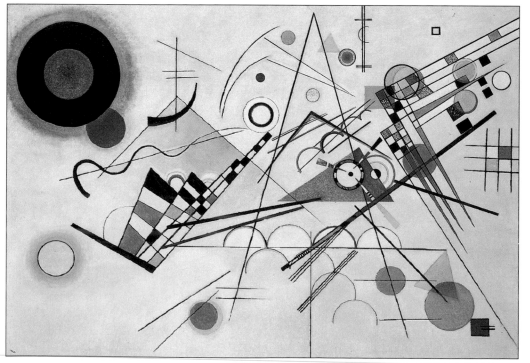

26.35 Vassily Kandinsky, *Composition 8*, 1923. Oil on canvas, 55⅛ in × 79⅛ in (140 × 200 cm). Guggenheim Museum, New York.

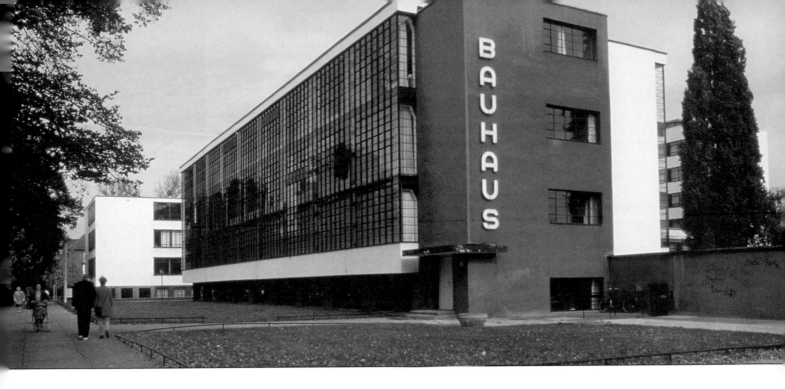

26.36 Walter Gropius, Bauhaus workshop wing, 1925–6.

motivated primarily by a philosophy of simplicity and harmony intended to integrate art and architecture into society. The Bauhaus exteriors, devoid of any regional identity, were an international concept translated into architectural form.

France: Le Corbusier The best-known exponent of the International Style in France during the 1920s and early 1930s was the Swiss-born architect Charles-Edouard Jeanneret, known as Le Corbusier (1887–1969). The Villa Savoye (fig. **26.37**), a weekend residence built from 1928 to 1930 at Poissy, near Paris, is the last in a series of International Style houses by Le Corbusier. It is regarded as his masterpiece.

The Villa Savoye is a grand version of what Le Corbusier described as a "machine for living." It rests on very

26.37 Le Corbusier, Villa Savoye, Poissy-sur-Seine, France, 1928–30. Le Corbusier believed that houses should be mass-produced. To this end, he reduced architectural components to simple forms—concrete slabs for floors, concrete pillars for vertical support, stairs linking the floors, and a flat roof. In his *Towards a New Architecture* (1931), Le Corbusier wrote "If we eliminate from our hearts and minds all dead concepts in regard to houses ... we shall arrive at the 'House-Machine,' the mass-production house, healthy (and morally so too) and beautiful in the same way that the working tools and instruments which accompany our existence are beautiful."

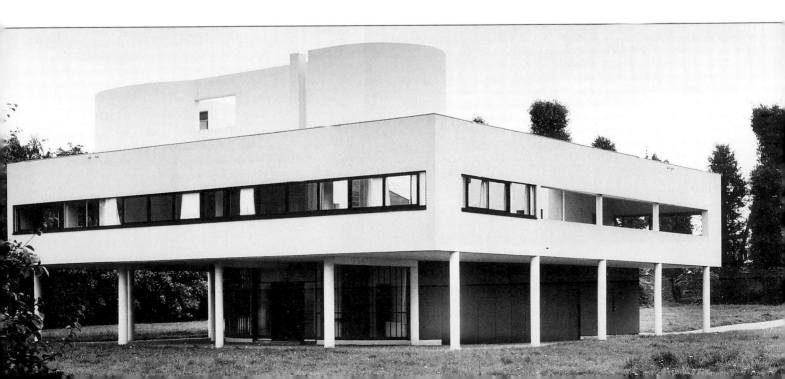

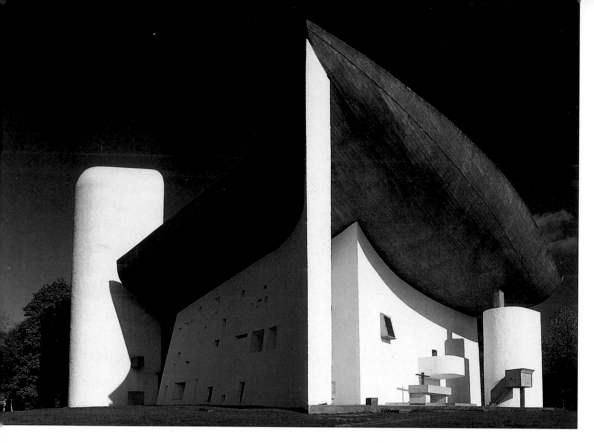

slender reinforced concrete pillars, which divide the second-floor windows. The second floor contains the main living area, and it is connected to the ground floor and the open terrace on the third floor by a staircase and a ramp. The driveway extends under the house and ends in a three-car carport. This part of the ground floor is deeply recessed under the second-floor overhang, and contains an entrance hall and servants' quarters. All four elevations of the house are virtually identical, each having the same ribbon windows running the length of the wall.

Le Corbusier was active into his seventies and his designs underwent a series of evolutions. In the late 1940s he worked in a style that has come to be known as the New Brutalism, a reference to his habit of leaving the surface of concrete (still his favorite material) rough and unfinished, so that it remained true to its natural texture. He also experimented with the sculptural properties inherent in the material, as in Notre-Dame-du-Haut (fig. **26.38**), a pilgrimage chapel perched on the top of a hill at Ronchamp, in eastern France. The rough concrete walls are painted white, and the roof is a huge mantle of darker concrete curving organically over the eastern wall of the chapel. Piercing the south wall are several unevenly shaped and sized windows, which are inlaid with hand-painted glass. The thickness of the wall and the small size of the windows produce an effect of focused beams of light. Between the roof and the walls is a very thin strip of clear glass, which makes the heavy roof of the chapel appear to float in defiance of gravity.

The United States The architectural principles of the International Style were brought to the United States by Bauhaus artists who were forced to leave Germany in the late 1930s. Mies van der Rohe (1886–1969), the director of the Bauhaus from 1930, designed the glass and steel Lake Shore Drive Apartment Houses in Chicago (fig. 26.39) with the principles of **functionalism** in mind. The influence of Cubism in their geometric repetitions is inescapable. These vertical, cubic structures, which are reminiscent of Mondrian's late paintings, inspired many similar skyscrapers throughout America's large cities.

26.39 Mies van der Rohe, Lake Shore Drive Apartment Houses, Chicago, 1950–52.

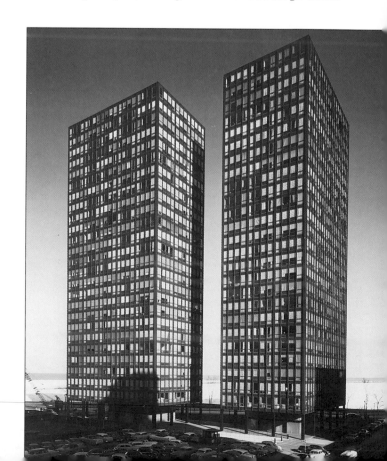

Style/Period	Works of Art	Cultural/Historical Developments
CUBISM, FUTURISM, AND RELATED STYLES	Pende Mbuya mask (**26.4**) Etoumbi mask (**26.3**)	
1900 1900–1910	Picasso, *Gertrude Stein* (**26.1**) Picasso, *Les Demoiselles d'Avignon* (**26.2**) Laurencin, *Group of Artists* (**26.7**) Wright, *Robie House* (**26.29**), Chicago Braque, *Violin and Pitcher* (**26.5**) Picasso, *Head of a Woman* (**26.6**) Mondrian, *Amaryllis* (**26.16**) Picasso, *Les Demoiselles d'Avignon*	Futurist manifesto published in *Le Figaro* (1909) Picasso, *Gertrude Stein*
1910 1910–1920	Brancusi, *The Kiss* (**26.26**) Picasso, *Man with a Hat* (**26.8**) Duchamp, *Nude Descending a Staircase, No. 2* (**26.18**) Brancusi, *Mademoiselle Pogany* (Version I) (**26.19**) Boccioni, *Unique Forms of Continuity in Space* (**26.14**) Malevich, *Composition with the Mona Lisa* (**26.22**) Léger, *The City* (**26.15**) Duchamp, *Nude Descending a Staircase, No. 2* Brancusi, *Mademoiselle Pogany*	Russell and Whitehead, *Principia Mathematica* (1910–13) De Stijl movement founded in the Netherlands (1910–20) Two Cubist exhibitions held in Paris (1911) Gustav Mahler, *Das Lied von der Erde* (1911) Max Beerbohm, *Zuleika Dobson* (1911) J. M. Synge, *Playboy of the Western World* (1912) R. F. Scott reaches the South Pole (1912) C. G. Jung, *The Theory of Psychoanalysis* (1912) D. H. Lawrence, *Sons and Lovers* (1913) Armory Show held in New York (1913) Marcel Proust, *Remembrance of Things Past* (1913–27) First World War (1914–18) Margaret Sanger jailed for advocating birth control (1915) Austria, Czechoslovakia, Germany, Poland become republics (1918) Lytton Strachey, *Eminent Victorians* (1918) Willa Cather, *My Antonia* (1918) Worldwide flu epidemic kills 22 million people (1918–20) Versailles Peace Conference (1919) Gropius establishes Bauhaus in Weimar, Germany (1919) League of Nations established (1920) Sinclair Lewis, *Main Street* (1920)
1920 1920–1930	Davis, *Lucky Strike* (**26.20**) Picasso, *Three Musicians* (**26.10**) Kandinsky, *Composition 8* (**26.35**) Rietveld, *Schroeder House* (**26.33**), Utrecht Gropius, *The Bauhaus* (**26.36**), Dessau Le Corbusier, *Villa Savoye* (**26.37**), Poissy-sur-Seine Malevich, *Black Square* (**26.23**) Rietveld, Schroeder House	Mussolini forms fascist government in Italy (1922) T. S. Eliot, *The Waste Land* (1922) Adolph Hitler, *Mein Kampf* (1924) F. Scott Fitzgerald, *The Great Gatsby* (1925) Invention of television (1926) Vassily Kandinsky, *Point and Line to Plane* (1926) Berthold Brecht, *Threepenny Opera* (1928) Margaret Mead, *Coming of Age in Samoa* (1928) Ernest Hemingway, *A Farewell to Arms* (1929) Stock market crash on Wall Street; economic depression (1929) Museum of Modern Art opens in New York (1929) Virginia Woolf, *A Room of One's Own* (1929) Erich Maria Remarque, *All Quiet on the Western Front* (1929) Evelyn Waugh, *Vile Bodies* (1930) Dashiell Hammett, *The Maltese Falcon* (1930)
1930 1930–1940	Picasso, *Girl Before a Mirror* (**26.11**) Malevich, *Self-portrait* (**26.24**) Douglas, *Aspects of Negro Life: From Slavery Through Reconstruction* (**26.21**) Wright, *Fallingwater* (**26.31**), Pennsylvania Picasso, *Guernica* (**26.12–26.13**) Brancusi, *The Gate of the Kiss* (**26.25**) Brancusi, *The Endless Column* (**26.27**) Wright, *Taliesin West* (**26.32**), Arizona Wright, Fallingwater	Robert Frost, *Collected Poems* (1931) Pearl S. Buck, *The Good Earth* (1931) Franklin Roosevelt introduces New Deal social and economic measures (1933) Adolph Hitler appointed German Chancellor (1933) Gertrude Stein, *Autobiography of Alice B. Toklas* (1933) Development of sulfa drugs (mid-1930s) Spanish Civil War (1936–9) World War II (1939–45) Bauhaus artists emigrate to the U.S.A. (late 1930s)
1940 1940–1950	Picasso, *Bull's Head* (**26.9**) Mondrian, *Broadway Boogie Woogie* (**26.17**)	
1960 1950–1960	van der Rohe, *Lake Shore Drive Apartment Houses* (**26.39**), Chicago Le Corbusier, *Notre-Dame-du-Haut* (**26.38**), Ronchamp	

27

Dada, Surrealism, Fantasy, and the United States Between the Wars

The devastation of World War I affected the arts as well as other aspects of Western civilization. For the first time in history, armies used trench warfare, barbed wire, machine guns firing along fixed lines, and chemical weapons. After treating the victims of gassing and shell-shock in World War I, Freud and other medical researchers published accounts of the long-term psychological traumas of the new warfare. "The lost generation," a phrase coined by Gertrude Stein, captured the overwhelming sense of desolation experienced by the post-World War I intellectuals. In the visual arts of that era, the same pessimism and despair emerged as Dada.

Dada

The term "Dada" refers to an international artistic and literary intellectual movement that began during World War I in the relative safety of neutral Switzerland. Artists, writers, and performers gathered at the Cabaret Voltaire, a café in Zurich, for discussion, entertainment, and creative exploration (see Box). Dada was thus not an artistic style in the sense of shared formal qualities that are easily recognized. Rather, it was an idea, a kind of "anti-art," predicated on a nihilist (from the Latin *nihil*, meaning "nothing") philosophy of negation. By 1916 the term Dada had appeared in print—a new addition to the parade of esthetic "manifestos" that developed in the nineteenth century. Dada lasted as a cohesive European movement until

The Cabaret Voltaire

In February 1916, the German pacifist actor and writer Hugo Ball (1886–1927) placed the following announcement in a Zurich paper:

> Cabaret Voltaire. Under this name a group of young artists and writers has formed with the object of becoming a center for artistic entertainment. The Cabaret Voltaire will be run on the principle of daily meetings where visiting artists will perform their music and poetry. The young artists of Zurich are invited to bring along their ideas and contributions.[1]

Among those who accepted Ball's invitation were Hans Arp, the *chanteuse* Emmy Hennings, who later married Ball, and the Romanian poet Tristan Tzara. The Cabaret was housed in a bar in a run-down quarter of Zurich, where poems, songs, and stories were recited and performed. Some of these were later published in the Cabaret's periodical, which was entitled *Dada*. The movement stood for the absence of an artistic program and of rules. Dadaists rebelled against bourgeois values, which Ball referred to as "a public execution of false morality." Arp described Dada sentiments as follows:

Revolted by the butchery of the 1914 World War, we in Zurich devoted ourselves to the arts. While the guns rumbled in the distance, we sang, painted, made collages and wrote poems with all our might. We were seeking an art based on fundamentals, to cure the madness of the age, and a new order of things that would restore the balance between heaven and hell.[2]

A feature of Dada expression was the "abstract phonetic poem," which Ball intended as a literary parallel to abstract painting and sculpture. "The next step," he wrote in his diary on March 5, 1917, "is for poetry to discard language as painting has discarded the object." One example of such poetry follows:

gadji beri bimba glandridi laula lonni cadori
gadjama gramma berida bimbala glandri galassassa
 laulitalomini
Gadjama tuffm i zimzalla binban gligia wowolimai bin
 beri ban
o katalominal rhinocerossola hopsamen laulitalomini
 hoooo gadjama
rhinocerossola hopsamen
bluku terullala blaulala loooo ...[3]

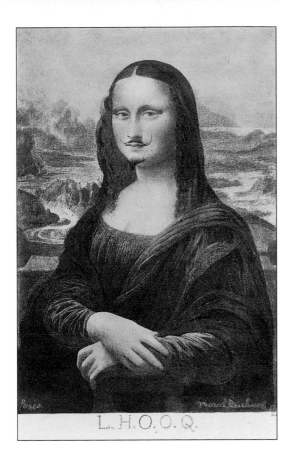

27.1 Marcel Duchamp, Replica of *L.H.O.O.Q.*, Paris, 1919, from "Boîte-en-Valise." Color reproduction of the *Mona Lisa* altered with a pencil, 7¾ × 5 in (19.7 × 12.7 cm). Philadelphia Museum of Art (Louise and Walter Arensberg Collection). Duchamp was born in Blainville, France, the third of three sons who were all artists. In 1915 he moved to New York and in 1955 became an American citizen. After painting only twenty works, Duchamp announced his retirement in 1923 and devoted the rest of his life to chess.

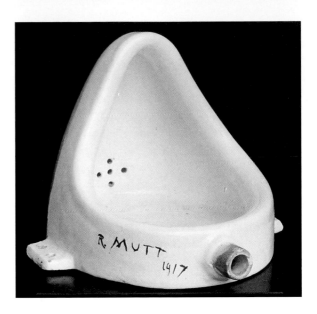

27.2 Marcel Duchamp, *Fountain (Urinal)*, 1917. Ready-made, 24 in (61 cm) high. Photo courtesy of Sidney Janis Gallery, New York. Duchamp declared that it was the artist's conscious choice that made a "Ready-made" into a work of art. In 1915 he bought a shovel in a New York hardware store and wrote on it "In advance of a broken arm." "It was around that time," he said, "that the word 'ready-made' came to my mind. ... Since the tubes of paint used by an artist are manufactured and ready-made products, we must conclude that all the paintings in the world are ready-made aided."[4]

about 1920. It also achieved a foothold in New York, where it flourished from about 1915 to 1923.

There were several accounts of the origin of the term Dada. The most widely accepted was that, when the leaders of the movement were trying to think of a name, they came upon a French–German dictionary which was opened at random at that point. According to the 1916 Manifesto, "Dada" is French for a child's wooden horse. "Da-da" are also the first two syllables spoken by children learning to talk, and thus suggests a regression to early childhood. The implication was that artists wished to "start life over." Likewise, Dada's iconoclastic force challenged traditional assumptions about art, and had an enormous impact on later twentieth-century **conceptual art**. Despite the despair that gave rise to Dada, however, a taste for the playful and the experimental was an important, creative, and ultimately hopeful aspect of the movement. This, in turn, is reflected in the Russian meaning of "da, da," which is "yes, yes."

Marcel Duchamp

One of the major proponents of Dada was Marcel Duchamp (1887–1968), whose *Nude Descending a Staircase* (see fig. 26.18) had already caused a sensation in the

1913 Armory Show. He shared the Dada taste for word-play and punning, which he combined with visual images. Delighting, like children, in nonsensical repetition, Duchamp entitled his art magazine *Wrong Wrong*. The most famous instance of visual and verbal punning in Duchamp's work is *L.H.O.O.Q.* (fig. **27.1**), which is reminiscent of Malevich's collage of 1914 that included the image of the *Mona Lisa* (see fig. 26.22). In contrast to the Malevich, Duchamp's title is a bilingual pun. Read phonetically in English, the title sounds like "LOOK," which, on one level, is the artist's command to the viewer. If each letter is pronounced according to its individual sound in French, the title reads "Elle (*L*) a ch (*H*) aud (*O*) au (*O*) cul (*Q*)," meaning in English "She has a hot ass." Read backwards, on the other hand, "LOOK" spells "KOOL," which counters the forward message.

When viewers do, in fact, look, they see that Duchamp has pencilled a beard and mustache onto a reproduction of Leonardo's *Mona Lisa* (see fig. 15.17), turning her into a bearded lady. One might ask whether Duchamp has "defaced" the *Mona Lisa*—perhaps a prefiguration of graffiti art (see p. 932)—or merely "touched her up." This dilemma plays with the sometimes fine line between creation and destruction. (The modern expression "You have to break eggs to make an omelet" illustrates the connection between creating and destroying that is made explicit by the Dada movement.)

Duchamp called the kind of work exemplified by *L.H.O.O.Q.* a "Ready-made-Aided." When he merely added a title to an object, he called the result a "Ready-Made." Duchamp's most outrageous Ready-made was a urinal (fig. **27.2**) that he submitted as a sculpture to a New York exhibition mounted by the Society of Independent

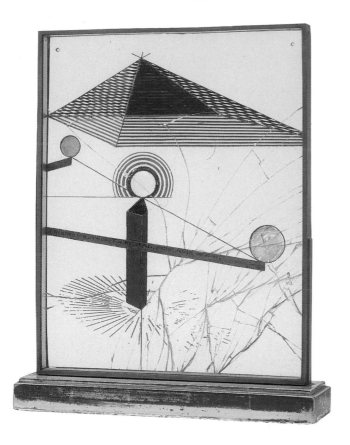

27.3 Marcel Duchamp, *To Be Looked at (From the Other Side of the Glass) with One Eye, Close to, for Almost an Hour*. Buenos Aires, 1918. Oil paint, silver leaf, lead wire, and magnifying lens on glass, overall height 22 in (55.8 cm). Museum of Modern Art, New York (Katherine S. Dreier Bequest).

Artists in 1917. He turned it upside-down, signed it "R. Mutt" and called it a *Fountain*. The work was rejected by the Society and Duchamp resigned his membership.

Despite the iconoclastic qualities of his Ready-mades and his Ready-mades-Aided, it must be said that both *L.H.O.O.Q.* and the *Fountain* have a place in the history of art. In the former, the connection with the past is obvious, for the work reproduces a classic icon. It comments on Leonardo's homosexuality and on the sexual ambiguity of the *Mona Lisa* herself, and reflects Duchamp's interest in creating his own alter ego as a woman, whom he named Rose Sélavy. The latter is a pun on "c'est la vie," which means "that's life." The *Fountain* makes a connection between the idea of a fountain and a urinating male, which in fact has been the subject of actual and painted fountains in many works of Western art.

A good example of Dada principles in a work by Duchamp is *To Be Looked at (From the Other Side of the Glass) with One Eye, Close To, For Almost an Hour* of 1918 (fig. **27.3**). A pyramidal shape painted on a glass surface above a balance, is tilted slightly by the weight of a circle. As in *L.H.O.O.Q.*, the title is about the viewer's relationship to the work of art and its potential for shock in looking and seeing. Whereas in the Renaissance artists controlled the viewer's direction of sight with linear perspective, Duchamp "instructs" the observer verbally via the title. He also plays with the point of view, making it two-sided, which can be seen as a development of the Cubist multiple viewpoint.

The glass surface of *To Be Looked at* cracked while it was being shipped, and the cracks were allowed to remain as part of the design. This accident and Duchamp's decision to let it stand are characteristic of the Dada artists' incorporation of the effects of chance into their works. For the Dada artists, chance became a subject of art, just as the medium itself became a subject in the late nineteenth century. In collage and assemblage, too, the medium is as prominent a feature of the image as brushstrokes were for Impressionists and Post-Impressionists. Art based on the "found object" relies on the conscious exploration of chance in finding the medium for the work. Accepting chance and using what it offers also require a degree of flexibility and spontaneity which are necessary aspects of creativity.

Jean Arp

A quality of playfulness pervades the work of the Swiss artist Jean Arp (1887–1966), who was one of the founders of European Dada. His cord collage, *The Dancer* of 1928 (fig. **27.4**), was created by arranging a string on a flat surface. The string is equivalent to the draughtsman's "line"—it defines the form and its character. By moving around the string to achieve the desired shapes, Arp

27.4 Jean Arp, *The Dancer*, 1928. Cord collage, 20 × 15½ in (50.8 × 39.4 cm). Courtesy Sidney Janis Gallery, New York.

"played" creatively, and arrived at a humorous image—a small head on a bulky torso with a circle in the center. The figure's slight tilt, the position of the left leg, and the upward curve of the right leg create a convincing impression of forward motion. The dancer literally seems to "kick up her heel," which, together with the flowing hair evoked by a single strand of string, conveys an impression of movement through space.

In moving the string, Arp also engaged in a form of visual free association, which was part of Dada and appealed to its interest in the spontaneous quality of chance. Dada artists and writers attempted a creative process designed to minimize the overlay of tradition and conscious control. Instead, they emphasized the expression of unconscious material through play, chance, and rapid execution. This approach was used in wordplay, as well as in visual punning. The connection of both with unconscious processes had been explicated in

27.5 Man Ray, *Indestructible Object (or Object to be Destroyed)*, 1964. Replica of the original of 1923. Metronome with cut-out photograph of an eye on a pendulum, 8⅞ × 4⅜ × 4⅜ in (22.5 × 11.1 × 11.1 cm). Museum of Modern Art, New York (James Thrall Soby Fund). The artist's real name was Emanuel Rudnitsky (1890–1976). His choice of the name Man Ray, although derived from his real name, illustrates the fondness for punning and word games that he shared with other Dada artists. He reportedly chose "Man" because he was male and "Ray" because of his interest in light.

The Guest Expulsed

Arp's efforts at Dada poetry are more comprehensible than those of Hugo Ball. He wrote several versions of "The Guest Expulsed," two of which follow:

THE GUEST EXPULSED 3

Gravestones I carry on my head.
From water-bearing mortal clay
I cast offending Adam out
—To pass the time—twelve times a day.

Standing in light up to the hilt,
I leap out through my mouth perforce
And, carrying owls to Athens town,
Harness myself before my horse.

Farewell a hund- and katzen-fold.
In line with Time's polarity
I follow in disguise, lead-glazed,
The spirit of hilarity.

I mingle camphor of my own
In with the elder-pith of Time,
And into all eternity
Inwards and upwards still I climb.

THE GUEST EXPULSED 5

Their rubber hammer strikes the sea
Down the black general so brave.
With silken braid they deck him out
As fifth wheel on the common grave.

All striped in yellow with the tides
They decorate his firmament.
The epaulette they then construct
Of June July and wet cement.

With many limbs the portrait group
They lift on to the Dadadado;
They nail their A B seizures up;
Who numbers the compartments? They do.

They dye themselves with blue-bag them
And go as rivers from the land,
With candied fruit along the stream,
An Oriflamme in every hand.[5]

Freud's 1911 publication *Jokes and their Relation to the Unconscious*. Several Dada artists, including Arp, wrote poems intended to illustrate these processes (see Box).

Man Ray

The American Dadaist Man Ray (1890–1976) also played with words, images, and objects, parts of which were "ready-made." His *Indestructible Object (or Object to be Destroyed)* of 1923 (fig. **27.5**), for example, consisted of a "ready-made" metronome. He attached a photograph of a

human eye to its pendulum, thereby combining the moving piece of the metronome with the eye that watches it move. The viewer is "looked at" by the metronome, which has been transformed by Man Ray's addition from a purely functional object to a work of art. The transitional state between looking and being looked at, between actual and implied motion, between utility and esthetics, is reflected in the ambivalence of the title. The object is both indestructible and intended to be destroyed. Like the European Dada artists, Man Ray played with the fine line separating creation from destruction, and the mundane "found objects" of everyday life from art.

Surrealism

Many members of the Dada movement also became interested in the Surrealist style that supplanted it. It was the writer André Breton who bridged the gap between Dada and Surrealism with his First Surrealist Manifesto of 1924 (see Box). He advocated an art and literature based on Freud's psychoanalytic technique of free association as a means of exploring the imagination and entering the world of myth, fear, fantasy, and dream. The very term "surreal" connotes a higher reality—a state of being, like that depicted in Picasso's *Girl Before a Mirror* (see fig. 26.11), that is more real than mere appearance.

Breton had studied medicine and, like Freud, had encountered the traumas experienced by World War I shell-shock victims. This led both Breton and Freud to recognize the power that trauma had over logical, conscious thinking. As a result, Breton wished to gain access to the unconscious mind where, he believed, the source of

creativity lay. He recommended that writers write in a state of free-floating association in order to achieve spontaneous, unedited expression. This was referred to as "automatic writing," which influenced European Abstract Surrealists and later, in the 1940s, had a significant impact

André Breton's First Surrealist Manifesto

The term "Surrealist" was coined by Apollinaire to describe one of his plays. In 1924 André Breton published the First Surrealist Manifesto, in which he defined the term as "pure psychic automatism by which it is intended to express, either verbally or in writing, the true function of thought. Thought dictated in the absence of all control exerted by reason, and outside all aesthetic or moral preoccupations."[6]

Surrealist aims followed logically from Dada interest in spontaneous, unconscious expressions of dreams and imagination. For this development, Breton gave full credit to Sigmund Freud's *Interpretation of Dreams*, which had been published in 1899. In dreams, according to both Freud and Breton, the dreamer is not inhibited by the possibility of action, and therefore gives freer reign to his unconscious thoughts. "Perhaps," wrote Breton in his opening paragraph, "the imagination is on the verge of recovering its rights. If the depths of our minds conceal strange forces capable of augmenting or conquering those on the surface, it is in our greatest interest to capture them ... and later to submit them, should the occasion arise, to the control of reason."[7]

27.6 Giorgio de Chirico, *Place d'Italie*, 1912. Oil on canvas, 18½ × 22½ in (47 × 57.2 cm). Collection, Dr. Emilio Jesi, Milan.

on the Abstract Expressionists in New York City (see Chapter 28). The Surrealists' interest in gaining access to unconscious phenomena led to images that seem unreal or unlikely, as dream images often are, and to odd juxtapositions of time, place, and iconography.

Giorgio de Chirico

Breton cited Giorgio de Chirico (1888–1978), who was born in Greece of Italian parents, as the paradigm of Surrealism. De Chirico had signed the 1916 Dada Manifesto and then developed an individual Surrealist style, which he termed *pittura metafisica*, or "metaphysical painting." His *Place d'Italie* (fig. **27.6**) of 1912 combines a perspective construction and architectural setting reminiscent of the Italian Renaissance with an unlikely marble reclining figure in the foreground and a train in the background. Diagonal shadows are cast by the buildings, the statue, and a standing couple in the distance. One shadow, entering the picture from the left, belongs to an unseen person.

In this painting, de Chirico combines anachronistic time and place within a deceptively rational space. The reclining figure is derived from Classical sculpture and thus denotes the Greek and Roman past. The moving train, on the other hand, refers to the industrial present and the passage of time. There is an eerie, uncanny quality to this scene, reinforced by the shadows, that is typical of de Chirico. Isolation and a sense of foreboding pervade the picture space, making the viewer uneasy, as if aware of a mystery that can never be solved.

Man Ray

Among the Surrealists who had also been part of the Dada movement was Man Ray. In 1921 he moved to Paris, where he showed his paintings in the first Surrealist exhibition of 1925. He worked as a fashion and portrait photographer, and avant-garde filmmaker. His experiments with photographic techniques included the **Rayograph**, made without a camera by placing objects on light- sensitive paper. Man Ray's most famous photograph, *Le Violon d'Ingres* (fig. **27.7**), combines Dada wordplay with Surrealist imagery. The nude recalls the odalisques of Ingres (see fig. 20.15), while the title refers to Ingres's hobby—playing the violin (which led to the French phrase *violon d'Ingres*, meaning "hobby"). Man Ray puns on the similarity between the nude's back and the shape of a violin by adding sound holes. The combination of the nude and the holes exemplifies the dreamlike imagery of Surrealism.

Man Ray strongly defended the art of photography and argued against those unwilling to treat it as an art form. In *Photography Can Be Art*, he wrote:

> When the automobile arrived, there were those that declared the horse to be the most perfect form of locomotion. All these attitudes result from a fear that the one will replace the other. Nothing of the kind has happened. We have simply increased our vocabulary. I see no one trying to abolish the automobile because we have the airplane.[8]

In true Dada fashion, Man Ray also published *Photography is not art*, and *Art is not Photography*.

27.7 Man Ray, *Le Violon d'Ingres*, 1924. Photograph. Savage Collection, Princeton, New Jersey.

Paul Klee

Fantasy characterizes the Surrealism of the Swiss artist Paul Klee (1879–1940), who had been a member of the Blue Rider. He made many pencil drawings that reveal his attraction to linear, childlike imagery, as well as the influence of Surrealist "automatic writing." His *Mask of Fear* of 1932 (fig. **27.8**) reflects all of these qualities, including the recollection of a painted wooden sculpture by the Zuni carvers of the American southwest (fig. **27.9**). Such allusions to works produced by seemingly exotic cultures exemplify the Surrealists' search for new sources of imagery, especially those with dreamlike and mythological content. As a young man, Klee had visited the folk art museum in Berlin, which had acquired the Zuni statue in 1880. In addition to formal correspondences, it is also possible that there are iconographic parallels. For the Zuni figure represents the war god, and as such might have been associated in Klee's mind with the rise of the Nazi storm troopers. They, too, wore zigzag insignia reminiscent of lightning, and they aroused fear of the kind suggested by the man hidden behind the mask.

In any event, Klee has transformed the Zuni sculpture into a flat image that plays with the boundaries between two- and three-dimensionality. The horizontal line defining the tip of the mask's nose is also the horizon line of the painting. Two pairs of legs either support the mask, whose size does not correspond naturally to theirs, or walk behind it. As a result, the viewer is somewhat startled by unlikely juxtapositions.

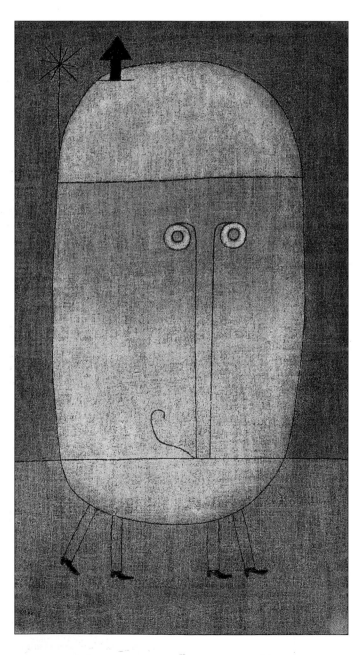

27.8 Paul Klee, *Mask of Fear*, 1932. Oil on burlap, 3 ft 3½ in × 1 ft 10½ in (1.0 × 0.57 m). Museum of Modern Art, New York (Nelson A. Rockefeller Fund). Klee described the creative process as follows: "Art does not reproduce the visible; rather, it makes visible."[9] Klee himself was enormously productive, recording a total of nearly 9000 works.

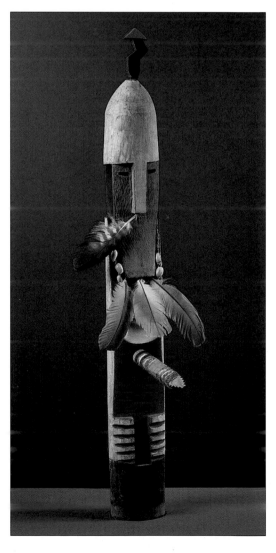

27.9 Zuni war god from Arizona or New Mexico. Painted wood and mixed media, 30½ in (77.5 cm). high. Museum für Volkerkunde, Berlin.

27.10 Joan Miró, *Dog Barking at the Moon*, 1926. Oil on canvas, 28¾ × 36¼ in (73 × 92.1 cm). Philadelphia Museum of Art (A. E. Gallatin Collection).

27.11 (below) Joan Miró, *Spanish Dancer*, 1945. Oil on canvas, 4 ft 9½ in × 3 ft 8⅜ in (1.46 × 1.14 m). Collection Beyeler, Basle.

Joan Miró

The Surrealist pictures of Joan Miró (1893–1983) are composed of imaginary motifs that are often reminiscent of childhood. His *Dog Barking at the Moon* of 1926 (fig. **27.10**) depicts a colorful, toylike dog standing alone on a hill. The night sky contains a fanciful moon and another shape, which could be a bird. The most surreal form in this picture is the unsupported ladder that seems to go nowhere. As the ladder rises, its reach becomes vast, while the space between earth and sky is condensed.

Miró's later style retains biomorphic, sexually suggestive, abstract forms, as well as primary colors, but there is an increase in linear movement and complex design. The *Spanish Dancer* of 1945 (fig. **27.11**), for example, captures the rapid rhythm of Spanish dancing by juxtaposing thin curves, diagonal planes, and flat shapes that shift abruptly from one color to another. The red-and-green curve on the red-and-black shape at the lower right seems to turn in space like a dancer's torso. Two legs kick energetically to the left, while a hand is poised above the torso. Surrounding the hand is a shape with two curved points—one black, one red—which resemble breasts. At the top, the large head tilts upward as a nose and mouth (two black eyes hang from the nose) project from it to the left. Two eyes—one red, one blue—each with two black circles within it, also occupy the large head. A corresponding eye shape is lodged in the lower leg. The exuberance of Miró's dancing figure and the illusion of speed created by curved lines and shifting planes reflects his interest in Surrealist "automatic writing."

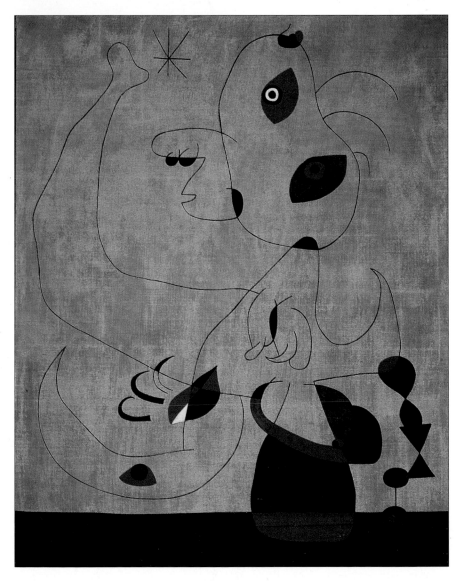

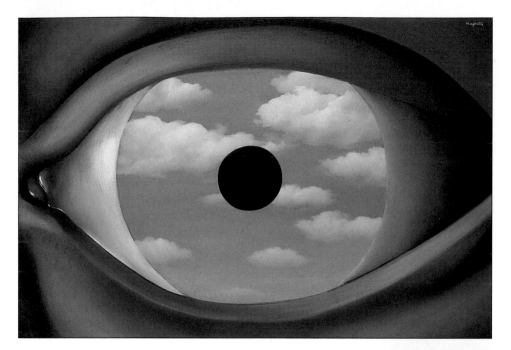

27.12 (above) René Magritte, *The False Mirror*, 1928. Oil on canvas, 21¼ × 31⅞ in (54 × 80.9 cm). Museum of Modern Art, New York.

27.13 (below) René Magritte, *Time Transfixed (La Durée poignardée)*, 1938. Oil on canvas, 4 ft 9⅝ in × 3 ft 2⅜ in (1.46 × 0.98 m). Art Institute of Chicago (Joseph Winterbotham Collection). Freud's discovery that time does not exist in the unconscious accounts for certain unlikely condensations in dreams. The uncanniness of temporal condensation contributes to the eerie quality of this painting, as does the impossible juxtaposition of realistic objects.

René Magritte

The Belgian artist René Magritte (1898–1967) painted Surrealist images of a more veristic kind. Individually they are realistic, often to the point of creating an illusion. However, their context, size, or their juxtaposition of objects is unrealistic or possible only in a world of dreams. Magritte's *False Mirror* of 1928 (fig. **27.12**) depicts a large eye (from which the familiar CBS logo is derived). The black circle at the center can refer both to the pupil and to an eclipsed sun. The observer is thrown off balance by the unusual close-up view of the "eye," as well as by its unexpected character. We do not know if we are looking into the eye and seeing a reflection of the sky, or if we are inside the eye, looking past the pupil at the sky. The "mirror" is "false," because, like the "pipe" in *The Betrayal of Images* (see fig. 1.4; 1.5 in the Combined Volume), it plays a visual trick. As puns, however, both contain truth. In *The False Mirror*, Magritte applies the simultaneous viewpoint of Cubism to clear, recognizable forms, but without the Cubist intrusion of geometric abstraction.

The simultaneous viewpoint saves the observer time, and is itself a Surrealist motif derived from Cubism. In *Time Transfixed* (*La Durée poignardée* in French) of 1938 (fig. **27.13**), Magritte juxtaposed two familiar objects in order to evoke the unfamiliar. Various motifs in this work are clearly depicted and easily identifiable, but their relation to each other is odd, and they convey an impression of immobility and timelessness. The clock indicates a specific hour, but the candlesticks are without candles, whose burning typically denotes the passage of time. The cold, sterile room is composed entirely of rectangular forms and is devoid of human figures. A steam engine has burst through the fireplace, but without disrupting the wall. A shadow cast by the train is unexplained, because there is no light source to account for it. The smoke, which indicates that the train is moving although it looks static, disappears up the chimney. *Poignardée* in the French title, literally meaning "stabbed" with a dagger or sword, expresses the "fixed," frozen quality of both the train and the time.

27.14 (right) Max Ernst, *The King Playing with the Queen*, 1944. Bronze (cast 1954, from original plaster), 38½ in (97.8 cm) high, at the base 18¾ × 20½ in (47.7 × 52.1 cm). Museum of Modern Art, New York (Gift of D. and J. de Menil).

27.15 (far right) Mossi whistle, Upper Volta. Wood, 22⅜ in (57 cm) high.

Sculpture Derived From Surrealism

Surrealism influenced sculptor as well as painters and photographers in Europe and America The Surrealist interest in the literal depiction of unconscious chance, and dream images contributed to the twentieth-centur break with many traditiona forms and techniques.

Max Ernst

Max Ernst (1891–1976) began his artistic career as a Dadaist in Germany. He moved to France after World War I, and eventually settled in the United States. *The King Playing with the Queen* (fig. **27.14**) of 1944 combines the influence of Surrealism, Cubism, a knowledge of Freud's theories, and the playful qualities of Picasso and Duchamp. A geometric king looms up from a chessboard, which is also a table. His horns are related to the role of the bull as a traditional symbol of male fertility and kingship. He dominates the board by his large size and extended arms. The king is a player sitting at the table, as well as a chesspiece on the board. He literally "plays" with the queen, who is represented as a smaller geometric construction at the left. On the right, a few tiny chesspieces seem detached from whatever "game" is taking place between the king and queen.

In the 1930s and 1940s, Max Ernst was the Surrealist most influenced by non-Western art. For example, *The King Playing with the Queen* has obvious affinities with a type of wooden whistle produced in Upper Volta, in Africa (fig. **27.15**). Its geometric head, vertical torso, and zigzag arms enclosing open space are remarkably similar to Ernst's sculpture. In addition to African sculpture, Ernst was influenced by Native American art, especially that of Arizona,

where he lived from 1946 to 1953. He collected Kachina carvings made by the Hopi tribe (fig. **27.16**), and identified strongly with its mythology, envisioning himself as a shaman and describing shamanistic hallucinations in his autobiography. For Ernst, the shaman—like the artist—had highly charged sensory experiences that offered new ways of interpreting and rendering ordinary phenomena.

27.16 Max Ernst with his Kachina doll collection, 1942. Photograph by James Thrall Soby. Collection of Elaine Lustig Cohen.

Hopi Kachinas

The Hopi Indians inhabited the American southwest, especially Arizona, undisturbed until they were relegated to reservations in the late nineteenth century. Theirs is an agricultural society; they live in pueblos, which are communal houses divided into individual units made of adobe (mudbrick). Figure **27.17** is a diagram of a typical pueblo unit. The thick walls keep the interior cool in summer and prevent freezing in winter. The photograph in figure **27.18** was taken in about 1929 by Ansel Adams (1902–84), who was perhaps the leading American photographer of the southwest. It shows a woman winnowing grain outside the Taos pueblo in New Mexico.

In Hopi villages, an open central space is a ceremonial site, in which Kachinas play a major role. According to Hopi mythology, Kachinas are supernatural spirits who dwell in the mountains. They exist in three forms: as unseen spirits, as impersonations by masked men, and as carved, wooden dolls. There are over 200 such Kachinas, some of which are deceased members of the Hopi tribe. Ceremonies involving Kachinas are performed from the winter solstice to mid-July in connection with agriculture, rites of spring, and weather conditions.

Each type of Kachina serves a particular function. There are runners, for example, who race with men in order to train boys in speed, and ogres, whose function is to frighten children into obedience. Clowns provide comic relief during intermissions between rites, a practice similar to the satyr plays in ancient Greece. Children are given Kachinas as presents, to serve an exemplary purpose and to train them to recognize the different classes of Kachina. Although there are female Kachinas, they are always impersonated by men.

The Hopi carve Kachinas by shaping the roots of dead cottonwood trees with a chisel and saw. The finer carving is done with a penknife, and the surface is then smoothed with a rasp and sanded. Facial features are attached with glue or pins. Kachinas are painted, and the colors symbolize geographic directions or spatial orientation—blue and green represent the west or southwest, red the south or southeast, white the east or northeast, black the depths, and all the colors together represent the top. Facial markings are also symbolic. For example, parallel lines under the eye denote a warrior's footprint, an inverted V over the mouth denotes an official, and phallic symbols indicate fertility.

The two Kachinas illustrated here represent Black Ogre (fig. **27.19**) and Butterfly Maiden (fig. **27.20**). Black Ogre wears a mask with movable jaws and prominent teeth. He has a blue crow's foot on his forehead, wears a white shirt and trousers, red leggings and moccasins, and holds a hammer and a bow. He is believed to take food from children, whom he swallows whole. Butterfly Maiden is a more benign Kachina. She wears a white mask decorated with triangles, a white robe with geometric designs, and her bare feet are yellow. Her feathered headdress is particularly elaborate. In contrast to Black Ogre, whose crowfoot between his eyes makes him seem to be frowning angrily, her expression is impassive.

27.17 Diagram of a typical pueblo adobe unit, American Southwest.

27.18 Ansel Adams, *Winnowing Grain, Taos Pueblo*, c. 1929. Photograph.

27.19 (below left) Black Ogre, Hopi Kachina. Carved cottonwood.

27.20 (below right) Butterfly Maiden, Hopi Kachina. Carved cottonwood.

27.21 Alberto Giacometti, *Large Standing Woman III*, 1960, and Piet Mondrian, *Composition with Red, Yellow, and Blue*, 1935–42. Giacometti: bronze, 7 ft 8½ in (2.35 m) high. Mondrian: oil on canvas, 3 ft 3¼ in × 1 ft 8¼ in (0.99 × 0.51 m). Photo courtesy of Sidney Janis Gallery. Born in Switzerland, Giacometti spent a formative period in the 1930s as a Surrealist. He met the Futurists in Italy and the Cubists in Paris, and finally developed a distinctive way of representing the human figure that has become his trademark.

Alberto Giacometti

In the 1930s Alberto Giacometti (1901–66) had been involved with the Surrealists in Paris, and from the 1940s he began exploring the paradoxical power of emaciated human form. The tall, thin, anti-Classical proportions of *Large Standing Woman III* (fig. **27.21**), one of his most imposing works, hark back to the rigid, standing royal figures of ancient Egypt (see Vol. I, Chapter 4), which had exerted a significant influence on Giacometti's development. In figures such as this, whether large or small, Giacometti plays with the idea of extinction. His obsession with existence and nonexistence is evident in the fact that he made these sculptures as thin as they can be without collapsing. Ironically, the thinner they become, the more their presence is felt. By confronting the observer with the potential for disappearance, Giacometti evokes existential anxiety and takes the viewer to the very threshold of being. The sculpture is shown here as installed at the Sidney Janis Gallery in New York. On the wall is Mondrian's *Composition with Red, Yellow, and Blue* of 1935–42; the juxtaposition shows the relationship of both artists to the avant-garde.

Henry Moore

In contrast to Giacometti, the British sculptor Henry Moore (1898–1986) was drawn to massive, biomorphic forms. The traditional motif of the reclining figure was one

27.22 (below) Henry Moore, *Reclining Figure*, Lincoln Centre for the Performing Arts, New York, 1963–5. Bronze, 16 ft (4.88 m) high. Moore's habit of collecting the chance objects of nature, such as dried wood, bone, and the smooth stones from beaches, recalls the use of "found objects" in collage and assemblage. Unlike the Dada and Surrealist artists, however, he used found objects as his inspiration rather than his medium, preferring the more traditional media of stone, wood, and bronze.

27.23 Henry Moore, *Helmet Head No. 1*, 1950. Bronze, 13 in (33 cm) high. Tate Gallery, London.

27.24 (below) Alexander Calder, *Big Red*, 1959. Painted sheet metal and steel wire, 6 ft 1 in (1.88 m) high, 9 ft 6 in (2.9 m) wide. Whitney Museum of American Art, New York (Purchase). The playfulness of Calder's mobiles has not been lost on the toy industry. Mobiles of various figures, often activated by a wind-up motor attached to a music box, have been suspended over the cribs of generations of babies.

of his favorite subjects. He himself related the image to the Mother Earth theme and to his fascination for the mysterious holes of nature. From the 1930s he began making

sculptures with hollowed-out spaces and openings, thereby playing with the transition between inside and outside, interior and exterior. Many of his reclining figures are intended as outdoor landscape sculptures. As such, their holes permit viewers to see through the work, as well as around it, and thus to include the surrounding landscape in their experience of the sculpture.

The Lincoln Center *Reclining Figure* (fig. **27.22**) illustrates a figure reclining in an architectural setting. The imposing, monumental forms are separated into two sections, relating the figure to the surrounding architecture. Softening the angular, urban quality of the work is the reflection in the pool, which includes the sky in the experience of the sculpture. In this work, Moore achieves a formal and psychological synthesis of the woman with architecture and landscape.

In his Helmet series of the 1950s, Moore continued to pursue the theme of interior and exterior. *Helmet Head No. 1* (fig. **27.23**) condenses the helmet with the head in a surreal way by the eyelike forms protruding from the helmet. The inside of the helmet is occupied by a cone, leaving open spaces behind it. In this series, Moore included the idea of protective covering, which is the practical function of a helmet. But he also related the theme of protection to another favorite motif, namely mother and child. For Moore, the helmet head is a metaphor for maternal protection, and the unformed interior figure represents the child.

Alexander Calder

From the 1930s, the American artist Alexander Calder (1886–1976) developed **mobiles**, or hanging sculptures that are set in motion by air currents. The catalyst for these works came from experiments with kinetic sculpture in Paris in the late 1920s and early 1930s. *Big Red* of 1959 (fig. **27.24**) is made from a series of curved wires set in a

sequence of horizontal, vertical, and diagonal planes. Flat, colorful metal shapes are attached to the wires. Because they hang from the ceiling, mobiles challenge the traditional viewpoint of sculpture. Their playful quality and the chance nature of air currents are reminiscent of Dada and Surrealism, although Calder is more abstract (in the nonfigurative sense) than many Dada and Surrealist artists. Of this mobile, Calder is quoted as saying, "I love red so much that I almost want to paint everything red."[10]

The United States: Regionalism and Social Realism

Painting

In spite of the variety of expression produced by the European avant-garde and exhibited in the 1913 Armory Show, painting in the United States of the 1920s and 1930s was, above all, affected by economic and political events, par-

ticularly the Depression and the rise of Fascism in Europe. Two different types of response to the times which had political overtones of their own can be seen in the work of American Regionalists and Social Realists.

American Gothic (fig. **27.25**) by Grant Wood (1892–1942) reflects the Regionalists' interest in provincial America and their isolation from the European avant-garde. Although the influence of Gothic is evident in the vertical planes and the pointed arch of the farmhouse window, the figures and their environment are unmistakably those of the American Middle West. The clapboard style of domestic architecture, developed in the nineteenth century by Richard Upjohn and referred to as "Carpenter's Gothic," is shown here. Wood's meticulous attention to detail and the linear quality of his forms recall the early fifteenth-century Flemish painters. All such European references, however, are subordinated to a distinctly regional American character.

The African-American artist Jacob Lawrence (b. 1917), who was influenced by the Harlem Renaissance, dealt with issues of racial inequality and social injustice. Figure 27.26 reveals the influence of European Expressionist and Cubist trends, although the subject and theme are purely American. Lawrence creates a powerful image of the abolitionist Harriet Tubman sawing a log by a combination of flattened planes and abrupt foreshortening. Tubman's singleminded concentration, as she fills the picture plane and focuses her energies on the task at hand, engages the observer directly in her activity. The geometric abstraction of certain forms, such as the raised left shoulder, contrasts with three-dimensional forms—the shaded right sleeve, for example—to produce a shifting tension. The result of such shifts is a formal instability that is stabilized psychologically by Tubman's determination.

Edward Hopper (1882–1967), also a painter of the American scene, cannot be identified strictly as either a Regionalist or a Social Realist. His work combines aspects of both styles, to which he adds a sense of psychological isolation and loneliness. His settings, whether urban or rural, are uniquely American, often containing self-absorbed human figures whose interior focus matches the still, timeless quality of

27.25 Grant Wood, *American Gothic*, 1930. Oil on **beaverboard**, 29¼ × 24½ in (74.3 × 62.4 cm). Art Institute of Chicago (Friends of American Art Collection). Wood studied in Europe, but returned to his native Iowa to paint the region with which he was most familiar. In this work, the two sober paragons of the American work ethic depicted as Iowa farmers are actually the artist's sister and dentist.

their surroundings. In *Gas* of 1940 (fig. **27.27**), a lone figure stands by a gas pump, the form of which echoes his own. The road, for Hopper a symbol of travel and time, seems to continue beyond the frame. Juxtaposed with the road are the figure and station that "go nowhere," as if frozen within the space of the picture plane.

Photography

Photography served the aims of social documentation in America as well as in Europe. The Harlem Renaissance photographer James Van Der Zee (1886–1983) took pictures in his Lenox Avenue studio, and also recorded the life of black New York. His *Portrait of Couple, Man with Walking Stick* of 1929 (fig. **27.28**) was taken in the studio against a landscape backdrop. The couple seems self-consciously well-dressed in an urban style that is slightly at odds with the scenery. Their attire places them in the 1920s, and their poses convey a sense of self-assurance. In the *Garveyite* of around 1924 (fig. **27.29**), the image alludes to a specific political subtext. The combination of the uniform with the self-confidence of the figure reflects the purposeful activism of the Universal Negro Improvement Association. This organization was the creation of the Jamaican-born Marcus Garvey, who planned to send black Americans to Africa as a declaration of ethnic pride. The officer in Van Der Zee's print conforms to Garvey's fondness for pageantry and parades to celebrate his movement.

27.26 (above) Jacob Lawrence, *Harriet Tubman Series, No. 7*, 1939–40. **Casein** tempera on hardboard, 17⅛ × 12 in (43.5 × 30.5 cm). Hampton University Museum, Hampton, Virginia. From the age of ten, Lawrence lived in Harlem; in 1990 he was awarded the National Medal of Arts. This painting is from his 1939–40 series celebrating Harriet Tubman (c. 1820–1913). She was an active abolitionist and champion of women's rights, who helped southern slaves to escape. From 1850 to 1860, as a "conductor" on the "underground railroad," she freed more than 300 slaves.

27.27 Edward Hopper, *Gas*, 1940. Oil on canvas, 2 ft 2¼ in × 3 ft 4¼ in (0.67 × 1.02 m). Museum of Modern Art, New York (Mrs. Simon Guggenheim Fund).

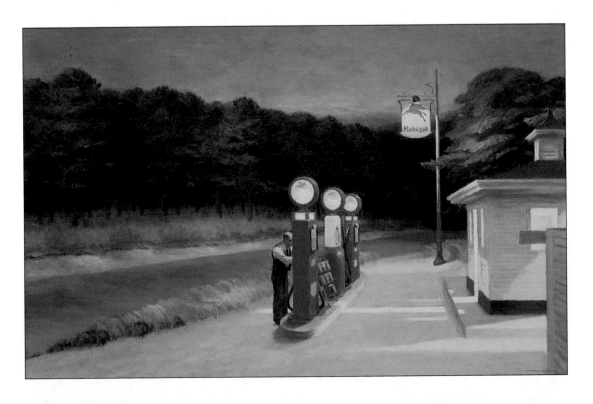

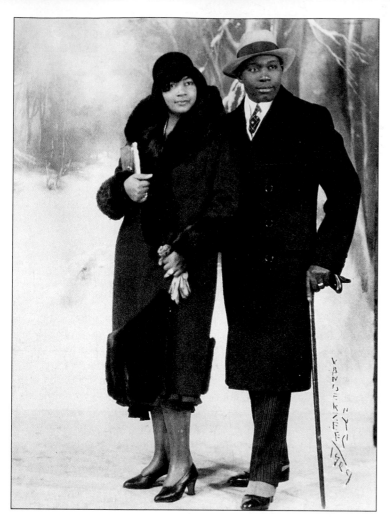

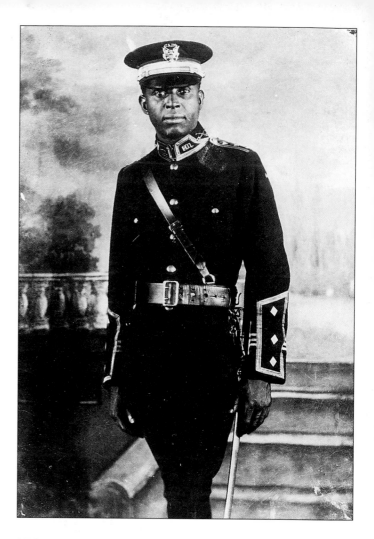

27.28 James Van Der Zee, *Portrait of Couple, Man with Walking Stick*, 1929. Silver print. James Van Der Zee Collection.

27.29 James Van Der Zee, *Garveyite*, c. 1924. Silver print.

27.30 Walker Evans, *Shoeshine Sign in a Southern Town*, 1936. Gelatin-silver print, 5⅝ × 6⅝ in (14.4 × 16.8 cm). Museum of Modern Art, New York (Stephen R. Currier Memorial Fund).

The *Shoeshine Sign in a Southern Town* of 1936 (fig. **27.30**) by Walker Evans (1903–1975) evokes the atmosphere of the Deep South in the 1930s. During the Depression, until 1937, Evans took pictures for the Resettlement Administration—later the Farm Security Administration (FSA). This organization hired photographers to illustrate rural poverty, as is suggested here by the ramshackle wall and the bare lightbulb. The necessity of earning money by shining shoes stands for the larger social picture of American life in the 1930s. At the same time, however, Evans has exploited the abstract qualities of black and white contrast and textured surfaces. The prominence of the word SHINE is reminiscent of early collage, and reflects Evans's interest in the formal possibilities of billboards, shop signs, and posters that are part of the American landscape.

Dorothea Lange (1895–1965) also worked for the FSA. But she was less interested in formal abstraction than Evans, and more committed to conveying the desired social message. Her *Migratory Cotton Picker* of 1940 (fig. **27.31**) is typical of the way in which she ennobled

the poor and the working class. The man is physically attractive, but worn by laboring in the fields and toughened by the hot sun. The earth still clings to his hands, the lines and veins of which create abstract patterns by virtue of the close-up view. Arizona's arid climate is reflected in the clear, crisp sky and the precise outlines of the worker. In such images, Lange succeeded in evoking sympathy for, and identification with, her subjects, thereby achieving her political goals.

Mexico

Diego Rivera

Another approach to social concerns can be seen in the murals of the Mexican artist Diego Rivera (1886–1957). From 1909 to 1921 he lived in Europe, where he painted in a Cubist style. On returning to Mexico, however, he renounced modernism and the avant-garde in favor of Mexican nationalism. The government commissioned him to create a series of large murals for the National Palace, which he used as a vehicle for depicting Mexican history. In this approach Rivera was influenced by the Socialist Realism of Soviet art under Communism.

27.31 Dorothea Lange, *Migratory Cotton Picker, Eloy, Arizona*, 1940. Gelatin-silver print, 10½ × 13½ in (26.8 × 34.3 cm). Oakland Museum.

27.32 Diego Rivera, *Ancient Mexico*, from the *History of Mexico* fresco murals, 1929–35. National Palace, Mexico City.

Figure **27.32** shows the first mural in the series. At the left, the Spanish conquerors fight the native population, who perform ancient ceremonies at the far right. References to Quetzalcoatl (see Vol. I, p. 354) appear on either side of the sun, which is above a Mesoamerican pyramid, an alignment recalling that of the Teotihuacan pyramids of the sun and moon. The seated figure in front of the pyramid resembles Lenin, which leaves no doubt about Rivera's political message. Rivera has thus combined a kind of historical imperative with contemporary issues and, even though he has diverged from the avant-garde, there are unmistakable Cubist forms in his imagery.

Frida Kahlo

Rivera's third wife, Frida Kahlo (1907–54), shared her husband's Marxist sentiments. In *Marxism Will Give Health to the Sick* (fig. **27.33**), painted in the last year of her life, she depicts Karl Marx strangling a surrealist image of Uncle Sam in the body of an eagle. At the same time, Marx is performing a "laying on of hands"—one hand with an eye embedded in the palm—thereby curing Kahlo and dispensing with her need for crutches. Formally, the released crutches create an inverted trapezoid that echoes Kahlo's wide green-and-white dress. The red plain on the right suggests the blood of her suffering, while the white dove of peace spreading its wings over the globe and fertile valleys on the left suggests a semblance of spiritual health and well-being.

27.33 Frida Kahlo, *Marxism Will Give Health to the Sick*, 1954. © Fundación Dolores Olmedo. Photo: Bob Schalkwijk.

Toward American Abstraction

Countering the Regional and Social Realist currents of Western art between the wars was the influence of the European avant-garde. The 1913 Armory Show had brought examples of avant-garde European art to America, and Duchamp had lived in New York since 1915. A few private New York galleries, run by dealers who understood the significance of the new styles, began to exhibit "modern" art. As early as 1905, the American photographer Alfred Stieglitz (1864–1946) had opened the 291 Art Gallery at 291 Fifth Avenue in New York, where he exhibited work by Rodin, Cézanne, the Cubists, and Brancusi along with that by more progressive American artists. The Museum of Modern Art, under the direction of Alfred Barr, Jr., opened in 1929, the year of the stock market crash. In 1930, Stieglitz opened the American Place Gallery to exhibit abstract art. Also during this period, government support for the arts was provided by the Federal Arts Project, which operated under the aegis of Franklin Roosevelt's social programs. The Project provided employment to thousands of artists and, in doing so, granted some measure of official status to abstract art.

Alfred Stieglitz

Stieglitz's photographs straddle the concerns of American Social Realism and avant-garde abstraction. Many of his pictures document contemporary society, while others are formal studies in abstraction. In 1922 he began a series of abstract photographs entitled *Equivalent* (fig. **27.34**), in which cloud formations create various moods and textures. Stieglitz believed in what is called "straight photography," as opposed to unusual visual effects achieved, among other means, by the manipulation of negatives and chemicals.

Edward Weston

The photography of Edward Weston (1886–1953) also transformed "straight" nature pictures into abstraction. His *Two Shells* (fig. **27.35**) of 1927, for example, shows the organic character of a chambered nautilus set inside another shell. Of these, Weston wrote:

> One of these two new shells when stood on end is like a magnolia blossom unfolding. The difficulty has been to make it balance on end and not cut off that important end, nor show an irrelevant base. I may have solved the problem by using another shell for the chalice ...[11]

27.34 (above) Alfred Stieglitz, *Equivalent*, 1923. Chloride print, 4⅝ × 3⅝ in (11.8 × 9.2 cm). Art Institute of Chicago (Alfred Stieglitz Collection). Stieglitz was born in Hoboken, New Jersey. He organized the 1902 exhibition that led to Photo-Secession, an informal group that held exhibitions all over the world and whose objective was to gain the status of a fine art for pictorial photography. In 1903 he founded the quarterly journal *Camera Work*, which encouraged modern esthetic principles in photography.

27.35 (right) Edward Weston, *Two Shells*, 1927. Photograph.

27.36 Arthur Dove, *Goin' Fishin'*, 1925. Mixed media collage, 19½ × 24 in (49.5 × 61 cm). Phillips Collection, Washington, D.C.

By virtue of the arrangement of the two shells, as well as their close-up view, Weston's image invites free association. The shells become more than shells as a result of the suggestive metaphorical nature of the forms. Weston's transformations of natural shapes into associative abstraction—like those of Stieglitz—allied him with the early twentieth-century avant-garde.

Arthur Dove

Another important figure in early American abstraction was Arthur Dove (1880–1946), who lived in Europe from 1907 to 1909. He had been influenced by Kandinsky's views of the spiritual in nature, and exhibited in the 1913 Armory Show. His *Goin' Fishin'* of 1925 (fig. **27.36**) is a construction of fishing poles, pieces of denim, and slabs of bark. The poles are curved, forming an arch around the flatter denim and bark, which creates a structured, architectural image. At the same time, the use of objects that are associated with fishing infuses the work with a sense of the texture of boats, workers, and bamboo. In this work, Dove "Americanizes" the collage technique by the choice of objects, and by the colloquial title. He also looks forward to the work of Robert Rauschenberg in the 1950s (see p. 901).

In *Fog Horns* (fig. **27.37**), painted four years later, Dove uses circular, biomorphic forms to suggest sound waves traveling through space. The shapes of sound correspond to the round openings of the horns, while their decreasing size indicates temporal distance. The pastel colors and foggy atmosphere create a mood that can be related to the mysterious, poetic quality of certain Symbolist painters. It is typical of Dove that he used the sea to convey such moods, which have a Romantic as well as a Symbolist character.

27.37 Arthur Dove, *Fog Horns*, 1929. Oil on canvas, 18 × 26 in (45.7 × 66 cm). Colorado Springs Fine Arts Center (Gift of Oliver B. James).

Georgia O'Keeffe

Georgia O'Keeffe (1887–1986), who was married to Stieglitz, is difficult to place within a specific stylistic category. But it is clear that she was influenced by photography and early twentieth-century abstraction, as well as by the landscape of the American southwest. She, along with Arthur Dove and other abstractionists, had exhibited at Stieglitz's 291 in the 1920s. Her *Black and White* of 1930 (fig. **27.38**) is an abstract depiction of various textures, motion, and form, without any reference to recognizable objects. By eliminating color, O'Keeffe makes use of the same tonal range that is available to the black and white photographer.

In her *Cow's Skull with Calico Roses* of 1931 (fig. **27.39**), O'Keeffe depicts one of the desiccated skulls regularly found in the dry desert of Arizona and New Mexico. The close-up view abstracts the forms. With the accent of the black vertical and the horizontal of the horns, the image evokes the Crucifixion. At the same time, the death content of O'Keeffe's subject is softened by the roses, which are still alive. This juxtaposition of living and dead forms recalls the death and resurrection themes of Christian art, as well as being a feature of the desert itself.

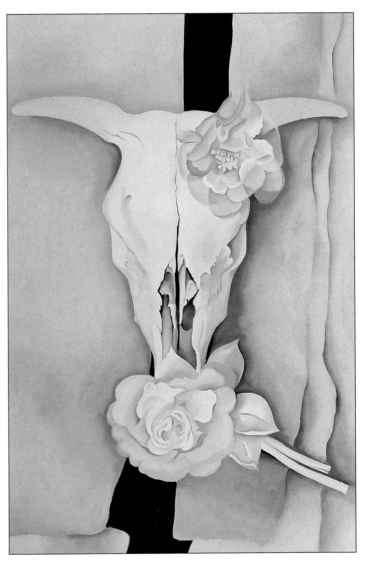

27.38 Georgia O'Keeffe, *Black and White*, 1930. Oil on canvas, 36 × 24 in (91.4 × 61 cm). Collection, Whitney Museum of American Art, New York (Gift of Mr. and Mrs. R. Crosby Kemper). O'Keeffe was born in Sun Prairie, Wisconsin. In 1917 Stieglitz gave O'Keeffe her first one-woman show at "291." She married Stieglitz in 1924, and after his death moved permanently to New Mexico, where desert objects—animal bones, rocks, flowers—became favorite motifs in her work.

27.39 Georgia O'Keeffe, *Cow's Skull with Calico Roses*, 1931. Oil on canvas, 36⁵⁄₁₆ × 24⅛ in (92.2 × 61.3 cm). Art Institute of Chicago (Gift of Georgia O'Keeffe). In July 1931, O'Keeffe wrote from New Mexico to the art critic Henry McBride: "Attempting to paint landscape—I must think it important or I wouldn't work so hard at it—Then I see that the end of my studio is a large pile of bones a horse's head—a cow's head—a calf's head—long bones—all sorts of funny little bones and big ones too—a beautiful ram's head has the center of the table—with a stone with a cross on it and an extra curly horn."[12]

27.40 (right) Alfred Stieglitz, *Georgia O'Keeffe: A Portrait: Hands and Bones (15)*, 1930. Silver-gelatin print, negative, 8 × 10 in (20.3 × 25.4 cm). National Gallery of Art, Washington D.C. Alfred Stieglitz Collection.

Similar juxtapositions characterize Stieglitz's *Georgia O'Keeffe: A Portrait: Hands and Bones (15)* of the previous year (fig. **27.40**). In addition to the opposition of living and dead form, Stieglitz contrasts flesh with bone, and soft texture with hardness. He made several "portraits" of Georgia O'Keeffe's hands—in this case identifying them by their connection with the desert skull. The close-up view, as well as the partial nature of the image, contributes to its abstraction.

Transcendental Painting

From 1938 to 1941 a unique group of avant-garde painters, who were dedicated to the principles of abstraction, was formed in New Mexico. These artists were inspired by the expanses of the southwestern landscape, and by Kandinsky's *Concerning the Spiritual in Art*. In a brochure published by the group, they stated that:

> Transcendental has been chosen as a name for this group because it best expresses its aim, which is to carry painting beyond the appearance of the physical world, through new concepts of space, color, light, and design, to imaginative realms that are idealistic and spiritual. The work does not concern itself with political, economic, or other social problems.[13]

The execution of these goals can be seen in the work of Agnes Pelton, who, like Dove, had participated in the Armory Show, and exhibited at Stieglitz's gallery in New York. Her *Blest* of 1941 (fig. **27.41**) is typical of the expanding, biomorphic forms depicted by the Transcendental painters. In this case, a large floral form rises and stretches like an explosion in slow motion. It seems to dissolve as it expands, creating a mystical, floating effect that is related to elusive notions of Transcendental spirituality.

The Transcendental painters, along with Stieglitz, Dove, O'Keeffe, and other abstractionists, were among the most avant-garde artists of the early twentieth century in America. At that time, despite the Armory Show and other inroads made by the new European styles, art in the United States was still primarily conservative. It was not until the 1950s that American art finally emerged as the most innovative on an international scale.

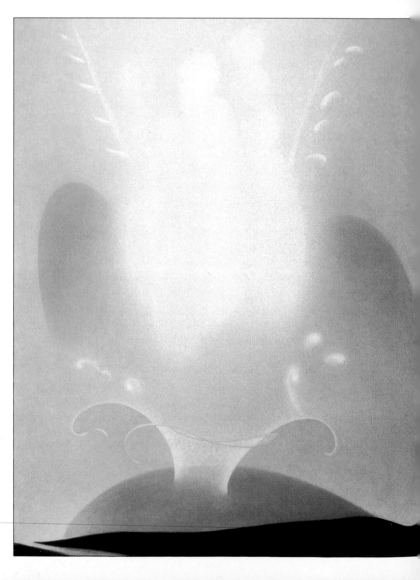

27.41 Agnes Pelton, *The Blest*, 1941. Oil on canvas, 38 × 29 in (96.5 × 73.6 cm). Collection, Georgia de Havenon, New York.

American Folk Art

The United States has had a strong, on-going folk art tradition. In the nineteenth century, folk art sculpture included shop signs, carousel horses, weather vanes, ships' figureheads, carved gravestones, and cigar-store Indians. Such works reveal the American attachment to objects, which re-emerged in the 1960s Pop Art style (see Chapter 29). Figure **27.42** illustrates a lifesize seated Indian, which was originally outside a tobacco shop in Brooklyn, New York. He is represented as a dignified chieftain, wearing feathers and smoking a long pipe. His pose suggests conventions of enthroned rulers—for example, his elevation on a platform—but he is also crossing his legs, which endows him with a more casual appearance. The act of smoking can be related to the Indian peace pipe.

Two-dimensional folk art works include quilts and embroidery, as well as painting. These have continued into the twentieth century—in some cases up to the present. One of the best-known folk artists is Anna Mary Robertson (Grandma) Moses (1860–1961). She worked mainly in embroidery until she was in her seventies, when she turned to painting. Scenes such as the *Old Checkerboard House* of 1944 (fig. **27.43**) show the persistent appeal of styles that have not been modified by formal training.

Although Grandma Moses, like Horace Pippin, was a self-taught artist, it is clear that the lively designs of embroidery provided her with a training of its own. Small patterns, particularly in the red and white squares of the house, recall those made by embroidered threads. Here they are flattened, as are the silhouetted horses, which creates an impression of naïveté. But there is a convincing sense of three-dimensional space. The hills diminish in clarity as well as in size compared with the foreground forms, indicating a familiarity with both aerial and linear perspective. There is no suggestion here of the momentous international events of the period, no reference to American participation in World War II (then in its third year), or to industrialization. Instead, the scene evokes a past era of rural life and horse-drawn carriages, and thus has a romantic, nostalgic quality.

27.42 Cigar-store Indian, attributed to Charles Dodge (1806–86). Painted wood, 5 ft 6 in (1.68 m) high. Brooklyn Historical Society.

27.43 Anna Mary Robertson (Grandma) Moses, *Old Checkerboard House*, 1944. Oil on pressed wood, 24 × 43 in (0.61 × 1.09 m). Galerie St. Etienne, New York.

Style/Period	Works of Art	Cultural/Historical Developments
1900 DADA, SURREALISM, SOCIAL REALISM, REGIONALISM, AND ABSTRACTION	Dodge (attrib.), Cigar-store Indian (**27.42**) Hopi Black Ogre (**27.19**) Hopi Butterfly Maiden (**27.20**) Zuni war god (**27.9**) Mossi whistle (**27.15**) Van Der Zee, *Garveyite* (**27.29**)	
1910–1920	De Chirico, *Place d'Italie* (**27.6**) Duchamp, *Fountain (Urinal)* (**27.2**) Duchamp, *To be Looked at (From the Other Side of the Glass) with One Eye, Close to, for almost an Hour* (**27.3**) Duchamp, *L.H.O.O.Q.* (**27.1**) **Duchamp, L.H.O.O.Q.**	World War I (1914–18) Dada movement begins in Zurich (c. 1915) Franz Kafka, *The Metamorphosis* (1915) Harlem Renaissance (1919–29) John Maynard Keynes, *The Economic Consequences of the Peace* (1919) Black migration to northern U.S.A. (1920s) Revival of Ku Klux Klan in American South (1920s) Gustav Holst, *The Planets* (1920) Herman Rorschach develops the "inkblot" test (1920)
1920 1920–1930	Stieglitz, *Equivalent* (**27.34**) Man Ray, *Indestructible Object (or Object to be Destroyed)* (**27.5**) Man Ray, *Le Violon d'Ingres* (**27.7**) Dove, *Goin' Fishin'* (**27.36**) Miró, *Dog Barking at the Moon* (**27.10**) Weston, *Two Shells* (**27.35**) Magritte, *The False Mirror* (**27.12**) Arp, *The Dancer* (**27.4**) Dove, *Fog Horns* (**27.37**) Van Der Zee, *Portrait of Couple, Man with Walking Stick* (**27.28**) Adams, *Winnowing Grain, Taos Pueblo* (**27.18**) Rivera, *Ancient Mexico* (**27.32**) **Man Ray, Le Violon d'Ingres**	Sacco and Vanzetti convicted of murder (1921) Foundation of British Broadcasting Corporation (1921) Sergei Prokofiev, *The Love for Three Oranges* (1921) John Dos Passos, *Three Soldiers* (1921) Ludwig Wittgenstein, *Logico-Philosophicus* (1921) Readers' Digest founded (1922) A. E. Housman, *Last Poems* (1922) James Joyce, *Ulysses* (1922) Hermann Hesse, *Siddhartha* (1922) e. e. cummings, *The Enormous Room* (1923) New Orleans-style jazz grows in popularity (1923) André Breton publishes first Surrealist Manifesto (1924) E. M. Forster, *A Passage to India* (1924) Sean O'Casey, *Juno and the Paycock* (1924) First Surrealist exhibition in Paris (1925) First edition of *The New Yorker* appears (1925) Scopes trial over teaching of evolution theory (1925) T. E. Lawrence, *The Seven Pillars of Wisdom* (1926) D. H. Lawrence, *Lady Chatterley's Lover* (1928) Jean Cocteau, *Les Enfants Terribles* (1929)
1930 1930–1940	O'Keeffe, *Black and White* (**27.38**) Wood, *American Gothic* (**27.25**) Stieglitz, *A Portrait (15)* (**27.40**) O'Keeffe, *Cow's Skull with Calico Roses* (**27.39**) Klee, *Mask of Fear* (**27.8**) Evans, *Shoeshine Sign in a Southern Town* (**27.30**) Magritte, *Time Transfixed (La Durée Poignardée)* (**27.13**) Lawrence, *Harriet Tubman Series, No. 7* (**27.26**) **Wood, American Gothic**	Social Realism in Russian art mandated by Stalin (1930s) Aldous Huxley, *Brave New World* (1932) Henry Miller, *Tropic of Cancer* (1934) George Gershwin, *Porgy and Bess* (1935) A. J. Ayer, *Language, Truth and Logic* (1936) John Steinbeck, *The Grapes of Wrath* (1939)
1940 1940–1950	Hopper, *Gas* (**27.27**) Lange, *Migratory Cotton Picker* (**27.31**) Pelton, *The Blest* (**27.41**) Kahlo, *Marxism Will Give Health to the Sick* (**27.33**) Ernst, *The King Playing with the Queen* (**27.14**) Moses, *Old Checkerboard House* (**27.43**) Miró, *Spanish Dancer* (**27.11**) **Lange, Migratory Cotton Picker**	Eugene O'Neill, *Long Day's Journey into Night* (1940) **Ernst, The King Playing with the Queen**
1950 1950–1960	Moore, *Helmet Head No. 1* (**27.23**) Calder, *Big Red* (**27.24**) Giacometti, *Large Standing Woman III*, and Mondrian, *Composition with Red, Yellow, and Blue* (**27.21**) Moore, *Reclining Figure* (**27.22**)	

28
Abstract Expressionism

By the middle of the 1930s, the New York avant-garde was clearly identified with abstraction, which paradoxically had emerged from the background of the more conservative Regionalism and Social Realism styles. Equally influential in its development, however, was the influx of artists and intellectuals from overseas. In Europe during the 1930s, totalitarian authorities prevented artists from pursuing modernism on the grounds that it was degenerate and corrupted the moral fiber of the nation (see Box). The waves of refugees who fled oppression and war during the last years of that decade therefore included many avant-garde architects, artists, musicians, and writers. By 1940, when Paris fell to the Nazis, the center of the art world had shifted to New York, whose cultural life was enriched by these émigré artists. Among the dealers and collectors who fled Europe was Peggy Guggenheim, who, in 1942, opened the Art of This Century Gallery in New York, which was dedicated to exhibiting the work of avant-garde artists.

The Teachers: Hans Hofmann and Josef Albers

Two of the most important emigrants from Germany were Hans Hofmann (1880–1966) and Josef Albers (1888–1976). They taught at the Art Students' League in New York and at Black Mountain College in North Carolina, respectively, and from 1950 to 1960 Albers chaired the Department of Architecture and Design at Yale. Both Hofmann and Albers influenced a generation of American painters as much through their teaching as through their work.

Hofmann's *The Gate* (fig. **28.1**) is, as the title implies, an architectural construction in paint. The intense, thickly applied color is arranged in squares and rectangles. It ranges from relatively pure hues, such as the yellow and red, to more muted greens and blues. For Hofmann, as for the Impressionists, it was the color in a picture that created light. In nature, the reverse is true; light makes color visible. In *The Gate*, edges vary from precise to textured. Everywhere, the paint is structured, combining bold,

"Degenerate Art"

On July 19, 1937, Hitler opened the first "Great German Art Exhibition" in Munich. He announced in his inaugural speech that he intended:

> to clear out all the claptrap from artistic life in Germany. "Works of art" that are not capable of being understood in themselves but need some pretentious instruction book to justify their existence ... will never again find their way to the German people. From now on, we are going to wage a merciless war of destruction against the last remaining elements of cultural disintegration.[1]

Hitler's notion of an esthetic "clearing out" was similar to the Nazi "Final Solution," which was intended to purge Europe of Gypsies, Jews, homosexuals, the mentally sick, and liberal intellectuals. Modern music, architecture, films, and plays were declared subversive. In May 1933, "un-German" books were burned and virtually all avant-garde artists dismissed from their teaching positions. On July 20, 1937, an exhibition of over 650 works by artists such as Ernst, Kandinsky, Kirchner, Klee, and other members of the avant-garde opened, the purpose of which was to make an "example" of "degenerate art." A pamphlet which accompanied the exhibition denounced the morals of certain modern artists, who were accused of viewing the world as a brothel inhabited by pimps and prostitutes. In an irony that was lost on the Nazi regime, the exhibition must have been one of the finest shows of avant-garde art that ever took place.

In June 1939, works by Gauguin, van Gogh, Braque, and Picasso were removed from German museums and auctioned to foreigners. Similar tendencies existed in other countries as well as in Germany. In France, non-French (especially Jewish) elements in the arts were eliminated by the pro-Nazi Vichy regime. In Russia, an exhibition held in Moscow in 1937 was aimed at discrediting the avant-garde.

expressive color with the tectonic qualities of Cubism and related styles.

Albers's series of paintings entitled *Homage to the Square* (fig. **28.2**) also explores color and geometry. But his surfaces are smooth, and the medium is subordinate to the color relationships between the squares. In his investigation of light and color perception, Albers concentrated on the square because he believed that it was the shape furthest removed from nature. "Art," he said, "should not represent, but present."[2]

28.2 Josef Albers, *Study for Homage to the Square*, 1968. Oil on masonite, 32 × 32 in (81.3 × 81.3 cm). Photo courtesy of Sidney Janis Gallery, New York.

Abstract Expressionism: The New York School

Abstract Expressionism was a term used in 1929 by Alfred Barr, Jr. to refer to the nonfigurative and nonrepresentational paintings of Kandinsky. The style was to put the United States on the map of the international art world. In the 1950s it was generally used to categorize the New York School of painters, which, despite its name, was actually comprised of artists from many different parts of America and Europe.

Nearly all the Abstract Expressionists had passed through a Surrealist phase. From this they had absorbed an interest in myths and dreams, and in the effect of the unconscious on creativity. From Expressionism they inherited an affinity for the expressive qualities of paint. This aspect emerged particularly in the so-called "action" or "gesture" painters of Abstract Expressionism.

Arshile Gorky

The Abstract Expressionist painter who was most instrumental in creating a transition from European Abstract Surrealism to American Abstract Expressionism was the Armenian Arshile Gorky (1904–48). After absorbing several European styles, including Impressionism and Surrealism, he developed his own pictorial "voice" in the 1940s.

Some time between about 1926 and 1936, Gorky painted his famous work *The Artist and his Mother* (fig. **28.3**). The slightly geometric character of the faces suggests the influence of early Cubism. Flattened planes of color—the mother's lap, for example—and visible brushstrokes

28.1 Hans Hofmann, *The Gate*, 1959–60. Oil on canvas, 6 ft 3⅛ in × 4 ft ½ in (1.9 × 1.23 m). Solomon R. Guggenheim Museum, New York. For Hofmann, nature was the source of inspiration, and the artist's mind transformed nature into a new creation. "To me," he said, "a work is finished when all parts involved communicate themselves, so that they don't need me."[3]

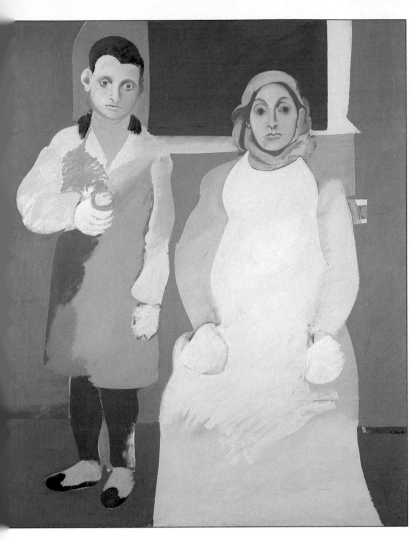

reveal affinities with Fauvism and Expressionism. To the left stands the rather wistful young Gorky. His more dominant mother recalls the mythic enthroned mother goddesses of antiquity (see the Etruscan *Mater Matuta*, Vol. I, fig. 7.9).

Entirely different in form, though it shares the nostalgic quality of *The Artist and his Mother*, is the *Garden in Sochi* of 1943 (fig. **28.4**). The third of a series depicting childhood recollections, this painting exemplifies Gorky's most characteristic innovations. Paint is applied thinly, and the colorful shapes are bounded by delicate curvilinear outlines, which create a sense of fluid motion. Both the title and the abstract biomorphic shapes suggest references to natural, organic protozoan or vegetable life. Gorky studied nature closely, sketching flowers, leaves, and grass from life before transforming the drawings into abstract forms. The suggestive, elusive identity of Gorky's shapes is reminiscent of Miró, who had influenced Gorky's Surrealist phase.

28.3 (left) Arshile Gorky, *The Artist and his Mother*, c. 1926–36. Oil on canvas, 5 ft × 4 ft 2 in (1.52 × 1.27 m). Collection, Whitney Museum of American Art, New York (Gift of Julien Levy for Maro and Natasha Gorky). Gorky was born Vosdanig Manoug Adoian in Turkish Armenia and emigrated to the United States in 1920. At the height of his career, a series of misfortunes—a fire that burnt most of his recent work, a cancer operation, a car crash that fractured his neck—led to his suicide in 1948. This painting was based on an old photograph.

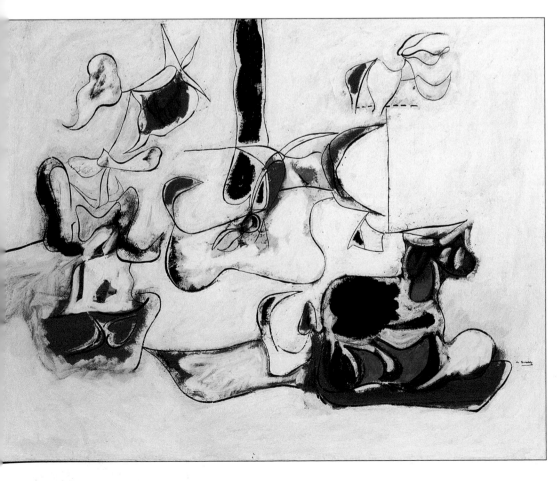

28.4 Arshile Gorky, *Garden in Sochi*, c. 1943. Oil on canvas, 31 × 39 in (78.7 × 99 cm). Museum of Modern Art, New York (Acquired through the Lillie P. Bliss Bequest). Gorky related this series to a garden at Sochi on the Black Sea. He recalled porcupines and carrots, and a blue rock buried in black earth with moss patches resembling fallen clouds. Village women rubbed their breasts on the rock— probably a fertility rite. Long shadows reminded him of the lancers in the battle scenes of Uccello. Passers-by tied colorful strips of clothing to a leafless tree. They blew in the wind like banners and rustled like leaves.

Art Critics and the Avant-Garde

Harold Rosenberg and Clement Greenberg were the two leading critics most closely associated with American Abstract Expressionism. In 1952, Rosenberg coined the term "Action Painting" to describe the new techniques of applying paint. For American artists, he said, the canvas became "an arena in which to act—rather than ... a space in which to reproduce. ... What was to go on the canvas was not a picture but an event." Rather than begin a painting with a preconceived image, the Abstract Expressionists approached their canvases with the idea of doing something *to* it. "The image," wrote Rosenberg, "would be the result of this encounter."[4]

Clement Greenberg took issue with Rosenberg's assessment on the grounds that painting thus became a private myth. Because such work did not resonate with a larger cultural audience, according to Greenberg, it could not be considered art. But he was nevertheless a staunch defender of abstraction, noting that subject-matter had nothing to do with intrinsic value. "The explicit comment on a historical event offered in Picasso's *Guernica*," he wrote in 1961, "does not make it necessarily a better or richer work than an utterly 'non-objective' painting by Mondrian."[5]

Greenberg described the shift in the artists' view of pictorial space as having "lost its 'inside' and become all 'outside.'" He surveyed this shift from the fourteenth century as follows:

> From Giotto to Courbet, the painter's first task had been to hollow out an illusion of three-dimensional space on a flat surface. One looked through this surface as through a proscenium into a stage. Modernism has rendered this stage shallower and shallower until now its backdrop has become the same as its curtain, which has now become all that the painter has left to work on.[6]

Action Painting

Just as brushstrokes are a significant aspect of Impressionism and Post-Impressionism, so the action painters developed characteristic methods of applying paint. They dripped, splattered, sprayed, rolled, and threw paint on their canvases, with the result that the final image reflects the artist's activity in the creative process itself (see Box).

Jackson Pollock Of the "action" or "gesture" painters who were part of the New York School, the best-known is Jackson Pollock (1912–56). He began as a Regionalist and turned to Surrealism in the late 1930s and early 1940s. His early paintings reflect the Regional style of his teacher, Thomas Hart Benton (1889–1975), at the Art Students' League in New York. *Going West* (fig. 28.5), which Pollock painted in the 1930s, is typical of Regionalism in that it is identifiable as a specific American region. Settlers traveling in covered wagons and the stark landscape evoke the pioneering spirit of the Old West. The curves in the landscape literally enclose the figures, who seem to struggle through a cavernous space toward their destination. Curvilinear rhythms dominate the picture plane and look forward to Pollock's mature abstract style.

Guardians of the Secret (fig. **28.6**) is from Pollock's period of Surrealist abstraction. A series of thickly painted rectangles enlivened by energetic curves and zigzags recalls the spontaneous character of graffiti. The painting's linear quality is also reminiscent of graffiti, and suggests the signs of a hidden and unintelligible language. The apparent spontaneity of Pollock's "signs" can be related

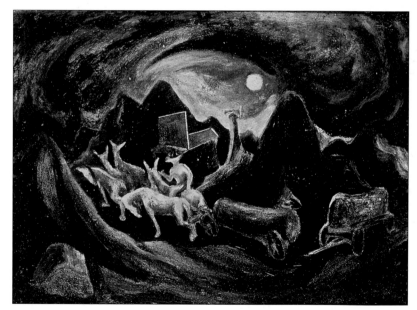

28.5 Jackson Pollock, *Going West*, 1934–5. Oil on gesso ground on composition board, 15⅜ × 20⅞ in (39 × 53 cm). Smithsonian Institution, Washington, D.C. Pollock, born in Wyoming, moved to New York in 1929. He worked for the Federal Arts Project and had his first one-man show in 1943 at Peggy Guggenheim's Art of This Century Gallery. In 1956 he died in a car accident in East Hampton, Long Island.

to Surrealist automatic writing as a means of gaining access to the unconscious.

From 1947 onward, Pollock used a **drip technique** to produce his most celebrated pictures, in which he engaged his whole body in the act of painting. From cans of commercial housepainter's paint, enamel, and aluminum,

Pollock dripped paint from the end of a stick or brush directly onto a canvas spread on the ground. In so doing, he achieved some of the chance effects sought by the Dada and Surrealist artists. At the same time, however, he controlled the placement of the drips and splatters through the motion of his arm and body (fig. 28.8). He described this process as follows: "On the floor I am more at ease. I feel nearer, more a part of the painting, since this way I can walk around it, work from the four sides and literally be *in* the painting. This is akin to the Indian sand painters of the West" (see Box). Pollock also declared that, when actually painting, he was unaware of his actions:

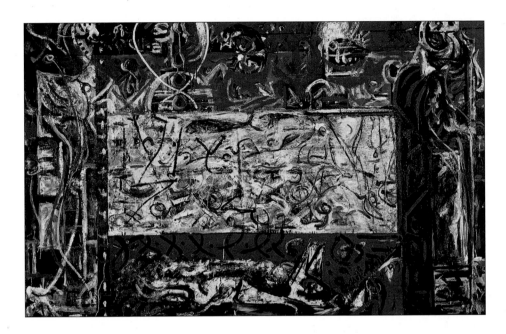

28.6 Jackson Pollock, *Guardians of the Secret*, 1943. Oil on canvas, 4 ft ⅜ in × 6 ft 3⅜ in (1.23 × 1.91 m). San Francisco Museum of Modern Art, California (Albert M. Bender Collection, Albert M. Bender Bequest Fund Purchase). Pollock's interest in Surrealism, unconscious processes, and myth, which is apparent in this painting, led him to undertake Jungian psychoanalysis.

Navaho Sand Painting

Pollock's "Indian sand painters" were the Navaho, who led a nomadic existence in the American Southwest. They made paintings out of crushed colored rocks, which were ground to the consistency of sand. These were typically the product of a medicine man, or shaman, who created image after image in order to exorcise the evil spirits of disease from a sick person. He continued to make the pictures until the patient either died or recovered. Then the image was erased, and its effect dissipated.

The Four "First Dancers" of the Navaho Night Chant Ceremony (fig. 28.7) is a twentieth-century sand painting. It depicts four long, thin vertical figures with rectangular torsos. They are composed of flat planes of color—black, yellow, blue, and white—which symbolize the cardinal points of the compass. Their geometric forms and clear outlines are unlike anything in Pollock's work. His interest was in their energetic execution, and the movement of the artist around an image on the ground. It is also likely that Pollock was drawn to the shamanistic character of the medicine man, and that he identified with the notion of the curative power of imagery.

28.7 *The Four "First Dancers" of the Navaho Night Chant Ceremony*, 20th century. Sand painting, 8 × 8 ft (2.11 × 2.44 m). Wheelwright Museum, Santa Fe, NM.

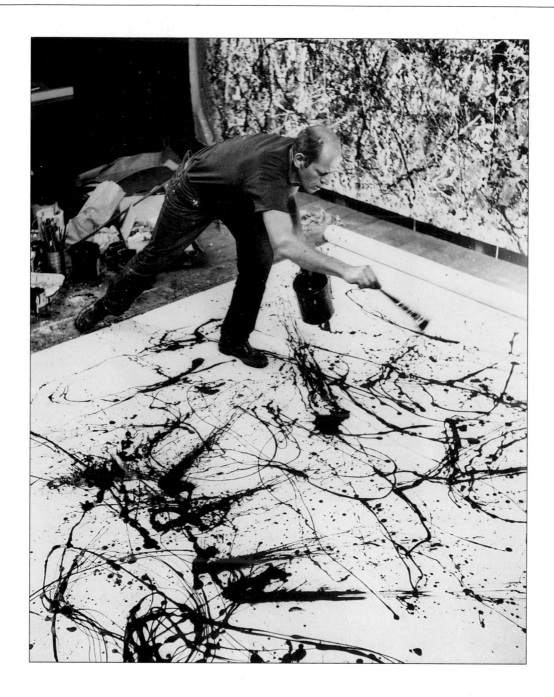

28.8 Hans Namuth, *Jackson Pollock Painting*, 1950. Photograph. Center for Creative Photography, University of Arizona.

"When I am *in* my painting, I'm not aware of what I'm doing . . . because the painting has a life of its own."[7]

Pollock's *Black and White* of 1948 (fig. **28.9**) eliminates all reference to recognizable objects. It is a celebration of dynamic line. Set against a yellow and white background is an elaborate build-up of interwoven dripped black lines. At certain points the paint spreads out, thereby varying the width and texture of the lines. Pollock's habit of trimming his finished canvases enhances their dynamic quality, for the lines appear to swirl rhythmically in and out of the picture plane, unbound by either an edge or a frame, as if self-propelled.

Franz Kline The dynamic energy of Pollock's monumental drip paintings is virtually unmatched, even among the Abstract Expressionist action painters. But Franz Kline (1910–62) achieved dynamic imagery through thick, bold strokes of paint slashing across the picture plane. He had his first one-man show in New York in 1950, by which time he had renounced figuration and begun working on his characteristic black and white canvases. *Mahoning* of 1956 (fig. **28.10**) is a typical example. Strong black diagonals are created by the wide brush of a housepainter and form a kind of "structured" calligraphy. The edges are too rough and the blacks too angular for classical calligraphy, while the architectural appearance tilts, as if beams are about to collapse. Drips and splatters enhance the textured quality of the surface.

28.9 Jackson Pollock, *Black and White*, 1948. Oil, enamel, and aluminum paint on canvas, mounted on wood, 81⅞ × 48 in (208 × 121.7 cm). Private collection. Pollock first exhibited paintings such as this in 1948 to a shocked public. A critic for *Time* magazine dubbed him "Jack the Dripper," but avant-garde critics came to his defense. Within a few years of his death, he was the most widely exhibited of all the artists of the New York School.

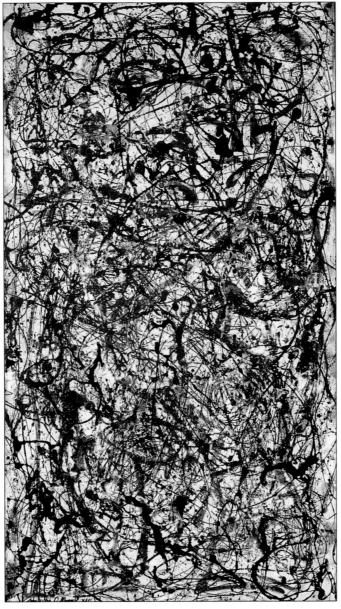

28.10 (below) Franz Kline, *Mahoning*, 1956. Oil and paper collage on canvas, 6 ft 8 in × 8 ft 4 in (2.03 × 2.54 m). Whitney Museum of American Art, New York (Purchase, funds from friends of Whitney Museum of American Art).

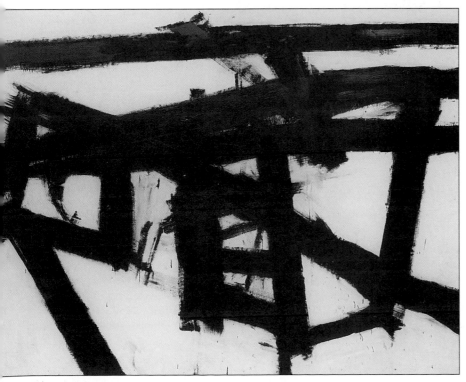

Willem de Kooning In the work of Willem de Kooning (1904–97), action painting is used in the service of explicit aggression and violence. This is particularly true of the series of pictures of women that de Kooning painted in the early 1950s. Unlike Pollock and Kline, de Kooning only partially eliminated recognizable subject-matter from his iconography. *Woman and Bicycle* of 1952–3 (fig. **28.11**), for example, combines the frontal image of a large, frightening woman with aggressive brushstrokes which literally tear through the figure's outline. The anxiety created by the woman's appearance—huge staring eyes, a double set of menacing teeth, and platform-like breasts, which reveal the influence of Cubist geometry—matches the frenzied violence of the brushstrokes. The assault on the figure, which seems to disintegrate into unformed paint, is also an attack on the idealized Classical image of female beauty.

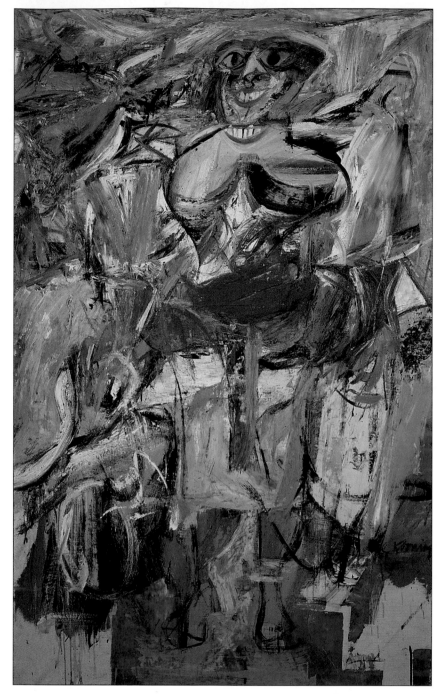

which revealed the staining process—a method that is basic to Color Field painting (see below). *The Bay* of 1963 (fig. **28.12**) is made of thinned paint poured on to the canvas in layers of color, engulfing the picture plane. The colors are delicate and, for the most part, pastel. The blue expands over the canvas, like water filling the recess in the yellow and green areas of color. We seem to be looking down on a body of water in a landscape.

Color Field Painting

At the opposite pole from the Action Painters are the artists who applied paint in a more traditional way. This has been variously referred to as "Chromatic Abstraction" and "Color Field Painting." The latter term refers to the preference for expanses of color applied to a flat surface in contrast to the domination of line in Action Painting. The imagery of Action Painting is more in tune with Picasso and Expressionism. Color Field painters, by contrast, were influenced by Matisse's broad planes of color. Compared with Action paintings, Color Field imagery is typically calm and inwardly directed, and is capable of evoking a meditative, even spiritual, response.

Helen Frankenthaler Helen Frankenthaler (b. 1928), another action painter, used synthetic media (see Box) to "stain" her canvas by pouring paint directly onto it. In 1952 she visited Pollock in his studio in the Springs, on eastern Long Island, with the critic Clement Greenberg. There she saw the effect of Pollock's paint on unprimed canvas,

Mark Rothko One of these artists was Mark Rothko (1903–70). Like Pollock, he had gone through a Surrealist period and was engaged in the search for universal symbols, which he believed were accessible through myths and dreams. His *Baptismal Scene* of 1945 (fig. **28.13**) conveys the sense of a pre-verbal, aquatic world. Delicate pro-

Acrylic

One of the most popular of the modern synthetic media is **acrylic**, a water-based paint. Acrylic comes in bright colors, dries quickly, and does not fade. It can be applied to paper, canvas, and board with either traditional brushes or **airbrushes**. It can be poured, dripped, and splattered. When thick, acrylic approaches the texture of oils. When thinned, it is fluid like water paint. In contrast to water paint, however, which mixes when more than one wet color is applied, acrylic can be applied in layers which do not blend even when wet. It is possible to build up several layers of paint, which retain their individual hues, and thus to create a structure of pure color—as Frankenthaler does in *The Bay* (see fig. 28.12).

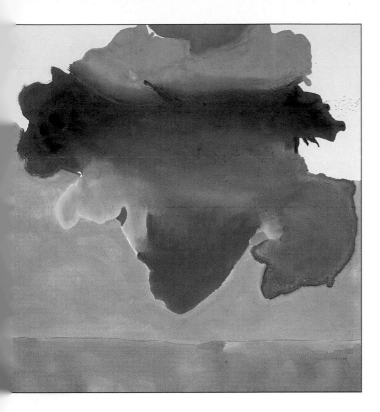

28.12 (above) Helen Frankenthaler, *The Bay*, 1963. Acrylic on canvas, 6 ft 8¾ in × 6 ft 9¾ in (2.05 × 2.12 m). Collection, Detroit Institute of Arts (Gift of Dr. and Mrs. Hilbert H. DeLawter).

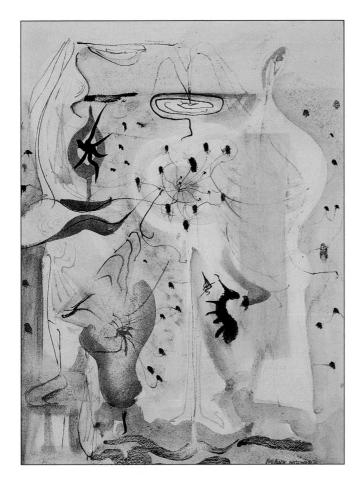

28.13 Mark Rothko, *Baptismal Scene*, 1945. Watercolor, 19⅞ × 14 in (50.4 × 35.5 cm). Whitney Museum of American Art, N.Y. (Purchase)

tozoan forms that elude identification swirl weightlessly in various directions, and the amoeba-like biomorphs seem to exist below the surface of consciousness. By the 1950s, Rothko had developed his most original style. Totally nonfigurative and nonrepresentational, Rothko's paintings are images of large rectangles hovering in fields of color. In *Green on Blue* of 1956 (fig. **28.14**), two rectangles—one green, the other white—occupy a field of blue. By muting the colors and blurring the edges of the rectangles, Rothko softens the potential contrast between them. He likewise mutes the observer's attention to the "process" of painting by virtually eliminating the presence of the artist's hand.

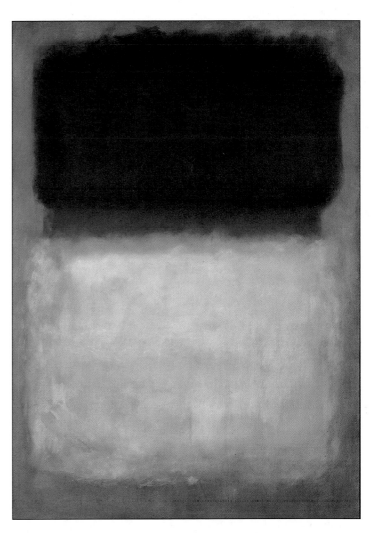

28.14 (above) Mark Rothko, *Green on Blue*, 1956. Oil on canvas, 7 ft 5¾ in × 5 ft 3¼ in (2.28 × 1.61 m). University of Arizona Museum of Art (Gift of Edward J. Gallagher, Jr.). Rothko was born in Latvia. In 1913 his family emigrated to Portland, Oregon, and in 1923 he moved to New York. Rothko suffered from depression, and committed suicide in 1970. He expressed his alienation from society as follows: "The unfriendliness of society to his [the artist's] activity is difficult ... to accept. Yet this very hostility can act as a lever for true liberation. ... Both the sense of community and of security depends on the familiar. Free of them, transcendental experiences become possible."[9] Rothko's striving for freedom from the familiar is evident in the absence of recognizable forms in paintings such as this one.

28.15 Adolph (Ad) Reinhardt, *Abstract Painting (Black)*, 1965. Oil on canvas, 5 × 5 ft (1.52 × 1.52 m). Photo Bill Jacobson, courtesy of the Pace Gallery, New York.

In eliminating references to the natural world, as well as to the creative process, Rothko attempted to transcend material reality. His pictures seem to have no context in time or space. The weightless quality of his rectangles is enhanced by their blurred edges and thin textures, which allow the underlying blue to filter through them. Whereas Pollock's light moves exuberantly across the picture plane, weaving in and out of the colors in the form of white drips, Rothko's light is luminescent. It flickers at the edges of the rectangles and shifts mysteriously from behind and in front of them.

Ad Reinhardt Even more luminous are the late Color Field paintings of Ad (Adolph) Reinhardt (1913–67). The longer one stares at these pictures, the stronger is the sense of light shimmering and glowing behind the paint.

Reinhardt's stated intention was to avoid all association with nature. He wanted the viewer to focus on the painting as an experience in itself—distinct from other, more familiar experiences. In his series of black paintings dating from the 1960s (fig. **28.15**), Reinhardt comes close to his aim. Color is eliminated, and nine squares of dark gray and black fill the picture plane.

Frank Stella Frank Stella (b. 1936) was trained in art during the heyday of the New York School of Abstract Expressionism, but he paints with a new vision of color and form. His early somber, largely monochrome pictures were indebted to the reductive art of Reinhardt, and departed from the traditional square, rectangular, or circular shapes. They are fitted into triangular, star-shaped, zigzag, and open rectangular frames—for example, in his *Empress of India* of 1965 (fig. **28.16**). By varying the shape of the canvas, Stella focused on the quality of picture as object-in-itself. Within the picture, he painted stripes of flat color, separated from each other and bordered by a precise edge. This technique is sometimes referred to as "Hard-Edge" painting.

Tahkt-i-Sulayman I of 1967 (fig. **28.17**) belongs to Stella's "Protractor Series," in which arcs intersect as if drawn with a compass. Here, a central circle is divided into two semicircles, which are repeated symmetrically on either side by flanking semicircles. These forms are related by sweeping curves, which interlace with all three sections in a continuous, interlocking motion. The intense, bright color strips in Stella's paintings of the 1960s combine dynamic exuberance with geometric control. Since the 1960s, Stella has continued to expand his repertory of shapes, formats, colors, and textures. He has evolved from early reductive clarity to complex, often very colorful three-dimensional wall sculptures of varying textures and materials.

Ellsworth Kelly Ellsworth Kelly (b. 1923) is another leading Hard-Edge Color Field painter, who works in the tradition of Josef Albers. His color is generally vibrant, and arranged in large, flattened planes that sometimes

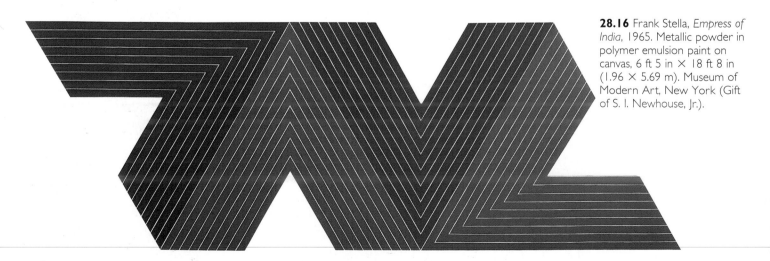

28.16 Frank Stella, *Empress of India*, 1965. Metallic powder in polymer emulsion paint on canvas, 6 ft 5 in × 18 ft 8 in (1.96 × 5.69 m). Museum of Modern Art, New York (Gift of S. I. Newhouse, Jr.).

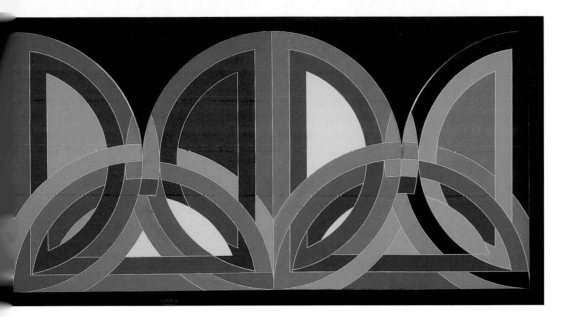

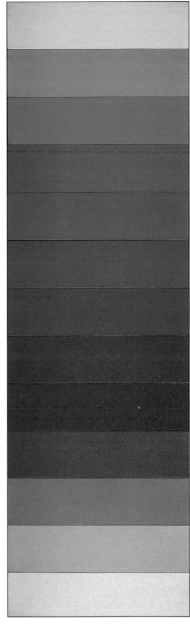

28.17 (above) Frank Stella, *Tahkt-i-Sulayman I*, 1967. Polymer and fluorescent paint on canvas, 10 ft ¼ in × 20 ft 2¼ in (3.05 × 6.15 m). Menil Collection, Houston, Texas. Stella has lived and worked in New York since 1958. The Near Eastern title of this painting indicates his interest in colorful Islamic patterns (which also influenced Matisse). The interlaced color strips reflect his study of Hiberno-Saxon designs.

28.18 (right) Ellsworth Kelly, *Spectrum III*, 1967. Oil on canvas, in 13 parts, overall 9 ft ⅜ in × 2 ft 9¼ in (2.76 × 0.84 m). Museum of Modern Art, New York (Sidney and Harriet Janis Collection).

28.19 Installation view of "Classic Modernism: Six Generations." On right: Ellsworth Kelly, *Red, Yellow, Blue*, 1965. Oil on canvas, 6 ft 10 in × 15 ft 5 in (2.08 × 4.7 m). On left: Piet Mondrian, *Trafalgar Square*, 1939. Oil on canvas, 4 ft 9 in × 3 ft 11 in (1.45 × 1.2 m). Exhibition held Nov. 15–Dec. 29, 1990 at the Sidney Janis Gallery, New York. Photo courtesy of Sidney Janis Gallery, New York.

seem to expand organically. In other instances—as in *Spectrum III* (fig. **28.18**)—bands of color create a temporal sequence of visual movement through the spectrum. By aligning the colors in this way, Kelly produces a tactile effect, despite the absence of modeling. The sequential arrangement of the rich hues causes a build-up of tension that proceeds through a progression of color.

In 1990, the Sidney Janis Gallery in New York mounted an exhibition entitled "Classic Modernism: Six Generations." Figure **28.19** is a view of the installation with Mondrian's *Trafalgar Square* of 1939 on the left and Ellsworth Kelly's *Red, Yellow, Blue* of 1965 on the right. This juxtaposition illustrates the relationship between Kelly's pure primary

colors, unframed and juxtaposed with the stark white wall of the gallery, and Mondrian's rectangles of color bounded by firm black verticals and horizontals. Kelly has enlarged the rectangles by comparison with Mondrian, and liberated the color from Mondrian's black "frames." By organizing the two paintings in this way, the gallery shows Mondrian's historical role as the link between Cubism and Color Field painting.

West Coast Abstraction: Richard Diebenkorn

An important group of abstract painters also developed on the west coast. It includes Richard Diebenkorn (1922–93), whose early pictures were of landscapes, often based on views of the San Francisco Bay area, and of anonymous, isolated figures reminiscent of Hopper in mysterious, rectangular settings. By the end of the 1960s, however, Diebenkorn had replaced figuration with nonrepresentational abstraction, building up layers of textured geometric shapes defined by straight lines. His monumental *Ocean Park* series (1970s–1980s) evokes the open spaces of the American West and the vast expanse of the Pacific Ocean. Most of his paintings contain a dominant horizontal, suggestive of landscape. The colors of *Ocean Park No. 129* of 1984 (fig. **28.20**), for example, evoke the blue

sea, while above the horizon is a narrow strip of abstract patches of color bounded by horizontals and diagonals. Despite the evident influence of Matisse and Cubism on Diebenkorn's vision, the strict geometry of the forms is relieved by the drips and emphasis on the paint texture, which relates his work to Abstract Expressionism.

Figurative Abstraction in Europe

Jean Dubuffet

During the 1950s, while American Abstract Expressionism was at its height, a more figurative kind of Expressionism developed in Europe. The French artist Jean Dubuffet (1901–85) was fascinated by the art of non-Western cultures, of children and the insane, as well as by graffiti and the naive painters. He amassed a significant collection of such work, which he believed would provide a route to unconscious sources of creativity. The influence of these styles pervades his own paintings. Dubuffet's early canvases are thickly textured, dark, and often built up with granular materials such as sand. They tend to be muddy—composed mainly of browns and blacks—and to convey the rough textures of walls, doors, and pavements.

28.20 Richard Diebenkorn, *Ocean Park No. 129*, 1984. Oil on canvas, 5 ft 6 in × 6 ft 9 in (1.68 × 2.06 m). Private collection. Courtesy, M. Knoedler & Co., Inc.

In the 1960s, Dubuffet's style changed radically, becoming more colorful and composed of lively, linear patterns. *The Reveler* of 1964 (fig. **28.21**) is a typical example of what Dubuffet called *L'Hourloupe*, or his "Twenty-third Period." It shows his use of animated, biomorphic form, which is generally outlined in pure hues of red and blue. The labyrinthine and doodle-like paths of line impart a quality of frenetic motion to Dubuffet's figure. This feature of his Twenty-third Period is reminiscent of certain figures from Papua New Guinea (fig. **28.22**), and shows the influence of the art he collected. Dubuffet's lines also suggest the spontaneous character of Surrealist automatic writing. Different as this style is from his early work, the scratchy quality of the lines and colored shapes maintains the emphasis on textured surfaces.

28.22 Spirit figure from Wapo Creek, Papua New Guinea. Painted wood and shell, 25 in (63.5 cm) high. Friede Collection, New York.

Francis Bacon

In England, the work of Francis Bacon (1909–92) comprises an entirely different kind of figurative Expressionism. His *Portrait of Isabel Rawsthorne Standing in a Street in Soho* (fig. **28.23**) exemplifies the transformation of figures into paint. This is reflected in Bacon's statement of 1952:

> It is in the search for the technique to trap the object at a given moment. The technique and the object become inseparable. The object is the technique and the technique is the object. Art lies in the continual struggle to come near to the sensory side of objects.[10]

When form becomes unformed color, as in the right shoe, the effect is less disturbing than in the face. There the features swivel into distortion and the mouth seems ripped

28.21 Jean Dubuffet, *The Reveler*, 1964. Oil on base of black acrylic, 6 ft 4¼ in × 4 ft 3¾ in (1.94 × 1.31 m). Dallas Museum of Art, Texas. Gift of Mr. and Mrs. James H. Clark.

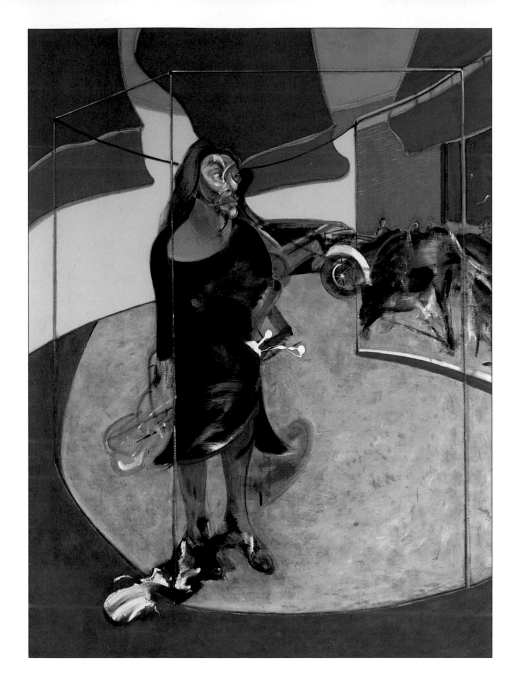

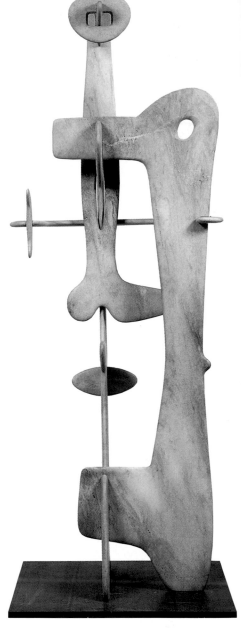

28.23 Francis Bacon, *Portrait of Isabel Rawsthorne Standing in a Street in Soho*, 1967. Oil on canvas, 6 ft 6 in × 4 ft 10 in (1.98 × 1.47 m). Staatliche Museen, Berlin.

28.24 (right) Isamu Noguchi, *Kouros*, 1944–5. Pink marble, slate base, 9 ft 9 in (2.97 m) high. Metropolitan Museum of Art, New York (Fletcher Fund, 1953). Noguchi was born in Los Angeles in 1904 to an American mother and a Japanese father. He grew up in Japan and was a pre-medical student at Columbia University (1921–4). He decided to become a sculptor and worked with Brancusi, whose influences can be seen in the smooth surfaces and elegant forms of the *Kouros*. In addition to sculpture, Noguchi has produced furniture and stage designs, public sculptural gardens, and playgrounds.

open. Bacon thus confronts the viewer with a partially flayed head that is nevertheless alive and in motion. His forms simultaneously stretch and contract, are at once clear and blurred, appealing and repulsive. They are uniquely powerful in their manner of seeming to dissolve into, and emerge from, the paint itself—not through the prominent brushstrokes of Impressionism, but by the personal, determined aggression of the artist.

Sculpture

Contemporary with the above developments in American and European painting were several sculptors whose work conveys a dynamic abstraction akin to both Abstract and Figurative Expressionism.

Isamu Noguchi

The *Kouros* (fig. **28.24**), by the Japanese-American Isamu Noguchi (1904–88), for example, contains biomorphic shapes that evoke those of Miró and Gorky. Flat, protozoan forms are arranged in interlocking horizontal and vertical planes, creating a configuration which, the artist claimed, "defies gravity." Although it conforms to the principles of twentieth-century abstraction, Noguchi's figure shares a vertical stance—softened by curvilinear stylization—with the Archaic Greek *kouros* (see Vol. I, fig. 6.19).

David Smith

Shapes and lines combine with open space in the sculpture of David Smith (1906–65). Smith welded iron and steel to produce a dynamic form of sculptural abstraction. His last great series of work, entitled *Cubi* (fig. **28.25**), is composed of cylinders, cubes, and solid rectangles. As both the title and the shapes indicate, Smith was influenced by Cubism. The works were intended to be installed outdoors (as in the illustration), their open spaces making it possible to experience the landscape through and around them. The surface, enlivened by variations of texture, contributes to the sense of planar motion in the individual shapes. Each sculpture is set against another, and often at an angle to it, so that they seem to move and stretch, though still firmly anchored by their pedestals.

Louise Nevelson

Louise Nevelson (1900–88) made assemblages consisting of "found objects"—especially furniture parts and carpentry tools—set inside open boxes. The boxes are piled on top of each other and arranged along a wall, much like bookshelves, so that they are seen, like paintings, from only one side. Typical of these works is *Black Wall* of 1959

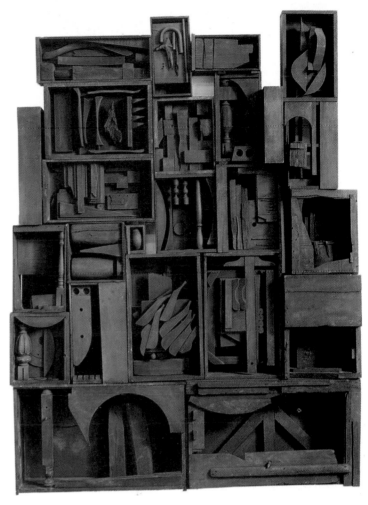

28.26 Louise Nevelson, *Black Wall*, 1959. Gilded wood, 9 ft 4 in × 7 ft 1¼ in × 2 ft 1½ in (2.64 × 2.16 × 0.65 m). Tate Gallery, London.

(fig. **28.26**), in which the framing device of the boxes orders the assembled objects. Although originally utilitarian in nature, the objects become abstractions by virtue of their arrangement. Further abstracting the assemblage from everyday experience is the fact that it is monochrome. As a result, the variety of shape and line takes precedence over the absence of color.

Many American Abstract Expressionists—some have been illustrated in this chapter—worked beyond the 1950s, when the novelty and excitement of the style was at its height. In painting, Abstract Expressionism can be seen as a logical development of Impressionist attention to the medium of paint. Brushstrokes became part of the critical vocabulary of Impressionism, Post-Impressionism, Fauvism, and the different forms of Expressionism. With the gestural Abstract Expressionists, paint and the way it behaved sometimes replaced narrative content entirely, emerging finally as the "subject" of painting. In sculpture as well, the texture of the medium became an increasingly significant feature of the work.

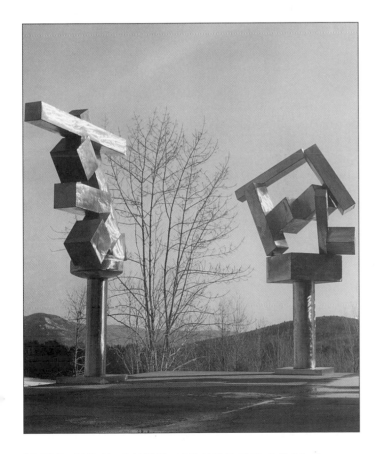

28.25 David Smith, *Cubi XVIII* and *Cubi XVII*, 1963–4. Polished stainless steel, 9 ft 7¾ in and 9 ft (2.94 and 2.74 m) high. Courtesy, Museum of Fine Arts, Boston (Gift of Susan W. and Stephen D. Paine), and Dallas Museum of Fine Arts.

Style/Period	Works of Art	Cultural/Historical Developments
ABSTRACT EXPRESSIONISM AND COLOR FIELD	The Four "First Dancers" of the Navaho Night Chant Ceremony (**28.7**) Wapo Creek spirit figure (**28.22**)	
1920–1940	Gorky, The Artist and his Mother (**28.3**) Pollock, Going West (**28.5**) Mondrian, Trafalgar Square (**28.19**)	Emigration of Bauhaus artists to the U.S.A. (late 1930s) World War II (1939–45) Gone with the Wind wins Oscar for Best Picture (1939)
1940–1950	Pollock, Guardians of the Secret (**28.6**) Gorky, Garden in Sochi (**28.4**) Noguchi, Kouros (**28.24**) Rothko, Baptismal Scene (**28.13**) Pollock, Black and White (**28.9**)	Graham Greene, The Power and the Glory (1940) Edmund Wilson, To the Finland Station (1940) Penicillin developed as an antibiotic (1940) Japan attacks Pearl Harbor; U.S.A. enters war (1941) Albert Camus, L'Etranger (1942) Aaron Copland, Rodeo (1942) Rodgers and Hammerstein, Oklahoma (1943) Jean-Paul Sartre, L'Etre et le Néant (1943) Atomic bomb dropped on Hiroshima (1945) Establishment of United Nations (1945) Beginning of the Cold War (1945) Benjamin Britten, Peter Grimes (1945) India achieves independence from British rule (1947) Tennessee Williams, A Streetcar Named Desire (1947) Nation of Israel established (1948) Alan Paton, Cry, The Beloved Country (1948) People's Republic of China established (1949)
1950–1960	Namuth, Jackson Pollock Painting (**28.8**) de Kooning, Woman and Bicycle (**28.11**) Kline, Mahoning (**28.10**) Rothko, Green on Blue (**28.14**) Nevelson, Black Wall (**28.26**) Hofmann, The Gate (**28.1**)	Korean War (1950–53) John Van Druten, I Am a Camera (1951) James Jones, From Here to Eternity (1951) J. D. Salinger, Catcher in the Rye (1951) Samuel Beckett, Waiting for Godot (1952) Watson and Crick describe the double-helix structure of DNA (1953) Arthur Miller, A View from the Bridge (1953) Vladimir Nabokov, Lolita (1955) Ingmar Bergman, The Seventh Seal (1956) Leonard Bernstein, West Side Story (1957) Boris Pasternak, Dr. Zhivago (1958) Truman Capote, Breakfast at Tiffany's (1958) Ionesco, Rhinocéros (1959)
1960–1990	Smith, Cubi XVIII and Cubi XVII (**28.25**) Frankenthaler, The Bay (**28.12**) Dubuffet, The Reveler (**28.21**) Kelly, Red, Yellow, Blue (**28.19**) Stella, Empress of India (**28.16**) Reinhardt, Abstract Painting (Black) (**28.15**) Stella, Tahkt-i-Sulayman I (**28.17**) Kelly, Spectrum III (**28.18**) Bacon, Portrait of Isabel Rawsthorne Standing in a Street in Soho (**28.23**) Albers, Homage to the Square (**28.2**) Diebenkorn, Ocean Park No. 129 (**28.20**)	Harper Lee, To Kill a Mocking Bird (1960) Construction of the Berlin Wall (1961) Joseph Heller, Catch-22 (1961) First U.S. intervention in Vietnam (1962) James Baldwin, Another Country (1962) President John F. Kennedy assassinated (1963) The Beatles, 'I Want to Hold Your Hand' (1964) Entire genetic code decoded (1966) Harold Pinter, The Homecoming (1967) Martin Luther King assassinated (1968) James D. Watson, The Double Helix (1968) Apollo II lands on the moon (1969)

Timeline sidebar years: 1920 | 1940 | 1950 | 1960 | 1990

Pollock, *Black and White*

Noguchi, *Kouros*

Rothko, *Green on Blue*

de Kooning, *Woman and Bicycle*

Stella, *Tahkt-i-Sulayman I*

29

Pop Art, Op Art, Minimalism, and Conceptualism

In the late 1950s and 1960s, a reaction against both the nonfigurative and seemingly egocentric character of Abstract Expressionism took the form of a return to the object. The most prominent style to emerge in America in the 1960s was "Pop," although the origins of the style are to be found in England in the 1950s. The popular imagery of Pop Art was derived from commercial sources, the mass media, and everyday life. In contrast to Abstract Expressionist subjectivity—which viewed the work of art as a revelation of the artist's inner, unconscious mind—the Pop artists strove for an "objectivity" embodied by an imagery of objects. What contributed to the special impact of Pop Art was the mundane character of the objects selected. As a result, Pop Art was regarded by many as an assault on accepted conventions and esthetic standards.

Despite the 1960s emphasis on the objective "here-and-now," however, the artists of that period were not completely detached from historical influences or psychological expression. The elevation of everyday objects to the status of artistic imagery, for example, can be traced to the early twentieth-century taste for "found objects" and assemblage. Likewise, the widespread incorporation of letters and numbers into the new iconography of Pop Art reflects the influence of the newspaper collages produced by Picasso and Braque.

Another artistic expression of the 1960s, the so-called **happenings**, probably derived from the Dada performances at the Café Voltaire in Zurich during World War I. Happenings, in which many Pop artists participated, were multimedia events that took place in specially created environments. They included painting, assemblage, television, radio, film, and artificial lighting. Improvisation and audience participation encouraged a spontaneous, ahistorical atmosphere that called for self-expression in the "here-and-now." Happenings were also a response to consumerism and the fact that works of art were valued as commodities. In a Happening, there is no commodity, for nothing about it—unless it is recorded and videotaped—is permanent.

Pop Art in England: Richard Hamilton

The small collage *Just what is it that makes today's homes so different, so appealing?* (fig. **29.1**), by the English artist Richard Hamilton (b. 1922), was originally intended for reproduction on a poster. It can be considered a visual manifesto of what was to become the Pop Art movement. First exhibited in London in a 1956 show entitled "This is Tomorrow," Hamilton's collage inspired an English critic to coin the term "Pop."

The muscleman in the middle of the modern living room is a conflation of the Classical *Spearbearer* (Vol. I, fig. 6.26) by Polykleitos and the *Medici Venus* (see fig. 14.28). The giant Tootsie Pop directed toward the woman on the couch is at once a sexual, visual, and verbal pun. Advertising references occur in the sign pointing to the vacuum hose, the Ford car emblem, and the label on the tin of ham. Mass media imagery is explicit in the tape recorder, television set, newspaper, and movie theater. The framed cover of *Young Romance* magazine reflects popular teenage reading of the 1950s.

Despite the iconographic insistence on what was contemporary, however, Hamilton's collage contains traditional historical references. The image of a white-gloved Al Jolson on the billboard advertising *The Jazz Singer* recalls an earlier era of American entertainment. The old-fashioned portrait on the wall evokes an artistic past, and the silicon pin-up on the couch is a plasticized version of the traditional reclining nude. Hamilton's detailed attention to the depiction of objects, especially those associated with the domestic interior, reveals his respect for fifteenth-century Flemish painters, as well as his stated admiration for Duchamp.

As a guide to subsequent Pop artists, Hamilton compiled a checklist of Pop Art subject-matter: "Popular (designed for a mass audience), transient (short-term solution), expendable (easily forgotten), low-cost, mass-produced, young (aimed at youth), witty, sexy, gimmicky, glamorous, big business."

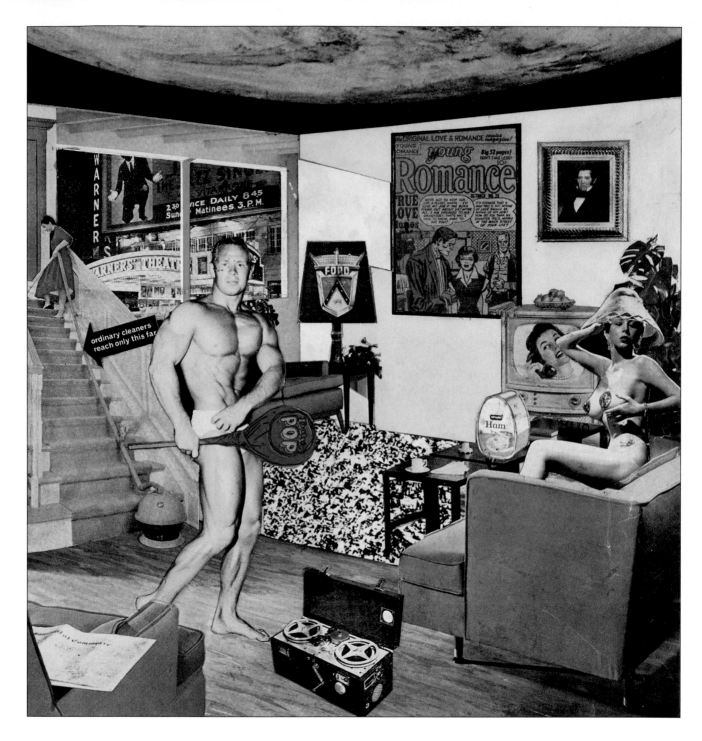

29.1 Richard Hamilton, *Just what is it that makes today's homes so different, so appealing?*, 1956. Collage on paper, 10¼ × 9¼ in (26 × 23.5 cm). Kunsthalle, Tübingen (Collection, Professor Dr. Georg Zundel).

Pop Art in the United States

Painting

Although Pop Art made its début in London in 1956 and continued in England throughout the 1960s, it reached its fullest development in New York. In 1962 an exhibition of the "New Realists" at the Sidney Janis Gallery gave Pop artists official status in the New York art world. Pop Art, however, was never a homogeneous style, and within this classification are many artists whose imagery and technique differ significantly. The first three artists dis-

cussed here—Jasper Johns, Larry Rivers, and Robert Rauschenberg—are actually transitional between Abstract Expressionism and Pop, for they combine textured, painterly brushwork with a return to the object.

Jasper Johns One of the constant themes of Jasper Johns (b. 1930) is the boundary between everyday objects and the work of art. In the late 1950s he chose a number of objects whose representation he explored in different ways, including the map and flag of the United States, targets, and stenciled numbers and words. In *Three Flags* of 1958 (fig. **29.2**) Johns depicts a popular image that is also

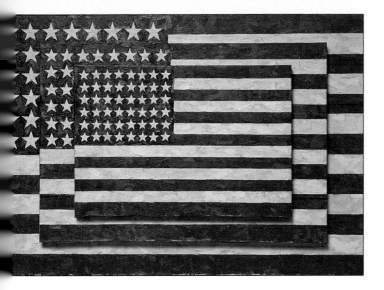

Abstract Expressionism with the representation of a popular and well-known object. One question raised by Johns's treatment of this subject is "When does the flag cease to be a patriotic sign or symbol and become an artistic image?"

Larry Rivers Larry Rivers (b. 1923) studied with Hans Hofmann (see Chapter 28) and has never lost his sense of painterly texture. His *Portrait of Frank O'Hara* (fig. **29.3**) combines words with the poet's image. "O'Hara" is stenciled over the poet's head, and individual words are written at the left. The picture is co-signed "Rivers" above "O'Hara" near the figure's shoulder on the right, signifying that the work is a collaborative effort of painter and poet. As such, the portrait recalls Dada combinations of words and pictures, and other forms of multimedia experimentation.

Robert Rauschenberg Robert Rauschenberg (b. 1925) was as liberal in his choice of imagery as Johns was frugal. His sculptures and "combines"—descendants of Duchamp's Ready-mades and Picasso's assemblages—include stuffed animals, quilts, pillows, and rubber tires. His paintings contain images from a wide variety of sources, such as newspapers, television, billboards, and old masters.

29.2 Jasper Johns, *Three Flags*, 1958. Encaustic on canvas, 30⅞ × 45½ × 5 in (78.4 × 115.6 × 12.7 cm). Collection, Whitney Museum of American Art, New York (50th Anniversary Gift of Gilman Foundation, Lauder Foundation, A. Alfred Taubman, anonymous donor, purchase).

a national emblem. His flags are built up with superimposed canvas strips covered with wax **encaustic**—a combination that creates a pronounced sense of surface texture. "Using the design of the American flag," Johns has been quoted as saying, "took care of a great deal for me because I didn't have to design it." The flag is abstract insofar as it consists of pure geometric shapes (stars and rectangles), but it is also an instantly recognizable, familiar object. The American flag has its own history, and the encaustic medium that Johns used to paint it dates back to antiquity (see Vol. I, p. 148). It thus combines the painterly qualities of

29.3 Larry Rivers, *Portrait of Frank O'Hara*, 1961. Oil on canvas, 36 × 36 in (91.4 × 91.4 cm). Private collection. Photo Maggie Nimkin. Rivers worked as a professional saxophonist before taking up painting in 1945. His portrait of Frank O'Hara (1926–66), a post-World War II poet, playwright, and art critic, reveals his interest in diverse expressive media. O'Hara himself worked as a curator at the Museum of Modern Art, New York, and his poems depict mental states of consciousness in a style reminiscent of Abstract Expressionism.

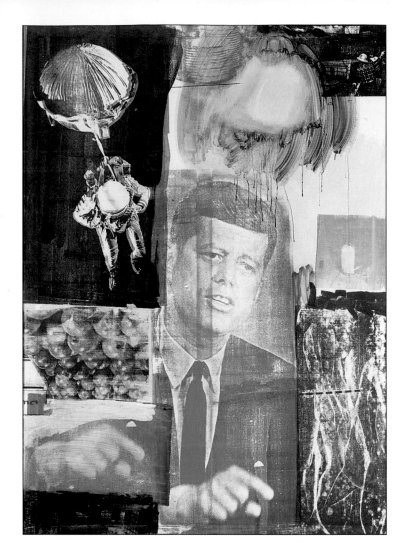

29.4 Robert Rauschenberg, *Retroactive I*, 1964. Silkscreen print with oil on canvas, 7 × 5 ft (2.13 × 1.52 m). Wadsworth Athenaeum, Hartford, Connecticut (Gift of Susan Morse Hilles).

The **silkscreen** print of 1964, *Retroactive I* (fig. **29.4**), is an arrangement of cut-outs resembling a collage. It illustrates the artist's expressed wish to "unfocus" the mind of the viewer by presenting simultaneous images that are open to multiple interpretations. The newspaper imagery evokes current events, reflecting the contemporary emphasis of Pop Art. A returning astronaut parachutes to earth in the upper left frame, while in the center President Kennedy, who had been assassinated the previous year, extends his finger as if to underline a point. The frame at the

lower right reveals a historical thread behind Rauschenberg's "current events" iconography. It contains a blow-up of a stroboscopic photograph of a take-off on Duchamp's *Nude Descending a Staircase* (see fig. 26.18); at the same time, it is strongly reminiscent of Masaccio's *Expulsion of Adam and Eve* of c. 1425 (see fig. 14.27).

Despite the presence of media images in this print, Rauschenberg seems to have covered it with a thin veil of paint. Brushstrokes and drips running down the picture's surface are particularly apparent at the top. The dripping motion of paint parallels the fall of the astronaut, while one drip lands humorously in a glass of liquid embedded in the green patch on the right. More hidden, or "veiled," is the iconographic parallel between the falling paint, the astronaut, and the "Fall of Man." Kennedy's "mythic" character is implied by his formal similarity to the Christ of Michelangelo's *Last Judgment* (see fig. 15.28) and to God in his *Creation of Adam* (see fig. 15.25).

Andy Warhol Andy Warhol (1928–87) was the chief protagonist of the Pop Art lifestyle, as well as the creator of highly individual works of art. With his flair for multimedia events and self-promotion, Warhol turned himself into a work of Pop Art, and became the central figure of a controversial cult. One of his most characteristic works, *200 Campbell's Soup Cans* of 1962 (fig. **29.5**), illustrates his taste for repeated commercial images. Since a label is, in effect, an advertisement for a product, Warhol's painting forces the viewer to confront the sameness and repetition inherent in advertising. The clear precision of his forms and the absence of any visible reference to paint texture intensify the confrontation with the object represented—with the object-as-object. Warhol's famous assertion "I want to be a machine" expresses his obsession with mass production and his personal identification with the mechanical, mindless, and repetitive qualities of mass consumption.

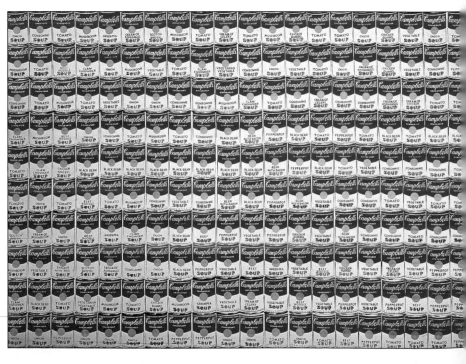

29.5 Andy Warhol, *200 Campbell's Soup Cans*, 1962. Synthetic polymer paint and silkscreen ink on canvas, 6 ft × 8 ft 4 in (1.83 × 2.54 m). The Andy Warhol Foundation for the Visual Arts/ARS. The smooth surface of Warhol's canvas replicates the illusion of paper labels stretched over metal cans.

Roy Lichtenstein Popular American reading matter of the 1940s and 1950s included comic books. These provided the source for some of the best-known images of Roy Lichtenstein (1923–97). He monumentalized the flat, clear comic-book drawings with "balloons" containing dialogue. *Torpedo … Los!* (fig. **29.6**) is a blow-up inspired by a war comic, illustrating a U-boat captain launching a torpedo. The impression of violence is enhanced by the close-up of the figure's open mouth and scarred cheek. The absence of shading, except for some rudimentary hatching, and the clear, outlined forms replicate the character of comic-book imagery.

In addition to comic books, Lichtenstein became inspired by the work of previous artists—Picasso, Matisse, Mondrian, and others—and he painted versions of their pictures. He also did a series of paintings in which he made "objects" out of brushstrokes (fig. **29.7**), which are implicit comments on the "objectlessness" of many Abstract Expressionist works. As with the comic-book imagery, Lichtenstein enlarges the brushstrokes along with their drips and splatters, indicating in solid black the indentations in the paint made by the bristles of the brush. But the flattening of the paint eliminates the natural texture of such a brushstroke. The background is composed of hundreds of Ben Day dots, which identify the surface of commercially printed paper and render the image itself static.

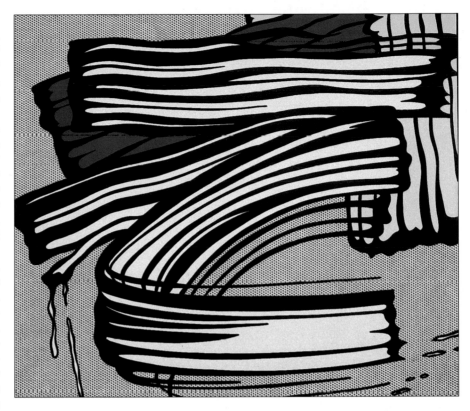

29.7 Roy Lichtenstein, *Little Big Picture*, 1965. Oil and synthetic polymer on canvas, 5 ft 8 in × 6 ft 8 in (1.73 × 2.03 m). Whitney Museum of American Art, New York (Purchase, friends of Whitney Museum of American Art).

By isolating the brushstroke, Lichtenstein "objectifies" it. At the same time, he retains the dynamic movement and gestural expressiveness of the Action painters. In this combination of techniques, he creates a synthesis of the Pop Art taste for objects with the Abstract Expressionist transformation of medium into content. The title of the painting illustrated here, *Little Big Picture*, refers to the battle of 1876, in which General George Armstrong Custer made his famous "last stand" against the Sioux—the Battle of Little Bighorn. Lichtenstein thus links the cultural struggles that made American history with conflicting styles of American art.

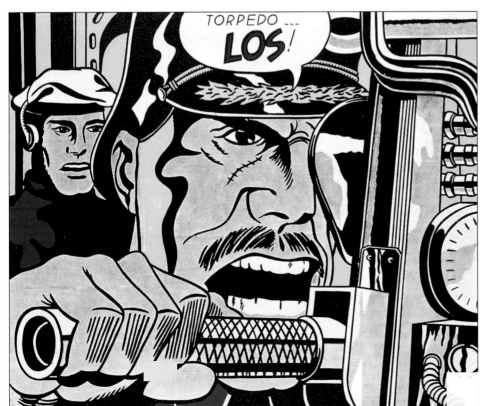

29.6 Roy Lichtenstein, *Torpedo … Los!*, 1963. Oil on canvas, 5 ft 8 in × 6 ft 8 in (1.73 × 2.03 m). Courtesy, Roy Lichtenstein.

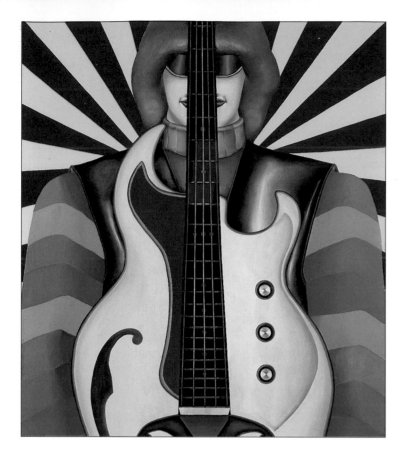

29.8 Richard Lindner, *Rock-Rock*, 1966–7. Oil on canvas, 5 ft 10 in ×
5 ft (1.78 × 1.52 m). Dallas Museum of Fine Arts (Gift of Mr. and
Mrs. James H. Clark).

Richard Lindner

Richard Lindner (1901–78) was born in
Hamburg, Germany, and emigrated to the United States in
1941. His mechanical figures are somewhat reminiscent of
Léger's brand of volumetric Cubism, but his bright colors,
and metallic and shiny leather surfaces have affinities with
Pop Art. *Rock-Rock* of 1966–7 (fig. **29.8**) has an electric
quality that recalls the blinking lights and tinny sounds of
pinball machines, as well as the dynamic energy of rock
music. It depicts the rock star in a frontal pose, as a cul-
tural icon of ambiguous gender. The dark glasses enhance
the anonymity of the figure, while the background diago-
nals radiate in the manner of a halo. Bisecting the compo-
sition is the electric guitar, which has become a hallmark
of the rock movement. It is also a formal reminder of Man
Ray's Surrealist photograph, *Le Violon d'Ingres* (see fig.
27.7), in which the violin is conflated with the back of the
nude woman. In *Rock-Rock*, the guitar merges with the
torso of the rock star—it curves around the collar, and the
holes at the right take on the quality of buttons. The figure

29.9 R. B. Kitaj, *Juan de la Cruz*, 1967. Oil on canvas, 6 ft × 5 ft
(1.83 × 1.52 m). Astrup Fearnley Museum of Modern Art, Oslo.
Kitaj was born in Cleveland, Ohio. After World War II he became
preoccupied with his Jewish heritage and the Holocaust. His interest
in Saint Theresa, originally a Jew, and in Saint John of the Cross, who
was rumored to have been Jewish, is related to Kitaj's sense of his
own cultural identity. Although she became a Christian mystic, Saint
Theresa was accused by the Inquisition of having relapsed. Saint John
of the Cross was her protégé, and a mystic poet.

seems literally to "wear" the guitar, which, in the end, *is* its
identity.

R. B. Kitaj An entirely different atmosphere pervades
the Pop Art of R. B. Kitaj (1932–97), an American artist
who lived and worked in London. His *Juan de la Cruz* of
1967 (fig. **29.9**) depicts a black American, Sergeant Cross,
as a soldier during the Vietnam War. Through the window
to his right, a nude Saint Theresa (see caption) wearing
high heels is ordered to walk the plank by two thugs in the
guise of Counter-Reformation Inquisitors. Kitaj relates the
abuses of the Inquisition to various forms of twentieth-
century discrimination by juxtaposing different cultural
allusions. For example, the woman's nudity accentuates
her victimization by the two men, the black sergeant fights
for a country that discriminates against his people, while
the Hispanic title of the painting merges another Ameri-
can minority with the Spanish martyr. Formally, too,
Kitaj's arrangement of slightly textured patches of color
recalls the juxtapositions of collage.

Tom Wesselmann The *Great American Nude* series of
Tom Wesselmann (b. 1931) combines Hollywood pin-ups
with the traditional reclining nude. In *No. 57* (fig. **29.10**)
the nude is a symbol of American vulgarity. She lies on a
leopard skin, while two stars on the back wall evoke the
American flag. She is faceless except for her open mouth,
and her body bears the suntan traces of a bathing suit. Her
pose is related to figures such as Titian's *Venus of Urbino*
(see fig. 15.54) and Manet's *Olympia* (see fig. 22.22), but

Wesselmann's surfaces are unmodeled. The partly drawn curtain reveals a distant landscape, and the oranges and flowers refer to the woman's traditional role as a fertile earth goddess. This metaphor is reinforced by the formal parallels between the mouth, nipples, and interior of the flowers. In this work, Wesselmann combines three-dimensional forms with flattened geometric abstractions, the interior bedroom with exterior landscape, and intimacy with universal themes.

Wayne Thiebaud Born in 1920, West Coast artist Wayne Thiebaud arranges objects in a self-consciously ordered manner. Although identified with Pop Art, he, like Larry Rivers, emphasizes the texture of paint. In the 1960s Thiebaud focused on cafeteria-style food arrangements, but his content of the following decades includes a wide range of objects, portraits, and atmospheric images of cloud formations and landscape.

His *Thirteen Books* of 1992 (fig. **29.11**) depicts a neat pile of books, which has a constructed, architectural quality that is enhanced by the oblique angle. Each book functions as an individual structural element that nevertheless contributes to the effect of the whole. The textured edges of the books and the bright colors of their spines contrast with the stark, white background. The titles are blurred and unreadable, thereby suggesting the hidden, secret content of the proverbial "closed book."

To the right of the stack, there is no distinction between the surface supporting the books and the background space. This leaves the viewer uncertain of their exact placement in space—they seem to float in a plane of white. At the left, on the other hand, the books cast a grey, trapezoidal shadow edged in orange, which identifies a source of light and confirms the presence of a supporting surface. The predominance of white is characteristic of the artist's paintings of objects. White was of particular interest to Thiebaud as it combines all colors, as well as simultaneously absorbing and reflecting light.

Sculpture

Generally included among the leading New York Pop artists are the sculptors Claes Oldenburg (b. 1929) and George Segal (b. 1924). Although both can be considered Pop artists in the sense that their subject-matter is derived from everyday objects and the media, their work is distinctive in maintaining a sense of the textural reality of their materials.

Claes Oldenburg Oldenburg has produced an enormous, innovative body of imagery, ranging from clothing, lightswitches, food displays, and furniture sets to tea bags.

29.10 (above) Tom Wesselmann, *Great American Nude No. 57*, 1964. Synthetic polymer on composition board, 4 ft × 5 ft 5 in (1.22 × 1.65 m). Whitney Museum of American Art, New York (Purchase).

29.11 Wayne Thiebaud, *Thirteen Books*, 1992. Oil on panel, 13 × 10 in (33 × 25.4 cm). Allan Stone Gallery, New York.

The *Giant Soft Drum Set (Ghost Version)* of 1972 (fig. **29.12**) is one of his "soft sculptures." In these works, which are composed of materials such as vinyl and canvas, he typically represents a hard, solid object in soft form. The effect on the observer can be startling, because tactile expectations are reversed. Since drums require a degree of tautness in order to create sound, soft drums are without sound and, therefore, impotent. In this sculpture, Oldenburg's drums and batons have collapsed on their pedestal, as if worn out from overwork. The drums sag, and the metal stays and batons are splayed and flat, assuming a spread-eagled human quality despite their inanimate nature.

Oldenburg takes a different approach with other popular objects. His giant *Clothespin* of 1976 in Philadelphia (fig. **29.13**) illustrates his enlargement of objects that are small in everyday experience. Like the soft drums, the *Clothespin* has an anthropomorphic quality. It resembles a tall man, standing with his legs apart, as if striding forward. The wire spring suggests an arm, and the curved top with its two circular openings, a head and face. Despite the hard texture of this work, Oldenburg manages to arouse a tactile response by association with actual clothespins. Pressing together the "legs," for example, would cause the spring to open up the spaces at the center of the "head." The tactile urge aroused by the clothespin, together with its anthropomorphic character, reflects Oldenburg's talent for conveying paradox and metaphor. The

29.13 Claes Oldenburg, *Clothespin*, Central Square, Philadelphia, 1976. Cor-ten and stainless steel, 45 ft × 6 ft 3¾ in × 4 ft ⅓ in (13.7 × 1.92 × 1.32 m). This is one of several "projects for colossal monuments," based on everyday objects, which Oldenburg proposed for various cities. Others include a giant *Teddy Bear* for New York, a *Drainpipe* for Toronto, and a *Lipstick* for London (presented to Yale University in 1969). Oldenburg says that he has always been "fascinated by the values attached to size."

clothespin thus assumes the quality of a visual pun, which is reminiscent of Picasso's *Bull's Head* (see fig. 26.9) and of the unlikely, surprising juxtapositions of the Surrealist esthetic that were calculated to raise the consciousness of the viewer.

George Segal The sculptures of George Segal differ from Oldenburg's in that they are quite literally "figurative." Segal creates environments in which he sets figures, singly or in groups, that convey a sense of isolation or self-absorption. In *Chance Meeting* (fig. **29.14**) three lifesize pedestrians encounter each other by a one-way street sign. Their otherworldliness is emphasized by Segal's "mummification" of living figures (see caption) and the impression that they do not communicate. Their light, textured surfaces create a paradoxical impression of emotional coldness for, although they have been molded from living people, they seem ghostly and alien.

Segal also uses his technique of "wrapping" living people in plaster for portraiture. His sculpture of *Sidney Janis Looking at a Painting by Mondrian* (fig. **29.15**) is about looking and seeing, as well as the development of twentieth-century abstraction. Segal combines his own figuration with the non-figural, geometric abstraction of Mondrian. Segal has described the gesture of Janis as a caress, expressing his kinship with the Mondrian. In 1932, before becoming an art dealer, Janis bought the painting for seventy-five dollars for his private collection. Thirty years later, when Segal did the portrait, he suggested including the Mondrian, which is removable and has been exhibited separately. In contemplating the Mondrian,

29.12 Claes Oldenburg, *Giant Soft Drum Set (Ghost Version)*, 1972. Wood, metal, canvas, polystyrene, acrylic, 4 × 7 × 6 ft (1.2 × 2.1 × 1.8 m). PaceWildenstein, New York. For many of his soft sculptures made mainly of vinyl, which has a shiny texture, Oldenburg created a "ghost" version, which was drained of color and made of canvas. This is the ghost version of his soft drum set.

29.15 George Segal, *Sidney Janis Looking at a Painting by Mondrian*, 1967. Sculpture, 66 in (167.6 cm) high; easel, 67 in (170 cm) high; Mondrian *Composition* (1933), oil on canvas, 16¼ × 13⅛ in (41.3 × 33.3 cm). Museum of Modern Art, New York (Sidney and Harriet Janis Collection). Janis was Segal's dealer and a promoter of the avant-garde. He mounted exhibitions of Duchamp, Mondrian, Brancusi, and the Abstract Expressionists before the "New Realists" show of 1962.

Janis symbolically gazes on the art of the past, on the work of a seminal artist of the twentieth century, while also participating in Segal's expression of the contemporary.

Marisol Escobar Marisol Escobar's (b. 1930) brand of Pop Art combines Cubist-inspired blocks of wood with figuration. In her monumental sculptural installation of *The Last Supper* (fig. 29.16) she recreates Leonardo's fresco

29.16 Marisol, *The Last Supper* (installed at the Sidney Janis Gallery), 1982. Wood, brownstone, plaster, paint, and charcoal, 10 ft 1 in × 29 ft 10 in × 5 ft 7 in (3.07 × 9.09 × 1.7 m). Photo courtesy of Sidney Janis Gallery, New York

29.14 (above) George Segal, *Chance Meeting*, 1989. Plaster, paint, aluminum post, and metal sign, 10 ft 3 in × 3 ft 5 in × 4 ft 7 in (3.12 × 1.04 × 1.4 m). Photo courtesy of Sidney Janis Gallery, New York. Segal wraps the subject's body in gauze bandages dipped in wet plaster. Once the plaster has hardened, he cuts it off in sections, which he then reassembles. His effigies, the descendants of Egyptian mummies and Roman death masks, are usually in unpainted white plaster, but sometimes in gray or color. Segal's subjects, however, are alive when the cast is made, and are often depicted in the course of some activity.

(see fig. 15.15) in a modern idiom. The architectural setting replicates the Leonardo, with four rectangular panels on either side that recede toward a back wall, a triple window, and a curved pediment. The apostles, like Leonardo's, are arranged in four groups of three, with corresponding poses. An image of Marisol herself sits opposite the scene, playing the role of viewer as well as artist. As viewer, Marisol contemplates the past, which she appropriates

and integrates into her own contemporary style. Art history itself is thus a subject of this installation, and is a component of other examples of Pop Art as well. Marisol, like Sidney Janis in Segal's portrait, communicates with the art-historical past by participating in the work.

Niki de Saint-Phalle Niki de Saint-Phalle (b. 1930) was born in Paris, grew up in New York, and returned to Paris in 1951. There she began painting and making combinations of reliefs and assemblages, using toys as a primary medium. She was originally part of the French *nouveaux réalistes*, a group of artists that was formed in 1960. In New York, these artists were termed the "New Realists," which was also the title of the exhibition held in 1962 at the Sidney Janis Gallery.

De Saint-Phalle's most characteristic works are her so-called *Nanas*, which are polyester sculptures of large women. Generally, as with her *Black Venus* of 1967 (fig. **29.17**), the *Nanas* are painted in bright, unshaded colors that are remininiscent of folk imagery. The torso of this figure looks inflated, ironically even more so than the beach ball, which seems to be losing its air. De Saint-Phalle's *Venus* shares exaggerated breasts and hips with the Paleolithic *Venus of Willendorf* (see Vol. I, fig. 2.1), but the head is small by comparison, a device that has a Mannerist quality. The figure also seems engaged in an energetic dance movement, which, together with its "blackness," allies it with the exuberance and modernism of jazz.

Op Art

Another artistic movement that flourished during the 1960s has been called Optical, or Op, Art. In 1965 the Museum of Modern Art contributed to the vogue for the style by including it in an exhibition entitled "The Responsive Eye." Op Art is akin to Pop Art in rhyme only, for the recognizable object is totally eliminated from Op Art in favor of geometric abstraction, and the experience of it is exclusively retinal. The Op artists produced kinetic effects (that is, illusions of movement), using arrangements of color, lines, and shapes, or some combination of these elements.

In *Aubade* (*Dawn*) of 1975 (fig. **29.18**), by the British painter Bridget Riley (b. 1931), there are evident affinities with Albers and the Color Field painters. Riley has arranged pinks, greens, and blues in undulating vertical curves of varying widths, evoking the vibrancy of dawn itself. The changing width of each line, combined with the changing hues, makes her picture plane pulsate with movement.

Minimalism

Sculptures of the 1960s "objectless" movement were called "minimal," or "primary," structures, because they were direct statements of solid geometric form. In contrast to

29.17 Niki de Saint-Phalle, *Black Venus*, 1965–7. Painted polyester, 110 × 35 × 24 in (279 × 88.5 × 61 cm). Whitney Museum of American Art, New York (Gift of Howard and Jean Lipman Foundation).

29.18 Bridget Riley, *Aubade (Dawn)*, 1975. Acrylic on linen, 6 ft 10 in × 8 ft 11½ in (2.08 × 2.73 m). Private collection. Photo courtesy of Sidney Janis Gallery, New York. Riley's work generally relies on two effects—producing a hallucinatory illusion of movement (as here), or encouraging the viewer to focus on a particular area before using secondary shapes and patterns to intrude and disturb the original perception. Riley's early Op Art pictures were in black and white and shades of gray. In the mid-1960s she turned to color compositions such as this one.

the personalized process of Abstract Expressionism, Minimalism, like Color Field painting, eliminates all sense of the artist's role in the work, leaving only the medium for viewers to contemplate. There is no reference to narrative or to nature, and no content beyond the medium itself. The impersonal character of Minimalist sculptures is intended to convey the idea that a work of art is a pure object having only shape and texture in relation to space.

Donald Judd

Untitled (fig. **29.19**) by Donald Judd (1928–94) is a set of rectangular "boxes" derived from the solid geometric shapes of David Smith's *Cubi* series (see fig. 28.25) and the "minimal" simplicity of Ad Reinhardt (see fig. 28.15). Judd's boxes, however, do not stand on a pedestal. Instead, they hang from the wall, thereby involving the immediate environment in the viewer's experience of them. They are made of galvanized iron and painted with green lacquer, reflecting the Minimalist preference for industrial materials. Judd has arranged the boxes vertically, with each one placed exactly above another at regular intervals, to create a harmonious balance. The shadows cast on the wall, which vary according to the interior lighting, participate in the design. They break the monotony of the repeated modules by forming trapezoids between each box, and between the lowest box and the floor. The shadows also emphasize the vertical character of the boxes by linking them visually, and creating the impression of a modern, nonstructural pilaster.

29.19 Donald Judd, *Untitled*, 1967. Green lacquer on galvanized iron, each unit 9 × 40 × 31 in (23 × 102 × 79 cm). Museum of Modern Art, New York. Helen Achen Bequest and gift of Joseph A. Helman. Photo © 1998 Museum of Modern Art.

Dan Flavin

Light is the primary medium of the Minimalist fluorescent sculptures of Dan Flavin (b. 1933). As store-bought objects transformed into "art" by virtue of the artist's intervention, they can be related to Duchamp's Ready-mades. Flavin defines interior architectural spaces with tubes of fluorescent lights arranged in geometric patterns or shapes. Light spreads from the tubes and infiltrates the environment, creating an installation within an available space. The technological character of the medium and its impersonal geometry is typical of the Minimalist esthetic. Sometimes, as in *Untitled (in Honor of Harold Joachim)* (fig.

29.20 Dan Flavin, *Untitled (in Honor of Harold Joachim)*, 1977. Fluorescent light fixtures with pink, blue, green, and yellow tubes, 8 ft (2.44 m) square across the corner. Courtesy, Dia Center of the Arts, New York. Flavin described this work as a "corner installation ... intended to be beautiful, to produce the color mix of a lovely illusion. ... [He] did not expect the change from the slightly blue daylight tint on the red rose pink near the paired tubes to the light yellow midway between tubes and the wall juncture to yellow amber over the corner itself."[1]

29.20), the color combinations are quite unexpected. Flavin's merging of light and color, dependent as it is on technology and twentieth-century nonrepresentation, nevertheless has a spiritual quality that ironically allies his work with stained glass windows and the play of light and color inside Gothic cathedrals.

Agnes Martin

The early work of Agnes Martin (b. 1912) was an inspiration to the Minimalists, but she developed in a more painterly direction. She was born in Saskatchewan, Canada, and moved to the United States in the 1930s. Her first one-woman show was held at the Betty Parsons Gallery in New York City. Martin's early all-over grid paintings consisted of grids penciled by hand that criss-crossed the canvas, which appeared, like Minimalist sculpture, to "minimalize" the presence of the artist. In contrast to the Minimalists, however, she filled the picture plane with glowing color that seems to radiate from an inner mental landscape projected

29.21 Agnes Martin, *Untitled No. 9*, 1990. Synthetic polymer and graphite on canvas, 6 × 6 ft (1.83 × 1.83 m). Whitney Museum of American Art, New York (Gift of American Art Foundation).

beneath the material surface of the finished work. In so doing, she revealed affinities with the vast—because conceptually vast—pictorial spaces of Ad Reinhardt and Mark Rothko.

From 1967 to 1974, Martin took a "sabbatical" from painting, and traveled through Canada and the American West, finally settling into an isolated existence in New Mexico. When she returned to painting in the 1970s, her work had changed, progressing even further beyond the material world—possibly influenced by her interest in Far Eastern philosophy. *Untitled No. 9* (fig. **29.21**) is an example of her work in 1990. The all-over grid has been replaced by gray horizontal bands that potentially extend beyond the confines of the frame. Their geometry and the fact that the grays lighten as they rise present an image that combines the structure of architecture with the changing, cyclical quality of nature.

The following are excerpts from Martin's writings that were selected to accompany her exhibition of 1992–93 at the Whitney Museum of American Art in New York:

I didn't paint the plane
I just drew this horizontal line
Then I found out about all the other lines
But I realized what I liked was the horizontal line

Art restimulates inspirations and awakens sensibilities
That's the function of art

Any thing is a mirror.
There are two endless directions. In and out.[2]

Eva Hesse

The American sculptor Eva Hesse (1936–70) took Minimalism in a new direction by consciously "writing" her autobiography into her work. As a result, she is sometimes referred to as a Post-Minimalist. She was born a Jew in Hamburg, Germany, and was taken to Amsterdam to escape Nazi persecution. After a traumatic few years, she went with her family to New York, where her mother killed herself. Hesse's psychological difficulties and sense of abandonment found expression in an art that was rooted in the forms and materials of Minimalism. She studied at the Yale School of Art, where she came under the influence of Josef Albers, and after graduation returned to Germany. She had her first solo exhibition in Düsseldorf in 1965 and, by the time of her own early death at the age of thirty-four, she had produced an influential body of work.

Hesse's *Metronomic Irregularity I* of 1966 (fig. **29.22**), the first in a series of three, explores the relationship of line to plane in a literal way. The surfaces of the rectangles are inscribed with a grid pattern; there is a small hole in the corner of each square of the grid. White cotton-covered wires are threaded from holes in one rectangle through holes in another. Formally, Hesse has juxtaposed actual, three-dimensional lines (the threads) with the flat planes of the two vertical plaques. The space between them participates in the image, creating a nonrepresentational triptych in which medium and content converge. From an autobiographical point of view, one can read the threads as attachments, binding together the plaques across a space, as a metaphor for Hesse's fear of separation and abandonment, and also as links between her two identities as German and American. Her life-long sense of anxiety is perhaps reflected in the frantic, though lyrical, quality of the connecting threads.

A similar esthetic informs her *Laocoön* of the same year (fig. **29.23**). This work, too, although not part of a series, evolved in stages. A vertical armature of plastic pipes—a combination ladder and scaffold—is wrapped in cloth. Cloth-covered cords are intertwined around the open cubes, animating their spaces.

29.22 Eva Hesse, *Metronomic Irregularity I*, 1966. Painted wood, sculpmetal, and cotton-covered wire, 12 × 18 × 1 in (30.5 × 45.7 × 2.5 cm). Robert Miller Gallery. Collection, Robert Smithson, New York.

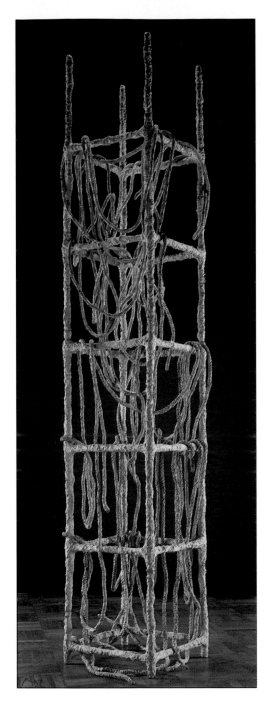

29.23 Eva Hesse, *Laocoön*, 1966. Acrylic paint, cloth-covered cord, wire, and papier-mâché over plastic plumber's pipe, 120 × 24 × 24 in (304.8 × 61 × 61 cm). Allen Memorial Art Museum, Oberlin College, Ohio. Fund for Contemporary Art and gift of the artist and the Fischbach Gallery, 1970

Hesse's sense of irony and identification with the work is revealed in its title, which refers to the second-century B.C. Hellenistic sculpture *Laocoön and his Two Sons* (fig. **29.24**). Hesse's cords bind her armature as, in the Greek statue, the snakes bind and connect the figures. But Laocoön's snakes are also the messengers and instruments of his death. Just as the snakes envelop and kill the Trojan seer and his two sons, so the cords seem both to connect and to strangle Hesse's structure. The structure is herself, uncannily prefiguring her own death from a brain tumor four years later. "My life and art," she said, "have not been separated. They have been together."[3]

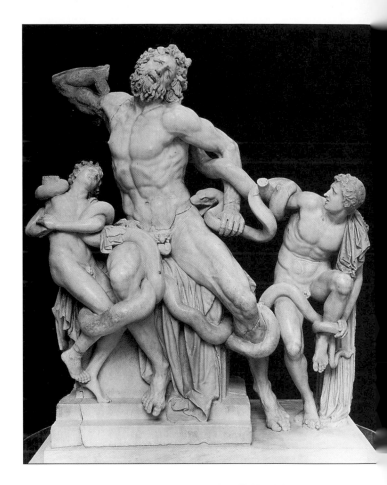

29.24 *Laocoön and his Two Sons*. Marble, 7 ft (2.13 m) high. Musei Vaticani, Rome.

From Happenings to Action Sculpture: Joseph Beuys

The German artist Joseph Beuys (1921–86), like Eva Hesse, was significantly affected by World War II, although in an entirely different way. He flew a Stuka for the Luftwaffe and was shot down by the Russians in 1943. This event led Beuys to construct an autobiographical myth that continually informed his art, and has become a staple of art-world mythology. According to Beuys, he was rescued by Tartars (a Mongolian people of central Asia) and wrapped in animal fat and felt, which kept him alive. Beuys viewed this event as a kind of resurrection through which he identified with the sufferings of Christ. Influenced by German Romanticism and Germanic myth, and impelled to atone for the German atrocities in the war, Beuys was drawn to mysticism and spirituality, and projected the self-image of a shaman on an international scale. As such, he set out to cure the social, economic, and political ills of the world. To this purpose he dedicated thousands of drawings, sculptures and, above all, a series of carefully choreographed so-called "action sculptures" with moving figures and music, conceived of as neither happenings nor performances, but containing elements of both.

Like Marc (p. 828), Beuys believed in the spirituality of animals and, like Kandinsky (p. 827), in the spiritual in art. In being a shaman, he played with the boundary between

human and animal, just as politically he worked toward peace between nations and cultures by crossing borders and merging boundaries. On July 20, 1964 (the anniversary of the unsuccessful attempt on Hitler's life), for example, he staged a performance in the cathedral at Aachen, where Charlemagne (see Vol. I, p. 339) had his court in the ninth century. Disrupted by Neo-Nazi students, Beuys became even more politically engaged, founding several leftist groups, including the predecessor to the Green Party.

Individual works of sculpture such as the *Fat Chair* (a chair wrapped in fat) and *Ur-sled* (composed of an orange box, ribbon, and fat), both of 1964, were inspired by his rescue. Other materials that were relics from his war experiences were batteries and transistors, and these, like the fat, assumed the quality of religious icons for Beuys.

The Pack (fig. **29.25**) of 1969 creates the impression of a sculpture in the process of becoming. It shows twenty sleds emerging from the back of a Volkswagen bus. Each sled carries a felt blanket roll, fat, and a flashlight, all elements Beuys associated with his rescue in a Russian snowstorm by Tartars. Their nomadic form of transportation is juxtaposed with the vehicle (*wagen*) of the "civilized" German people (*volk*), which is a reference to World War II. The arrangement and forms of the sleds animate them; they resemble enlarged insect-like creatures pouring forth from the bus and rushing to a scene of rescue. Their runners resemble legs, their flashlights, eyes, and their blanket rolls, bodies.

In 1973 Beuys became seriously ill, and once again associated his recovery with Christ's Resurrection. After that he lectured passionately about art and the state of the world, writing and drawing on a blackboard before audiences. In 1974 Beuys performed one of his most famous action sculptures, *Coyote, I Like America and America Likes Me* (figs. **29.26** and **29.27**). He arrived in New York and was taken, wrapped in felt, by ambulance to the René Block Gallery. For a week he and a live coyote performed the sculpture on the floor of the gallery, which had a pile of felt for the coyote to sit on. Fifty copies of the *Wall Street Journal* were placed on the floor every day as a sign of the financial values overwhelming modern culture. Beuys himself was wrapped up in a tent-like felt blanket with a Tartar's crook emerging from the top. As he moved, the coyote moved, and vice versa. Tied together by their gazes, at once uniting them and signifying their mutual suspicion, Beuys and the coyote engaged in a dance calculated, shaman-like, to blur the boundaries between man and animal.

Many meanings have been read into this performance, most based on Beuys' autobiographical myth. The Tartar's felt that kept him alive protects him from the wild animal, while the crook has associations with Christ-as-shepherd. To celebrate the plane crash and subsequent rescue at the Eurasian border of two continents, Beuys tries to bridge the borders of human and animal, of the Native American worship of the coyote and the white man's fear and hatred

29.25 Joseph Beuys, *The Pack*, 1969. Volkswagen bus with twenty sleds, felt, fat, and flashlights. Neue Gallery, Staatliche Museen, Kassel.

of it, and of modern commercial society and the values of a less technological age.

The esthetic quality of the action sculpture is in the planned and unplanned movements and positions of the two performers, and the lighting and setting as captured by the camera. Figure 29.26 shows the coyote gazing fixedly at the triangular felt "tent," with the crook protruding at the top in the manner of a Native American tepee. Back-lit from the window at the left, the coyote and the tent create stark silhouettes against the back wall. Both are static, frozen in space. In figure 29.27, the close-up camera angle captures the simultaneity of movement as both figures now turn in space, and the diagonal of the coyote's head and neck parallels that of the crook. The nature of the relationship, Beuys seems to be saying, moves dynamically from enmity, to suspicious contemplation and mutual assessment, to harmony. Such was his program for the world.

Conceptualism

For Beuys, thinking about art was creative, and therefore the idea itself was a work of art. In that view, he had affinities with the Conceptual artists of the 1960s, who wanted to extend Minimalism so that the materials of art would be eliminated, leaving only the idea, or concept, of the art. Like Duchamp and the Dadaists, for the Conceptualists the mental concept takes precedence over the object. This is also related to the Minimalist rejection of the object as a consumer product. Although the term itself was coined in the 1960s, Conceptual art attained official status through the 1970 exhibition at the Museum of Modern Art, New York. The show's title—"Information"—reflected the

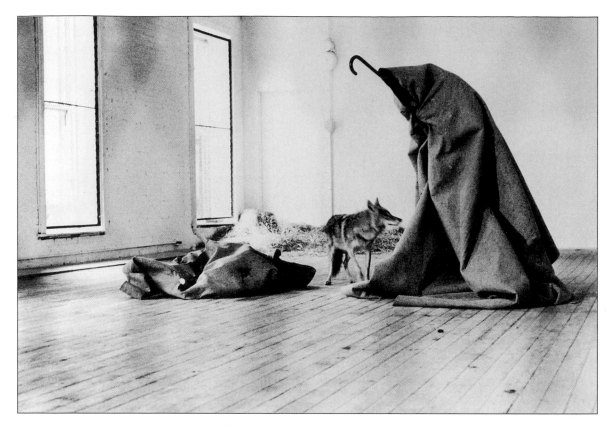

29.26 and **29.27** Joseph Beuys, *Coyote, I Like America and America Likes Me*, 1974. Action sculpture, New York, two views of a week-long sequence.

emphasis of Conceptual art on language and text, rather than on imagery.

Joseph Kosuth

Some Conceptual works combine objects with text, and others, such as Joseph Kosuth's (b. 1945) *Art as Idea as Idea* of 1966 (fig. **29.28**), consist only of text. The "text" in this instance is composed of five dictionary definitions of the noun "painting." Definition numbers 4 and 5, which are marked "Obs.," or "obsolete," describe the term in its most painterly ("colors laid on") and pictorial ("vivid image") sense. Their "obsolescence," therefore, is consistent with the takeover by the idea, and with the presumed demise of the object. At the same time, however, Kosuth presents the text as a photographic enlargement within a pictorial field. As a result, the text is as much an "object" as it is the expression of an idea.

The dichotomy of words and pictures, which Magritte portrayed in *The Betrayal of Images* (see fig. 1.3; 1.5 in the Combined Volume), is a subtext of Kosuth's *Art as Idea as Idea*. Due to the flat, empty space between Magritte's "pipe" and his written words, the artist "pictures" the developmental and conceptual space between words and pictures—children "read" pictures and objects before they read words. And animals, like the ancient Greek horse who neighed at the painted horse of Zeuxis and the birds who tried to eat his painted grapes, read images but not words. Conceptual art makes images of words by arranging ideas conveyed through words on a pictorial surface.

The 1960s was a decade of social and political upheaval both in the United States and in western Europe. It culminated in the Paris riots of May 1968, campus takeovers by

päint'ing, *n.* 1. the act or occupation of covering surfaces with paint.
2. the act, art, or occupation of picturing scenes, objects, persons, etc. in paint.
3. a picture in paint, as an oil, water color, etc.
4. colors laid on. [Obs.]
5. delineation that raises a vivid image in the mind; as, word-*painting*. [Obs.]

29.28 Joseph Kosuth, *Art As Idea as Idea*, 1966. Mounted photostat, 4 × 4 ft (1.22 × 1.22 m).

college students, and radical changes in educational curricula. The burgeoning women's movement, advances in civil rights—especially in the United States—and, above all, the Vietnam War contributed to the cultural turmoil. In the arts, these currents were expressed in the "here and now" character of the happenings and other types of artistic performances, in the protests against commercialism implied by some Pop Art, in the withdrawal from figuration by the Minimalists, and in the exaltation of the idea by the Conceptualists.

The contradictory aspect of the 1960s, in which two generations clashed over social and political issues, was reflected in the arts. On the one hand, Pop artists imposed the "object" by making it a central image, and on the other hand, they protested against the abuses of materialism and the profit motives of industry. Minimalists avoided the "figurative" object in favor of geometric form, but used industrial materials to do so. In the next and final chapter, we shall see that it is in the nature of art to evolve dynamically by continually responding to the past, while also "pushing the envelope" into the future.

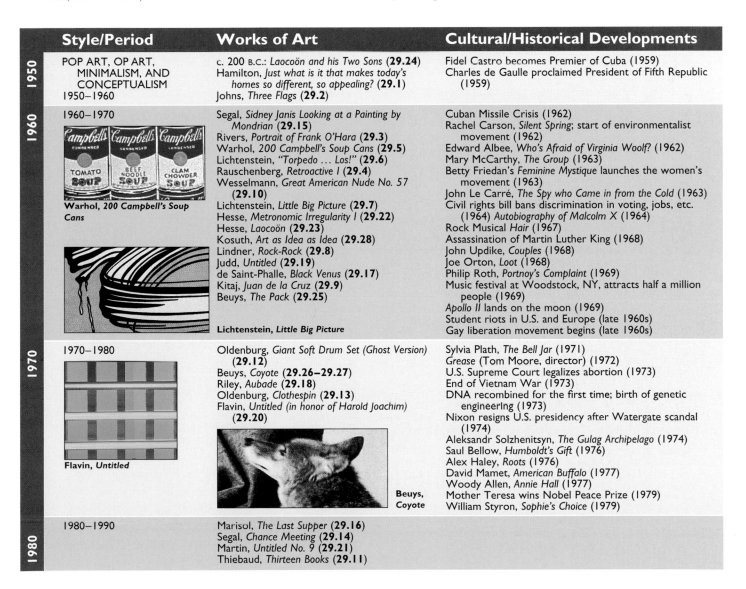

	Style/Period	Works of Art	Cultural/Historical Developments
1950	POP ART, OP ART, MINIMALISM, AND CONCEPTUALISM 1950–1960	c. 200 B.C.: *Laocoön and his Two Sons* (**29.24**) Hamilton, *Just what is it that makes today's homes so different, so appealing?* (**29.1**) Johns, *Three Flags* (**29.2**)	Fidel Castro becomes Premier of Cuba (1959) Charles de Gaulle proclaimed President of Fifth Republic (1959)
1960	1960–1970 **Warhol, 200 Campbell's Soup Cans** **Lichtenstein, Little Big Picture**	Segal, *Sidney Janis Looking at a Painting by Mondrian* (**29.15**) Rivers, *Portrait of Frank O'Hara* (**29.3**) Warhol, *200 Campbell's Soup Cans* (**29.5**) Lichtenstein, *"Torpedo ... Los!"* (**29.6**) Rauschenberg, *Retroactive I* (**29.4**) Wesselmann, *Great American Nude No. 57* (**29.10**) Lichtenstein, *Little Big Picture* (**29.7**) Hesse, *Metronomic Irregularity I* (**29.22**) Hesse, *Laocoön* (**29.23**) Kosuth, *Art as Idea as Idea* (**29.28**) Lindner, *Rock-Rock* (**29.8**) Judd, *Untitled* (**29.19**) de Saint-Phalle, *Black Venus* (**29.17**) Kitaj, *Juan de la Cruz* (**29.9**) Beuys, *The Pack* (**29.25**)	Cuban Missile Crisis (1962) Rachel Carson, *Silent Spring*; start of environmentalist movement (1962) Edward Albee, *Who's Afraid of Virginia Woolf?* (1962) Mary McCarthy, *The Group* (1963) Betty Friedan's *Feminine Mystique* launches the women's movement (1963) John Le Carré, *The Spy who Came in from the Cold* (1963) Civil rights bill bans discrimination in voting, jobs, etc. (1964) *Autobiography of Malcolm X* (1964) Rock Musical *Hair* (1967) Assassination of Martin Luther King (1968) John Updike, *Couples* (1968) Joe Orton, *Loot* (1968) Philip Roth, *Portnoy's Complaint* (1969) Music festival at Woodstock, NY, attracts half a million people (1969) *Apollo II* lands on the moon (1969) Student riots in U.S. and Europe (late 1960s) Gay liberation movement begins (late 1960s)
1970	1970–1980 **Flavin, Untitled**	Oldenburg, *Giant Soft Drum Set (Ghost Version)* (**29.12**) Beuys, *Coyote* (**29.26–29.27**) Riley, *Aubade* (**29.18**) Oldenburg, *Clothespin* (**29.13**) Flavin, *Untitled (in honor of Harold Joachim)* (**29.20**) **Beuys, Coyote**	Sylvia Plath, *The Bell Jar* (1971) *Grease* (Tom Moore, director) (1972) U.S. Supreme Court legalizes abortion (1973) End of Vietnam War (1973) DNA recombined for the first time; birth of genetic engineering (1973) Nixon resigns U.S. presidency after Watergate scandal (1974) Aleksandr Solzhenitsyn, *The Gulag Archipelago* (1974) Saul Bellow, *Humboldt's Gift* (1976) Alex Haley, *Roots* (1976) David Mamet, *American Buffalo* (1977) Woody Allen, *Annie Hall* (1977) Mother Teresa wins Nobel Peace Prize (1979) William Styron, *Sophie's Choice* (1979)
1980	1980–1990	Marisol, *The Last Supper* (**29.16**) Segal, *Chance Meeting* (**29.14**) Martin, *Untitled No. 9* (**29.21**) Thiebaud, *Thirteen Books* (**29.11**)	

30

Innovation and Continuity

As we respond to contemporary art, our sense of historical perspective inevitably diminishes. The more recent the development or style, the more necessary is the passage of time before one can properly evaluate a work of art and assess whether or not it will last. Accordingly, of all the chapters in this survey, this is the most subject to revision.

Continuing Controversy: Art and Politics

The difficulty in assessing the artistic value of a work of one's own time was reflected in the 1927 trial over whether Brancusi's *Bird in Space* (see fig. 1.2; 1.4 in the Combined Volume) was "art." More recently, from 1989 to 1990, controversial works have raised First Amendment issues of censorship in the United States. The work of two photographers, Andres Serrano (b. 1950) and Robert Mapplethorpe (1946–89), provoked heated national debates over the degree to which freedom of speech in the visual arts should be guaranteed by the Constitution. Both Serrano and Mapplethorpe tested the limits of convention and propriety, and challenged traditional taboos—Serrano in regard to religion, Mapplethorpe in regard to sexuality. Since both artists had been funded, directly or indirectly, by the National Endowment for the Arts (NEA), questions were raised about government funding for the arts in general.

Andres Serrano

In the 1980s, Serrano made a series of color photographs (Cibachromes) dealing with Catholic imagery and, in some cases, used body fluids as both subject-matter and symbol. For example, he filled with blood a plexiglass container in the shape of a cross, and photographed it against a dazzling sky. He photographed a transparent cross filled with milk, which was immersed in a vat of blood, thereby creating a sharp contrast of red and white. In these images, Serrano evokes traditional Christian iconography, making the "Blood of the Cross" into a concrete form. The reference to milk evokes associations with the Virgin

Mary's role as both the mother of Christ and the maternal intercessor for all Christians. More controversial was the artist's picture of his own semen in the form of an illuminated streak against a dark background. Such content reflects Serrano's interest in the life forces that are normally contained within the body, and hidden from view.

The work that ultimately caused a furor and brought Serrano into the limelight was his photograph of a Crucifixion set against a red background and lit up as if by a flash of soft, yellow light. The latter turned out to have been the artist's urine, which he had saved up, and into which he had immersed a plastic Crucifix. By calling the work *Piss Christ*, Serrano left viewers in no doubt about the nature of his media.

Piss Christ was included in a group exhibition of 1989—"Awards in the Visual Arts 7"—which had been arranged by the Southeastern Center for Contemporary Art (SECCA), in Winston-Salem, North Carolina. Serrano was one of ten artists chosen from 599 entries and was awarded a $15,000 grant. The show ran in the Los Angeles County Museum and in the Carnegie-Mellon University Art Gallery in Pittsburgh without incident. But after it closed at the Museum of Fine Arts in Richmond, Virginia, a letter of protest was published on Palm Sunday in the *Richmond Dispatch Times*. The author of the letter accused the museum of promoting "hatred and intolerance," and asked whether Christianity had "become fair game in our society for any kind of blasphemy and slander?"

Piss Christ then came to the attention of the Reverend Wildmon, who had founded the National Federation of Decency (later renamed the American Family Association). Wildmon objected to Serrano *and* the NEA, and exhorted his supporters to write to Congress and the NEA, which they did by the thousand. Wildmon referred to the work as "hate-filled, bigoted, anti-Christian, and obscene art." In response, factions of the art world organized an Art Emergency Day—August 26, 1989.

Wildmon's vilification of the NEA was endorsed by Senators Alphonse D'Amato (New York) and Jesse Helms (North Carolina), the evangelist Pat Robertson, and army colonel Oliver North. Of Serrano, Helms declared: "He is not an artist, he is a jerk. Let him be a jerk on his own time and with his own resources. Do not dishonor our Lord."[1]

Robert Mapplethorpe

In 1989 federal funding also went to Mapplethorpe, whose subject matter ranges from flowers, to portraits, to nude studies, to frankly homosexual and sado-masochistic acts. From December 9, 1988 to January 29, 1989, Mapplethorpe exhibited 175 photographs at the Philadelphia Institute of Contemporary Art. Funded by the NEA, the show was entitled "Robert Mapplethorpe: the Perfect Image." It included three portfolios—the 1978 X-Portfolio depicting some homosexual and sado-masochistic scenes, the 1978 Y-Portfolio depicting flowers, and the 1981 Z-Portfolio of black men, mainly shown in Classical poses. From February 25 to April 9, 1989, the show was held in Chicago, where it was well attended.

Problems for Mapplethorpe began in Washington, D.C., in the midst of the Serrano controversy. Senator Helms cited the Mapplethorpe grant as another example of irresponsible NEA funding, whereupon the exhibition of photographs at the Corcoran Gallery (scheduled to open July 1, 1989) was cancelled by the director. The works were shown instead in an alternative space, the Washington Project for the Arts. Subsequent scheduled stops at the Wadsworth Athenaeum, in Hartford, Connecticut, and at the University Art Museum in Berkeley, California were quite successful.

Meanwhile, a five-year moratorium on funding for the SECCA was proposed by the Senate. NEA funding was cut by $45,000, equivalent to the $15,000 grant to Serrano and the $30,000 grant to Philadelphia for the Mapplethorpe exhibition. Congress also approved a one-year ban on government grants to artists who depict obscene or perverse subjects, or who exploit children for sexual purposes, provided that their work has no "serious literary, artistic, political, or scientific value."

"Robert Mapplethorpe: the Perfect Image" hit a new and unprecedented snag on the way to Cincinnati, Ohio. Dennis Barrie, Director of the Contemporary Arts Center in that city, had decided—over local protests—that the show would go on. It was scheduled to open on April 6 and to run until May 27, 1990. But, bowing to propriety, Barrie planned to segregate the X-Portfolio in a separate room and to exclude visitors under the age of eighteen. In addition, a notice posted outside the X-rated area would serve as a warning that sexually explicit photographs were on view.

In Washington, the Bush administration took a stand against censorship, and supported the NEA. Performers and arts administrators lobbied Congress on behalf of First Amendment protection for the arts. But in Cincinnati there was a flurry over "moral values." The Cincinnati Citizens for Community Values mounted vigorous opposition to the show. Editorials and caricatures flooded the press. In the March 24 edition of the *Cincinnati Enquirer*, three medical doctors argued against the show on the grounds that it was an attack on civilized society. Local law enforcement officials declared Mapplethorpe's pictures "criminally obscene." The Chief of Police warned, "There are no raving Neanderthals running amok in the streets of Cincinnati."[2] Cincinnati was, after all, the headquarters of the National Coalition against Pornography, and was noteworthy for the absence of peep shows, X-rated movies, adult bookstores, and the like.

The city also had its art lovers, for membership in the Contemporary Arts Center rose by 40 percent. A poll published by the *Cincinnati Post* on April 13 indicated that 59 percent of those questioned were in favor of the show, 39 percent were opposed to it, and 3 percent had no opinion. Three days later, *Newsweek* published Mapplethorpe's 1980 *Self-portrait* (fig. **30.1**) with the caption "Eye of the Storm." Although this photograph is not as graphic as some from the X-Portfolio, it clearly reveals Mapplethorpe's identification with homosexual themes. Here, he represents himself partly as a transvestite, partly as an androgynous, male–female figure. He plays with the boundaries of gender, and with the limits of sexual identity. The image itself is beautifully printed and, as with all his black and white photographs, the forms are imbued with a soft, silver glow.

30.1 Robert Mapplethorpe, *Self-portrait*, 1980. Unique gelatin silver print, 30 × 30 in (76.2 × 76.2 cm). Collection, Howard and Suzanne Feldman.

On April 7, an Ohio grand jury indicted the Arts Center and its director on obscenity charges. These focused on five pictures showing homosexual acts, and on two pictures of children with their genitals exposed. The following day, a federal district judge ruled that the exhibition could not be shut down, pending the outcome of the trial. The director, Dennis Barrie, pleaded not guilty, and the trial began on September 24 before a jury of four men and four women, none of whom was particularly interested in art.

30.2 Chuck Close, *Self-portrait*, 1968. Acrylic on canvas, 9 × 7 ft (2.74 × 2.13 m). Photo Kenny Lester, courtesy of the Pace Gallery, New York. The grid used to transfer this image from a photograph to a painting consisted of 567 squares ruled on a piece of paper measuring 14 × 11 inches (35.6 × 27.9 cm). The photographic data in each small square were enlarged to fill squares of approximately 16 square inches (103 cm²).

The art world, including prominent museum directors, came out in force to testify for the defense. The position of the defense resembled that of the modernists in the 1927 Brancusi trial—namely, that works in museums, like works made by artists, are, by definition, ART. And, they further argued, artistic statements made by artists are protected by the First Amendment. At one point, the prosecutor asked the jury to consider whether the offending photographs were "van Goghs," as if that were the ultimate criterion. The irony of that question, rhetorical as it may have been, lies in the fact that van Gogh's paintings were not considered ART by the prevailing taste of his own generation, and that van Gogh lived in poverty because no one would buy his pictures. Recourse to the example of van Gogh is thus a risky business when arguing the cause of esthetic judgment.

After five days of testimony, the judge instructed the jury on the legal test for obscenity: "That the average person applying contemporary community standards would find that the picture, taken as a whole, appeals to prurient interest in sex, that the picture depicts or describes sexual conduct in a patently offensive way and that the picture, taken as a whole, lacks serious literary, artistic, political, or scientific value." The jury deliberated for two hours and on October 5 acquitted both the museum and Barrie. When the jurors were interviewed later, one stated: "We learned that art doesn't have to be pretty."

When the Mapplethorpe show closed in Cincinnati, it traveled to the Boston Institute of Contemporary Art, where it was exhibited without incident.

We have seen that even in the most controversial contemporary works age-old themes are expressed in new ways. Of the two examples discussed above, one is a traditional Christian subject and the other a self-portrait. Political and social subtexts, and environmental concerns, which have informed works of art throughout Western history, also persist in contemporary art.

Return to Realism

With the development of photography in the nineteenth century, artists found a new medium for capturing a likeness. Many painters and sculptors used photographs to decrease the posing time of their sitters. In the late 1960s, the popularity of photography, its relationship to Pop Art, and the belief that it permits an objective record of reality, led to the development of the Photo-Realist style.

of Cubism with the illusion of a computer-derived image, and assembling the building blocks of paint as if each were a mosaic **tessera**, Close creates a head that emerges in a blaze of light and color from the black edge of his picture plane.

Gilbert Proesch and George Passmore

Transitional elements of another kind can be seen in the work of two English performing artists, Gilbert (Proesch, b. 1943) and George (Passmore, b. 1942). In a series of performances related to the "happenings" of the 1960s, Gilbert and George, like Joseph Beuys, became their own works of art. Figure **30.4** illustrates a 1969 performance of their much-repeated piece, *Singing Sculptures*, in which they mimed in slow motion to a recording of an old English music hall song while standing on a low platform. Both gilded their faces and hands, and wore business suits. Their only props were Gilbert's cane and George's gloves. This and similar performances raised the issue of the boundary between artists and their work. By describing themselves as "living sculptures," Gilbert and George explored the ambiguous transitional areas between living and nonliving, and between illusion and reality.

30.4 (below) Gilbert Proesch and George Passmore, *Singing Sculptures*, 1969.

30.3 Chuck Close, *Self-portrait*, 1997. Oil on canvas, 8 ft 6 in × 7 ft (2.59 × 2.13 m). PaceWildenstein Gallery, New York.

Chuck Close

In his 1968 study for a *Self-portrait* (fig. **30.2**), Chuck Close (b. 1940) used a grid to convert a photographic image—in this case a black-and-white passport-style close-up of his own head—into a painting. The final picture conveys a sense of rugged monumentality. Because the face is frontal and seen from slightly below the chin, the nose and cigarette are foreshortened. At the same time, there is an interplay between the curvilinear strands of the hair and the textures of the flesh. Up to 1970 it was Close's habit to paint mainly in black and white, as here, and to use an airbrush to create a smooth surface. The result is a work that resembles a photographic enlargement and, in a sense, forms a transition between painting and photography.

For the past thirty years, Close has been creating portraits of art-world figures. He is the first artist in the history of art to produce a large body of work consisting of portraits of other artists, appropriating them for a new brand of iconography. Figure **30.3** is an example of his recent work, his *Self-portrait* as a close-up, still based in photography but painstakingly painted, colored square by colored square. Combining the crystalline structure

30.5 Laurie Anderson, the *Nerve Bible Tour*, 1995. Photo: Adriana Friere.

Laurie Anderson

The more recent multimedia performance art of Laurie Anderson (b. 1947) uses photography, video, film, and music. Her message, which is typically delivered in spoken narrative, is political and social. Figure **30.5** is a still from the *Nerve Bible Tour* in July 1995 at the Park Theater in Union City, New Jersey. Anderson describes her performances as being "about a collaboration between people and technology." Like Gilbert and George, she participates as an actor in her own work of art. In so doing, she explores the boundary between artist and art, subject and object, and the natural and the technological worlds.

Duane Hanson

No less transitional is the Photo-Realist style of the American artist Duane Hanson (1925–96). Whereas no one would mistake Gilbert and George for actual sculptures, Hanson's sculptures are often taken for real people. As in the all-over white plaster figures of George Segal, Hanson's sculptures are created directly from the models themselves. His convincing *trompe l'oeil* illusionism is reminiscent of ancient Greek legends about the artist Daidalos, who reportedly rivaled the gods by making living sculptures. In clothing his figures, Hanson also evokes Ovid's tale of Pygmalion, the sculptor who dressed and attended to his statue of Galatea as if she were a real woman.

Despite its contemporary esthetic and dependence on modern materials, Hanson's *Artist with Ladder* (fig. **30.6**) replicates the relaxed *contrapposto* pose of Polykleitos's *Spearbearer* (see Vol. I, fig. 6.26). The artist's bent left arm, which in the Polykleitos originally held a spear, rests casually on the ladder. A comparison of these two statues reveals the relationship between artists of very different times and places. It also emphasizes the striking distinction between the Classical idealization of fifth-century B.C. Greece and modern Photo-Realism.

30.6 Duane Hanson, *Artist with Ladder*, 1972. Polyester resin polychromed in oil, lifesize. Hanson molded each section of the model's body and assembled the sections. Flesh-colored polyester resin was then poured in the mold and reinforced with fiberglass. When the mold was broken, the figure was painted and dressed in actual clothing, and real accessories such as hair and glasses were added.

Richard Estes

One of the most prominent painters of the Photo-Realist style is Richard Estes (b. 1936). His oil paintings resemble color photographs, although they are on a larger scale and are more crisply defined than a photograph of similar size would be. His *Williamsburg Bridge* of 1987 (fig. **30.7**) combines an urban landscape with the reflections of steel, chrome, and glass. Divided by the strong vertical accent of the red subway car, the painting is an optical play between the interior on the left and the exterior, visible through the window of the car, on the right. The self-absorption of the subway riders contrasts with the moving cars and distant city skyline on the right. As in the Renaissance, Estes's illusionistic effects are enhanced by the use of linear perspective.

Developments in Architecture

Estes's Photo-Realist painting of the Guggenheim Museum (fig. **30.8**) is an urban landscape of another kind. It will serve to illustrate the exterior of Frank Lloyd Wright's unusual structure in New York City. Its purpose was to house the Guggenheim collection and to provide space for exhibitions of twentieth-century art.

Built between 1956 and 1959, somewhat earlier than the other works in this chapter, the Guggenheim embodies the climax of Wright's interest in curvilinear form. Its most imposing feature is the large inverted cone, which encloses a six-story ramp coiling around a hollow interior. Natural light enters from a flat skylight. Viewers inside the Guggenheim Museum look at paintings and sculptures as they walk down the ramp, so that they are always slightly tilted in relation to the works of art.

Despite a design that is frankly inconvenient for viewing art, the Guggenheim is itself a monumental work of art. Unlike Wright's Prairie Style architecture, it cannot be said to blend into its surroundings. Located on Fifth Avenue, directly across from Central Park, the spiral cone can be conceived of organically as growing upward and

30.7 (right) Richard Estes, *Williamsburg Bridge*, 1987. Oil on canvas, 3 ft × 5 ft 6 in (0.91 × 1.68 m). Courtesy, Allan Stone Gallery, New York. Estes assembles color photographs and recreates the scene with brushes and oil on canvas. "The incorporation of the photograph into the means of painting," he wrote, "is the direct way in which the media have affected the type of painting. That's what makes New Realism new."[3]

30.8 Richard Estes, *The Solomon R. Guggenheim Museum*, 1979. Oil on canvas, 2 ft 7⅛ in × 4 ft 7⅛ in (0.79 × 1.4 m). Solomon R. Guggenheim Museum, New York.

outward, toward the sky, like the trees opposite. Most observers, however, experience the museum in relation to the neighboring rectangular buildings, which generally tend to become smaller toward the top. These apparent formal anomalies between the Guggenheim and its environment were, for a while, a source of considerable controversy.

Less than a mile away from the Guggenheim Museum is the Whitney Museum of American Art (fig. **30.9**). This was designed by the German architect Marcel Breuer (1902–81) in a style inspired by the stark rectangularity he had encountered at the Bauhaus. The floors are cantilevered out toward Madison Avenue like a chest with its drawers pulled out at increasing distances. The only features that interrupt the wall surfaces are the slightly projecting trapezoidal windows. Inside and out, the museum is constructed of concrete and dark gray granite blocks, which correspond to its stark, angular character.

Unlike the Guggenheim, the Whitney is well conceived for viewing works of art. The floors are horizontal rather than slanted, and the galleries are ample and flexible, with ceilings that can support mobile wall partitions. Both buildings, however, have thick, massive walls, in contrast to the earlier International Style developed at the Bauhaus.

R. Buckminster Fuller

One of the more interesting personalities of twentieth-century design was R. Buckminster Fuller (1895–1983), philosopher, poet, architect, and engineer, as well as a cult figure among American college students. His architecture expresses his belief that the world's problems can be solved through technology. One of his first designs

(1927–8) was a house which he called Dymaxion, a name conflating "dynamic" and "maximum." These reflect key concepts for Fuller, who aimed at achieving the maximum output with the minimum energy consumption. The Dymaxion house was a prefabricated, factory-assembled

30.9 Marcel Breuer, Whitney Museum of American Art, New York, 1966. Breuer was one of the first graduates of the Bauhaus. He became chairman of its carpentry department and designed his celebrated S-shaped chairs in aluminum, plywood, and steel tubing. In 1936 he emigrated to the U.S.A., where he taught at Harvard under Gropius and established an architectural practice which was responsible for, among other things, the UNESCO building in Paris.

30.10 R. Buckminster Fuller, American Pavilion, Expo '67, Montreal, 1967. Fuller was descended from eight generations of New England lawyers and ministers. He was expelled from Harvard twice, served in the U.S. Navy in World War I, and worked in the construction business. In 1959 he became a professor of design science at Southern Illinois University. Fuller's abiding interest in education is revealed by his belief that all children are born geniuses. "It is my conviction from having watched a great many babies grow up," he said, "that all of humanity is born a genius and then becomes de-geniused very rapidly by unfavourable circumstances and by the frustration of all their extraordinary built-in capabilities."[4]

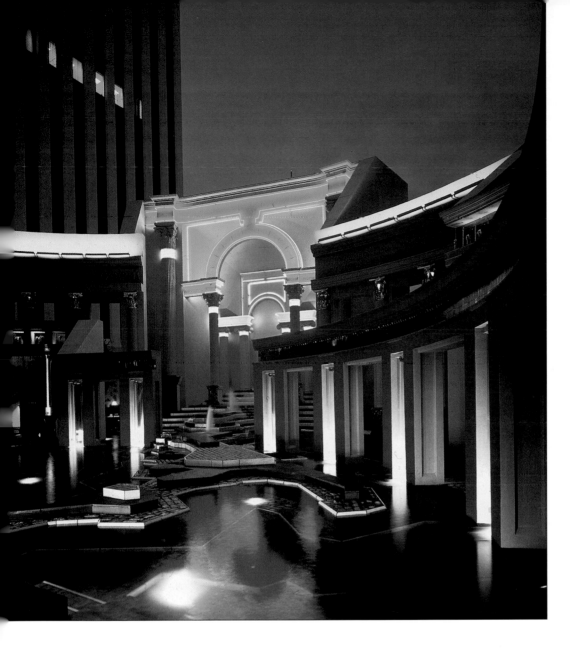

30.11 Charles W. Moore and William Hersey, Piazza d'Italia, New Orleans, 1978–9. The piazza was built to celebrate the contributions made to New Orleans by Italian immigrants. Its eclecticism is characteristic of the Post-Modern style.

structure that hung from a central mast and cost no more than a car to build. A later invention was a three-wheeled Dymaxion car (1933), but, like the house, it was never produced commercially.

Buckminster Fuller is best known for the principle of structural design that led to the invention of the **geodesic dome**. It is composed of polyhedral units (from the Greek *poly* meaning "many," and *hedron*, meaning "side")— usually either tetrahedrons (four-sided figures) or octahedrons (eight-sided figures). The units are assembled in the shape of a sphere. This structure offers four main advantages. First, because it is a sphere, it encloses the maximum volume per unit of surface area. Second, the strength of the framework increases logarithmically in proportion to its size. This fulfills Fuller's aim of combining units to create a greater strength than the units have individually. Third, it can be constructed of any material at very low cost. And fourth, it is easy to build. Apart from purely functional structures like greenhouses and hangars, however, the geodesic dome has been used very little. Fuller's design for the American Pavilion at the Montreal Expo of 1967 (fig. **30.10**) reveals both its utility and its curious esthetic attraction. (The architectural principle underlying the geodesic dome is shared by a class of carbon molecules named "fullerenes," after Buckminster Fuller. They were discovered in the late 1980s, and possess unique qualities of stability and symmetry.)

Post-Modern Architecture

Fuller's architectural ideas remained isolated from the stylistic mainstream of the late twentieth century. Post-Modernism, on the other hand, has developed into a widespread movement. Post-Modern architecture is eclectic. It combines different styles from the past to produce a new vision, which is enhanced, but not determined, by modern technology. Post-Modernism rejects the International Style philosophy that "form follows function," and juxtaposes traditional architectural features without regard for their historical contexts.

Charles Moore A good example of Post-Modernism is Charles Moore's (b. 1925) Piazza d'Italia (fig. **30.11**), or Italy Square, in New Orleans. In this illustration, the piazza

is shown at night, illuminated by colored neon lights. The lights define space and accentuate architectural form—an effect that relates the piazza to Flavin's sculptures. Color conforms to each particular architectural element; the central entablature and its round arch are green, and the supporting Corinthian columns are red. Curved colonnades on either side are alternately red and yellow, while the inner Corinthian capitals are predominantly blue. The shiny pavement reflects the interplay of colored neon lights and shadows.

The Piazza d'Italia is a Post-Modern rearrangement of Classical, Renaissance, and Baroque architectural forms, enlivened by the light and color possibilities of twentieth-century technology. Whereas Flavin's light sculptures are designed for interiors and are intimate in scale, those in the Piazza d'Italia contribute to its expansive relationship with the surrounding buildings and open sky.

Michael Graves The massive, blocklike Post-Modern buildings of Michael Graves (b. 1934) reveal his affinities for Cubism, while certain details are derived from Classical architecture. In addition to buildings, Graves designs furniture and household objects such as teapots and bookends. His striking Portland Building (fig. **30.12**) in Portland, Oregon, built from 1980 to 1982, uses color as a significant architectural feature. He defined the stepped base in green and the upper cube in a cream color. Planned mainly for offices, the Portland Building is decorated on the exterior with multiple square windows piercing the wall surfaces. The side most visible in figure 30.12 incorporates two sets of six dark verticals accented like fluted columns against a glass rectangle. Capping these are projecting, inverted trapezoidal blocks that are the visual—not the structural—equivalent of Classical capitals. Above these is a large, flat, inverted trapezoid enclosing horizontal strips of windows separated by dark cream-colored horizontal sections.

Complaints that the building is not "environmentally correct"—i.e. that it does not conform to the surrounding architecture—ignore the fact that it is "color coded" with the blue sky and green trees. It looms upward from a green base, corresponding to the green trees, with the cream block framed above and below by green. Since the green combines cream with blue, the building is unified with its natural, if not with its architectural, surroundings. Architecturally it is an amalgam of the Mesopotamian ziggurat, the Egyptian **pylon**, the Greek temple, and the contemporary American office building. In the original model for the Portland Building, Graves had planned to add a group of small structures, inspired by Greek temples and Renaissance churches. Their function would have been to enclose the machinery used to run the building, but they were eliminated from the final version.

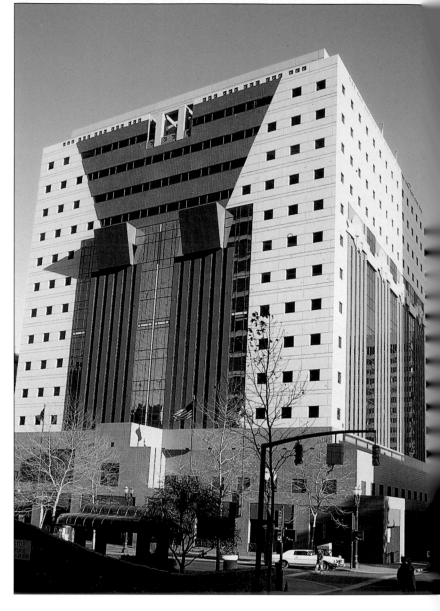

30.12 Michael Graves, Public Services Building, Portland, Oregon, 1980–82.

I. M. Pei: The Louvre Pyramid

In contrast to the Post-Modern amalgam of past styles, glass and steel form the prevailing esthetic in I. M. Pei's (b. 1917) Louvre Pyramid (fig. **30.13**). In 1983 the French government commissioned Pei to redesign parts of the Louvre in Paris. Completed in 1988, the pyramid includes an underground complex of reception areas, stores, conference rooms, information desks, and other facilities, all located below the vast courtyard. To serve as a shelter, skylight, and museum entrance for the underground area, Pei built a large glass pyramid between the wings of the sixteenth-century building.

Paris had not witnessed such architectural controversy since the construction of the Eiffel Tower in 1889. Not only was the architect not a Frenchman, but the imposing façade of the Louvre, former residence of French kings, was to be blocked by a pyramid—and a glass one at that. Pei's Pyramid has an undeniable presence, with transparent glass that allows a fairly clear view of the buildings

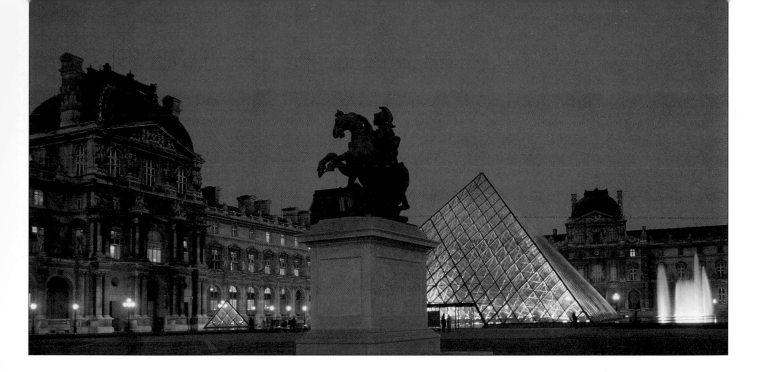

30.13 I. M. Pei, Louvre Pyramid, Paris, 1988. The pyramid is 65 ft (19.8 m) high at its apex, 108 ft (32.9 m) wide, and contains 105 tons (107,000 kg) of glass.

beyond. Broad expanses of water around the Pyramid create a reflective interplay with the glass, literally mirroring the old in the new. The night view in figure 30.13 illustrates the dramatic possibilities of the Pyramid as a pure geometric form juxtaposed with a Baroque environment.

Richard Rogers: The Lloyd's Building

By 1977 Lloyd's of London, the international insurance market, needed new quarters. In addition to accommodating the more than five thousand people who use the building every day, the new Lloyd's had to adapt to the technological changes, principally in communications, that were revolutionizing the insurance and other financial markets. Unlike the Neolithic structures, the Egyptian pyramids, and the Gothic cathedrals, the technology on which modern structures are based may be obsolete within five or ten years of their construction.

The commission for the new Lloyd's building went to the firm of Richard

Rogers (b. 1933), an English architect who had been jointly responsible for the Pompidou Center in Paris in the 1970s. The irregular, triangular space that Rogers had to work with in London was large, but not large enough to accommodate all of the underwriting staff on one floor. Rogers solved the problem in two ways. First, he created an *atrium*—the original central court of Etruscan and Roman houses—and wrapped all the floors around it. The *atrium*, an architectural feature that was widely revived in the 1970s, is a rectangle rising the entire height of the building (twelve floors) and culminating in a barrel-vaulted, glass and steel roof (fig. **30.14**). The three lower floors form galleries around the *atrium*. Together, they make up the approximately 115,000 square feet (10,700 m²) where underwriters sit and negotiate terms with brokers. This

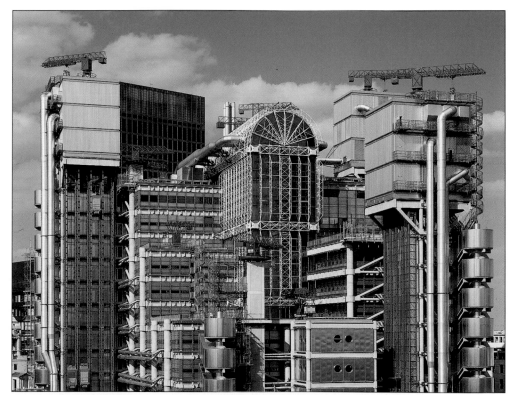

30.14 Richard Rogers, Lloyd's Building, London, 1986. Rogers wrote that "esthetically one can do what one likes with technology ... but we ignore it at our peril. To our practice, its natural functionalism has an intrinsic beauty." In the Lloyd's Building, Rogers has fulfilled his philosophical view of uniting technology with esthetic appeal.

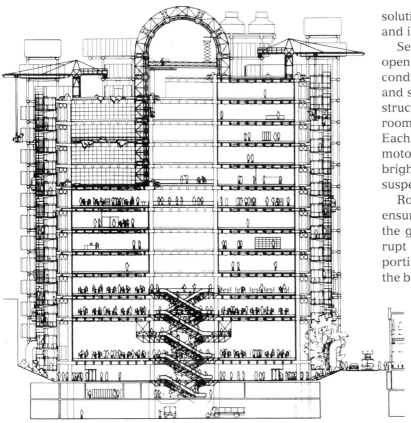

solution visually unified the working areas of the building and illuminated them from above.

Second, Rogers left the *atrium* space as flexible and open as possible, by housing all the ancillary services—air conditioning ducts, elevators, staircases, toilet facilities, and so forth—in satellite towers built apart from the main structure. At the top of the towers are boxlike "plant rooms," which dominate distant views of the building. Each room is three stories high and contains elevator motors, tanks, and an air-handling plant. On the roofs, bright yellow cradles for carrying maintenance crews are suspended from blue cranes.

Rogers' system (see fig. **30.15**) has the advantage of ensuring the greatest flexibility of space on each floor. On the ground floor, the only structural elements that interrupt the working space are eight concrete columns supporting the galleries, and the escalator block which links the basement and the underwriting floors. Since the mechanical services are located in the towers, they can be replaced or upgraded in the future without disturbing the main floors.

30.15 (left) Schematic section of the Lloyd's Building.

30.16 (below) Frank O. Gehry, Solomon R. Guggenheim Museum Bilbao, Bilbao, Spain, 1993–7. The museum is 257,000 square feet (24,290 m²), with 112,000 square feet (10,560 m²) of gallery space, and stands on the site of an old factory and parking lot. Its construction was part of an urban renewal project for Bilbao and cost $100 million.

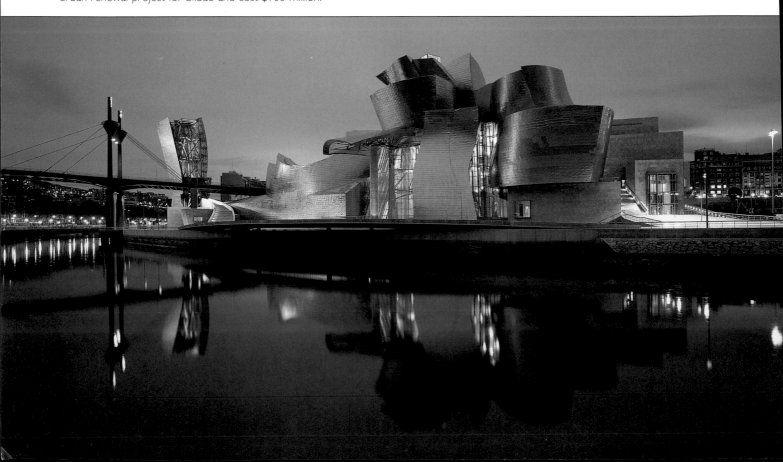

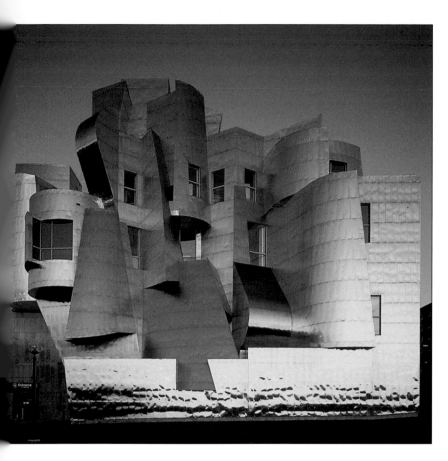

30.17 Frank O. Gehry, Frederick R. Weisman Museum, Minneapolis, Minnesota, finished 1990.

Frank Gehry: The Solomon R. Guggenheim Museum Bilbao

In 1997 the Solomon R. Guggenheim Museum Bilbao opened in Bilbao, on the Bay of Biscay, in Spanish Basque country (fig. **30.16**). The architect, Frank Gehry (b. 1929), originally from Toronto, Canada, came to the United States in 1974, living and working mainly in Los Angeles. He is known for his ability to integrate striking new forms into existing spaces. In the 1980s, for example, he assisted in the placement of a giant pair of binoculars by Oldenburg at the entrance to the city of Venice, in California. In 1990 Gehry completed the Frederick R. Weisman Museum in Minneapolis (fig. **30.17**), which shows his interest in merging sculptural with architectural form, animating the building so that it seems to grow and expand upward from its site.

The Bilbao Guggenheim, begun in 1993, is situated by the Nervion River, across from a bridge and a thriving port, and surrounded by a water garden. Its striking, curvilinear roof forms, referred to as a "metallic flower," are made of titanium, which is durable in the salty atmosphere of Bilbao, and the main structural elements are of limestone-covered blocks. The complexity of the design and its unusual variety of shapes is clear from the plan in figure **30.18** and from the north and south elevations in

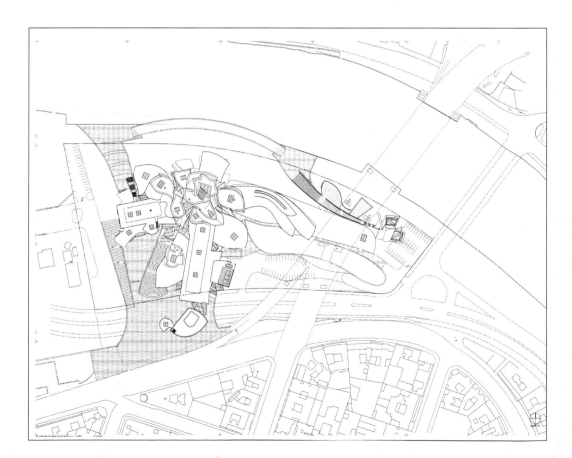

30.18 Frank O. Gehry, plan of the Solomon R. Guggenheim Museum Bilbao, finished 1997.

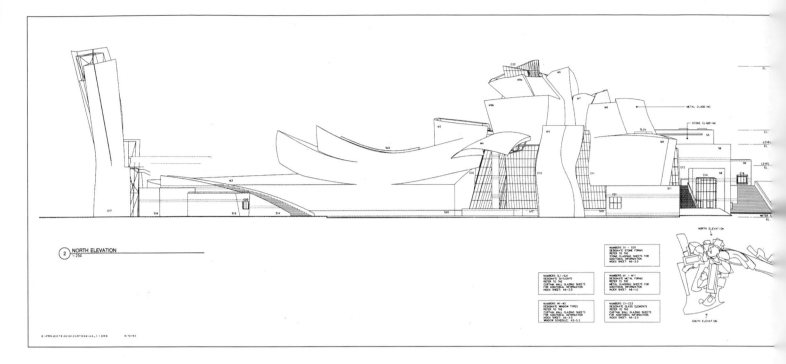

30.19 Frank O. Gehry, north side elevation of the Solomon R. Guggenheim Museum Bilbao.

figures **30.19**, which shows the way in which the building seems to transform itself as one viewpoint succeeds another. The otherwise prohibitive cost of such a building was mitigated by a three-dimensional computer program known as Catia, designed in France for aerospace projects. Figure **30.20** is a computer image generated by digital mapping of paper and wood models that saved the architect time and reduced expenses by virtually building the museum prior to its actual construction. Gehry described the computer as his "interpreter."

The interior of the museum consists of a large *atrium*, 165 feet (50 m) high, which is illuminated by light from windows in the roof. The style of the galleries varies from traditional to boat-shaped (fig. **30.21**), the latter with no columns to interrupt the viewing of installation pieces. All the galleries surround the *atrium* and are accessed by a glass elevator, a system of bridges, and towers containing stairs.

Environmental Art

All works of art affect the environment in some way. In its broadest sense, the environment encompasses any indoor or outdoor space. Today, the term tends to refer more to the outdoors—the rural and urban landscape—than to indoor spaces. Three recent artists whose work has had a startling, though usually temporary, impact on the natural environment are Robert Smithson (1938–73) and the Christos (both b. 1935). The environmental works of Nancy Holt (b. 1933), on the other hand, are intended to be permanent.

Robert Smithson

Robert Smithson's *Spiral Jetty* (fig. **30.22**), a huge, single spiral that jutted four hundred yards (366 m) out into the Great Salt Lake of Utah, is his best-known "earthwork." As an isolated form, set against a background—in this case, water—*Spiral Jetty* was rooted in 1960s Minimalism, but its concept and actuality is related to the gesture painting

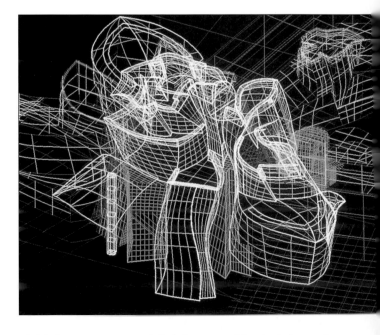

30.20 Computer-generated Catia image used for the Solomon R. Guggenheim Museum Bilbao.

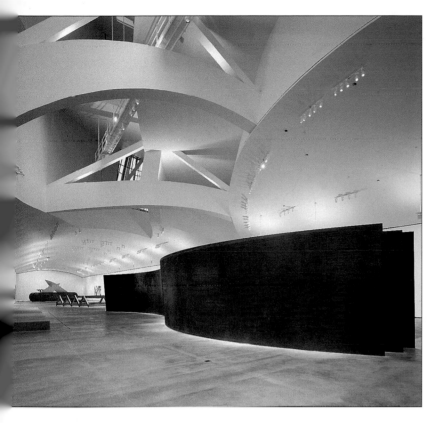

30.21 (above) Interior gallery, Solomon R. Guggenheim Museum Bilbao.

of Abstract Expressionism. The philosophy of Smithson's earthworks, however, which is extensively described in his writings, has many levels of meaning. In some of his gallery exhibits, he placed rocks and earth—reflecting his interest in the natural landscape—in boxes and bins indoors (the "non-site," in Smithson's terminology). Crystals, in particular, appealed to him as examples of the earth's geometry, and he used them, along with earth, as an artistic medium.

Ecology, as one might expect, was one of Smithson's primary concerns. *Spiral Jetty* and his other earthworks are all degradable and will eventually succumb to the natural elements. Smithson's interest in the earth has a primeval character. He was inspired by the Neolithic stone structures of Great Britain and their mythic association with the land. Although he created his own earthworks with modern

30.22 (below) Robert Smithson, *Spiral Jetty*, Great Salt Lake, Utah, 1970. Rock, salt crystals, earth, and algae; coil 1500 ft (457 m) long, approx. 15 ft (4.57 m) wide. Financed by two art galleries, Smithson took a twenty-year lease on 10 acres (1 ha) of land. He hired a contractor to bulldoze some 6000 tons of earth. The resulting spiral consists of black rock, earth, and salt crystals. The algae inside the spiral change the water's color to red. Smithson wrote an essay on this work, and photographed and filmed it from a helicopter. The *Jetty* itself is now under water and no longer visible.

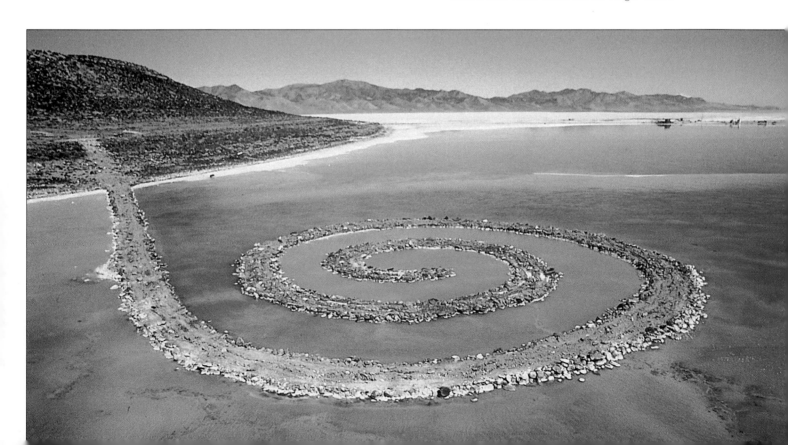

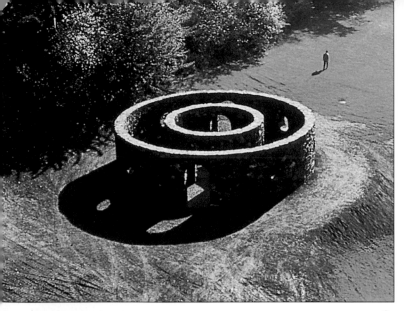

calls the "dead center of the universe." The round holes are connected diagonally by lines of sight corresponding to the directions of the compass. The plane of the structure evokes the antiquity of ideas connecting the circle with divine form. By virtue of the formal association to Stonehenge and other Neolithic cromlechs, and to the later development of arch construction, *Stone Enclosure* embodies the continued existence of the past in the present.

The Christos

Another approach to shaping the environment can be seen in the work of Christo and Jeanne-Claude. They evoke a sense of mystery by "wrapping up"

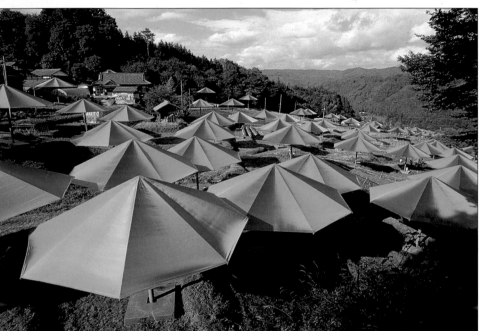

construction equipment, his affinity for the prehistoric earth mounds of the United States and Mexico also influenced the shape of his monuments and their integration with the landscape.

Nancy Holt

Architectural and sculptural ideas merge in Nancy Holt's approach to environmental art. She was introduced to the subject by her late husband Robert Smithson and, after his death, continued to pursue an independent career. Her *Stone Enclosure: Rock Rings* of 1977–8 (fig. **30.23**) is located in the landscape of Western Washington University (Bellingham, Washington). It is constructed of two concentric rings of stone, which are pierced by arches and twelve circular openings at eye level. Like Stonehenge (see Vol. I, figs. 2.27, 2.31–2.32), *Stone Enclosure* rises abruptly from a green expanse, and is related to the sky—what Holt

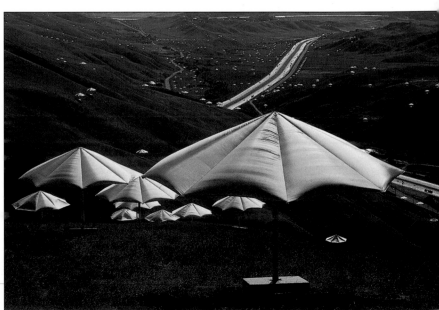

buildings or sections of landscape, paradoxically covering something from view while accentuating its external contour. Among the structures they have "wrapped" are the Kunsthalle in Berne (1968) and the Pont-Neuf, the oldest bridge in Paris (1985). They have surrounded eleven islands in Biscayne Bay, Florida, with over six million square feet (560,000 m²) of pink fabric (*Surrounded Islands*), and have run a white fabric fence (*Running Fence*) 24½ miles (39 km) long, 18 feet (5.5 m) tall, through two California counties.

Christo and Jeanne-Claude's work is sometimes referred to as Conceptual art, which emphasizes its relation to an idea, or concept. This is not, however, the case, because the Christos actually realize the concept and give it concrete form. Unlike artists who intend their works to last, the Christos always remove their projects from their sites, leaving the environment intact. The temporary nature of their large-scale works is part of their esthetic identity. The continued existence of the work depends on film, photographs, drawings, and models. It endures as a series of visual concepts, temporarily realized on a monumental scale. Another feature distinguishes the Christos from many artists—a unique view of patronage. They accept no financial sponsorship or commissions for large-scale projects, and personally provide the funding for construction. Money is raised by selling drawings, collages, and scale models for the projects, as well as early work from the 1950s and 1960s.

Figures **30.24** and **30.25** illustrate sections of the blue and yellow *Umbrellas* in Japan and California, respectively. Their placement is related to their environment. The blue *Umbrellas* are close together, reflecting the limited space of Japan, and the yellow *Umbrellas* are farther apart, whimsically spread out in harmony with the vast California landscape. Blue is consistent with the water that fertilizes the Japanese rice fields, while the yellow echoes the blond grass and brown hills of the dry valley in which the California *Umbrellas* are located. As free-standing, dynamic forms, *Umbrellas* have a sculptural quality. They define space and interact with it, casting shadows and swaying with the wind.

On June 24, 1995, the Christos completed the wrapping of the Reichstag in Berlin (figs. **30.26** and **30.27**). They had spent twenty-four years, and made fifty-four trips to Germany in their efforts to obtain permission for the project, which was denied three times—in 1977, 1981, and 1987.

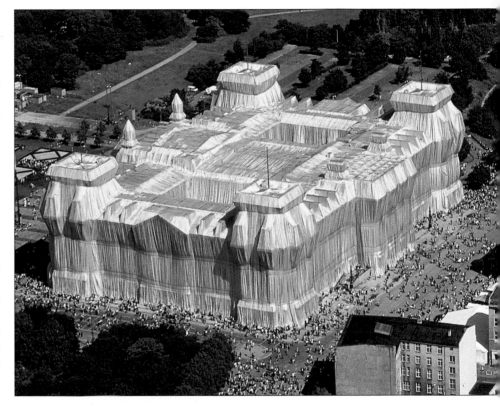

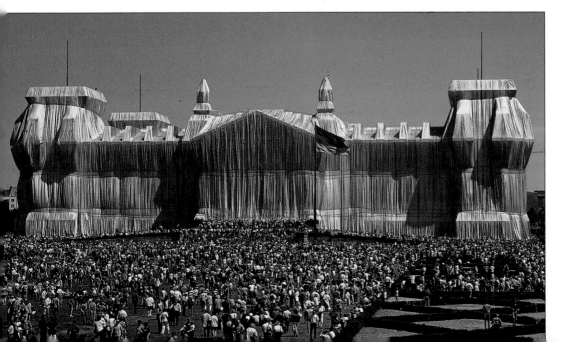

30.26 and **30.27** Christo and Jeanne-Claude, *Wrapped Reichstag*, Berlin, 1971–95. Photos Wolfgang Volz, Christo. The wrapping was carried out in 1995 by 90 climbers and 120 installation workers, and 10 German companies manufactured the equipment. The wrapping material consisted of 1,076,000 square feet (99,964 m²) of woven polypropylene fabric with an aluminum surface, and 51,181 feet (15,600 m) of blue polypropylene rope, 1¼ inches (3.2 cm) thick.

The building itself was originally designed in 1894. In 1933, soon after Hitler became Chancellor, it was set on fire. The Reichstag was destroyed again in 1945, during the Battle of Berlin, and later restored. In 1990, following the reunification of Germany, the seat of German government moved from Bonn to Berlin, and the Reichstag building was occupied by the Bundestag, the lower house of the German parliament. Permission for the "wrapping" was finally granted in February, 1994, after members of the Bundestag debated the issue and voted 292 in favor, 223 against, with 9 abstentions.

Figure 30.26 is an aerial view of the wrapped building, a silver-gray architectural specter surrounded by crowds of visitors. Figure 30.27 shows the texture of the silvery fabric, the vertical folds of which are reminiscent of Classical draperies. It is held against the building with blue ropes, which accent the Reichstag's structural elements and create a sense of expanding, organic form. Two weeks from the day of its completion, on July 7, the "wrapped" Reichstag was unwrapped, and the aluminum and steel were recycled.

One of the more recent projects planned by Christo and Jeanne-Claude is *Over the River, Project for the Arkansas River, State of Colorado* (fig. **30.28**). The illustration shows a photograph of the river, a section of river spanned by the project, and a view of the project itself. The site was chosen in 1996 for its high banks, which allowed the suspension of steel cables, and a road running alongside. It was also necessary that the river be suitable for white water rafting and canoeing. Woven fabric panels are suspended horizontally over the river, whose changing course they follow. It is possible to see the sky through the fabric, so that the viewer is both under the sky and under the fabric, which blend visually from below. In this project, the Christos reveal the natural movements of water and sky, and the ways in which a river channels them. By organizing the space in, around, and over the river, the Christos accentuate the power of nature and also, in a sense, tame it. They bring art to nature, transforming the one into the other.

Urban Environment

The urban environment has also been influenced by artistic "projects." *Long Division* of 1988 (fig. **30.29**) by Valerie Jaudon (b. 1945) is a painted steel barrier commissioned by the Metropolitan Transportation Authority in New York City. Located in a subway station, *Long Division* is an "open wall" enlivened by curves and diagonals that seem to dance across the vertical bars. The surrounding neon lights and broad areas of color create a sharp contrast to the dark accents of the barrier.

A recent development in painting that has been inspired by an aspect of the modern urban environment are works with imagery derived from graffiti. Graffiti—which are visual statements and often a personal affirmation—and public reactions call into question the boundary between the creative and destructive impulses.

CARBON/OXYGEN of 1984 (fig. **30.30**) by Jean-Michel Basquiat (1960–88) conveys the frenetic pace and mortal dangers of the city in a harsh, linear style derived from graffiti. The childlike drawing of the buildings is ironically contrasted with scenes of explosion and death. Various methods of transportation—cars, planes, and rocket ships—create a sense of the speed and technology that pollute the environment. The black face at the center of the picture plane stares blankly at the viewer as if warning of threatened destruction. The words of the title implicitly pose the question whether we are going to poison the air we breathe or ensure that it remains clean.

30.28 Christo and Jeanne-Claude. *Over the River, Project for the Arkansas River, State of Colorado*. Drawing by Christo, 1998. In two parts: 15 × 65 in (38 × 165 cm) and 42 × 65 in (106.6 × 165 cm). Pencil, charcoal, crayon, photograph by Wolfgang Volz, topographic map, and tape. © Christo 1998. Photo: Wolfgang Volz.

30.29 (above) Valerie Jaudon, *Long Division*, 23rd Street Station, IRT Subway Line, New York, 1988. Painted steel, 12 × 60 ft (3.66 × 18.29 m). Photo courtesy of Sidney Janis Gallery, New York.

30.30 (above right) Jean-Michel Basquiat, *CARBON/OXYGEN*, 1984. Acrylic, oilstick, and silkscreen on canvas, 66 × 60 in (167.6 × 152.4 cm). Private collection, Switzerland. Courtesy, Robert Miller Gallery, New York.

30.31 Judy Chicago, *The Dinner Party*, 1974–9. Mixed media, each side 48 ft (14.63 m). Collaborative work involving over 400 people. In 1970 at Valencia, California, Chicago co-founded the first feminist art program in the United States. This involved the collection of historical data about female artists and other consciousness-raising activities, including *Womanhouse* (1972), a project in which Chicago and others renovated a disused house and filled it with mixed-media constructions on the theme of traditional female roles.

Feminist Art

Although women artists have made significant contributions to the history of western art, the iconography of feminism *per se* is a twentieth-century phenomenon.

Judy Chicago: *The Dinner Party*

In 1979 Judy Chicago (née Cohen; b. 1939) created her monumental installation *The Dinner Party* (fig. **30.31**) with the assistance of hundreds of female co-workers. The result is a triangular feminist version of *The Last Supper* (see fig. 15.15). We saw in Marisol's *Last Supper* (see fig. 29.16) that the artist introduced herself as both viewer and participant in the work. Here, on the other hand, Christ and his apostles have been replaced by the place-settings of thirty-nine distinguished women, such as Queen Hatshepsut of Egypt, Georgia O'Keeffe, and the author Virginia Woolf. The settings are designed to commemorate the achievements of such women, even though the women themselves are not actually represented.

Thirty-nine is three times the number of Christ plus his twelve apostles. The tiled floor contains 999 names of famous women not referred to in the place settings. Traditional female crafts, such as embroidery, appliqué, needlepoint, painting on china, and so forth, are used for details. In part, this is to emphasize the value of these skills, which feminists believe to have been undervalued by a male-dominated society.

The artist established a foundation to send *The Dinner Party* on tour, and later published a monograph on it that included the biographies of the women it celebrated. Despite the originality of Chicago's conception and the new iconographic content of her piece, the work would have less impact without its historical relevance. For although the triangle can be read as a female symbol, it also refers to the Trinity, and is thus rooted in Christian art and culture. Likewise, the numerical regularity and symmetry of the design links the formal arrangement of *The Dinner Party* with Leonardo's *Last Supper*.

Body Art

A recent development, particularly in sculpture, that is derived from the feminist movement is so-called Body Art. In general, Body Art signals a return to the interest in the human form, which in some artists focuses primarily on the female body.

Kiki Smith The Body Art of Kiki Smith (b. 1954) challenges viewers by refusing to be "pretty." Smith has developed an iconography of body parts, in particular those that reveal the interior functions of the female. There is a political significance for Smith in the metaphor of the body and the "body politic," with the hidden body systems as signs of hidden social issues. She has been engaged with contemporary controversies over AIDS, gender, race, and battered women.

Smith was born in Germany to American parents; her father (David Smith) and sister were artists. When her parents died, she made death masks of them, as well as of her grandmother when she died. In 1976 Smith came to New York, studied *Gray's Anatomy* in 1979, and in 1985 trained as an emergency medical technician. Among her works are her mother's feet cast in glass, a bronze womb, hanging heads and hands, and veins, arteries, and body fluids preserved in jars. In these subjects, Smith evokes both the embalming practices of ancient Egypt, and the severed body parts of Brancusi.

Smith's *Mary Magdalene* of 1994 (figs. **30.32** and **30.33**) is a traditional Christian subject rendered in a new light. The bronze body is covered with incised lines, except for the smooth breasts and navel area. The lines are reminiscent of the Magdalene's hair, grown long after the Crucifixion as penance for her sins. As such, the figure represents the penitent Magdalene, like that depicted by Donatello (see fig. 14.64) and other Renaissance artists. The long hair, combined with the ankle chain, endow the figure with a subhuman quality, which places her at the

30.32 (left) Kiki Smith, *Mary Magdalene*, front view, 1994. Silicon bronze and forged steel, edition 2 of 3, 59⅜ × 20½ × 21⅝ in (152 × 52 × 55 cm).

30.33 (above right) Rear view of *Mary Magdalene*, fig. 30.32.

borderline between human and animal, saint and sinner, chastity and lust. Seen from the front, she seems to be gazing upward, and from the back, moving in a lyrical dance-like motion.

Smith has related this sculpture to French folktales about the Magdalene's life after Christ's death. According to these stories, Mary Magdalene lived in the wilderness for seven years. When, on one occasion, she happened to catch sight of her reflection in a pool, she was punished for her narcissism and condemned to do further penance. Her flowing tears created the seven rivers of Provence, in the South of France.

Rona Pondick The Body Art of Rona Pondick (b. 1952) has an entirely different quality than Smith's. She creates surreal juxtapositions, or disjunctions, of body parts that often participate in a narrative setting. Her *Tree* of 1995 (fig. **30.34**), a model for a larger project, is seen here installed in 1997 at the Sidney Janis Gallery in New York. The bare tree is cast in aluminum, and the polished metallic fruit is strewn across the earth on the floor of the gallery. It seems that the fruit has fallen from the tree, and become orphaned. The oral rage of the infant deprived of food is indicated by the individualized fruit in the foreground—the teeth are cast from Pondick's teeth biting into the wax. Head and mouth are merged in a display of fear and aggression engendered by abandonment.

30.34 Rona Pondick, *Tree* (model), 1995. Mixed media, 32 × 24 × 24 in (81 × 61 × 61 cm). As installed in 1997, at the Sidney Janis Gallery, New York.

30.35 Maya Ying Lin, *The Women's Table*, Yale University, 1993. Green granite on black granite base, 30 in (76.2 cm) high, 10 × 15 ft (3.05 × 4.57 m) in diameter.

The teeth are also those of the predators who gather up these biomorphic fruits to eat. But the little heads, like enraged children, will have their revenge; for despite their defenselessness, they will surely break the teeth of anyone attempting to bite into them. Pondick achieves an uncanny effect in such work by appealing to what is familiar in the infantile past of the viewer as well as of herself. Her stated interest in psychoanalytic narratives is reflected in drawings of heads accompanied by the written words "No," or "I want." Working like Smith in the tradition of severed body parts, Pondick shows her connections to Brancusi and the Surrealists.

Maya Ying Lin: *The Women's Table*

On October 1, 1993, Yale University dedicated *The Women's Table* (fig. **30.35**) by Maya Ying Lin (b. 1960). Juxtaposed here with the more traditional campus architecture, the *Table* memorializes Yale's decision to admit women. Designed as a place for students to meet, talk, and read, the *Table* is also a "fountain." A smooth swirl of water slides across the tabletop and echoes the curvilinear shape of the green granite spiral. This, in turn, is supported by an irregular triangular base made of black granite, on which students

can sit. The smooth texture of the granite and its sleek, elegant forms are reminiscent of the high polish and "essential" forms achieved by Brancusi. Lin also has affinities with the outdoor sculptures and taste for varieties of stone that are characteristic of Noguchi's work.

Carved into the top of the *Table* is a spiral, which records the numbers of females attending Yale (fig. **30.36**). At the center of the spiral are about three rings of zeros. The last zero is followed by the number 13, which

30.36 Spiral diagram of *The Women's Table*, fig. 30.35. Drawing by Ian Hunt.

corresponds to the year 1873, when thirteen women were enrolled in the School of Fine Arts. Carved to the side of the spiral are the decades from 1870 to 1990, during which period 4823 women attended Yale. As the spiral expands, the number of women increases, and its open-ended design looks forward to the growing future of women on the Yale campus.

Plus ça change …

At times, history seems to repeat itself. The French expression *Plus ça change, plus c'est la même chose* ("The more things change, the more they remain the same") well describes this historical paradox. In the visual arts, it is possible to witness this phenomenon unfolding before our very eyes. Themes persist, styles change and are revived. New themes appear, old themes reappear. The media of art also persist; artists still use bronze and marble, oil paint, and encaustic. Nevertheless, modern technology is constantly expanding the media available to artists, as well as introducing new subjects and inspiring stylistic developments. This can be illustrated by four trends of the early twentieth century that continue to emerge in contemporary art—Expressionism, the preeminence of the object, the rejection of the object by Conceptual artists, and Surrealism. Technology has also influenced artistic media, and this has given rise to new art forms—among them, video art—although similar themes continue to be represented.

Susan Rothenberg

In a striking break with the geometric abstraction of the late 1960s and early 1970s, the animal imagery of Susan Rothenberg (b. 1945) marks a partial return to figuration. This is exemplified in her paintings of horses, which have been a subject of western art since the Paleolithic era. Rothenberg's *IXI* of 1976–7 (fig. **30.37**) is figurative, but the impasto character of the paint, from which the horse literally seems to emerge, has an Expressionist quality. The paint's rich texture, together with the horse's submersion in it, creates the impression that paint and horse are one. The two asymmetrical black diagonals enhance the movement of the horse, while the white verticals restrain it. By this dynamic balance, Rothenberg achieves a unique simultaneity of arrest and motion.

Anselm Kiefer

Anselm Kiefer (b. 1945), a prominent German Neo-Expressionist and a student of Joseph Beuys, creates powerful canvases using aggressive lines and harsh textures. His *To the Unknown Painter* of 1983 (fig. **30.38**) protests the Fascist persecution of artists in Europe and tyranny of all kinds. It also evokes one of the primary impulses to make art, namely the wish to keep alive the memory of the deceased. The somber colors and jagged surface evoke the devastation of war. From beneath the scorched picture plane a large, rectangular structure comes into focus, looming forward to memorialize those who stand for the forces of creativity and to defeat the

30.37 Susan Rothenberg, *IXI*, 1976–7. Vinyl emulsion and acrylic on canvas, 6 ft 6⅛ in × 8 ft 8 in (1.98 × 2.64 m). Hirshhorn Museum and Sculpture Garden, Smithsonian Institution (Joseph H. Hirshhorn Purchase Fund, 1990). Rothenberg is married to Bruce Nauman and they live on a ranch in northern New Mexico, where horses continue to be a large part of her life (although she has not painted one since 1979).

forces of war and destruction. It seems to be engaged in its own process of becoming, literally forming itself from the formlessness of what has been destroyed.

Maya Ying Lin

Some eleven years before the dedication of *The Women's Table*, when Maya Lin was a student at the Yale School of Architecture, she won the commission to design a memorial to those who died in the Vietnam War. Known as the *Vietnam Veterans Memorial* (fig. **30.39**), the work is a more understated form of protest than Kiefer's. On two wings of polished granite, each 246 feet (75 cm) long, seventy slabs display the names of every American killed in the war. A total of 58,183 names are inscribed in the order of their deaths. Viewers become engaged in reading the names as the reflective nature of the wall mirrors the world of the living. In this work, therefore, it is the name of the deceased, rather than the image or likeness, that conveys immortality.

Bruce Nauman

For Bruce Nauman (b. 1941), figuration is part of a more general return to the object. His wide range of media includes neon lighting, holography, video, and audio effects, as well as the more traditional forms of painting and sculpture. He has filmed himself in a variety of performance sequences, using dance, music, and language. His attraction to the object is consistent with Dada, especially the multimedia of Man Ray and the wordplay of Duchamp. "My interest in Duchamp," Nauman has said, "has to do with his use of objects to stand for ideas. I like Man Ray better: there's less 'tied-upness' in his work, more unreasonableness."[5]

30.38 Anselm Kiefer, *To the Unknown Painter*, 1983. Oil, emulsion, woodcut, shellac, latex, and straw on canvas, 9 ft 2 in × 9 ft 2 in (2.79 × 2.79 m). Carnegie Museum of Art, Pittsburgh. (Richard M. Scaife Fund and A. W. Mellon Acquisition Endowment Fund, 83.53)

30.39 Maya Ying Lin, Vietnam Veterans Memorial, polished granite, The Mall, Washington, D.C. 1981–3.

Figure **30.40** shows a photomontage of Nauman's *Model for Animal Pyramid II*. (A first version had been commissioned as an outdoor sculpture for the Des Moines, Iowa, Art Center.) It consists of molds of polyurethane foam (used by taxidermists in stuffing animals), which have been placed on top of each other in a pyramidal structure. The identity of the animals is intentionally elusive; they resemble skinned carcases, but their lack of features endows them with an alien quality. Just as Rothenberg's horse is transitional between paint and image, so Nauman's animals are both real and not real,

30.40 Bruce Nauman, *Model for Animal Pyramid II*, 1989. Cut and taped photographs, 7 ft 6½ in × 5 ft ⅛ in (2.3 × 1.53 m). Museum of Modern Art, New York (Gift of Agnes Gund and Ronald S. Lauder). Nauman is fascinated by philosophical and literary language, as well as wordplay—especially of certain modern French writers. He is quoted as saying, "I think the point where language starts to break down as a useful tool for communication is the same edge where poetry or art occurs. ... If you only deal with what is known, you'll have redundancy; on the other hand, if you only deal with the unknown, you cannot communicate at all. There's always some combination of the two, and it is how they touch each other that makes communication interesting."[6]

30.41 Jeff Koons, *New Hoover Convertibles, Green, Blue; New Hoover Convertibles, Green, Blue; Double-decker*, 1981–7. Vacuum cleaners, plexiglass, fluorescent lights; 22 units overall, 9 ft 8 in × 3 ft 5 in × 2 ft 4 in (2.95 × 1.04 × 0.71 m). Collection, Whitney Museum of American Art, New York (Purchase, funds from Sondra and Charles Gilman, Jr., Foundation/Painting and Sculpture Committee).

alive and dead, in motion and inert. Nauman's use of photographic strips, which are reminiscent of the staggered descent in Duchamp's *Nude Descending a Staircase No. 2* (see fig. 26.18), creates a sense of movement in an otherwise static work.

Jeff Koons

The "objects" of Jeff Koons (b. 1955), sometimes dismissed as kitsch, are clearly derived from Duchamp's Readymades. They are also related to Oldenburg's Pop Art

30.42 Nancy Graves, *Morphose*, 1986. Bronze and copper with polychrome patina and baked enamel, 4 ft 6 in × 3 ft 3 in × 3 ft 3 in (1.37 × 0.99 × 0.99 m). Courtesy, M. Knoedler & Co., Inc. Among Graves's earlier works are a series of freestanding abstract forms based on the objects and rituals of Native Americans and other tribal societies. From the late 1970s, she took to adding three-dimensional *objets trouvés* to her paintings and surface colors to her sculptures.

iconography of everyday household objects, and Flavin's neon light sculptures. They lack the Expressionist attraction to the material textures of paint and the traditional media of sculpture. His *New Hoover Convertibles, Green, Blue; New Hoover Convertibles, Green, Blue; Double-decker* of 1981–7 (fig. **30.41**), for example, consists of four vacuum cleaners in Plexiglas cases illuminated by fluorescent lights. Koons enshrines the vacuums, revealing them as icons of our technological society. His title is a kind of verbal collage, juxtaposing the brand of vacuum (Hoover) with the formality of color (blue and green) and references to modern transportation (convertible—as in cars—and double-decker—as in buses).

Nancy Graves

The continuing influence of Dada and Surrealism, in which content and objects are often playfully infused with ideas, can be seen in *Morphose* (fig. **30.42**) by Nancy Graves (1940–95). Her linear abstractions of natural form are reminiscent of Calder's witty mobiles. The central part is a turbine rotor from a ship, which integrates the "object" into a sculptural assemblage, as Picasso did in his *Bull's Head* of

1943 (see fig. 26.9). Anthropomorphic quality is created by Graves in a series of visual metaphors—ball for head, sardines for hair, bronze bananas for fingers. At the same time, however, the sculpture as a whole resembles a sea animal rotating slowly in space. Graves's title is itself a kind of Surrealist pun, containing the words "metamorphosis," "anthropomorphism," and "metaphor." All are related to the Greek word *morphe*, meaning "shape" or "form," which is a foundation of every work of art.

Cindy Sherman

The theme of innovation and continuity is expressed literally in some of the work of Cindy Sherman (b. 1954). Her medium is photography, and she is her own model. She has photographed herself in various guises from fashion model to cadaver. In an early series of black-and-white photographs she showed herself as if in stills from gangster movies. Her *Untitled* of 1989 (fig. **30.43**) is a photograph of herself as Raphael's *Fornarina* (fig. **30.44**). In what is apparently a satire on its Renaissance inspiration, Sherman attaches a pair of false breasts, and shows herself as pregnant. Her left hand replicates the traditional gesture signifying both modesty and seduction (cf. figs. 14.27, 14.28, 14.63, 16.3). With her right hand she holds up the heavy mesh drapery resembling a household curtain, which contrasts with Raphael's lighter, more diaphanous material. This gesture recalls that of Arnolfini's bride (see fig. 14.74). Instead of the orderly, embroidered headscarf of the Fornarina, Sherman wears a ragged cloth. In such transformations of the Renaissance work, Sherman creates a pregnant, housewifely replacement of Raphael's idealized, Classical muse.

The Fornarina ("baker's wife" in Italian) was reputed to have been one of Raphael's mistresses, a reading which is reinforced by the background leaves of laurel, myrtle, and quince. All are attributes of Venus, and are therefore associated with love. This work is also one of Raphael's very few signed paintings—the neatly jeweled armband is inscribed "Raphael of Urbino," suggesting his possession of the woman. Cindy Sherman, on the other hand, wears a garter on her arm, as if to declare her independence from men. At the same time, however, she plays on various aspects of the woman's role in society, including the sense that she is weighed down by childbearing and household chores. Sherman's humor lies in her visual punning, and in the fine line between aspects of her own role, which shifts between artist and model, self and other.

Video Art: Nam June Paik

The medium of video has offered artists new ways of conveying old, as well as contemporary, themes. One of the leading exponents of video art is the Korean-born composer, performer, and visual artist Nam June Paik (b. 1932). He studied philosophy, esthetics, and music at the University of Tokyo, and in 1956 went to Munich to study music. In Germany Paik met the avant-garde

30.43 Cindy Sherman, *Untitled*, 1989. Color photograph, 5 ft 1½ in × 4 ft ¼ in (1.56 × 1.22 m). Metro Pictures, New York. One of Sherman's best-known projects of the late 1970s was a series of black-and-white film stills, in which she dressed as a stereotypical female character—the heroine, the ingénue, the vamp—in grade-B Hollywood movies.

30.44 Raphael, *The Fornarina*, c. 1518. Oil on panel, 33½ × 23½ in (85 × 60 cm). Galleria Nazionale (Palazzo Barberini), Rome.

musician John Cage, and worked with Joseph Beuys. In the late 1960s Paik began to create video sculptures consisting of television monitors arranged in significant shapes and projecting specific, controlled images. He has developed a philosophy of cybernetics (the study of communication processes) that he translates into works, merging the transitory character of performance art with the durability of the created object. In a pamphlet entitled *Manifestos* of 1966, Paik wrote: "As the Happening is the fusion of various arts," he wrote, "so cybernetics is the exploitation of boundary regions between and across various existing sciences."[8]

In *TV Buddha* of 1974 (fig. **30.45**), Paik plays with the border between spiritual meditation and the technology of the machine age.

30.45 Nam June Paik, *TV Buddha*, 1974. Video installation with statue. Stedelijk Museum, Amsterdam.

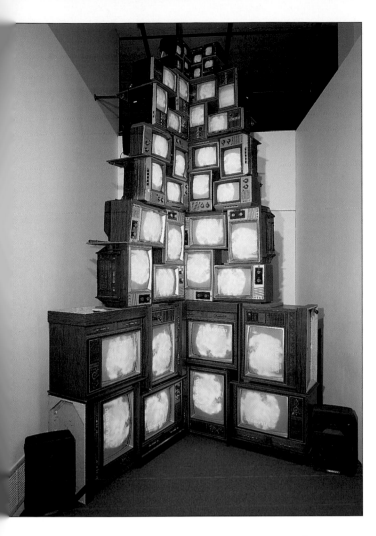

30.46 Nam June Paik, *V-yramid*, 1982. 40 TV monitors. Whitney Museum of American Art, New York (Purchase, funds from Lemberg Foundation, in honor of Samuel Lemberg).

Sometimes referred to as the "Zen Master of Video," Paik juxtaposes the religious leader with the new religion of the masses—the TV set. The Buddha sits in a traditional pose and sees himself on the screen, a metaphor, like Picasso's *Girl Before a Mirror* (see fig. 26.11), in which the reflection is an instrument of self-contemplation. The rotundity of both the TV set and the Buddha accentuates the narcissistic pun—are we seeing the ideal selflessness of Buddhism or the mindlessness of one who is "glued to the television"? *TV Buddha* exemplifies Paik's assertion that "Cybernated art is very important, but art for cybernetic life is more important, and the latter need not be cybernated."[8]

In *V-yramid* of 1982 (fig. **30.46**), Paik arranged forty television monitors in diminishing sizes. The result resembles the ziggurats of Mesopotamia and the step pyramids of ancient Egypt, but when the monitors are turned on and the lights dimmed, the wall dissolves into a polyptych of moving colors and shapes. The images are controlled by a synthesizer which Paik worked with an engineer to develop, and the accompanying soundtrack combines traditional Korean music with Western rock-and-roll. The pun contained in the title has an extremely Dada quality—"V" of "TV" and "video," and "yramid" without the "p," or a "Video Pyramid." These connections evoke

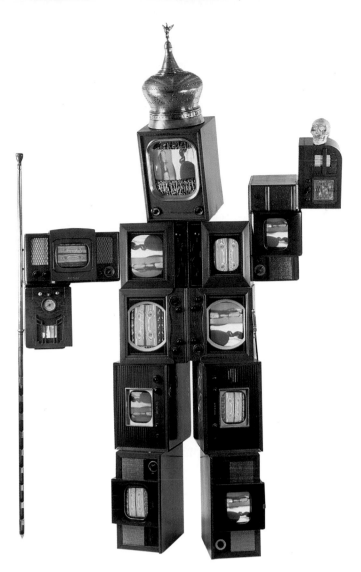

30.47 Nam June Paik, *Hamlet Robot*, 1996. 2 radios, 24 TVs, transformer, 2 laser disk players, laser disks, crown, scepter, sword, and skull, 12 ft 1 in × 7 ft 4⅕ in × 2 ft 7⅞ in (3.66 × 2.24 × 0.81 m). Whitney Museum of American Art, New York. Photo: Chris Gomien.

the contrast between the real interiors of the pyramids which, when opened, yield real works of art, and the virtual television image that can be turned on or off. But neither image "lives" in the mind of the viewer until the interiors are opened up—the pyramid excavated and the television turned on.

In 1996 Paik returned to portraiture. Inspired by a trip to Denmark, he produced the *Robot* series—portraits of six famous Danes. Figure **30.47** is *Hamlet Robot*, composed of radios, televisions, and laser disk players. Paik's *Hamlet*, like Shakespeare's, is a man who would be king but bows his crowned head as if weighed down by despair. The artist conveys Hamlet's proverbial ambivalence by the contrast of the lowered right arm holding the staff of rule with the raised left arm. The skull of Yorick posed on Hamlet's left hand is reminiscent of the warnings inherent in *vanitas* iconography, and its juxtaposition with Hamlet's head seems to foreshadow his tragic end. "The Buddhists also say," according to Paik, that "karma is samsara. Relationship is metempsychosis. We are in open circuits."[10]

Vitaly Komar and Alexander Melamid: America's Most Wanted

In the 1990s two Russians who had emigrated to the United States in 1978 also had something to say about the state of the world and its art. Vitaly Komar (b. 1943) and Alexander Melamid (b. 1945) had been dissident artists in Soviet Russia, where they participated in private exhibitions hidden from the government authorities. Their *Stalin and the Muses* of 1981–2 (fig. **30.48**) satirizes the anti-avant-garde art of the communist regime in Russia. Painted in an Academic, Socialist Realist style is a dignified Stalin, standing on a raised platform before his desk. His uniform, the books and papers on his desk, and his imposing demeanor are related to David's paintings of Napoleon and denote his position as head of state. Stalin greets four Classical Muses who offer him their inspiration, although they are careful to pay their respects and bow slightly before him.

In December 1993 Komar and Melamid decided to find out what the American people want in a painting. To that end they hired a Boston-based public opinion research firm which worked from Indiana, telephoning Americans for eleven days. The people questioned were a representative group of over one thousand adults from all over the United States, yielding a statistically accurate poll with a ± 3.2 percent margin of error. A total of 102 questions were asked.

Sixty percent of those questioned replied that they wanted a realistic painting, preferably an outdoor scene (88 percent) with a body of water (49 percent), and wild animals (51 percent) in their natural setting (89 percent). Thirty-three percent preferred fall to the other seasons, 48 percent preferred human figures in a group, fully dressed (68 percent) and at leisure (43 percent). Those polled were equally divided (50 percent) over whether the human figures should be famous or anonymous. When asked about the formal elements, 44 percent chose blue, 53 percent chose brush-strokes, 68 percent wanted some blended color, and 66 percent liked soft curves and whimsical designs. Sixty-seven percent wanted their most wanted painting to be about the size of the average American dishwasher.

To oblige, in 1994 Komar and Melamid painted *America's Most Wanted* (fig. **30.49**). It has everything the majority of those polled wanted, plus a little figure of

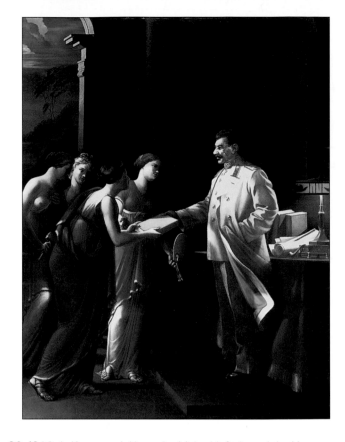

30.48 Vitaly Komar and Alexander Melamid, *Stalin and the Muses*, 1981–2. Oil on canvas, 6 ft × 4 ft 7 in (1.82 × 1.4 m). Ronald Feldman Gallery, New York.

George Washington in eighteenth-century dress standing slightly to the left of center. When asked about the poll in an interview, Melamid pointed to the American system of voting for its leaders: "If 20,000 more people voted for you, it means that you are the President. That's why we mimic this in the poll." And about the result? "I think," he continued, "that it's a better picture, because there was more effort put into it. So many people worked ... more than 1,001. We spent $40,000! For the size of this picture [dishwasher size], it's quite expensive, I think."[10]

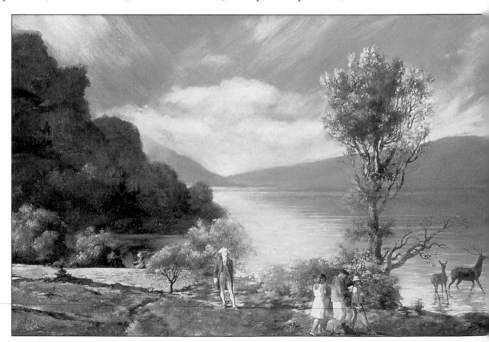

30.49 Vitaly Komar and Alexander Melamid, *America's Most Wanted*, 1994. Oil and acrylic on canvas, 24 × 32 in (61 × 81.3 cm).

30.50 Vitaly Komar and Alexander Melamid, *America's Most Unwanted*, 1994. Oil and acrylic on canvas, 5½ × 8½ in (14 × 21.6 cm).

When asked how they arrived at the idea for the poll, Melamid replied that they wanted to understand the Americans, and they realized that the best way to do so—the way that the President, for example, gets to know the American people—is to poll them. They discovered, to their surprise, that in a society known for freedom of the individual, their poll "revealed sameness of majority. Having destroyed communism's utopian illusion, we collided with democracy's virtual reality."[11]

It is interesting that in the one detail where the poll was non-committal (because it was exactly fifty–fifty), namely whether the figure included should be famous or not, Komar and Melamid were most free to make an independent decision. That they chose George Washington is perhaps their most individual choice (although they hedged their bets and also included anonymous people). The question is: do they think George Washington is the figure most wanted by Americans, does he appeal to their instincts for freedom from kings and dictators, or does he, like Stalin, represent their nostalgia for a strong leader?

Komar and Melamid also painted *America's Most Unwanted* (fig. **30.50**). It is nonrepresentational and non-figurative, composed entirely of geometric shapes (30 percent of those polled), of dark (22 percent) golds, oranges, peaches, and teal (1 percent), and of painterly surfaces (40 percent). The colors are not blended (18 percent) and have sharp edges (39 percent), and the picture is small in size—paperback book-size (4 percent). "Different-looking" with "imaginary objects" was definitely unwanted—30 percent and 36 percent respectively.

If one didn't known better, one might conclude from this poll that the twentieth century had never happened in America—certainly not twentieth-century art. Geometric abstraction, nonrepresentation, and painterly brushwork do not seem to have significantly affected the esthetic sensibilities of the American people. But, avoiding accusations of a skewed sampling, Komar and Melamid followed up the American poll with a similar survey in Russia, the Ukraine, France, Finland, Iceland, Denmark, Turkey, Kenya, and China. In ten countries, representing 1,824,690,000 people—over 32 percent of the total world population—the same 102 questions were answered.

The two Russians then proceeded to paint the *Most Wanted* and *Unwanted* [paintings] of the nine remaining countries. All of the former are blue landscapes with bodies of water, clothed human figures at leisure, and at least one animal in its natural habitat—except for the *Ukraine's Most Wanted*, which has no figures, human or animal, in its predominately blue landscape. *Denmark's Most Wanted* (fig. **30.51**) actually has more red than the other *Most Wanteds*—in the clouds and in the Danish flag. It also has three ballerinas in white tutus. *Kenya's Most Wanted* has more green, as does *China's Most Wanted*, though both are still primarily blue.

It would seem, therefore, that most of the world has missed out on the innovations of twentieth-century art. But there is more. Obviously Komar and Melamid take their polls seriously, for they also found that 38 percent of those polled had never heard of Picasso, 64 percent of Monet, 58 percent of Pollock, and 57 percent of Warhol. Sixty percent of the population of China, Finland, Kenya, Turkey, and the United States (equal to 27.8 percent of the total world population) only likes art that makes people happy. Maybe Rembrandt does not make people happy, for, according to the same poll, 66 percent of the population has never heard of him.

The implication of these findings is clearly that, without artists, there is no esthetic originality, no esthetic adventure, no esthetic change or development, no visual intellect or imagination. The poll also highlights the odds against which artists have to fight to change the way people see and experience the world around them.

30.51 Vitaly Komar and Alexander Melamid, *Denmark's Most Wanted*, 1995. Oil on canvas, 28 × 48 in (71.1 × 121.9 cm).

For no other reason than the implications of this poll, the United States Congress should go out of its way to fund the arts and to defend the First Amendment rights of free speech in works of art—even in difficult works of art.

As we move into the twenty-first century, we are presented with a proliferation of artistic styles and expanding definitions of what actually constitutes art. The pace of technological change, particularly in communications and the media, spawns new concepts and styles at an increasing rate. Taste as well as style changes, and it will be for future generations to look back at our era and to separate the permanent from the impermanent. How long a work of art must endure for it to claim a place in the artistic pantheon is a matter of dispute. The little *Venus of Willendorf* has existed for over 25,000 years, the Sistine ceiling for over 450. And yet some of the modern art discussed in this chapter is intentionally transitory. Performance art, for example, lasts no longer than the performance itself, except in memory or on film.

In this survey we have considered some of the artists whose works have stood the test of time. Artists, the "children" of preceding generations of artists, are influenced by their predecessors. This survey will have fulfilled its purpose if readers are affected by some of the best of what has survived.

Style/Period	Works of Art	Cultural/Historical Developments
INNOVATION AND CONTINUITY	c. 1518: Raphael, *The Fornarina* (**30.44**)	
1960 1960–1970	Breuer, Whitney Museum of American Art (**30.9**), New York Fuller, American Pavilion (**30.10**), Montreal Close, *Self-portrait* (**30.2**)	
1970 1970–1980	Smithson, *Spiral Jetty* (**30.22**) Gilbert and George, *Singing Sculptures* (**30.4**) Hanson, *Artist with Ladder* (**30.6**) Paik, *TV Buddha* (**30.45**) Rothenberg, *IXI* (**30.37**) Holt, *Stone Enclosure: Rock Rings* (**30.23**) Moore and Hersey, *Piazza d'Italia* (**30.11**), New Orleans Estes, *The Solomon R. Guggenheim Museum* (**30.8**) Chicago, *The Dinner Party* (**30.31**)	
1980 1980–1990	Graves, *Portland Building* (**30.12**), Oregon Mapplethorpe, *Self-portrait* (**30.1**) Komar and Melamid, *Stalin and the Muses* (**30.48**) Lin, *Vietnam Veterans Memorial* (**30.39**) Koons, *New Hoover Convertibles* (**30.41**) Paik, *V-yramid* (**30.46**) Kiefer, *To the Unknown Painter* (**30.38**) Basquiat, *Carbon/Oxygen* (**30.30**) Christo and Jeanne-Claude, *Umbrellas* (**30.24–30.25**) Anderson, *Nave Bible Tour* (**30.5**) Graves, *Morphose* (**30.42**) Rogers, *Lloyd's Building* (**30.14**), London Estes, *Williamsburg Bridge* (**30.7**) Pei, *Louvre Pyramid* (**30.13**), Paris Jaudon, *Long Division* (**30.29**) Nauman, *Model for Animal Pyramid II* (**30.40**) Sherman, *Untitled* (**30.43**)	Norman Mailer, *The Executioner's Song* (1980) Tom Wolfe, *The Right Stuff* (1980) Ronald Reagan elected President of the U.S. (1980) Thomas Keneally, *Schindler's List* (1982) First patient receives permanent artificial heart (1982) Alice Walker, *The Color Purple* (1983) David Mamet, *Glengarry Glen Ross* (1984) Milan Kundera, *The Unbearable Lightness of Being* (1984) Early stages of AIDS epidemic in the U.S. (mid-1980s) Toni Morrison, *Beloved* (1988) Communist governments in eastern Europe fall (1989)
1990 1990–2000	Gehry, *Frederick R. Wiseman Museum* (**30.17**), Minneapolis Lin, *The Women's Table* (**30.35–30.36**) Smith, *Mary Magdalen* (**30.32–30.33**) Christo and Jeanne-Claude, *Wrapped Reichstag* (**30.26–30.27**) Pondick, *Tree* (model) (**30.34**) Paik, *Hamlet Robot* (**30.47**) Komar and Melamid, *America's Most Wanted* (**30.49**) Komar and Melamid, *America's Most Unwanted* (**30.50**) Komar and Melamid, *Denmark's Most Wanted* (**30.51**) Close, *Self-portrait* (**30.3**) Gehry, *Solomon R. Guggenheim Museum Bilbao* (**30.16, 30.18–30.21**) Christo and Jeanne-Claude, *Over the River* (**30.28**)	August Wilson, *The Piano Lesson* (1990) Apartheid ends in South Africa; Nelson Mandela freed (1990) Iraq invades Kuwait; Operation Desert Shield (1990–91) Dissolution of U.S.S.R. (1992) Bill Clinton elected President of the U.S. (1992) North American Free Trade Agreement takes effect (1994) Federal office building in Oklahoma City bombed (1995)

Fuller, American Pavilion

Estes, The Solomon R. Guggenheim Museum

Christo and Jeanne-Claude, Umbrellas

Close, Self-portrait

Komar and Melamid, America's Most Wanted

Glossary

Abstract: in painting and sculpture, having a generalized or essential form with only a symbolic resemblance to natural objects.

Academy: (a) the gymnasium near Athens where Plato taught; (b) from the eighteenth century, the cultural and artistic establishment and the standards that they represent.

Achromatic: free of color.

Acrylic: a fast-drying, water-based synthetic paint **medium**.

Aedicule: (a) a small building used as a shrine; (b) a **niche** designed to hold a statue. Both types are formed by two **columns** or **pilasters** supporting a **gable** or **pediment.**

Aerial: (or **atmospheric**) **perspective**: a technique for creating the illusion of distance by the use of less distinct contours and a reduction in color intensity (see p. 500).

Airbrush: a device for applying a fine spray of paint or other substance by means of compressed air.

Aisle: a passageway flanking a central area (e.g. the corridors flanking the **nave** of a **basilica** or **cathedral**).

Allegory: the expression (artistic, oral, or written) of a generalized moral statement or truth by means of symbolic actions or figures.

Altar: (a) any structure used as a place of sacrifice or worship; (b) a tablelike structure used in a Christian church to celebrate the **Eucharist**.

Altarpiece: a painted or sculpted work of art designed to stand above and behind an **altar.**

Ambulatory: a vaulted passageway, usually surrounding the **apse** or **choir** of a church (Vol. I, fig. **11.4**).

Apocalypse: (a) a name for the last book of the New Testament, generally known as the Revelation of Saint John the Divine; (b) a prophetic revelation.

Apostle: in Christian terminology, one of the twelve followers, or disciples, chosen by Christ to spread his Gospel; also used more loosely to include early missionaries such as Saint Paul.

Apse: a projecting part of a building (especially a church), usually semi-circular and topped by a half-**dome** or **vault**.

Aquatint: a **print** from a metal **plate** on which certain areas have been "stopped out" to prevent the action of the acid (fig. **21.14**).

Arabesque: literally meaning "in the Arabian fashion," an intricate pattern of interlaced or knotted lines consisting of stylized floral, foliage, and other **motifs**.

Arcade: a **gallery** formed by a series of **arches** with supporting **columns** or **piers** (Vol. I, fig. **12.5**), either freestanding or blind (i.e. attached to a wall).

Arch: a curved architectural member, generally consisting of wedge-shaped blocks (**voussoirs**), which is used to span an opening; it transmits the downward pressure laterally (see Vol. I, p. 213).

Architrave: the lowest unit of an **entablature**, resting directly on the **capital** of a **column**.

Arena: the central area in a Roman amphitheater where gladiatorial spectacles took place.

Arriccio: the rough first coat of plaster in a **fresco.**

Assemblage: a group of **three-dimensional** objects brought together to form a work of art.

Asymmetrical: characterized by asymmetry, or lack of **balance**, in the arrangement of parts or components.

Atmospheric perspective: see **aerial perspective.**

Atrium: (a) an open courtyard leading to, or within, a house or other building, usually surrounded on three or four sides by a **colonnade**; (b) in a modern building, a rectangular space off which other rooms open.

Avant-garde: literally the "advanced guard," a term used to denote innovators or nontraditionalists in a particular field.

Axonometric projection: the depiction on a single plane of a **three-dimensional** object by placing it at an angle to the **picture plane** so that three faces are visible (Vol. I, fig. **9.31**).

Balance: an esthetically pleasing equilibrium in the combination or arrangement of elements.

Baldacchino: a canopy or canopylike structure above an **altar** or throne (fig. **18.2**).

Balustrade: a series of balusters, or upright pillars, supporting a rail (as along the edge of a balcony or bridge).

Baptistry: a building, usually round or polygonal, used for Christian baptismal services.

Barrel (or **tunnel**) **vault**: a semicylindrical **vault**, with parallel abutments and an identical **cross-section** throughout, covering an oblong space (see Vol. I, p. 213).

Base: (a) that on which something rests; (b) the lowest part of a wall or **column** considered as a separate architectural feature.

Basilica: (a) in Roman architecture, an oblong building used for tribunals and other public functions (see Vol. I, p. 219); (b) in Christian architecture, an early church with similar features to the Roman prototype (Vol. I, fig. **9.7**).

Bay: a unit of space in a building, usually defined by **piers**, **vaults**, or other elements in a structural system (Vol. I, fig. **12.2**).

Beaverboard: a type of fiberboard used for partitions and ceilings.

Binder, **binding medium**: a substance used in paint and other **media** to bind particles of **pigment** together and enable them to adhere to a surface.

Biomorphic: derived from or representing the forms of living things rather than abstract shapes.

Broken pediment: a **pediment** in which the **cornice** is discontinuous or interrupted by another element.

Burin: a metal tool with a sharp point to incise designs on pottery and **etching plates**, for example.

Burr: in **etching**, the rough ridge left projecting above the surface of an engraved **plate** where the design has been incised (see p. 663).

Bust: a sculptural or pictorial representation of the upper part of the human figure, including the head and neck (and sometimes part of the shoulders and chest).

Buttress: an external architectural support that counteracts the lateral thrust of an **arch** or wall.

Caduceus: the symbol of a herald or physician, consisting of a staff with two snakes twined around it and two wings at the top.

Calligraphy: the art of fine (literally "beautiful") handwriting.

Camera obscura: a dark enclosure or box into which light is admitted through a small hole, enabling images to be projected onto a wall or screen placed opposite that hole; the forerunner of the photographic camera (fig. **22.10**).

Cantilever construction: an architectural system in which a beam or member, supported at only one end, projects horizontally from a wall or **pier** to which it is fixed (fig. **26.31**).

Capital: the decorated top of a **column** or **pilaster**, providing a transition from the **shaft** to the **entablature**.

Caricature: a representation in art or literature that distorts, exaggerates, or oversimplifies certain features.

Cartoon: (a) a full-scale preparatory drawing for a painting; (b) in more modern usage, a comical or satirical drawing.

Cartouche: an oval or **scroll**-shaped design or ornament, usually containing an inscription, a heraldic device, or (as in Egypt) a ruler's name.

Caryatid: a supporting **column** in **post-and-lintel construction** carved to represent a human or animal figure.

Casein: a light-colored, protein-based substance derived from milk, used in the making of paint, adhesives, etc.

Casting: a sculptural process in which liquid metal or plaster is poured into a mold to create a copy of the original model.

Cathedral: the principal church of a diocese (the ecclesiastical district supervised by a bishop).

Cella: the main inner room of a temple, often containing the cult image of the deity.

Centering: the temporary wooden framework used in the construction of **arches**, **vaults**, and **domes**.

Centrally planned: radiating from a central point.

Chancel: that part of a Christian church, reserved for the clergy and choir, in which the **altar** is placed.

Château: French word for a castle or large country house.

Chattra: a royal parasol crowning the dome of a Buddhist **stupa**, symbolically honoring the Buddha.

Chiaroscuro: the subtle gradation of light and shadow used to create the effect of **three-dimensionality.**

Choir: part of a Christian church, near the **altar**, set aside for those chanting the services (Vol. I, fig. **11.4**); usually part of the **chancel**.

Chroma: see **intensity**.

Chromatic: colored or pertaining to color.

Clerestory: the upper part of the main outer wall of a building (especially a church), located above an adjoining roof and admitting light through a row of windows (Vol. I, fig. **9.8**).

Coffer, **coffering**: a recessed geometrical panel in a ceiling (Vol. I, fig. **8.32**).

Collage: a work of art formed by pasting fragments of printed matter, cloth, and other materials (occasionally **three-dimensional**) to a flat surface.

Colonnade: a series of **columns** set at regular intervals, usually supporting **arches** or an **entablature**.

Colonnette: a small, slender **column**, usually grouped with others.

Color wheel: a circular, two-dimensional model illustrating the relationships of the various **hues** (Vol. I, fig. **1.18**).

Column: a cylindrical support, usually with three parts—**base**, shaft, and **capital** (see Vol. I, p. 160).

Complementary colors: **hues** that lie directly opposite each other on the **color wheel.**

Composition: the arrangement of formal elements in a work of art.

Conceptual art: art in which the idea is more important than the **form** or style.

Content: the themes or ideas in a work of art, as distinct from its **form**.

Contour: a line representing the outline of a figure or form.

Contrapposto (or **counterpoise**): a stance of the human body in which one leg bears the weight, while the other is relaxed, creating an **asymmetry** in the hip–shoulder axis (Vol. I, fig. **6.26**).

Contrast: an abrupt change, such as that created by the juxtaposition of dissimilar colors, objects, etc.

Convention: a custom, practice, or principle that is generally recognized and accepted.

Corbelling: brick or masonry courses, each projecting beyond, and supported by, the one below it; the meeting of two corbels would create an **arch** or **vault**.

Corinthian: see **Order**.

Cornice: the projecting horizontal unit, usually molded, that surmounts an **arch** or wall; the topmost member of a Classical **entablature** (see Vol. I, p. 160).

Counterpoise: see *contrapposto*.

Crayon: a stick for drawing formed from powdered **pigment** mixed with wax.

Cromlech: a prehistoric monument consisting of a circle of **monoliths**.

Cross-hatching: pattern of superimposed parallel lines (**hatching**) on a two-dimensional surface used to create shadows and suggest **three-dimensionality** (Vol. I, fig. **1.16**).

Cross-section: a diagram showing a building cut by a vertical **plane**, usually at right angles to an axis (Vol. I, fig. **8.31**).

Crossing: the area in a Christian church where the **transepts** intersect the **nave**.

Cupola: a small, domed structure crowning a roof or **dome**, usually added to provide interior lighting.

Curvilinear: composed of, or bounded by, curved lines.

Daguerreotype: mid-nineteenth-century photographic process for **fixing** positive images on silver-coated metal **plates** (see p. 747).

Deësis: a tripartite **icon** in the Byzantine tradition, usually showing Christ enthroned between the Virgin Mary and Saint John the Baptist.

Diptych: a writing tablet or work of art consisting of two panels side by side and connected by hinges.

Dome: a **vaulted** (frequently hemispherical) roof or ceiling, erected on a circular base, which may be envisaged as the result of rotating an **arch** through 180 degrees about a central axis.

Doric: see **Order**.

Drip technique: a painting technique in which paint is dripped from a brush or stick onto a horizontal canvas or other **ground**.

Drum: (a) one of the cylindrical blocks of stone from which the shaft of a **column** is made; (b) the circular or polygonal wall of a building surmounted by a **dome** or **cupola**.

Drypoint: an **engraving** in which the image is scratched directly into the surface of a metal **plate** with a pointed instrument.

Easel: a frame for supporting a canvas or wooden panel.

Edition: a batch of **prints** made from a single **plate** or print form.

Elevation: an architectural diagram showing the exterior (or, less often, interior) surface of a building as if projected onto a vertical plane.

Emulsion: a light-sensitive, chemical coating used to transfer photographic images onto metal **plates** or other surfaces.

Encaustic: a painting technique in which **pigment** is mixed with a **binder** of hot wax and fixed by heat after application (see Vol. I, p. 148).

Engaged (half-) column: a **column**, decorative in purpose, which is attached to a supporting wall.

Engraving: (a) the process of incising an image on a hard material, such as wood, stone, or a copper **plate**; (b) a **print** or impression made by such a process (see p. 617).

Entablature: the portion of a Classical architectural **order** above the **capital** of a **column** (see Vol. I, p. 160).

Entasis: the slight bulging of a Doric **column**, which is at its greatest about one third of the distance from the **base**.

Esthetic: the theory and vocabulary of an individual artistic style.

Esthetics: the philosophy and science of art and artistic phenomena.

Etching: (a) a printmaking process in which an impression is taken from a metal **plate** on which the image has been etched, or eaten away by acid (see p. 663); (b) a **print** produced by such a process.

Etching ground: a resinous, acid-resistant substance used to cover a copper **plate** before an image is etched on it.

Eucharist: (a) the Christian sacrament of Holy Communion, commemorating the Last Supper; (b) the consecrated bread and wine used at the sacrament.

Façade: the front, or "face," of a building.

Figura serpentinata: a snakelike twisting of the body, typical of Mannerist art.

Figurative: representing the likeness of a recognizable human (or animal) figure.

Fixing: the use of a chemical process to make an image (a photograph, for example) more permanent.

Fleur-de-lys: (a) a white iris, the royal emblem of France; (b) a **stylized** representation of an iris, common in artistic design and heraldry.

Flutes, fluting: a series of vertical grooves used to decorate the shafts of **columns** in Classical architecture.

Foreground: the area of a picture, usually at the bottom of the **picture plane**, that appears nearest to the viewer.

Foreshortening: the use of **perspective** to represent a single object extending back in space at an angle to the **picture plane**.

Form: the overall plan or structure of a work of art.

Found object (or *objet trouvé*): an object not originally intended as a work of art, but presented as one.

Fresco: a technique (also known as *buon fresco*) of painting on the plaster surface of a wall or ceiling while it is still damp, so that the **pigments** become fused with the plaster as it dries.

Frieze: (a) the central section of the **entablature** in the Classical **Orders**; (b) any horizontal decorative band.

Functionalism: a philosophy of design (in architecture, for example) holding that **form** should be consistent with material, structure, and use.

Gable (or **pitched**) **roof**: a roof formed by the intersection of two **planes** sloping down from a central beam.

Gallery: the second story of a church, placed over the side **aisles** and below the **clerestory**.

Genre: a category of art representing scenes of everyday life.

Geodesic dome: a **dome**-shaped framework consisting of small, interlocking polygonal units (fig. **30.10**).

Geometric: based on mathematical shapes such as the circle, square, or rectangle.

Gesso: a white coating made of chalk, plaster, and **size** that is spread over a surface to make it more receptive to paint.

Gilding: a decorative coating made of gold leaf or simulated gold; objects to which gilding has been applied are "gilded" or "gilt."

Glaze: in **oil painting**, a layer of translucent paint or varnish, sometimes applied over another color or **ground**, so that light passing through it is reflected back by the lower surface and modified by the glaze.

Glyptic art: the art of carving or **engraving**, especially on small objects such as seals or precious stones.

Gospel: one of the first four books of the New Testament, which recount the life of Christ.

Gouache: an opaque, water-soluble painting **medium**.

Greek cross: a cross in which all four arms are of equal length.

Grisaille: a **monochromatic** painting (usually in shades of black and gray, to simulate stone sculpture).

Groin (or **cross-**) **vault**: the ceiling configuration formed by the intersection of two **barrel vaults**.

Ground: in painting, the prepared surface of the support to which the paint is applied.

Ground plan: a plan of the ground floor of a building, seen from above (as distinguished from an **elevation**).

Guild: an organization of craftsmen, such as those that flourished in the Middle Ages and Renaissance (see Vol. I, p. 396).

Half-column: see **engaged column**.

Halo: a circle or disk of golden light surrounding the head of a holy figure.

Happening: an event in which artists give an unrehearsed performance, sometimes with the participation of the audience.

Hatching: close parallel lines used in drawings and prints to create the effect of shadow on **three-dimensional** forms. See also **cross-hatching**.

Highlight: in painting, an area of high **value** color.

Hôtel: in eighteenth-century France, a city mansion belonging to a person of rank.

Hue: a pure color with a specific wavelength.

Iconography: the analysis of works of art through the study of the meanings of symbols and images in the context of the contemporary culture.

Iconology: the study of the meaning or content of a larger **program** to which individual works of art belong.

Idealized, idealization: the representation of objects and figures according to ideal standards of beauty rather than to real life.

Ignudi (pl.): nude figures (in Italian).

Illuminated manuscript: see **manuscript**.

Illusionism, illusionistic: a type of art in which the objects are intended to appear real.

Impasto: the thick application of paint, usually **oil** or **acrylic**, to a canvas or panel.

Installation: a **three-dimensional** environment or ensemble of objects, presented as a work of art.

Intensity: the degree of purity of a color; also known as **chroma** or **saturation**.

Intaglio: a printmaking process in which lines are incised into the surface of a **plate** or **print** form (e.g. **engraving** and **etching**).

Ionic: see **Order**.

Isocephaly, Isocephalic: the horizontal alignment of the heads of all the figures in a composition.

Jambs: the upright surfaces forming the sides of a doorway or window, often decorated with sculptures in Romanesque and Gothic churches (Vol. I, fig. **12.22**).

Japonisme: the adoption of features characteristic of Japanese art and culture.

Keystone: the wedge-shaped stone at the center of an **arch**, **rib**, or **vault**, which is inserted last, locking the other stones into place.

Kouros (pl. *kouroi*): Greek word for young man; an Archaic Greek statue of a standing nude youth (Vol. I, fig. **6.19**).

Krater: a wide-mouthed bowl for mixing wine and water in ancient Greece (Vol. I, fig. **6.8**).

Lancet: a tall, narrow, arched window without **tracery**.

Landscape: a pictorial representation of natural scenery.

Lantern: the structure crowning a **dome** or tower, often used to admit light to the interior.

Latin cross: a cross in which the vertical arm is longer than the horizontal arm, through the midpoint of which it passes (Vol. I, fig. **9.9**).

Linear: a style in which lines are used to depict figures with precise, fully indicated outlines.

Linear (or **scientific**) **perspective**: a mathematical system devised during the Renaissance to create the illusion of depth in a two-dimensional image, through the use of straight lines converging toward a **vanishing point** in the distance (see p. 490).

Lintel: the horizontal cross-beam spanning an opening in the **post-and-lintel** system.

Lithography: a printmaking process (see p. 744) in which the printing surface is a smooth stone or **plate** on which an image is drawn with a **crayon** or some other oily substance.

Loggia: a roofed gallery open on one or more sides, often with **arches** or **columns**.

Lunette: (a) a semicircular area formed by the intersection of a wall and a **vault**; (b) a painting, **relief** sculpture, or window of the same shape.

Magus: (pl. **magi**): in the New Testament, one of the three Wise Men who traveled from the East to pay homage to the infant Christ.

Manuscript: a handwritten book produced in the Middle Ages or Renaissance. If it has painted illustrations, it is known as an **illuminated manuscript**.

Martyrium: a church or other structure built over the tomb or relics of a martyr.

Masonite: a type of fiberboard used in insulation and paneling.

Mausoleum (pl. **mausolea**): an elaborate tomb (named for Mausolos, a fourth-century-B.C. ruler commemorated by a magnificent tomb at Halikarnassos).

Medium (pl. **media**): (a) the material with which an artist works (e.g. **watercolor** on paper); (b) the liquid substance in which **pigment** is suspended, such as oil or water.

Memento mori: an image, often in the form of a skull, to remind the living of the inevitability of death.

Metope: the square area, often decorated with **relief** sculpture, between the **triglyphs** of a Doric **frieze** (see Vol. I, p. 160).

Mezzotint: a method of **engraving** by burnishing parts of a roughened surface to produce an effect of light and shade.

Minaret: a tall, slender tower attached to a **mosque**, from which the *muezzin* calls the Muslim faithful to prayer (Vol. I, fig. **10.14**).

Miniature: a representation executed on a much smaller scale than the original object.

Mobile: a delicately balanced sculpture with movable parts that are set in motion by air currents or mechanical propulsion.

Modeling: (a) in two-dimensional art, the use of **value** to suggest light and shadow, and thus create the effect of mass and weight; (b) in sculpture, the creation of form by manipulating a pliable material such as clay.

Module: a unit of measurement on which the **proportions** of a building or work of art are based.

Molding: a continuous contoured surface, either recessed or projecting, used for decorative effect on an architectural surface.

Monastery: a religious establishment housing a community of people living in accordance with religious vows (see Vol. I, p. 343).

Monochromatic: having a color scheme based on shades of black and white, or on **values** of a single **hue**.

Monolith: a large block of stone that is all in one piece (i.e. not composed of smaller blocks), used in **megalithic** structures.

Monumental: being, or appearing to be, larger than lifesize.

Mosaic: the use of small pieces of glass, stone, or tile (**tesserae**), or pebbles, to create an image on a flat surface such as a floor, wall, or ceiling (see Vol. I, p. 282).

Mosque: an Islamic (Muslim) house of worship.

Motif: a recurrent element or theme in a work of art.

Mural: a painting on a wall, usually on a large scale and in **fresco**.

Naive art: art created by artists with no formal training.

Naos: the inner sanctuary of an ancient Greek temple.

Naturalism, naturalistic: a style of art seeking to represent objects as they actually appear in nature.

Nave: in **basilicas** and churches, the long, narrow, central area used to house the congregation.

Niche: a hollow or recess in a wall or other architectural element, often containing a statue; a blind niche is a very shallow recess.

Nike: a winged statue representing Nike, the goddess of victory.

Nonrepresentational (or **nonfigurative**): not representing any known object in nature.

Objet trouvé: see **found object**.

Oculus: a round opening in a wall or at the apex of a **dome**.

Oil paint: slow-drying and flexible paint formed by mixing **pigments** with the **medium** of oil.

One-point perspective: a **perspective** system involving a single **vanishing point**.

Order: one of the architectural systems (Corinthian, Ionic, Doric) used by the Greeks and Romans to decorate and define the **post-and-lintel** system of construction (see Vol. I, p. 160).

Organic: having the quality of living matter.

Orthogonals: the converging lines that meet at the **vanishing point** in the system of **linear perspective**.

Pagoda: a multistoried Buddhist reliquary tower, tapering toward the top and characterized by projecting eaves (Vol. I, figs. **12.D–F**).

Painterly: in painting, using the qualities of color and **texture**, rather than line, to define form.

Palette: (a) the range of colors used by an artist; (b) an oval or rectangular tablet used to hold and mix the **pigments**.

Palette knife: a knife with a flat, flexible blade and no cutting edge, used to mix and spread paint.

Pastel: a **crayon** made of ground **pigments** and a gum **binder**, used as a drawing **medium**.

Patron: the person or group that commissions a work of art from an artist.

Pedestal: the base of a **column**, statue, vase, or other upright work of art.

Pediment: (a) in Classical architecture, the triangular section at the end of a **gable roof**, often decorated with sculpture; (b) a triangular feature placed as a decoration over doors and windows.

Pendentive: in a domed building, an inwardly curving triangular section of the **vaulting** that provides a transition from the round base of the **dome** to the supporting **piers** (Vol. I, fig. **9.33**).

Peristyle: a **colonnade** surrounding a structure (Vol. I, fig. **8.4**); in Roman houses, the courtyard surrounded by **columns**.

Perspective: the illusion of depth in a two-dimensional work of art.

Picture plane: the flat surface of a drawing or painting.

Pier: a vertical support used to bear loads in an **arched** or **vaulted** structure (Vol. I, fig. **12.5**).

Pietà: an image of the Virgin Mary holding and mourning over the dead Christ (fig. **15.19**).

Pigment: a powdered substance that is used to give color to paints, inks, and dyes.

Pilaster: a flattened, rectangular version of a **column**, sometimes load-bearing, but often purely decorative.

Plane: a surface on which a straight line joining any two of its points lies on that surface; in general, a flat surface.

Plate: (a) in **engraving** and **etching**, a flat piece of metal into which the image to be printed is cut; (b) in photography, a sheet of glass, metal, etc., coated with a light-sensitive **emulsion**.

Podium: a raised platform or **pedestal**.

Polyptych: a painting or **relief**, usually an **altarpiece**, composed of more than three sections.

Portal: the doorway of a church and the architectural composition surrounding it.

Portico: (a) a **colonnade**; (b) a porch with a roof supported by **columns**, usually at the entrance to a building.

Portrait: a visual representation of a specific person; a likeness.

Portraiture: the art of making portraits.

Post-and-lintel construction: an architectural system in which upright members, or posts, support horizontal members, or **lintels** (see Vol. I, p. 45).

Predella: the lower part of an altarpiece, often decorated with small scenes that are related to the subject of the main panel (Vol. I, figs. **13.14** and **13.23**).

Primary colors: the pure **hues**—blue, red, yellow—from which all other colors can in theory be mixed.

Print: a work of art produced by one of the printmaking processes—**engraving**, **etching**, and **woodcut**.

Print matrix: an image-bearing surface to which ink is applied before a **print** is taken from it.

Program: the arrangement of a series of images into a coherent whole.

Proportion: the relation of one part to another, and of parts to the whole, in respect of size, height, and width.

Pulpit: in church architecture, an elevated stand, surrounded by a parapet and often richly decorated, from which the preacher addresses the congregation.

Putto (pl. *putti*): a chubby male infant, often naked and sometimes depicted as a Cupid, popular in Renaissance art (fig. **14.60**).

Pylon: a pair of truncated, pyramidal towers flanking the entrance to an Egyptian temple.

Quatrefoil: an ornamental "four-leaf clover" shape, i.e. with four lobes radiating from a common center.

Rayograph: an image made by placing an object directly on light-sensitive paper, using a technique developed by Man Ray.

Realism, realistic: attempting to portray objects from everyday life as they actually are; not to be confused with the nineteenth-century movement called Realism (see p. 741).

Rectilinear: consisting of, bounded by, or moving in a straight line or lines.

Red-figure: describing a style of Greek pottery painting of the sixth or fifth century B.C., in which the decoration is red on a black background.

Reinforced concrete: concrete strengthened by embedding an internal structure of wire mesh or rods.

Relief: (a) a mode of sculpture in which an image is developed outward ("high" or "low relief") or inward ("sunken relief") from a basic plane; (b) a printmaking process in which the areas not to be printed are carved away, leaving the desired image projecting from the **plate**.

Reliquary: a casket or container for sacred relics.

Representational: representing natural objects in recognizable form.

Rib: an arched diagonal element in a **vault** system that defines and supports a **ribbed vault**.

Ribbed vault: a **vault** constructed of arched diagonal **ribs**, with a web of lighter masonry in between.

Romanticize: to glamorize or portray in a romantic, as opposed to **realistic**, manner.

Rose window: a large, circular window decorated with **stained glass** and **tracery** (Vol. I, fig. **12.31**).

Rosin: a crumbly resin used in making varnishes and lacquers.

Rusticate: to give a rustic appearance to masonry blocks by roughening their surface and beveling their edges so that the joints are indented.

Salon: (a) a large reception room in an elegant private house; (b) an officially sponsored exhibition of works of art (see p. 722).

Sarcophagus: a stone coffin, sometimes decorated with **relief** sculpture.

Saturation: see **intensity**.

Satyr: an ancient woodland deity with the legs, tail, and horns of a goat (or horse), and the head and torso of a man.

Scientific perspective: see **linear perspective**.

Scroll: a curved **molding** resembling a scroll (e.g. the **volute** of an Ionic or Corinthian **capital**).

Sculptured wall motif: the conception of a building as a massive block of stone with openings and spaces carved out of it.

Secondary colors: **hues** produced by combining two **primary colors**.

Section: a diagrammatic representation of a building intersected by a vertical **plane**.

Sfumato: the definition of form by delicate gradations of light and shadow (see p. 555).

Shading: decreases in the **value** or intensity of colors to imitate the fall of shadow when light strikes an object.

Sibyl: a prophetess of the ancient, pre-Christian world.

Silhouette: the outline of an object, usually filled in with black or some other uniform color.

Silkscreen: a printmaking process in which **pigment** is forced through the mesh of a silkscreen, parts of which have been masked to make them impervious.

Size, sizing: a mixture of glue or resin that is used to make a **ground** such as canvas less porous, so that paint will not be absorbed into it.

Skeletal (or **steel-frame**) **construction**: a method of construction in which the walls are supported at ground level by a steel frame consisting of vertical and horizontal members.

Spandrel: the triangular area between (a) the side of an **arch** and the right angle that encloses it and (b) two adjacent arches.

Stained glass: windows composed of pieces of colored glass held in place by strips of lead (see Vol. I, p. 392).

State: one of the successive printed stages of a **print**, distinguished from other stages by the greater or lesser amount of work carried out on the image (see p. 663).

Steel-frame construction: see **skeletal construction**.

Stigmata (pl.): marks resembling the wounds on the crucified body of Christ (from "stigma," a mark or scar).

Still life: a picture consisting principally of inanimate objects such as fruit, flowers, or pottery.

Stucco: (a) a type of cement used to coat the walls of a building; (b) a fine plaster used for **moldings** and other architectural decorations.

Stupa: in Buddhist architecture, a **dome**-shaped or rounded structure made of brick, earth, or stone containing the relics of a Buddha or other honored individual (Vol. I, figs. **8.K–L**).

Style: in the visual arts, a manner of execution that is characteristic of an individual, a school, a period, or some other identifiable group.

Stylization: the distortion of a representational image to conform to certain artistic conventions or to emphasize particular qualities.

Stylus: a pointed metal instrument used to scratch an image on the **plate** to produce an **etching**.

Suspension bridge: a bridge in which the roadway is suspended from two or more steel cables, which usually pass over towers and are then anchored at their ends.

Symmetry: the esthetic balance that is achieved when parts of an object are arranged about a real or imaginary central line, or axis, so that the parts on one side correspond in some respect (shape, size, color) with those on the other.

Tempera: a fast-drying, water-based painting **medium** made with egg yolk, often used in **fresco** and panel painting.

Tenebrism: a style of painting used by Caravaggio and his followers, in which most objects are in shadow, while a few are brightly illuminated.

Tensile strength: the internal strength of a material that enables it to support itself without rupturing.

Terracotta: (a) an earthenware material, with or without a **glaze**; (b) an object made of this material.

Tessera (pl. **tesserae**): a small piece of colored glass, marble, or stone used in a **mosaic**.

Texture: the visual or tactile surface quality of an object.

Tholos: a round building modeled on ancient circular tombs of beehive shape.

Three-dimensional: having height, width, and depth.

Thrust: the lateral force exerted by an **arch**, **dome**, or **vault**, which must be counteracted by some form of **buttressing**.

Tondo: a circular painting or **relief** sculpture.

Tracery: a decorative, **interlaced** design (as in the stonework in Gothic windows).

Transept: a cross arm in a Christian church, placed at right angles to the **nave**.

Travertine: a hard limestone used as a building material by the Etruscans and Romans.

Triglyph: in a Doric **frieze**, the rectangular area between the **metopes**, decorated with three vertical grooves (glyphs).

Triptych: an **altarpiece** or painting consisting of one central panel and two **wings**.

Trompe l'oeil: **illusionistic** painting that "deceives the eye" with its appearance of reality.

Trumeau: in Romanesque and Gothic architecture, the central post supporting the **lintel** in a double doorway.

Truss construction: a system of construction in which the architectural members (such as bars and beams) are combined, often in triangles, to form a rigid framework.

Type: a person or object serving as a prefiguration or symbolic representation, usually of something in the future (see Vol. I, p. 273).

Typology: the Christian theory of **types**, in which characters and events in the New Testament (i.e. after the birth of Christ) are prefigured by counterparts in the Old Testament.

Underpainting: a preliminary painting, subsequently covered by the final layer(s) of paint.

Value: the degree of lightness (high value) or darkness (low value) in a **hue** (Vol. I, fig. **1.19**).

Vanishing point: in the **linear perspective** system, the point at which the **orthogonals**, if extended, would intersect (see p. 490).

Vanitas: a category of painting, often a **still life**, the theme of which is the transitory nature of earthly things and the inevitability of death.

Vault, vaulting: a roof or ceiling of masonry, constructed on the **arch** principle, (see Vol. I, p. 213); see also **barrel vault**, **groin vault**, and **ribbed vault**.

Villa: (a) in antiquity and the Renaissance, a large country house; (b) in modern times, a detached house in the country or suburbs.

Volute: in the Ionic order, the spiral **scroll** motif decorating the **capital** (see Vol. I, p. 160).

Voussoir: one of the individual, wedge-shaped blocks of stone that make up an **arch** (see Vol. I, p. 213).

Wash: a thin, translucent coat of paint (e.g. in **watercolor**).

Watercolor: (a) paint made of **pigments** suspended in water; (b) a painting executed in this **medium**.

Wing: a side panel of an **altarpiece** or screen.

Woodcut: a **relief** printmaking process (see p. 617) in which an image is carved on the surface of a wooden block by cutting away those parts that are not to be printed.

Ziggurat: a stepped structure representing a mountain in ancient Mesopotamia.

Suggestions for Further Reading

General

Adams, Laurie. *Art on Trial*. New York: Walker & Co., 1976.
—. *Art and Psychoanalysis*. New York: HarperCollins, 1993.
—. *Methodologies of Art: An Introduction*. New York: HarperCollins, 1996.
Arntzen, Etta, and Robert Rainwater. *Guide to the Literature of Art History*. Chicago, American Library Association/Art Book Company, 1980.
Barasch, Moshe. *Theories of Art: From Plato to Winckelmann*. New York: New York University Press, 1985.
—. *Modern Theories of Art, I: From Winckelmann to Baudelaire*. New York: New York University Press, 1990.
Baxandall, Michael. *Patterns of Intention: On the Historical Explanation of Pictures*. New Haven: Yale University Press, 1985.
Bois, Yve-Alain. *Painting as Model*. Cambridge, MA: MIT Press, 1990.
Broude, Norma, and Mary D. Garrard, eds. *Feminism and Art History: Questioning the Litany*. New York: Harper & Row, 1982.
—, eds. *The Expanding Discourse: Feminism and Art History*. New York: HarperCollins, 1992.
Bryson, Norman, ed. *Vision and Painting: The Logic of the Gaze*. New Haven: Yale University Press, 1983.
—. *Vision and Painting*. New Haven: Yale University Press, 1987.
—, et al., eds. *Visual Theory: Painting and Interpretation*. New York: Cambridge University Press, 1991.
Cahn, Walter. *Masterpieces: Chapters of the History of an Idea*. Princeton: Princeton University Press, 1979.
Carrier, David. *Principles of Art History Writing*. University Park, PA: Pennsylvania State University Press, 1994.
Chadwick, Whitney. *Women, Art, and Society*. New York: Thames & Hudson, 1990.
Chicago, Judy, and Miriam Schapiro. *Anonymous Was a Woman*. Valencia, CA: Feminist Art Program, California Institute of the Arts, 1974.
Chilvers, Ian, and Harold Osborne, eds. *The Oxford Dictionary of Art*. New York: Oxford University Press, 1988.
Clark, Kenneth M. *The Nude: A Study in Ideal Form*. Garden City, NY: Doubleday, 1959.
Clark, Toby. *Art and Propaganda in the Twentieth Century*. New York: Harry N. Abrams, 1997.
Derrida, Jacques. *The Truth in Painting*. Trans. Geoff Bennington and Ian McLeod. Chicago and London: University of Chicago Press, 1987.
Ehresmann, Donald L. *Architecture: A Bibliograph Guide to Basic Reference Works, Histories and Handbooks*. Littleton, CO: Libraries Unlimited, 1984.
—. *Fine Arts: A Bibliographical Guide to Basic Reference Works, Histories and Handbooks*. 3rd ed. Littleton, CO: Libraries Unlimited, 1990.
Eliade, Mircea. *A History of Religious Ideas*. 2 vols. Trans. W.R. Trask. Chicago: University of Chicago Press, 1978.
Elsen, Albert E. *The Purposes of Art*. 4th ed. New York: Holt, Rinehart & Winston, 1981.
Encyclopedia of World Art. 14 vols., with index and supplements. New York: McGraw-Hill, 1959–68.
Fine, Elsa Honig. *Women and Art*. Montclair, NJ: Allanheld & Schram, 1978.

Flynn, Tom. *The Body in Three Dimensions*. New York: Harry N. Abrams, 1998.
Freedberg, David. *The Power of Images*. Chicago: University of Chicago Press, 1989.
Gilbert, Rita. *Living with Art*. 5th ed. New York: McGraw-Hill, 1998.
Gombrich, Ernst. *Art and Illusion*. New York: Pantheon, 1972.
—. *The Image and the Eye*. Ithaca, NY: Cornell University Press, 1982.
—. *Meditations on a Hobby Horse*. London: Phaidon, 1963.
—. *Shadows: The Depiction of Cast Shadows in Western Art*. London: National Gallery, 1995.
Hall, James. *Subjects and Symbols in Art*. 2nd ed. New York: HarperCollins, 1979.
—. *Illustrated Dictionary of Symbols in Eastern and Western Art*. New York: HarperCollins, 1994.
Harris, Ann S., and Linda Nochlin. *Women Artists, 1550–1950*. Los Angeles: County Museum of Art; New York: Knopf, 1977.
Harrison, Charles, and Paul Woods, eds. *Art in Theory, 1900–1990*. Cambridge, MA: Blackwell, 1993.
Hauser, Arnold. *The Philosophy of Art History*. Cleveland: World Publishing Company, 1963.
—. *The Social History of Art*. 4 vols. New York: Vintage Books, 1958.
Hedges, Elaine, and Ingrid Wendt. *In Her Own Image: Women Working in the Arts*. New York: McGraw-Hill, 1980.
Heller, Nancy G. *Women Artists: An Illustrated History*. Rev. ed. New York: Abbeville, 1991.
Hess, Thomas B., and Elizabeth Baker, eds. *Art and Sexual Politics*. New York: Macmillan, 1973.
Hins, Berthold. *Art in the Third Reich*. Trans. Robert Kimber and Rita Kimber. Oxford: Basil Blackwell, 1979.
Holt, Elizabeth G. *A Documentary History of Art*. 2 vols. Garden City: Doubleday, 1981.
Kemp, Martin. *The Science of Art: Optical Themes in Western Art from Brunelleschi to Seurat*. New Haven: Yale University Press, 1989.
Kleinbauer, Walter E., and Thomas P. Slavens. *Research Guide to Western Art History*. Chicago: American Library Association, 1982.
Kleinbauer, Walter E. *Modern Perspectives in Western Art History: An Anthology of Twentieth-Century Writings on the Visual Arts*. Reprint of 1971 ed. Toronto: University of Toronto Press, 1989.
Kostof, Spiro. *The Architect: Chapters in the History of the Profession*. New York: Oxford University Press, 1977.
—. *A History of Architecture: Settings and Rituals*. New York: Oxford University Press, 1985.
Kris, Ernst, and Otto Kurz. *Legend, Myth, and Magic in the Image of the Artists*. New Haven: Yale University Press, 1979.
Kultermann, Udo. *The History of Art History*. New York: Abaris Books, 1993.
Lever, Jill, and John Harris. *Illustrated Dictionary of Architecture, 800–1914*. Boston: Faber & Faber, 1993.
Levine, Lawrence. *Highbrow, Lowbrow: The Emergence of Cultural Hierarchy in America*. Cambridge, MA: Harvard University Press, 1988.
Mayer, Ralph. *The HarperCollins Dictionary of Art Terms & Techniques*. 2nd ed. New York: HarperCollins, 1991.
—. *The Artists' Handbook of Materials and Techniques*. 5th ed. New York: Viking, 1991.

McCoubrey, John W. *American Art, 1700–1960: Sources and Documents*. Englewood Cliffs, NJ: Prentice-Hall, 1965.
Mitchell, W. J. T. *Picture Theory*. Chicago and London: University of Chicago Press, 1994.
Munsterberg, Hugo. *A History of Women Artists*. New York: Clarkson N. Potter, 1975.
Murray, Peter, and Linda Murray. *A Dictionary of Art and Artists*. 5th ed. New York: Penguin, 1988.
Nochlin, Linda. *Women, Art, and Power and Other Essays*. New York: Harper & Row, 1988.
Ocvirk, Otto G., Robert E. Stinson, Philip R. Wigg, and Robert O. Bone. *Art Fundamentals: Theory and Practice*. 8th ed. New York: McGraw-Hill, 1998.
Panofsky, Erwin. *Meaning in the Visual Arts*. Garden City, NY: Doubleday, 1955.
—. *Idea: A Concept in Art Theory*. Columbia: University of South Carolina Press, 1968.
—. *Perspective as Symbolic Form*. New York: Zone Books, 1991.
Parker, Roszika, and Griselda Pollock. *Old Mistresses: Women, Art and Ideology*. New York: Pantheon Books, 1981.
Penny, Nicholas. *The Materials of Sculpture*. New Haven: Yale University Press, 1993.
Peterson, Karen, and J.J. Wilson. *Women Artists*. New York: Harper & Row, 1976.
Pollock, Griselda. *Vision and Difference: Feminity, Feminism and the Histories of Art*. London: Routledge & Kegan Paul, 1988.
Praz, Mario. *Mnemosyne*. Princeton: Princeton University Press, 1967.
Pultz, John. *The Body and the Lens*. New York: Harry N. Abrams, 1995.
Reid, Jane D., ed. *The Oxford Guide to Classical Mythology in the Arts, 1330–1990*. 2 vols. New York: Oxford University Press, 1993.
Roth, Leland M. *Understanding Architecture: Its Elements, History and Meaning*. New York: HarperCollins, 1993.
Saxl, Fritz. *A Heritage of Images*. Harmondsworth: Penguin, 1970.
Schiller, Gertrud. *Iconography of Christian Art*. 2 vols. Greenwich, CT: New York Graphic Society, 1971.
Sporre, Dennis J. *The Creative Impulse: An Introduction to the Arts*. 4th ed. Upper Saddle River, NJ: Prentice-Hall, 1996.
Stephenson, Jonathan. *The Materials and Techniques of Painting*. New York: Watson-Guptill, 1989.
Summerson, John. *The Classical Language of Architecture*. Cambridge, MA: MIT Press, 1963.
Trachtenberg, Marvin, and Isabelle Hyman. *Architecture, from Pre-History to Post-Modernism*. New York: Harry N. Abrams, 1986.
Van Keuren, Frances. *Guide to Research in Classical Art and Mythology*. Chicago: American Library Association, 1991.
Verhelst, Wilbert. *Sculpture: Tools, Materials, and Techniques*. Englewood Cliffs, NJ: Prentice-Hall, 1973.
Watkin, David. *The Rise of Architectural History*. Chicago: University of Chicago Press, 1980.
Westermann, Mariet. *A Worldly Art*. New York: Harry N. Abrams, 1996.
Williams, Raymond. *Culture and Society, 1870–1950*. New York: Harper & Row, 1966.
—. *The Sociology of Culture*. New York: Schocken Books, 1982.
Winternitz, Emanuel. *Musical Instruments and their Symbolism in Western Art*. London: Faber & Faber, 1967.

Wittkower, Rudolf. *Allegory and the Migration of Symbols.* London: Thames & Hudson, 1977.

—, and Margot Wittkower. *Born Under Saturn.* New York: Norton, 1969.

Wodehouse, Lawrence, and Marian Moffet. *A History of Western Architecture.* Mountain View, CA: Mayfield Publishing, 1989.

Wolff, Janet. *The Social Production of Art.* 2nd ed. New York: New York University Press, 1993.

Wölfflin, Heinrich. *Classic Art.* London, 1952.

—. *Principles of Art History: The Problem of the Development of Style in Later Art.* 7th ed. New York: Dover, 1950.

—. *The Sense of Form in Art.* New York: Chelsea, 1958.

Wollheim, Richard. *Art and its Objects.* New York: Cambridge University Press, 1980.

—. *Painting as an Art.* Princeton: Princeton University Press, 1984.

Wren, Linnea H., and David J. Wren, eds. *Perspectives on Western Art, Vol. 1.* New York: Harper & Row, 1987.

—. *Perspectives on Western Art, Vol. 2.* New York: HarperCollins, 1994.

Yates, Frances A. *The Art of Memory.* London: Routledge & Kegan Paul, 1966.

Precursors of the Renaissance

Art and Politics in Late Medieval and Early Renaissance Italy, 1250–1500. South Bend, IN: University of Notre Dame Press, 1990.

Barasch, Moshe. *Giotto and the Language of Gesture.* Cambridge: Cambridge University Press, 1987.

Baxandall, Michael. *Giotto and the Orators.* Oxford: Oxford University Press, 1971.

Barolsky, Paul. *Giotto's Father and the Family of Vasari's Lives.* University Park, PA: Pennsylvania State University Press, 1992.

Bomford, David. *Art in the Making: Italian Painting before 1400.* London: National Gallery, 1989.

Borsook, Eve. *The Mural Painters of Tuscany.* London: Phaidon, 1960.

—, and Fiorelli Superbi Gioffredi. *Italian Altarpieces 1250–1550: Function and Design.* Oxford: Clarendon Press, 1994.

Burckhardt, Jakob C. *The Civilization of the Renaissance in Italy.* Trans. S.G.C. Middlemore. 3rd rev. ed. London: Phaidon, 1950.

Campbell, Lorne. *Renaissance Portraits: European Portrait-Painting in the 14th, 15th, and 16th Centuries.* New Haven: Yale University Press, 1990.

Cennini, Cennino. *The Craftsman's Handbook (Il Libro dell'Arte).* Trans. Daniel V. Thompson, Jr. New York: Dover, 1954.

Chiellini, Monica. *Cimabue.* Trans. Lisa Pelletti. Florence: Scala, 1988.

Cole, Bruce. *Giotto and Florentine Painting, 1280–1375.* New York: Harper & Row, 1975.

—. *The Renaissance Artist at Work.* New York: Harper & Row, 1983.

—. *Sienese Painting: From its Origins to the 15th Century.* Bloomington: Indiana University Press, 1985.

Davis, Howard McP. *Gravity in the Paintings of Giotto.* 1971. Reprinted in Schneider, 1974.

Martindale, Andrew. *The Rise of the Artist.* New York: McGraw-Hill, 1972.

—. *Simone Martini.* New York: New York University Press, 1988.

Meiss, Millard. *Painting in Florence and Siena after the Black Death.* New York: Harper & Row, 1951.

—. *French Painting in the Time of Jean de Berry: The Late Fourteenth Century and the Patronage of the Duke.* New York: Braziller, 1967.

—. *The "Belles Heures" of Jean, Duke of Berry.* New York: Braziller, 1974.

Moskowitz, Anita. *The Sculpture of Andrea and Nino Pisano.* Cambridge: Cambridge University Press, 1986.

Schneider, Laurie M., ed. *Giotto in Perspective.* Englewood Cliffs, NJ: Prentice-Hall, 1974.

Smart, Alastair. *The Dawn of Italian Painting, c. 1250–1400.* Ithaca, NY: Cornell University Press, 1978.

Stubblebine, James H., ed. *Giotto: The Arena Chapel Frescoes.* New York: Norton, 1969.

—. *Assisi and the Rise of Vernacular Art.* New York: Harper & Row, 1985.

—. *Ducento Painting: An Annotated Bibliography.* Boston: G.K. Hall, 1985.

Vasari, Giorgio. *The Lives of the Most Eminent Painters, Sculptors, and Architects.* Trans. Gaston du C. de Vere. New York: Harry N. Abrams, 1979.

White, John. *The Birth and Rebirth of Pictorial Space.* 2nd ed. Boston: Boston Book and Art Shop, 1967.

—. *Duccio: Tuscan Art and the Medieval Workshop.* New York: Thames & Hudson, 1979.

The Early Renaissance

Adams, Laurie Schneider. *Key Monuments of the Italian Renaissance.* Denver: Westview Press, 1999.

Alazard, Jean, *The Florentine Portrait.* New York: Schocken Books, 1969.

Alberti, Leon Battista. *On Painting.* Trans. J. R. Spencer. Rev. ed. New Haven: Yale University Press, 1966.

—. *Ten Books on Architecture.* Ed. J. Rykwert. Trans. J. Leoni. London: Tiranti, 1955.

Ames-Lewis, Francis. *Drawing in Early Renaissance Italy.* New Haven: Yale University Press, 1981.

Antal, Frederick. *Florentine Painting and Its Social Background.* Boston: Boston Book and Art Shop, 1965.

Barolsky, Paul. *Infinite Jest: Wit and Humor in Italian Renaissance Art.* Columbia, MO: University of Missouri Press, 1978.

——. *Walter Pater's Renaissance.* University Park, PA: Pennsylvania State University Press, 1987.

Baxandall, Michael. *Painting and Experience in 15th-Century Italy.* 2nd ed. Oxford: Oxford University Press, 1988.

Beck, James. *Italian Renaissance Painting.* New York: HarperCollins, 1981.

Bennett, Bonnie A., and David G. Wilkins. *Donatello.* London: Phaidon, 1984.

Berenson, Bernard. *The Drawings of the Florentine Painters.* 3 vols. Reprint of 1938 ed. Chicago: University of Chicago Press, 1973.

—. *Italian Painters of the Renaissance.* Rev. ed. London: Phaidon, 1967.

—. *Italian Painters of the Renaissance: Central and Northern Italian Schools.* 3 vols. London: Phaidon, 1968.

—. *Italian Pictures of the Renaissance: Florentine School.* 2 vols. London: Phaidon, 1963.

Blunt, Anthony. *Artistic Theory in Italy, 1450–1600.* New York: Oxford University Press, 1956.

Bober, Phyllis P., and Ruth O. Rubenstein. *Renaissance Artists and Antique Sculpture.* New York: Oxford University Press, 1986.

Borsook, Eve. *The Mural Painters of Tuscany.* London: Phaidon, 1960.

Butterfield, Andrew. *The Sculptures of Andrea del Verrocchio.* New Haven and London: Yale University Press, 1997.

Chastel, André. *The Studios and Styles of Renaissance Italy, 1460–1500.* New York: Braziller, 1964.

Christiansen, Keith. *Gentile da Fabriano.* Ithaca: Cornell University Press, 1982.

—, Laurence B. Kanter, and Carl B. Strehle, eds. *Painting in Renaissance Siena, 1420–1500.* New York: Metropolitan Museum of Art, 1988.

Clark, Kenneth. *The Art of Humanism.* New York: Harper & Row, 1970.

Cole, Alison. *Virtue and Magnificence: Art of the Italian Renaissance Courts.* New York: Harry N. Abrams, 1995.

d'Ancona, M. L. *The Garden of the Renaissance: Botanical Symbolism in Italian Painting.* Florence, 1977.

Edgerton, Samuel Y., Jr. *The Renaissance Rediscovery of Linear Perspective.* New York: Harper & Row, 1976.

Gilbert, Creighton E. *Italian Art, 1400–1500. Sources and Documents.* Englewood Cliffs, NJ: Prentice-Hall, 1980.

—, ed. *Renaissance Art.* New York: Harper & Row, 1970.

Goffen, Rona, ed. *Masaccio's Trinity.* Cambridge: Cambridge University Press, 1998.

Goldthwaite, Richard A. *The Building of Renaissance Florence.* Baltimore: Johns Hopkins University Press, 1980.

Gombrich, Ernst H. *The Heritage of Apelles.* Ithaca: Cornell University Press, 1976.

—. *New Light on Old Masters.* Chicago: University Press, 1986.

—. *Norm and Form: Studies in the Art of the Renaissance.* London: Phaidon, 1966.

—. *Symbolic Images.* London: Phaidon, 1972.

Grendler, P. *Schooling in the Renaissance.* Baltimore: Johns Hopkins University Press, 1989.

Greenstein, Jack M. *Mantegna and Painting as Historical Narrative.* Chicago: University of Chicago Press, 1992.

Hale, J. R. *Artists and Warfare in the Renaissance.* New Haven: Yale University Press, 1990.

Harbison, Craig. *The Mirror of the Artist.* New York: Harry N. Abrams, 1995.

Hartt, Frederick. *A History of Italian Renaissance Art.* 4th rev. ed. New York: Thames & Hudson, 1994.

Heydenreich, Ludwig H., and Wolfgang Lotz. *Architecture in Italy, 1400–1600.* Harmondsworth, Penguin, 1974.

Hibbert, Christopher. *The House of Medici: Its Rise and Fall.* New York: Morrow Quill, 1980.

Hind, Arthur M. *History of Engraving and Etching.* 3rd ed., rev. Boston: Houghton Mifflin, 1923.

Horster, Marita. *Andrea del Castagno.* Ithaca: Cornell University Press, 1980.

Jacks, Philip. *The Antiquarian and the Myth of Antiquity: The Origins of Rome in Renaissance Thought.* Cambridge: Cambridge University Press, 1993.

Janson, Horst W. *The Sculpture of Donatello.* 2 vols. Princeton: Princeton University Press, 1957.

Kemp, Martin. *Behind the Picture: Art and Evidence in the Italian Renaissance.* New Haven: Yale University Press, 1997.

Krautheimer, Richard, and Trude Krautheimer-Hess. *Lorenzo Ghiberti.* 2nd ed. Princeton: Princeton University Press, 1970.

Lavin, Marilyn A. *Piero della Francesca: The Flagellation.* London: Allen Lane, 1972.

Lee, Rensselaer W. *Ut Pictura Poesis: The Humanistic Theory of Painting*. New York: Norton, 1967.

Lightbown, Ronald. *Sandro Botticelli*. 2 vols. Berkeley: University of California Press, 1978.

Lowry, Bates. *Renaissance Architecture*. New York: Braziller, 1962.

Machiavelli, Niccolò. *Florentine Histories*. Trans. Laura F. Banfield and Harvey Mansfield, Jr. Princeton: Princeton University Press, 1988.

Murray, Peter. *Renaissance Architecture*. New York: Harry N. Abrams, 1976.

Panofsky, Erwin. *Renaissance and Renascences in Western Art*. New York: Harper & Row, 1969.

—. *Studies in Iconology: Humanistic Themes in the Art of the Renaissance*. New York: Oxford University Press, 1939.

—, and Dora Panofsky. *Pandora's Box: The Changing Aspects of a Mythical Symbol*. New York: Harper & Row, 1965.

Pater, Walter. *The Renaissance: Studies in Art and Poetry*. Ed. D. L. Hill. Berkeley: University of California Press, 1980.

Pope-Hennessy, John. *An Introduction to Italian Sculpture*. 3rd ed. 3 vols. New York: Phaidon, 1986.

—. *The Portrait in the Renaissance*. Princeton: Princeton University Press, 1966.

Prager, F., and G. Scaglia. *Brunelleschi: Studies of his Technology and Inventions*. Cambridge, MA: Harvard University Press, 1970.

Rabil, Albert, Jr. *Renaissance Humanism: Foundations, Forms and Legacy*. 3 vols. Philadelphia: University of Pennsylvania Press, 1988.

Rosenberg, Charles M. *The Este Monuments and Urban Developments in Renaissance Ferrara*. Cambridge: Cambridge University Press, 1997.

Ruggiero, Guido. *Violence in Early Renaissance Venice*. New Brunswick, NJ: Rutgers University Press, 1980.

Saxl, Fritz. *A Heritage of Images*. London: Penguin, 1970.

Seidel, Linda. *Jan van Eyck's Arnolfini Portrait: Stories of an Icon*. Cambridge: Cambridge University Press, 1993.

Seymour, Charles, Jr. *The Sculpture of Verrocchio*. Greenwich, CT: New York Graphic Society, 1971.

Seznec, Jean. *The Survival of the Pagan Gods*. Trans. B. F. Sessions. First printed 1953. Reprint by Bollingen Foundation and Pantheon Books. Princeton: Princeton University Press, 1972.

Thomson, David. *Renaissance Architecture: Critics, Patrons, and Luxury*. Manchester: Manchester University Press, 1993.

Turner, A. Richard. *Renaissance Florence: The Invention of a New Art*. New York: Harry N. Abrams, 1997.

Valentiner, W. R. *Studies of Italian Renaissance Sculpture*. London: Phaidon, 1950.

Wackernagel, Martin. *The World of the Florentine Renaissance Artist: Projects and Patrons, Workshop and Art Market*. Princeton: Princeton University Press, 1981.

Weiss, Roberto. *The Renaissance Discovery of Classical Antiquity*. Oxford: Basil Blackwell, 1969.

Wind, Edgar. *Pagan Mysteries in the Renaissance*. Rev. ed. New York: Barnes & Noble, 1968.

Wittkower, Rudolf. *Architectural Principles in the Age of Humanism*. New York: Random House, 1965.

—. *Idea and Image: Studies in the Italian Renaissance*. 3rd rev. ed. New York: Thames & Hudson, 1962.

Wölfflin, Heinrich. *Classic Art: An Introduction to the Italian Renaissance*. Trans. L. and P. Murray. 3rd ed. New York: Phaidon, 1968.

—. *Renaissance and Baroque*. Trans. Kathrin Simon. Ithaca, NY: Cornell University Press, 1966.

Woods-Marsden, Joanna. *The Gonzaga of Mantua and Pisanello's Arthurian Frescoes*. Princeton: Princeton University Press, 1988.

The High Renaissance in Italy

Ackerman, James S. *The Architecture of Michelangelo*. Rev. ed. New York: Viking Press, 1966.

Barolsky, Paul. *Michelangelo's Nose: A Myth and Its Maker*. University Park, PA: Pennsylvania State University Press, 1990.

—. *Why Mona Lisa Smiles and Other Tales by Vasari*. University Park, PA: Pennsylvania State University Press, 1991.

Brown, D. *Leonardo's Last Supper: The Restoration*. New Haven: Yale University Press, 1983.

Brown, Patricia Fortini. *Art and Life in Renaissance Venice*. New York: Harry N. Abrams, 1997.

—. *Venetian Narrative Painting in the Age of Carpaccio*. New Haven: Yale University Press, 1988.

Castiglione, Baldesar. *The Book of the Courtier* (1528). Trans. G. Bull. New York: Penguin, 1967.

Chastel, André. *The Sack of Rome, 1527*. Trans. Beth Archer. Princeton: Princeton University Press, 1983.

Clark, Kenneth M. *Leonardo da Vinci*. Baltimore: Penguin, 1967.

Collins, Bradley I. *Leonardo, Psychoanalysis and Art History*. Evanston, IL: Northwestern University Press, 1997.

de Tolnay, Charles. *Michelangelo*. 2nd rev. ed. 5 vols. Princeton: Princeton University Press, 1969–71.

Eissler, K. R. *Leonardo da Vinci: Psychoanalytic Notes on the Enigma*. New York: International Universities Press, 1961.

Fischel, Oskar. *Raphael*. Trans. B. Rackham. 2 vols. London: Spring Books, 1964.

Freedberg, Sidney J. *Painting in Italy, 1500–1600*. 2nd ed. Pelican History of Art. Baltimore: Penguin, 1971.

—. *Painting of the High Renaissance in Rome and Florence*. 2 vols. Cambridge, MA: Harvard University Press, 1961.

Gilbert, Creighton. *Michelangelo On and Off the Sistine Ceiling*. New York: Braziller, 1994.

Goffen, Rona. *Giovanni Bellini*. New Haven: Yale University Press, 1989.

—. *Piety and Patronage: Bellini, Titian and the Franciscans*. New Haven: Yale University Press, 1986.

—, ed. *Titian's Venus of Urbino*. Cambridge: Cambridge University Press, 1998.

Hall, Marcia, ed. *Raphael's School of Athens*. Cambridge: Cambridge University Press, 1998.

Heydenreich, Ludwig H. *Leonardo. The Last Supper*. London: Allen Lane, 1974.

Hibbard, Howard. *Michelangelo*. 2nd ed. New York: HarperCollins, 1983.

Humfrey, Peter. *Painting in Renaissance Venice*. New Haven: Yale University Press, 1995.

Huse, Norbert, and Wolfgang Wolters. *The Art of Renaissance Venice*. Trans. E. Jephcott. Chicago: University of Chicago Press, 1990.

Kemp, Martin, ed. *Leonardo on Painting*. Trans. Martin Kemp and Margaret Walker. New Haven: Yale University Press, 1989.

Leonardo da Vinci. *The Notebooks*. Trans. E. MacCurdy. 2 vols. New York: Harcourt, Brace, 1938.

Levey, Michael. *High Renaissance*. Harmondsworth: Penguin, 1975.

Murray, Linda. *The High Renaissance and Mannerism*. New York: Oxford University Press, 1977.

Panofsky, Erwin. *Problems in Titian, Mostly Iconographic*. London, 1969.

Partridge, Loren. *The Art of Renaissance Rome*. New York: Harry N. Abrams, 1996.

—, and Randolph Starn. *A Renaissance Likeness*. Berkeley: University of California Press, 1980.

Pedretti, Carlo. *Leonardo Da Vinci on Painting: A Lost Book*. Berkeley: University of California Press, 1964.

—. *Leonardo: Studies for the Last Supper*. Cambridge: Cambridge University Press, 1983.

Pope-Hennessy, John. *Italian High Renaissance and Baroque Sculpture*. 3rd ed. 3 vols. New York: Phaidon, 1986.

—. *Raphael*. New York: New York University Press, 1970.

Riess, Jonathan B. *The Renaissance Antichrist: Luca Signorelli's Orvieto Frescoes*. Princeton: Princeton University Press, 1995.

Robertson, Giles. *Giovanni Bellini*. New York: Hacker Art Books, 1981.

Rosand, David. *Painting in Cinquecento Venice: Titian, Veronese, Tintoretto*. New Haven: Yale University Press, 1982.

—. *Titian*. New York, 1978.

Ruggiero, Guido. *The Boundaries of Eros: Sex Crime and Sexuality in Renaissance Venice*. New York: Oxford University Press, 1985.

—. *Binding Passions: Tales of Magic, Marriage, and Power at the End of the Renaissance*. New York: Oxford University Press, 1993.

Saslow, James M. *Ganymede in the Renaissance: Homosexuality in Art and Society*. New Haven: Yale University Press, 1986.

—. *The Poetry of Michelangelo*. New Haven: Yale University Press, 1991.

Settis, Salvatore. *Giorgione's Tempest: Interpreting the Hidden Subject*. Chicago: University of Chicago Press, 1990.

Tafuri, Manfredo. *Venice and the Renaissance*. Trans. Jessica Levine. Cambridge, MA: MIT Press, 1995.

Turner, A. Richard. *Inventing Leonardo*. Berkeley: University of California Press, 1992.

Vasari, Giorgio. *Vasari on Technique*. Trans. L. Maclehose. New York, 1960.

Wethey, Harold E. *The Paintings of Titian*. 3 vols. London: Phaidon, 1969.

Wilde, Johannes. *Venetian Art from Bellini to Titian*. Oxford: Clarendon Press, 1981.

Mannerism and the Later Sixteenth Century in Italy

Ackerman, James S. *Palladio*. New York: Penguin, 1978.

Cellini, Benvenuto. *Autobiography*. Trans. J. A. Symonds. Ed. John Pope-Hennessy. London: Phaidon, 1960.

Cochrane, E. *Florence in the Forgotten Centuries: 1527–1800*. Chicago: University of Chicago Press, 1973.

Cox-Rearick, Janet. *The Drawings of Pontormo*. Cambridge, MA: Harvard University Press, 1964.

—. *Dynasty and Destiny in Medici Art: Pontormo, Leo X, and the Two Cosimos*. Princeton: Princeton University Press, 1984.

—. *Bronzino's Chapel of Eleonora in the Palazzo Vecchio.* Berkeley: University of California Press, 1993.

Freedberg, Sidney J. *Parmigianino.* Cambridge, MA: Harvard University Press, 1950.

Hauser, Arnold. *Mannerism: The Crisis of the Renaissance and the Origin of Modern Art.* Cambridge, MA: Belknap Press, 1986.

Holt, Elizabeth Gilmore, ed. *A Documentary History of Art,* vol. 2. *Michelangelo and the Mannerists: The Baroque and the 18th Century.* 2nd ed. Garden City: Doubleday, 1957.

Pope-Hennessy, John. *Cellini.* London: Macmillan, 1985.

Shearman, John K. G. *Mannerism.* Baltimore: Penguin, 1967.

Smythe, Craig H. *Mannerism and Maniera.* Locust Valley, NY: J. J. Augustin, 1963.

Tomlinson, Janis. *From El Greco to Goya: Painting in Spain.* New York: Harry N. Abrams, 1997.

Würtenberger, Franzsepp. *Mannerism: The European Style of the 16th Century.* New York: Holt, Rinehart & Winston, 1963.

Sixteenth-Century Painting in Northern Europe

Benesch, Otto. *The Art of the Renaissance in Northern Europe.* Rev. ed. London: Phaidon, 1965.

—. *German Painting from Dürer to Holbein.* Trans. H. S. B. Harrison. Geneva: Skira, 1966.

Chastel, André. *The Age of Humanism: Europe, 1480–1530.* Trans. K. Delavenay and E. M. Gweyer. New York: McGraw-Hill, 1964.

Cuttler, Charles P. *Northern Painting from Pucelle to Bruegel.* New York: Holt, Rinehart & Winston, 1968.

Davies, Martin. *Rogier van der Weyden: An Essay with a Critical Catalogue of Paintings.* New York: Phaidon, 1972.

Friedländer, Max J. *Early Netherlandish Painting.* 14 vols. Trans. Heinz Norden. New York: Praeger, 1967–73.

—. *From Van Eyck to Bruegel: Early Netherlandish Painting.* New York: Phaidon, 1969.

Fuchs, Rudolph H. *Dutch Painting.* London: Thames & Hudson, 1978.

Gilbert, Creighton E. *History of Renaissance Art Throughout Europe; Painting, Sculpture, Architecture.* New York: Harry N. Abrams, 1973.

Harbison, Craig. *The Mirror of the Artist: Northern Renaissance Art in its Historical Context.* New York: Harry N. Abrams, 1995.

Hayum, Andrée. *The Isenheim Altarpiece: God's Medicine and the Painter's Vision.* Princeton: Princeton University Press, 1989.

Hind, Arthur M. *A History of Engraving and Etching from the 15th Century to the Year 1914.* 3rd rev. ed. New York: Dover, 1963.

—. *An Introduction to a History of Woodcut.* New York: Dover, 1963.

Koerner, Joseph. *The Moment of Self-Portraiture in German Renaissance Art.* Chicago: University of Chicago Press, 1993.

Lane, Barbara G. *The Altar and the Altarpiece: Sacramental Themes in Early Netherlandish Painting.* New York: Harper & Row, 1984.

Panofsky, Erwin. *Early Netherlandish Painting.* 2 vols. Cambridge, MA: Harvard University Press, 1958.

—. *Life and Work of Albrecht Dürer.* 2 vols. 3rd ed. Princeton: Princeton University Press, 1948.

Pevsner, Nikolaus, and Michael Meier, *Grünewald.* New York: Harry N. Abrams, 1958.

Philip, Lotte Brand. *The Ghent Altarpiece and the Art of Jan van Eyck.* Princeton: Princeton University Press, 1971.

Snyder, James. *Northern Renaissance Art.* New York: Harry N. Abrams, 1985.

Stechow, Wolfgang. *Northern Renaissance Art, 1400–1600: Sources and Documents.* Englewood Cliffs, NJ: Prentice-Hall, 1966.

The Baroque Style in Western Europe

Adams, Laurie Schneider. *Key Monuments of the Baroque.* Denver: Westview Press, 1999.

Alpers, Svetlana. *The Art of Describing: Dutch Art in the Seventeenth Century.* Chicago: University of Chicago Press, 1983.

—. *The Making of Rubens.* New Haven: Yale University Press, 1995.

—. *Rembrandt's Enterprise: The Studio and the Market.* Chicago: University of Chicago Press, 1988.

Avery, Charles. *Bernini.* London: Thames & Hudson, 1998.

Bazin, Germain. *Baroque and Rococo Art.* New York: Praeger, 1974.

Berger, Robert W. *The Palace of the Sun: The Louvre of Louis XIV.* University Park, PA: Pennsylvania State University Press, 1993.

—. *Versailles: The Chateau of Louis XIV.* University Park, PA: Pennsylvania State University Press, 1985.

Blunt, Anthony. *Art and Architecture in France, 1500–1700.* 4th ed. Harmondsworth: Penguin, 1980.

—, et al. *Baroque and Rococo: Architecture and Decoration.* New York: Harper & Row, 1982.

Brown, Christopher. *Scenes of Everyday Life: Dutch Genre Painting of the Seventeenth Century.* London: Faber & Faber, 1984.

Brown, Jonathan. *The Golden Age of Painting in Spain.* New Haven: Yale University Press, 1991.

—. *Velázquez: Painter and Courtier.* New Haven: Yale University Press, 1988.

Carrier, David. *Poussin's Paintings.* University Park PA: Pennsylvania State University Press, 1993.

Clark, Kenneth. *Rembrandt and the Italian Renaissance.* New York: New York University Press, 1966.

Domingues Ortiz, Antonio, Alfonso E. Perez Sanchez, and Julian Gallego. *Velázquez.* New York: Metropolitan Museum of Art, 1989.

Enggass, Robert, and Jonathan Brown. *Italy and Spain, 1600–1750: Sources and Documents.* Englewood Cliffs, NJ: Prentice-Hall, 1970.

Friedländer, Walter F. *Caravaggio Studies.* Princeton: Princeton University Press, 1955.

Garrard, Mary D. *Artemisia Gentileschi.* Princeton: Princeton University Press, 1989.

Gerson, Horst, and E. H. ter Kuile. *Rembrandt Paintings.* Trans. Heinz Norden. Ed. Gary Schwartz. New York: Reynal, 1968.

Goldscheider, Ludwig. *Vermeer: The Paintings: Complete Edition.* 2nd ed. London: Phaidon, 1967.

Grimm, Claus. *Frans Hals: The Complete Work.* Trans. Jurgen Riehle. New York: Harry N. Abrams, 1990.

Haak, Bob. *The Golden Age: Dutch Painters of the 17th Century.* London: Thames & Hudson, 1984.

Haskell, Francis. *Patrons and Painters: A Study in the Relations between Italian Art and Society in the Age of the Baroque.* New Haven: Yale University Press, 1980.

Haverkamp-Begemann, E. *Rembrandt: The Nightwatch.* Princeton: Princeton University Press, 1982.

Held, Julius, and Donald Posner. *17th- and 18th-Century Art.* New York: Harry N. Abrams, 1974.

Hibbard, Howard. *Bernini.* Baltimore: Penguin, 1966.

—. *Caravaggio.* New York: HarperCollins, 1983.

Kahr, Madlyn M. *Dutch Painting in the 17th Century.* 2nd ed. New York: Harper & Row, 1993.

Kitson, Michael. *The Age of Baroque.* London: Hamlyn, 1976.

Koning, Hans. *The World of Vermeer, 1632–1765.* New York: Time-Life, 1967.

Martin, John R. *Baroque.* New York: Harper & Row, 1977.

Moir, Alfred. *Anthony van Dyck.* New York: Harry N. Abrams, 1994.

—. *The Italian Followers of Caravaggio.* 2 vols. Cambridge, MA: Harvard University Press, 1967.

Montagu, Jennifer. *Roman Baroque Sculpture: The Industry of Art.* New Haven: Yale University Press, 1989.

Nicolson, Benedict. *The International Caravaggesque Movement.* London: Phaidon, 1979.

Norbert-Schulz, Christian. *Baroque Architecture.* New York: Harry N. Abrams, 1985.

—. *Late Baroque and Rococo Architecture.* New York: Harry N. Abrams, 1974.

Orso, Steven N. *Velázquez, Los Borrachos, and Painting at the Court of Philip IV.* Cambridge: Cambridge University Press, 1993.

Powell, Nicolas. *From Baroque to Rococo: An Introduction to Austrian and German Architecture from 1580 to 1790.* London: Faber & Faber, 1959.

Renaissance Medals from the Samuel H. Kress Collection at the National Gallery of Art. London: Phaidon, 1967.

Rosenberg, Jakob. *Rembrandt: Life and Work.* 3rd ed. London: Phaidon, 1968.

—, Seymour Slive, and E. H. ter Kuile. *Dutch Art and Architecture, 1600–1800.* 3rd ed. Pelican History of Art. New York: Penguin, 1977.

Schama, Simon. *The Embarrassment of Riches: An Interpretation of Dutch Culture in the Golden Age.* New York: Knopf, 1986.

Schwartz, Gary. *Rembrandt, His Life, His Paintings.* New York: Penguin, 1991.

Scribner, Charles, III. *Gianlorenzo Bernini.* New York: Harry N. Abrams, 1991.

—. *Peter Paul Rubens.* New York: Harry N. Abrams, 1989.

Slive, Seymour. *Rembrandt and His Critics, 1630–1730.* New York: Hacker, 1988.

—, et al. *Frans Hals.* London: Royal Academy of Arts, 1989.

Snow, Edward. *A Study of Vermeer.* Rev. and enlarged ed. Berkeley: University of California Press, 1994.

Stechow, Wolfgang. *Dutch Landscape Painting of the 17th Century.* London: Phaidon, 1966.

Strong, Roy. *Van Dyck: Charles I on Horseback.* London: Allen Lane, 1972.

Sutton, Peter. *The Age of Rubens.* Boston: Museum of Fine Arts, 1993.

Varriano, John. *Italian Baroque and Rococo Architecture.* New York: Oxford University Press, 1986.

Wallace, Robert. *The World of Bernini, 1598–1680.* New York: Time-Life, 1970.

Waterhouse, Ellis K. *Baroque Painting in Rome.* London: Phaidon, 1976.

Wedgwood, C. V. *The World of Rubens, 1577–1640.* New York: Time-Life, 1967.

Welu, James A., and Pieter Biesboer, eds. *Judith Leyster: A Dutch Master and her World.* New Haven: Yale University Press, 1993.

Wheelock, Arthur K., Jr. *Jan Vermeer.* New York: Harry N. Abrams, 1988.
—, Susan J. Barnes, and Julius S. Held. *Anthony Van Dyck.* Washington, D.C.: National Gallery of Art, 1990.
White, Christopher. *Peter Paul Rubens: Man and Artist.* New Haven: Yale University Press, 1987.
—. *Rembrandt.* London: Thames & Hudson, 1984.
Wittkower, Rudolf. *Art and Architecture in Italy, 1600–1750.* 3rd ed. Pelican History of Art. Baltimore: Penguin, 1973.
—. *Gian Lorenzo Bernini, The Sculptor of the Roman Baroque.* 2nd ed. London: Phaidon, 1966.
Wright, Christopher. *The French Painters of the 17th Century.* New York: New York Graphic Society, 1986.

Rococo and the Eighteenth Century

Abrams, Ann Uhry. *The Valiant Hero: Benjamin West and Grand-Style History Painting.* Washington, D.C.: Smithsonian Institute, 1985.
Alpers, Svetlana, and Michael Baxandall. *Tiepolo and the Pictorial Intelligence.* New Haven: Yale University Press, 1994.
Antal, Frederick. *Hogarth and His Place in European Art.* London: Routledge & Kegan Paul, 1962.
Bryson, Norman. *Word and Image: French Painting of the Ancien Régime.* Cambridge: Cambridge University Press, 1981.
Burke, Joseph. *English Art, 1714–1800.* New York: Oxford University Press, 1976.
Châtelet, Albert, and Jacques Thuillier. *French Painting from Le Nain to Fragonard.* Geneva: Skira, 1964.
Conisbee, Philip. *Painting in 18th-Century France.* Ithaca, NY: Cornell University Press, 1981.
Crow, Thomas E. *Painters and Public Life in Eighteenth-Century Paris.* New Haven: Yale University Press, 1985.
Duncan, Carol. *The Pursuit of Pleasure: The Rococo Revival in French Romantic Art.* New York: Garland, 1976.
Frankenstein, Alfred Victor. *The World of Copley, 1738–1815.* New York: Time-Life, 1970.
Grasselli, Margaret Morgan, and Pierre Rosenberg. *Watteau, 1684–1721.* Washington, D.C.: National Gallery of Art, 1984.
Hitchcock, Henry R. *Rococo Architecture in Southern Germany.* London: Phaidon, 1968.
Kalnein, Karl W., and Michael Levey. *Art and Architecture of the 18th Century in France.* Harmondsworth: Penguin, 1972.
Kimball, Sidney F. *The Creation of the Rococo.* New York: Norton, 1964.
Levey, Michael. *Painting in 18th-Century Venice.* London: Phaidon, 1959.
—. *Rococo to Revolution.* New York: Oxford University Press, 1977.
Manners and Morals: Hogarth and British Painting, 1700–1760. London, Tate Gallery, 1987.
Minguet, J. Philippe. *Esthétique du Rococo.* Paris: J. Vrin, 1966.
Palladio, Andrea. *The Four Books of Architecture.* 1738. Reprint of the Isaac Ware edition. New York: Dover, 1965.
Paulson, Ronald. *The Age of Hogarth.* London: Phaidon, 1975.
Pignatti, Terisio. *The Age of Rococo.* New York: Hamlyn, 1969.
Posner, Donald. *Watteau: A Lady at Her Toilet.* New York: Viking Press, 1973.
Rosenberg, Pierre. *Chardin, 1699–1779.* Trans. Emilie P. Kadish and Ursula Korneitchouk. Ed. Sally W. Goodfellow. Cleveland: Cleveland Museum of Art, 1979.

Rosenblum, Robert. *Transformation in Late Eighteenth-Century Art.* Princeton: Princeton University Press, 1967.
Snodin, Michael. *Rococo: Art and Design in Hogarth's England.* London: Trefoil Books/Victoria and Albert Museum, 1984.
Summerson, John. *Architecture of the Eighteenth Century.* New York: Thames & Hudson, 1986.
Wittkower, Rudolf. *Palladio and Palladianism.* New York: Braziller, 1974.

Neoclassicism: The Late Eighteenth and Early Nineteenth Centuries

Arnason, Hjorvardur H. *The Sculptures of Houdon.* New York: Oxford University Press, 1975.
Boime, Albert. *Art in an Age of Revolution, 1750–1800.* Chicago: University of Chicago Press, 1987.
—. *Art in an Age of Bonapartism, 1800–1815.* Chicago: University of Chicago Press, 1990.
Bryson, Norman. *Tradition and Desire: From David to Delacroix.* New York: Cambridge University Press, 1984.
Burchard, John, and Albert Bush-Brown. *The Architecture of America: A Social and Cultural History.* Boston: Little, Brown, 1965.
Cooper, Wendy A. *Classical Taste in America, 1800–1840.* Baltimore: Baltimore Museum of Art, 1993.
Eitner, Lorenz. *Neoclassicism and Romanticism, 1750–1850: An Anthology of Sources and Documents.* New York: Harper & Row, 1989.
—. *An Outline of 19th-Century European Painting: From David through Cézanne.* New York: HarperCollins, 1996.
Elsen, Albert E. *Auguste Rodin: Readings on His Life and Work.* Englewood Cliffs, NJ: Prentice-Hall, 1965.
—. *Rodin.* New York: The Museum of Modern Art, 1963.
Friedländer, Walter F. *From David to Delacroix.* Cambridge, MA: Harvard University Press, 1952.
Honour, Hugh. *Neo-Classicism.* Harmondsworth: Penguin, 1987.
Irwin, David. *English Neoclassical Art.* London: Faber & Faber, 1966.
Jaffe, Irma B. *Trumbull: The Declaration of Independence.* London: Allen Lane, 1976.
Lindsay, Jack. *Death of the Hero: French Painting from David to Delacroix.* London: Studio, 1960.
McLaughlin, Jack. *Jefferson and Monticello: The Biography of a Builder.* New York: Henry Holt & Co., 1988.
Middleton, Robin, and David Watkin. *Neoclassical and 19th-Century Architecture.* 2 vols. New York: Electa/Rizzoli, 1987.
Nanteuil, L. de. *David.* New York: Harry N. Abrams, 1985.
Novotny, Fritz. *Painting and Sculpture in Europe, 1780–1880.* Pelican History of Art. Harmondsworth: Penguin, 1980.
Roberts, Warren E. *Jacques-Louis David, Revolutionary Artist: Art, Politics, and the French Revolution.* Chapel Hill: University of North Carolina Press, 1989.
Rosenblum, Robert. *Jean-Auguste-Dominique Ingres.* New York: Harry N. Abrams, 1967.
—. *Transformations in Late 18th-Century Art.* Princeton: Princeton University Press, 1970.
Roworth, Wendy Wassyng. *Angelica Kauffmann: A Continental Artist in Georgian England.* London: Reaktion, 1992.

Rykwert, Joseph, and Anne Rykwert. *Robert and James Adam: The Men and the Style.* New York: Rizzoli, 1985.
Stillman, Daime. *English Neoclassical Architecture.* 2 vols. London: A. Zwemmer, 1988.
Vaughan, Will, and Helen Weston. *David's Death of Marat.* Cambridge: Cambridge University Press, 1998.

Romanticism: The Late Eighteenth and Early Nineteenth Centuries

Athanassoglou-Kallmyer, Nina M. *Eugène Delacroix.* New Haven: Yale University Press, 1991.
Bindman, David. *William Blake: His Art and Time.* New Haven: Yale Center for British Art, 1982.
Born, Wolfgang. *American Landscape Painting: An Interpretation.* New Haven: Yale University Press, 1948.
Borsch-Supan, Helmut. *Caspar-David Friedrich.* New York: Braziller, 1974.
Brion, Marcel. *Art of the Romantic Era: Romanticism, Classicism, Realism.* New York: Praeger, 1966.
Clark, Kenneth. *The Romantic Rebellion.* New York: Harper & Row, 1973.
Clay, Jean. *Romanticism.* New York: Phaidon, 1981.
Courthion, Pierre. *Romanticism.* Geneva: Skira, 1961.
Eitner, Lorenz. *Géricault's "Raft of the Medusa."* London: Phaidon, 1972.
—. *Géricault: His Life and Work.* Ithaca, NY: Cornell University Press, 1982.
Faxon, Alicia Craig. *Dante Gabriel Rossetti.* London: Phaidon, 1989.
Gage, John. *J. M. W. Turner.* New Haven: Yale University Press, 1987.
Harris, Enriqueta. *Goya.* Rev. ed. London: Phaidon, 1994.
Hilton, Timothy. *Pre-Raphaelites.* London: Thames & Hudson, 1970.
Honour, Hugh. *Romanticism.* New York: Harper & Row, 1979.
Kroeber, Karl. *British Romantic Art.* Berkeley: University of California Press, 1986.
Licht, Fred. *Goya: The Origins of the Modern Temper in Art.* New York: Harper & Row, 1983.
Lopez-Rey, José. *Goya's Caprichos: Beauty, Reason, and Caricature.* 2 vols. Princeton: Princeton University Press, 1953.
Mendelowitz, Daniel M. *A History of American Art.* 2nd ed. New York: Holt, Rinehart & Winston, 1970.
Murphy, Alexandra R. *Jean-François Millet.* Boston: Museum of Fine Arts, 1984.
Parry, Ellwood C., III. *The Art of Thomas Cole: Ambition and Imagination.* Newark, NJ: Associated Universities Press, 1988.
Pérez Sánchez, Alfonso E., and Eleanor A. Sayre. *Goya and the Spirit of Enlightenment.* Boston: Museum of Fine Arts, 1989.
Powell, Earl A. *Thomas Cole.* New York: Harry N. Abrams, 1990.
Praz, Mario. *The Romantic Agony.* New York: Oxford University Press, 1983.
The Pre-Raphaelites. London: Tate Gallery, 1984.
Prideaux, Tom. *The World of Delacroix.* New York: Time-Life, 1966.
Raine, Kathleen. *William Blake.* New York: Oxford University Press, 1970.
Rosenblum, Robert, and Horst W. Janson. *19th-Century Art.* New York: Harry N. Abrams, 1984.

Truettner, William H., and Allan Wallach, eds. *Thomas Cole: Landscape into History.* New Haven: Yale University Press, 1994.

Vaughan, William. *German Romantic Painting.* New Haven: Yale University Press, 1980.

—. *Romanticism and Art.* New York: Thames & Hudson, 1994.

Walker, John. *John Constable.* New York: Harry N. Abrams, 1991.

Wilton, Andrew. *Turner and the Sublime.* Chicago: University of Chicago Press, 1980.

—. *Turner in His Time.* New York: Harry N. Abrams, 1987.

Wolf, Bryan Jay. *Romantic Revision: Culture and Consciousness in Nineteenth-Century American Painting and Literature.* Chicago: University of Chicago Press 1986.

Nineteenth-Century Realism

Ashton, Dore. *Rosa Bonheur: A Life and a Legend.* New York: Viking, 1981.

Barger, M. Susan, and William B. White. *The Daguerreotype: Nineteenth-Century Technology and Modern Science.* Washington, D.C.: Smithsonian Institution, 1991.

Boime, Albert. *A Social History of Modern Art.* Chicago: University of Chicago Press, 1987.

Cachin, Françoise, Charles S. Moffet, and Michel Melot, eds. *Manet, 1832–1883.* New York: Metropolitan Museum of Art, 1983.

Carrier, David. *High Art.* University Park, PA: Pennsylvania State University Press, 1996.

Clark, T. J. *The Absolute Bourgeois: Artists and Politics in France, 1848–51.* London: Thames & Hudson, 1973.

—. *Image of the People: Gustave Courbet and the 1848 Revolution.* London: Thames & Hudson, 1983.

Eisenmann, Stephen F. *19th-Century Art: A Critical History.* New York: Thames & Hudson, 1994.

Elsen, Albert. *Rodin.* New York: The Museum of Modern Art, 1963.

Farwell, Beatrice. *Manet and the Nude. A Study in the Iconology of the Second Empire.* New York: Garland Press, 1981.

Fried, Michael. *Courbet's Realism.* Chicago: University of Chicago Press, 1990.

Gosling, N. *Nadar.* New York: Knopf, 1976.

Hamilton, George H. *Manet and His Critics.* New Haven: Yale University Press, 1954.

Homer, William Innes. *Thomas Eakins: His Life and Art.* New York: Abbeville, 1992.

Isaacson, Joel. *Manet: Le Déjeuner sur l'Herbe.* London: Allen Lane, 1972.

Janson, Horst W. *19th-Century Sculpture.* New York: Harry N. Abrams, 1985.

Johns, Elizabeth. *Thomas Eakins: The Heroism of Modern Life.* Princeton: Princeton University Press, 1983.

Krell, Alain. *Manet and the Painters of Contemporary Life.* London: Thames & Hudson, 1996.

Lindsay, Jack. *Gustave Courbet: His Life and Art.* New York: State Mutual Reprints, 1981.

Maison, K.E. *Honoré Daumier: Catalogue Raisonné of the Paintings, Watercolors and Drawings.* 2 vols. Greenwich, CT: New York Graphic Society, 1968.

McKean, John. *Crystal Palace: Joseph Paxton and Charles Fox.* London: Phaidon, 1994.

Meredith, Roy. *Mr. Lincoln's Camera Man.* 2nd ed. New York: Dover, 1974.

Needham, Gerald. *19th-Century Realist Art.* New York: Harper & Row, 1988.

Newhall, Beaumont. *The History of Photography from 1839 to the Present Day.* New York: The Museum of Modern Art, 1982.

Nicholson, Benedict. *Courbet: The Studio of the Painter.* London: Allen Lane, 1973.

Nochlin, Linda. *Gustave Courbet: A Study of Style and Society.* New York: Garland, 1976.

—. *Realism.* Harmondsworth: Penguin, 1971.

—. *Realism and Tradition in Art, 1848–1900: Sources and Documents.* Englewood Cliffs, NJ: Prentice-Hall, 1966.

Novak, Barbara. *American Painting of the 19th Century.* New York: Praeger, 1969.

O'Gorman, James F. *Three American Architects: Richardson, Sullivan, and Wright, 1865–1915.* Chicago: University of Chicago Press, 1991.

Passeron, Roger. *Daumier.* Secaucus, NJ: Popular Books, 1981.

Reff, Theodore. *Manet: Olympia.* London: Allen Lane, 1976.

Schneider, Pierre. *The World of Manet, 1832–1883.* New York: Time-Life, 1968.

Sullivan, Louis. *The Autobiography of an Idea.* New York: Dover, 1956.

Touissant, Hélène. *Gustave Courbet, 1819-1877.* London: Arts Council of Great Britain, 1978.

Tucker, Paul H., ed. *Manet's Déjeuner sur l'Herbe.* Cambridge: Cambridge University Press, 1998.

Weisberg, Gabriel P. *The European Realist Tradition.* Bloomington: Indiana University Press, 1982.

Nineteenth-Century Impressionism

Bell, Quentin. *John Ruskin.* New York: Braziller, 1978.

Boggs, Jean Sutherland, et al. *Degas* (exhibition catalog). New York: Metropolitan Museum of Art, 1988.

Clark, T. J. *The Painting of Modern Life: Paris in the Art of Manet and his Followers.* Princeton: Princeton University Press, 1984.

Gerdts, William H. *American Impressionism.* New York: Abbeville, 1984.

Guth, Christine. *Art of Edo Japan.* New York: Harry N. Abrams, 1996.

Hanson, Anne C. *Manet and the Modern Tradition.* New Haven: Yale University Press, 1977.

Hanson, Lawrence. *Renoir: The Man, the Painter, and His World.* London: Thames & Hudson, 1972.

Herbert, Robert L. *Impressionism: Art, Leisure and Parisian Society.* New Haven: Yale University Press, 1988.

Higonnet, Anne. *Berthe Morisot's Images of Women.* Cambridge, MA: Harvard University Press, 1992.

Kelder, Diane. *The French Impressionists and their Century.* New York: Praeger, 1970.

Kendall, Richard. *Degas Beyond Impressionism.* London: National Gallery Publications, 1996.

Mathews, Nancy Mowll. *Mary Cassatt.* New York: Harry N. Abrams, 1987.

Nochlin, Linda. *Impressionism and Post-Impressionism, 1874–1904: Sources and Documents.* Englewood Cliffs, NJ: Prentice-Hall, 1966.

Pissarro, Joachim. *Camille Pissarro.* New York: Harry N. Abrams, 1993.

Pool, Phoebe. *Impressionism.* New York: Praeger, 1967.

Prideaux, Tom. *The World of Whistler, 1834–1903.* New York: Time-Life, 1970.

Rewald, John. *The History of Impressionism.* 4th rev. ed. New York: New York Graphic Society for the Museum of Modern Art, 1973.

—. *Studies in Impressionism.* New York: Harry N. Abrams, 1986.

Rouart, Denis. *Renoir.* New York: Skira/Rizzoli, 1985.

Smith, Paul. *Impressionism: Beneath the Surface.* New York: Harry N. Abrams, 1995.

Spate, Virginia. *Claude Monet: Life and Work.* New York: Rizzoli, 1992.

Tucker, Paul Hayes. *Claude Monet: Life and Art.* New Haven: Yale University Press, 1995.

Walker, John. *James McNeil Whistler.* New York: Harry N. Abrams, 1987.

Post-Impressionism and the Late Nineteenth Century

Andersen, Wayne. *Gauguin's Paradise Lost.* New York: Viking Press, 1971.

Badt, Kurt. *The Art of Cézanne.* Trans. S. A. Ogilvie. Berkeley: University of California Press, 1965.

Champigneulle, Bernard. *Rodin.* New York: Oxford University Press, 1980.

d'Alleva, Anne. *Arts of the Pacific Islands.* New York: Harry N. Abrams, 1998.

Denvir, Bernard. *Post-Impressionism.* New York: Thames & Hudson, 1992.

—. *Toulouse-Lautrec.* New York: Thames & Hudson, 1991.

Edvard Munch: Symbols and Images. Washington, D.C.: National Gallery of Art, 1978.

Eggum, Arne. *Edvard Munch: Peintures-Esquisses-Etudes.* Trans. (into French) M.-C. Schjoth-Iversen and C. Parodi. Oslo: J. M. Stenersens Forlag A.S., 1995.

Geist, Sidney. *Interpreting Cézanne.* Cambridge, MA: Harvard University Press, 1988.

Gogh, Vincent van. *The Complete Letters of Vincent van Gogh.* Trans. J. van Gogh-Bonger and C. de Dood. 3 vols. Greenwich: New York Graphic Society, 1958.

Goldwater, Robert. *Paul Gauguin.* New York: Harry N. Abrams, 1957.

Gordon, Robert, and Andrew Forge. *Degas.* Trans. Richard Howard. New York: Harry N. Abrams, 1988.

Gowing, Lawrence, ed. *Cézanne: The Early Years, 1859–72.* New York: National Gallery of Art, Washington, D.C., in assoc. with Harry N. Abrams, 1988.

Hamilton, George H. *Painting and Sculpture in Europe, 1880–1940.* 2nd ed. Pelican History of Art. Harmondsworth: Penguin, 1991.

Heller, Reinhold. *Munch: The Scream.* New York: Viking, 1972.

Holt, Elizabeth Gilmore, ed. *The Expanding World of Art, 1874–1902.* New Haven: Yale University Press, 1988.

Huisman, P., and M. G. Dortu. *Toulouse-Lautrec.* Garden City, NY: Doubleday, 1973.

Jullian, Phillippe. *The Symbolists.* New York: E. P. Dutton, 1973.

Pickvance, Ronald. *Van Gogh in Arles.* New York: Metropolitan Museum of Art in assoc. with Harry N. Abrams, 1984.

—. *Van Gogh in Saint-Rémy and Auvers.* New York: Metropolitan Museum of Art in assoc. with Harry N. Abrams, 1986.

Post-Impressionism: Cross-Currents in European and American Painting, 1880–1906. Washington, D.C.: National Gallery of Art, 1980.

Rewald, John. *Post-Impressionism from Van Gogh to Gauguin.* 3rd ed. New York: The Museum of Modern Art, 1978.

—. *Studies in Post-Impressionism.* New York: Harry N. Abrams, 1986.

Rubin, William, ed. *Cézanne: The Late Work.* New York: The Museum of Modern Art, 1977.

Russell, John. *Seurat.* New York: Praeger, 1965.

Schapiro, Meyer. *Paul Cézanne.* 3rd ed. New York: Harry N. Abrams, 1962.

—. *Vincent van Gogh.* New York: Harry N. Abrams, 1950.

Shiff, Richard. *Cézanne and the End of Impressionism.* Chicago and London: University of Chicago Press, 1984.

Smith, Paul. *Seurat and the Avant-Garde.* New Haven: Yale University Press, 1997.

Stang, Ragna. *Edvard Munch.* Trans. Geoffrey Culverwell. New York: Abbeville, 1988.

Thomson, Belinda. *Gauguin.* New York: Thames & Hudson, 1987.

Thomson, Richard, et al. *Toulouse-Lautrec.* New Haven: Yale University Press, 1991.

Wood, Mara-Helen, ed. *Edvard Munch: The Frieze of Life.* London: National Gallery Publications, 1992.

Turn of the Century: Early Picasso, Fauvism, Expressionism, and Matisse

Arnason, Hjorvardur H. *History of Modern Art.* 4th ed. New York: Harry N. Abrams, 1998.

Barr, Alfred H., Jr. *Matisse, His Art, and His Public.* Reprint of 1951 ed. by the Museum of Modern Art. New York: Arno Press, 1966.

Bascom, William Russell. *African Art in Cultural Perspective.* New York: Norton, 1973.

Ben-Amos, Paula G. *The Art of Benin.* Rev. ed. London: British Museum, 1995.

Berlo, Janet, and Lee A. Wilson. *Arts of Africa, Oceania, and the Americas.* 2nd ed. Englewood Cliffs, NJ: Prentice-Hall, 1989.

Blier, Suzanne. *The Royal Arts of Africa: The Majesty of Form.* New York: Harry N. Abrams, 1998.

Chipp, Herschel B. *Theories of Modern Art.* Berkeley: University of California Press, 1968.

Duncan, Alastair. *Art Nouveau.* Thames & Hudson, 1994.

Duthuit, Georges. *The Fauvist Painters.* New York: Wittenborn, Schultz, 1950.

Elderfield, John. *The Cut-Outs of Henri Matisse.* New York: Braziller, 1978.

Flam, Jack D. *Matisse: The Man and His Art, 1869–1918.* Ithaca: Cornell University Press, 1986.

—. *Matisse on Art.* London: Phaidon, 1973.

Gordon, Donald E. *Expressionism: Art and Idea.* New Haven: Yale University Press, 1987.

Hahl-Koch, Jelena. *Kandinsky.* New York: Rizzoli, 1993.

Herbert, James D. *Fauve Painting: The Making of Cultural Politics.* New Haven: Yale University Press, 1992.

Kerchache, Jacques, Jean-Louis Paudrat, and Lucien Stephan. *Art of Africa.* New York: Harry N. Abrams, 1993.

Lloyd, Jill. *German Expressionism: Primitivism and Modernity.* New Haven: Yale University Press, 1991.

Magnin, André, and Jacques Soulillon. *Contemporary Art of Africa.* New York: Harry N. Abrams, 1996.

Messer, Thomas. *Kandinsky.* New York: Harry N. Abrams, 1987.

Myers, Bernard. *The German Expressionists: A Generation in Revolt.* New York: Praeger, 1956.

Perani, Judith, and Fred T. Smith. *The Visual Arts of Africa: Gender, Power, and Life Cycle Rituals.* Upper Saddle River, NJ: Prentice-Hall, 1998.

Prelinger, Elizabeth. *Käthe Kollwitz.* Washington, D.C.: Yale University Press/National Gallery of Art, 1992.

Richardson, John. *A Life of Picasso: Vol. I 1881–1906.* Random House, 1991.

Russell, John. *The World of Matisse, 1869–1954.* New York: Time-Life, 1969.

Schmutzler, R. *Art Nouveau.* New York: Harry N. Abrams, 1962.

Schneider, Pierre. *Matisse.* Trans. M. Taylor and B. S. Romer. New York: Rizzoli, 1984.

Steinberg, Leo. *Other Criteria: Confrontations with 20th-Century Art.* New York: Oxford University Press, 1972.

Taylor, Brandon. *Avant-Garde and After.* New York: Harry N. Abrams, 1995.

Vogt, Paul. *Expressionism: German Painting, 1905–20.* New York: Harry N. Abrams, 1980.

Cubism, Futurism, and Related Twentieth-Century Styles

Ashton, Dore. *20th-Century Artists on Art.* New York: Pantheon, 1985.

Barr, Alfred H., Jr. *Cubism and Abstract Art: Painting, Sculpture, Constructions, Photography, Architecture, Industrial Art, Theatre, Films, Posters.* Cambridge, MA: Belknap, 1986.

—. *Picasso, Fifty Years of his Art.* Reprint of 1946 ed. by the Museum of Modern Art. New York: Arno Press, 1966.

Bayer, Herbert, Walter Gropius, and Ise Gropius. *Bauhaus, 1919–1928.* New York: Museum of Modern Art, 1975.

Blake, Peter. *Frank Lloyd Wright.* Harmondsworth: Penguin, 1960.

Brown, Milton. *The Story of the Armory Show: The 1913 Exhibition That Changed American Art.* 2nd ed. New York: Abbeville, 1988.

Chipp, Herschel B. *Picasso's Guernica.* Berkeley: University of California Press, 1988.

Cooper, Douglas. *The Cubist Epoch.* New York: Phaidon, 1971.

Cowling, Elizabeth. *Picasso: Sculptor/Painter.* London: Tate Gallery, 1994.

Curtis, William J.R. *Le Corbusier: Idea and Forms.* New York: Rizzoli, 1986.

van Doesburg, Theo. *Principles of Neo-Plastic Art.* Greenwich: New York Graphic Society, 1968.

Elsen, Albert E. *Origins of Modern Sculpture.* New York: Braziller, 1974.

Fry, Edward E. *Cubism.* New York: Oxford University Press, 1978.

Geist, Sidney. *Brancusi: The Kiss.* New York: Harper & Row, 1978.

—. *Brancusi: The Sculpture and Drawings.* New York: Harry N. Abrams, 1975.

Golding, John. *Cubism: A History and an Analysis, 1907–1914.* Cambridge, MA: Belknap, 1988.

Gray, Camilla. *Russian Experiment in Art, 1863–1922.* New York: Harry N. Abrams, 1970.

Green, Christopher, ed. *Picasso's Demoiselles d'Avignon.* Cambridge: Cambridge University Press, 1998.

Harrison, Charles, Francis Frascina, and Gill Perry. *Primitivism, Cubism, Abstraction: The Early Twentieth Century.* New Haven: Yale University Press, 1993.

Hilton, Timothy. *Picasso.* New York: Praeger, 1975.

Hulten, Pontus. *Futurism and Futurisms.* New York: Abbeville, 1986.

Hunter, Sam, and John Jacobus. *American Art of the 20th Century: Painting, Sculpture, Architecture.* New York: Harry N. Abrams, 1973.

—. *Modern Art.* 3rd ed. New York: Harry N. Abrams, 1992.

Jaffe, Hans L. C. *De Stijl, 1917–1931: The Dutch Contribution to Modern Art.* Cambridge, MA: Belknap, 1986.

Kuenzli, Rudolf, and Francis M. Naumann. *Marcel Duchamp: Artist of the Century.* Cambridge: MIT Press, 1989.

Larkin, David, and Bruce Brooks Pfeiffer. *Frank Lloyd Wright: The Masterworks.* New York: Rizzoli, 1993.

Lodder, C. *Russian Constructivism.* New Haven: Yale University Press, 1983.

Mondrian, Piet C. *Plastic Art and Pure Plastic Art.* New York: Wittenborn, 1945.

Overy, Paul. *De Stijl.* New York: Thames & Hudson, 1991.

Pfeiffer, Bruce Brooks, and Gerald Nordland, eds. *Frank Lloyd Wright in the Realm of Ideas.* Carbondale, IL: Southern Illinois University Press, 1988.

Read, Herbert. *A Concise History of Modern Painting.* New York: Oxford University Press, 1959.

Richardson, John. *A Life of Picasso. Vol. II 1907–1917.* Random House, 1996.

Rosenblum, Robert. *Cubism and 20th-Century Art.* Rev. ed. New York: Harry N. Abrams, 1984.

Rubin, William, comp. *Picasso and Braque: Pioneering Cubism.* New York: Museum of Modern Art, 1989.

—, ed. *Pablo Picasso: A Retrospective.* New York: The Museum of Modern Art, 1980.

Schiff, Gert, ed. *Picasso in Perspective.* Englewood Cliffs, NJ: Prentice-Hall, 1976.

Silver, Kenneth E. *Esprit de Corps: The Art of the Parisian Avant Garde and the First World War, 1914–1925.* Princeton: Princeton University Press, 1989.

Taylor, Joshua C. *Futurism.* New York: The Museum of Modern Art, 1961.

Tomkins, Calvin. *Duchamp: A Biography.* New York: Henry Holt, 1996.

Tisdall, Caroline, and Angelo Bozzolla. *Futurism.* New York: Oxford University Press, 1978.

Weiss, Jeffrey S. *The Popular Culture of Modern Art: Picasso, Duchamp, and Avant-Gardism.* New Haven: Yale University Press, 1994.

Whitford, Frank. *Bauhaus.* London: Thames & Hudson, 1984.

Wilkin, Karen. *Georges Braque.* New York: Abbeville, 1991.

Wright, Frank Lloyd. *American Architecture.* Ed. E. Kaufmann. New York: Horizon, 1955.

Zhadova, Larissa A. *Malevich: Suprematism and Revolution in Russian Art.* Trans. Alexander Lieven. London: Thames & Hudson, 1982.

Dada, Surrealism, Fantasy, and the United States Between the Wars

Alexandrian, Sarane. *Surrealist Art.* London: Thames & Hudson, 1970.

Arp, Hans. *Arp on Arp: Poems, Essays, Memories.* Ed. Marcel Jean. New York: Viking Press, 1972.

Baigell, Matthew. *The American Scene: American Painting of the 1930s.* New York: Praeger, 1974.

Barr, Alfred H., Jr., ed. *Fantastic Art, Dada, Surrealism.* Reprint of 1936 ed. by The Museum of Modern Art. New York: Arno Press, 1969.

Bearden, Romare, and Harry Henderson. *A History of African-American Artists from 1792 to the Present.* New York: Pantheon Books, 1993.

Dachy, Marc. *The Dada Movement, 1915–1923.* New York: Skira/Rizzoli, 1990.

Davidson, Abraham A. *Early American Modernist Painting, 1910–1935*. New York: Harper & Row, 1981.

Eldredge, Charles C. *Georgia O'Keeffe*. New York: Harry N. Abrams, 1991.

Foucault, Michel. *This is Not A Pipe*. Trans. J. Harkness. Berkeley: University of California Press, 1982.

Franciscono, Marcel. *Paul Klee: His Work and Thought*. Chicago: University of Chicago Press, 1991.

Herrera, Hayden. *Frida Kahlo: The Paintings*. New York: HarperCollins, 1991.

Homer, William Innes. *Alfred Stieglitz and the American Avant-Garde*. Boston: New York Graphic Society, 1977.

Lane, John R., and Susan C. Larsen. *Abstract Painting and Sculpture in America, 1927–1944*. Pittsburgh: Pittsburgh Museum of Art, Carnegie Institute, 1984.

Levin, Gail. *Edward Hopper: An Intimate Biography*. New York: Alfred A. Knopf, 1995.

Lippard, Lucy R. *Surrealists on Art*. Englewood Cliffs, NJ: Prentice-Hall. 1970.

Lynes, Barbara B. *O'Keeffe, Stieglitz, and the Critics, 1916–29*. Chicago: University of Chicago Press, 1989.

Mashek, Joseph, ed. *Marcel Duchamp in Perspective*. Englewood Cliffs, NJ: Prentice-Hall, 1975.

Norman, Dorothy. *Alfred Stieglitz, an American Seer*. New York: Aperture, 1990.

Picon, Gaetan. *Surrealists and Surrealism, 1919–1939*. Trans. James Emmons. New York: Rizzoli, 1977.

Powell, Richard J. *Black Art and Culture in the 20th Century*. London: Thames & Hudson, 1997.

Richter, Hans. *Dada: Art and Anti-Art*. New York: McGraw-Hill, 1965.

Rubin, William: *Dada and Surrealist Art*. New York: Harry N. Abrams, 1968.

Russell, John: *Max Ernst: Life and Work*. New York: Harry N. Abrams, 1967.

Schwarz, Arturo. *The Complete Works of Marcel Duchamp*. London: Thames & Hudson, 1965.

—. *Man Ray: The Rigors of Imagination*. New York: Rizzoli, 1967.

Stich, Sidra. *Anxious Visions: Surrealist Art*. New York: Abbeville, 1990.

Sylvester, David. *Magritte: The Silence of the World*. New York: The Menil Foundation/Harry N. Abrams, 1992.

Waldberg, Patrick. *Surrealism*. New York: Oxford University Press, 1965.

Wheat, Ellen Harkins. *Jacob Lawrence: American Painter*. Seattle: University of Washington Press, 1986.

Abstract Expressionism

Albright, Thomas. *Art in the San Francisco Bay Area, 1945–80*. Berkeley: University of California Press, 1985.

Alloway, Lawrence. *Topics in American Art Since 1945*. New York: W. W. Norton, 1975.

Ashton, Dore. *About Rothko*. New York: Oxford University Press, 1983.

—. *American Art Since 1945*. New York: Oxford University Press, 1983.

Barron, Stephanie, ed. *Degenerate Art: The Fate of the Avant-Garde in Nazi Germany*. Los Angeles: Los Angeles County Museum of Art, 1991.

Doss, Erika. *Benton, Pollock, and the Politics of Modernism: From Regionalism to Abstract Expressionism*. Chicago: University of Chicago Press, 1991.

Frascina, Francis, ed. *Pollock and After: The Critical Debate*. New York: Harper & Row, 1985.

Francis, R. H. *Jasper Johns*. New York: Abbeville, 1984.

Geldzahler, Henry. *New York Painting and Sculpture: 1940–1970*. New York: E. P. Dutton, 1969.

Gordon, John. *Louise Nevelson*. New York: Whitney Museum, 1967.

Gray, Cleve. *David Smith on David Smith: Sculpture and Writings*. London: Thames & Hudson, 1968.

Greenberg, Clement. *Art and Culture: Critical Essays*. Boston: Beacon, 1961.

Guberman, Sidney. *Frank Stella: An Illustrated Biography*. New York: Rizzoli, 1985.

Herbert, Robert L. *Modern Artists on Art*. Englewood Cliffs, NJ: Prentice-Hall, 1971.

Hertz, Richard, ed. *Theories of Contemporary Art*. Englewood Cliffs, NJ: Prentice-Hall, 1985.

Hess, Thomas B. *Willem de Kooning*. New York: The Museum of Modern Art, 1968.

Howell, John, ed. *Breakthroughs: Avant-Garde Artists in Europe and America, 1950–1960*. New York: Rizzoli, 1991.

Hughes, Robert. *The Shock of the New*. New York: Knopf, 1981.

Hunter, Sam. *An American Renaissance: Painting and Sculpture Since 1940*. New York: Abbeville, 1986.

Johnson, Ellen H. *American Artists on Art: From 1940 to 1980*. New York: Harper & Row, 1980.

—. *Modern Art and the Object*. New York: Harper & Row, 1976.

Krauss, Rosalind E. *The Originality of the Avant-Garde and Other Modernist Myths*. Cambridge, MA: MIT Press, 1985.

—. *Passages in Modern Sculpture*. New York: Viking, 1977.

Lipman, Jean. *Calder's Universe*. Philadelphia and London: Running Press, 1989.

Lucie-Smith, Edward. *Movements in Art since 1945*. London: Thames & Hudson, 1984.

O'Connor, Francis V. *Jackson Pollock*. New York: The Museum of Modern Art, 1967.

Reinhardt, Ad. *Art as Art: The Selected Writings of Ad Reinhardt*. Ed. Barbara Rose. New York: Viking, 1975.

Rose, Barbara. *American Art since 1960*. Rev. ed. New York: Praeger, 1975.

—. *Frankenthaler*. New York: Harry N. Abrams, 1975.

—. *Jackson Pollock: Drawing into Painting*. New York: Museum of Modern Art, 1980.

Rosenberg, Harold. *Art on the Edge: Creators and Situations*. New York: Macmillan, 1971.

—. *The De-Definition of Art: Action Art to Pop to Earthworks*. New York: Museum of Modern Art, 1980.

—. *The Tradition of the New*. New York: Horizon, 1959.

Rosenblum, Robert. *Frank Stella*. Harmondsworth: Penguin, 1971.

Rubin, William, ed. *Primitivism in 20th-Century Art*. 2 vols. New York: The Museum of Modern Art, 1984.

Russell, John. *The Meanings of Modern Art*. New York: Museum of Modern Art/Harper & Row, 1981.

Sandler, Irving. *American Art of the 1960s*. New York: Harper & Row, 1989.

—. *The Triumph of American Painting: A History of Abstract Expressionism*. New York: Harper & Row, 1970.

Selz, Peter. *Art in Our Times*. New York: Harry N. Abrams, 1981.

Tomkins, Calvin. *The Scene: Reports on Post-Modern Art*. New York: Viking Press, 1976.

Waldman, Diane. *Mark Rothko, 1903–70: A Retrospective*. New York: Solomon R. Guggenheim Museum, 1978.

Wheeler, Daniel. *Art Since Mid-Century: 1945 to the Present*. New York: Vendome, 1991.

Pop Art, Op Art, Minimalism, and Conceptualism

Alloway, Lawrence. *American Pop Art*. New York: Whitney Museum, 1974.

—. *Robert Rauschenberg*. Washington, D.C.: Smithsonian Institution, 1976.

Baker, Kenneth. *Minimalism*. New York: Abbeville, 1990.

Battock, Gregory, ed. *Minimal Art: A Critical Anthology*. New York: Studio Vista, 1969.

Bourdon, David. *Warhol*. New York: Harry N. Abrams, 1989.

Crichton, Michael. *Jasper Johns*. New York: Whitney Museum/Harry N. Abrams, 1977.

Crow, Thomas. *The Rise of the Sixties: American and European Art in the Era of Dissent*. New York: Harry N. Abrams, 1996.

Frith, Simon, and Howard Horne. *Pop into Art*. London: Methuen, 1987.

Geldzahler, Henry, and Robert Rosenblum. *Andy Warhol: Portraits of the Seventies and Eighties*. London: Anthony d'Offay Gallery/Thames & Hudson, 1993.

Goodyear, Frank H., Jr. *Contemporary American Realism since 1960*. Boston: New York Graphic Society, 1981.

Lippard, Lucy R. *Mixed Blessings: New Art in a Multicultural America*. New York: Pantheon Books, 1990.

—. *Pop Art*. New York: Praeger, 1966.

—. *Six Years: The Dematerialization of the Art Object from 1966 to 1972*. New York: Praeger, 1973.

Livingston, Marco. *Pop Art: A Continuing History*. New York: Harry N. Abrams, 1990.

Lucie-Smith, Edward. *American Art Now*. New York: William Morrow, 1990.

—. *Art in the Eighties*. New York: Phaidon, 1985.

—. *Art in the Seventies*. Ithaca, NY: Cornell University Press, 1980.

McShine, Kynaston. *Andy Warhol: A Retrospective*. New York: The Museum of Modern Art, 1989.

Meyer, Ursula. *Conceptual Art*. New York: E. P. Dutton, 1972.

Rose, Barbara. *Claes Oldenberg*. New York: The Museum of Modern Art, 1970.

Russell, John, and Suzi Gablik. *Pop Art Redefined*. London: Thames & Hudson, 1969.

Varnedoe, Kirk. *Jasper Johns: A Retrospective*. New York: Museum of Modern Art, 1996.

—, and Adam Gopnik, eds. *Modern Art and Popular Culture: Readings in High and Low*. New York: Museum of Modern Art, 1990.

Warhol, Andy. *America*. New York: Harper & Row, 1985.

Innovation and Continuity

Alloway, Lawrence. *Christo*. New York: Harry N. Abrams, 1969.

Auping, Michael. *Susan Rothenberg: Paintings and Drawings*. New York: Rizzoli, 1992.

Baal-Teshuva, Jacob, ed. *Christo: The Reichstag and Urban Projects*. Munich: Prestel Verlag, 1993.

Barents, Els. *Cindy Sherman*. Munich: Schirmer/Mosel, 1982.

Barrette, Bill. *Eva Hesse Sculpture: Catalogue Raisonné*. New York: Timkin Publishers, 1989.

Battock, Gregory. *Super Realism: A Critical Anthology*. New York: E. P. Dutton, 1975.

Beardsley, Richard. *Earthworks and Beyond: Contemporary Art in the Landscape*. New York: Abbeville, 1984.

Bourdon, David. *Christo*. New York: Harry N. Abrams, 1972.

Bruggen, Coosje van. *Bruce Nauman*. New York: Rizzoli, 1988.

Carmean, E. A., Jr., et al. *The Sculpture of Nancy Graves: A Catalogue Raisonné*. New York: Hudson Hills Press, 1987.

Carrier, David. *The Aesthete in the City*. University Park, PA: Pennsylvania State University Press, 1994.

Chicago, Judy. *The Dinner Party: A Symbol of Our Heritage*. Garden City, NY: Anchor Books/Doubleday, 1979.

—. *The Birth Project*. Garden City, NY: Doubleday, 1985.

Cruz, Amanda, Elizabeth A. T. Smith, and Amelia Jones. *Cindy Sherman: Retrospective*. London: Thames & Hudson, 1997.

Danto, Arthur C. *Cindy Sherman History Portraits*. New York: Rizzoli, 1991.

Flam, Jack, ed. *Robert Smithson: The Collected Writings*. Berkeley: University of California Press, 1996.

Frank, Peter, and Michael McKenzie. *New, Used and Improved: Art for the 80s*. New York: Abbeville, 1987.

Gilmour, John C. *Fire on the Earth: Anselm Kiefer and the Postmodern World*. Philadelphia: Temple University Press, 1990.

Godfrey, Tony. *The New Image: Painting in the 1980s*. New York: McGraw-Hill, 1986.

Goldberg, Rose Lee. *Performance Art from Futurism to the Present*. New York: Harry N. Abrams, 1988.

Haskell, Barbara. *Agnes Martin*. New York: Whitney Museum of American Art, 1993.

Hebdige, Dick, et al. *Jean-Michel Basquiat*. New York: Whitney Museum of Art, 1993.

Henri, Adrian. *Total Art: Environments, Happenings, and Performances*. New York: Praeger, 1974.

Hobbs, Robert. *Robert Smithson: Sculpture*. Ithaca, NY: Cornell University Press, 1981.

—, Wendy Steiner, and Marcia Tucker. *Andres Serrano: Works 1983–1993*. Philadelphia: Institute of Contemporary Art, University of Pennsylvania, 1994.

Hunter, Sam. *Valerie Jaudon*. Bottrop, Germany: Quadrat Museum/Amerika House, 1983.

Koons, Jeff. *The Jeff Koons Handbook*. London: Thames & Hudson, 1992.

Laporte, Dominique G. *Christo*. New York: Pantheon, 1985.

Lippard, Lucy. *Eva Hesse*. New York: New York University Press, 1976.

Marshall, Richard, et al. *Robert Mapplethorpe*. New York: Whitney Museum of Art, 1992.

—. *Jean-Michel Basquiat*. New York: Whitney Museum of American Art, 1992.

Meyer, Ursula, ed. *Conceptual Art*. New York: E. P. Dutton, 1971.

Ratcliff, Carter. *Komar and Melamid*. New York: Abbeville, 1988.

Rosen, Randy, and Catherine C. Brawer, eds. *Making Their Mark: Women Artists Move into the Mainstream, 1970–1985*. New York: Abbeville, 1989.

Sandler, Irving. *Art of the Postmodern Era*. New York: HarperCollins, 1996.

Smithson, Robert. *The Writings of Robert Smithson*. Ed. N. Holt. New York: New York University Press, 1975.

Stachelhaus, Heiner. *Joseph Beuys*. Trans. David Britt. New York: Abbeville, 1991.

Storr, Robert. *Chuck Close*. New York: Museum of Modern Art, 1998.

Tisdall, Caroline. *Joseph Beuys*. New York: Solomon R. Guggenheim Museum, 1989.

Valzey, Marina. *Christo*. New York: Rizzoli, 1990.

Wolf, Jahn. *The Art of Gilbert and George, or an Esthetic of Existence*. Trans. David Britt. London: Thames & Hudson, 1989.

Wypijewski, Joann, ed. *Painting by Numbers: Komar and Melamid's Scientific Guide to Art*. New York: Farrar Straus Giroux, 1997.

African Art

Bascom, William Russell. *African Art in Cultural Perspective*. New York: Norton, 1980.

Ben-Amos, Paula G. *The Art of Benin*. Rev. ed. London: British Museum Press, 1995.

Berlo, Janet and Lee A. Wilson. *Arts of Africa, Oceania, and the Americas*. 2nd ed. Englewood Cliffs, NJ: Prentice-Hall, 1989.

Blier, Suzanne. *The Royal Arts of Africa: The Majesty of Form*. New York: Harry N. Abrams, 1998.

Kerchache, Jacques, Jean-Louis Paudrat, and Lucien Stephan. *Art of Africa*. New York: Harry N. Abrams, 1993.

Magnin, Andre, and Jacques Sonlillon. *Contemporary Art of Africa*. New York: Harry N. Abrams, 1996.

Perani, Judith, and Fred T. Smith. *The Visual Arts of Africa: Gender, Power, and Life Cycle Rituals*. Upper Saddle River, NJ: Prentice-Hall, 1998.

Indian Art

Asher, Catherine B. *Architecture of Mughal India*. New York: Cambridge University Press, 1992.

Basham, Arthur Llewellyn. *The Wonder that was India*. 3rd ed. London: Sidgwick & Jackson, 1985.

Coomaraswamy, Ananda K. *History of Indian and Indonesian Art*. New York: Dover, 1985.

Craven, Roy C. *Indian Art: A Concise History*. New York: Thames & Hudson, 1985.

Goetz, Hermann. *The Art of India: Five Thousand Years of Indian Art*. 2nd ed. New York: Crown, 1964.

Harle, James C. *The Art and Architecture of the Indian Subcontinent*. Pelican History of Art. Harmondsworth: Penguin, 1987.

Lannoy, Richard. *The Speaking Tree: A Study of Indian Culture and Society*. Oxford: Oxford University Press, 1971.

Michell, George. *The Penguin Guide to the Monuments of India*. 2 vols. New York: Viking, 1989.

Nou, Jean-Louis. *Taj Mahal*. Text by Amina Okada and M.C. Joshi. New York: 1993.

Sivaramamurti, Calambur. *The Art of India*. New York: Harry N. Abrams, 1977.

Volwahsen, Andreas. *Living Architecture: India*. London: Macdonald, 1970.

Japanese Woodblock Prints

Andō, Hiroshige. *One Hundred Famous Views of Edo*. Introductory essays by Henry D. Smith II and Amy G. Poster; commentaries on the plates by Henry D. Smith; preface by Robert Buck. New York: George Braziller/Brooklyn Museum, 1986.

Chibbert, David. *The History of Japanese Printing and Book Illustration*. Tokyo, New York, and San Francisco: Kodanska International, 1977.

Lane, Richard. *Images from the Floating World: The Japanese Print*. New York: Putnam, 1978.

Ukiyo-e. *The Art of Japanese Woodblock Prints*. Amy Newland and Chris Uhlenbeck eds. New York: Smithmark Publishers, 1994.

Native American Art

Corbin, George A. *Native Arts of North America, Africa, and the South Pacific*. New York: Harper & Row, 1988.

Feest, Christian F. *Native Arts of North America*. Rev. ed. London: Thames & Hudson, 1992.

Hunt, Mary Austin. *Taos Pueblo*. Photographed by Ansel Adams and described by Mary Austin. San Francisco: 1930.

Whiteford, Andrew. *North American Indian Arts*. New York: Golden Press, 1973.

Oceanic Art

Barrow, Terrence. *The Art of Tahiti and the Neighbouring Society, Austral and Cook Islands*. New York: Thames & Hudson, 1979.

Corbin, George A. *Native Arts of North America, Africa, and the South Pacific*. New York: Harper & Row, 1988.

Hanson, Allan, and Louise Hanson. *Art and Identity in Oceania*. Honolulu: University of Hawaii Press, 1990.

Persian Painting and Miniatures

Binyon, Laurence, J.V.S. Wilkinson, and Basil Gray. *Persian Miniature Painting*. London: Burlington House, 1931. Reprinted New York: Dover, 1971.

Canby, Sheila R., ed. *Persian Masters: Five Centuries of Painting*. Bombay: Marg Publications, 1990.

—. *Persian Painting*. New York: Thames & Hudson, 1993.

Titley, Norah M. *Persian Painting and its Influence on the Arts of Turkey and India*. Austin: University of Texas Press, 1984.

Notes

Chapter 13

1. Cited by Laurie M. Schneider, *Giotto in Perspective*, Englewood Cliffs, NJ, 1974, p. 29.
2. Dante, *Purgatory*, vol. II, lines 91–95, in Millard Meiss, *Painting in Florence and Siena after the Black Death*, Princeton, 1951, p. 5.
3. Cited by Laurie M. Schneider, ed., *Giotto in Perspective*, Englewood Cliffs, NJ, 1974, p. 38.
4. Cited by Elizabeth Holt, *A Documentary History of Art*, New York, 1957, p. 137.
5. Cited by Linnea H. Wren and David J. Wren, eds., *Perspectives on Western Art*, New York, 1987, p. 270.
6. Cited by Linnea H. Wren and David J. Wren, eds., *ibid*, pp. 274–77.

Chapter 14

1. Cited by Linnea H. Wren, ed., *Perspectives on Western Art*, vol. II, New York, 1994, p. 33.
2. Cited by Linnea H. Wren, ed., *ibid*, pp. 36–37.
3. Marsilio Ficino, *Commentary on Plato's Symposium on Love*, trans. Sears Jayne, Dallas, 1985, pp. 53–54. Cited by Linnea H. Wren, *Perspectives on Western Art*, ed., vol. II, New York, 1994.

Chapter 15

1. Vasari, *Lives of the Most Eminent Painters, Sculptors, and Architects*, vol. II, trans. Gaston du Vere, New York, 1979, p. 800.
2. Vasari, *ibid*.

Chapter 16

1. John Ashberry, *Selected Poems*, New York, 1985, p. 188.
2. Vasari, *Lives of the Most Eminent Painters, Sculptors, and Architects*, vol. II, trans. Gaston du Vere, New York, 1979, p. 1045.
3. Cited by Linnea H. Wren, ed., *Perspectives on Western Art*, vol. II, New York, 1994, pp. 77–78.
4. Cited by Linnea H. Wren, ed., *ibid*, p. 126.

Chapter 17

1. Cited by Linnea H. Wren, ed., *Perspectives on Western Art*, vol. II, New York, 1994, p. 105.
2. Cited by Linnea H. Wren, ed., *ibid*, p. 109.
3. W. H. Auden, *Collected Poems*, ed. Edward Mendelson, London, 1976, p. 146.
4. Saint Bridget, *Revelations*, Bk IV. Cited by James Snyder, *Northern Renaissance Art*, New York, 1985, pp. 349–50.

Chapter 18

1. Giovanni Pietro Bellori, *The Lives of Annibale and Agostino Carracci,* trans. Catherine Enggass, University Park and London, 1968, p. 33.
2. Karel van Mander, *Het Schilder-Boeck*, Haarlem, 1604. Cited by Howard Hibbard, *Caravaggio*, New York, 1983, p. 344.

Chapter 20

1. Cited by William Howard Adams, *Jefferson's Monticello*, New York, 1983, p. 16.

Chapter 21

1. Edmund Burke, "Philosophical Enquiry into the Origin of our Ideas of the Sublime and Beautiful" in *The Works of The Right Honorable Edmund Burke*, Boston, 1889, ninth edition, vol. I, pp. 110–11, 130.

Chapter 22

1. Julia Margaret Cameron, *Annals of My Glass House*, Claremont, CA, 1996.

Chapter 23

1. James Baldwin, in an introduction at the opening of Beauford Delaney's exhibition at the Gallery Lambert, Paris, December 4, 1964.
2. Henry Miller, *Remember to Remember*, New York, 1941 (reprinted in *New Directions*, 1947).
3. James McNeill Whistler, in a letter to Fantin-Latour in 1867, cited by Stanley Weintraub, *Whistler*, New York, 1974, p. 124.

Chapter 24

1. Cited by W. H. Auden, ed., *Van Gogh: A Self-Portrait*, New York, 1989, p. 15.
2. Vincent van Gogh, letter 554, reprinted from *The Complete Letters of Vincent van Gogh*, Boston, 1991.
3. Paul Gauguin, *L'Echo de Paris*, February 23, 1891. Cited by Daniel Guerin, ed., *The Writings of a Noble Savage*, New York, 1990, p. 48.
4. Paul Gauguin, *L'Echo de Paris*, May 13, 1895. Cited by Daniel Guerin, ed., *The Writings of a Noble Savage*, New York, 1990, p. 109.
5. Cited by Arne Eggum, *Symbols and Images*, National Gallery of Washington catalog, 1978, p. 391.
6. Cited by Arne Eggum, *ibid*.

Chapter 25

1. Wallace Stevens, *The Collected Poems*, New York, 1964, pp. 165–84.
2. Cited by Reidmeister, *Das Ursprüngtiche und die Moderne*, Berlin, 1964, no. 92. Also cited in *Primitivism in 20th-century Art*, ed. William Rubin, vol. II, 1984, p. 373.
3. Emil Nolde, *Jahre der Kampf*. Cited by Donald E. Gordon, "German Expressionism," in *Primitivism in 20th-century Art*, ed. William Rubin, vol. II, 1984, p. 383, as trans. in Herschel B. Chipp, *Theories of Modern Art*, Berkeley, 1968, pp. 150–51.
4. Vassily Kandinsky, "Der Blau Reiter (Rück blick)," *Das Kunstblatt*, 1930, as trans. in Kandinsky, *Complete Writings on Art*, ed. Kenneth C. Lindsay and Peter Vergo, Boston, 1982, vol. II, p. 746. Cited by Robert Goldwater, *Primitivism*, 1967, p. 127 and in *Primitivism in 20th-century Art*, ed. William Rubin, vol. II, 1984, p. 375.
5. Franz Marc, in August Macke and Franz Marc, *Briefwechel*, Cologne, 1964, pp. 39–41. Also cited in *Primitivism in 20th-century Art*, ed. William Rubin, vol. II, 1984.
6. Cited by D. H. Kahnweiler, *Juan Gris et son oeuvre*, Paris, 1946, pp. 155–56. Also cited in *Primitivism in 20th-century Art*, ed. William Rubin, vol. I, 1984, p. 216.
7. Pablo Picasso, *La Tête d'obsidienne*, in André Malraux, *Picasso's Mask*, trans. June Guicharnaud and Jacques Guicharnaud, Paris 1974, p. 18. Also cited in *Primitivism in 20th-century Art*, ed. William Rubin, vol. I, 1984, p. 255.
8. Cited by Dora Vallier, "Braque, la peinture et nous," in *Cahiers d'art*, 29, nos. 1–2, Oct. 1954, p. 14. Also cited in *Primitivism in 20th-century Art*, ed. William Rubin, vol. I, 1984, p. 307.

Chapter 26

1. Gertrude Stein, *Camera Work*, New York, August 1912, pp. 29–30.
2. Guillaume Apollinaire, "Du sujet dans la peinture moderne," *Les Soirées de Paris*, no. 1, Feb. 1912, pp. 1–4.
3. Fernand Léger, *Contemporary Achievements in Painting*, Paris, 1914. Cited in Edward Fry, *Cubism*, New York, 1978, pp. 135–39.
4. From an interview with James Johnson Sweeney in "Eleven Europeans in America," *Bulletin of the Museum of Modern Art* (New York), XIII, nos. 4–5, 1946, pp. 19–21.
5. From the New York *Evening Sun*, 1913. Cited in Milton Brown, *The Story of the Armory Show*, New York, 1963, p. 113.
6. Kazimir Malevich, *The World as Non-objectivity: Unpublished Writings, 1922–25*, ed. Troels Andersen, trans. Xenia Glowacki-Prus, Copenhagen, 1976.
7. Sidney Geist, *Artforum*, Feb. 1983, p. 69.

Chapter 27

1. Cited by Hans Richter, *Dada: Art and Anti-art*, trans. David Britt, London, 1965, p. 16.
2. Hans Arp, *Dadaland, Zurcher Erinnerungen aus der Zeit des Ersten Weltkrieges*, Zurich, 1948.
3. Cited by Hans Richter, *Dada: Art and Anti-art*, trans. David Britt, London, 1965, p. 42.
4. Cited by Hans Richter, *ibid*, p. 89.
5. Cited by Hans Richter, *ibid*, pp. 38, 52–53.
6. Cited by Patrick Waldberg, *Surrealism*, London, 1965, p. 11.
7. Cited by Patrick Waldberg, *ibid*, p. 66.
8. Man Ray, "Photography can be Art," in *Man Ray Photographs*, New York, 1982, p. 34.
9. Paul Klee, "Creative Credo," 1920, originally published as *Schöpferische Konfession*, ed. K. Edschmid, Berlin, 1920. Cited by Herschel B. Chipp, *Theories of Modern Art*, Berkeley, 1968, p. 182.
10. Cited by Jean Lipman, with Margaret Aspinwall, *Alexander Calder and His Magical Mobiles*, New York, 1981, p. 53.
11. Cited by Nancy Newhall, ed., *Edward Weston*, New York, 1975, p. 23.
12. Georgia O'Keeffe, letter to Henry McBride, July 1931. Cited by Jack Cowart, Juan Hamilton, Sarah Greenoush, eds., *Georgia O'Keeffe*, Washington, D.C., 1987, p. 203.

13. Cited by Alfred Morang, *Transcendental Painting*, American Foundation for Transcendental Painting Inc., Santa Fe, 1940.

Chapter 28

1. Cited by Willibald Sauerlander, "Un-German Activities," *New York Review of Books*, April 7, 1994.
2. Excerpt from a transcript of an artists' session held in New York, 1948, cited by Herschel B. Chipp, *Theories of Modern Art*, Berkeley, 1968.
3. Cited by Herschel B. Chipp, *ibid.*
4. Harold Rosenberg, "Getting Inside the Canvas," *Art News*, New York, Dec. 1952, pp. 22–23. Reprinted in Harold Rosenberg, *The Tradition of the New*, New York, 1959. Cited by Herschel B. Chipp, *Theories of Modern Art*, Berkeley, 1968, p. 580.
5. Clement Greenberg, "Abstract, Representation, and So Forth," in *Art and Culture*, Boston, 1961, pp. 133–38. Cited by Herschel B. Chipp, *Theories of Modern Art*, Berkeley, 1968, p. 579.

6. Clement Greenberg, *ibid.* Cited by Herschel B. Chipp, *Theories of Modern Art*, Berkeley, 1968, p. 580.
7. Jackson Pollock, *Arts and Architecture*, LXI, Feb. 1944, p. 193. Cited by Herschel B. Chipp, *Theories of Modern Art*, Berkeley, 1968, p. 546.
8. Willem de Kooning, from the symposium "What Abstract Art Means to Me," held at the Museum of Modern Art, New York, 1951.
9. Mark Rothko, "The Romantics were Prompted," *Possibilities I*, New York, Winter 1947/48, p. 84.
10. Francis Bacon, *Statements, 1952–1955* in *Time*, New York, 1952; 1953. Cited by Herschel B. Chipp, *Theories of Modern Art*, Berkeley, 1968, p. 620.

Chapter 29

1. Cited by Brydon Smith, *etc.* from *Dan Flavin*, exhibition catalog, The National Gallery of Canada, Ottawa, 1969, p. 206.
2. Cited by Barbara Haskell, *Agnes Martin*, exhibition catalog, Whitney Museum of American Art, New York, 1992, pp. 16, 17, 24.

3. Cited by Lucy Lippard, *Eva Hesse*, New York, 1976, p. 5.

Chapter 30

1. Jesse Helms, in *Art in America*, Sept. 1989, p. 39.
2. Cited in *Newsweek*, April 16, 1990, p. 27.
3. Cited by Linda Chase and Tom McBurnett, "Tom Blackwell," in "The Photo-Realists: Twelve Interviews," *Art in America*, Nov.–Dec. 1972, p. 76.
4. Cited in the *New York Times*, July 3, 1983.
5. Cited by Robert Storr, *Bruce Nauman*, catalog of The Museum of Modern Art, New York, 1995, p. 59.
6. Cited by Robert Storr, *ibid*, p. 55.
7. Nam June Paik, *Manifestos*, New York, 1966.
8. Jam June Paik, *ibid.*
9. Jam June Paik, *ibid.*
10. Vitaly Komar and Alexander Melamid, *Painting by Numbers*, New York, 1997, p. 6.
11. Vitaly Komar and Alexander Melamid, *ibid*, p. 8.

Literary Acknowledgments

Ch. 13, p. 588 John Ashbery, "Self-portrait in a Convex Mirror." Reprinted by permission of Georges Borchardt, Inc., for the author.

Ch. 17, p. 614 W. H. Auden, "Musée des Beaux-Arts" (1938), from *W. H. Auden: Collected Poems*. Copyright © 1940, 1952, and renewed 1968 by W. H. Auden. Reprinted by permission of Random House, Inc. and Faber & Faber, Ltd.

Ch. 25, p. 819 Wallace Stevens, "The Man with the Blue Guitar" (1937), from *Collected Poems*. Copyright © 1936 by Wallace Stevens and renewed 1964 by Holly Stevens. Reprinted by permission of Alfred A. Knopf, Inc., and Faber & Faber, Ltd.

Ch. 26, p. 848 Kazimir Malevich, from *The World as Non-objectivity: Unpublished Writings, 1922–25*, ed. Troels Andersen, trans. Xenia Glowacki-Prus. English translation copyright © 1976 Borgens Vorlag, Valby, Denmark.

Ch. 28, p. 886 Clement Greenberg, "Abstract, Representation, and So Forth," from *Art and Culture* (1961), pp. 133–38. Reprinted by permission of Beacon Press.

Ch. 29, p. 911 Agnes Martin, selections in Barbara Haskell, *Agnes Martin* (New York: Whitney Museum of American Art, 1992). Reprinted by permission of Pace Wildenstein for the artist.

Acknowledgments

Many of the line drawings in this book have been specially drawn by Taurus Graphics, Kidlington. Calmann & King Ltd. are grateful to all who have allowed their plans and diagrams to be reproduced. Every effort has been made to contact the copyright holders, but should there be any errors or omissions, they would be pleased to insert the appropriate acknowledgment in any subsequent edition of this publication.

14.7 From Peter Murray, *Renaissance Architecture*. New York: Harry N. Abrams, 1975. © Electa Archive, Milan, Italy.

18.5 From Lawrence Wodehouse and Marian Moffett, *A History of Western Architecture*. Mountain View, CA: Mayfield Publishing, 1989.

18.16, 20.21, 20.23 From Werner Blaser, *Drawings of Great Buildings*. Basel, Switzerland: Birkhäuser Verlag AG.1983. © Werner Blaser.

Picture Credits

Index